CW01067105

ART AND THE SENSES

ART AND THE SENSES

Edited by

FRANCESCA BACCI

Researcher, Center for Mind/Brain Sciences,
University of Trento, Rovereto (TN), Italy

and

DAVID MELCHER

Associate Professor, Center for Mind/Brain Sciences,
University of Trento, Rovereto (TN), Italy

OXFORD
UNIVERSITY PRESS

OXFORD
UNIVERSITY PRESS

Great Clarendon Street, Oxford OX2 6DP

Oxford University Press is a department of the University of Oxford.
It furthers the University's objective of excellence in research, scholarship,
and education by publishing worldwide in

Oxford New York

Auckland Cape Town Dar es Salaam Hong Kong Karachi
Kuala Lumpur Madrid Melbourne Mexico City Nairobi
New Delhi Shanghai Taipei Toronto

With offices in

Argentina Austria Brazil Chile Czech Republic France Greece
Guatemala Hungary Italy Japan Poland Portugal Singapore
South Korea Switzerland Thailand Turkey Ukraine Vietnam

Oxford is a registered trade mark of Oxford University Press
in the UK and in certain other countries

Published in the United States
by Oxford University Press Inc., New York

British Library Cataloguing in Publication Data
Data available

Library of Congress Cataloging in Publication Data
Data available

Typeset in Minion by Glyph International, Bangalore, India
Printed in Great Britain
on acid-free paper by
CPI Antony Rowe, Chippenham, Wiltshire

ISBN 978–0–19–923060–0

10 9 8 7 6 5 4 3 2 1

FOREWORD

SIÂN EDE

A book devoted to the Art and Science of anything immediately suggests a binary attitude to the way we consider the workings of the world and of ourselves in it. The categorizing of the five senses suggests a further attempt to take taxonomizing to possibly reductive extremes. The 'Art and the Senses' symposium, held in Oxford in 2006, examined those interfaces between art and science and between the senses, and, because all the speakers were exquisitely thoughtful academics, the level of interaction and the complexity of the discourse was profound, with each side exceptionally willing to listen to the other perspective and even subsequently announcing new approaches in forthcoming research. In this paper I look briefly at the way we communicate our experience of the senses and at the poetic language necessary to convey something of the felt physiological experience.

The experience of actually living in the world is multiply layered. We translate the input from discrete sense organs into a blur of embodied sensation and, because we are more than unself-conscious diatoms or zoophytes, we bring or 'bind' a range of associations acquired from memory to make sense of the prelinguistic experience, translating it more reflectively into what emerges as thought, and eventually even into self-conscious awareness of thought—and thence to the pronouncements we make in art history and scientific discourses. In humans, language is the key to this translation and by language I include art, besides the spoken and written word, symbolic systems where meaning is attributed to forms not literally associated with their referents. This is so even in science. The palaeontologist Steven Mithen has created a hypothetical framework for explaining the emergence of the human mind in later *Homo sapiens* (Mithen 1996). Over millions of years we developed four kinds of intelligence, he suggests—a natural history intelligence, a technical intelligence, a social intelligence, and more recently, the capacity for language. At some point in the evolution of the mind these separate facilities began to interact. The evolutionary psychologist Nicholas Humphrey proposes that the significant factor in an increased cognitive fluidity was the development of a capability to see into the minds of others, a consequence of advanced social intelligence. This internalized the communication processes which had taken place between individuals in a social group in the outside world and self-reflexively enabled the different domains in the individual's private mind to 'talk to' each other. An increasing facility with language may have been the critical factor: social

intelligence beginning to be invaded by non-social information, thereby making the non-social world available for consciousness to explore, with a consequently rich expansion of connective ideas (Mithen 1996). The ability to use language, both as a form of external social communication and as a means of internal cognitive thought-processing coincided with the compulsion to make art—generally thought to have occurred between 30 000 to 60 000 years ago (although new archaeological finds keep pushing the dates back). Our responses to objects in the world, then, are processed through a sequence which begins with the sensory stimulus, are made sense of through an internalized top-down/bottom-up feedback loop and may end with intelligent awareness in a kind of prelinguistic state, followed by self-conscious reflective thought, expressions both internalized and communicated to others through language and art.

This process has been beautifully illustrated in an essay by the writer and critic A. S. Byatt in *The Cambridge Companion to John Donne* (Byatt 2006). In considering the impact of this great seventeenth-century metaphysical poet, Byatt points out that her pleasure in Donne's complex poetic conceits comes not so much from their stimulus to her senses, as from the effort of the mental activity required to experience the full *intellectual* force of the metaphorical constructs. Metaphysical poets, she says, 'describe not images but image-*making*, not sensations but *the process of sensing*, not concepts but the *idea* of the relations of concepts'. [my italics]

On the one hand, Byatt's statement is surprising. Art, and, famously, Donne's ability to give a vigorous representation of the sensually, not to say, erotically charged, certainly directly communicate to our physical senses—and there are many equivalents in classical and romantic art, and even, too, in abstract, non-representational works which contain hints and disruptions. Why else do we sometimes feel that shiver up the spine, that *almost* palpable sense of 'qualia', the sense of being *almost* in the here and now, *almost* being able to smell the rose, feel the arrows, cry the tears?

In a contemporary visual equivalent, Jane Wildgoose presents a sensuous arrangement of objects with the heightened clarity afforded by a skilful use of digital photography which has an immediate physical appeal. Art isn't the real thing, but its sensuous imagery triggers a deeply felt physical response which stimulates the mind through the emotions, almost below the level of consciousness.

But Byatt takes this physical response to art yet further and analyses the way the mind reconstructs our physical responses into *mental* imagery, emphasizing that the more complex the metaphorical connections, the more deeply pleasurable they are. They are at their most exciting when in our minds we reconstruct new images, making new links beyond those already laid down in memory, forming a brand-new connection, a concept, or 'conceit'. All the best artists, whether visual or poetic, invent new ways of seeing, sometimes making arbitrary connections, visually and conceptually, surprising us to think freshly. The pleasure is at its most intense when we are able somehow to observe the workings of our own minds and those of the artist in the very act of new metaphorical connection-making. Sensory perceptions and intelligent conceptions combine. Different parts of the brain are involved in perceiving through the different senses, which then draw on memory to recreate new concepts, purely from thought. The secondary pleasure in Jane Wildgoose's images comes from our knowledge of the

fact that she is playing on imagery familiar in art history, from the *vanitas* paintings of the seventeenth century, which she has particularly studied (Fig. 1), and also through the symbols of death familiar to us from Victorian funeral ritual, all of which set up a cascade of association-making.

In addressing the effect of Donne's disparate image creation, Byatt pictures the reader's brain at work in bringing many layers of understanding together, describing 'millions of cells with connecting dendrites and long questing axons, some of which can cross into the opposite hemisphere of the brain.' At first sight, this appears to be purely the technical language of science—'cells', 'axons', 'brain'—but metaphors are unavoidable. Her language is both physically representational and intellectually loaded. 'Cells' themselves were so-named by Robert Hooke peering down his microscope and reminded of monks' separate enclaves. I'm not sure whether scientists at their microscopes would use Byatt's anthropomorphized active participle 'questing' to describe the presumably flailing axons, but that seems exactly what they are doing

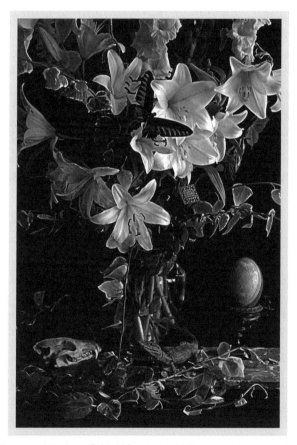

Fig. 1 Jane Wildgoose, *Vanitas Still Life at the Wildgoose Memorial Library*, 2005. (See Colour plate 1)

(photo: courtesy of the artist)

in her description. And 'hemisphere' is not quite technically or semantically correct if one considers the two walnut halves of the wrinkled cortex, but has a hint of association with that the other sphere we know, the earth itself—the brain/the world both forming complete circles containing all we know. It is hard to escape poetic conceits even in science.

The word 'dendrite' refers to a mineral crystallization in a branching or tree-like form inside another mineral bearing such a crystal formation, in a nerve-cell, the fine branch of a dendron. 'Dendrite' comes from New Latin, from the Greek for dendron or tree. The ramifications (literally) of this image are beautifully brought out in Andrew Carnie's artwork *Magic Forest*, in which the viewer wanders through an ethereal woodland of lacy winter trees, at once dreamlike and familiar, and suffused with the kind of poignant evanescence that is indicative of the artist's individual style (Fig. 2). The 'trees' are actually images of living brain cells viewed through a laser-scanning confocal microscope, drawn with the aid of computer-imaging techniques, stained with fluorescent dyes, and projected on to layers of fine fabric. We can sensuously enjoy the experience but also relish a new knowledge of the scientific processes and combine the two—our sensuous brain, our thinking brain operating together, flickering from thought to sensation and back, to widen our understanding.

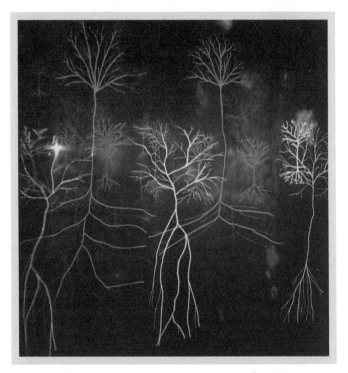

Fig. 2 Andrew Carnie, *Magic Forest*, 2001. (See Colour plate 2)

(photo: courtesy of the artist)

In unpacking the multiple layers of image-making—perceiving the object through one or multiple senses, feeling it physically with an implicit potential to act, internalizing it as a symbol or metaphor, bringing remembered associations into play and then re-creating a new concept or conceit—I would further surmise that the pleasure is the consequence of a release of endorphins, a small reward for seeing an unusual juxtaposition and then being creative with it. This occurred to me recently when I was talking to a physicist who was describing the immense satisfaction he felt when solving an equation. And it ties in with research undertaken by the neuroscientist V. S. Ramachandran, who, in attempting to systemize (rather in vain, I tend to think) a finite set of rules for what he calls 'neuroaesthetics', explains that when we identify an unfamiliar object from background noise (essential in crude survival terms) we are given a sensory reward, because perceptual processes link to the limbic system which controls emotions (Ramachandran and Hirstein 1999). How much richer is this experience if we now consider the extra intellectual pleasure we gain from the act of internal image-making itself and our self-conscious awareness of this process?

All this connection-making seems rather dense when we come to regard the five senses in their original Aristotlean separateness, because in our experience of life and art we do not think and feel in a modular way.

This is cleverly illustrated in a work that looks quizzically at the material science of sensual processing and turns it into art resonant with many meanings. In projects entitled 'Seeing' and 'Hearing' the artist Annie Cattrell worked with neuroscientists Steve Smith and Mark Lythgoe to capture fMRI (functional magnetic resonance imaging) digital data as brain images relayed while subjects were caught in the act of looking and listening, and then used Rapid Prototyping to transform these isolated processes into computerized virtual models (Fig. 3). Using three-dimensional computer information, stereolithography, the images were transferred through laser technology into a variety of different materials, such as wax, resin, and nylon, so they could be seen and felt as 'real'. Out of these she made waxy resin sculptures, embedding them in solid square 'brain-boxes' made of transparent hot-cure resin. These split-second images of the brain in the act of seeing and hearing are more than simply representational. They are the impenetrable made visual and tactile. As the viewer's own saccadic eye movements shift about the light and shine of the transparent materials, so the images continually change position and shape, the hi-tech imaging reflecting the hi-tech imaging of the observer's brain.[1] Here is a work that operates on many levels, then, using technology to yoke a sensual response to an intellectual concept—we feel, imagine, think, and learn at the same time—a rewarding piece of art-science metaphysics.

It is salutary to realize that one of the best ways of understanding the senses is through the work undertaken by neurologists and psychologists on people who have

[1] *Head On: art with the brain in mind*, catalogue for Wellcome Trust exhibition at the Science Museum, (London, The Wellcome Trust, 2002) curated by Caterina Albano, Ken Arnold, and Marina Wallace p. 38. Dr Mark Lythgoe assisted by suggesting ways of using the technology to realize the concept; Dr Steve Smith provided the fMRI scans, 3D Systems the Rapid Prototyping, and Hobarts the encapsulation of the models.

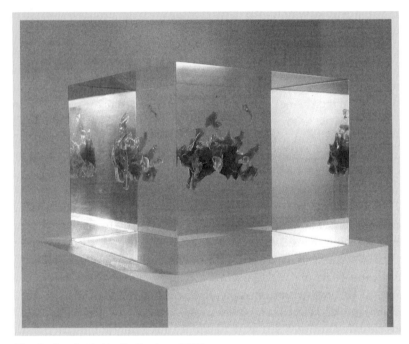

Fig. 3 Annie Cattrell, *Seeing*, 2001.

(photo: courtesy of the artist)

a deficit in particular ones. Such experiences can throw real insight into the workings of the normal mind. When such deficits are described as literature the language employed is not the language of logical explanation, the preferred language of science. It is, instead, a poetic discourse which affects the reader by eloquently describing visual images, affecting the emotions through heightened rhythms and cadences which reverberate silently in the mind, reaching the other senses through the imagination. Literary writing is an apt medium in which to reflect on the art and science of the senses, because threaded through the metaphor, simile and other vivid sensuous re-evocations are veins of rational presentation and contemplation, in an attempt to convey exactly what experience is like. Of particular interest is the way in which a deficit in one sense relies on imagery from the other senses to describe sensation.

The American poet and writer Stephen Kuusisto was born prematurely and suffers from the retinopathy of immaturity and also nystagmus, 'darting eyes'. He is not completely blind but sees the world through a blur of colour and motion. His book, *The Planet of the Blind*, describes his refusal to acknowledge his disability and his risk-taking struggle to maintain a normal life from childhood through to adulthood, even riding a bicycle and negotiating new cities on his own (Kuusisto 1998). The book is as much about failure and stubbornness as it is about depicting the world of the visually impaired, but it leaves a strong sensuous impression on the reader. Kuusisto is familiar with the visual arts through sporadic close-up studies of books, or through visiting

galleries with friends, and it is interesting how he speaks of his world-view in t
paintings:

Faces loom, adults are rising from the vista like sensate stones. These are gorgeous m
of not-seeing, moments red and green and black as the studios of Matisse. The moment
seriocomic: a white horse stands at the circus, no, it's a bed-sheet in the wind . . .

(Kuusisto 199

This is a good example of how a sensory 'bottom-up' perception is shaped throug
applying a 'top-down' rationalization when memory and a kind of internal logic ar
brought into play, and illustrates how much we impose our conceptions on our
perceptions in order to interpret what we are seeing.

Kuusisto goes on:

Dear Jackson Pollock, I've entered your *Autumn Rhythm*. The irregular or sometimes certain
flight of colour and shape is a wild skein, a tassel of sudden blue here, a wash of red. The
very air has turned to hand-blown glass with its imperfect bubbles of amethyst or hazel blue.
I stand on the ordinary street corner as if I've awakened at the bottom of a stemware vase. The
glassblower's molten rose has landed in my eyes . . .

His experience of the world also involves a compound of other sensory intelligences
focused around spatial orientation:

Delicate, skinny, inordinately active, I was sharpening a sixth sense that fostered the impres-
sion in my parents that I could see far better than I really could. Such acting requires a capa-
cious memory; in the gaudy nets of pastel colours where I lived, every inch of terrain had to
be accurately remembered. In the heart of every blooming and buzzing confusion, I found
a signpost, something to guide me back along my untutored path. . . I suppose this plum-
meting through the world involves the same inexplicable faith known to skydivers. Fast blind
people have exceptional memories and superior spatial orientation. By the age of five, I was
a dynamo. Wanting to see me run, my mother saw me run and guessed that I must be seeing
more than I really could. And so I landed like the bee who sees poorly but understands destina-
tion by motion and light and temperature.

The brain quickly reads sensory stimuli and brings ready-made meanings to the fore
to assist interpretation. The desire to make sense of things seems unavoidable, so much
so that given a few hints, we can imagine things that are not actually there. An auditory
equivalent of this top-down/bottom-up processing is amusingly described in Jonathan
Raban's sailing book, *Coasting*:

The engine, the engine. Its thump and clatter, all mixed up with the smell of diesel oil and the
continuous slight motion of the sea, is so regular and monotonous that you keep on hearing
voices in it. Sometimes when the revs are low, there's a man under the boards reciting poems
that you vaguely remember in a resonant bass. Sometimes the noise rises to the bright non-
sense of a cocktail party in the flat downstairs. At present, though, you're stuck with your usual
cruising companion at sixteen hundred revs, an indignant old fool grumbling in the cellar.

Where'd I put it? Can't remember. Gerroff you, blast and damn you. Where'd I put it? Can't
remember . . .

(Raban 1986)

, and speechless as the consequence of scarlet fever at the age of two,
describes her multi-sensory deprivation:

been at sea in a dense fog, when it seemed as if a tangible white darkness shut
e great ship, tense and anxious, groped her way towards the shore with plummet
ʒ-line, and you waited with beating heart for something to happen? I was like the
my education began, only I was without compass or sounding-line, and had no
ing how near the harbour was.

(Keller 1903)

riting here with eloquent hindsight using the image of the lost ship to give a
te sense of her sensory deprivation, but the isolation of her situation is more
ecause she had no language with which to articulate her feelings. Her first
on of the power of self-expression comes in a famous breakthrough. Her
teacher Anne Sullivan has been introducing her to language by getting her to
object and then spelling out the written word on her hand.

lked down the path to the well-house, attracted by the fragrance of the honeysuckle
which it was covered. Someone was drawing water and my teacher placed my hand under
spout. As the cool stream gushed over one hand she spelled into the other the word *water*,
rst slowly, then rapidly. I stood still, my whole attention fixed upon the motion of her fingers.
Suddenly I felt a misty consciousness as of something forgotten – a thrill of returning thought;
and somehow the mystery of language was revealed to me. I knew then that 'w-a-t-e-r' meant
the wonderful cool something that was flowing over my hand . . .

I left the well-house eager to learn. Everything had a name, and each name gave birth to a
new thought.

She was learning not simple vocabulary but setting down an understanding of
generic ideas which would bring in top-down processing to speed up her understand-
ing when she came across a new object. She goes on to understand the nature of
conceptual thinking:

I was stringing beads of different sizes in symmetrical groups – two large beads, three small
ones, and so on. I had made many mistakes, and Miss Sullivan had pointed them out again
and again with gentle patience. Finally I noticed a very obvious error in the sequence and
for an instant I concentrated my attention on the lesson and tried to think how I should
have arranged the beads. Miss Sullivan touched my forehead and spelled with decided
emphasis, 'Think.'

In a flash I knew that the word was the name of the process that was going on in my head. That
was my first conscious perception of an abstract idea.

We can see here how the senses are a route not simply to an animal sensation
but form part of a chain of intelligent and self-aware construction of the out-
side world.

The artist Alexa Wright effectively illustrates the brain at work where the body
sense ought effectively to be absent altogether in a project she undertook with neuro-
scientists and patients with phantom limb syndrome, which occurs where people who

have had amputations continue to experience sensations in the non-existent limb.[2] Neurologists understand that sensations arise as a result of a dynamic plasticity in the brain which allows it to re-map bodily awareness, often very soon after the limb has been removed. Areas on the cortex which formerly received sensory input from the amputated limb continue to be activated from parts of the brain on adjacent areas of the cortex linked to parts of the body surface close to the amputated limb, so it feels as if the limb is still there, though not always in a normal state. 'One man had a phantom arm fixed at right angles which he had to accommodate when passing through a door,' writes neuro-psychologist Peter Halligan, who with his colleague John Kew worked with Wright, 'another was plagued by his phantom arm floating up through the bedclothes when he was trying to sleep.'

The subjects of Wright's photographs were gratified to see their non-existent sensations made visible, and the neurologists claimed that this helped them to be more therapeutically accurate. Exhibited in conventional gallery spaces as art, the images are moving because of their paradoxical ordinariness, enabling viewers to share an intimate identification with the subjects' unconventional self-perceptions (Figs 4 and 5). That the brain can compensate for loss, even if in strange ways, that it can continue to alter and re-programme itself, is somehow both reassuring and surprising too. But though we are talking here of actual material plasticity with real change in brain tissue and the brain's capacity to invent and reinvent experience, it almost explains the flexibility and scope of the imagination.

In a work shown at Liverpool Biennial 2006 called *Outsidein*, the Norwegian artist Sissel Tolaas walked with Liverpuddlians from the north, west, south, and east of the city, and using high-end technology collected smells from the streets. She then took the smells back to her laboratory in Berlin where she used micro-capsulation to infuse micro-eggs with oils, which respond to touch or friction to be diffused into the atmosphere. This might be sensuous enough but Tolaas recognized the need to stimulate a higher, more introspective smell awareness through the use of a language which could be communicated further. For this part of the project she worked with linguist Andrew Hamer, who specializes in Liverpool's Scouse dialect, and asked the participants to describe the smells of their city. The resulting vocabulary is delightfully pungent, funny, and somehow accurately suggestive of Liverpuddlian character and of particular places in the city:

The smell of a filthy channel, for example is MOODO

a tobacco factory NEEK
lemonade OOR
a pub SMOUBEE

[2] Wellcome Trust sci-art report, September 1997; Wellcome News Supplement, *Science and Art* 2002; also conversations with the artist.

Fig. 4 Alexa Wright, *After Image*, 1997.

(photo: courtesy of the artist)

rubbish is BIISH
leather SKENN
take-away food TCKOO
natural flowers NIIS
a train TRAKEE
a caramel factory SUIIS

One cannot think about the effect of taste (and smell) without referring to the most iconic passage in literature, that describing Proust's sip of tea in which had been soaked a morsel of madeleine. The incident has become a touchstone for explaining the almost magical effect that taste and smell sometimes have on memory, evoking an immediate and vivid 'qualic' sensation of an often unlocatable sense of time past. In evolutionary respects smell is a primitive sense, and its receptors transmit signals to the olfactory bulbs that lie close behind, the most direct process system of any of the senses. This short pathway has direct links to the limbic system, which deals with vigilance and emotions, and there are also links to the hippocampus where memory is stored. However, there is no contact with the parts of the brain responsible for language or speech. This might explain why we have a limited vocabulary for smell

Fig. 5 Alexa Wright, *After Image (RD2)*, 1997.

(photo: courtesy of the artist)

beyond analogy (smells 'like') and why, like Proust, we often find it hard to locate the original source of a sudden waft of familiar perfume.[3]

Proust is a master in evoking the sensuous filtered through the intellect, so the pleasure is doubled. But it takes him four pages of close introspection to chase the original stimulus and the ripples it then sets up.

Here is Proust's initial moment:

I raised to my lips a spoonful of the tea in which I had soaked a morsel of the cake. No sooner had the warm liquid mixed with the crumbs touched my palate than a shiver ran through me and I stopped, intent upon the extraordinary thing that was happening to me. An exquisite pleasure had invaded my senses, something isolated, detached, with no suggestion of its origin. And at once the vicissitudes of life had become indifferent to me, its disasters innocuous, its brevity illusory – this new sensation having had the effect, which love has, of filling me with a precious essence or rather this essence was not in me, it *was* me.

[3] Marcel Proust, *In Search of Lost Time* (1913–27). Information on smell and memory is well described in Chapter 3 of Douwe Draaisma's compelling book on memory, *Why Life Speeds Up as You Get Older* (2006 Cambridge, Cambridge University Press).

In trying to locate the source of this overwhelming sensation, Proust takes a couple more sips but finds that the initial impact is becoming diluted, the memory still elusive. He tries to re-trace his thoughts, acknowledging how difficult it is to maintain a concentration on one's own thought processes, trying to give his mind a rest by distracting it and then searching within himself again.

It is interesting how Proust describes this memory pursual of one sensation in terms of the other senses:

I do not yet know what it is, but I can *feel it* mounting slowly; I can measure the resistance, I can *hear the echo* of great spaces traversed. Undoubtedly what is thus *palpitating* in the depths of my being must be the *image, the visual memory* which, being linked to that taste, is trying to follow it into my conscious mind. But its struggles are too far off, too confused and chaotic; scarcely can I perceive the neutral glow into which the elusive *whirling medley of stirred-up colours* is fused, and I cannot distinguish its form, cannot invite it, as the one possible interpreter, to translate for me the evidence of its contemporary, its inseparable paramour, the taste, cannot ask it to inform me what special circumstance is in question, from what period in my past life. [my italics]

The reader shares the tension, the effort required, until:

And suddenly the memory revealed itself. The taste was that of the little piece of madeleine which on Sunday mornings at Combray . . . my aunt Leonie used to give me, dipping it first in her own cup of tea or tisane.

He goes on to remark:

taste and smell alone, more fragile but more enduring, more immaterial, more persistent, more faithful, remain poised a long time, like souls, remembering, waiting, hoping, amid the ruins of all the rest; and bear unflinchingly, in the tiny and almost impalpable drop of their essence, the vast structure of recollection.

One doesn't have to be diagnosed as synaesthetic to recognize how the input from different sensual stimuli quickly blurs and is made sense of through multiple association. Language is second-hand (note the bodily metaphor there) to the immediate physical stimulus but it helps us combine an intellectual and creative response.

In considering simultaneously the Art and Science of the senses, the felt or imagined experience and the material processes involved, our minds cannot reconcile the ambiguity of such a dual approach, but there is pleasure in blending together physical understanding and an intellectual appreciation of how it works. The heightened language of poetry aids this exploration, bringing together the second-hand vigour of sensuous experience with an intellectual pleasure in making links and analogies to communicate feelings normally too deep for words.

REFERENCES

Byatt AS (2006). Feeling thought: Donne and the embodied mind. In A Guibbory (ed.) *The Cambridge Companion to John Donne*, pp. 247–58. Cambridge University Press, Cambridge.
Keller H (1903). *The Story of my Life.* Doubleday, New York.

Kuusisto S (1998). *The Planet of the Blind.* Faber and Faber, London.

Mithen S (1996). *The Prehistory of the Mind.* Thames and Hudson Ltd, London.

Raban J (1986). *Coasting.* Collins Harvill, London.

Ramachandran VS and Hirstein W (1999). The science of art: a neurological theory of aesthetic experience. *Journal of Consciousness Studies,* **6–7**, 15–51.

CONTENTS

Foreword v

List of Contributors xxiii

 Editors' Introduction 1

1. Making Sense of Art, Making Art of Sense 9
 FRANCESCA BACCI IN CONVERSATION WITH
 ACHILLE BONITO OLIVA

2. The Science and Art of the Sixth Sense 19
 NICHOLAS J. WADE

3. The Art of Touch in Early Modern Italy 59
 GERALDINE A. JOHNSON

4. The Multisensory Perception of Touch 85
 CHARLES SPENCE

5. Aesthetic Touch 107
 ROSALYN DRISCOLL

6. Rendering the Sensory World Semantic 115
 ELIO FRANZINI

7. Sculpture and Touch 133
 FRANCESCA BACCI

8. Touch and the Cinematic Experience 149
 JENNIFER M. BARKER

9. Hearing Scents, Tasting Sights: Toward a Cross-Cultural
 Multimodal Theory of Aesthetics 161
 DAVID HOWES

10. The Science of Taste and Smell 183
 TIM JACOB

11. 'Sound Bites': Auditory Contributions to the Perception and
 Consumption of Food and Drink 207
 CHARLES SPENCE, MAYA U. SHANKAR, AND HESTON
 BLUMENTHAL

12. Thinking Multisensory Culture 239
 LAURA U. MARKS

13. Sighting Sound: Listening with Eyes Open 251
 SIMON SHAW-MILLER

14. The Sight and Sound of Music: Audiovisual Interactions
 in Science and the Arts 265
 DAVID MELCHER AND MASSIMILIANO ZAMPINI

15. Improvisation in Time: The Art of Jazz 293
 DAVID MELCHER INTERVIEWS GREG OSBY AND
 SKIP HADDEN

16. Musical Tension 311
 CAROL L. KRUMHANSL AND FRED LERDAHL

17. Cause and Affect: A Functional Perspective on Music
 and Emotion 329
 GUY MADISON

18. The Mystery of Representation: A Conversation
 with Vik Muniz 351
 VIK MUNIZ AND DAVID MELCHER

19. Pictorial Cues in Art and in Visual Perception 359
 DAVID MELCHER AND PATRICK CAVANAGH

20. The Many Dimensions of the Third One 395
 RUGGERO PIERANTONI

21. Film, Narrative, and Cognitive Neuroscience 435
 JEFFREY M. ZACKS AND JOSEPH P. MAGLIANO

22. Mirror Neurons and Art 455
 VITTORIO GALLESE

23. Pictorial Art Beyond Sight: Revealing the Mind of a
 Blind Painter 465
 AMIR AMEDI, LOTFI B. MERABET, NOA TAL, AND
 ALVARO PASCUAL-LEONE

24. Visual Music in Arts and Minds: Explorations
 with Synaesthesia 481
 JAMIE WARD

25. Visual Music and Musical Paintings: The Quest for
 Synaesthesia in the Arts 495
 CRETIEN VAN CAMPEN

26. Dance, Choreography, and the Brain 513
 IVAR HAGENDOORN

27 Neuroaesthetics of Performing Arts 529
 BEATRIZ CALVO-MERINO AND PATRICK HAGGARD

28. Multisensory Aesthetics in Product Design 543
 HENDRIK N. J. SCHIFFERSTEIN AND PAUL HEKKERT

29. Architecture and the Body 571
 ALBERTO PÉREZ-GÓMEZ

30. Architecture and the Existential Sense: Space, Body,
 and the Senses 579
 JUHANI PALLASMAA

31. Multimodal, Interactive Media and the
 Illusion of Reality 599
 ELENA PASQUINELLI

 Index 619

List of Contributors

Amir Amedi Physiology Department, Faculty of Medicine, The Hebrew University of Jerusalem, Jerusalem, Israel

Francesca Bacci Centro Interdipartmentale Mente/Cervello University of Trento, Palazzo Fedrigotti, Corso Bettini 31, 38068 Rovereto (Trento), Italy

Jennifer M. Barker Moving Image Studies, Department of Communication, Georgia State University, 1047 One Park Place, Atlanta, GA 30302, USA

Heston Blumenthal The Fat Duck Restaurant, High Street, Bray, Berks SL6 2AQ, UK

Beatriz Calvo-Merino Departamento de Psicologia Basica II: Procesos Cognitivos, Universidad Complentense de Madrid, Spain & Department of Psychology, City University London Northampton Square EC1V OHB, London, UK

Patrick Cavanagh Vision Sciences Laboratory, Department of Psychology, Harvard University, 33 Kirkland Street, Cambridge, MA 02138, USA

Rosalyn Driscoll One Cottage Street, Easthampton, MA 01027, USA

Siân Ede, Calouste Gulbenkian Foundation (UK), 50 Hoxton Square, London, N1 6PB, United Kingdom

Elio Franzini Dipartimento di Filosofia, Università degli Studi di, Milano, Via Festa del Perdono 7, 20122 Milano, Italy

Vittorio Gallese Department of Neuroscience, Section of Physiology, University of Parma, Via Volturno, 39/E, 43100 Parma, Italy

Ivar Hagendoorn www.ivarhagendoorn.com

Patrick Haggard Institute of Cognitive Neuroscience & Dept of Psychology, Alexandra House, 17 Queen Street, London, WC1N 3AR, UK

Paul Hekkert ID Studio Lab, Delft University of Technology, Landbergstraat 15, 2628 CE Delft, Netherlands

David Howes Dept of Sociology & Anthropology, Concordia University, 1455 de Maisonneuve, boulevard West, Montréal, Québec, Canada, H3G 1M8

Tim Jacob School of Biosciences, Biomedical Building, Cardiff University, Museum Avenue, Cardiff CF10 3US, UK

Geraldine A. Johnson Department of History of Art, University of Oxford, Oxford OX1 1PT, UK

Carol L. Krumhansl Department of Psychology, Cornell University, 214 Uris Hall, Ithaca NY 14853-7601, USA

Fred Lerdahl Department of Music, Columbia University, 621 Dodge Hall, 2960 Broadway, New York, NY 10027, USA

Guy Madison Department of Psychology, Social Sciences Building, Umeå University, S-901 87 Umeå, Sweden

Joe Magliano Department of Psychology, Northern Illinois University, DeKalb IL 60115, USA

Laura U. Marks Art and Culture Studies, Simon Fraser University, 8888 University Drive, Burnaby BC, Canada V5A 1S6

David Melcher Faculty of Cognitive Sciences, University of Trento, Corso Bettini, 31, Rovereto, Italy

Lofti B. Merabet Laboratory for Magnetic Brain Stimulation, Beth Israel Deaconess Hospital, Department of Neurology, 330 Brookline Avenue, Boston MA 02215, USA

Vik Muniz 47 Lexington Avenue, New York, NY 11238, USA

Juhani Pallasmaa Architect, Juhani Pauasmaa Architects, Helsiuki

Alvaro Pascual-Leone Laboratory for Magnetic Brain Stimulation, Beth Israel Deaconess Hospital, Department of Neurology, 330 Brookline Avenue, Boston MA 02215, USA

Elena Pasquinelli Institut Jean Nicod, UMR 8129, Pavillon Jardin, Ecole Normale Supérieure, 29, rue d'Ulm, F-75005 Paris, France

Alberto Perez-Gomez School of Architecture, McGill University, Macdonald Harrison Building, 815 Sherbrooke Street West, Montreal, Quebec H3A 2K6, Canada

Ruggero Pierantoni Visiting Professor, Dizraeli School of Architecture, Carleton University, Ottawa, CA.

Hendrik N. J. Schifferstein ID Studio Lab, Delft University of Technology, Landbergstraat 15, 2628 CE Delft, Netherlands

Maya U. Shankar Department of Experimental Psychology, University of Oxford, South Parks Road, Oxford, OX1 3UD, UK

Simon Shaw-Miller Department of History of Art and Screen Media, Birkbeck College, University of London, 43 Gordon Square, London WC1H 0PD

Charles Spence Department of Experimental Psychology, University of Oxford, South Parks Road, Oxford OX1 3UD, UK

Noa Tal Physiology Department, Faculty of Medicine, PO Box 12272, The Hebrew University of Jerusalem, Jerusalem 91220, Israel

Cretien van Campen Synesthetics Netherlands, Rubicondreef 20 3561 JC Utrecht, The Netherlands

Nicholas J. Wade Department of Psychology, University of Dundee, Nethergate, Dundee DD1 4HN

Jamie Ward School of Psychology, University of Sussex, Falmer, Brighton, BN1 9QH

Jeffrey M. Zacks Department of Psychology, Washington University in St Louis, One Brookings Drive, St. Louis, MO 63130-4899, USA

Massimiliano Zampini Faculty of Cognitive Sciences, University of Trento, Corso Bettini 31, Rovereto, Italy

EDITORS'
INTRODUCTION

THE senses are our source for vital knowledge about the objects and events in the world, as well as for insights into our private sensations and feelings. Each sense is unique, in terms of subjective feelings and regarding the array of information that it yields, yet each sense interacts with the others to produce experiences that cannot be reduced to a single sense. In addition, our sensory perception reflects our personal history, our culture, and the way that our brain has learned to combine sensory inputs. In this book, as in life, no sense is privileged over another. No sense exists in isolation from the other senses, the body, and one's personal experience in a specific culture.

Just as there are multiple senses, there are also multiple approaches to the study of the senses. The arts, humanities, and the sciences provide different methodologies for investigating the world and our relationship to it. In order to reflect the contribution of these different fields, this book includes an approximately equal number of artists, scientists, and humanist scholars. These essays provide a compelling argument for multi- and interdisciplinary research. Both the convergence and, equally important, the divergence found in these essays provide a snapshot—from a particular time period and from specific points of view—of sensory research in each discipline.

This collection of essays explores some of the issues raised in a 2006 workshop in Oxford, England, entitled 'Art and the Senses'. Approximately half of the chapters have been written by speakers or participants at that workshop. While not all interdisciplinary workshops are successful, the participants at the Oxford meeting were unusually open and engaged in learning together about the issues of common interest across the various disciplines. This book builds on that openness, daring to include in the same volume essays by scientists, architects, art historians, a cultural anthropologist, musicians, visual artists, a chef, a choreographer, and many others. This could have easily resulted in a confused mess. Instead, we hope that the reader will see that there are common threads that weave in and out of many of the essays and will find new connections beyond those envisaged by the contributors of this book. The aim

of this project, in addition to providing a unique multidisciplinary resource on the senses, is to inspire future cross-boundary interactions. As we hope these essays make clear, multidisciplinarity, like multisensoriality, can offer a richer perception than that available from any single point of view.

It is impossible, in one volume, to fully do justice to both the breadth and depth of sensory studies. Instead, this book offers a collection of examples on how scientists, artists, and scholars in the humanities are investigating and commenting on the senses. Every book is necessarily limited in scope, and this is no exception. Perhaps foremost is the lack of a clear definition of 'art', which means that different contributors will bring different conceptions of what is or is not art, so that certain boundaries in scope are necessarily arbitrary. Undoubtedly, there are unavoidable exclusions in this collection, such as the limited coverage of literature (addressed only in Siân Ede's preface). Any exclusion, in terms of subject matter or methodology, should not be interpreted as a theoretical statement about art or the senses in general, but as a pragmatic editorial choice. In the case of literature, for example, there are already numerous resources exploring the topic of literary representations of perceptions. Starting with the seminal statement by Horatio, *ut pictura, poësis*, history is replete with theories of the ongoing debate on the relationship between the written and spoken word and its representation, all the way to Lessing, Nietzsche, and to contemporary scholars such as W.J.T. Mitchell.

Common themes

During the 'Art and the Senses' workshop, a number of common themes that cut across the disciplines emerged. These connections surfaced despite many obstacles, such as significant differences in how certain terms are used across academic fields, and became the focus point of discussions and, in several cases, interdisciplinary collaborations which continued beyond the final day of the workshop. We offer a few of these themes here, but hope that readers will discover new connections and ideas from their own personal reading of this collection.

The first common theme, which motivated the initial organization of the workshop, was a perceived consonance across various fields in reconsidering the value of the body and the senses of taste, touch, and smell. Contemporary art practice has already explored and exploited a multisensory approach. Art history, on the other hand, has largely tended towards privileging the visual, both through the more recent inclusion of 'visual culture' as a field of study and through its traditional, if criticized, ocularcentic approach. Among the humanistic disciplines, social sciences, critical studies and anthropology have been open to a diverse approach, which include a sensory-oriented reading of their subject (see, for example, *The Empire of the Senses: The Sensual Culture Reader*, edited by David Howes). In science as well, perception

is no longer synonymous with vision, even if reading most psychology textbooks would still lead to the idea that humans have only eyes or, occasionally, little-used ears. The focused effort to investigate multisensory perception is evidenced by birth of the International Multisensory Research Forum (IMRF) in 1999 and the publishing of *The Handbook of Multisensory Processes* in 2004. Such research has led to a major revision in the way that the senses are conceived of and studied in the mind/brain sciences.

A second theme is embodiment. Contemporary artists are exploring, in various ways, the nature of the body as a physical object, a cultural construct, and as a component of our personal self. Cognitive psychology and neuroscience have also seen the emergence of theories that challenge, via an 'embodied' and/or 'situated' cognition, a perceived flaw in traditional cognitive science (for reviews, see Clark 1997; Lakoff and Johnson 1999; Weiss and Haber 1999). Currently, scientists are considering aspects of cognition that go beyond earlier metaphors of a 'brain in a vat' (no body, no emotions) or an abstract, symbolic system for computation. Many of the essays here reflect this movement within the cognitive sciences.

A third major theme, across the collection, is the role of learning and experiencing in shaping the way that people use their senses. This is not a particularly new idea in the humanities, which unfailingly start their investigations from the specific place, period, and culture of pertinence, but in the cognitive sciences the role of experience in shaping our sensory perception, as opposed to the role of our senses in shaping our experience, is receiving increasing interest. Many of the essays in this book examine the importance of flexibility and experience in influencing the way that the senses are actively used by individuals in a particular cultural context. The concept pioneered in 1972 by art historian Michael Baxandall, who discussed the reception and interpretation of visual arts as affected by what he called the 'period eye', summarizes how what we see is influenced by context and previous experiences, an intuition now further underpinned by the result of the scientific studies mentioned earlier. One can view this flexibility—in terms of sensitivity to social cues and experience—as one of the great strengths of the human mind.

A fourth theme is the role of art in making us more aware of our senses. As discussed by many of the authors, sensory perception is typically used as a means to an end—to guide action, to recognize objects, to enable social interaction, and so on. Art can provide a context—a defined space and time—in which to sense our sensations themselves, rather than just the object of the sensations. Touch, given its interactive and temporally extended nature, is one sense that lends itself to the experience of the development of sensation-in-time, but the other senses can be active as well. Smell perception incorporates the active seeking (sniffing) of odorous molecules, while taste requires putting something in our mouth. Auditory art, in particular the interplay between performer/composer and audience, evolves over shared time. Visual artists such as Vik Muniz deliberately present challenges and ambiguities to our fast visual recognition system, in order to make us 'feel' our visual sense. Art allows us to experience more directly our sensations without being distracted by function: rather than 'art for art's sake', we might think more broadly in terms of 'sense for sense's sake', through the experience of art.

THE COLLECTION

The order of the essays in the book is loosely related to the sense, or senses, of interest. We start with the body sense, moving then to the 'chemical senses' of taste and smell, then to audition and vision. Essays in the final part of the book touch on synaesthesia and the multisensory arts. The problematic relationship between sculpture and touch provides a clear example of the ways in which history, culture, and economic interests can shape our sensory relationship to specific artworks. In her essay, Rosalyn Driscoll describes how she has personally taken up the challenge, as an artist, of creating sculptures that are specifically made to be touched rather than hidden behind a glass vitrine and an alarm system. Geraldine Johnson provides an historical analysis of the relationship between sculpture and touch during the Renaissance, when theoretical debates on the superiority of the different forms of knowledge and on the hierarchy of the various art media flourished. In 'The Multisensory Perception of Touch', Charles Spence reviews recent scientific research which, together, argues that our experience of touch depends strongly on what we see, hear, and smell during our haptic interaction with the material surface. Nicholas Wade surveys the history of the senses, noting the arbitrariness in choosing a 'number' of senses, and showing that, in many cases, popular (mis)understanding or appeals to authority have played a greater role in numbering the senses than scientific data. Elio Franzini surveys the history of aesthetics in Western thought, focusing in particular on how ideas about the aesthetic values of touch and vision have changed over time. As Jennifer Barker notes, touch can become involved even in experiences, such as watching a film, which artificially limit the sensory stimulation to visual and auditory signals. She examines touch and the cinematic experience using the film *Street of Crocodiles* (1986) as a case study on the tactile and visceral interaction between the viewer and the film.

Like touch and the body senses, smell and taste are ancient and deeply embodied sources of powerful interactions with the environment and our own past. David Howes provides a number of examples from anthropology of how the senses can interact in non-Western cultures. The scientific underpinnings of taste and smell are reviewed by Tim Jacob, whose essay clearly describes both the great strides in our understanding of these systems and the many unanswered questions that remain. The perfect marriage of science and (culinary) art is exemplified by the collaborative work between scientists Charles Spence and Maya Shankar, and celebrated chef Heston Blumenthal. Blumenthal's restaurant The Fat Duck is consistently rated among the best in the world, and his cuisine investigates how the multisensory experience of flavour is influenced by our personal expectations and cultural history. Often unbeknownst to us, a Fat Duck dinner's taste is the result of countless hours of experimentation, both in the kitchen and in scientific laboratories. The results of some of these recent studies, which examine how sound and expectations influence the experience of eating, are described and placed in the context of scientific research on multisensory interactions between audition and taste. Laura Mark's essay, which includes olfactory stimuli as 'illustrations', argues for the importance of taste, smell, and touch in epistemology,

aesthetics, and even ethics: areas in which verbal and written/pictured information have traditionally been considered dominant. It re-examines the 'sensory hierarchy' that has devalued the proximal senses. While exalting the relatively neglected values of the proximal senses, her essay also considers the hidden dangers of uncritically embracing a reversed sensory pyramid with smell and taste now at the top. For example, the re-emergence of smell and taste also reflects marketing strategies to sell, for example, an artificially scented dish-soap or expensive coffee drink. Such products provide quick doses of sensory pleasure so that today's busy consumer can fulfil this need outside of his/her sensorially sanitized workplace.

The link between science and the arts might be most fully explored in the realm of music. Simon Shaw-Miller's essay considers the interactions between auditory and visual aspects of performance. David Melcher and Massimiliano Zampini review research on how certain features of sound and sight are more likely to be combined than others, and this finding has interesting implications for how auditory stimuli are used in the arts. The chapter entitled 'Improvisation in Time: The Art of Jazz' combines interviews with two musicians working within the tradition of jazz and, more generally, creative improvisational music: drummer Skip Haden and saxophonist Greg Osby. These two musicians, in addition to performing at the highest level in their field, are dedicated teachers. Thus, in addition to sharing personal experiences and anecdotes from smoky jazz clubs and high-tech recording studios, both musicians contribute insights from their years of theoretical investigations into the nature of music and creativity. Scientists Carol Krumhansl and Fred Lehrdahl report on recent experiments which test a computational model of musical tension. In addition to providing a case study on how cognitive psychology has developed theories that predict and explain aspects of music, this essay emphasizes the way that composers and musicians have developed strategies to take advantage of our expectations of what will come next in a musical piece. Guy Madison's essay tackles the fundamental question: why is music such a popular and powerful medium? Music would seem, at first glance, a surprising and costly way to spend one's time, rather than caring for more pressing needs which show clear 'adaptive' value (in terms of evolution). Madison critically reviews evidence for the main theories, ranging from suggestions that music is just 'auditory cheesecake' serving no real evolutionary purpose, to other theories which attribute an important role to musical sensitivity in language development, in consolidating social bonds, or in choosing a mate.

Like music, visual art is ubiquitous across cultures yet offers a bewildering diversity in style. This combination of cultural specificity and cross-culturality provides a real challenge to scholars investigating the arts. Artist Vik Muniz answers questions about his investigations into the nature of representation and vision itself. David Melcher and Patrick Cavanagh provide a review of the visual 'cues' which can be used by artists in creating two-dimensional images. In his essay, Ruggero Pierantoni surveys the history of pictorial cues to depth. From a fantasy encounter with a deceased scientist, to an erudite excursion through Roman and Renaissance artworks, Pierantoni follows his reasoning like a detective, seeking to recompose the puzzle of depth perception from a series of historical and visual cues.

Indeed, there is more to understanding vision than the static, pictorial marks used in drawing or painting: our real environment is dynamic. As Jeff Zacks and Joe Magliano describe in their essay, when viewing a movie our brain interprets the flow of images in terms of meaningful events. Their work, which brings together textual analysis and neuroimaging, provides a fascinating case study on neuroscience and the arts. An interview with Vittorio Gallese examines the role of 'mirror neurons' in the understanding, via vision, of the bodily actions of others. This much-publicized discovery needs a careful contextualization in order to fully illuminate its possible consequences on the cultural world. Here Gallese explores how a sense of shared embodiment can form the basis of a common understanding of art as a universal human expression. The role of art in understanding the nature of perception is further illustrated by research examining the brain activity of a blind painter, described by scientists Amir Amedi, Lofti Merabet, Noa Tal and Alvaro Pascual-Leone. Through their work, they provide a thoughtful and entertaining look into the mind (and brain) of a visual artist who happens to have been blind from birth.

The synaesthetic nature of perception is explored in more detail in essays by Jamie Ward and Cretien van Campen. In the first of these, Ward gives an overview of scientific research on synaesthesia, including recent, cutting-edge work showing experimental and neural evidence for this fascinating condition. True synaesthesia involves a perceptual experience of a feature which is not actually carried by that stimulus, such as 'tasting' a particular shape or hearing sounds when viewing a colour. Ward and van Campen argue for the importance of synaesthesia as a source of evidence for understanding the mechanisms of perception in all persons, including non-synaesthetes. Multisensoriality is also an important feature of dance, which involves the artful organization of body movements. Across cultures, people have reacted to music or even basic patterns of percussion by moving their bodies. Dance as an art form, in addition to as a popular pastime, is the subject of two essays that link dance to scientific studies of the human motor system. In the first essay, Ivar Hagendoorn describes how his choreographic work is influenced by theories from cognitive neuroscience. The link between dance and the brain is further explored by neuroscientists Beatriz Calvo-Merino and Patrick Haggard.

The final essays in this collection examine the role of senses in design and architecture. Rick Shifferstein and Paul Hekkert guide us through a process of design that is motivated by the senses and not just functionality. Likewise, planning a building, from the exterior to the interior, involves a set of decisions that can work with, or against, the ways in which people tend to interact with their surrounding space. Influential architectural historian Alberto Pérez-Gómez and archi-star Juhani Pallasmaa have each contributed an essay on multisensory architecture. The final paper in the collection, by Elena Pasquinelli, brings the study of the senses to the present, and indeed the future, by considering the digital sensorium: our physical body in a virtual environment.

ACKNOWLEDGEMENTS

The editors thank the following for funding and assistance with the 'Art and the Senses' workshop and art exhibitions: the Wellcome Trust, Quest International, Science Oxford and the Institute for Historical and Cultural Research–Oxford Brookes University. Many thanks to the commissioning editor Martin Baum, and to Martin Kemp, Charles Spence, and Marius Kwint for useful discussion in planning the workshop and book.

Francesca Bacci would like to thank the Centre for Visual Studies (Department of the History of Art, Oxford University), the Center for Mind/Brain Studies (CIMeC, University of Trento, Italy), and the MART museum of Rovereto for support during the writing and editing process.

David Melcher thanks the Center for Mind/Brain Sciences (CIMeC) at the University of Trento, the Brain and Cognition Laboratory (Oxford University), the Laboratoire de Physiologie de la Perception et de l'Action (College de France), and the Department of Psychology at Harvard University for providing various resources (particularly space and much needed time) to the editing and revising of the essays in the book.

Thanks to our families for their support, and to Chiara Sophie, especially, for inspiration.

REFERENCES

Calvert GA, Spence C, and Stein BE, eds (2004). *The Handbook of Multisensory Processes.* MIT Press, Cambridge, MA.

Clark A (1997). *Being There: Putting Brain, Body and World Together Again.* MIT Press, Cambridge, MA.

Howes D (ed.) (2005). *The Empire of the Senses: The Sensual Culture Reader.* Berg, Oxford.

Lakoff G and Johnson M (1999). *Philosophy In The Flesh: the Embodied Mind and its Challenge to Western Thought.* Basic Books, New York.

Weiss G and Haber HF, eds (1999). *Perspectives on Embodiment: The Intersections of Nature and Culture.* Routledge, New York.

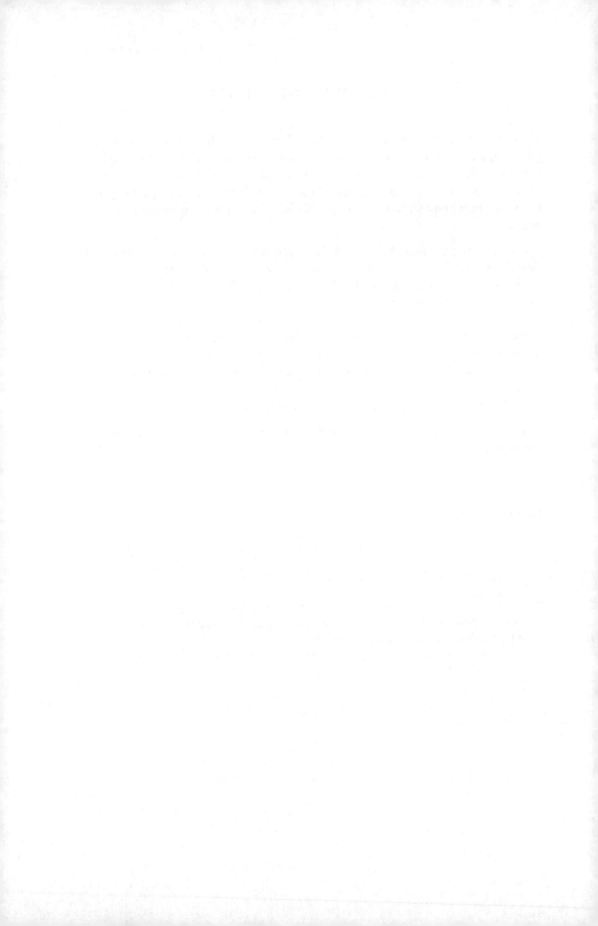

MAKING SENSE OF ART, MAKING ART OF SENSE

FRANCESCA BACCI IN CONVERSATION WITH ACHILLE BONITO OLIVA

Francesca Bacci (F.B.): The image that opens this conversation is a work by Ella Clocksin, titled *Touch together* (2006), featured in the 'Art and the senses' exhibition in Oxford (Fig. 1.1).It looks remarkably like skin but is made of plastics, nylon, and polyester thread. In the words of the artist, 'skin's tactile intelligence provides a highly sensitive interface for non-verbal communication, especially so for new babies who cannot yet make sense of what they hear or see.' Besides being a powerful reminder of the fact that we wear our most expansive sense organ at all times, Clocksin chose to emphasize our nature as feeling creatures, by excluding the wearer's body, and at the same time evoking it through the mother and infant-sized garments. Our sentient nature is inseparable from—and in fact defines—who we are.

Using this as a starting point, I would like to ask: when I say the word 'multisensory', which artists or specific artworks do you think about?

Achille Bonito Oliva (A.B.O.): I think about Beuys, who worked with a multiplicity of languages, I think about works by the group Gutai, and then by artists belonging to the movement Fluxus. In general I think about artists who activated practices of tres-passing, I would say, lingering in the passage from a contamination of materials, tech-niques, and languages, such as Nam June Paik, and more recently Claus Rinke, Marina

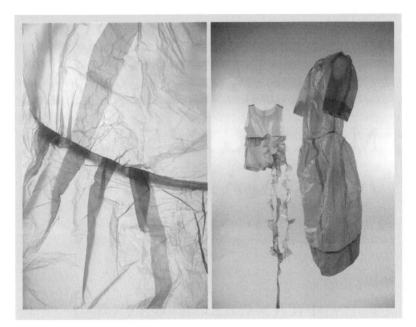

Fig. 1.1 Ella Clocksin, *Touch Together*, 2006.

(Photographs: Ella Clocksin.)

Abramovic, Vito Acconci. All these artists have worked on this 'art of trespassing', investing their own body in a performative yet personal way, to the point of mutilation or masturbation. Vito Acconci did a gallery performance where he masturbated; Marina Abramovic cut herself with knives. Naturally also Viennese Actionism, with its protagonists Günter Brus, Hermann Nitsch, and Rudolf Schwarzkogler, comes to mind.

F.B.: I am often intrigued by artists who choose to address mainly the most neglected senses, such as taste and smell, because often the use of edible material as an art medium operates a sort of displacement. I am thinking, for example, about another piece that was exhibited in the Oxford show 'Art and the Senses'. It was *The Radcliffe Camera as a Celebration Cake* (2006), by Helen Ganly and Heather Peers.

Modelled in the shape of one of the most iconic buildings in Oxford, this work was made of brandy, butter, sugar, eggs, flour, and milk and covered in icing sugar. It conjured up an ethereal architectural form that could be smelled, tasted, viewed, and touched—and challenged the aura of grandeur and eminence characteristic of the real building. At the same time, the case around it hinted at its inaccessibility, like the horizon in the landscape. Due to its perishable nature, this work provided also a brilliant commentary on the special attention commanded by objects on the brink of disappearance, and on the fact that stone, too, is destined to turn into dust one day.

A.B.O.: There have been terrific artists who worked with chocolate (like Meret Oppenheim in the U.S.), which stimulate olfactory and touch senses, and also indirectly

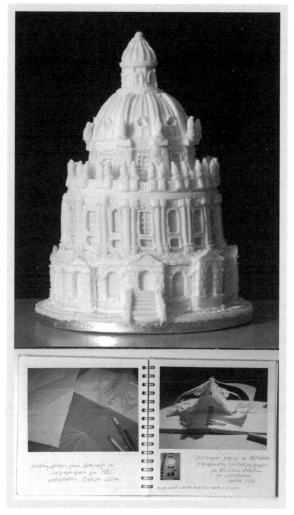

Fig. 1.2 Helen Ganly and Heather Peers, *The Radcliffe Camera as a Celebration Cake and its Workbook*, 2006.

(Photographs: Keith Barnes.)

the sense of taste. Also Mondrian did some works with candy and sugar cubes. The first to do it, at least conceptually, was Marcel Duchamp, who made an actual cage with sugar cubes. Only they were made of marble! Almost a sculptural *trompe-l'oeil*. It is possible to evoke the senses of smell and taste through the visual channel with painting, as, for example, in seventeenth-century still-life paintings made in the Netherlands or in Naples. They are a feast for the sight, but they also serve to mentally excite the senses of smell and taste—fruit, flowers—you can go all the way down to contemporary, with Mario Merz, who worked on still life with his spiral tables on which he placed fruit. He then left it there until it decayed completely, to putrefaction. Even Jannis

Kounellis worked with meat, starting from the example of Rembrandt's painting with the quarter of an ox. In his case, though, the quarter of beef was really exhibited.

F.B.: It seems to me that, in the past few years, contemporary art has undergone a multisensory turn, concerning itself with maximizing its expressive powers by investing several sensory modalities simultaneously, rather than sublimating its entire message through sight. Is the era of ocularcentrism over?

A.B.O.: After the 'anorexia of the image' caused by the digital era and the internet, after conceptual art, now we are witnessing a polysensory comeback, in order to give real foundations to what we see through its materiality, its technical explicitness, and also with elements that reach beyond the traditional limits of the medium (for example, *trompe-l'oeil*). Now we have the presentation of materials rather than their representation—real materials.

F.B.: True, but yet, interestingly, parallel to the sensory impoverishment caused by the digitalization of the image and the consequent loss of its physicality, there is an increasing physical distance between some artists and their works. Many sculptors today do not come in contact with their own work, rather they are detached from it since its conception, preferring to entrust 'fabricators' with the realization of their pieces.

A.B.O.: But that is fine. That is because they present themselves as designers, project-makers, so they build a visual machine that then gets delivered, to reveal itself to the life of the spectators. There is project but not execution—but effectively the result is three-dimensional, material.

F.B. Sculpture especially, it seems to me, is well suited to encapsulate an array of sensory stimuli in one object. I remember one group of sculptures by Carole Andrews, called *Sentinels* (2005) (Fig. 1.3).

Shaped as a group of tall conifers, the work was constructed in roofing felt, finely pleated and worked into a complicated surface using an embroidery technique known as smocking. A noticeable odour of bitumen exuded from the surface, creating a mental oxymoron between the industrial and natural attributes of the piece. To one's surprise, an unexpected sound of quiet breathing could be heard when hugging these tree-like black forms, which made them feel uncannily alive.

This taps into a well-established trend of today. In the past, the senses were used by perceivers to capture as much of a percept as possible, since their survival depended on the amount of information gathered and on their accuracy. Today, we are subjected to a continuous sensory 'attack', with information competing for our attention all the time—different realities, including art, strive to be perceived, almost throwing themselves in the public's face. For the purpose of 'visibility', it seems that artworks that feature multisensory stimuli may have a greater chance of being noticed by the public. Do you share my impression that embedding multisensoriality as a characteristic of the work is a conscious goal pursued by contemporary artists (as synaesthesia or *Gesamtkunstwerk* used to be in Romantic times)?

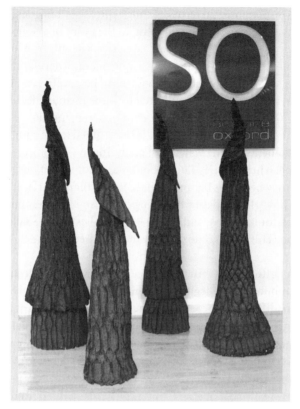

Fig. 1.3 Carole Andrews, *Sentinels*, 2005.

(Photograph: Keith Barnes.)

A.B.O.: I think it's a conscious attempt, almost like creating the simulation of a new life, a complete artificial life which is entirely the result of the artist's creative process. I think that contemporary art is the most democratic art form that ever existed, since it has come increasingly closer to life, it uses everyday objects that are recognizable, a familiar iconography which belongs to our daily-life rituals, therefore this polysensoriality is strategically embedded in the concept of contemporary art in order to develop a higher rate of communication. The message of art and its communication manage to percolate in a capillary way thanks to the public's multisensorial engagement.

F.B.: How would you contextualize historically the multitude of new media and artistic techniques that have arisen at the end of the last century, in relation to the multisensory discourse (forms such as video and digital art, performance, land art, and others)?

A.B.O.: In terms of continuity with the previous history of art, absolutely. Let's not forget that Borromini had designed a corridor that looks so long, but if you walk through it you realise that it is just eight metres in total (Palazzo Spada Rome). Let's not forget, also, that perspective comes about as a *trompe-l'oeil*, since it is the

representation in bi-dimensional terms, through the use of Euclidean geometry, of an illusory depth—that is to say, non-existent up to the point of anamorphosis, which is the intentional deformation of a shape that one can look at only from one specific point, often laterally, in order to see it. Art history is a long march, a development from the two dimensions of the surface to the three dimensions of perspective, up to the *tabula rasa* of Impressionism, which restarted this march towards the outside, towards the three-dimensionality of the spectators, not illusory but material, through the collage. Picasso is the father of all this. His collage with the train ticket glued to the painting was a prelude to adding other elements, all the way to the ready-made—an object which substitutes the pictorial shape. Then there is Lucio, Fontana, who, with a cut, opened a way in through the canvas, which thus became a space rather than a surface, which then leads to installations. These offer a space where the public can physically move, the nomadic nature of the spectator is excited, and this by itself implies—how shall I say it?—a poly-sensory dimension. This is the context where the new media came on to the scene.

F.B.: As a curator, I often find it difficult to mediate between the need to make the work available to the public and the legitimate concern about its preservation. Culturally speaking, there are different approaches to the care and treatment of artworks, such as the idea, common in Asia, that conservation should be geared not just at preserving the physical integrity of the object, but rather its intelligibility. Often we witness instances of historical materials being replaced with new ones, in order to preserve the object in like-new condition.

A.B.O.: Yes, they reckon that it is fine to replace the old with the new, for the purpose of maintaining a full sensory experience of the art.

F.B.: This makes one wonder whether it is sensible to carry out what is commonly referred to as 'philological' or 'scientific' restoration (in Cesare Brandi's terms) of contemporary artworks—ultimately, whether it makes sense at all to stubbornly pursue the eternal physical integrity of art, since all that is material is headed towards dissolution anyway.

A.B.O.: This is an open debate, which I addressed 20 years ago with a series of articles in which I wrote: how can you restore a work by Alberto Burri, where he used plastic that is destined to waste anyway? Do you know what solution I came up with? I proposed to bury artists with their artworks, like pharaohs. Do you like this idea?

F.B.: Well, I may like it, but I suppose that this proposal has not found much support among collectors and institutions. . .

A.B.O.: This need for the survival of artworks is born both from the desire of immortal-ity of the artist, and also from the desire of the collector to preserve the work in which s/he has invested money, so really it is the art system that requires this continuity—hence the restoration that can also be carried out on contemporary artworks, although

often these works are very delicate, requiring deep knowledge of the materials and chemicals employed, coupled with a conceptual knowledge of the work. The profession of 'contemporary art restorer' is still very 'futuristic', as one works on an inner paradox of preserving contemporary artefacts that could be easily replaced by other indistinguishable and identical contemporary artefacts.

F.B.: And let us not forget that the pursuit of the physical integrity of the artwork often comes at the cost of forbidding the full apprehension of the art through all senses (especially touch), which is to say at the expense of the work's full expressive power.

A.B.O.: That is part of the European tradition, it is a Western characteristic. In Eastern countries, such as India for example, everything is left to decay because it is time that counts. In China what counts is the experience. Here it is the object that counts; there is this fetish of the artwork tied to the concept of the *unicum.*

F.B.: This leads us to consider the long-standing debate between original and copy, and Walter Benjamin's idea that the aura may be lost when the work is reproduced a great number of times.

A.B.O.: Well, while contemporary artworks may be more democratic because of their reproducibility, the fact remains that, when a work is unique, it retains a greater value.

F.B.: This sounds dangerously similar to the economic law of supply and demand. What, then, distinguishes contemporary art from any other object of consumption? To peruse, to use all of one's senses on an artwork, means to consume it.

A.B.O.: What is crucial is the frame in which the object is placed. This is, again, Duchamp's teaching. A sanitary device placed in a toilet is just that, while the same object on a plinth in a museum gets recognized as a 'Fountain'. It is the frame that can make art be art, differentiating it from any other object.

F.B.: It is a well-known fact that artists' curiosity responds quickly to the advancement of science. Historically, one can trace a trail of artworks that incorporate notions from optics, perception psychology, and now also vision science. A stunning example of this trend in contemporary practice, which effectively summarizes the three fields just mentioned, is provided by Georgia Chatzivasileiadi's *Aftertrace* (2006) (Fig. 1.4).

 This installation, shaped as a dark room with an entrance and an exit, is based on a particular afterimage phenomenon, which is known as 'the rainbow effect'. The visual effect is a result of the combination of the eye movement ('saccade') and the rate of projection. This creates the illusion of a two-dimensional image from a one-dimensional light source. When a viewer moves in front of the light beam, a stream of different coloured afterimages of the moving person follows their figure, as a live portrait, unachievable in any other medium. The new decomposed image expands into

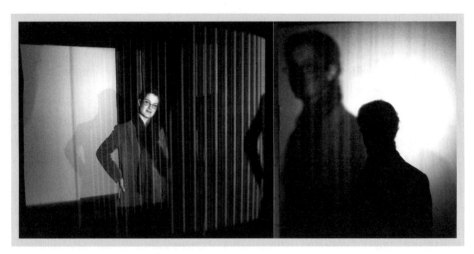

Fig. 1.4 Georgia Chatzivasileiadi, *Aftertrace*, 2006.

(Photograph: Georgia Chatzivasileiadi.)

the third dimension: it is detached from the two-dimensional surface, and spreads into the entire projection space, thus becoming, in the words of the artist, an 'experiential perception of the projected image'.

As a consequence of, or parallel to, such growing neuroscientifically oriented artistic production, one can notice an increased interdisciplinary trend merging the fields of art criticism and neuroscience. Let us discuss the recent article by Freedberg and Gallese (2007), where the idea of mirror neuron system has been considered in the context of the history of art. Basically, these authors claim that by observing a representation of a real action we can experience, at the level of neural activation, the same sensation as if we were protagonists of that action. This seems to put all figurative art in a new context.

A.B.O.: This process of substitution is one that one can suspect in all phenomena, even in collecting. A collector, in exchange for his money, 'lives' a work and manages it with a sense of possession as if s/he was the artist. The spectator who goes to the museum establishes a rapport, solitary even if temporary, with the painting, puts her/himself in the presence of the work, thus achieving an emotion that should correspond to that of the artist. Quite frankly, these are scientific hypotheses that do not concern me intellectually. Can you explain why one has to raise this problem? Why do I have to care if the neurons activated through contemplation are the same as the ones activated through action?

F.B.: Because it means that in the observer there is a physical involvement that goes well beyond the simple observation, into the domain of empathy.

A.B.O.: If these scientists had pondered Heisenberg's uncertainty principle, Erwin Schrödinger's quantum mechanics, and Einstein relativity, they would have understood that contemporary art is happily open-ended requiring a spectator's intervention to find its completeness, so there is active and proactive coparticipation of the public, which is no longer exclusively a *voyeur*.

Reference

Freedberg D and Gallese V (2007). Motion, emotion and empathy in aesthetic experience. *Trends in Cognitive Sciences*, **11**, 197–203.

THE SCIENCE AND ART OF THE SIXTH SENSE

NICHOLAS J. WADE

INTRODUCTION

MANY artists have sought to represent the pleasures of the senses and the genre has ancient origins. However, studies of the senses display paradoxes associated with science as well as art. In both, the senses tend to be limited to the classical five listed and restricted by Aristotle: 'There is no sixth sense in addition to the five enumerated – sight, hearing, smell, taste, touch' (WD Ross 1931, p. 424b). In the context of art, one sense—vision—is typically used to represent the others, often in allegorical form. The sensuousness of touch, taste, smell, and hearing are depicted in a medium that denies experience of them. For science, the paradoxes have been otherwise. Experimental emphasis has certainly focused on vision, but theoretically touch has been accorded dominance. This has been so despite the problems, evident to Aristotle, associated with defining this sense.

The present chapter will examine the history of the science of the senses, with flourishes of art, and will examine the factors that extended their number from the Aristotelian five. The main contributors to this scientific history will be depicted as 'perceptual portraits'. The faces themselves are not always easy to discern—readers will need to apply the power of their own perception to extract the facial features from the designs that carries them. They can usually be seen more easily by squinting the eyes, shaking the head from side to side, viewing the page from a distance, removing

your spectacles if you wear them—in fact any procedure that reduces the sharpness of the fine lines in the pattern that make up the motif. The aim of perceptual portraits is both artistic and historical. They generally consist of two elements—the portrait and some appropriate motif. The nature of the latter depends upon the endeavours for which the portrayed person was known. In some cases the motif is drawn specifically to display a phenomenon associated with the individual, in others it is derived from a figure or text in one of their books, or apparatus which they invented. The portraits and motifs have themselves been manipulated in a variety of ways, using graphical, photographical, and computer graphical procedures. It could be the case that such perceptual portraits both attract attention and engage the spectator's interest to a greater degree than do conventional paintings, prints, or photographs. It is hoped that this visual intrigue will enhance the reader's desire to discover why particular motifs have been adopted, and in turn to learn more about the persons portrayed: it is intended to be an instance of art serving science. Further examples can be found in Wade (1990, 1995, 2006, 2009).

The senses have always been at the heart of the sciences. They were not only studied in their own right but they provided the evidence for assessing other natural phenomena. Indeed, for Aristotle (c.384–322 BC) (Fig. 2.1), sensation was housed in the heart because of its perceptible warmth in contrast to the cool of the exposed brain to touch. At the beginning of the nineteenth century, with the growing knowledge of nerve function, the relation of the senses to the brain was explored in greater detail, and one question was repeatedly addressed: how many senses are there? The five senses of sight, hearing, smell, taste, and touch are rooted in our culture. The prominence of eyes, ears, nose, and tongue on the head, and the specific experiences associated with them, have acted in the past, as well as in the present, to fix these four senses. Touch presents more problems because its sensitivity is not localized to a particular sense organ, and the experiences derived from the skin are many and varied. Aristotle confronted these aspects of anatomy and experience and reached similar conclusions. Nonetheless, touch, requiring contact in order to experience it, was often taken as the most important sense, and the one relative to which others could be related: 'The primary form of sense is touch, which belongs to all animals' (WD Ross 1931, p. 413b). It is perhaps for this reason that Aristotle maintained that touch is a single sense, that the number of senses is restricted to five. Boring's conclusion about this dogma was clear: 'It was certainly Aristotle who so long delayed the recognition of a sixth sense by his doctrine that there are but five senses' (1942, p. 525). For Boring, as for most other historians of the senses, the additional one that emerged in the early nineteenth century was the muscle sense.

The analysis of experiences deriving from stimulation of the senses has often been placed in a philosophical context. However, the anatomy of the senses and the phenomena associated with them has guided the ways in which they can be classified. In what follows, the anatomical and phenomenological aspects of the senses will be emphasized. It will be argued that the separation of a muscle sense from touch was given empirical support in the late eighteenth century, as was the evidence for a movement or vestibular sense. The multiple dimensions of touch (like temperature

Fig. 2.1 Nicholas Wade, *Aristotle's Senses*. A partial portrait of Aristotle derived from an engraving in *The Historic Gallery of Portraits and Paintings* (Vol. 5. 1810, Vernor, Hood, and Sharpe, London). Specification of the senses of seeing, hearing, taste, and smell was straightforward, but problems were caused by the skin senses, which he variously called touch or feeling.

(©Nicholas Wade)

and pressure) were voiced on phenomenological grounds in the same century, but received experimental support in the eighteenth and nineteenth centuries, first from behavioural and galvanic studies, then later from anatomy.

THE CLASSICAL FIVE SENSES

Aristotle's survey of the senses was more extensive than those of his predecessors (see Beare 1906), but it was similarly based on gross anatomy and phenomenology. In associating the heart with sensation, Aristotle was contradicting the deliberations of Alcmaeon (fl. 500 BC), who located the centre of sensation in the brain. In the context of touch, Anaxagoras (c.500–438 BC) discussed sensing warmth and cold, and Democritus (c.460–370 BC) contrasted heavy with light, and hard with soft.

Plato (427–347 BC) wrote that touch distinguished between hot and cold, hard and soft, heavy and light, as well as rough and smooth. The approach by Galen (c.130–200) to the senses displayed the advantages of anatomical dissection. He berated Aristotle for denying that all the senses do not have connections with the brain: 'Hence all the instruments of the senses – if we are to believe our eyes that see and our hands that touch them – communicate with the encephalon' (May 1968, p. 391). Galen's theory of the senses was physiological, and it was based on the concept of pneuma advocated by Empedocles (c.493–433 BC): 'Unless the alteration in each sense instrument comes from the encephalon and returns to it, the animal will still remain without sense perception' (May 1968, p. 403). Galen restricted his discussion to the 'four sense instruments in the head, namely, the eyes, ears, nose, and tongue, all of which take the source of their sensation from the encephalon' (p. 400).

The situation remained relatively unchanged through the medieval period: 'Aristotle's account of sensation and perception was held in great esteem in the Middle Ages, and his systematic approach and many of his specific doctrines were widely copied' (Kemp 1990, p. 35). Attention was directed principally at interpretations of vision, with much less heed paid to the other senses. Developments did occur in fusing Aristotle's account of the senses with Galen's pneumatic physiology, and the medical tradition of describing diseases of the senses became more refined.

When Galileo Galilei (1562–1642; 1623) (Fig. 2.2) considered the senses and sensation he did so in the context of this medieval tradition. Nonetheless, he did not share Aristotle's faith in the veracity of the signals provided by the senses, and his approach to sensation can be seen as breaking with the medieval tradition (Piccolino 2007; Piccolino and Wade 2008a,b). He clearly appreciated the indirectness of sensory experiences: 'I think that tastes, odors, colors and so on are no more than mere names so far as the object in which we place them is concerned, and that they reside only in the consciousness' (Drake 1957, p. 274). The deceits of these senses were matters for the proper sensibles (such as colour, tone, and saltiness) rather than the common sensibles (like size, shape, location, motion, and number). From the viewpoint of sensory physiology, Galileo's statement can be taken as a forerunner of Müller's doctrine of specific nerve energies, formulated in the early nineteenth century. Johannes Müller (1801–1858) argued that we only have available to us the signals that are sent to the sensorium, and this sentiment is clearly evident in Galileo's writing:

To excite in us tastes, odors and sounds I believe that nothing is required in external bodies except shapes, numbers, and slow or rapid movements. I think that if ears, tongues, and noses were removed, shapes and numbers and motions would remain, but not odors or tastes or sounds.

(Drake 1957, pp. 276–77)

In expanding on the relation of stimulus to sensation, Galileo devoted more attention to the senses of hearing, taste, smell, and touch than to vision. For touch he stated:

A body which is solid and, so to speak, quite material, when moved in contact with any part of my person produces in me the sensation which we call touch. This, though it exists over

Fig. 2.2 Nicholas Wade, *The sensory messenger*. A portrait of Galileo has been embedded in the title page of his book *Il Saggiatore* (Galileo 1623), in which he provided an analysis of the senses.

(©Nicholas Wade)

my entire body, seems to reside principally in the palms of the hands and in the fingertips, by whose means we sense the most minute differences of texture that are not easily distinguished by other parts of our bodies.

(Drake 1957, p. 275)

Note that specialization within the sense was also described, with greater sensitivity assigned to the fingertips than to other parts of the skin surface. For taste and smell Galileo stated:

Perhaps the origin of two other senses lies in the fact that there are bodies which constantly dissolve into minute particles, some of which are heavier than air and descend, while others are lighter and rise up. The former may strike upon a certain part of our bodies that is much more sensitive than the skin, which does not feel the invasion of such subtle matter. This is the upper surface of the tongue; here the tiny particles are received, and mixing with and penetrating its moisture, they give rise to tastes, which are sweet or unsavoury according to the various shapes, numbers and speeds of the particles. And those minute particles that rise up

may enter by our nostrils and strike upon some small protuberances which are the instrument of smelling; here likewise their touch and passage is received by our like or dislike according as they have this or that shape, are fast or slow, and are numerous or few. The tongue and nasal passages are providently arranged for these things, as the one extends from below to receive descending particles, and the other is adapted to those which ascend. Perhaps the excitation of tastes may be given a certain analogy to fluids, which descend through the air, and odors to fires, which ascend.

(Drake 1957, pp. 275–6)

With regard to sound, Galileo adopted a similar mechanistic interpretation:

Then there remains the air itself, and element available for sounds, which come to us indifferently from below, above, and all sides – for we reside in the air and its movements displace it equally in all directions. The location of the ear is most fittingly accommodated to all positions in space. Sounds are made and heard by us when the air – without any special property of 'sonority' or 'transonority' – is ruffled by a rapid tremor into very minute waves and moves certain cartilages of a tympanum in our ear. External means capable of thus ruffling the air are very numerous, but for the most part they may be reduced to the trembling of some body which pushes the air and disturbs it. Waves are propagated very rapidly in this way, and high tones are produced by frequent waves and low tones by sparse ones.

(Drake 1957, p. 276)

Touch, taste, smell, and hearing were related to the elements of earth, water, fire, and air. The analysis of these four senses was mechanical, both in terms of the stimulus and the response to it. Essentially, Galileo was following the Aristotelian path of treating touch, a patently mechanical sense, as the yardstick against which taste, smell, and hearing should be considered. By contrast, Galileo was much more enigmatic in his consideration of vision:

And as these four senses are related to the four elements, so I believe that vision, the sense eminent above all others in the proportion of the finite to the infinite, the temporal to the instantaneous, the quantitative to the indivisible, the illuminated to the obscure – that vision, I say, is related to light itself. But of this sensation and the things pertaining to it I pretend to understand but little, and since even a long time would not suffice to explain that trifle, or even to hint at an explanation, I pass this over in silence.

(Drake 1957, p. 277)

Both Aristotle and Galileo felt secure in their analyses of four of the putative five senses, but they were not the same four! Touch posed a problem for Aristotle because of its multiple dimensions, its wide distribution over the skin surface, and its primacy as the quintessential contact sense. The other senses were clearly localized to specialized sense organs. Galileo was more concerned with the stimulus than with sensation. Touch, taste, smell, and hearing could all be interpreted in terms of the response to mechanical stimulation; vision did not fit easily with this scheme, as little was then known about its physical basis. Accordingly, Galileo did not embrace it in the manner he adopted for the other senses and he wrote very little about the process of vision (Wade 2007a).

Contact and movement were considered by René Descartes (1596–1650; 1637/1902, 1664/1909) to be the touchstone of all the senses. He used the analogy of a blind man feeling his way through space by means of sticks held in each hand as the paradigm for hearing and vision as well as touch. In his philosophy of the senses, all perception was traced back to movement, and all stimuli were thought to be mechanical. The importance of touch and muscular activity was also a cornerstone of George Berkeley's (1685–1753; 1709) empiricism. He proposed that we learn to see distance by associating sight with touch. Moreover, the degrees of muscular contraction involved in converging the eyes are also correlated with distance, and provide a source of association with sight for perceiving distance. In order to perceive distance visually, Berkeley argued that we learn the relationship between the visual stimulation and the states of the muscles controlling the eyes. The muscular and touch systems were considered to provide direct and undistorted spatial information that could be used to teach vision the dimensions of space. Like Berkeley, Hartley (1749) held that touch was the fundamental source of information to integrate the senses. This was evident from the order in which the senses were surveyed: feeling was first, followed by taste, smell, sight, and hearing. If there is conflict between touch and sight 'we always depend upon Touch' (1749, p. 138). This was considered to be so, in large part, because touch was not thought to be as readily deceived as vision: 'we call Touch the Reality, Light the Representative' (p. 138).

The dominance of touch was such as to obscure the view of other sensory experiences, even when they involved movement. One common experience discussed since antiquity, but was not incorporated into the senses, was vertigo. Theophrastus (c.370–286 BC) commented on vertigo or dizziness (as when looking down from a great height) and the visual motion that accompanies it (see Stratton 1917; Sharples 2003). Aristotle referred to the visual vertigo that follows drinking too much wine, and later Lucretius (c.98–55 BC) gave a graphic description of vertigo following rotation of the body: 'The room seems to children to be turning round and the columns revolving when they themselves have ceased to turn, so much so that they can hardly believe all the building is not threatening to fall in upon them' (1975, pp. 307–9). Ptolemy (c.85–165) was able to induce vertigo by visual means alone (see Smith 1996). Vertigo was related to the movements of the animal spirit in the head. For example, Paulus Ægineta (1844, fl. 680) noted that:

Vertigo is occasioned by a cold and viscid humour seizing upon the brain, whence the patients are ready to fall down from a very slight cause, such as sometimes from looking at any external object which turns round, as a wheel or top, or when they themselves are whirled round, or when their head has been heated, by which means the humours or spirit in it are set in motion.

(1844, p. 374)

Generating visual vertigo, even in healthy individuals, by rotating the body and then stopping, was a source of regular reflection by medieval medical and optical writers (see Wade 2000a). Vertigo accompanies many diseases and has been described frequently

over the centuries in medical texts. It will be argued that the experimental study of vertigo in the eighteenth century heralded the appreciation of a sixth sense before experimental evidence for a muscle sense or the fractionation of touch was available.

CLASSIFYING THE SENSES

The sources of evidence available to Aristotle (and to those who followed him over the next 2000 years) for distinguishing between the senses were perception and anatomy. They could report on their experiences when stimulated, and they could relate them to their body parts. For example, sight ceased when the eyes were closed, and hearing diminished when the ears were blocked. Additional inferences could be drawn from disease or injury. At a theoretical level, recourse was made to philosophy, usually linking the senses to the elements—fire, earth, water, and air—which permeated perception. The classical accounts of the senses drew principally upon psychological (or behavioural) evidence for their independence. In contrast, developments in the last few centuries have relied increasingly on anatomical and physiological indications of separate senses, and the behavioural dimension has been given less prominence.

While emphasizing the veridicality of sensing in general, Aristotle did entertain the possibility of errors (illusions) entering into a particular sense. The examples he mentioned were those of colour or sound confusion and errors in spatial localization of colours or sounds. Illusions are often considered to be a modern preoccupation, based on specific theories of perception, but their origins are ancient and illusions can be investigated with little in the way of theory (see Wade 1990, 1998, 2005a). If there is an assumption of object permanence, then an illusion occurs when the same object appears to have different properties (of colour, position, size, shape, motion, etc.) under different circumstances. Thus, the existence of an illusion might provide evidence of a sensory system. For example, we normally feel stable and still when we stand upright; however, an illusion of body motion can occur when we are standing upright—if we have previously rotated the body rapidly.

The situation regarding the senses was radically revised in the nineteenth century, with developments in physics, anatomy, and physiology. Sources of stimulation could be specified and controlled more precisely. This had already occurred in the context of colour, with Isaac Newton's (1642–1727; 1704) methods of spectral separation of white light and mixing components of it. Thomas Young (1773–1829; 1802) applied the colour mixing method and found that all colours could be produced by appropriately compounding three primaries; he suggested that the eye was selectively sensitive to each. Young (1807/2002) also introduced the term 'energy' in the context of weight, and this concept was related by others to different dimensions of sensitivity, like light and sound.

The link between energy and sense organs was forged soon thereafter. Charles Bell (1774–1842) (Fig. 2.3, left) is noted for discovering that the anterior spinal nerve roots carry motor nerves (see Cranefield 1974). His principal concern, however, was in specifying the senses and their nerve pathways to the brain. His experiments were described in a privately published pamphlet which also related stimulation to specific senses:

In this inquiry it is most essential to observe, that while each organ of sense is provided with a capacity for receiving certain changes to be played upon it, as it were, yet each is utterly incapable of receiving the impression destined for another organ of sensation. It is also very remarkable that an impression made on two different nerves of sense, though with the same instrument, will produce two distinct sensations; and the ideas resulting will only have relation to the organ affected.

(Bell 1811/2000, pp. 8–9)

In the context of vision, the demonstration of this fact had been known to Alcmaeon: pressure to the eye, even in darkness, produced the experience of light (see Grüsser and Hagner 1990; Park 1997). Bell was able to bolster this observation with the application of electricity to the eye:

If light, pressure, galvanism, or electricity produce vision, we must conclude that the idea in the mind is the result of an action excited in the eye or in the brain, not any thing received,

Fig. 2.3 Nicholas Wade, Left, *The nerves of Bell's head*; Bell is shown within his diagram of the cranial nerves (from Bell 1844). Right, *Vieth–Müller circle*; Müller's portrait is presented within text from Vieth (1818) describing the binocular circle of corresponding points.

(©Nicholas Wade)

though caused by an impression from without. The operations of the mind are confined not by the limited nature of things created, but by the limited number of our organs of sense.

(1811/2000, p. 12)

A similar sentiment, voiced with primary reference to the nerves and their pathways, was written a few decades earlier by John Hunter (1728–1793; 1786). The examples he gave to support this contention were the referred sensations arising after damage or amputation. The seeds of this idea can be found in antiquity, although it was based on philosophical rather than physiological speculation. Galileo sought to link the stimulus with sensation for what he saw as the mechanical senses, but the seeds blossomed in the nineteenth century. The doctrine of specific nerve energies, as it became called, was given further support by Müller (Fig. 2.3, right), in a monograph on comparative physiology and on eye movements (Müller 1826) and it was amplified in his influential handbook of human physiology (Müller 1838, 1843, 2003). Although the doctrine was framed in terms of differences between the senses, it was used increasingly to determine qualitative distinctions within them (see Finger and Wade 2002; Wade 2003b). Müller considered the criteria that would need to be satisfied in order to increment the number of senses:

The essential attribute of a new sense is, not the perception of external objects or influences which ordinarily do not act upon the senses, but that external causes should excite in it a new and peculiar kind of sensation different from all the sensations of our five senses.

(1843/2003, p. 1087)

Anatomy

The gross structures of the nervous system could be examined with the naked eye, but a new anatomical world was exposed by the microscope (see Wilson 1995; Harris 1999; Schickore 2007). However, this formerly unseen territory was not sharply resolved by its seventeenth-century explorers due to the optical aberrations inherent in the relatively simple devices and the lack of techniques for preparing specimens for observation. While the microscopes of Robert Hooke (1635–1703) (Fig. 2.4, left) and Antoni van Leeuwenhoek (1632–1723) (Fig. 2.4, right) bared the cell before the human eye, they did little to expose its fine structure. This was to await the development of achromatic microscopes in the early nineteenth century.

Hooke (1665) gave the name 'cell' to the structures visible in sections of cork. His compound microscope was capable of magnifying by 40 times, but he also described a superior instrument of greater optical power. He did not make such a microscope, but Leeuwenhoek (1674) did (see Ford 1991, 2007). He gave accounts of several animal cells, including optic nerve fibres, when he directed his simple magnifier to animal tissue. His major achievement was to refute the long-held view that nerve fibres were hollow. Moreover, Leeuwenhoek (1675) suggested that signals were propagated mechanically along the nerves (in the fluids they contained) from eye to brain (Wade 2005b).

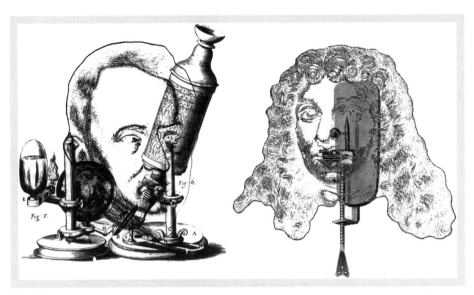

Fig. 2.4 Nicholas Wade, *Early microscopes and microscopists.* Left, derived from a portrait, said to be of Hooke, in Jardine (2003) and his compound microscope (Hooke 1665). Right, Leeuwenhoek, after a frontispiece engraving in Leeuwenhoek (1684), is combined with his simple magnifier.

(©Nicholas Wade)

Despite occasional forays into this field throughout the eighteenth century, relatively little attention was paid to these observations because the resolving power of the microscopes was poor as a consequence of the aberrations introduced by their optical components. The microscopic world was transformed by the introduction of powerful achromatic instruments in the 1820s, and rapid advances were made thereafter (Polyak 1957; Harris 1999; Schickore 2001, 2007). The cell doctrine was most clearly articulated at the end of the next decade by Matthias Schleiden (1804–1881; 1838) (Fig. 2.5) and Theodor Schwann (1810–1882; 1839; figure 2.5) and its impact on the biological sciences was dramatic. However, it was not until the end of the nineteenth century that Wilhelm von Waldeyer's (1836–1921) neuron doctrine began to be widely accepted (Spillane 1981; Shepherd 1991; Finger 1994).

In 1832, Jan Evangelista Purkinje or Purkyně (1787–1869) (Fig. 2.6, left) obtained an achromatic microscope made by Plössl of Vienna. Purkinje directed it at the large cells in the cerebellum, thereby identifying his eponymous cells. His microscopic observations were made before any adequate staining methods had been developed. Purkinje used alcohol to fix his preparations, and he made thin sections so that they could be examined microscopically. It is an irony of science that Purkinje was not able to resolve the amazingly detailed structure of the cells bearing his name. By the time Santiago Ramón y Cajal (1852–1934) (Fig. 2.6, right) was directing his microscope at neural structures great strides had been made in both sectioning and staining specimens. A single Purkinje cell sprouted arborizations of astonishing complexity.

Fig. 2.5 Nicholas Wade, *Cell doctrine*; Hooke's
(1665) diagram of the cell structure of cork has had
incorporated within it the portraits of Schleiden
(left) and Schwann (right).

(©Nicholas Wade)

Cajal expressed his artistry not only in observing the fine detail of neural structures but also in their depiction. He used the silver staining methods, which was developed by Camillo Golgi (1843–1926) (Fig. 2.6, centre) in 1873. The method enabled both Golgi and Cajal to see detailed neural structures that had otherwise been invisible or overlooked (Mazzarello 1999; Mazzarello et al. 2006). Cajal examined the microanatomy of the retina, the cerebellum and the spinal cord, and made some improvements to the Golgi technique. He used his histological studies of the brain to lend support to the emerging neuron doctrine, which was enunciated by Waldeyer in 1891. Two views were entertained about the structure of the nervous system. On the one hand, Golgi argued that the nerves were connected in a vast reticulum, on the other that the nerves were independent units which were not physically connected (see Wade and Piccolino 2006).

The structure of the senses soon came under the gaze of the microscopists and there was surprise at the variety of cells they beheld. The microscopes revealed specialized cells, called receptors, and they could be related to the stimuli that excited them. Those located in well-defined sense organs were named on the basis of their morphology (rods, cones, hair cells, etc.), whereas the receptors in or beneath the skin were generally named after those who first described them (e.g. Golgi tendon organs, Krause end bulbs, Meissner corpuscles, Merkel discs, Pacinian corpuscles, and Ruffini cylinders).

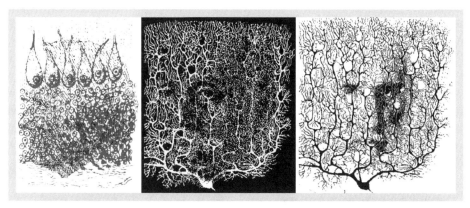

Fig. 2.6 Nicholas Wade, Left, *Purkinje cells*; Purkinje after a portrait in Purkinje (1918) embedded in his representation of cells in the cerebellum. Centre, *Reazione nera*; the black reaction transformed histological studies of the nervous system, and was extensively used by Golgi, who is dimly discernable within a Purkinje cell. Right, *Purkinje cell*; Cajal after a portrait in Finger (1994) combined with his drawing of a single Purkinje cell.

(©Nicholas Wade)

The isolation of receptors that were specialized to respond to specific forms of environmental energy was adopted as a criterion for defining the senses (Neff 1960).

Physiology

The manner in which the nerves themselves worked was hinted at by Luigi Galvani (1737–1798; 1791) (Fig. 2.7, left) when he made a case for 'animal electricity'. He applied a discharge from a Leyden jar to the exposed crural nerve or muscle of an isolated frog's leg and it twitched. Galvani suggested that this was due to a special type of electrical fluid that accumulates in the muscles of animals (see Piccolino 1997; Bresadola 1998). Alessandro Volta (1745–1827) (Fig. 2.7, right) suggested that Galvani's experiments were flawed, maintaining that animal tissue was not necessary for a current to pass. Volta had interests in the effects of electrical discharges on the senses; he carried out studies of galvanic light figures in the 1790s, and also found that intermittent stimulation produced longer lasting effects than constant stimulation. In his letter describing the pile or battery, Volta (1800) described how he applied electrical stimulation to the eyes, ears, nose, and tongue. He connected the wires from a battery between the mouth and conjunctiva of the eye, which resulted in the experience of light, even in a dark room. Moreover, he noted that the visual sensation was associated with the onset and offset of the current, and a continuous impression of light could be produced by rapid alternation of polarity (see Piccolino 2000; Piccolino and Bresadola 2003). When he applied a current to the two ears he reported: 'At the moment the circuit was completed I felt a shaking in the head' (Volta 1800, p. 427). This shaking did not last

Fig. 2.7 Nicholas Wade, Left, *Galvani's legs*; a diagram from Galvani (1797) showing a wire connecting to a frog's leg has been multiplied to partially hide Galvani's portrait. Right, *Volta's piles*; Volta can be seen in the stacked piles of his battery.

(©Nicholas Wade)

long; when the current was continued he experienced sound and then noise. The sensations were so disagreeable that he thought them potentially dangerous, and he did not wish to repeat the experiments.

A few years earlier, Volta had applied a current to his tongue and noted an acidic taste (Piccolino 1997). Volta's pile did much to hasten experimental studies of the senses. Electricity was a common stimulus that could be applied to different sensory organs, inducing different sensations. Müller used the effects to support his doctrine: 'The stimulus of electricity may serve as a second example, of a uniform cause giving rise in different nerves of sense to different sensations' (1843/2003, p. 1063). The first example was mechanical stimulation, as had been alluded to by Galileo.

The action of nerves on muscles led first Carlo Matteucci (1811–1862) and later Emil du Bois Reymond (1818–1896) to propose the ways in which nerves propagate impulses (Brazier 1959, 1988). Experimental evidence of action potentials was to await technological advances in recording and amplifying small electrical signals; this was provided by Adrian (1928) who was able to record action potentials (Finger 2000). When recordings of nerve impulses could be made from individual cells in the visual pathway their adequate stimuli could be determined. Adrian coined the term 'receptive field' to refer to this, and it was applied to other senses, too.

With developments in the microanatomy of the senses and the physiology of their responses to stimulation attention moved away from gross anatomy and phenomenology. The criteria applied to separating the senses became the quality of the experience, the nature of the stimulus, the gross and microanatomy of the receptor system, and the pathways to and representation on the cortex. The psychological dimension is the oldest of these, and yet less weight has been attached to behavioural evidence for distinguishing and adding to the senses than to that derived from anatomy and physiology.

It is in this context that a claim can be made that the systematic consequences of vestibular stimulation preceded those for the muscle and skin senses.

Muscle sense

The ability to detect the position of the limbs, even with the eyes closed, has a long history (Hamilton 1846). The term 'Muskelsinn' had been used by German writers in the eighteenth century, and it was suggested that the idea was described even earlier. For example, Julius Cæsar Scaliger (1484–1558; 1557) distinguished between active and passive dimensions of touch. Appeals to muscular sensitivity have been commonplace in philosophy, particularly among the empiricists. It proved central to common sense philosophers, too. For example, Thomas Brown (1778–1820) suggested it was a separate sense, and asked:

To what organ, then, are we to ascribe the external influences, which give occasion to these feelings of resistance and extension? It is not touch, as I conceive, that either of these be traced. Our feeling of resistance, in all its varieties of hardness, softness, roughness, smoothness, solidity, liquidity, &c. I consider as the result of organic affections, not tactual, but muscular; our muscular frame being truly an organ of sense, that is affected in various ways, by various modifications of external resistance to the effort of contraction.

(Brown 1820, pp. 78–9)

It was the physiological dimension in a paper by Bell (1826) that led Boring (1942) to nominate him as the founder of this new muscle sense. Bell argued that the anterior spinal nerve roots, which are involved in muscular contraction, also carry sensory signals. Moreover, a nerve circuit was proposed, which passed from the voluntary muscles to the brain. Muscle spindles were not isolated until four decades later (Kühne 1863). In fact, Bell had provided behavioural evidence for the muscular sense three years earlier, in the context of determining the visual direction of afterimages:

There is an inseparable connection between the exercise of the sense of vision and the exercise of the voluntary muscles of the eye. When an object is seen, we enjoy two senses; there is an impression upon the retina; but we receive also the idea of position or relation which it is not the office of the retina to give. It is by the consciousness of the degree of effort put upon the voluntary muscles, that we know the relative position of an object to ourselves . . . If we move the eye by the voluntary muscles, while the impression [of an afterimage] continues on the retina, we shall have the notion of place or relation raised in the mind; but if the motion of the eye-ball be produced by any other cause, by the involuntary muscles, or by pressure from without, we shall have no corresponding change of sensation.

(Bell 1823, pp. 178–9)

That is, the visual direction of an object is not determined by visual stimulation alone, but also involves information about the position of the eyes—otherwise objects

would appear to move with every movement of the eyes. Helmholtz (1867) also referred to this distinction between what have become called outflow and inflow theories. The former refers to deriving the eye movement information from efferent (centrally generated) impulses to the eye muscles, whereas the latter reflects use of afferent (sensory) signals from the eye muscles themselves.

It is surprising that Bell did not refer to the earlier experiments by William Charles Wells (1757–1817) on this topic, because the monograph by Wells (1792, reprinted in Wade 2003a) was referred to by Bell (1803) in the context of vertigo. Wells had performed essentially the same experiment as Bell (1823) later did and reached a similar conclusion:

When we have looked steadily for some time at the flame of a candle, or any other luminous body, a coloured spot [afterimage] will appear upon every object, to which we shortly after direct our eyes, accompanying them in all their motions, and exactly covering the point, which we desire to see the most accurately . . . The apparent situation of the spot being . . . at the same time affected by the *voluntary* motions of the eye, it must, I think, be necessarily owing to the *action* of the muscles by which these motions are performed . . . the apparent direction of an object, which sends its picture to any given point of the retina, depends upon the state of action existing at the same time in the muscles of the eye, and consequently that it cannot be altered, except by a change in the state of that action.

(Wells 1792, pp. 65, 70–1)

Bell also followed Wells in suggesting that the muscle sense is involved in the maintenance of balance: 'Let us consider how minute and delicate the sense of muscular motion is by which we balance the body, and by which we judge of the position of the limbs, whether during activity or rest' (Bell 1823, p. 181). Both Wells (1792) and Bell (1823) provided evidence for a muscle sense based on perceptual experiments, but these were not considered to carry the same weight as Bell's (1826) anatomical dissections and physiological speculations:

The muscles have no connection with each other, they are combined by the nerves; but these nerves, instead of passing betwixt the muscles, interchange their fibres before their distribution to them, and by this means combine the muscles into classes. The question therefore may thus be stated: why are nerves, whose office is to convey sensation, profusely given to muscles in addition to those motor nerves which are given to excite their motions? and why do both classes of muscular nerves form plexus? To solve this question, we must determine whether muscles have any other purpose to serve than merely to contract under the impulse of the motor nerves . . . That we have a sense of the condition of the muscles, appears from this: that we feel the effects of over exertion and weariness, and are excruciated by spasms, and feel the irksomeness of continued position. We possess a power of weighing in the hand: what is this but estimating the muscular force? We are sensible of the most minute changes of muscular exertion, by which we know the position of the body and limbs, when there is no other means of knowledge open to us.

(Bell 1826, pp. 166–7)

Bell provided phenomenological support for his physiological hypothesis. In addition, he drew attention to the ability to discriminate between small differences in weight when they are handled. This technique of comparing lifted weights was at

the heart of Ernst Heinrich Weber's (1795–1878) (Fig. 2.8, left) psychophysics. In his first monograph devoted to the sense of touch, Weber (1834) distinguished between judging weights by touch alone or by the additional action of the muscle sense:

The weight of an object is perceived in two ways: first by the touch-sense in the skin, and then by the special sense of the voluntary muscles. The latter sense tells us the degree of tension of the muscle when lifting weights and other objects. These two methods of discovering the weights of objects are very different: the former method depends upon the objective sense of touch, while the latter depends on the subjective sense of muscular kinaesthesis. This assumes, of course, that we call a sense 'objective' when we use it to perceive objects that have a certain pressure on our organs and produces some effect; and that we call it 'subjective' when we seem to perceive only the effect of the objects and not the objects themselves.

(HE Ross and Murray 1978, p. 55)

In making this distinction between objective and subjective, Weber is displaying his reliance on the philosophy of Aristotle, rather than the then contemporary physiology (HE Ross 1999). Müller's doctrine of specific nerve energies was based on all sensation being subjective, that is, not in perfect accord with the stimulus giving rise to it.

The combination of Bell's tentative hypothesis of a nervous circle, the specific nerve energies doctrine, and psychophysical studies of lifted weights confirmed for many the force of the muscle sense as the sixth sense. By the end of the century, Charles Sherrington (1857–1952) (Fig. 2.8, right) was able to devote a chapter of a textbook to

Fig. 2.8 Nicholas Wade, Left, *Weber fractions*; the psychometric functions contain portraits of Weber at the upper and lower thresholds (from Wade 1995). Right, *Scratch reflex*; Sherrington was able to trace the reflexes of experimental animals, and relate them to the integration between sensory and motor systems.

(©Nicholas Wade)

the muscular sense; he defined it as including 'all reactions on sense rising in motor organs and their accessories' (1900, p. 1002). Six years later, he introduced a novel classification of the senses into extero-ceptors, proprio-ceptors, and intero-ceptors:

The excitation of the receptors of the *proprio-ceptive* field in contradistinction from those of the *extero-ceptive* is related only secondarily to the agencies of the environment. The proprio-ceptive receive their stimulation by some action, *e.g.* a muscular contraction, which was itself a primary reaction to excitation of a surface receptor by the environment.

(Sherrington 1906/2000, p. 130)

Thus, the contention that the muscle sense is the sixth sense was reasonably well supported by phenomenology, physiology, and psychophysics in the nineteenth century.

TEMPERATURE SENSE

Classical divisions of touch into independent qualities were often repeated up to the nineteenth century, when they were given some experimental support (see Finger 1994). For example, Thomas Reid (1710–1796) noted that: 'by touch we perceive not one quality only, but many, and those of different kinds. The chief of them are heat and cold, hardness and softness, roughness and smoothness, figure, solidity, motion, and extension' (1764, p. 99). Some experimental support for the distinction between the touch and temperature senses was provided by Erasmus Darwin (1731–1802, 1794) (Fig. 2.9, left): he described a patient who was insensitive to skin pressure but did respond to heat. Darwin was distinguishing not only between touch and temperature sensitivity, but also according the muscle sense its independence. A few years later, Bell (1803/2000) stated:

By the sense of touch we perceive several qualities, and of very different kinds: hardness, softness, figure, solidity, motion, extension, and heat and cold. Now, although heat be a quality, and cold be the privation of that quality, yet in relation to the body, heat and cold are distinct sensations. But in a more precise acceptance of the term, the sense of touch is said to be the change arising in the mind from external bodies applied to the skin.

(p. 472)

Two years earlier, further experimental support for warmth and cold as sensory qualities had been obtained by Johann Wilhelm Ritter (1776–1810) using galvanic stimulation of the tongue. Ritter was an ardent student of galvanism and its general application. His interpretations of galvanic phenomena in the context of German Romantic philosophy has led to some neglect of his experimental work, but he did follow Volta in applying electrical discharges to the areas around his sense organs. Ritter's first reports regarding warm and cold were in 1801: 'Another contrast in sensation is that between warm and cold . . . if one brings into contact a zinc pole on the

Fig. 2.9 Nicholas Wade, Left, *Doctor Darwin*; Portrait of Erasmus Darwin superimposed on one of the paving stones in the garden at Erasmus Darwin House, Lichfield. Centre, *Temperature sensitivity*; Blix is shown together with some of his instruments for measuring sensitivity to temperature. Right, *Sensory spots*; von Frey is enclosed in a pattern derived from the distribution of pain spots on the skin surface.

(©Nicholas Wade)

tongue and silver on the gums, that on the tongue feels very clearly warm, but it feels cold with silver in the same arrangement' (p. 458). That is, stimulation by the positive pole produced the sensation of warmth whereas the negative pole resulted in experiencing cold. Slightly earlier in the same year, Pfaff (1801) had described the sensation of coldness when he applied a current to his finger. Ritter (1805) extended the studies on temperature sensitivity on the tongue as well as the finger; he found that the sensation could vary according to the intensity and duration of the current. His general conclusion was that: 'one must consider the sense of temperature (for warmth and cold) as essentially different from the common sense, and as a special sense' (p. 10). Galvanic stimulation resulted in a short shock as well as the particular sensation. In the case of temperature sensitivity, Ritter reported that the shock remained constant even when the sensation changed from warm to cold. Rather than merely speculating that warmth and cold are separate sensory qualities, Ritter afforded experimental evidence for this via his studies of galvanic stimulation.

Weber (1846) also followed Volta's lead in applying electric currents to the sense organs, although he was critical of Ritter's work. He added little to what was known at that time about galvanic stimulation, but he did conduct experiments that supported the existence of a temperature sense: 'The sensations of warmth and cold are not like the sensations of brightness and darkness, for the former are positive and negative quantities between which lies a null point determined by the source of heat within us' (HE Ross and Murray 1978, p. 210). Weber's great contribution was the introduction of experimental methods, like determining two-point thresholds, which enabled quantification of sensitivity over the skin surface (Weber 1834). These could then be applied to establish acuity differences over the skin surface, and interpreted in terms of regions of receptiveness (Weber 1846). Furthermore, Weber suggested that the sensory circles could be related to the underlying nerve supply:

But no matter how the elementary nerves do extend to cover the skin, the suggestion may be put forward that the skin is divided into small *sensory circles*, i.e., into small subdivisions each

of which owes its sensitivity to a single elementary nerve-fibre. Now my investigations have shown that two stimulations of similar kind applied to separate sites within a single sensory circle on the skin are felt as if they were made at one and the same site; and moreover, that the sensory circles of the skin are smaller in regions provided with an accurate touch-sense and larger in areas provided with a less accurate touch-sense.

(HE Ross and Murray 1978, p. 187)

Cutaneous sensory 'spots' specifically responsive to touch (pressure) and pain, as well as warmth and cold, were isolated later in the century, using more sensitive and specific apparatus (see Norrsell *et al.* 1999). A division of the skin senses into three separate systems (one to register temperature, a second for pressure, and a third for touch) was proposed by Ludwig Natanson (1822–1871). He supported the contention of peripheral independence by describing how these systems succumb in sequence when a limb 'falls asleep' (Natanson 1844). Three sets of independent studies were reported in the 1880s by Magnus Blix (1849–1904) (Fig. 2.9, centre), Alfred Goldscheider (1858–1935) and Henry Donaldson (1857–1938), and they are jointly credited with the discovery. All were principally concerned with establishing cold and warm spots. Blix (1884) continued in the tradition of applying low intensity electric currents to the skin, and he found separate warm and cold spots (see Norrsell 2000). Goldscheider (1884) stimulated the skin with a range of devices, like needles, heated brass cylinders, cooled capillary tubes, and brushes coated with ether, to isolate the cutaneous spots. Donaldson (1885) discovered the warm and cold sensory spots independently in the course of moving metal points slowly over the skin.

Not only were there discernable spots for warmth, cold, and pressure, but Max von Frey (1852–1932) (Fig. 2.9, right) found clearly defined spots for pain. The various sensory spots could be mapped and attempts were made to match them to receptors revealed by histological sections of excised skin. Towards the end of the century von Frey (1895) advanced the theory that the sensations of warmth, cold, pressure, and pain are subserved by specific end organs in the skin (see Norrsell *et al.* 1999; Pearce 2005). His theory was soon under attack on empirical as well as theoretical grounds (Dallenbach 1939; Sinclair 1967), but it hastened the incorporation of pain into the theatre of the senses. Sensory fibres of different diameter were found to serve different aspects of pain, and these were to provide the clue for a radical revision of theories of pain (see Melzack and Wall 1965; Melzack 2001).

Ritter's observations faded into oblivion with the discovery of specific receptors in the skin. This provided the platform for Blix and others to relate structure to function. Perhaps it was the equation of cutaneous sensations with the underlying nerves that has given authority to Blix; he stated 'The different sensations of cold and warmth are produced by stimulation of separate specific nerve end-organs in the skin' (Zotterman 1959, p. 431). In the context of sensory physiology Blix had clearly defined a path that would be followed by others. For example, Zotterman (1959) opened his survey of thermal sensations thus: 'Since the discovery by Blix of cold and warm spots from which adequate or electrical stimuli elicited cold and warm sensations, respectively, numerous authors have described the distribution of cold and warm spots in the skin' (p. 431).

The phenomenological distinctions between the dimensions of touch, voiced since antiquity, were given some empirical support from the late eighteenth century and integrated with cutaneous anatomy and physiology in the late nineteenth century.

Movement sense

What became known as the movement sense is mediated by the vestibular and joint systems. The behavioural consequences of vestibular stimulation have long been appreciated, but they were not integrated with the anatomy and physiology of the semi-circular canals until the late nineteenth century. Thus, the earlier claims for a movement sense were based almost entirely on behavioural evidence relating to apparent visual or body movement. That is, the vestibular system had been examined indirectly through studies of vertigo, which have a long history. Hartley (1749) provided a clear definition of the vertigo, as well as providing some of the conditions for inducing it:

Giddiness, or an apparent irregular Motion in the Objects of Sight, almost always goes before any general Confusion or Privation of Sense and Motion; which is very agreeable to the Doctrine of Vibrations. For the general Disorder in the Vibrations in the medullary Substance may be expected to be perceived in the Optic Nerve, and corresponding Part of the Brain, first and chiefly, on account of the Acuteness and Precision of the Sense of Sight. Upon the same Principles it is easy to see, how great and unusual Agitations of the Body, Impressions on the Stomach, on the olfactory Nerves, on the Eye, by the quick Transition of Objects, on the Eye and Fancy together, by looking down a Precipice, &c. should occasion a temporary Giddiness.

(Hartley 1749, p. 200)

Vertigo

The feeling of dizziness or giddiness has been given many names, but vertigo is perhaps the most widely used. Galen referred to it as 'skotoma' and commented on the effects caused by observing whirling patterns as well as by body rotation. These were described in the context of diseases which lead to dizziness:

All these affections start obviously in the head and especially the affection which is called *skotoma* (vertigo), the name of which indicates its nature. People who are subject to this ailment are affected by *skotoma* of their vision on account of the smallest causes, so that they often fall, especially when they turn round. Then, what happens to other people only after having turned round a great many times, that will overcome these people after one single turn. They can even be affected by vertigo, when they see another person or a wheel turning or anything else which whirls, even when their head had been overheated for any other reason . . . There is general agreement upon the fact that such frequent turning movements

provoke an unequal, tumultuous and disorderly flow of humors and pneuma. Therefore it is only natural that people subject to *skotoma* are on guard against any motion of this kind.

(Siegel 1970, p. 138)

Galen was probably describing a disorder that is now called Ménière's disease, after it was linked to disease of the vestibular system by Prosper Ménière (1799–1867; 1861). Developments did occur in fusing Aristotle's account of the senses with Galen's pneumatic physiology, and the medical tradition of describing diseases of the senses became more refined. Conditions like visual vertigo were related to the movements of the animal spirit in the head. Generating visual vertigo, even in healthy individuals, by rotating the body and then stopping, was a source of regular reflection by medieval medical and optical writers.

Two great anatomists of the brain, Felix Platter (1536–1614) (Fig. 2.10, left) and Thomas Willis (1621–1675) (Fig. 2.10, right) heralded the early modern era of research on the movement sense. They each suggested a mechanistic interpretation for vertigo in terms of motion of the animal spirit in the brain. Platter (1583) observed that:

An intense, uniform, and extended movement of the head transfers itself in a similar way to the spiritus. Despite holding the head still afterwards, it appears to continue moving for a while, before it eventually feels still. This is the basis for dizziness, if one rotates the head and body in a circle for a long time.

(Koelbing 1967, p. 89)

Willis defined vertigo as 'an affection in which visible objects appear to rotate' (1672, p. 353), and devoted a chapter of his book to describing its pathology and the

Fig. 2.10 Nicholas Wade, Left, *Platter's brain*; the diagram of the brain is taken from Platter (1583) and the portrait is derived from Freher (1688). Right, *Circle of Willis*; Christopher Wren made the illustration of the base of the brain printed in Willis (1672), and the portrait was derived from Birch (1743).

conditions that can induce it, including body rotation in healthy individuals. Platter and Willis interpreted vertigo in Galenic terms: motion of the animal spirit in the head produced the apparent motion during rotation, rather like smoke in a flask lagging behind that of the rotating vessel. Moreover, Willis described the visual motion that continues after body rotation ceases, and this was attributed to the continued motions of the animal spirit relative to the stationary head. Willis gave a graphic description of it in his Oxford lectures:

Vertigo arises from the circular motion of the spirits, and, as it were, their rotations in the brain and its medullary part. It takes place just as smoke and vapour contained in a glass or phial are sent into similar motion if you spin the vessel round. This motion lasts longer in the smoke or vapour than in the vessel. Thus we find people whose spirits are very thin, and therefore flexible and weak, pass into vertigo as soon as the body or head is rotated and this sensation persists after the body has ceased its turning motion.

(Dewhurst 1980, pp. 113–14)

So little was then known about the functions of the brain that this interpretation was long held. Even when the attraction of the animal spirit was waning, the logic of the explanation was retained. In his medical text on vertigo, Herz (1786) modified the interpretation slightly by referring to movement of nervous humours in the brain rather than animal spirits, but how these humours moved remained mysterious.

In the eighteenth century, François Boissier de Sauvages (1706–1767) discussed vertigo in his classification of diseases, and described it as:

an hallucination which takes place when stationary objects appear to move and rotate around us . . . The cause of vertigo is nothing other than an impression on the retina which is equivalent to that excited by objects that paint their images successively on different parts of that membrane.

(Boissier de Sauvages 1772, p. 50)

He drew parallels between vertigo and visual persistence with rapidly moving lights, and suggested that the sensitivity of the retina was changed by the retrograde movements of blood in the vessels supplying it. He did discuss the effects of body rotation, and the possibility of unconscious eye movements was entertained.

An alternative to speculating on processes in the retina or brain was to study the phenomenon of vertigo itself. Eighteenth-century interest in it was principally medical, and most observations on it were made in that context. For example, Robert Whytt (1714–1766) included giddiness amongst the symptoms for nervous diseases:

Many people of a delicate, nervous, and vascular system, after stooping and suddenly raising their head, are apt to be seized with a *vertigo*, which is sometimes accompanied by faintness. In this case, the vessels of the brain being too weak, seem to yield more than usual to the weight of the blood, when the head is inclined; and afterwards, when it is suddenly raised, and the blood at once descends towards the heart, those vessels do not contract fast enough, so as to accommodate themselves to the quantity of blood remaining in them: At the same time the brain, on account of its too great sensibility, is more affected than usual, by any sudden change in the motion of the fluids through its vessels.

(Whytt 1765, p. 309)

Diseases of the inner ear were discussed by Bell (1803/2000), but their association with vertigo was not explicitly entertained. While he mentioned that 'Of the diseases of the labyrinth, there is little on record' (p. 451), he did observe that inflammation around the auditory nerve was accompanied by an increased sensitivity to slight head movements and to vertigo. The paradox of these investigations is that the gross anatomy of the labyrinthine organs was reasonably well known at that time.

At the beginning of the nineteenth century, galvanic stimulation was applied to the regions around the ears and provided some indication that more than hearing was involved in the structures of the inner ear. As was noted earlier, Volta (1800) reported that his head seemed to be shaking when current was applied to his ears. Ritter (1801) described the dizziness generated by experiments on applying galvanic stimulation to the head. A similar account was given by Augustin (1803): 'If one surrounds the ears with wire . . . one becomes dizzy and sees electrical lights' (p. 129). Purkinje (1820) carried out further studies on galvanic stimulation of the ear and the subsequent vertigo that it induced. He constructed a voltaic pile from twenty zinc and copper pairs and applied the current to the ear. The immediate sensations were of light flashes and a metallic taste, and then he reported feeling dizzy. It was like a motion from ear to ear, and its direction depended on the polarity of stimulation. He felt nauseous following ten minutes continuous stimulation, and experienced after effects for the following two hours. These sensations could only be produced when the current was applied to the ears; similar application elsewhere on the head did not produce vertigo. Purkinje extended his observations in a later article:

The direction of the rotary motion from vertigo goes from right to left if the copper pole is in the right ear, and the zinc pole is in the left, and in the opposite direction from left to right, if the copper pole is applied to the left and the zinc pole to the right ear. As often as the galvanic current is alternated, the vertigo is experienced in the opposite direction and lasts for a longer or shorter time according to the longer or shorter application.

(Purkinje 1827, p. 297)

More systematic investigations were conducted by Eduard Hitzig (1838–1907). In examining the effects of vestibular stimulation, Hitzig (1871) applied electrical currents between the mastoid bones and recorded not only the direction of apparent visual motion but of actual body and eye movements. When the head moved in one direction the eyes moved in the opposite direction. The actual and apparent movements of the body were in the same direction. Hitzig found that the effects of galvanic stimulation were more pronounced when they were applied with the head tilted, and that it was difficult to maintain balance under these conditions. Two blind subjects felt that their bodies were rotating when the current was applied, as did sighted subjects with their eyes closed.

After effects of body rotation

Experiences associated with vestibular stimulation are unlike those of seeing or hearing because they are referred to other bodily organs. Thus, motion illusions based on

body rotation relate to the feelings of body rotation, as well as of visual motion. It is these aspects that were investigated before galvanic studies were undertaken, and it is in this regard that the essential aspects of vestibular function had been outlined experimentally. The investigations were conducted initially by Wells (1792), although they were not related to the vestibular system itself (see Wade 1998, 2000a, 2003b), nor were they recognized by historians. The received opinion was clearly stated by Boring:

The history of what has been called vestibular equilibration, the static sense, ampullar sensation, giddiness, vertigo, the sense of rotation, and the sensibility of the semicircular canals is voluminous and simple. It is voluminous because there has been so much written about it: in 1922 Griffith cited 1685 titles from 1820 on. It is simple because it can all be organized about Purkinje's description of dizziness (1820–1825), Flourens' discovery that lesions of the semicircular canals produce muscular incoordination in the plane of the affected canals (1824–1830), the Mach-Breuer-Brown experiments and their theory of the function of the canals (1873–1875), and the discovery of vertiginous habituation by the psychologists of the U.S. Army (1918), Griffith (1920) and Dodge (1923).

(Boring 1942, p. 535)

The history is certainly voluminous, but it is not simple. Robert Bárány (1876–1936), who was awarded the Nobel Prize in 1914 for his vestibular researches, also surveyed its history. He remarked that he had come across (but did not cite) over 100 dissertations on vertigo from the sixteenth to the eighteenth centuries. These were, however, dismissed as adding little to what had been known to the ancients:

The reality is that they all say much the same thing. In the Middle Ages one had become fully accustomed to the complete description. Whoever wrote a book studied the texts of his predecessors and wrote more or less the same thing with small variations. For example, regarding the interesting question of vertigo from rotation, many authors have speculated whether it is accompanied by unconscious eye movements. It did not occur to any of them to rotate themselves a few times and to feel if their eyes were moving, or to ask his good friend to rotate and observe his eyes. The often insightful considerations would only be carried out at the writing table. The first to make the observations that will be discussed here was *Purkinje* in 1825.

(Bárány 1913, pp. 396–7)

Both Bárány and Boring were correct in citing the physiological experiments of Pierre Flourens (1794–1867), and the hydrodynamic theory of Ernst Mach (1838–1916) (Fig. 2.11, left), Josef Breuer (1842–1925) (Fig. 2.11, centre), and Alexander Crum Brown (1838–1922) (Fig. 2.11, right). However, Boring placed undue reliance on the historical accuracy of Griffith's (1922) monograph, as have others (see Wendt 1951; Kornhuber 1974). Perhaps all of them were in thrall of Mach's historical authority, which was amplified in his book on movement perception (Mach 1875; Young *et al.* 2001). Mach commenced:

The work before you attempts, for the first time, to present a complete chapter of physiology, to which the incontestable Purkinje (Purkyně), Flourens and Goltz have laid the foundations . . . The elder Darwin and Purkyně have studied the remarkable subjective sensations of rotation that take place if one rotates rapidly several times and then stops suddenly.

(Mach 1875, pp. iii and 1)

Fig. 2.11 Nicholas Wade, Left, *Mach's chair*; Mach used the rotating chair to examine vertigo. Centre, *Breuer's pigeons*; the influence of semicircular canals on the posture of pigeons was confirmed by Breuer. Right, *Crum Brown's nystagmus*; Crum Brown was able to record the slow movements of the eyes and their rapid return (nystagmus) during body rotation, as well as the adaptation that occurs; the sawtooth patterns are derived from Crum Brown's (1878b) diagrams.

(©Nicholas Wade)

Crum Brown (1878a) similarly surveyed the past in Purkinje's favour. With regard to the aftereffects of body rotation he wrote:

Purkinje studied the conditions under which this apparent rotation occurs, and arrived at the following conclusions, which have been confirmed by all succeeding observers: 1. That the direction of apparent motion of surrounding objects depends upon the direction of the preceding real motion of our body, and is always opposite to it. 2. That the axis about which the apparent motion takes place is always that line in the head which was the axis of the preceding real rotation.

(p. 634)

In a second article by Crum Brown (1878b), mention is made of Erasmus Darwin's investigations of body rotation; post-rotational nystagmus is both described and illustrated, but again its initial observation is credited to Purkinje. Darwin was also mentioned by Griffith (1922), Boring (1942), and Cohen (1984), but they did not recount the reasons why he chose to carry out his studies. It was William Porterfield (c.1696–1771) whose speculations regarding the link between eye movements and post-rotational visual motion stimulated renewed interest in the visual dimension of vertigo in the late eighteenth century (see Wade 2007b). Motion was the last of the phenomena of vision described in the second volume of Porterfield's *Treatise on the Eye, the Manner and Phænomena of Vision*, and his analysis of it was subtle. Vertigo was the final phenomenon discussed in the final section:

But, before I dismiss this Subject, I shall endeavour to explain another *Phænomenon* of Motion, which, tho' very common, and well known, yet, so far as I know, has not as yet had any Solution given to it. If a Person turns swiftly round, without changing his Place, all

Objects about will seem to move in a Circle to the contrary Way, and the Deception contin-
ues, not only when the Person himself moves round, but, which is more surprising, it also
continues for some time after he stops moving, when the Eye, as well as the Objects, are at
absolute Rest.

(Porterfield 1759, pp. 424–5)

The evidence that the eyes do not move following rotation was subjective. Porterfield
was not conscious of any movements of his eyes and so he was convinced that they
remained stationary following rotation. The situation was clarified by Wells (1792);
he distrusted the recourse to subjective experience in deciding upon a matter of
science, and he found that experiments with afterimages were preferable because
of their increased objectivity. It was Wells's monograph that galvanized Erasmus
Darwin to deliberate further on vertigo, and it was Wells who engaged in a public
dispute with Darwin concerning the involvement of eye movements in visual vertigo
following body rotation (see Wade 2003a).

Wells (1792, 1794a,b) conducted sophisticated experiments on postrotational ver-
tigo and nystagmus long before Purkinje's studies. Wells's analysis of vertigo should
be considered as heralding the first clear behavioural evidence for the vestibular sense.
His experiments satisfied Müller's (1843/2003) requirement: 'The essential attribute
of a new sense is, not the perception of external objects or influences which ordinarily
do not act upon the senses, but that external causes should excite in it a new and pecu-
liar kind of sensation different from all the sensations of our five senses' (p. 1087). The
external causes are linear and angular accelerations, and the sensation is one of rotation
both of the body and the visual scene.

A common feature of many of Wells' experiments on vision was the use of after-
images to assess the manner in which the eyes moved. He used the term 'spectra' to
describe afterimages; they were so called by Robert Darwin (1766–1848), Erasmus's
son and the father of Charles, in an article a few years earlier (R. Darwin 1786). It seems
likely that the Robert's article received more that a little assistance in its writing from
Erasmus (Wade 2002)! Wells enlisted afterimages to determine how the eyes move
during postrotational vertigo, although his initial observation was accidental: 'During
a slight fit of giddiness I was accidentally seized with, a coloured spot [afterimage],
occasioned by looking steadily at a luminous body, and upon which I happened at that
moment to be making an experiment, was moved in a manner altogether independent
of the positions I conceived my eyes to possess' (Wells 1792, p. 95). Wells capitalized
on this happy accident and provided experimental evidence to link the pattern of eye
movements to the direction of visual vertigo. He gave the first clear description of the
fast and slow phases of postrotational nystagmus, and its decreasing amplitude with
time (Tatler and Wade 2003; Wade and Tatler 2005; Wade 2007c). Furthermore, he
described how the direction of postrotational afterimage motion was dependent on
head position during rotation. Wells was not aware of feeling his eyes moving after
rotation and so he asked another person to rotate and then stop 'and I could plainly
see, that, although he thought his eyes were fixed, they were in reality moving in their
sockets, first toward one side, and then toward the other' (Wells 1792, p. 97). In the
space of a few pages, Wells encapsulated the essential features of vestibular function
as they are expressed through eye movements and postrotational vertigo.

Purkinje (Fig. 2.12, left) unknowingly repeated many of Wells' experiments on body rotation, although he was able to add a mechanically rotating device to study vertigo. Initially Purkinje examined the introspective aspects of postrotational vertigo and made many experimental manipulations of it. He described rotary and postrotational eye movements and suggested that 'visual vertigo is a consequence of the conflict between unconscious involuntary muscular actions and voluntary conscious ones in the opposite direction' (Purkinje 1820, p. 95). Among the few sources of earlier research he cited were a translation into German of Erasmus Darwin's *Zoonomia* (Darwin 1795) and Herz's (1786) medical text on dizziness and its treatment. Purkinje deduced a general principle from his experiments: 'that the midpoint of the head (considered as a sphere), around which the initial rotation was performed, invariably determined the direction of apparent motion regardless of the subsequent position of the head' (1820, p. 86). Kruta (1964) referred to this as 'Purkinje's law of vertigo'. There was no clear indication of how such motions in the head could be detected, and his initial interpretation was that motion of the brain itself lagged behind that of the head, with particular

Fig. 2.12 Nicholas Wade, Left, *Purkinje's schaukel*; Purkinje and a rotating device like that used in his experiments on the effects of body rotation. Right, *Bárány's chair*; Bárány devised a rotating chair for studying semicircular canal function. It was very similar to the chairs devised for the treatment of maniacs early in the nineteenth century; the one shown here was derived from an illustration in Hallaran (1818).

(©Nicholas Wade)

influence exerted by the cerebellum. Purkinje concluded his first article with a statement that was soon to be realized: 'It remains for a future work to establish the possible movements in the brain which measure its structure and organization' (1820, p. 125). Purkinje later wrote several briefer articles on vertigo, but his interpretation of it did not change substantially (see Wade and Brožek 2001). The dimension that Purkinje added to Wells' studies was the application of galvanic stimulation to the ears.

Vestibular system

The significance of the vestibular system to the maintenance of posture and balance slowly emerged after Flourens conducted his lesion studies, initially on the cerebellum and later on the semicircular canals (Flourens 1824, 1830, 1842). In the year that his first book was published he sectioned the semicircular canals of pigeons:

On 15 November 1824, I cut the two horizontal semicircular canals of a pigeon. This lesion was immediately followed by two habitual phenomena: the horizontal oscillation of the head, and the turning of the animal in the same direction.

(Flourens 1842, p. 452)

In later experiments, he was able to demonstrate that sectioning a particular semicircular canal elicited nystagmus in the same plane, as well as disturbances of posture and equilibrium: the bodies of the experimental animals always turned in the direction of the severed canal. Similar results were obtained with rabbits. Despite providing this experimental evidence, Flourens did not make the link between semicircular canal function and the movement sense. This was to wait another fifty years, when Mach, Breuer, and Crum Brown independently formulated the hydrodynamic theory: during head rotation the endolymph in the canals displaces receptors in the ampulla, signalling angular accelerations and exerting control over posture and eye movements.

Mach (1873, 1875) constructed a rotating chair that was mounted in a frame that could also rotate, and he examined the perception of the visual vertical during static tilt and also visual after effects of body rotation. From experiments using this apparatus he concluded that it was not angular velocity that was sensed, but angular acceleration. Breuer (1874) made systematic lesions of the semicircular canals of pigeons and dogs; he also distinguished between the canal receptors and the otolith organs of the vestibular system, which detected orientation with respect to gravity. Crum Brown (1874, 1875) based his analysis on thresholds for detecting body rotation on a revolving stool; the thresholds were lowest when the head was positioned so that one of the semicircular canals was in the plane of rotation. Mach (1910) placed these observations in the context of Aristotle's strictures about the senses:

But at times some extremely artless animadversions are heard that almost nonplus us. 'If a sixth sense existed it could not fail to have been discovered thousands of years ago.' Indeed, there was a time, then, when only seven planets could have existed! But I do not believe that any one will lay any weight on the philological question whether the set of phenomena which we have been considering should be called a sense. The phenomena will not disappear when

the name disappears. It was further said to me that animals exist which have no labyrinth, but which can yet orientate themselves, and that consequently the labyrinth has nothing to do with orientation. We do not walk forsooth with our legs, because snakes can propel themselves without them! But if the promulgator of a new idea cannot hope for any great pleasure from its publication, yet the critical process which his views undergo is extremely helpful to the subject-matter of them.

(p. 297)

Mach, Breuer, and Crum Brown continued to investigate the consequences of the hydrodynamic theory of semicircular canal function, but Crum Brown, in 1878, made a particularly astute prediction: if deaf-mutes have defects in all the parts of the inner ear, then they will not be able to experience vertigo nor have the eye movements characteristically associated with it:

A great deal of valuable information might be obtained by carefully testing the delicacy and accuracy of the sense of rotation in deaf-mutes. Many deaf-mutes have not only the cochlea, but the whole internal ear, destroyed; if, then, the inmates of deaf and dumb establishments were systematically tested by means of such experiments as Mach and Brown made upon themselves, experiments which would, no doubt, greatly interest and amuse them, and if the condition of the internal ear were, in each case of *post-mortem* examination of a deaf-mute, accurately noted, we should soon obtain a mass of information which would do more to clear up the relation between the sense of rotation and the semicircular canals than any number of experiments on animals unable to describe to us their sensations.

(Crum Brown 1878b, p. 658, original italics)

William James (1842–1910; 1882) put this to the test with a specially constructed device for rotating the body. Almost all normal observers experienced vertigo. However, of over 500 deaf-mutes tested, almost 200 experienced no dizziness. The results were confirmed by Kreidl (1891), who found that over 80% of congenitally deaf individuals experienced no vertigo following rotation. Moreover, there were no nystagmic eye movements in those who did not experience vertigo. James (1890) provided a general account of eye movements in vertigo in his *Principles of psychology*. He related eye movements following body rotation to those involved in optokinetic nystagmus. James believed that the rapid return movements of the eyes were voluntary because 'it often ceases if we voluntarily fix our eyes upon a given point' (p. 90). Wells (1794b) had made the same observation but did not reach the same conclusion. James related the eye movements in vertigo to a range of other motion illusions. His analysis of motion perception was essentially similar to that proposed by Porterfield (1759): objects are seen as moving when they move over the retina and the eyes are considered to be still or when they remain stationary on the retina but the eyes are thought to move. James was integrating visual vertigo with his analysis of space perception generally.

Clinical studies

An alternative approach was taken by Bárány (Fig. 2.12, right) who examined the medical aspects of vertigo and eye movements. Bárány used nystagmic eye movements as a

clinical index of vestibular function. Indeed, the rotating chair is now called the Bárány chair. This is puzzling because essentially similar devices were employed a century earlier in order to treat the mentally ill (Wade 2005c; Wade *et al.* 2005). In 1906 he refined a caloric method of stimulating the semicircular canals so that the eye movements they induce could be easily observed. Bárány (1913) wrote two articles on the relationship of vertigo to the semicircular canals, and these also surveyed the history of research on the topics. His history fell short of the standard set by Mach (1875), even though Mach was cited! Nonetheless, in addition to the descriptions of the experiments by Purkinje and Flourens, as well as outlining the hydrodynamic theory of Mach, Breuer, and Crum Brown, Bárány integrated the clinical studies of Ménière (1861). He summarized their endeavours with a musical allusion:

Purkinje and *Flourens* (1825–1828) have devised an ingenious prelude, *Ménière* (1861) has introduced the first phrase, *Goltz* (1870) addressed a new theme, and the theory of *Mach, Breuer,* and *Crum Brown* concluded the movement, with a powerful, full-bodied accord. The second movement is like a fugue, where many voices whirl around one another, at one time with harmonic combination, and a moment later they are in conflict.

(1913, p. 399, original italics)

Bárány standardized a form of stimulating the vestibular system that did not involve rotation—irrigation of the ear with warm and cold water. The procedure was known about and had been applied for many years; Goltz (1870) referred to it as common knowledge. This is now called caloric stimulation and it is a standard clinical test for vestibular function.

Vertigo was considered to provide insights into motion illusions generally by those with a psychological interest. For physicians it was seen as a useful tool for determining the integrity of vestibular function. These two activities became more closely integrated with the perceptual demands of first aircraft and then space flight in the twentieth century. That is, there were practical applications of the knowledge derived from both experimental and medical research on vertigo.

Visual orientation

Mach extended his own research to examine visual orientation during body tilt, as well as visual motion following body rotation. He was able to use his rotating chair and to exclude the visibility of the surround. His research on orientation was stimulated by an experience of visual disorientation when travelling in a vehicle:

Thus my attention was drawn to this point by the sensation of falling and subsequently by another singular occurrence. I was rounding a sharp railway curve once when I suddenly saw all the trees, houses, and factory chimneys along the track swerve from the vertical and assume a strikingly inclined position. What had hitherto appeared to me perfectly natural, namely, the fact that we distinguish the vertical so perfectly and sharply from every other direction, now struck me as enigmatical. Why is it that the same direction can now appear vertical to me and now cannot? By what is the vertical distinguished for us?

(Mach 1910, pp. 286–7)

Mach appreciated that judgements of orientation are made with respect to frames of reference. Normally those available from the senses correspond with the cardinal directions defined by gravity, but occasionally this accord is disrupted. Mach did have recourse to the structures within the inner ear—the 'secret reference'—that could 'indicate these positions of the body', and he conducted experiments with his tilting chair to confirm it.

Wells (1792) was similarly searching for the sixth sense that occupied many scholars throughout the nineteenth century, and he also discussed the manner in which we can orient our bodies with respect to gravity, and how our judgements of visual orientation are influenced by changes in body posture. He was aware, on theoretical grounds, that there must be some system that registers the position of the body with respect to gravity: 'In the estimates we make by sight of the situation of external objects, we have always some secret reference to the position of our own bodies, with respect to the plane of the horizon' (1792, p. 85). Although he asked 'What is there within us, to indicate these positions of the body?' (p. 86), he could not answer to his satisfaction, since he could only draw on the actions of the voluntary muscles. Thus, the orientational aspects of otolithic function were examined behaviourally, as well as the rotational consequences of semicircular canal stimulation.

The receptors that mediate vestibular sensitivity are closely linked to those for hearing. Hair cells in the cochlea were first observed in the 1850s, and they were later identified in the vestibular system (see Finger 1994). In the twentieth century, the fine detail of the hair-cell receptors could be observed with electron microscopes and a cortical projection from the vestibular nuclei was demonstrated. The vestibular sense is unusual in various respects. First, the sensory experiences following stimulation are not localized as they are with the other senses; we feel giddy or see the world spin rather than have a single sensation like sight or hearing. Secondly, the gross anatomy of the vestibular system was known long before its function was appreciated. Thirdly, systematic evidence indicating the action of the semicircular canals (in vertigo) was available from the late eighteenth century. Nonetheless, behavioural studies which provided support for a new sense were not accorded the status given to isolating specific receptors or establishing projections to the brain. It was the behavioural dimension that encouraged Crum Brown (1895) to state: 'I am not sure whether in this account of the sense of rotation, of its organ, and of the use of it, I have carried all my hearers with me, and convinced you of the real existence and the real practical use of this sense' (p. 28).

Conclusion

Aristotle restricted the number of senses to five for theoretical rather than empirical reasons, although the sense of touch or feeling remained an enigma. The subsequent

search for a sixth sense fractionated feeling into movement (vestibular) and muscle senses and multiple dimensions of cutaneous sensitivity. In science, the sixth sense gradually emerged from the mass of names given to the experiences deriving from external stimulation (Fig. 2.13). Ancient phenomenological distinctions between the senses of feeling were given empirical support from the late eighteenth century. First, the dependence of visual vertigo (and eye movements) on the direction of head rotation provided evidence for a movement sense. Shortly afterwards, the separation of touch from temperature sensitivity was demonstrated both behaviourally and by galvanic stimulation. The muscle sense was established by psychophysical experiments. The success of the search for a sixth sense reflected the advances made in anatomy, physiology, and psychophysics in the nineteenth century. The criteria for distinguishing between the senses were extended from sensory quality and gross anatomy to include microanatomy (of receptors and sensory pathways), physiology (of nerve stimulation and extirpation), and psychophysics (stimulus manipulation and behavioural measurement). Evidence for the separation of the senses relied more on microanatomy and physiology than on psychophysics.

Studies of the movement sense provide a telling example of the manner in which our understanding of perception has been advanced by the specification of sense.

Fig. 2.13 Nicholas Wade, *The sixth sense.*

(©Nicholas Wade)

The gross anatomy of the vestibular system was described before its function was appreciated; the visual consequences of vestibular stimulation were subjected to observation and experiment between these two events. Rotating the body to induce vertigo resulted in postrotational nystagmus and apparent visual motion, the directions of which were dependent upon head orientation during rotation. Applying electric currents to the outer ears produced feelings of dizziness, as well as movements of the body and of the eyes. These responses to rotation and galvanic stimulation could be understood when the hydrodynamic theory of semicircular canal function was advanced in the 1870s. Moreover, the absence of these responses in many who were deaf and dumb added to the evidence for a separate sense.

In an historical sense, it is difficult to imagine originating a classification of the senses that did not depend on anatomical and perceptual distinctions. Such a classification would have preceded others based on energy because the characteristics of perception were described long before there was an adequate understanding of energy sources in the environment. These categories were later reinforced by evidence from neuroanatomy and neurophysiology: specialized receptors respond to features of the stimulus and these are analysed in discrete regions of the brain.

The number of senses has always been arbitrary, depending on the criteria that are applied. Adding one or more senses to Aristotle's five reflected the advances that took place in nineteenth-century neuroscience. Despite these advances in science, the restriction of the senses remains fixed at five in both our language and our art. Perhaps this is an instance in which art has dominated science!

References

Adrian ED (1928). *The basis of sensation*, Christophers, London.

Ægineta P (1844). *The seven books of Paulus Ægineta, Vol. 1* (F Adams trans.). The Sydenham Society, London.

Augustin FL (1803). *Versuch einer vollständigen systematischen Geschichte der galvanischen Elektricität und ihre medizinischen Anwendung*, Felisch. Berlin.

Bárány R (1913). Der Schwindel und seine Beziehungen zum Bogengangapparat des inneren Ohres. Bogengangapparat und Kleinhirn. (Historische Darstellung. Eigene Untersuchungen.) *Naturwissenschaften* 1, 396–401.

Beare JI (1906). *Greek theories of elementary cognition from Alcmaeon to Aristotle*. Clarendon, Oxford.

Bell C (1803). *The anatomy of the human body. Vol. III. Containing the nervous system*. Longman, Rees, Cadell, and Davies, London. (Reprinted in NJ Wade (ed.) (2000). *The emergence of neuroscience in the nineteenth century. Vol. 1*. Routledge/Thoemmes, London.)

Bell C (1811). *Idea of a new anatomy of the brain; submitted for the observations of his friends*. Published by the author; printed by Strahan and Preston, London. (Reprinted in NJ Wade (ed.) (2000). *The emergence of neuroscience in the nineteenth century. Vol. 1*. Routledge/Thoemmes, London.)

Bell C (1823). On the motions of the eye, in illustration of the uses of the muscles and of the orbit. *Philosophical Transactions of the Royal Society*, 113, 166–86.

Bell C (1826). On the nervous circle which connects the voluntary muscles with the brain. *Philosophical Transactions of the Royal Society*, **116**, 163–73.

Bell C (1844). *The anatomy and philosophy of expression as connected with the fine arts*, 3rd edn. John Murray, London

Berkeley G (1709). *An essay towards a new theory of vision*. Pepyat, Dublin.

Birch T (1743). *The heads of illustrious persons of Great Britain. Vol. 1*. Knapton, London.

Blix M (1884). Experimentelle Beiträge zur Lösung der Frage über die specifische Energie der Hautnerven. *Zeitschrift für Biologie*, **20**, 141–56.

Boissier de Sauvages F (1772). *Nosologie méthodique, ou distribution des maladies en classes, en genres et en especes, suivant l' de Sydenham, & la méthode des botanistes. Vol. 4*. Bruyset, Lyon.

Boring EG (1942). *Sensation and perception in the history of experimental psychology*. Appleton-Century, New York.

Brazier MAB (1959). The historical development of neurophysiology. In J Field, HW Magoun, VE Hall (eds.) *Handbook of physiology. Neurophysiology. Vol. 1.*, pp. 1–58. American Physiological Society, Washington DC.

Brazier MAB (1988). *A history of neurophysiology in the 19th century*. Raven, New York.

Bresadola M (1998). Medicine and science in the life of Luigi Galvani (1737-1798). *Brain Research Bulletin*, **46**, 367–80.

Breuer J (1874). Über die Funktion der Bogengänge des Ohrlabyrinthes. *Wiener medizinische Jahrbuch*, **4**, 72–124.

Brown T (1820). *Sketch of a system of the philosophy of the human mind*. Bell, Bradfute, Manners & Miller, and Waugh & Innes, Edinburgh.

Cohen B (1984). Erasmus Darwin's observations on rotation and vertigo. *Human Neurobiology*, **3**, 121–8.

Cranefield PF (1974). *The way in and the way out: François Magendie, Charles Bell and the roots of the spinal nerves*. Futura, Mount Kisco, NY.

Crum Brown A (1874). Preliminary note on the sense of rotation and the function of the semi-circular canals of the internal ear. *Proceedings of the Royal Society of Edinburgh*, **8**, 255–7.

Crum Brown A (1875). On the sense of rotation and the anatomy and physiology of the semi-circular canals of the internal ear. *Journal of Anatomy and Physiology*, **8**, 327–31.

Crum Brown A (1878a). Cyon's researches on the ear. I. *Nature*, **18**, 633–5.

Crum Brown A (1878b). Cyon's researches on the ear. II. *Nature*, **18**, 657–9.

Crum Brown A (1895). *The relation between the movements of the eyes and the movements of the head*. Frowde, London.

Dallenbach KM (1939). Pain: History and present status. *American Journal of Psychology*, **52**, 331–47.

Darwin E (1794). *Zoonomia; or, the laws of organic life. Vol. 1*. Johnson, London.

Darwin E (1795). *Zoonomia, oder, Gesetze des organischen Lebens* (JD von Brandis trans.). Hahn, Hannover.

Darwin RW (1786). New experiments on the ocular spectra of light and colours. *Philosophical Transactions of the Royal Society*, **76**, 313–48.

Descartes R (1637/1902). La dioptrique. In C Adam and P Tannery (eds.) *Oeuvres de Descartes*, Vol. VI. Cerf, Paris.

Descartes R (1664/1909). Traite de l'homme. In C Adam and P Tannery (eds.) *Oeuvres de Descartes*, Vol. XI. Cerf, Paris.

Dewhurst K (1980). *Thomas Willis's Oxford lectures*. Sandford, Oxford.

Donaldson HH (1885). On the temperature-sense. *Mind*, **10**, 399–416.

Drake S (1957). *Discoveries and opinions of Galileo*. Doubleday, New York.

Finger S (1994). *Origins of neuroscience. A history of explorations into brain function.* Oxford University Press, New York.

Finger S (2000). *Minds behind the brain.* Oxford University Press, New York.

Finger S and Wade NJ (2002). The neuroscience of Helmholtz and the theories of Johannes Müller. Part 2. Sensation and perception. *Journal of the History of the Neurosciences,* **11**, 234–54.

Flourens P (1824). *Recherches expérimentales sur les propriétés et les fonctions du système nerveux dans les animaux vertébrés.* Baillière, Paris.

Flourens P (1830). Expériences sur les canaux semi-circulaires de l'orielle. *Mémoire de l' Royale des Sciences de Paris,* **9**, 455–66.

Flourens P (1842). *Recherches expérimentales sur les propriétés et les fonctions du système nerveux dans les animaux vertébrés,* 2nd edn. Baillière, Paris.

Ford BJ (1991). *The Leeuwenhoek legacy.* Biopress, Bristol.

Ford BJ (2007). Enlightening neuroscience: Microscopes and microscopy in the eighteenth century. In HA Whitaker, CUM Smith, and S Finger, eds. *Brain, mind, and medicine: essays in 18th century neuroscience,* pp. 29–41. Springer, New York.

Freher P (1688). *Theatrum virorum eruditione clarorum.* Hofmann, Nuremburg.

Frey M von (1895): Beiträge zur Sinnesphysiologie der Haut. *Sächsische Akademie der Wissenschafte zu Leipzig,* **47**, 166–84.

Galileo G (1623). *Il saggiatore.* Mascardi, Rome.

Galvani L (1791). De viribus electricitatis in motu musculari. *De Bononiensi Scientiarum et Artium Instituto atque Academia Commentarii,* **7**, 363–418.

Galvani L (1797). *Memorie sull' animale al cerebre abate Lazzaro Spallanzani.* Bologna.

Goldscheider A (1884). Die specifische Energie der Temperaturenerven. *Monatsschrift für praktische Dermatologie,* **3**, 198–208.

Goltz F (1870). Ueber die physiologische Bedeutung der Bogengänge des Ohrenlabyrinths. *Archiv für die gesammte Physiologie,* **3**, 172–92.

Griffith CR (1922). *An historical survey of vestibular equilibration.* University of Illinois Press, Urbana, IL.

Grüsser OJ and Hagner M (1990). On the history of deformation phosphenes and the idea of internal light generated in the eye for the purpose of vision. *Documenta Ophthalmologica,* **74**, 57–85.

Gudden B von (1870). Experimentaluntersuchungen über das peripherische und centrale Nervensystem. *Archiv für Psychiatrie und Nervenkrankheit,* **2**, 693.

Hallaran WS (1818). *An enquiry into the causes producing the extraordinary addition to the number of insane, together with extended observations on the cure of insanity: with hints as to the better management of public asylums* 2nd edn. Edwards & Savage, Cork.

Hamilton W (1846). *The works of Thomas Reid, D.D.* MacLachlan, Stewart, Edinburgh.

Harris H (1999). *The birth of the cell.* Yale University Press, New Haven, CT.

Hartley D (1749). *Observations on man, his frame, his duty, and his expectations.* Leake and Frederick, Bath.

Helmholtz H (1867). Handbuch der physiologischen *Optik.* In G Karsten ed. *Allgemeine Encyklopädie der Physik. Vol. 9.* Voss, Leipzig.

Herz M (1786). *Versuch über den Schwinde.* Voss, Berlin.

Hitzig E (1871). Ueber die bei Galvanisiren des Kopfes entstehenden Störungen des Muskelinnervation und der Vorstellungen vom Verhalten im Raume. *Archiv für Anatomie, Physiologie und wissenschaflichen Medizin,* 716–70.

Hooke R (1665). *Micrographia: or some physiological descriptions of minute bodies made by magnifying glasses with observations and inquiries thereupon.* Martyn and Allestry, London.

Hunter J (1786). *Observations on certain parts of the animal œconomy.* published by the author, London.

James W (1882). The sense of dizziness in deaf-mutes. *American Journal of Otology,* **4**, 239–54.

James W (1890). *Principles of psychology.* Holt, New York.

Jardine L (2003). *The curious life of Robert Hooke.* Harper Collins, London.

Kemp S (1990). *Medieval psychology.* Greenwood, New York.

Koelbing HM (1967). *Renaissance der Augenheilkunde. 1540-1630.* Huber, Bern.

Kornhuber HH (1974). Introduction. In HH Kornhuber, ed. *Handbook of sensory physiology. Volume VI/1. Vestibular system. Part 1: Basic mechanisms,* pp. 3–14. Springer, New York.

Kreidl A (1891). Beiträge zur Physiologie des Ohrenlabyrinthes auf Grund von Versuchen an Taubstummen. *Archiv für die gesammte Physiologie,* **51**, 119–50.

Kruta V (1964). *M.-J.-P. Flourens, J.-E. Purkyne et les débuts de la physiologie de la posture et de l'équilibre.* Alençonnaise, Paris.

Kühne W (1863). Die Muskelspindeln. *Archiv für pathologische Anatomie, Physiologie und klinische Medizin,* **28**, 528–38.

Leeuwenhoek A van (1674). More observations from Mr. Leewenhoeck, concerning the optick nerve. *Philosophical Transactions of the Royal Society,* **9**, 178–82.

Leeuwenhoek A van (1675). Microscopical observations from Mr. Leewenhoeck, concerning the optick nerve. *Philosophical Transactions of the Royal Society,* **9**, 378–80.

Leeuwenhoek A van (1684). *Ontledingen en beschouwingen der onsigtbare geschapene waarheden.* Leiden.

Lucretius (1975). *De rerum natura* (WHD Rouse trans.). Harvard University Press, Cambridge, MA.

Mach E (1873). Physiologische Versuche über den Gleichgewichtssinn des Menschen. *Sitzungsberichte der Wiener Akademie der Wissenschaften,* **68**, 124–40.

Mach E (1875). *Grundlinien der Lehre von den Bewegungsempfindungen.* Engelmann, Leipzig.

Mach E (1910). *Popular scientific lectures,* 4th edn. (TJ McCormack trans.). Open Court, Chicago, IL.

May MT (1968). *Galen. On the usefulness of the parts of the body.* Cornell University Press, Ithaca, NY.

Mazzarello P (1999). *The hidden structure. A scientific biography of Camillo Golgi.* (HA Buchtel and A Badiani trans.). Oxford University Press, Oxford.

Mazzarello P, Calligaro A, Garbarino C and Vannini V (2006). *Golgi, architetto del cervello. Cento anni dal primo Nobel italiano.* Skira, Milan.

Melzack R (2001). Pain and the neuromatrix in the brain. *Journal of Dental Education,* **65**, 1378–82.

Melzack R and Wall PD (1965). Pain mechanisms: A new theory. *Science,* **150**, 171–9.

Ménière P (1861). Mémoire sur des lésions de l' interne donnant lieu à des symptoms de congestion cérébrale apoplectiforme. *Gazette médicales de Paris,* **16**, 597–601.

Müller J (1826). *Zur vergleichenden Physiologie des Gesichtssinnes des Menschen und der Thiere, nebst einem Versuch über die Bewegung der Augen und über den menschlichen Blick.* Cnobloch, Leipzig.

Müller J (1838). *Handbuch der Physiologie des Menschen für Vorlesungen. Vol. 2.* Hölscher, Bonn.

Müller J (1843). *Elements of physiology,* 2nd edn. (W Baly trans.). Taylor and Walton, London.

Müller J (2003). *Müller's Elements of Physiology.* Thoemmes, Bristol.

Natanson LN (1844). Analyse der Functionen des Nervensystems. *Archiv für Physiologie und Heilkunde,* **3**, 515–35.

Neff WD (1960). Sensory discrimination. In J Field, HW Magoun, and VE Hall, eds. *Handbook of physiology. Neurophysiology. Vol. 3.*, pp. 1447–70. American Physiological Society, Washington DC.

Newton I (1704). *Opticks: or, a treatise of the reflections, refractions, inflections and colours of light.* Smith and Walford, London.

Norrsell U (2000). Magnus Gustaf Blix (1849-1904): neurophysiological, physiological, and engineering virtuoso. *Journal of the History of the Neurosciences,* **9**, 238–49.

Norrsell U, Finger S and Lajonchere C (1999). Cutaneous sensory spots and the 'law of specific nerve energies': History and development of ideas. *Brain Research Bulletin,* **48**, 457–65.

Park D (1997). *The fire within the eye.* Princeton, Princeton University Press, NJ.

Pearce JMS (2005). The law of specific nerve energies and sensory spots. *European Neurology,* **54**, 115–17.

Piccolino M (1997). Luigi Galvani and animal electricity: two centuries after the foundation of electrophysiology. *Trends in Neurosciences,* **20**, 443–8.

Piccolino M (2000). The bicentennial of the Voltaic battery (1800-2000): the artificial electric organ. *Trends in Neurosciences,* **23**, 147–51.

Piccolino M (2007). I sensi, l'ambiguità, la conoscenza nell' di Galileo. *Galilæana,* **4**, 245–78.

Piccolino M and Bresadola M (2003). *Rane, torpedini e scintilla. Galvani, Volta e l' animale.* Bollati Boringhieri, Turin.

Piccolino M and Wade NJ (2008a). Galileo's eye: a new vision of the senses in the work of Galileo Galilei. *Perception,* **37**, 1312–40.

Piccolino M and Wade NJ (2008b). Galileo Galilei's vision of the senses. *Trends in Neurosciences,* **31**, 585–90.

Pfaff CW (1801). Vorläufige Nachricht von seinen galvanischen Versuchen mit Voltaischen Batterie. *Annalen der Physik,* **7**, 247–54.

Platter F (1583). *De corporis humani structura usu libri III.* Basel.

Polyak SL (1957). *The vertebrate visual system.* University of Chicago Press, Chicago, IL.

Porterfield W (1759). *A treatise on the eye, the manner and phænomena of vision. Vol. 2.* Hamilton and Balfour, Edinburgh.

Purkinje J (1820). Beyträge zur näheren Kenntniss des Schwindels aus heautognostischen Daten. *Medicinische Jahrbücher des kaiserlich-königlichen öesterreichischen Staates,* **6**, 79–125.

Purkinje J (1825). *Beobachtungen und Versuche zur Physiologie der Sinne. Neue Beiträge zur Kenntniss des Sehens in subjectiver Hinsicht.* Reimer, Berlin.

Purkinje J (1827). Ueber die physiologische Bedeutung des Schwindels und die Beziehung desselben zu den neuesten Versuchen über die Hirnfunctionen. *Magazin für die gesammte Heilkunde,* **23**, 284–310.

Purkinje J (1918). *Opera omnia. Vol. 1.* (KJ Lhotak ed.). Society of Czech Physicians, Prague.

Reid T (1764). *An inquiry into the human mind, on the principles of common sense.* Millar, Kincaid & Bell, Edinburgh.

Ritter JW (1801). Versuche und Bemerkungen über den Galvanismus der Voltaischen Batterie. *Annalen der Physik,* **7**, 431–84.

Ritter JW (1805): Neue Versuche und Bemerkungen über den Galvanismus. *Annalen der Physik,* **19**, 1–44.

Ross HE (1999). The prehistory of weight perception. In PR Killeen and WR Uttal, eds. *Fechner Day '99: The end of 20th century psychophysics,* pp. 31–6. The International Society for Psychophysics, Tempe, AR.

Ross HE and Murray DJ (1978). *E. H. Weber: The sense of touch.* Academic Press, London.

Ross WD, ed. (1931). *The works of Aristotle. Vol. 3.* Clarendon, Oxford.

Scaliger JC (1557). *Exotericarum exercitationum liber quintus decimus, de subtilitate, ad Hieronymum Cardanum.* Vascosani, Paris.

Schickore J (2001). Ever present impediments: exploring instruments and methods of microscopy. *Perspectives in Science*, **9**, 126–46.

Schickore J (2007). *The microscope and the eye. A history of reflections 1740-1870.* University of Chicago Press, Chicago, IL.

Schleiden M (1838). Beiträge zur Phytogenesis. *Müller's Archiv für Anatomie, Physiologie und wissenschaftliche Medizin*, pp. 136–76.

Schwann T (1839). *Mikroskopische Untersuchungen über die Übereinstimmung in der Struktur und dem Wachsthum der Tiere und Pflanzen.* Reimer, Berlin.

Sharples RW (2003). On dizziness. In WW Fortenbaugh, RW Sharples, and MG Sollenberger, eds. *Theophrastus of Eresus on sweat, on dizziness, and on fatigue.* pp. 169–250. Brill, Leiden.

Shepherd G (1991). *Foundations of the neuron doctrine.* Oxford, Oxford University Press.

Sherrington CS (1900). The muscular sense. In AE Schäfer, ed. *Text-book of physiology Vol. 2.* pp. 1002–25. Pentland, Edinburgh.

Sherrington CS (1906). *The integrative action of the nervous system,* Scribner, New York. (Reprinted in NJ Wade, ed. (2000). *The emergence of neuroscience in the nineteenth century. Vol. 8.* Routledge/Thoemmes, London.)

Siegel RE (1970). *Galen on sense perception.* Karger, Basel.

Sinclair D (1967). *Cutaneous sensation.* Oxford University Press, London.

Smith AM (1996). *Ptolemy's theory of visual perception: an English translation of the* Optics *with introduction and commentary.* The American Philosophical Society, Philadelphia, PA.

Spillane JD (1981). *The doctrine of the nerves.* Oxford University Press, Oxford.

Stratton GM (1917). *Theophrastus and the Greek physiological psychology before Aristotle.* Macmillan, New York.

Tatler BW and Wade NJ (2003). On nystagmus, saccades, and fixations. *Perception*, **32**, 167–84.

Vieth GUA (1818). Über die Richtung der Augen. *Annalen der Physik und Chemie*, **58**, 233–55.

Volta A (1800). On the electricity excited by the mere contact of conducting substances of different species. *Philosophical Transactions of the Royal Society*, **90**, 403–31.

Wade NJ (1990). *Visual allusions: pictures of perception.* Lawrence Erlbaum Associates, Hove, East Sussex.

Wade NJ (1995). *Psychologists in word and image.* MIT Press, Cambridge, MA.

Wade NJ (1998). *A natural history of vision.* MIT Press, Cambridge, MA.

Wade NJ (2000a). William Charles Wells (1757-1817) and vestibular research before Purkinje and Flourens. *Journal of Vestibular Research*, **10**, 127–37.

Wade NJ (2000b). Porterfield and Wells on the motions of our eyes. *Perception*, **29**, 221–39.

Wade NJ (2002). Erasmus Darwin (1731-1802). *Perception*, **31**, 643–50.

Wade NJ (2003a). *Destined for distinguished oblivion: the scientific vision of William Charles Wells (1757-1817).* Kluwer/Plenum, New York.

Wade NJ (2003b). The search for a sixth sense: The cases for vestibular, muscle, and temperature senses. *Journal of the History of the Neurosciences*, **12**, 175–202.

Wade NJ (2005a). *Perception and illusion. Historical perspectives.* Springer, New York.

Wade NJ (2005b). Vision and the dimensions of nerve fibers. *Journal of the History of the Neurosciences*, **14**, 281–94.

Wade NJ (2005c). The original spin doctors – the meeting of perception and insanity. *Perception*, **34**, 253–60.

Wade NJ (2006). Perceptual portraits. In F Clifford Rose, ed. *Neurobiology of painting.* pp. 17–38. Elsevier, San Diego, CA.

Wade NJ (2007a). Galileo and the senses: vision and the art of deception. *Galilæana*, **4**, 259–88.

Wade NJ (2007b). The vision of William Porterfield. In H Whitaker, CUM Smith, and S Finger, eds. *Brain, mind, and medicine: essays in 18th century neuroscience*, pp. 163–76. Springer, New York.

Wade NJ (2007c). Scanning the seen: vision and the origins of eye movement research. In RPG van Gompel, MH Fischer, WS Murray, and RL Hill, eds. *Eye movements: a window on Mind and Brain*, pp. 31–61. Elsevier, Oxford.

Wade NJ (2009). Allusions to visual representation. In M Skov and O Vartanian, eds. *Neuroaesthetics*. pp. 171–220. Baywood Publishing, Amityville, NY.

Wade NJ and Brožek J (2001). *Purkinje's vision. The dawning of neuroscience*. Lawrence Erlbaum Associates, Mahwah, NJ.

Wade NJ, Norrsell U, and Presly A (2005). Cox's chair: 'a moral and a medical mean in the treatment of maniacs'. *History of Psychiatry*, **16**, 73–88.

Wade NJ and Piccolino M (2006). Nobel stains. *Perception*, **35**, 1–8.

Wade NJ and Tatler BW (2005). *The moving tablet of the eye: the origins of modern eye movement research*. Oxford University Press, Oxford.

Weber EH (1834). *De pulsu, resorptione, auditu et tactu*. Koehler, Leipzig.

Weber EH (1846). Der Tastsinn und das Gemeingefühl. In R Wagner, ed. *Handwörterbuch, der Physiologie, Vol. 3*, pp. 481–588. Vieweg, Braunschweig.

Wells WC (1792). *An essay upon single vision with two eyes: together with experiments and observations on several other subjects in optics*. Cadell, London. (Reprinted in Wade 2003a.)

Wells WC (1794a). Reply to Dr. Darwin on vision. *The Gentleman's Magazine and Historical Chronicle*, **64**, 794–7. (Reprinted in Wade 2003a.)

Wells WC (1794b). Reply to Dr. Darwin on vision. *The Gentleman's Magazine and Historical Chronicle*, **64**, 905–7. (Reprinted in Wade 2003a.)

Wendt GR (1951). Vestibular functions. In SS Stevens, ed. *Handbook of experimental psychology*, pp. 1191–223. Wiley, New York.

Whytt R (1765). *Observations on the nature, causes, and cure of those disorders which have commonly been called nervous hypochondriac, or hysteric*. Becket, Du Hondt, and Balfour, Edinburgh.

Willis T (1672). *De anima brutorum*. Wells & Scott, London.

Wilson C (1995). *The invisible world. Early modern philosophy and the invention of the microscope*. Princeton University Press, Princeton, NJ.

Young LR, Henn V, and Scherberger H (2001). *Fundamentals of the theory of movement perception by Dr. Ernst Mach*. Kluwer/Plenum, New York.

Young T (1802). On the theory of lights and colours. *Philosophical Transactions of the Royal Society*, **92**, 12–48.

Young T (1807). *A course of lectures on natural philosophy and the mechanical arts*. Johnson, London. (Reprinted by Thoemmes Press, Bristol 2002.)

Zotterman Y (1959). Thermal sensations. In J Field, HW Magoun, and VE Hall, eds. *Handbook of physiology. Neurophysiology. Vol. 1*, pp. 431–58. American Physiological Society, Washington, DC.

CHAPTER 3

THE ART OF TOUCH IN EARLY MODERN ITALY*

GERALDINE A. JOHNSON

SINCE the early 1980s, reception theory (also known as 'reader-response criticism' from its origins in literary studies) has become an increasingly important tool in the historical and theoretical analysis of visual and material culture.[1] However, in most reception-oriented art historical research, the focus has almost exclusively been on the ocular, on how beholders, both real and imagined, have looked at art objects. Clearly, the visual reception of art is crucial. But as this chapter will suggest through the example of Early Modern Italy, a careful consideration of other senses such as touch demonstrates the ways in which non-optical models of reception can provide new insights into how images and objects were actually made, engaged, and understood by their contemporary beholders.[2]

In Early Modern Italy, texts on sculpture in particular confirm that many writers believed that touch was indeed an important way of negotiating encounters with art objects. Not only writers, but fifteenth-, sixteenth-, and seventeenth-century painters

* This essay was completed during a Leverhulme Trust Research Fellowship.

[1] Reader-response criticism was first formulated in theoretical terms in the 1970s by literary scholars such as Hans Robert Jauss and Wolfgang Iser, and then taken up by art historians such as Michael Fried, Hans Belting, and Wolfgang Kemp (Belting 1981; Fried 1980; Iser 1978; Jauss 1977; Kemp 1983).

[2] In this chapter, 'Early Modern' (often used interchangeably with 'Renaissance and Baroque') refers to the period stretching from the early fifteenth through the seventeenth century.

and sculptors working in Italy also explored the notion of tactility in some of their projects. By considering a wide range of texts, images, and objects, one can begin to appreciate the importance of attending to the sense of touch in this period. More significantly, by considering tactility in the context of Early Modern Italy, one can begin to explore the possibility of writing a more general history of art—or rather, a history of the senses used to apprehend art—that goes beyond the ocularcentric and instead considers other modes of experience and forms of attention, such as those made available by touch—a theme that runs through many of the other chapters in the present volume.[3]

Given the evident interest displayed by Early Modern writers and artists in the sense of touch, it is surprising that most scholars working on this period have tended to ignore issues related to tactility in their studies. Three important exceptions are Michael Baxandall, Suzanne Butters, and Jennifer Montagu, art historians who have considered the materiality of Early Modern sculpture, if not explicitly its tactile reception (Baxandall 1980; Butters 1996; J Montagu 1996). Authors who have explored the importance of the sense of touch itself in this era have often done so only in passing or in abstract or metaphorical ways, for instance, as a textual theme or as the subject of works of art, rather than as an actual physical phenomenon involving beholders literally handling an object (Barolsky 1995; Bolland 2000; Boyle 1998; Harvey 2003; Hecht 1984; Sherman 2000; Summers 1981, 1987).

Tactility as an abstract concept has also interested a number of influential art historians working on periods other than the Early Modern one. Indeed, already in the late nineteenth and early twentieth century, key figures such as Adolf von Hildebrand, Alois Riegl, and Heinrich Wölfflin investigated the tactile qualities of sculpture in particular, although generally from a theoretical rather than from an historical or somatic point of view (von Hildebrand 1893; Iversen 1993; Olin 1992; Podro 1982; Riegl 1901; Wölfflin 1915; Wood 1998). Bernard Berenson likewise explored what he called 'tactile values' in paintings produced in Renaissance Italy, but not touch as an actual physical practice (Berenson 1897, pp. 33–4). More recently, a few scholars have considered the role touch plays in the work of Modern artists such as Cézanne, Kandinsky, and the Surrealists (Olin 1989; Powell 1997; Shiff 1991). As with Berenson, however, the sense of touch is once again considered in relation to the subject, composition, or style of paintings, rather than to the actual physical production and reception of art objects, whether sculpted or painted.

[3] 'Ocularcentric' refers here to theoretical or historical approaches to art objects that privilege the visual. See especially Jay 1993, p. 3 and *passim*. On touch and the senses see my forthcoming book entitled *The Sound of Marble: The Sensory Reception of Art in Renaissance Italy* and also, among others: Classen 2005; Hall 1999, pp. 80–103; Howes 1991, 2003, 2005; Johnson 2002a; Marks 2002; A Montagu 1986; Nordenfalk 1985, 1990; Petrelli 1994; Rivlin and Gravelle 1984; Stewart 2002; Synnott 1993; Vasseleu 1998; and the journal *The Senses and Society* (first issue published in March 2006). Growing interest in tactility is also demonstrated by events such as the 'Sculpture and Touch' symposium in May 2008, organized by Peter Dent at the Courtauld Institute of Art, London.

Some philosophers and intellectual historians have begun to critique the ocular-centric assumptions of Western culture, in the process occasionally considering touch in passing. The feminist scholar Luce Irigaray, for instance, has claimed that '[w]oman takes pleasure more from touching than from looking' and has proposed the sense of touch as a possible alternative to what Martin Jay has called the 'phallogocularcentrism' of contemporary culture (Irigaray 1985, p. 26; Jay 1993, pp. 493 ff). Similarly, behavioural psychologists, developmental biologists, and anthropologists (including some contributors to the present volume) are also beginning to privilege senses other than vision in their studies and experiments.[4] Nevertheless, it is striking that most scholars of Early Modern art, the period in which the ocularcentric tendencies of Modern and contemporary culture are often assumed to have originated, have only rarely touched on the sense of touch.

THE SENSE OF TOUCH IN THE
PRE-MODERN ERA

Ever since antiquity, touch has repeatedly been contrasted with sight in discussions about the hierarchy of the senses (Hall 1999, pp. 80 ff; Summers 1987, pp. 32 ff; Synnott 1991). Plato, for example, ranked touch well below sight, while Aristotle considered touch the most animalistic of the senses, attitudes that persisted throughout the Middle Ages. In the Early Modern period, many writers continued to stress the primacy of vision, especially in relation to touch. For example, the Florentine bishop and eventual saint, Antoninus, asserted that sight was the most perfect of the senses, while the architect and art theorist Leon Battista Alberti claimed that the eye was 'more powerful than anything . . . It is . . . the first, chief, king, like a god of human parts' (Summers 1987, pp. 36–8). Similarly, the Neo-Platonic philosopher Marsilio Ficino equated touch with the baser, more carnal forms of love and contrasted it with the higher, spiritual love associated with vision: 'the love of the contemplative man ascends from sight into the mind; [while] that of the voluptuous man descends from sight into touch' (Mendelsohn 1982, p. 61). Leonardo da Vinci also praised sight above all other senses—'the eye embraces the beauty of the whole world'—while the art theorist Vincenzio Borghini asserted that touch was 'bestial', 'the coarsest sense', and sight the most 'divine' (Barocchi 1971, p. 637; Summers 1987, p. 38).

Since antiquity, vision has also often been proposed as a model for how knowledge is gained and assimilated by the mind, as when Aristotle compared memory to seeing a picture or St Augustine used vision as a paradigm for spiritual and

[4] See n. 3 for selected references.

intellectual contemplation (Miles 1983; Summers 1987, pp. 89, 200). The thirteenth-century philosopher Roger Bacon went so far as to claim that all knowledge of the world can only be obtained from sight, and thus a blind man could learn 'nothing that is worthy in this world' (Summers 1987, pp. 36). In the sixteenth century, the artist and art historian Giorgio Vasari asserted that knowledge and judgements about art in particular were best obtained through vision rather than touch: 'it is necessary to have the compasses in the eyes and not in the hand, because the hand works and the eye judges' (Summers 1981, p. 371). More generally in the Early Modern period, the ocular practice of linear perspective became a model not only for vision, but for subjectivity itself, that is, for how one formulates a 'point of view' about the world in which one lives, as discussed by Erwin Panofsky in his influential essay on perspective as symbolic form, as well as by other more recent authors (Panofsky 1927).

The primacy of sight in Ancient, Medieval, and Early Modern thought is, however, neither absolute, nor uncontested. For instance, visual anxiety is a common theme in Classical mythology, as in the stories of Narcissus, Orpheus, and the Medusa, while touch is seen as a positive, life-giving force in the myths of Pygmalion and Prometheus. Likewise, for Plato, it was sight's perilous powers of illusion that were most worrying, while St Augustine warned of the dangers associated with ocular desire, a subject of continuing interest to Medieval theologians and philosophers (Jay 1993, pp. 13, 27–8). Vision was also not universally accepted as the only model for explaining how we gain knowledge about the world. In the case of Aristotle, while he clearly praised sight above touch in terms of its relative dignity, he nevertheless concluded that the sense of touch was the basis for knowledge obtained from all the senses, a notion reiterated by Thomas Aquinas in the thirteenth century (Summers 1987, p. 103). The ancient Atomists and Stoics went as far as using touch as a means of explaining vision itself when they compared sight to touching something with a stick, a metaphor that still informs an illustration in the 1724 edition of Descartes's book on optics, La dioptrique (Crary 1990, p. 61; Lindberg 1976, pp. 3, 9–10). Metaphors for a variety of mental processes and experiences were likewise not exclusively visual in the pre-Modern era. For example, Plotinus, a third-century theologian, compared perfecting one's inner soul to the process of carving a statue (Bann 1989, p. 118). Similarly, a fourteenth-century text states that the figure of Christ is firmly imbedded in memory only once it has been 'sculptured in the flesh' within the mind of a true believer (Summers 1981, p. 116). And, in direct contrast to Aristotle's claim that memory is like seeing a painting, the sixteenth-century humanist Giordano Bruno instead likened memory to a series of tactile statues carved in the mind (Yates 1966, pp. 249, 280–4).

Thus conceptions about the sense of touch, especially in relation to vision, in Ancient, Medieval, and Early Modern thought were complex and variable. By and large, scholars have focused on the ocularcentric orientation of Early Modern culture in particular, especially as demonstrated by growing interest in the practice of linear perspective. Indeed, many scholars have assumed that the primacy of vision, which is such an important characteristic of Modern and contemporary culture, was equally valid for the Early

Modern period as well.[5] However, as we shall see, touch did indeed matter in this era as demonstrated by numerous texts on sculpture, as well as by images and objects that thematize tactility both implicitly and explicitly.

TACTILITY AND THE ART OF
EARLY MODERN ITALY

Some of the first post-Classical writings on art were technical manuals composed by practising artists working in Italy (Cennini 2004). These volumes were filled primarily with recipes and practical advice intended for use in the workshops of craftsmen and artisans. Throughout the Early Modern period, Italian writers continued to emphasize the active, physical, and very tactile process of hand-crafting a statue or relief. Indeed, as one might expect, the *topos* of the sculptor's manual prowess in making and handling sculpture is found in almost every Early Modern art treatise and technical manual. The first treatises that considered art from a more theoretical perspective were written in the first half of the fifteenth century by Alberti. However, while his famous book *De pictura* treated painting as a practice worthy of serious humanistic and scientific consideration, his much less well-known treatise on sculpture, *De statua*, essentially continued the earlier tradition of writing technical manuals for craftsmen (Alberti 1972; Aurenhammer 2001). Alberti's distain for the manual labour involved in creating sculpture, which he opposed to painting's more cerebral demands, was a theme that would resurface repeatedly in later art treatises.

It is perhaps not surprising that the first treatise demonstrating an explicit concern with raising the status of sculpture to that of a liberal art was written around the middle of the fifteenth century by a practising sculptor with intellectual ambitions, Lorenzo Ghiberti (Ghiberti 1947). Rather than primarily giving technical advice to its readers, Ghiberti's text instead displays the sculptor's humanist pretensions and, by extension, the aspirations of the art he practised. At the same time, Ghiberti's concern with the tactile values of sculpture foreshadow important aspects of later writings on sculpture.

When speaking in the abstract about sculpture, Ghiberti stresses the importance of vision, optics, and lighting effects. When he begins to discuss specific statues he has personally encountered, however, Ghiberti often introduces tactility as a key element in the reception of sculpture. In one passage, Ghiberti describes a recently unearthed Classical female statue. Ghiberti states that this 'marvelous' figure had 'so much refine-ment [*dolcezze*], which the face [*il viso*, i.e. looking with one's eyes] could not appre-ciate by either strong or moderate light, only [by] the hand touching it could this be

discovered' (Ghiberti 1947, p. 55). In other words, Ghiberti claims that only by touching this sculpture with his hands, only by exploring what was inaccessible to vision alone, was he able to understand it fully. Elsewhere, Ghiberti records his encounter with another Classical statue, an hermaphrodite with male genitals and female breasts:

> I have seen by diffused light the most perfect sculptures . . . made with the greatest skill and care, including . . . a statue of an hermaphrodite the size of a 13-year-old girl, which statue had been made with admirable skill . . . It is not possible in words to tell of this statue's perfection . . . In this [statue] there was the greatest refinement [*dolcezze*], which the face [*il viso*, i.e. looking with one's eyes] would not have seen, had not the touch [of] the hand sought it out.

> (Ghiberti 1947, pp. 54–5)

This passage suggests that Ghiberti may well have discovered or, at the very least, confirmed the male sexual attributes of the hermaphrodite only after touching it with his hand, especially since his initial assumption seems to have been that the figure was female, in his own words, 'a 13-year-old girl'. Ghiberti's manual encounters with female and bi-gendered statues also suggest that sculpture's tactile accessibility can at times be profoundly intertwined with questions of sexual desire and differentiation. Unlike a painting, a touchable sculpture always has another side to explore, which allows for realms of bodily experience to exist that are unimaginable in two-dimensional works of art.

There were, of course, many different types of touch associated with sculpture in the Early Modern period. For instance, touch could have a talismanic or devotional quality, as when wooden figures of Christ were taken down from supporting crucifixes for ceremonies associated with Holy Week, or when pilgrims eagerly tried to touch carved reliquary caskets or saints tombs (Fig. 3.1). Another religious practice was the ritual handling of life-size statues of the Christ Child, often in wood or terracotta. Documents describe nuns in particular cradling such objects, with the statues occasionally appearing to come to life in the women's arms (Hale 1992; Klapisch-Zuber 1985). Perhaps not surprisingly, later Church reformers worried about the dangers of idolatry inherent in these and related devotional practices that involved physically handling and worshipping sacred sculpture.

The tactile encounter with sculpture was also seen in the inquisitive, admiring, and proprietary hands of the collector and connoisseur. Indeed, Early Modern beholders often describe and depict themselves touching three-dimensional art objects, as in Titian's *Portrait of Jacopo Strada* (Vienna, Kunsthistorisches Museum) in which a Venetian art dealer and collector is shown holding a Classicizing female statuette (Fig. 3.2). Other texts and images confirm the importance of the sense of touch to the evaluation and appreciation of art. For instance, an apocryphal anecdote in Cesare Ripa's *Iconologia* of 1603 claimed that Michelangelo relied on touch alone to judge the merits of Antique and Modern statues as he gradually grew blind in old age (Hall 1999, p. 87). A number of other sixteenth- and seventeenth-century texts and images likewise focus on the *topos* of the blind man's tactile handling of works of art. Jusepe da Ribera and Luca Giordano, for instance, both painted versions of this subject, while the writers Vincenzio Borghini, Raffaele Borghini, and Giovan' Ambrogio Mazenta all

Fig. 3.1 Master of St Sebastian (Josse Lifferin?),
Pilgrims visiting a saint's shrine, oil painting,
c.1500. Rome, Galleria nazionale d'Arte antica.

(Photograph: Geraldine A. Johnson.)

describe a blind man evaluating a painting and a sculpture using only his hands, with Mazenta even claiming that one such demonstration was staged by the great Leonardo himself (Barocchi 1971, pp. 616, 675; Hecht 1984, pp. 128–30, 134–5).[6]

When considering the tactile reception of works of art, it is important to acknowledge that sculptural tactility could be implicit, as well as explicit. For example, small-scale statuettes made for elite collectors, such as the many bronzes by Giambologna and his followers, were specifically designed to be held, turned, and otherwise manipulated by a beholder (Fig. 3.3). Handling such objects also would have enhanced a beholder's ability to imagine touching large-scale statues, like Giambologna's over life-size marble group of the *Rape of a Sabine* displayed on Florence's Piazza della Signoria, which were often literally out of hand's reach (Fig. 3.4). Thus, the owner

[6] The theme of how the blind gain knowledge about art and the world in general is also a key feature of the philosophical debate known as Molyneux's problem, on which see n. 5.

Fig. 3.2 Titian, *Portrait of Jacopo Strada*, oil
on canvas, 1567–8. Vienna, Kunsthistorisches
Museum.

(Photograph: The Yorck Project (http://commons.wikimedia.org).)

of a small female statuette by Giambologna, with its smoothly polished surface
and elegantly serpentine design, would have been encouraged by his or her manual
manipulation of such an object to relate to the implicit tactility of much larger works
such as the *Rape of a Sabine*. Indeed, the female figure in the large sculpture group
could, in some ways, be interpreted as a statuette that has suddenly grown to full size
and come to life in the hands of an owner, out of whose possessive grasp she struggles
to free herself. Thanks to the increasing availability of small-scale statuettes as well
as long-standing religious practices that involved manually engaging sculpture, an
Early Modern beholder's mimetic impulse to touch and his or her awareness of the
implied tactility of large-scale works would thus have been encouraged and reinforced,
even if, practically speaking, it would have been difficult or even impossible actually to
engage such objects manually. The power of such imagined or anticipated tactil-
ity is discussed in an interesting letter probably sent in the 1950s to the art historian
Meyer Schapiro by the anthropologist Alfred Kroeber. In it, Kroeber claimed that,
because we learn as infants about the world around us first and foremost by touch:

what is seen and touched is always made part of ourselves more intensely and more meaning-
fully than what is only seen . . . [Something] we *only* see but cannot, in imagination, touch,

Fig. 3.3 After Giambologna, *Venus bathing*, bronze, c. late 16th–early 17th century. Oxford, Ashmolean Museum.

(Photograph: Geraldine A. Johnson.)

does not carry the same attraction and concentration of interest as the one we can, imaginatively, handle and touch as well as see clearly.

(A Montagu 1986, pp. 236–7)

 In addition to the real or imagined collector's caress and religious devotee's grasp, there was also the sculptor's own touch, the hand of the maker. Ghiberti, for instance, refers in his writings to sculpture being made by the 'hand' of a particular artist, a term that he applies only rarely to works produced in two-dimensional media (Ghiberti 1947). Of course, the idea of the 'painter's hand' was important in Early Modern artistic culture as well (Barolsky 1995; Koerner 1993, pp. 139–59 and *passim*; Sherman 2000), but the emphasis on the hand's physical engagement with the medium is particularly striking in discussions about sculpture. For example, Anton Francesco Doni's

Fig. 3.4 Giambologna, *Rape of a Sabine*, marble,
1580–2. Florence, Piazza della Signoria.

(Photograph: Arnold Paul (http://commons.wikipedia.org).)

mid-sixteenth-century dialogue between a sculptor and a painter begins with the former exclaiming: 'Look what I have suddenly made with my hands!' (Barocchi 1971, p. 563). Even writers who anxiously sought to move sculpture out of the realm of craft and into the world of humanist scholarship and the liberal arts could not ignore the importance of the sculptor's hands. Indeed, Pomponius Gauricus, a humanist and amateur sculptor, stated that '[w]e should allow sculpture to be practiced only by those who can combine great intellectual powers with manual dexterity' (Gauricus 1969, p. 63).

The significance of the sculptor's touch is attested to not only by Early Modern texts, but also by material evidence. Michelangelo, for instance, became famous (or rather, infamous) for leaving many of his statues and reliefs unfinished, possibly in order to attest to the presence and potency of his hand.[7] While the smooth surfaces of Giambologna's bronze statuettes seem to have been designed in order to erase any vestiges of the maker's hand, thereby enticing the inquisitive and acquisitive

[7] See Schulz 1975. For a contrary view of Michelangelo's *non-finito*, see Hirst 1996.

Fig. 3.5 Michelangelo Buonarroti, *Madonna, Christ Child, and Young Baptist (Pitti Tondo)* (detail showing unfinished surface and figures), marble, c.1504. Florence, Bargello Museum.

(Photograph: Geraldine A. Johnson.)

hands of the collector-connoisseur, Michelangelo's rough, often unfinished surfaces and figures in works such as his *Pitti Tondo* (Florence, Bargello Museum) may instead suggest a desire to preserve the tactile traces of the sculptor's touch for posterity (Fig. 3.5).

TOUCH VERSUS VISION; SCULPTURE VERSUS PAINTING

All three types of sculptural tactility encountered thus far—the devotional, the possessive, and the generative—are considered in Early Modern writings devoted to the so-called *paragone* debate, the theoretical discussion concerned with comparing and contrasting sculpture and painting in order to establish which art was more noble (Barocchi 1971; Mendelsohn 1982; Thomas 1996; White 1983). Not surprisingly, one of the key issues raised by this debate revolved around the status of touch. Writers who favoured sculpture often saw tactility as one of this art's most positive attributes, while advocates of painting repeatedly used sculpture's tactile qualities as evidence of its lower status, especially in comparison to vision. For instance, the sculptor known as Il Tribolo responded to the humanist Benedetto Varchi's mid-sixteenth-century

questionnaire on the *paragone* by making tactility central to his argument in favour of sculpture:

if a blind man . . . only having the sense of touch . . . encountered a marble or wood or clay figure, he would declare that it was the figure of a man, . . . woman, . . . [or] child; and contrarily, if it had been a painting . . . he would have discovered nothing at all, . . . [because] sculpture is the real thing, and painting is a lie.

(Barocchi 1971, p. 518)

The inherent truthfulness of touch is also presented by other writers as a key virtue of sculpture. Varchi himself in his lecture on the *paragone* stated that vision:

is not the most reliable sense, indeed it often deceives . . . [while] the most reliable sense is touch . . . [W]hen we see something and we are doubtful about it, . . . we use touch to verify it. Everyone thus knows that touching a statue confirms everything the eye sees . . . therefore sculptors say that their art is truthful and painting is [not].

(Barocchi 1971, pp. 533–4)

In contrast, sculpture's tactile qualities were presented very negatively by writers intent on proving painting's superiority. For instance, in a letter written in 1612 to the painter Lodovico Cigoli, Galileo Galilei claimed that touching a statue would be terribly disappointing, for only the 'simple-minded . . . think that sculpture can deceive the sense of touch . . . Who would believe that a man, when touching a statue, would think that it is a living human being?' (Edgerton 1991, pp. 224–5; Panofsky 1954, p. 35). Vincenzio Borghini, who considered touch to be the crudest sense and mocked women who were obsessively drawn to touching sculptures, jeered at Il Tribolo's specific example of the blind man touching a statue. In Borghini's opinion, asking a blind man to evaluate the life-like qualities of a painting would be as pointless as asking a man with no hands his opinion about the life-like qualities of a statue (Barocchi 1971, pp. 614–17, 637, 639). The art theorist Paolo Pino likewise ridiculed the tactile allure of sculpture by citing the story of an ancient Athenian youth who sexually assaulted a statue of Venus (Barocchi 1971, p. 550). Pino's allusion to the tempting tactility of sculpture also suggests anxiety about the dangers associated with handling sculpted objects inappropriately, especially by allowing them to become objects of sexual desire.

Such arguments for and against sculpture and, especially, for and against its tactile qualities characterize much of the theoretical writing on the *paragone* in sixteenth- and seventeenth-century Italy. Many of the terms of this debate, however, had already been set by the late fifteenth century thanks to an influential collection of writings by Leonardo (Farago 1992). Although Leonardo was a practising sculptor as well as a painter, in his writings he came down firmly in favour of painting, which he saw as an intellectual activity pursued by proper gentlemen, an art that could use colours to imitate even nature's most ephemeral effects. Leonardo may well have sought to allude to such effects in the *Portrait of Ginevra de' Benci* (Washington, DC, National Gallery of Art), which uses paint to show reflections on the surface of the lake to the right of the sitter and the glint of sunlight on the woman's carefully combed hair (Fig. 3.6). By depicting a fictive speckled marble surface on the back of this panel, Leonardo further attests

Fig. 3.6 Leonardo da Vinci, *Portrait of Ginevra de' Benci*,
oil on wood, c. mid–1470s. Washington, DC, National
Gallery of Art.

(Photograph: The Yorck Project (http://commons.wikimedia.org).)

visually to painting's power to imitate the very materials of sculpture itself (Butters 1996, I, p. 109, and II, p. XXXI) (Fig. 3.7).

The *paragone* debate seems to have inspired several other painters to demonstrate visually the advantages of their chosen medium as well. Titian's *La Schiavona* (London, National Gallery), for example, depicts the same women twice, once in full colour and a second time in profile in a monochromatic marble relief, thereby proving the chromatic advantages of painting (Fig. 3.8). By showing the same figure from two different views at the same time, Titian was also rebutting advocates of sculpture who claimed that, unlike sculpture, two-dimensional paintings could only provide a single view of a figure. Indeed, the sculptor Benvenuto Cellini had gone as far as asserting that a single sculpture could consist of more than 40 different views.[8]

[8] Jacobs 1988, p. 149, n. 50. Other paintings that seem to rebut such claims by having multiple views of their sitters include Gian Girolamo Savoldo's so-called *Gaston de Foix* (Paris, Louvre Museum) and Giorgione's lost *St George*, praised by both Vasari and Pino (Barocchi 1971, pp. 552–3; Farago 1992, pp. 21, 49; Hecht 1984, p. 126).

Fig. 3.7 Leonardo da Vinci, *Motto and emblems on fictive marble background* (verso of *Portrait of Ginevra de' Benci*), oil on wood, c. mid-1470s. Washington, DC, National Gallery of Art.

(Photograph: Sailko (http://commons.wikipedia.org).)

Thematizing the *paragone* not just verbally but visually also seems to have intrigued Leonardo's teacher, the painter-sculptor Andrea del Verrocchio. Before Leonardo's *Ginevra de' Benci* was cut down along its bottom edge, the sitter's now-lost hands (which are documented in a drawing) may well have echoed those seen in Verrocchio's marble *Bust of a Lady with Flowers* (Florence, Bargello Museum) (Butterfield 1997, pp. 90 ff) (Fig. 3.9). Indeed, the sitter in Leonardo's painting could even be the same woman depicted in the bust, a figure who, incidentally, highlights the erotic potential of sculptural tactility through her fingers, which seem to strain to touch her thinly-clothed breast. Although the chronology of these two works in relation to one another remains unclear, it is possible that the student, Leonardo, produced his full-colour portrait in order to demonstrate to his teacher the supremacy of painting over sculpture, thereby giving visible form to the pro-painting arguments he later presented in his theoretical writings. If we believe the testimony of Vasari, Leonardo's virtuosity in painting such images convinced Verrocchio to stop painting altogether and instead devote himself only to sculpture (Vasari 1965, p. 236). Given that Vasari was a key

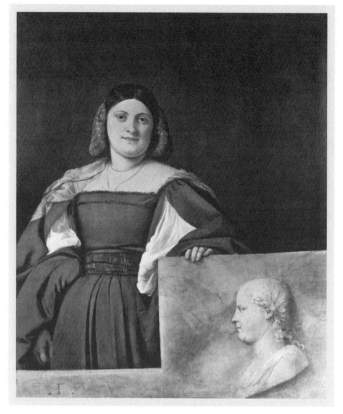

Fig. 3.8 Titian, *La Schiavona*, oil on canvas, c.1510.
London, National Gallery.

(Photograph: The Yorck Project (http://commons.wikimedia.org).)

advocate of painting's superiority in the *paragone* debate, however, his account should
perhaps be taken with a grain of salt.

In fact, although Verrocchio does indeed seem to have stopped painting after
a certain point in his career, he may have tried to meet Leonardo's challenge in his
Incredulity of St Thomas, a two-figure bronze sculpture group executed for the exterior
of Or San Michele, Florence's guild church. The project illustrates the Gospel story in
which Thomas refused to accept Jesus's miraculous resurrection without first literally
touching the risen Christ's wounds: until 'I shall . . . put my finger into the print of the
nails, and thrust my hand into his side, I will not believe' (John 20:25) (Fig. 3.10). It was
precisely sculpture's ability to give tactile proof to doubtful beholders that became
a key theme of many pro-sculpture arguments presented by Early Modern writers.
Although the subject of Thomas's incredulity had been assigned to Verrocchio by
Florence's *Mercanzia,* the chamber of commerce-like organization that had commis-
sioned the sculpture, his design nevertheless thematizes the much-contested sense
of touch. Indeed, in some ways, one could argue that touch itself is the real subject

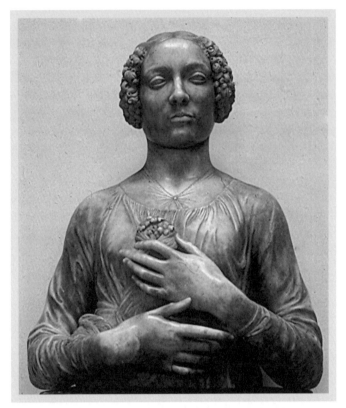

Fig. 3.9 Andrea del Verrocchio, *Bust of a Lady with
Flowers*, marble, c. mid–1470s. Florence, Bargello Museum.
(Photograph: Geraldine A. Johnson.)

of this sculpture. In their writings, later advocates of sculpture such as Varchi and
Il Tribolo repeatedly verbalized what Verrocchio had already implied visually in his
statue group, namely, that sculpture's tactile qualities were proof of its greater truthful-
ness to nature, the ultimate goal of art in the eyes of many pre-Modern artists, patrons,
and theorists.

Tactility was also an important issue in discussions about the relative social status of
painters versus sculptors. From the middle decades of the fifteenth century onwards,
sculptors with social and intellectual aspirations used a variety of strategies in their writ-
ings to try to downplay the manual labour involved in producing sculpture, thereby
confirming their status as gentlemen-artists rather than as mere artisans. Although
sculptor-writers such as Ghiberti and Gauricus strived to include in their texts
numerous Classical references and suggested that the cerebral process of design or
disegno was crucial to the production of sculpture, nevertheless their treatises also
inevitably included digressions on technical matters more closely associated with
artisan traditions than with the concerns of gentlemen and scholars—something that
happens much less frequently in the theoretical writings of painters (Gauricus 1969;
Ghiberti 1947). This suggests that, in their writings, even intellectually and socially

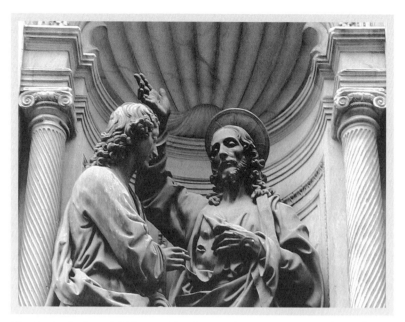

Fig. 3.10 Andrea del Verrocchio, *Incredulity of St Thomas* (detail),
bronze, 1467–83. Florence, Orsanmichele.

(Photograph: Stefan Bauer (http://commons.wikimedia.org).)

ambitious sculptors could not completely avoid the manual and material aspects of
the art they practised.

Similarly, a woodcut in a popular fortune-telling book compiled by Sigismondo
Fanti in 1526 tried to put a humanistic veneer on the scene by depicting the great
Michelangelo himself in the guise of a loincloth-wearing Classical sculptor while in
the process of carving his *Dawn* for the Medici Chapel in Florence (Johnson 2002b).
At the same time, however, the print unavoidably highlights the intense physical
labour involved in producing sculpture. In fact, the image of Michelangelo hard at
work, swinging his hammer and with his knee wedged uncomfortably into the fig-
ure's abdomen, seems to confirm visually the negative views of sculptors presented by
pro-painting advocates such as Leonardo:

The sculptor in creating his work does so by the strength of his arm and the strokes of his
hammer . . . a most mechanical exercise often accompanied by much perspiration . . . His face
is smeared all over with marble powder so that he looks like a baker . . . and his house is dirty
and filled with flakes and dust of stone.

(Leonardo 1952, p. 330)

This description stands in sharp contrast to Leonardo's vision of the ideal painter
as an educated gentleman who avoids the manual toil and all-too-intimate physical
contact associated with the grimy work of the sweating sculptor:

How different [is] the painter's lot . . . for the painter sits in front of his work at perfect
ease. He is well dressed and moves a very light brush dipped in delicate color . . . his home

is clean . . . and he often is accompanied by music or by the reading of various beautiful works to which he can listen with great pleasure without the interference of hammering and other noises.

(Leonardo 1952, p. 330)

One of the most influential texts on the relative status of painters and sculptors was Baldassarre Castiglione's *Book of the Courtier* of 1528. In this book, a debate on the *paragone* takes place, with painting emerging as the proper art of the ideal gentle-man-courtier (Castiglione 1967, pp. 98–101). The sculptor Baccio Bandinelli strived to embody Castiglione's ideal of the gentleman-artist in both his life and his sculp-tural practices. Bandinelli's social ambitions, for instance, are revealed by his almost inordinate pride in having been made a knight of Sant'Iago. In an engraving of his studio made just three years after Castiglione's book appeared, Bandinelli also seems to have succeeded in banishing the sweat and dust of the working-class artisan's shop from his sculpture academy (Fig. 3.11). Instead, the well-dressed apprentices that surround him are shown sketching Classicizing statuettes. However, in an uninten-tionally telling detail, Bandinelli himself, despite his social and academic pretensions,

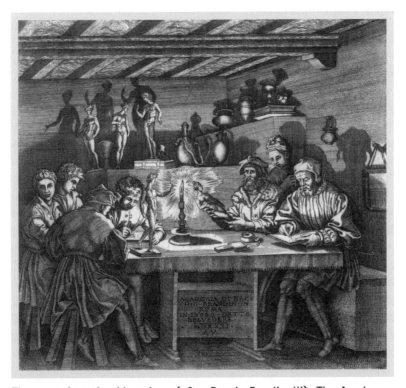

Fig. 3.11 Agostino Veneziano (after Baccio Bandinelli), *The Academy of Baccio Bandinelli*, engraving, 1531. Oxford, Ashmolean Museum.

(Photograph: Ashmolean Museum, with permission.)

simply can't keep his hands off of sculpture: the inevitable tactile allure of the art he practises is inadvertently demonstrated here by his two-handed handling of a nude female statuette.

A number of sixteenth-century paintings also depict male artists or collectors literally man-handling nude female sculptures, something that suggests that one should attend carefully to the gendered power relations implicit in such manual encounters with sculpture. In the case of the *Portrait of Jacopo Strada* by Titian mentioned earlier, the female statuette held by the sitter is painted in the flesh tones of a living woman, rather than in the colours of white marble, plaster, terracotta, or polished bronze (see Fig. 3.2). In other words, Titian's chromatic palette serves to equate visually the sculpted female body with the body of a living woman. In this portrait and the engraving of Bandinelli's academy, the relationship between the toucher and the touched seems to remain essentially hierarchical and heterosexual, with the male artist or beholder clearly in control of the sculpted female body. At the same time, in comparison to an act of ocular scrutiny, this type of tactile relationship is comparatively reciprocal and thus retains the potential to subvert the hierarchical relationship between object and beholder. Indeed, as the philosopher Maurice Merleau-Ponty asserted, the act of touching is 'an ambiguous set-up in which . . . the rôles of "touching" and being "touched"' can alternate (Merleau-Ponty 1962, p. 93).

The complexities of tactile engagements with sculpture are also demonstrated by the fact that some images depict male sitters holding sculpted male figures as, for instance, in Paolo Veronese's *Man with a Statuette of St Sebastian* (New York, Metropolitan Museum of Art) or Giovanni Battista Moroni's *Man with an Antique Male Torso* (Vienna, Kunsthistorisches Museum). Although it would be interesting to consider the homoerotic aspects of these same-sex manual encounters, in the context of a discussion about sculptural tactility it is perhaps most relevant to note that the sitter in both portraits has been tentatively identified as the Venetian sculptor Alessandro Vittoria (Currie 1997, pp. 122–3). If this is true, one could suggest that, while male collectors and sculptors are often shown possessively holding sculpted female bodies, a male sculptor could also be depicted gripping a male body, which Early Modern culture in general believed to be the ideal and normative human form.

Unlike the images encountered thus far, one sixteenth-century artist in particular produced paintings in which sitters resolutely avoid manual contact with sculpted objects. Instead, portraits by the painter Agnolo Bronzino often depict sitters who maintain an intellectual, emotional, and physical distance from three-dimensional art objects (Currie 1997). Significantly, Bronzino's haughty sitters, as in his *Portrait of Pierantonio Bandini with a* Venus Pudica *Statuette* (Ottawa, National Gallery of Canada), do not even deign to look at, let alone touch, the sculpted figures displayed beside them (Fig. 3.12). This determined antitactility vis-à-vis sculpture is readily explicable, however, if one realizes that Bronzino was one of the strongest advocates of painting in the ongoing *paragone* debate. In his response to Varchi's questionnaire, Bronzino unambiguously stated his position: 'I intend to align myself with one of the two [sides of this debate], because I honestly feel I am aligning myself with the truer side, that is with the side of painting' (Barocchi 1971, p. 500). It is thus not surprising

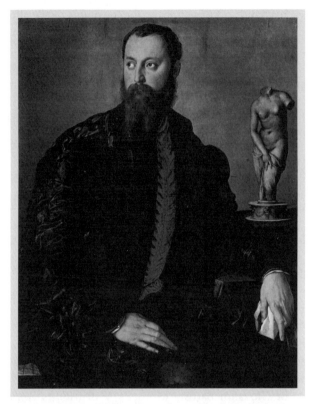

Fig. 3.12 Agnolo Bronzino, *Portrait of Pierantonio
Bandini with a* Venus Pudica *Statuette*, oil on wood,
c.1550–5. Ottawa, National Gallery of Canada.

(Photograph: The Yorck Project (http://commons.wikimedia.org).)

that Bronzino's painted depictions of three-dimensional art objects de-emphasize
the tactile allure of sculpture and instead highlight painting's ability to imitate coolly
and dispassionately the natural and artificial world in full colour. In fact, according to
Bronzino, sculpture's three-dimensional tactility excluded the medium by definition
from the realm of art altogether. In his own words, 'all that pertains to art are the lines
that circumscribe a body, which are on the surface; therefore, the three-dimensional
does not appertain to art but to nature' (Jacobs 1988, p. 148, n. 2).

As previously suggested, writers who favoured sculpture and sculptors themselves
refused to accept such negative assessments of sculptural tactility. In Michelangelo's
writings, for example, it is clear that he ranked sculpture well above two-dimensional
art forms. Indeed, he even went as far as claiming that painting was best the more it
resembled sculptural relief, while sculpture was worse the more it resembled paint-
ing (Barocchi 1971, p. 522). Michelangelo's interest in touch and tactility is particu-
larly evident in his poetry. For instance, he often used the physical labour involved in
carving a marble block by hand as a poetic metaphor for the lover's desire to uncover

the beloved's inner emotions. In other sonnets, the sculptor's god-like hand is seen as a powerful, life-giving force that is capable of animating carved figures. For example, in one of his best-known poems, 'Non ha l'artista...' (Sonnet 151), Michelangelo describes a sculptor bringing a statue to life with 'the hand that obeys the mind' (Michelangelo 1975, p. 212).

Michelangelo also thematized hands in many of his statues, as in the autoerotic, probing hand of the so-called *Dying Slave* (Paris, Louvre Museum), which recalls the hand of the sculptor-as-lover described in some of his poems, or the dramatically oversized hands of his famous marble *David*. Likewise, Michelangelo's *Moses* (Rome, San Pietro in Vincoli), who insistently fingers his flowing beard, alludes visually to the important role played by touch in the enjoyment and evaluation of sculpted forms (Fig. 3.13). Even in the design he provided for Jacopo Pontormo's painting of *Noli me Tangere* (Florence, Casa Buonarroti), the focus is on the figures' hands: Christ, whose index finger seems just to touch Mary Magdalene's breast, and the Magdalene herself,

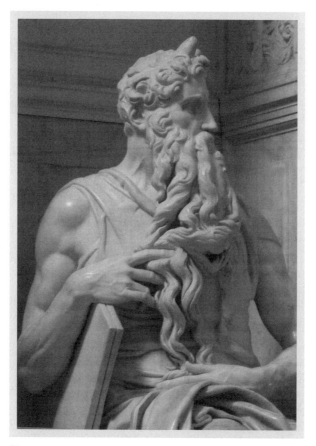

Fig. 3.13 Michelangelo Buonarroti, *Moses* (detail), marble, c.1506–16. Rome, San Pietro a Vincoli.

(Photograph: Geraldine A. Johnson.)

who unusually for this subject appears actually to be grasping Jesus's back (Wallace 1988). The prominence of hands in these and other works associated with Michelangelo suggests that, at some level, this member may have functioned for the sculptor as a visual synecdoche, that is, as a part symbolically representing the sculptor—or perhaps the art of sculpture—as a whole.

However, some of Michelangelo's contemporaries who were avowed advocates of painting repeatedly tried to deny the physicality of his sculptures. Vasari, for example, praised the beard of Michelangelo's *Moses* for being so well made that it almost looked painted, the highest compliment a painter could give, but one that seems wilfully to ignore the material reality of the three-dimensional medium (Barolsky 1995, p. 16). Similarly, another painter, Francisco da Hollanda, referred to Michelangelo's statues in the Medici Chapel as paintings in marble (Summers 1981, p. 263). Such a response to Michelangelo's insistent tactility can best be explained in light of the ongoing *paragone* debate in which painters and their supporters were eager to claim Michelangelo, the great universal artist of the sixteenth century, for their own camp.

In the seventeenth century, Gian Lorenzo Bernini thematized tactility in some of his sculptural projects as well. In the *Apollo and Daphne* (Rome, Galleria Borghese), for example, Bernini depicted the very moment when the god's touch begins to transform the nymph into a laurel tree (Bolland 2000). Ovid's description of this instant may even have suggested to Bernini that Daphne was turning into a white marble maiden, for just at the very moment that Apollo nearly embraces her, his breath already touching her hair, the nymph 'grew pale' (Ovid 1955, p. 43). Tactility is alluded to not only in the narrative moment chosen, but also in Bernini's virtuoso sculptural technique itself, which depicts Daphne's delicate fingers being transformed into wafer-thin laurel leaves and her smooth flesh metamorphosing into the rough bark of a tree, thereby reminding beholders of the transformative powers of the sculptor's own god-like hands. The sculptor's almost divine ability to use his hands to transform a marble block into a maiden is alluded to by showing the maiden herself mutating into a different sculptural material, namely, wood. Like Michelangelo, Bernini also focuses particular visual attention on the hand itself in a number of his works. For instance, in his monument for the Blessed Lodovica Albertoni (Rome, San Francesco a Ripa), the power traditionally associated with the talismanic touch of the saint is linked to an autoerotic, manual exploration of the female body. Indeed, Bernini's sophisticated manipulation of light and shadow in his design serves to highlight Lodovica's probing marble fingers against her decorously covered breast (Fig. 3.14).

One could cite many more examples, visual as well as textual, that would confirm the importance Early Modern culture accorded to issues related to touch and tactility, especially in relation to sculpture. By reconsidering fifteenth-, sixteenth-, and seventeenth-century texts, images, and objects in light of these concerns, important new insights can be gained into the reception of art in Italy in this period. Perhaps more importantly, by attending to tactility in one of art history's paradigmatic moments, we can also embark on a more general exploration of the sense of touch in relation to past and present artistic practices, as well as can begin to consider more broadly why the reception of art objects should not be limited to optical experiences alone.

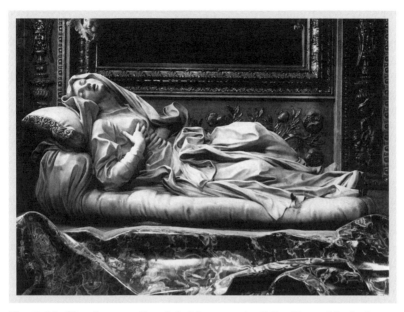

Fig. 3.14 Gian Lorenzo Bernini, *Monument of the Blessed Ludovica Albertoni* (detail), marble, c.1673–4. Rome, San Francesco a Ripa.

(Photograph: (http://commons.wikimedia.org).)

REFERENCES

Alberti LB (1972). *On Painting and On Sculpture: The Latin texts of* De pictura *and* De statua (C Grayson trans. and ed.). Phaidon, London.

Aurenhammer HH (2001). Phidias als Maler: Überlegungen zum Verhältnis von Malerei und Skulptur in Leon Battista Alberti's *De Pictura. Römisches Historisches Mitteilungen*, **43**, 355–410.

Bann S (1989). *The True Vine: On Visual Representation and the Western Tradition.* Cambridge University Press, New York.

Barocchi P (ed.) (1971). *Scritti d' del cinquecento: Pittura e scultura*, III. Riccardo Ricciardi editore, Milan and Naples.

Barolsky P (1995). The Artist's Hand. In A Ladis and P Wood (eds.) *The Craft of Art: Originality and Industry in the Italian Renaissance and Baroque*, pp. 5–24. University of Georgia Press, Athens, GA.

Baxandall M (1980). *The Limewood Sculptors of Renaissance Germany.* Yale University Press, New Haven, CT.

Belting H (1981). *Das Bild und sein Publikum im Mittelalter: Form und Funktion früher Bildtafeln der Passion.* Gebr. Mann Verlag, Berlin.

Berenson B (1897). *The Central Italian Painters of the Renaissance.* GP Putnam's Sons, New York.

Bolland A (2000). *Desiderio* and *Diletto*: Vision, Touch, and the Poetics of Bernini's *Apollo and Daphne. Art Bulletin*, **82**, 309–30.

Boyle MO (1998). *Senses of Touch: Human Dignity and Deformity from Michelangelo to Calvin.* EJ Brill, Leiden.

Butters SB (1996). *The Triumph of Vulcan: Sculptors' Tools, Porphyry, and the Prince in Ducal Florence, I–II*. Leo S Olschki, Florence.

Butterfield A (1997). *The Sculptures of Andrea del Verrocchio*. Yale University Press, New Haven, CT.

Castiglione B (1967). *The Book of the Courtier* (G Bull trans.). Penguin Books, Harmondsworth. (Originally publ. 1528.)

Cennini C (2004). *Il libro dell' arte della pittura* (AP Torresi ed.). Liberty House, Ferrara. (Originally written c.1430s.)

Classen C (ed.) (2005). *The Book of Touch*. Berg, Oxford.

Crary J (1990). *Techniques of the Observer: On Vision and Modernity in the Nineteenth Century*. MIT Press, Cambridge, MA.

Currie S (1997). Discerning the sculptural content of Bronzino's early male portraits: A preliminary investigation. In S Currie and P Motture (eds.) *The Sculpted Object 1400-1700*, pp. 117–38. Scolar Press, Aldershot.

Degenaar M (1996). *Molyneux's Problem: Three Centuries of Discussion on the Perception of Forms* (MJ Collins trans.). Kluwer Academic Publishers, Boston, MA. (Originally publ. 1992.)

Edgerton SY, Jr. (1991). *The Heritage of Giotto's Geometry: Art and Science on the Eve of the Scientific Revolution*. Cornell University Press, Ithaca, NY.

Farago C (1992). *Leonardo da Vinci's Paragone: A Critical Interpretation with a New Edition of the Text in the Codex Urbinas*. EJ Brill, Leiden.

Fried M (1980). *Absorption and Theatricality: Painting and Beholder in the Age of Diderot*. University of Chicago Press, Chicago, IL.

Gauricus P (1969). *De sculptura* (A Chastel and R Klein eds.). Librairie Droz, Geneva. (Originally publ. 1504.)

Ghiberti L (1947). *I commentari* (O Morisani ed.). Riccardo Ricciardi editore, Naples. (Originally written c. late 1440s.)

Hale RD (1992). '*Imitatio Mariae*: Motherhood Motifs in Late Medieval German Spirituality.' Unpublished Harvard University Ph.D., Cambridge, MA.

Hall J (1999). *The World as Sculpture: The Changing Status of Sculpture from the Renaissance to the Present Day*. Chatto & Windus, London.

Harvey ED (ed.) (2003). *Sensible Flesh: On Touch in Early Modern Culture*. University of Pennsylvania Press, Philadelphia, PA.

Hecht P (1984). The *Paragone* Debate: Ten Illustrations and a Comment. *Simiolus*, **14**, 125–36.

Hildebrand A von (1893). *Das Problem der Form in der bildenden Kunst*. JHE Heitz, Strasbourg.

Hirst M (1996). Michelangelo and his First Biographers. *Proceedings of the British Academy*, **94**, 63–84.

Howes D, ed. (1991). *The Varieties of Sensory Experience: A Sourcebook in the Anthropology of the Senses*. University of Toronto Press, Toronto.

Howes D (2003). *Sensual Relations: Engaging the Senses in Culture and Social Theory*. University of Michigan Press, Ann Arbor, MI.

Howes D, ed. (2005). *Empire of the Senses: The Sensual Culture Reader*. Berg, Oxford.

Irigaray L (1985). *This Sex Which is Not One* (C Porter trans. with C Burke.). Cornell University Press, Ithaca, NY. (Originally publ. 1977.)

Iser W (1978). *The Act of Reading: A Theory of Aesthetic Response*. The Johns Hopkins University Press, Baltimore, MD.

Iversen M (1993). *Alois Riegl: Art History and Theory*. MIT Press, Cambridge, MA.

Jacobs FA (1988). An Assessment of Contour Line: Vasari, Cellini and the *Paragone*. *artibus et historiae*, 9(18), 139–50.

Jauss HR (1977). *Ästhetische Erfahrung und literarische Hermeneutik*. W Fink, Munich.

Jay M (1993). *Downcast Eyes: The Denigration of Vision in Twentieth-Century French Thought*. University of California Press, Berkeley, CA.

Johnson GA (2002a). Touch, Tactility, and the Reception of Sculpture in Early Modern Italy. In P Smith and C Wilde (eds.) *The Blackwell Companion to Art Theory*, pp. 61–74. Blackwell Publishing, Oxford.

Johnson GA (2002b). Michelangelo, Canon Formation and Fortune Telling in Fanti's *Triompho di Fortuna*. In L Jones and L Matthew (eds.) *Coming About: A Festschrift for John Shearman*, pp. 199–205. Harvard University Art Museums, Cambridge, MA.

Kemp W (1983). *Der Anteil des Betrachters: Rezeptionsästhetische Studien zur Malerei des 19. Jahrhunderts*. Mäander Verlag, Munich.

Klapisch-Zuber C (1985). Holy dolls: play and piety in Florence in the Quattrocento. In *idem, Women, Family, and Ritual in Renaissance Italy* (LG Cochrane trans.), pp. 310–29. University of Chicago Press, Chicago, IL.

Koerner JL (1993). *The Moment of Self-Portraiture in German Renaissance Art*. University of Chicago Press, Chicago, IL.

Leonardo da Vinci (1952). *The Notebooks of Leonardo da Vinci* (IA Richter ed.). Oxford University Press, Oxford. (Originally written c. late 15th–early 16th century.)

Lindberg DC (1976). *Theories of Vision from Al-Kindi to Kepler*. University of Chicago Press, Chicago, IL.

Marks LU (2002). *Touch: Sensuous theory and multisensory media*. University of Minnesota Press, Minneapolis, MN.

Mendelsohn L (1982). Paragoni: *Benedetto Varchi's* Due Lezzioni *and Cinquecento Art Criticism*. UMI Research Press, Ann Arbor, MI.

Merleau-Ponty M (1962). *Phenomenology of Perception* (C Smith trans.). Routledge and Kegan Paul, London. (Originally publ. 1945.)

Michelangelo Buonarroti (1975). *Rime* (G Testori intro. and E Barelli ed.). Rizzoli, Milan. (Originally written 16th century.)

Miles M (1983). Vision: the eye of the body and the eye of the mind in Saint Augustine's *De trinitate* and *Confessions*. *Journal of Religion*, **63**, 125–42.

Montagu A (1986). *Touching: The Human Significance of the Skin*, 3rd edn. Perennial Library, New York. (1st edn. publ. 1971.)

Montagu J (1996). *Gold, silver, and bronze: Metal sculpture of the Roman baroque*. Princeton University Press, Princeton, NJ.

Morgan MJ (1977). *Molyneux's Question: Vision, Touch and the Philosophy of Perception*. Cambridge University Press, Cambridge.

Nordenfalk C (1985). The Five Senses in Late Medieval and Renaissance Art. *Journal of the Warburg and Courtauld Institutes*, **48**, 1–22.

Nordenfalk C (1990). The Sense of Touch in Art. In K-L Selig and E Sears (eds.) *The Verbal and the Visual: Essays in Honor of William Sebastian Heckscher*, pp. 109–32. Italica Press, New York.

Olin M (1989). Validation by Touch in Kandinsky's Early Abstract Art. *Critical Inquiry*, **16**, 144–72.

Olin M (1992). *Forms of Representation in Alois Riegl's Theory of Art*. Pennsylvania State University Press, University Park, PA.

Ovid (1955). *The Metamorphoses* (MM Innes trans.). Penguin Books, Harmondsworth.

Panofsky E (1927). Die Perspektive als 'symbolische Form'. In *Vorträge der Bibliothek Warburg 1924–1925*, pp. 258–330. GB Teubner, Leipzig.

Panofsky E (1954). *Galileo as a Critic of the Arts*. Matinus Nijhoff, The Hague.

Petrelli M (1994). *Valori tattili e arte del sensibile*. Alinea editrice, Florence.

Podro M (1982). *The Critical Historians of Art*. Yale University Press, New Haven, CT.

Powell KH (1997). Hands-On Surrealism. *Art History*, **20**, 516–33.

Riegl A (1901). *Die spätrömische Kunst-Industrie, nach den Funden in Österreich-Ungarn, I.* KK Hof- und Staatsdruckerei, Vienna.

Rivlin R and Gravelle K (1984). *Deciphering the Senses: The Expanding World of Human Perception*. Simon and Schuster, New York.

Schulz J (1975). Michelangelo's Unfinished Works. *Art Bulletin*, **57**, 366–73.

Sherman CR, ed. (2000). *Writing on Hands: Memory and Knowledge in Early Modern Europe*. University of Washington Press, Seattle, WA.

Shiff R (1991). Cézanne's physicality: The politics of touch. In S Kemal and I Gaskell (eds.) *The Language of Art History*, pp. 129–80. Cambridge University Press, Cambridge.

Stewart S (2002). Facing, Touch, and Vertigo. In S Stewart (ed.) *Poetry and the Fate of the Senses*, pp. 145–95. University of Chicago Press, Chicago, IL.

Summers D (1981). *Michelangelo and the Language of Art*. Princeton University Press, Princeton, NJ.

Summers D (1987). *The Judgment of Sense: Renaissance Naturalism and the Rise of Aesthetics*. Cambridge University Press, Cambridge.

Synnott A (1991). Puzzling over the Senses: From Plato to Marx. In D Howes (ed.) *The Varieties of Sensory Experience: A Sourcebook in the Anthropology of the Senses*, pp. 61–76. University of Toronto Press, Toronto.

Synnott A (1993). *The Body Social: Symbolism, Self and Society*. Routledge, New York.

The Senses and Society (2006–). Berg, Oxford.

Thomas B (1996). 'The paragone debate and sixteenth-century Italian art, I-II.' Unpublished D.Phil., University of Oxford.

Vasari G (1965). *Lives of the Artists* (G Bull trans.). Penguin Books, Harmondsworth.

Vasseleu C (1998). *Textures of Light: Vision and Touch in Irigaray, Levinas and Merleau-Ponty*. Routledge, London.

Wallace WE (1988). Il *Noli me Tangere* di Michelangelo: tra sacro e profano. *Arte Cristiana*, **76**, 443–50.

White J (1983). *Paragone*: Aspects of the Relationship between Painting and Sculpture. In *idem, Studies in Renaissance Art*, pp. 1–67. Pindar Press, London.

Wölfflin H (1915). *Kunstgeschichtliche Grundbegriffe: Das Problem der Stilentwicklung in der neueren Kunst*. F Bruckmann, Munich.

Wood CS (1998). Germany's Blind Renaissance. In M Reinhart (ed.) *Infinite Boundaries: Order, Disorder, and Reorder in Early Modern German Culture*, pp. 225–44. Sixteenth Century Journal Publishers, Kirksville.

Yates FA (1966). *The Art of Memory*. Routledge and K Paul, London.

THE MULTISENSORY PERCEPTION OF TOUCH

CHARLES SPENCE

INTRODUCTION

THE majority of textbooks on human perception consider each of the senses (e.g. vision, hearing, touch, olfaction, and taste) in isolation, as if each one represented an entirely separate and independent perceptual system (e.g. Schmidt 1986). A similar segmentation of the sensorium (or sensory milieu) also takes place in books on human well-being and the senses (de Vries 1997), on guides to interior designing for all five senses (Bailly Dunne and Sears 1998), and even in books on marketing and the senses (Lindstrom 2005); in fact, wherever one looks, the standard approach is, and apparently always has been, to look at the role/influence of each sense in isolation, with rarely any thought given to how the senses may interact with one another. In many situations, however, our senses receive correlated information about the same external objects and events. What's more, this information is typically combined to yield the multisensorially determined sensations that fill our daily lives (e.g. see MacDonald 2002; Spence 2002; Calvert et al. 2004a; Schifferstein and Spence, 2008). Consequently, what we see, hear, and smell can all change what we feel through the skin.

An extensive body of empirical research now demonstrates that visual, auditory, and olfactory cues can all influence people's tactile perception of the substance properties

(such as the texture) of haptically explored (i.e. explored through active touch) objects and surfaces. Visual cues have also been shown to dominate over the sense of touch when people evaluate an object's structural properties (e.g. Gibson 1933; Rock and Victor 1964), and applied researchers have demonstrated that the information available to the various senses can all contribute to an object's perceived pleasantness and functionality (see Spence and Zampini 2006; Schifferstein and Spence, 2008). When taken together, this rapidly–growing body of empirical research from the fields of experimental psychology, psychophysics, cognitive neuroscience, and multisensory product design all converges on the conclusion that whenever people think about the factors that affect people's touching and handling of objects, they really need to consider (and be made aware of) the variety of sensory inputs that may be contributing to people's evaluation and appreciation of those objects. This article provides a brief overview of the literature on multisensory perception that is designed to demonstrate just how dramatically the various senses can influence people's 'tactile' perception of many different objects and surface qualities, no matter whether people realize it or not.

Sensory dominance and visual capture

According to the traditional view, touch was thought to educate vision (see Berkeley 1709/1957; Arnold 2003; Classen 2005). However, early empirical research came to exactly the opposite conclusion concerning the interaction between vision and touch. Perhaps the earliest data to be reported on this question was highlighted by Sir David Brewster (1832) in his book *Natural magic* (see Epstein 1971). There, Brewster describes how optically left–right reversing an indented object (an engraved watch seal) results in the concavities (or depressions) of the seal appearing visually as protruberences (or elevations) instead. According to Brewster, the seal will actually '*feel*' as if it is elevated as well when explored haptically, thus showing the dominance of vision over the conflicting tactile/haptic sensations. When, more than a century later, scientists started to collect more rigorous experimental data concerning the influence of one sense on another (using variations of the conflict situation, in which discrepant information is presented to each sense, and psychologists perceive how people resolve this sensory conflict perceptually)[1], they also observed what appeared to be a complete dominance of vision over touch as well (e.g. Gibson 1933; Rock and Victor 1964; Hay et al. 1965; Rock and Harris 1967).

[1] Welch and Warren (1980) have suggested that the term 'discrepancy' (or 'discordance') might be more appropriate than 'conflict', since, according to them, the latter term connotes an awareness of, and possibly an aversive response toward, the stimulus situation (cf. Derrick and Dewar 1970). However, 'intersensory conflict' is the term that has been used more frequently in the literature over the years.

For example, Gibson (1933) showed that when people ran their fingers up and down a straight metre stick they perceived it as being curved if they simultaneously looked through lenses that made the stick appear curved. As soon as the participants closed their eyes, however, or turned their gaze away, the edge of the rule felt straight again, as, of course, in reality, it was. Meanwhile, Rock and his colleagues (Rock and Victor 1964; Rock and Harris 1967) reported a number of experiments in which people had to rate their impression of the size of a small object which they could either see, feel, or both see and feel at the same time. In one experiment, the participants looked at a square object for five seconds through a pair of distorting (reducing) lenses which made the square look as if it was only half as large as it actually was (although the participants were unaware of this fact), and then indicate how large the square was. Under such conditions, vision was found to dominate completely over touch (see Fig. 4.1A). Further experiments in which distorting lenses that made the square look rectangular instead gave rise to exactly the same pattern of results (see Fig. 4.1B). Findings such as these led Rock and Harris (1967, p. 96) to conclude that 'vision completely dominates touch and even shapes it'.

The two articles published by Rock and his colleagues in the prestigious scientific journals *Science* and *Scientific American* during the 1960s had a profound impact on the thinking (and experimentation) of many psychologists over the decades that followed (see Warren and Rossano 1991, for a review). While the majority of these subsequent studies replicated the basic finding that vision can modulate tactile/haptic perception

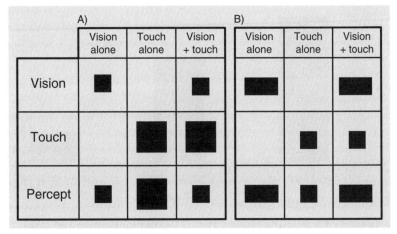

Fig. 4.1 This schematic figure highlights the basic pattern of results observed in Rock and Victor's (1964) classic studies of sensory dominance, in which the apparent visual size of various objects was altered (either reduced in size (A) or elongated (B)) by means of distorting lenses. The figure shows how participants' perception of the object changed depending upon what they saw and/or felt. Note that the participants always perceived the object to be the size that they had seen it to be visually (i.e. vision completely overrode their haptic/tactile perception when the two senses were put into conflict).

of the size, volume, and shape (i.e. structural properties) of an object when the sensory cues relating to that object were put into conflict, it is important to note that not all of the studies showed a complete dominance of vision over touch (e.g. Over 1966; Kinney and Luria 1970; McDonnell and Duffett 1972; Miller 1972; Fishkin et al. 1975; Power and Graham 1976; Power 1980, 1981; Heller 1992). For example, Fishkin et al. reported an experiment in which they observed strong, but incomplete, visual capture in a slant judgement task in which the participants had to orient a bar until it was horizontal, an approximate compromise between the senses of vision and touch in a length judgement task, while a trend toward tactile capture was observed in a texture matching task (see Fig. 4.2). Lederman and Abbott (1981) also found that participants tended to made compromise judgements (weighing the two modalities about equally) when vision and touch were put into conflict in a task in which they had to match the texture of two abrasive sandpaper samples. Meanwhile, a long series of experiments by Lederman, Thorne, and Jones (1986) showed that the extent to which one sensory input is preferred over another may depend on the nature of the task that participants have to perform. They were able to demonstrate that certain texture discrimination tasks appear better suited (or more appropriate) to vision (e.g. determining the spatial density of texture elements), while others appear more appropriate to touch (e.g. determining the roughness of fine textures).

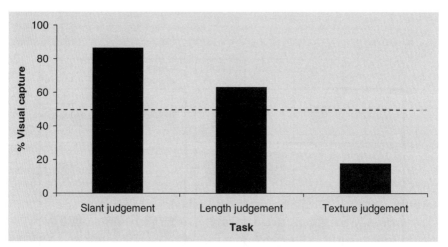

Fig. 4.2 Results of a study by Fishkin et al. (1975) highlighting the task–dependency of the visual dominance (or capture) of touch. A variety of different distorting lenses were used in order to introduce a conflict between what participants saw and what they felt. The percentage of visual capture represents the extent to which participants' judgements were consistent with what they saw visually. If the participants had weighted the input from the two modalities equally, then 50% visual capture should have been observed (dashed line in figure).

(Data taken from Fishkin et al. 1975, Table 1.)

Converging evidence for the dominance of touch over vision in the perception of fine surface texture comes from a study reported by Heller (1989), in which touch was shown to be superior to vision in the judgement of the texture of very smooth Japanese abrasive sharpening stones. Finally, Guest and Spence (2007) have shown recently that touch can dominate completely over vision in the judgement of fine surface texture. The participants in their study had to make judgements concerning the roughness of the surface texture of a series of pilled fabric samples (i.e. fabric samples that had been roughened to varying degrees through a process of abrasion), discriminating between pairs of pilled fabric samples using touch, vision, or both senses together. Participants were able to discriminate between the pairs of pilled fabric samples (in terms of which sample was more pilled, or rougher) more accurately using touch alone than using just vision. However, when fabric samples having slightly different pill values were presented to the participants' eyes and to their fingertips at the same time, touch dominated completely over vision in terms of participants' judgements of how pilled the samples were (see Fig. 4.3). These results

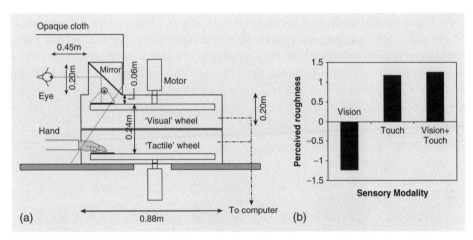

Fig. 4.3 A) Schematic view of the experimental set-up used by Guest and Spence (2007) in order to assess the relative contributions of vision and touch to texture perception. Separate pilled fabric samples were presented to touch and vision upon individually controlled motorized wheels. Note that the apparatus was designed so that participants were given the impression that they were seeing and feeling the same fabric (i.e. the two sensory impressions appeared to originate from the same spatial position). B) Bar graph highlighting the results obtained when incongruent stimuli (i.e. fabric swatches having different pilling values) were presented to vision and to touch. These results show that touch completely dominates over visual in the perception of the roughness (or amount of pilling) on the surface of these fabric swatches. These results are consistent with the view that touch can dominate over vision in the perception of very fine surface texture (i.e. microgeometric surface features), presumably because by itself touch is better at this task than is vision.

therefore demonstrate that tactile cues can dominate completely over vision, at least when people have to evaluate fine pilled fabrics (see also Guest and Spence 2003a).

Researchers have observed that the influence of vision on tactile perception tends to be more pronounced when the stimuli in the two modalities are presented (or appear to originate) from the same spatial position (Miller, 1972; Gephstein et al. 2005; Congedo et al. 2006; though see also Helbig and Ernst 2007). This may, in part, be because people are more likely to believe that various different sensory impressions belong together (i.e. they are more likely to make an 'assumption of unity'; Spence 2007; Welch and Warren 1980) when the stimuli originate from the same (rather than different) spatial location (and if they occur synchronously in time). The dominance of vision over touch is larger when people assume that what they are seeing and feeling actually refer to the same object or event (see Miller 1972; Welch 1972; Heineken and Schulte 2007; Spence 2007). Consequently, the majority of psychologists have tried to keep the participants in their studies naïve to any intersensory conflict that may have been present within their experimental set-ups (e.g. Rock and Victor 1964; Miller 1972; Ernst and Banks 2002). Although multisensory interactions can still take place if people notice (or are made aware of) the presence of intersensory conflict (e.g. Over 1966; Welch 1972; Heineken and Schulte 2007; Helbig and Ernst 2007), the magnitude of any visual influence on tactile perception tends to be much weaker. What's more, top-down factors and individual differences come to play a more important role in determining any intersensory interactions that are observed (see Miller 1972; Welch and Warren 1980; Heller 1992). That is, once people become aware of the discrepancy between their senses, they then have the choice of responding either on the basis of what they are seeing or on the basis of what they are feeling.

EARLY THEORIES OF SENSORY DOMINANCE

Posner, Nissen, and Klein (1976) put forward one of the first theories that tried to account for research on sensory dominance. They suggested that people may direct their attention more toward the visual sense due to the poor alerting, or arousing, qualities of visual stimuli. Posner et al. argued that this attentional bias often results in (attended) visual inputs (i.e. those sensory impressions that people are concentrating on) having a larger influence on people's judgements than those inputs from the other relatively 'less attended' senses. However, the emergence of a growing number of studies demonstrating a compromise between the senses, or demonstrating that the other senses (such as touch) could apparently dominate vision under the appropriate conditions (e.g. Fishkin et al. 1975; Lederman and Abbott 1981; Lederman et al. 1986; Welch et al. 1986; Guest and Spence 2007), led to the development of an alternative account of sensory dominance, modality appropriateness (Welch and Warren 1980). Building on Freides's (1974) earlier observation that different sensory modalities are

specialized for different tasks, Welch and Warren went on to suggest that the most accurate modality might actually be the one that will dominate over perceptual judgements under conditions of conflict (see also Becker-Carus, 1973). According to the modality appropriateness hypothesis, the reason why visual information tends to dominate over tactile information so frequently in the published studies of intersensory conflict is simply because vision is the sense that normally provides the most accurate, or appropriate, source of information concerning the judgement being made (at least for the kinds of perceptual judgements that psychologists typically ask their participants to make). According to the modality appropriateness hypothesis, our brains tend to weight information in the sensory modality that is most appropriate to the task at hand more heavily. That is, while vision may dominate when people have to make judgements regarding the macrogeometric properties of an object or surface (i.e. judgements concerning the structural properties of the object, or concerning the macrogeometric properties of the surface texture), touch may dominate when they have to make judgements concerning the microgeometric surface properties instead (i.e. when people have to try and discriminate between very fine surface textures). Several researchers have supported the view that people may choose to attend to the sensory modality that happens to provide the most accurate information concerning a particular perceptual attribute (or judgement; e.g. Lederman and Abbott 1981; Lederman et al. 1986; Heller 1992; Guest and Spence 2003a,b, 2007), hence enhancing the dominance of that modality over the multisensory percept that people become aware of (see also Warren and Rossano 1991).

THE MAXIMUM-LIKELIHOOD ACCOUNT OF SENSORY DOMINANCE

Ernst and Banks (2002) put forward the theory of sensory dominance that is currently very popular amongst researchers. They conducted an influential series of experiments in which they were able to show that the human brain weights the most accurate sensory modality (i.e. the modality in which people's estimates of a particular sensory attribute shows the least variance) more heavily than the inputs from those modality estimates having more variance. The particularly novel contribution of their work was that it allowed researchers to predict mathematically how much sensory dominance would occur in any given situation. According to the maximum-likelihood estimation account of sensory dominance, the human brain may actually operate in a manner that is very close to that of a statistically optimal multisensory integrator (see Ernst and Bülthoff 2004, for further details). That is, the multisensory integration of disparate unisensory inputs appears to maximally reduce the uncertainty of (or variance associated with) our multisensory estimates of external stimulus qualities

(given that all of our sensory estimates are intrinsically noisy; see Fig. 4.4). In the experiments reported by Ernst and Banks, participants had to try and judge the height of a bar which could either be seen on a screen or else felt between the participant's finger and thumb (using two force-feedback devices). Using this set-up, bars of either the same or different height could be presented to vision and touch/haptics. Ernst and Banks were able to show that whether people demonstrated visual dominance, tactile dominance, or some intermediate weighting of vision and touch/haptics was critically dependent on the variance associated with each of the sensory estimates (see also Becker-Carus 1973; though see Derrick and Dewar 1970; Miller 1972).

Although Ernst and Banks's (2002) original study used a virtual reality haptic display (thus raising some concern regarding the ecological validity of the stimulus displays used), Helbig and Ernst (2007) have recently demonstrated a very similar pattern of results under conditions where participants had to evaluate the shape of a number of real objects that were held in their hands. In fact, the maximum-likelihood estimation account of sensory dominance has now been shown to provide a remarkably good account of the relative contributions of the senses (audition, vision, touch, and proprioception) to multisensory perception in a variety of different experimental settings (e.g. see Alais and Burr 2004; Andersen et al. 2005; see Ernst and Bülthoff 2004, for a review). It should, however, be noted that some residual role for directed attention may still be necessary (see Battaglia et al. 2003; though see also Witten and Knudsen 2005).

AUDITORY CONTRIBUTIONS TO TACTILE PERCEPTION

Researchers have demonstrated that manipulating the sounds that people hear when they touch a surface can have a dramatic effect on the perceived roughness of that surface (Jousmäki and Hari 1998; Guest et al. 2002). What's more, people's perception of the pleasantness, powerfulness, and forcefulness of many different products has also been shown to be influenced by the sounds that they make when used (Zampini et al. 2003; Susini et al. 2004; Spence and Zampini 2007). For example, Guest et al. highlighted a particularly dramatic demonstration of the auditory modulation of tactile perception, known as the 'parchment-skin' illusion (Jousmäki and Hari 1998). They showed that people's perception of the 'feel' of the palmar skin of their own hands could be changed simply by changing the sounds that they heard when they rubbed them together.

The participants in Guest et al.'s (2002) study either heard the actual sound of their hands being rubbed together (which was picked up by a microphone and played back over headphones), or else the sound was manipulated in order to reduce the overall

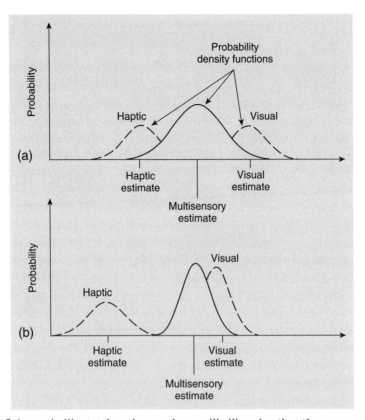

Fig. 4.4 Schematic illustrating the maximum-likelihood estimation account of sensory dominance (see Ernst and Bülthoff 2004, for a review). Under situations of intersensory conflict (as found in the majority of research studies of sensory dominance), visual and tactile/haptic estimates of a particular object property (such as its size) will differ. The graphs highlight the probability density functions for unimodal haptic and visual estimates of the object's size (dashed functions). Note that the estimates are different due to the introduction of the conflict. The two estimates are distributed in a Gaussian manner given that any perceptual estimate of an external object property will be inherently noisy (that is, if we were to make two separate judgements concerning the felt size of an object, those judgements would be unlikely to be exactly the same). According to the maximum-likelihood estimation account, the relative contribution of each sense to our multisensory perceptual judgements depends on the variance associated with each modality estimate. In the upper graph (A), an equal amount of variability is associated with each of the unimodal estimates, and so the multisensory perceptual estimate (the function highlighted by the continuous line) represents a weighted average of the two unimodal estimates (i.e. 50% visual capture). However, in many cases, the visual estimate of a particular object quality will be less noisy (i.e. more accurate) than the tactile/haptic estimate (B), and hence the person will perceive something that is much closer to what they see (i.e. they will experience visual dominance). Note that the variance associated with the multisensory percept is also less than that associated with either of the unimodal perceptual estimates. (Figure based on Ernst and Banks 2002, Figure 1).

sound intensity level (by either 20 or 40dB) or to amplify or attenuate just the high-frequency components of the sounds (i.e. those above 2kHz) by 12dB. The partici-pants made separate ratings concerning how rough and how moist their hands felt. The participants rated their hands as feeling significantly dryer when listening to the louder hand-rubbing sounds or when just the high-frequency sounds were boosted. Changing the auditory feedback also had a small but significant effect on participants' ratings of the roughness of their hands as well. Guest et al.'s results therefore highlight the significant role that auditory cues can play in influencing people's evaluation of the 'feel' of a surface, even for one that is as familiar to them as the palmar skin of their own hands.

Kitagawa and Igarashi (2005) have even shown that simply hearing the sound of someone else's ear (in this case the ear on a dummy head) being gently stroked with a brush can give rise to the illusion of being touched, provided that the sound (which was recorded by a tiny microphone placed inside the dummy head's ear canal) was played back from close to the participant's own ear (the participants also saw a video recording of the ear of the dummy head being stroked). Many of the participants in this experiment reported that they felt as if they themselves had actually been touched (or rather tickled) on their own ear. These results therefore demonstrate that touch-related sounds can, by themselves, induce illusory tactile experiences (see Kitagawa and Spence 2006). The auditory modulation of tactile expe-rience is not, however, restricted to the perception of our own skin/bodies: for Guest et al. (2002) have shown that peoples' perception of the texture (roughness) of sand-papers varying in roughness (or grit) value can also be modified simply by varying the auditory feedback that they heard when touching them. In this case, the amplification of the high frequency sounds appeared to result in an increased perception of sandpa-per roughness, while the attenuation of these sounds made the touched surfaces feel smoother instead.

A growing body of more applied research has now demonstrated that auditory cues also play a very important role in people's perception of many everyday products (e.g. Wolkomir 1996; Spence and Zampini, 2006). For example, Zampini et al. (2003) have shown that people's perception of the pleasantness and powerfulness of an elec-tric toothbrush is influenced by the particular sound that it makes when people brush their teeth. Similarly, the perceived forcefulness and pleasantness of an aerosol spray can also be systematically influenced by changing the particular spectral profile of the spraying sounds it makes when used (Spence and Zampini 2007). Results such as these, when taken together with a large number of other studies (see Spence and Zampini 2006, for a review), demonstrate just how important auditory cues are to our percep-tion of many everyday products and surfaces. It is, however, important to note that the particular auditory manipulations that are required to change our tactile perception appear to depend on the particular surface, or object, that is being judged or evaluated (see Spence and Zampini 2007, on this point).

Finally in this section it is worth noting that, by themselves, auditory cues often provide sufficient information for people to be able to judge the approximate (or rela-tive) size of the sound-making objects, as well as certain of their material properties

(e.g. Freed 1990; Carello et al. 1998; Klatzky et al. 2000; Kunkler-Peck and Turvey 2000; Giordano and McAdams 2006). For example, Freed (1990) has shown that people can determine the relative hardness of percussive mallets on the basis of the impact sounds that they make. Auditory cues can also provide sufficient information with which to discriminate an object's length (Carello et al. 1998). The one thing that audi-tory cues apparently cannot be used to determine is the shape of a drum (Cipra 1992; Gordon and Webb 1996; Kac 1966). As yet, however, no one has attempted to manip-ulate these auditory cues (e.g. in a manner equivalent to the visual distortions induced when participants look at an object through a distorting lens) in order to determine whether they would influence the perceived size/material properties of objects that were simultaneously being explored haptically. This clearly represents an interesting area for future research (cf. Bee et al. 2000, for a possible example of this phenomenon in nature).

Olfactory contributions
to tactile perception

To date, far less research has been directed at investigating the nature of any cross-modal influence of olfaction on the sense of touch (see Laird 1932; Cox 1967; Demattè et al. 2006). Laird, in a now classic study, described a house-to-house survey in which each of 250 housewives was presented with four pairs of silk stockings and then asked to judge which pair had the best/highest quality. The housewives were instructed to: *'Feel them in your fingers, look through them, stretch them, look at the seams. Do anything you would ordinarily do to pick out the best for your own use.'* (Laird 1932, p. 244). The stockings were actually identical except for the fact that one pair had a slightly rancid fragrance, another had a fruity fragrance, a third pair had a synthetic scent, while the fourth pair had a 'sachet' scent. Fifty per cent of the housewives reported that they pre-ferred the narcissus-scented hosiery (24% preferred the fruity scent, 18% preferred the sachet scent, and the remaining 8% preferred the slightly rancid scent). The majority of the housewives attributed their preferences not to the smell of the scented hosiery (which only six of them noticed), but to the texture, durability, sheen, weight, or weave of the stockings instead (i.e. to their tactile and/or visual material qualities, qualities that were presumably much easier to articulate verbally than are olfactory descriptors; see McKenzie 1923; Richardson and Zucco 1989).

Demattè et al. (2006) recently followed up on Laird's (1932) early research to inves-tigate whether or not the presence of an odour would modulate people's perception of the *softness* of fabric samples under rather more controlled laboratory conditions. The participants in this study sat in front of a rotating wheel on which a number of differ-ent swatches of fabric were hung (to allow for a naturalistic rubbing of the materials

between the participant's thumb and forefinger). On each trial, the participants felt one of the swatches (the participants were not allowed to see the fabric samples) and had to rate its perceived softness. While the participants were evaluating the feel of a particular fabric swatch, a lemon or an animal-like odour was occasionally delivered direct to the participant's nostrils by means of a custom-built olfactometer. On each trial, the participants first had to classify any odour as either pleasant or unpleasant, or else respond that no odour had been presented. For the majority of participants, the lemon odour was judged as pleasant while the animal odour was judged as being unpleasant. Next, the participants indicated how soft the fabric felt. The participants rated the fabrics as feeling significantly softer when presented at the same time as the 'pleasant' lemon odour than when presented together with the 'unpleasant' animal odour.

In a subsequent experiment, Demattè et al. (2006) went on to show that olfactory cues (in this case, the smell of lavender and/or animal) can also influence people's judgements of fabric softness when the fragrance was applied directly to the fabric swatches themselves (i.e. using a somewhat more ecologically-valid experimental design). It is, however, at present unclear whether the olfactory modulation of tactile perception highlighted by previous research is restricted to the perception of fabrics (i.e. to surfaces/materials that are commonly scented), or whether instead such cross-modal influences can also influence people's perception of other surfaces (such as, for example, sandpaper) that may not typically be associated with any particular fragrance. Once again, this represents an important question for future research.

Many studies have demonstrated the significant effect that olfactory cues have on people's perception of (and responses to) various different products (e.g. see Byrne-Quinn 1988; Bone and Jantrania 1992; Gulas and Bloch 1995; Neff 2000; Ebster and Kirk-Smith 2005; Demattè et al. 2007). Pairing a product with an appropriate scent has been shown to enhance people's evaluation of the product, while the addition of an inappropriate scent tends to lower people's product evaluations. For example, a major European electronics goods manufacturer recently reported that they had become aware of the fact that people's perception of their newly purchased (and often very expensive) electronic consumer goods was sometimes being adversely affected by the unpleasant smells emanating from the packaging when it was initially opened after purchase. In this case, the company was actually considering the introduction of a pleasant fragrance to the packaging materials themselves in order to avoid this negative (and incongruent) initial impression of their products. It should be noted that people's judgements can be influenced by ambient odours even when they are presented at such low concentrations that they are not perceived consciously, or else when people simply fail to notice the odour any more because they have adapted to it (see Spence 2002). Thus, the failure to discern the presence of an odour does not guarantee that one is not unwittingly being led by one's nose! In summary, the studies reviewed in this section highlight the important, if often unrecognized, role that olfactory cues can play in determining our reactions to a variety of different materials and products.

Consequences of sensory loss for tactile and multisensory perception

So far, the focus of this chapter has been on highlighting the multisensory influences on tactile/haptic perception for individuals who are sensorially unimpaired. However, a large body of empirical research has also been directed at the question of how the residual senses function, both individually and in concert, following the complete loss, or in the congenital absence, of a particular sense (usually vision; see Galton 1883; Griesbach 1899; Hötting and Röder 2004; Röder and Rösler 2004). Although the evidence on this issue is not entirely clear, it is certainly true that a number of researchers have now shown that the loss of one sense (typically vision or hearing) can result in an improved acuity in one or more of the residual senses. For example, Brigitte Röder and her colleagues in Hamburg have shown that the congenitally blind find it much easier to judge the temporal order in which two near-simultaneous tactile stimuli are presented to their hands than do either the late blind or the sighted (Röder et al. 2004). What's more, they also found that while the sighted and late blind often get confused about the temporal order in which two tactile stimuli are presented to their hands when they are crossed over the midline, congenitally blind individuals rarely make any such mistakes, even when matched on their baseline performance in the uncrossed hands posture. It should, however, be noted that not everyone has observed such dramatic improvements in tactile perception in the blind (e.g. see Galton 1883; Grant et al. 2000), and some researchers have even failed to find any such differences in tactile perception between the blind and sighted across a range of different tasks (see Heller 1989; Hollins 1989).

The congenitally blind also appear to hear more acutely in the periphery than do the sighted (Röder et al. 1999; see also Lessard et al. 1998). Interestingly, professional orchestra conductors have been shown to exhibit a similarly enhanced pattern of responses to peripheral sounds (Münte et al. 2001). Furthermore, while there is some anecdotal evidence for the blind having an enhanced ability to smell (e.g. Gault 1923), more recent (and better-controlled) laboratory studies have provided absolutely no evidence for enhanced olfactory (or gustatory) sensitivity in the blind, although there is some evidence to suggest that the blind may find it easier to label/name odours than the sighted (see Murphy and Cain 1986; Smith et al. 1993; Rosenbluth et al. 2000).

Currently, the available empirical evidence would therefore appear to support the conclusion that those deprived of input from one sense, such as vision, can outperform the sighted on certain other perceptual tasks in their residual sensory modalities. However, it would seem most parsimonious to agree with Grant et al.'s (2000, p. 309) claim (based on both their own data, and previous tactile research) that: 'people deprived of one or more senses do not develop truly supernormal sensitivities of the remaining ones but rather learn to use them proficiently for purposes other than those for which they are normally used'. This conclusion would seem to fit well with

the results of those studies in which 'experienced' sighted individuals have been shown to perform just as well as the blind (e.g. Smith et al. 1993; Röder et al. 1999; Münte et al. 2001). Thus, it would appear that it is their extensive or specialized training, rather than cortical plasticity *per se* (though note that training can result in cortical reorganization), that is responsible for the enhanced sensory/perceptual abilities shown by blind people (and others with sensory loss) in certain tasks.

Cognitive neuroscientists have been able to show that the part of the brain that is normally used by sighted people in order to process what they see (known as the occipital cortex) appears to be used in congenitally blind individuals in order to augment the tactile information processing taking place in their somatosensory cortex (e.g. see Sadato et al. 1996; Cohen et al. 1997). Similarly, the visual cortex also appears to be recruited when blind people perform auditory tasks as well (Kujala et al. 1995). In fact, the latest research has shown that even normally sighted individuals begin to show the first signs of such cortical reorganization after a few days without vision (Merabet et al. 2004). Brain scans of the participants in Merabet et al.'s study showed that their visual cortices had started to be recruited to help them perform purely tactile tasks after five days of blindfolding. In fact, spending as little as an hour and a half in the dark has now been shown to result in significant (if short-lasting) improvements in both tactile and auditory perception in the sighted (Facchini and Aglioti 2003; Lewald 2007; see also Boroojerdi et al. 2000).

Given our growing understanding of the neural mechanisms behind, and the behavioural consequences of, the various changes in performance that have now been documented in each of the senses that remain intact following the loss (or congenital absence) of a particular sense (Röder and Rösler 2004), researchers are now beginning to investigate whether the rules of multisensory (rather than just unisensory) perception also change following sensory loss. For example, Hötting and Röder (2004) recently looked for any changes in the auditory modulation of tactile perception in the congenitally blind. The participants in their study had to try and report how many tactile stimuli had been presented in a rapidly-presented stream of touches delivered to their right index finger. At the same time, the participants were also presented with an irrelevant stream of auditory distractors. The number of sounds that were presented on any given trial (0–4) was completely independent of the number of tactile stimuli that were presented (1–4). Hötting and Röder's results showed that when multiple auditory stimuli were presented together with a single tactile stimulus, the participants frequently reported feeling more than one touch, even though the participants in this study had been explicitly told to try and ignore what they heard and concentrate solely on what they were feeling. More importantly, this crossmodal effect of sound on tactile perception was found to be more pronounced in the sighted than in the congenitally blind participants tested (see Fig. 4.5). Hötting and Röder's results therefore suggest that there may indeed be some change in the relative weighting of the residual senses following sensory loss. In fact, this change may be explainable in terms of the modality-appropriateness hypothesis outlined earlier (see Freides 1974; Welch and Warren 1980), given that the congenitally blind generally outperformed the sighted in their tactile judgements. Given these intriguing results, it would be particularly

interesting in future research to investigate whether the congenitally blind would also be less influenced by sound in the parchment skin illusion described earlier (see Jousmäki and Hari 1998; Guest et al. 2002).

One important issue that hasn't been dealt with here, and which, for that matter, hasn't actually really been studied much by experimental psychologists to date (see Howes 2006), concerns the role that cultural factors may play in the various aspects of uni- and multisensory perception (e.g. see Wober 1966, 1991; Howes 1991; MacDonald 2002). While it seems likely that the same general rules of multisensory integration (such as superadditivity and the importance of spatial and temporal coincidence to multisensory integration) are likely to apply the world over (as they have already been shown to apply across the animal kingdom, from unicellular organisms all the way up to humans; e.g. see Calvert et al. 2004b), the particular weighting of the various senses may be expected to exhibit significant cultural difference. In fact, many years ago, Wober (1966) introduced the notion of the 'sensotype' to refer to the differing patterns of importance of the various senses that he speculated might be found in different cultures. He argued that the predominance of vision in Western cultures might differ from the putatively greater importance associated with audition (and/ or proprioception) in certain other (e.g. African) cultures. Further interdisciplinary research is urgently needed on this topic in order to explore more adequately any such cross-cultural differences in human perception. Note that Wober's notion of different

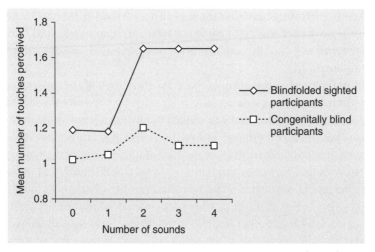

Fig. 4.5 Graph highlighting the results of Hötting and Röder's (2004) recent study comparing the multisensory influence of sound on touch in the congenitally blind and sighted. The results show that the congenitally blind were overall better able to perceive the number of touches presented to their fingertip than the sighted. More importantly, however, the results also show that the sighted were more influenced by what they heard under conditions of sensory conflict (where the number of felt and heard stimuli differed) than are the congenitally blind.

(Redrawn from Hötting and Röder 2004, Figure 1.)

sensotypes can also be used to describe the consequences of sensory loss (such as congenital blindness) that were documented earlier. Finally, even within Western cultures, it is important to note that there appear to be some marked individual differences in the extent to which one sense dominates over another (e.g. Binns 1937; McDonnell and Duffett 1972; Samuel 1981; Heller 1992).

Conclusions

The research outlined in this chapter clearly shows that there is far more to the sense of touch than simply what is going on at the skin surface. A large body of experimental data has now convincingly shown that the tactile/haptic perception of both the structural and surface properties of objects, as well as their perceived functionality, can be profoundly influenced by what people see (see also Warren and Rossano 1991), as well as what they hear (Spence and Zampini 2006), and even what they smell (Spence 2002) when touching, interacting with, or evaluating an object, product, or even an exhibit in a museum setting. The tactile/haptic perception and appreciation of objects must, therefore, be considered as a genuinely multisensory experience (see Calvert et al. 2004a; Spence and Zampini 2006; Schifferstein and Spence 2008). It is perhaps worth reiterating here that these multisensory contributions to tactile perception occur no matter whether people are aware of them or not, and whether they want them to or not (i.e. the multisensory integration of sensory information is normally automatic).

In terms of the precise weighting of the input from each of the senses to our overall tactile (multisensory) experience, the evidence now supports the view that each and every sense that is stimulated can (and typically does) contribute to our overall multisensory perceptual experience. The relative weight (or importance) given to each sensory input depends primarily on the amount of noise in the perceptual system that is associated with that particular estimate (see Ernst and Bülthoff 2004, for a review), with noisy perceptual estimates being weighted less heavily than estimates that are less variable. This means that our tactile experience can indeed be dominated by the impressions available to the other senses (i.e. by what we see)—as claimed so forcefully by Rock and his colleagues back in the 1960s—at least for those features of an object where vision provides more reliable information than touch. However, it is just as important to realize that touch can also dominate vision (and the other senses) under the appropriate conditions (i.e. when touch provides the most accurate, least noisy or variable, estimate). For instance, touch has been shown to dominate over vision in the judgement of fine surface textures (see Heller 1992; Guest and Spence 2007). In practice though, it seems likely that the complete dominance of one sense by another (a phenomenon known as 'visual capture', when visual inputs completely override the inputs from one or more of the other senses) is probably a fairly rare

occurrence outside of the psychologist's laboratory (though see Kinney and Luria 1970; Connor 2000). Instead, each of the senses that are stimulated by a particular object, event, or environment will likely contribute meaningfully to our overall multisensory perceptual experiences.

The growing understanding of the multisensory nature of human perception, and the rules governing it, that has emerged from recent cognitive neuroscience research (e.g. Calvert et al. 2004a) is now beginning to offer a principled means of enhancing/optimizing the multisensory nature of our tactile experience of the objects we interact with and the environments in which those objects are placed (e.g. Spence 2002; Spence and Zampini 2006; Schifferstein and Spence 2008). What's more, the multisensory design of objects and environments that more effectively stimulate the senses seems to constitute a particularly worthwhile endeavour given that multisensory experiences are typically far richer, more pleasurable, and more memorable than the individual unisensory experiences from which they are constituted (e.g. Knasko 1993; Stein and Meredith 1993; Aggleton and Waskett 1999; Spence 2002; Howes 2005; Schifferstein and Spence, 2008).

References

Aggleton JP and Waskett L (1999). The ability of odours to serve as state-dependent cues for real-world memories: Can Viking smells aid the recall of Viking experiences? *British Journal of Psychology*, **90**, 1–7.

Alais D and Burr D (2004). The ventriloquist effect results from near-optimal bimodal integration. *Current Biology*, **14**, 257–62.

Andersen TS, Tiippana K, and Sams M (2005). Maximum likelihood integration of rapid flashes and beeps. *Neuroscience Letters*, **380**, 155–60.

Arnold K (2003). Skulls, mummies and unicorns' horns: Medicinal chemistry in early English museums. In RGW Anderson, ML Caygill, AG MacGegor, and L Syson, eds. *Enlightening the British: Knowledge, Discovery and the Museum in the Eighteenth Century*, pp. 74–80. The British Museum Press, London.

Bailly Dunne C and Sears M (1998). *Interior Designing for all Five Senses*. St. Martin's Press, New York.

Battaglia PW, Jacobs RA, and Aslin RN (2003). Bayesian integration of visual and auditory signals for spatial localization. *Journal of the Optical Society of America A*, **20**, 1391–7.

Becker-Carus C (1973). Verändert die Wahrnehmungsschwelle die dominanz zwichen sehen und tasten? [Does the perception threshold change the dominance of vision and touch?] *Zeitschrift für Experimentelle und Angewandte Psychologie*, **20**, 347–65.

Bee MA, Perrill SA, and Owen PC (2000). Male green frogs lower the pitch of acoustic signals in defense of territories: A possible dishonest signal of size? *Behavioral Ecology*, **11**, 169–77.

Berkeley G (1709/1957). *A new theory of vision*. J.M. Dent & Sons, London.

Binns H. (1937). Visual and tactual 'judgement' as illustrated in a practical experiment. *British Journal of Psychology*, **27**, 404–10.

Bone PF and Jantrania S (1992). Olfaction as a cue for product quality. *Marketing Letters*, **3**, 289–96.

Boroojerdi B, Bushara KO, Corwell B, et al. (2000). Enhanced excitability of the human visual cortex induced by short-term light deprivation. *Cerebral Cortex*, **10**, 529–34.

Brewster D (1832). *Natural Magic*. John Murray, London.

Byrne-Quinn J (1988). Perfume, people, perceptions and products. In S Van Toller and G Todd, eds. *Perfumery: The Psychology and Biology of Fragrance*, pp. 205–16. Chapman and Hall, New York.

Calvert GA, Spence C, and Stein BE, eds. (2004a). *The Handbook of Multisensory Processes*. MIT Press, Cambridge, MA.

Calvert G, Spence C, and Stein BE (2004b). Introduction. In GA Calvert, C Spence, and BE Stein, eds. *The Handbook of Multisensory Processing* pp. xi–xvii. MIT Press, Cambridge, MA.

Carello C, Anderson KL, and Kunkler-Peck AJ (1998). Perception of object length by sound. *Psychological Science*, **9**, 211–14.

Cipra B (1992). You can't hear the shape of a drum. *Science*, **225**, 1642–3.

Classen C (2005). Touch in the museum. In C Classen, ed. *The Book of Touch*, pp. 275–86. Berg, Oxford.

Cohen LG, Celnik P, Pascual-Leone A, et al. (1997). Functional relevance of cross-modal plasticity in blind humans. *Nature*, **389**, 180–3.

Congedo M, Lécuyer A, and Gentaz E (2006). The influence of spatial delocation on perceptual integration of vision and touch. *Presence: Teleoperators & Virtual Environments*, **15**, 353–7.

Connor S (2000). *Dumbstruck: A Cultural History of Ventriloquism*. Oxford University Press, Oxford.

Cox DF (1967). The sorting rule model of the consumer product evaluation process. In *Risk Taking and Information Handling in Consumer Behaviour*, pp. 324–71. Graduate School of Business Administration, Harvard University, Boston, MA.

de Vries J (1997). *The Five Senses: If you lose these senses you lose your sense of living*. Mainstream Publishing Company, Edinburgh.

Demattè ML, Sanabria D, Sugarman R, and Spence C (2006). Cross-modal interactions between olfaction and touch. *Chemical Senses*, **31**, 291–300.

Demattè ML, Österbauer R, and Spence C (2007). Olfactory cues modulate judgments of facial attractiveness. *Chemical Senses*, **32**, 603–10.

Derrick E and Dewar R (1970). Visual-tactual dominance relationship as a function of accuracy of tactual judgment. *Perceptual and Motor Skills*, **31**, 935–9.

Ebster C and Kirk-Smith M (2005). The effect of the human pheromone androstenol on product evaluation. *Psychology and Marketing*, **22**, 739–49.

Epstein W (1971). David Brewster's observations on perception when touch and vision conflict: An historical note. *Perception & Psychophysics*, **10**, 97.

Ernst MO and Banks MS (2002). Humans integrate visual and haptic information in a statistically optimal fashion. *Nature*, **415**, 429–33.

Ernst MO and Bülthoff HH (2004). Merging the senses into a robust percept. *Trends in Cognitive Sciences*, **8**, 162–9.

Facchini S and Aglioti SM (2003). Short term light deprivation increases tactile spatial acuity in humans. *Neurology*, **60**, 1998–9.

Fishkin SM, Pishkin V, and Stahl ML (1975). Factors involved in visual capture. *Perceptual and Motor Skills*, **40**, 427–34.

Freed DJ (1990). Auditory correlates of perceived mallet hardness for a set of recorded percussive sound events. *Journal of the Acoustical Society of America*, **87**, 311–22.

Freides D (1974). Human information processing and sensory modality: Cross-modal functions, information complexity, memory, and deficit. *Psychological Bulletin*, **81**, 284–310.

Galton F (1883). *Inquiries Into Human Faculty And Its Development*. MacMillan, London.

Gault RH (1923). An unusual case of olfactory and tactile sensitivity. *Journal of Abnormal Psychology*, **17**, 395–401.

Gephstein S, Burge J, Ernst MO, and Banks MS (2005). The combination of vision and touch depends on spatial proximity. *Journal of Vision*, **5**, 1013–23.

Gibson JJ (1933). Adaptation, after-effect and contrast in the perception of curved lines. *Journal of Experimental Psychology*, **16**, 1–31.

Giordano BL and McAdams S (2006). Material identification of real impact sounds: Effect of size variation in steel, glass, wood, and plexiglass plates. *Journal of the Acoustical Society of America*, **119**, 1171–81.

Gordon C and Webb D (1996). You can't hear the shape of a drum. *American Scientist*, **84**, 46.

Grant AC, Thiagarajah MC, and Sathian K (2000). Tactile perception in blind braille readers: A psychophysical study of acuity and hyperacuity using gratings and dot patterns. *Perception & Psychophysics*, **62**, 301–12.

Griesbach H (1899). Vergleichende Untersuchungen über die Sinnesschärfe Blinder und Sehender [Comparative studies of perceptual acuity in the blind and the sighted]. *Pflügers Archiv*, **74**, 577–638.

Guest S and Spence C (2003a). What role does multisensory integration play in the visuotactile perception of texture? *International Journal of Psychophysiology*, **50**, 63–80.

Guest S and Spence C (2003b). Tactile dominance in speeded discrimination of pilled fabric samples. *Experimental Brain Research*, **150**, 201–7.

Guest S and Spence C (2007). Tactile dominance in fabric texture perception. Manuscript submitted for publication.

Guest S, Catmur C, Lloyd D, and Spence C (2002). Audiotactile interactions in roughness perception. *Experimental Brain Research*, **146**, 161–71.

Gulas CS and Bloch PH (1995). Right under our noses: Ambient scent and consumer responses. *Journal of Business and Psychology*, **10**, 87–98.

Hay JC, Pick HL Jr, and Ikeda K (1965). Visual capture produced by prism spectacles. *Psychonomic Science*, **2**, 215–16.

Helbig HB and Ernst MO (2007). Optimal integration of shape information from vision and touch. *Experimental Brain Research*, **179**, 595–606.

Heller MA (1989). Texture perception in sighted and blind observers. *Perception & Psychophysics*, **45**, 49–54.

Heller MA (1992). Haptic dominance in form perception: Vision versus proprioception. *Perception*, **21**, 655–60.

Heineken E and Schulte FP (2007). Seeing size and feeling weight: The size-weight illusion in natural and virtual reality. *Human Factors*, **49**, 136–44.

Hollins M (1989). *Understanding Blindness*. Erlbaum, Hillsdale, NJ.

Hötting K and Röder B (2004). Hearing cheats touch, but less in congenitally blind than in sighted individuals. *Psychological Science*, **15**, 60–4.

Howes D, ed. (1991). *The Varieties of Sensory Experience: A Sourcebook in the Anthropology of the Senses*. University of Toronto Press, Toronto.

Howes D (2005). Hyperesthesia, or, the sensual logic of late capitalism. In D Howes, ed. *Empire of the senses: The Sensual Culture Reader*, pp. 281–303. Berg, Oxford.

Howes D (2006). Cross-talk between the senses. *The Senses and Society*, **1**, 381–90.

Jousmäki V and Hari R (1998). Parchment-skin illusion: sound-biased touch. *Current Biology*, **8**, 869–72.

Kac M (1966). Can one hear the shape of a drum? *Mathematics Monthly*, **13**, 21–3.

Kinney JAS and Luria SM (1970). Conflicting visual and tactual-kinesthetic stimulation. *Perception & Psychophysics*, **8**, 189–92.

Kitagawa N and Igarashi Y (2005). Tickle sensation induced by hearing a sound. *Japanese Journal of Psychonomic Science*, **24**, 121–2.

Kitagawa N and Spence C (2006). Audiotactile multisensory interactions in information processing. *Japanese Psychological Research*, **48**, 158–73.

Klatzky RL, Pai DK, and Krotkov EP (2000). Perception of material from contact sounds. *Presence: Teleoperators and Virtual Environments*, **9**, 399–410.

Knasko SC (1993). Lingering time in a museum in the presence of congruent and incongruent odors. *Chemical Senses*, **18**, 581.

Kujala T, Huotilainen M, Sinkkonen J, et al. (1995). Visual cortex activation in blind humans during sound discrimination. *Neuroscience Letters*, **183**, 143–6.

Kunkler-Peck AJ and Turvey MT (2000). Hearing shape. *Journal of Experimental Psychology: Human Perception and Performance*, **26**, 279–94.

Laird DA (1932). How the consumer estimates quality by subconscious sensory impressions: With special reference to the role of smell. *Journal of Applied Psychology*, **16**, 241–6.

Lederman SJ and Abbott SG (1981). Texture perception: Studies of intersensory organisation using a discrepancy paradigm and visual versus tactual psychophysics. *Journal of Experimental Psychology: Human Perception and Performance*, **7**, 902–15.

Lederman SJ and Klatzky RL (2004). Multisensory texture perception. In GA Calvert, C Spence, and BE Stein, eds. *The Handbook of Multisensory Processes*, pp. 107–22. MIT Press, Cambridge, MA.

Lederman SJ, Thorne G, and Jones B (1986). Perception of texture by vision and touch: Multidimensionality and intersensory integration. *Journal of Experimental Psychology: Human Perception and Performance*, **12**, 169–80.

Lessard N, Paré M, Lepore F, and Lassonde M (1998). Early-blind human subjects localize sound sources better than sighted subjects. *Nature*, **396**, 278–80.

Lewald J (2007). More accurate sound localisation induced by short-term light deprivation. *Neuropsychologia*, **45**, 1215–22.

Lindstrom M (2005). *Brand Sense: How to Build Brands Through Touch, Taste, Smell, Sight and Sound*. Kogan Page, London.

MacDonald AS (2002). The scenario of sensory encounter: Cultural factors in sensory-aesthetic experience. In WS Green and PW Jordan, eds. *Pleasure with Products*, pp. 113–23. Taylor & Francis, London.

McDonnell PM and Duffett J (1972). Vision and touch: A reconsideration of conflict between the two senses. *Canadian Journal of Psychology*, **26**, 171–80.

McKenzie D (1923). *Aromatics and the Soul: A Study of Smells*. William Heinemann, London.

Merabet LB, Maguire D, Warde A, Alterescu K, Stickgold R, and Pascual-Leone A (2004). Visual hallucinations during prolonged blindfolding in sighted subjects. *Journal of Neuro-opthalmology*, **24**, 109–13.

Miller EA (1972). Interaction of vision and touch in conflict and nonconflict form perception tasks. *Journal of Experimental Psychology*, **96**, 114–23.

Münte TF, Kohlmetz C, Nager W, and Altenmüller E (2001). Superior auditory spatial tuning in conductors. *Nature*, **409**, 580.

Murphy C and Cain WS (1986). Odor identification: The blind are better. *Physiology and Behavior*, **37**, 177–80.

Neff J (2000). Product scents hide absence of true innovation. *Advertising Age*, **February** 21, 22.

Over R (1966). An experimentally induced conflict between vision and proprioception. *British Journal of Psychology*, **57**, 335–41.

Posner MI, Nissen MJ, and Klein RM (1976). Visual dominance: an information-processing account of its origins and significance. *Psychological Review*, **83**, 157–71.

Power RP (1980). The dominance of touch by vision: sometimes incomplete. *Perception*, **9**, 457–66.

Power RP (1981). The dominance of touch by vision: occurs with familiar objects. *Perception*, **10**, 29–33.

Power RP and Graham A (1976). Dominance of touch by vision: generalization of the hypothesis to a tactually experienced population. *Perception*, **5**, 161–6.

Richardson JTE and Zucco GM (1989). Cognition and olfaction: a review. *Psychological Bulletin*, **105**, 352–60.

Rock I and Harris CS (1967). Vision and touch. *Scientific American*, **216** (17 May), 96–104.

Rock I and Victor J (1964). Vision and touch: an experimentally created conflict between the two senses. *Science*, **143**, 594-596.

Röder B and Rösler F (2004). Compensatory plasticity as a consequence of sensory loss. In GA Calvert, C Spence, and BE Stein, eds. *The Handbook of Multisensory Processes*, pp. 719–47. MIT Press, Cambridge, MA.

Röder B, Rösler F, and Spence C (2004). Early vision impairs tactile perception in the blind. *Current Biology*, **14**, 121-124.

Röder B, Teder-Saläjärvi W, Sterr A, Rösler F, Hillyard SA, and Neville HJ (1999). Improved auditory spatial tuning in blind humans. *Nature*, **400**, 162–6.

Rosenbluth R, Grossman ES, and Kaitz M (2000). Performance of early-blind and sighted children on olfactory tasks. *Perception*, **29**, 101–10.

Sadato N, Pascual-Leone A, Grafman J, et al. (1996). Activation of the primary visual cortex by Braille reading in blind subjects. *Nature*, **380**, 526–8.

Samuel JMF (1981). Individual differences in the interaction of vision and proprioception. In RD Walk and HL Pick, Jr, eds. *Intersensory Perception and Sensory Integration*, pp. 375–98. Plenum, New York.

Schifferstein HNJ and Spence C (2008). Multisensory product experience. In P Hekkert and HNJ Schifferstein, eds. *Product Experience*, pp. 133–161, Amsterdam: Elsevier.

Schmidt RF, ed. (1986). *Fundamentals of Sensory Physiology*. Springer-Verlag, Berlin.

Smith RS, Doty RL, Burlingame GK, and McKeown DA (1993). Smell and taste function in the visually impaired. *Perception & Psychophysics*, **54**, 649–55.

Spence C (2002). *The ICI Report on the Secret of the Senses*. The Communication Group, London.

Spence C (2007). Audiovisual multisensory integration. *Acoustical Science and Technology*, **28**, 61–70.

Spence C and Zampini M (2006). Auditory contributions to multisensory product perception. *Acta Acustica united with Acustica*, **92**, 1009–25.

Spence C and Zampini M (2007). Affective design: modulating the pleasantness and forcefulness of aerosol sprays by manipulating aerosol spraying sounds. *CoDesign*, 3(Suppl 1), 109–23.

Stein BE and Meredith MA (1993). *The Merging of the Senses*. MIT Press, Cambridge, MA.

Susini P, McAdams S, Winsberg S, Perry I, Vieillard S, and Rodet X (2004). Characterizing the sound quality of air-conditioning noise. *Applied Acoustics*, **65**, 763–90.

Warren DH and Rossano MJ (1991). Intermodality relations: Vision and touch. In MA Heller and W Schiff, eds. *The Psychology of Touch*, pp. 119–37. Lawrence Erlbaum, Hillsdale, NJ.

Welch RB (1972). The effect of experienced limb identity upon adaptation to simulated displacement of the visual field. *Perception & Psychophysics*, **12**, 453–6.

Welch RB, DuttonHurt LD, and Warren DH (1986). Contributions of audition and vision to temporal rate perception. *Perception & Psychophysics*, **39**, 294–300.

Welch RB and Warren, DH (1980). Immediate perceptual response to intersensory discrepancy. *Psychological Bulletin*, **3**, 638–67.

Witten IB and Knudsen EI (2005). Why seeing is believing: merging auditory and visual worlds. *Neuron*, **48**, 489–96.

Wober M (1966). Sensotypes. *Journal of Social Psychology*, **70**, 181–9.

Wober M (1991). The sensotype hypothesis. In D Howes, ed. *The Varieties of Sensory Experience: A Sourcebook in the Anthropology of the Senses*, pp. 31–42. University of Toronto Press, Toronto.

Wolkomir R (1996). Decibel by decibel, reducing the din to a very dull roar. *Smithsonian Magazine*, **February**, 56–65.

Zampini M, Guest S, and Spence C (2003). The role of auditory cues in modulating the perception of electric toothbrushes. *Journal of Dental Research*, **82**, 929–32.

CHAPTER 5

AESTHETIC TOUCH

ROSALYN DRISCOLL

A YOUNG man leans forward and lightly touches his lips to a sculpture. This act is not a transgression but an exploration: the young man is blind, the sculpture is meant to be touched, and lips happen to be exquisitely sensitive.

Touching of any sort is taboo for most artworks in most museums. As a visual artist, I accepted this prohibition for my finished work. That is, until I began to think about ways to create access to my art for people with visual impairments. At the time I was making handmade paper, which is an immensely tactile process. Making books with the paper, I noticed that books have to be touched to be known. Could touch, I wondered, be a way for people with visual limitations to know art? There was no consensus on this question in 1990. I was forging into unknown territory. To make sculptures that would accommodate the touch of viewers required a radical reorientation, a retooling of my working process, the use of new materials, and research into tactile perception. I had to learn to think and make art through a new perceptual, expressive language.

In the process I discovered that touch is a way for *all of us* to know art. By making art that people of all abilities can touch consciously, I am developing a little-used aspect of the sense of touch. Most of the touching we do in our daily lives is manipulative, functional, and largely unconscious. *Aesthetic touch* is conscious, inquiring touch that explores forms, materials, and spaces for their qualities, their effects, and their meanings. It's like aesthetic looking, which we readily understand as a special application of sight—primarily for the arts, but also occasionally for ordinary objects and situations. Like aesthetic sight, aesthetic touch involves a departure from habitual recognition and functional use; attention to formal elements such as shape, space, and pattern; transformation of the object or situation into alternative structures, concepts, or meanings; and openness to the emotional implications of what we perceive. An enormous body of writing and thinking exists about aesthetic sight and how

it works. Very little is written or known about aesthetic touch. Although it resembles aesthetic sight in the ways just described, aesthetic touch differs in other ways, which enrich the aesthetic experience.

My understanding of aesthetic touch has come through several avenues: through the observations of people who had trained as visual artists before becoming blind, who were willing to share with me their experiences as they touched sculpture of all kinds; through the process of learning to make and exhibit my own tactile sculptures; and through documenting the accounts of people who touch my work, especially those who were blindfolded, a condition which reveals the possibilities and limitations of touch without the interference of sight. I have extended my research into reading about tactile perception and exploring the phenomenology of touch with neuroscientists, psychologists, engineers, art historians, curators, artists, anthropologists, and philosophers.

Although touch is increasingly being allowed and advocated in art museums for people who are blind or visually impaired, I would like to see touch move out of the ghetto of disability into the realm of possibility for everyone. Touch can be a satisfying, appropriate, even profound way for people of all abilities to know sculpture.

Our colloquial use of the word *touch* usually means contact with something by the skin, especially the hand. My use of the word is more expansive, encompassing kinesthesia, proprioception, balance, temperature, pain, and pleasure—indeed the whole body. The haptic sense (which includes movement and proprioception) is the oldest, most comprehensive and complex of the senses, with receptors embedded throughout the body from the skin down into the joints and muscles. Aesthetic touch draws from this deep well of sensory input to inform us about what we are touching as well as about the self who does the touching.

Touch is reciprocal, a two-way exchange. Every time I touch, I am also touched. I affect the world and the world affects me, unlike sight and hearing, which seem to

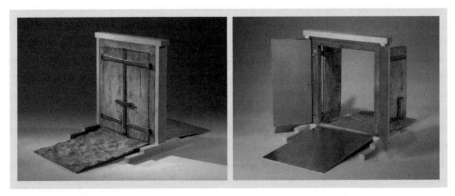

Fig. 5.1 Rosalyn Driscoll, *Limen*, 2008. Wood, copper, steel, resin.

(Photograph: David Stansbury.)

leave me relatively independent of what I perceive. Touching generates a feeling for the reality of things as well as my own reality. It conveys the qualities of things such as wood, sand, and steel at the same time that it reminds me I am softer than wood, firmer than sand, and warmer than steel.

Furthermore, all touching involves movement, which reveals the shapes, spaces, and textures I contact, but also generates kinesthetic sensations, giving me feedback about the location of my body and limbs and the shape, direction and qualities of my motions—fast, slow, jerky, smooth, or tense. The haptic sense fuses our perception of the world and our perception of our selves.

Our body images, which inform our sense of our selves, are not fixed once and for all, but are constantly changing and evolving. Somatic therapist Deane Juhan writes:

My sense of my own surface is very vague until I touch; the moment of contact, two simultaneous streams of information begin to flow: information about the object . . . and information about my body . . . We could even say that this role of the tactile senses in establishing a fuller and fuller sense of self is their primary function . . .

(Juhan 1987)

This sense of self emerges where the two streams converge. Remarkable congruence occurs between my body image and my sense of the world. Body and world shape one another. When I feel vulnerable, the world seems threatening. When meeting something balanced and still, like a statue of a Buddha, I discover in myself a feeling of stability and calm.

Perceptual psychologist David Katz asserts that touch alone, among the senses, can operate anywhere on the continuum between subjective and objective impressions. In perceptual terms, *subjective* means that the perceptual processes colour the percept; *objective* means that the percept seems independent of perceptual processes. The processes of seeing are typically too subtle, swift, and small to generate detectable sensations. This can make the object seem independent from us and from our perception of it. Touch, however, creates a more subjective impression by generating sensations we can easily feel—sensations that fuse with our impression of the object. When touching, we can attend to the object and its qualities, creating an objective impression; we can attend to the sensations, the subjective aspect; or we can move anywhere on the continuum between the two (Katz 1989).

Expanding on Katz's meaning of objective and subjective, both sight and touch provide us with the 'objective' qualities of an object, such as form, space, textures, temperature, mass, weight, and materials, informed by and suffused to varying degrees with the 'subjective' aspects of our response, such as sensations, emotions, memories, associations, and imagination. The difference between touching and looking in the context of art is subtle but compelling: touching provides more sensory feedback; it brings us back to our selves, reminding us that we are bodies exploring other bodies and selves exploring other selves.

Art is produced by the artist through a combination of inner and outer conditions, and experienced by the viewer as such a combination (whether through sight or

touch). The use of touch to explore art amplifies and intensifies our awareness of this complex interplay of self and object. The shared capacity of art and touch to fuse inner and outer conditions makes touch a deeply effective and affecting way to know art.

People who touch my sculptures often discover this. Knowing a work of art through touch, especially without sight (whether visually impaired or blindfolded), occurs in a slow, cumulative, sequential, physical process. Through touching, people gradually build for themselves a sense of the sculpture's structure, materials, spaces, and meanings. This creates the impression that they are forming the artwork through their physical actions and decisions. They speak of creating it like the artist does: 'I come closer to the artist's process in the studio; the artist touches all the time.'

Touching has an intentionality that differs from sight: one must reach out to touch, which requires a different level of commitment and engagement. Touching gives people a direct, intimate experience of an artwork. Touch has an authenticity and concreteness that gives people confidence in their perceptions. It cuts through physical and psychological distance and disarms the notion many people have that they don't know enough about art to enjoy it. As someone said, 'You just get to be. No expectations. You get to be and feel and there's no right or wrong'. The authority of their own perceptions becomes the grounds for understanding and meaning. Haptic knowing generates a feeling of ownership of the aesthetic experience and, by extension, of the artwork itself.

Sight tends to categorize and identify things seen. Touch is less effective and less used for that kind of summary information, tending to remain more fluid, adaptable, and mutable, without as much concern for consistency or conflict. This openness to evolving perceptual interpretations is ideal for the experience of art, which supports multiple, ambiguous readings and meanings. Because sight and touch may be used for different purposes according to the context, the use of both sight and touch for art enriches the sensory range and therefore the scope of meaning.

Those who explore a sculpture first by touching (by wearing a blindfold) and later by looking, often generate two different versions of the artwork: a haptic one and a visual one. A woman touching a sculpture while blindfolded thought she was in a forest with trees and moss; when she took off her blindfold she was astonished to see flat, rectilinear, bronze surfaces. When people experience multiple but distinctly different versions of a sculpture with touch and then with sight, they realize that the sensory mode determines the nature of what they perceive. This is a profound insight. We discover that what we see is not the whole story.

Knowing artworks only through a visual lens can distort or limit their meanings. The art critic Michael Brenson says of Giacometti's figures that to the eye they seem ravaged, but:

When you engage Giacometti's figures with your hands, it is apparent that they have every bit as much to do with tenderness as they do with violence. To hold their shoulders, backs and heads is to ease the violence committed by the eye.

(Brenson 1995)

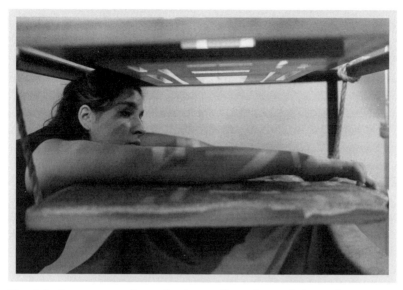

Fig. 5.2 A woman explores the inner dimensions of the sculpture
Elegy 5, 1996. Steel, stone, leather, rope, gauze.

(Photograph: Ellen Augarten.)

The tensions between tactile and visual impressions convey the complexity of an artwork. To encompass such contradictions by including touch in the aesthetic experience widens the available emotional territory and reminds us of the contradictions inherent in life.[1]

Touching grounds the aesthetic experience in the body—in muscle and bone, gut and heart. Touching is the body asking questions and finding answers. Aesthetic touch is not a bloodless, intellectual exercise but a somatic, sensory knowing by the body–mind. It provides a direct route to the heart and the viscera. The participation of the body in exploring art expands the possible sources of meaning. Bodily motions in themselves, in addition to their ability to convey shape, texture, spaces, and weight, carry aesthetic and emotional meaning, associations, and memories. We draw meaning from movements and spatial orientations as simple and profound as left and right, centre and periphery, horizontal and vertical, near and far, above and below, round and square. This is the language of the body: reach, rise, descend, slide, encircle, grip, tap, caress. These motions carry metaphoric and aesthetic meaning as well as somatic, perceptual meaning (Lakoff and Johnson 1980).

Every memory, psychologists suggest, is triggered by a cue. Gestures used in exploring an artwork may echo familiar motions such as planing wood, playing an instrument, caressing a lover. Contact, movement, and gesture generate a cascade of cues for one's memory that may be different than those generated by sight, enriching the associations and meanings of an artwork.

[1] See Francesca Bacci's essay 'Sculpture and Touch' in this volume (Chapter 7).

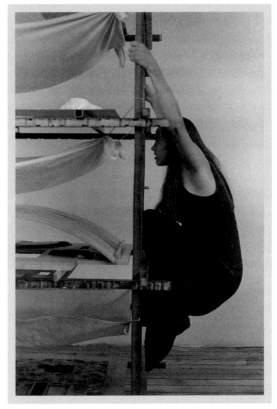

Fig. 5.3 Visitors are encouraged to investigate every aspect of this artwork by a ladder built into the side of the sculpture itself. *Troy*, 2001. Steel, copper, alabaster, wood, leather, cloth, stone, resin.

(Photograph: Ellen Augarten.)

The sense of touch necessarily implicates the whole body, since every gesture, even the motion of a hand, affects and is supported by the rest of the body. In the haptic experience of a sculpture, touch by one body part, such as the hand, can draw in the entire body. I can spontaneously project myself into my hand—as if my hand were standing in for my whole body. The sense of touch is less literal than sight; scale becomes more malleable. One woman said, 'My hand reached a place inside the sculpture where it didn't touch anything; everything dropped away and I was standing in a void, in the wind, on a mesa'.

When touching, space becomes palpable rather than empty.[2] The moving hand or body experiences itself moving, generating kinesthetic sensations even if there is no contact with a surface. Another woman said, 'I had a sense of space I have never

[2] Empty space can also be made visual. Examples range from the wooden models of space developed in the Renaissance to the sculpture *Ghost* (1990) by Rachel Whiteread, which is a cast of the inside of a room.

experienced before because it was not made finite and given limits by visual measurement'. Touching one of David Smith's *Cubi*—tilted, stacked metal cubes—I was more attracted to the triangular spaces between the cubes than to the cubes themselves. These spaces may have been negative to my eye but they were positive to my hand; I found them interesting in their shape and size, fitting around my hand. The visual categories of positive and negative prove to be less useful in haptics. The visual categories of figure and ground also assume different meanings for the sense of touch; they become more interchangeable, mobile, transient. Whatever I am touching is figure to my inquiring hand; everything I have already touched becomes ground to that figure. Seeing seeks to identify and categorize an image and its parts, to create hierarchies of salience, form, space, and colour. Haptic knowing is more horizontal, non-hierarchical, and democratic. It produces a more fluid, changing, evolving, open-ended sense of an artwork, supporting the transient nature of reality and the multivalent nature of art.

This fluidity includes our neurological relationship with a sculpture. We now know that the brain is not only constantly mapping our bodies, but is also mapping the space around us, including things near us or that we are touching. So when I touch a sculpture, as far as my nervous system is concerned it becomes part of my map of my body. I enter its space and it enters mine, so that the boundary between inside and outside quite literally dissolves (Blakeslee and Blakeslee 2007).

At times the skin's function as a boundary reasserts itself. Because touch is so critical to survival, we are quick to detect risk in touching even a sculpture. Touch can evoke a sense of vulnerability and danger as well as intimacy and affection. Its closeness to visceral feelings and to emotions, which are bodily sensations too, makes touching a more likely trigger for emotions. As one person said, 'This experience is very fundamental, basic, primitive, more direct than intellectual experiences and therefore stronger'. Touching often raises memories of childhood, or evokes a sense of play, because as children we openly explore the world through touch and movement. As we grow up, conscious, exploratory touch becomes socially prescribed and often limited to sex, making it easy to confuse sensuous and sexual. These unconscious connections to danger, vulnerability, emotion, childhood, play, and sexuality make haptic experience of art especially powerful. Add the taboo against touching art, and you have the potential for a highly charged encounter. Deep, unconscious currents run through even the most cursory of touches.

Haptic experience of art is powerful at another, even less conscious level. Sensory and motor functions normally operate below the level of awareness. Most of our daily haptic experience remains unconscious. When we bring touch into conscious awareness and even into the realm of aesthetics and meaning, as we do in touching sculpture, we join lower and higher functions of the brain, generating a more integrative, holistic experience.

The unconscious aspect of haptics is operating when we encounter the vast number of artworks that are not touchable. The connection between inner and outer realms that is true of the haptic experience of art also holds in the visual encounter with art. Haptic perception underlies and informs visual perception, both developmentally

and experientially, throughout our lives. Even when we are only looking, tactile perception is subliminally implicated in the appreciation of art. When we look at a sculpture, we draw on our haptic memories of textures, forms, spaces, motion, and materials to inform our understanding of what we see. We engage haptically when seeing by projecting ourselves into an artwork, by identifying with elements in it, and by attributing movement to what is static. We imagine ourselves interacting with the artwork or with the forces represented in it. We imagine ourselves *being* the forces or the figures in an artwork. We inhabit landscapes, rooms, fields of colour—whether in a painting, a sculpture, a photograph, or a building. At a subtle muscular, proprioceptive level, we feel in our bodies the attitudes and tensions within an artwork, subliminally mimicking those forces. We feel in ourselves—and therefore know—the thrust of a figure's gesture, the arc of a brushstroke, the expansiveness of a space.

Because we are multisensory beings, our senses inform and integrate with each other. Haptic experience enriches and enhances visual perception. We can learn to see more deeply by engaging in haptic exploration. Touching sculpture embodies and amplifies our visual tendencies to identify with, project into, and energize sculpture. This merging and blending of self and sculpture, whether through actual or imagined touch, gives us the experience of entering another reality, a shared space that enlarges our sense of ourselves and the world. This complex response of body and mind is nothing less than empathy. And empathy is both the seed and the fruit of art.

References

Brenson M (1995). Memory of the Hand. *Sculpture*, **14**(3).

Blakeslee S and Blakeslee M (2007). *The Body Has a Mind of its Own*. Random House, New York.

Juhan D (1987). *Job's Body: A Handbook for Bodywork*. Station Hill Press, Barrytown, NY.

Katz D, ed. (1989). *The World of Touch* (LE Krueger trans.). Lawrence Erlbaum Associates, Hillsdale, NJ.

Lakoff G and Johnson M (1980). *Metaphors We Live By*. University of Chicago Press, Chicago, IL.

CHAPTER 6

RENDERING THE SENSORY WORLD SEMANTIC

ELIO FRANZINI

The meaning of art can be revealed in many ways. One can carry out a historical, critical, iconological, or iconographic analysis. One can analyse forms and styles. Here we try a different way, in which the meaning of art is defined by reflecting on the nature of visibility and of the senses, on the model of knowledge itself, as it has developed in Western civilization. Here we examine art as a reality that can be seen and sensed. It is translated into images and figures, without being exhausted by those representations. In fact, art always alludes to its original invisibility, which belongs to the nature of all things, ill-represented by words and that images can allow us to grasp intuitively.

The knowledge that is within images cannot be fully understood through a classicist paradigm, but rather by unearthing their symbolic value. In art one grasps a symbolic idea of form, which mediates between visible and invisible. In sum, art is not reduced to an imitation of reality: the artistic form is not a mimetic image. It is rather the symbolic and expressive meaning of a sensory reality, which has our body—that is also a sensory reality—at its very centre.

Art is space, it is time that we can touch and see—but it is irreducible to the act of seeing and touching. The senses are essential to our understanding of form, but paradoxically the sensory form stands beyond what our senses can apprehend. From Diderot to Lessing, Winckelmann, Baumgarten, Kant and Herder through the phenomenological tradition, we will show how the sense of the body and that of art interact. Not only do they contribute to an abstract idea of form, they also enrich each other

through exchanges of meanings which unfold, in their figural expression, into the historical reality of artworks.

Aesthetics and logic

Aesthetics is, from the point of view of its etymological meaning, the 'theory of sensitivity'. Historically it turned toward the study of the *sensibilia* and of the acts of perception, of imagination and of memory. Among the *sensibilia* that offer themselves to be apprehended by subjects and cultural communities, some objects of symbolic value have taken on a special role: artworks. It is not possible to build a unified canon of art that is universally accepted as valid. For example, writing can be considered as an image that, through signs, carries some representational content; in contrast the reproduction of visible things offers immediately the reality of what's represented through a direct image. Nonetheless there is a basic difference that marks the relationship between the different areas of knowledge: things that are sensible—that one can see, touch, and hear with their specific qualities that elicit emotions, passions, pleasure and sorrow— have a different relationship with the image represented than those of the realm of thoughts. Knowledge is the link between these two processes and much of philosophy can be viewed in terms of the history of attempts to find connections of knowledge between thinking and sensing, which are situated at the origins of *aesthetics* and *logic*.

Obviously, logic and aesthetics cannot be entirely separated. The epistemological problem of how we acquire knowledge assumes their connection, even if in different ways. But if we consider aesthetics, which is the study of the different aspects of sensing such as feelings and sensations, not as merely preliminary to the science of thinking, but as an autonomous territory inaugurating a specific forefront of knowledge, then their relationship can be reconsidered in search for a, perhaps paradoxical, *aesthetic world logos*.[1] If, as Aristotle teaches, there cannot be a science of particulars but only of universals, then the aesthetic judgement, which refers to single things falling under our senses in a contingent way, will not be able to offer absolute knowledge: its images will have to be mediated through a categorical synthesis, i.e. every single object will have to find its place into a system of objects. Imagination, or representation, involves two moments: the passive given image and its active conceptual processing. The first operation pertains to the world of sensation (*aesthetics*), the second to the world of thought (*logic*). Representation, even if it has to encompass sensation, *aisthesis*, finds its truth and its universality only in the *logos*, in its translation into categorical and conceptual terms.

[1] The search for a 'logos of the aesthetic world' is a characteristic of Edmund Husserl's phenomenology.

There is no doubt that the Aristotelian model, summarized for centuries in the expression (from the *De anima*) 'nothing is in the intellect that was not first in the senses', has been influential on subsequent thought. The double status of the image gives the priority of immediacy to aesthetics and to its sensory rapport with the particulars of the world, but it gives to logic the possibility to reach knowledge with certainty. It is not our intention here to discuss Aristotle's view, but only to presume that the Aristotelian distinction between *aistheta* and *noeta*, between sensory things and intellectual things, between sensory images and logical figures (from which we started), may leave space for a series of questions from which aesthetics has developed in the multiplicity of its views.

For example, in Leonardo's thoughts one finds two different directions that appear to continue, on several levels and in a more pragmatic way, the debate on the nature of the image and of the representation that started in classic Greek philosophy. Besides the common idea in sixteenth-century treatises that painting is a 'high' mimesis of the real that is geared towards an ideal dimension, there is also an insistence that this noble imitation continues the metaphorical tradition started by Gregory the Great and by the Carolingian books. In fact, Leon Battista Alberti writes that the first task of a painter is to represent a 'history', but to give to it an 'ideal' meaning. Leonardo adds one element to these theories: painting is superior over all the other arts, including even poetry, since the sense of sight is superior to all other senses. Leonardo, 'overcoming the monotonous unanimity of the critics regarding the harmonious sisterhood of poetry and painting, manifests the vivifying belief that, rather than twins, these arts are totally different in many respects' (Lee 1974, p. 96). This debate, as we have seen, is not at all new and will have wide consequences, of which we will analyse here some historical and theoretical aspects.

The superiority of the sense of sight is affirmed not for physiological, mystical or theological reasons, but for its characteristic of being a 'mental eye' having the ability to summarise and formulate aesthetic judgements. It is obvious that the first goal of Leonardo is to locate painting among the liberal arts, but there is also the aim to under-line the intrinsic judgemental potential of vision. Pictorial representations are truly judgements because, differently from poetry, they pose an immediate relationship with the pictured objects. Painting is superior to poetry for its larger communicability. Moreover, painting owes such a superiority to the fact that it manages to be a life-like interpretation of nature through figures, which are visible data of immediate visual apperception. This is how Leonardo unhinges the classicist paradigm: it is not true that poetry and painting are sister arts and that their rules are equally effective in reaching a perfect formal measure. Painting is superior because it goes to the qualita-tive root of things themselves. It is the presence of a technical capability to construct that makes painting superior to poetry: unlike the latter, painting does not register just the names of things, but also the universality itself of their shapes—a form which is visible, as according to Leonardo the eye is the organ that gives shape. Leonardo's attack on classicism will be resumed by some eighteenth-century authors: some echoes of the idea that pictorial art may be an expressive and aesthetic/imaginative interpreta-tion of nature are found in Bacon, Vico, or Diderot. There is a claim that art interprets

nature by and thus makes visible what would otherwise remain hidden. In summary, the classicist tradition holds that painting and poetry are sister arts. Nonetheless, according to classicism, painting finds its completion in the word: as the Carolingian held, it is the word that can best come close to the purity and immediacy of truth. Painting is, by nature and unavoidably, something material. In the post-Renaissance art systems, painting does not always manage to maintain its equivalence with poetry. In other words, the symbolic layer is increasingly occupied by the word, leaving analogy and metaphor—considered rhetorical forms of inferior epistemological value—to the image. The symbol's power of allusion, made manifest in poetry, establishes its superiority over the metaphorical materiality of painting, unless the latter can subjugate itself to a 'manner'—to the rules of perfection, of iconicity and immutability that characterize poetry.

Even if these are the dominant views, they are not the only ones and, as demonstrated by Leonardo, they will not rule the century uncontested. Beyond its historical limits, classicism is simply that view that tends, in a Platonic way, to bring the image back to the *logos*, and the seeing to the *eidos*, temporarily blocking the aesthetic and material layer. The image is thus limited to performing only a 'minor' task, which tends to limit it to narration, denying the possibility of switching from the metaphor to the symbol, which is so characteristic of the iconic painting. In order to make painting take on that role of symbolic mediation—as a symbol of thought itself—that the Nicaean had attributed to it, it is necessary to exit from classicist paradigms in order to recover the formative sense of the image, as a certain thought that goes through the body's sensitivity and holds the power to render the sensory world semantic, through a gesture of *poiesis*.

Vision and touch

To this purpose, we shall now trace the main stages of the debate regarding the nature of visibility that may seem to pertain only to figurative arts, but that instead provide the occasion to show in an emblematic way how knowledge is not limited to a logic-discursive, abstract and formal, representation. What emerges in this debate is the key idea that sensory and visible reality, which is translated into images and figures, always alludes to an originary *invisibility*, embedded in the nature of things, that cannot be reduced to the word and can be shown only through the images themselves.

The 'knowledge' in images is graspable only by breaking free from a classicist paradigm controlled by rules and by reinstating a *symbolic idea of form*. This symbolic idea of form has the visible and the invisible always simultaneously present (and mediated): not more than the word, but in a different way. The artistic 'form' is not a mimetic image, but it is, as Kant will say, an aesthetic idea not reducible to the word. To see and to touch (as Herder will maintain: see Herder 1994) what is beyond

the sensory world allows us to place art in a symbolic rapport with the aesthetic dimension of space and of time. At the same time, just as there is no single concept of 'art' or 'theory of art', there is no single concept of aesthetics. Moreover, the link between the field of *aisthesis* (and of *aestheta*) and artistic objects has not always been considered. Diderot, for one, talks about these links, but it is only in the wake of the Leibnitz-Wolff school of thought that this discourse can find some systematic premises. It was Lessing[2], who knew the writings of Winckelmann and Baumgarten, who explicitly theorized them, since he differentiated among figurative and poetic arts through the aesthetic-intuitive dimensions of space and time. In this context, the specificity of figurative art, which is deployed in space and escapes the temporal dimension of action, is given to the body that is exhibited in it. The way of exhibiting bodies is, in aesthetic terms, visibility. According to Lessing, it is visibility that dictates the rules of painting.

At the same time, it would be inappropriate and not justifiable by Lessing's *Laocoon* to hold that the founding role of visibility implies the rejection of the sense of touch. Highlighting the visible value of aesthetics in figurative arts has another goal, i.e. denying (or, even better, giving new meaning to) the link between painting and the *invisible*. Beauty, traditionally linked with seeing, has become a way to address form that only an artform meant for bodies can satisfy. This formulation rejects the complexity of ugliness. In order to be accepted, this complexity needs a futher aesthetic dimension, and that is the temporal dimension that is characteristic of poetic art. From this one can deduce that, for Lessing, modernity and all its layers of representational rapports can find in poetry a more adequate and complete expressive form. This also entails, as the following generations will confirm, that a form of aesthetics having its main reference point in the empathic connection between visibility and beauty is profoundly limited. Obviously it is not just Lessing, in the second half of the eighteenth century, who let go of the corporeal visibility of beauty. It is a phenomenon that happens wherever one questions the tradition of a rhetorical classicism, born in France in the wake of Boileau, which garnered so much success in different parts of Europe due to all its academic inheritances. Therefore, even the specific attention that Lessing devotes to 'visibility' need not be interpreted as a refusal of other aesthetic dimensions in order to grasp the beauty of bodies, but only as an adoption of the models of visibility that, since the Renaissance, associated the corporeal and natural qualities of beautiful forms with the act of seeing.

Instead, we need to consider as similar to Lessing those authors who explicitly address tactility. The consideration of tactility can be viewed as the sign of a critical attitude towards the 'closed' and 'regulated' concept of an artistic beauty is unable to grasp its sensory meaning, its aesthetic origin. On the contrary, touch emphasizes this origin, even without opposing visibility, but rather supplying further possibilities to perceive beauty. Generally speaking (in philosophical terms), this is testified by the role that Condillac outlines for touch in his *Treatise of sensations*. He associates touch

[2] See G.E. Lessing (1729–1781), *Laocoon* (1766). This text continues the debate on this marble sculptural group. Its theme is told even in Virgil's *Aeneid*. This discussion was continued also by Goethe and Winckelmann.

with sight as a sensation fundamental for knowledge, and defining it as a 'philosophical and profound' organ.[3] This idea is, at a different level, confirmed by Berkeley and, more generally, in English eighteenth century culture, within which Burke's *On the Sublime and Beautiful* (the 'manifesto' of artistic anti-classicism in this period) plays a fundamental role. In the context of a sensory vision of the aesthetic categories (both 'beautiful' and 'sublime'), it gives to tactility a special attention, explicitly paired up with sight in its ability to relate itself to form and to the formless.

There is a passage in which Burke specifies that the description of beauty starting from sight could also be illustrated through touch, which produces a 'similar effect' (Burke 1992, p. 136): it provokes 'the same kind of pleasure' and demonstrates how there is 'a link between all of our sensations', which 'are nothing but different types of impressions' provoked by different kinds of objects, but 'all in the same way' (Burke 1992, pp. 136–7). Moreover, not only does Burke go so far as to present the famous paradox through which he formulates the hypothesis of an enjoyment of colours through touch, but also, and more importantly, he designs his entire aesthetic theory of beauty around sensory qualities that are mainly tactile. In fact, the variability of bodies (which is a crucial element for a non-classicist and non-model-ruled concept of beauty) can be best 'grasped' through touch. His definition of beauty, notoriously sensual and feminine, is totally tactile, since pleasure—the same phenomenon that, when brought into the sensory world, grants the continuation of species—is not linked to geometric objects but rather to 'soft, smooth, sensual bodies', to 'beautiful' bodies, evidently associated with femininity. In sum, touch is the true sense of beauty, the one that defines its kind of pleasure and also, through sex, its social usefulness, since 'touch receives pleasure from softness, which is not originarily an object for sight' (Burke 1992, pp. 136-7). Where there is 'form' (more in the beautiful than in the sublime), touch is absolutely necessary because it allows an empathic rapport with the object, thus causing a 'relaxation' of bodies. Still, even the opacity of the sublime and the formlessness that comes with it can get excited by the tactile powers, where 'rough and sharp bodies' cause an 'impression of pain', 'which consists of a violent tension or a contraction of the muscle fibres'. In conclusion, touch has a precise aesthetic role in the beautiful and in the sublime and, particularly for the beautiful, it is the primary cause of that pleasure that defines its form and function. It reveals itself as an 'aesthetic' organ because it does not grasp the *unity* of bodies, but rather, against every form of classicism, the *variety*, which is necessary to beauty (Burke 1992, pp. 162-3).

When Herder, in his essay on sculpture, *Sculpture*, (1994, originally published in German in 1778), seems to attribute a special role to tactility, he is simply continuing the eighteenth-century tradition. This is confirmed, in the first place, by his cultural references who, other than the members of Wolff's school, are Condillac, Diderot, Burke (and with him all of English empiricism), Winckelmann and Lessing. Herder's underlining of the 'antique' and 'past' aspects of figurative art, and of sculpture in particular, was already present in Lessing and, perhaps, could be deduced from

[3] Etienne Bonnot de Condillac (1715–1780) wrote his *Treatise of Sensations*, inspired by Anglo-Saxon philosophy, in 1754. As a consequence, he was accused of materialism.

Winckelmann. The true novelty of the Herderian discourse is elsewhere, in the explicit link between 'touch' and 'sculpture'—even if this is not completely new, if one considers the treatises or iconography of the Renaissance—almost as if this art may come to represent the axiological reference of the aesthetic-corporeal sense, and re-define the debate between the visible and the invisible, which, until that moment, had involved only painting and poetry, image and *logos*.

The alternating fortune of tactility within the sixteenth-century debate on the *Paragone* between the arts had been surpassed in the eighteenth century or, at least, brought within the context of knowledge. But never before Herder had anyone theorized the link with sculpture in a context meant to specify an organic system of the arts (in the wake of Lessing and on aesthetic-intuitive bases, and not on rhetorical bases). In fact Herder, in an advance that is full of consequences, argues that tactility confronts us with the third dimension, with that spatial characteristic that identifies the aesthetics of sculpture: the haptic moment, as Riegl will call it.[4] Even if this moment was forgotten by his contemporaries and by the next generation, it is the starting point of a path that, through Lipps or Fiedler, leads to multiple theorizations on the relationship between touch and sculpture, which has been characteristic of the critical reflection of the twentieth century.

Herder is at the origin of a problem that, even if present and made possible in the aesthetic-philosophical thought of the eighteenth century, leads far from its premises: the aesthetic-artistic collaboration between visual and tactile that the eighteenth century theorized is here cast in doubt, with a resulting backlash against the general definition of the idea of artistic form. Herder maintains, at the beginning of *sculpture* that 'sight shows only figures, while touch only bodies: everything that is shape can be recognized only through the sense of touch, while through sight only surface, and not even of bodies, but only the surface exposed to light' (Herder 1994, p. 41). One needs to doubt not only that (as Lessing said) all figurative arts may be arts pertaining to the body, but also that 'form' may be apprehended through sight. The 'body' (i.e. the object that is present in space through its three dimensions) can be represented only by sculpture, while painting will have to make do with the figure. But the 'body' of sculpture is such because it is in tactile contact with *our* body, that is to say, with a body that can really make one 'feel' the form, its 'impenetrability, hardness, softness, smoothness, form, figure, roundness'—and here one can see the general epistemological concept that underlies the Herderian discourse. One need not compare and contrast touch and vision, but rather comprehend that only when taken together can they lead to *judgement*. As a consequence, those artforms where touch guides sight, i.e. sculpture, will have such an epistemological centrality as to be able to give, alone, the 'form' of things. In Herder, therefore, the canonical eighteenth-century reasons for the epistemological association between the two senses are utilized

[4] In 1901 Alois Riegl published an important text, *Late Roman art industry*, in which he discussed the artistic forms related to the optic and to the tactile. The principle of the 'will of art' (*Kunstwollen*) drives his thinking and it is very strictly linked to the historical relativity of the several ways of the phenomenology of vision.

both to distinguish between the respective arts and to differentiate their epistemological roles.

In addition to having an intrinsic phenomenological validity (in the proper sense of the word, since he explicitly alludes to Lambert: Herder 1994, p. 45), the Herderian distinction also explains the double level on which the topic of touch needs to be understood. On the one hand, by continuing the anti-classicist traditions of the eighteenth century and the debate on *Paragone* between the arts and their interpretative potential, Herder argues against the epistemological centrality of sight by adding to it the necessary and complementary role of touch. On the other hand, though, he highlights the rapport between sight and touch to further a philosophical discourse on the arts which implicitly challenges the eighteenth-century 'systems of the arts'. According to Herder, these systems are built only on hearing and sight: to these senses one now needs to add touch, since it does not limit itself to perceiving what is 'outside' of it (sight), and does not only put one object 'next' to the other, but can perceive them 'one in the other', thus offering not only surfaces or sounds but also forms.

If, implicitly referring to Alberti, painting is *tabula* and proceeds with a clear reference to rhetoric (in fact, Herder maintains that it always has to come back to invention and disposition, that is to say, to the two fundamental parts of the construction of the discourse), sculpture is a spatio-temporal form (he writes 'it is here and it lasts'), it is the existence of the corporeal presence of life itself, which aspires to aesthetically present 'the soul of the body' (Herder 1994, p. 50).[5]

What we have is not a dichotomy between 'sight' and 'touch', but rather, to better understand the superior formal completeness of the latter corporeal sense, a partition between the respective artistic correlates, i.e. between painting and sculpture. The first is 'dream' and 'enchantment', while the second, by contrast, is truth and presentation (*Darstellung*); the first is rhetorical or 'novel', the second a living presence. Sight, by itself, is only 'the hand's reason', while 'only the hand gives forms, concepts of what the forms mean, of what lives in them' (Herder 1994, p. 67). Moreover, following Burke, if the hand prefers a rounded and sensual form, sculpture does not limit itself to it, to the beauty, but rather it tends toward the sublime which demands reverence. This is the paradox of a sublime form that 'creates its light' and 'creates its own space': exhibition of infinity that demonstrates the infinite nature of artistic form, its ability to build a space that, in order to be complete, needs the other intuitive form, i.e. time. This time is not linear and narrative but is that of a hand that actively moves across the surface of the matter through touch, going beyond the limits of visibility and pronounceability. One can thus grasp the epistemological possibilities of art starting from an originary aesthetic act that pursues the pre-categorical through a spatio-temporal present form. In fact, Herder writes, even bypassing the issue of sculpture, what the hands touches 'seems bigger than what the eye sees in a flash as fast as lightning', and is thus appropriate for the sublime (Herder 1994, p. 98).

[5] Adolf von Hildebrand (1847–1921) is, as is Fiedler, one of the 'fathers' of the so-called pure visibility movement. In 1893 he wrote a book, titled *The problem of shape*, which influenced greatly the following generation of thinkers, particularly Riegl and Worringer.

Touch indicates the aesthetic tension that is in the form, in the sublime aim of art, in the form's endeavour to be not only a representation, but also a figure: 'the hand never touches completely, it cannot grasp any shape in one go, aside from the sphere, which is the shape of quiet and of perfection resolved in itself' (Herder 1994, p. 99). Touch is, in art, a sensory way to feel infinity, the sublime, without totally constraining it in the illusory finitude of the visible representation. Sculpture is, for touch, at the same time unitary and indefinite, present and overcoming its finitude: 'the sculptor stands in the darkness of the night and goes searching for gods' figures' (Herder 1994, p. 99). It is form, but not reducible to allegory or to abstaction, because it is never entirely given to one single form, keeping its opacity as an invitation to deepen, time and again, the formal temporality of space.

Herder's conclusions on tactility and sculpture find their first justification, as already mentioned, in eighteenth-century culture. Nonetheless, on the bases of these 'contextual' premises, they raise a more general problem. In fact, starting from this point, one can question why touch should embody the sublime opacity of art, the ability to grasp infinity in a form, the same ability that allows us to overcome a conception of art as a mimetic and repetitive illusion (connecting back to the *fil rouge* of the interpretative theories of art which started in the Italian Renaissance). The consequences of these issues have been numerous, particularly in art criticism of the nineteenth and twentieth centuries. Some led towards the detemination of a specific 'value' connected to tactility, be it touching with the eyes (Hildebrand[5]), the gothic-barbaric haptics of Riegl and Worringer[6] or the 'tactile values' of Berenson.[7] Others have affirmed that these art theories are not sufficient to solve the 'aesthetic problems' (epistemological and philosophical) that Herder brings in (Merleau-Ponty 1979).[8] The problem, in fact, is why it should be touch that indicates the limits of representation. Historically speaking, one can maintain that this happens because Herder is within a discourse where the link between tactility and sculpture aims to show that sublimity of art which is unknown to the classicism of the 'sister arts'.

The Herderian position can be described as an attempt to raise to the sublime, via touch, the Lessingian system of art. Instead, one can hypothesize that through Herder one can approach other questions which bring back the classical debates in aesthetics between visible and invisible. On the one hand, touch is the sense that escapes isolation and opens to the totality of the aesthetic experience. It is an *embodied* perception, which goes beyond the clarity of 'visibility' to include also the hidden power behind the apparent transparency of the representation. Touch indicates the

[6] Wilhelm Worringer (1881–1965) was indebted to Lipps for the notion of 'empathy', and to the theories of Riegl and Hildebrand. He is known mainly for his dissertation, published in 1907 with the title *Abstraction and empathy*. This work gave impulse to the artistic theories of artists such as Marc, Klee, and Kandinsky.

[7] In 1896 Bernhard Berenson published a study on Renaissance Italian painting, in which he develops the theme of 'tactile values'. He maintained that one cannot gather a precise sense of the third dimension through sight alone.

[8] Maurice Merleau-Ponty (1908–1961) is the main protagonist of phenomenology in France.

possibility of reaping the hidden aspects of form, the invisible, the 'unfinished' that, since the time of Leonardo, has been the best response to the exclusively narrative, metaphorical or rhetorical view of art. In this way, one can affirm that touch is an ulterior method of opening the symbolic dimension of art, which is precluded—as Diderot taught—by its reduction to language or to only one of the senses. Touch is, instead, bound to the ambiguity of a bodily gesture: for Herder, touch was irreconcilable with any form of allegory or rhetoric.

MERLEAU-PONTY AND THE 'TOTAL EXPERIENCE'

Herder's arguments or, perhaps more generally the entire *Settecento* in its anti-classicist mode, find their theoretical reference outside art criticism (which, indeed, was perhaps not their intended destination) and therefore outside any particular axiology of the various arts or any scientific, physiological claim about the capacity of the different senses. It is, in fact, in contemporary thought regarding aesthetics and art that one finds links to the questions raised by Herder. The first and most evident path leads to Merleau-Ponty, for whom painting has the task of offering a 'visible existence' to what 'the profane vision believes to be invisible', in such a way that the 'muscular sense' is not needed to perceive the 'voluminous nature of the world'. Doubtlessly, for Merleau-Ponty, the eye and visibility were of supreme value, in that painting 'even when destined for other purposes always celebrates the enigma of visibility'. However, visibility, the eye itself, is occupied with more than mere 'visual data': it is the intention, truly platonic, to seek the Being, its 'traces', that transforms vision into a 'mirror or concentration of the universe', a 'metamorphosis of Being in the vision of the painter' (Merleau-Ponty 1979, p. 211). The centrality of the gaze, therefore, is not to the detriment of touch but rather focuses our attention not on the physiological, but rather on the ontological nature of perception: returning to the theme imposed by Herder. Thus, when Merleau-Ponty writes about the eye and visibility, he shows how painting is an 'interrogation' of the invisible through the visible: but this interrogation always begins with a unitary body, with the 'delirious and secret genesis of the aspects of our body'. Vision and the eye, privileged because paintings refer to the act of seeing, are metaphors for a corporeal access to the hidden truth of Being. Additional evidence for this idea comes from Merleau-Ponty's suspicion of the optical-physical systems of vision, in particular perspective theories of vision.

Metaphors transport us beyond the 'illusionism' of vision, back to the 'metaphysical' significance of painting: to an invisible Being made of contingencies, reversibility, of living and lived bodies. Consequently painting is not complete either in the visual or in touch's unveiling: it is not 'adding a dimension to the two dimensions of the canvas' but, instead, echoing Nicea, it supersedes entirely the consideration

of painting as a pure and simple representation. As Herder had argued for sculpture, the work is more than an object in space, rather an object that constructs its own space. According to Merleau-Ponty, in this space 'it is the painter that is born in these things, in a sort of concentration and returning to self of the visible' (Merleau-Ponty 1979, p. 228-9).

To argue that in painting 'vision is the encounter of all the aspects of Being like at a crossroads' (Merleau-Ponty 1979, p.236) gives rise to a body that is not just the eye but a combination of tactile and visual, a protagonist in an 'integral experience in which it is impossible to measure the contribution of each sense' (Merleau-Ponty 1968, p. 174). The centrality of this 'embodied synthesis' is undeniable in the phenomenology of perception and is not contradicted by the privileging of the act of 'seeing', from the moment that tactile data, even if often left out of 'scientific' consideration of perception, are integrated into a total experience in which the separation is not ultimately discernible.

The search for this 'total experience' that transports Merleau-Ponty to ontology and the ontological sense of painting, is distant from an analysis of the objective specificity of the work, of the 'canvas' as a perceived object. But this total reality remains embodied, and the specificity of the sense or senses involved in the act of perception is always within a communicative context in which 'synaesthetic perception is the rule'. If this rule is not consciously explicit it is due to the 'cultural' intervention which Husserl called 'modern objectivism' and which he traced back to Galileo and Descartes. Scientific knowledge, according to Merleau-Ponty, has removed the experience of sensing: 'we are unaware of it only because scientific knowledge shifts the centre of gravity of experience, so that we have unlearned to see, hear and generally speaking feel in order to deduce, from our bodily organization and the world as the physicist conceives it, what we are able to see, hear and feel'. It is, instead, the communication between the senses that opens up the 'structure of things', in the conviction that 'the form of objects is not in their geometric shape: it stands in a certain relation to their specific nature and appeals to all our other senses as well as sight' (Merleau-Ponty 1968, p. 308).

We can then conclude that the 'form' of objects is inseparable from the 'total experience' of our embodied senses: our perception is the capacity to unite all of our sensory experiences into a 'single world'. This world differs from the one described by science. Instead, it is nearer to the way in which our binocular vision perceives a single object, where it is not the 'epistemological subject' that synthesizes but 'the body, which when it escapes from dispersion, pulls itself together and tends by all means in its power toward one single goal'.

We could continue with these citations from Merleau-Ponty, bringing us to the 'precategorical' sense that he attributes to our *body schema* , an aspect that has been ignored by the intellectualism against which he has always battled. However, these citations would bring us back to the central point: the unity of the senses, that 'fil rouge', which, as in the anti-classicist views of the *settecento* (from Burke to Herder) is defined as an opposition to a purely 'intellectual' form (and formation). Like Herder, Merleau-Ponty wants to go beyond a purely 'scientific' conception of

the body and form. He describes a dynamic 'common sense' in which the senses 'translate among themselves without needing an interpreter', without passing 'through the idea'. These observations, writes Merleau-Ponty, permit us to give full sense to the expression of Herder: 'Man is a perpetual common sense, which now is touched from one part and then touched by another.' This citation from Herder shows that, beyond the differences in historical contexts, the road is the same: via touch one reaches the totality of embodied experience to establish (with the aid of a phenomenological stance) that with the notion of the body schema 'it is not only the unity of the body that is described in a new way, but also through this, the unity of the senses and the unity of the object' (Merleau-Ponty 1968, p. 314). In this, 'the unity and identity of the tactile phenomenon do not come about through any synthesis of recognition in the concept, they are founded upon the unity and identity of the body as a synergic totality.' Thus, tactile experience is always a meeting between the organic totality and the embodied experience.

DELEUZE AND THE CRUEL BODY

One might then ask, at this point, what is the relationship between common sense and the aesthetic quality of being and object that defines the artwork. If, for Merleau-Ponty, in painting it is the Being which manifests its significance, it is perhaps necessary to ask what role might be reserved for the specific experience of the artistic object as a spatio-temporal aesthetic reality, with its capacity to bring forth precise thoughts. This is one of the central themes of contemporary aesthetic thought, which harkens back to the relationship between symbol and metaphor, between visible image and invisible meaning, and which seems to be a fundamental axis of the entire history of aesthetics. For Merleau-Ponty, painting is the figural expression of an ontological form that has its primary reference (genetic and interpretive) in the organic totality of the body and its actions. In contrast Gilles Deleuze, despite being included in a tradition that is outlined and rooted in a tactile vision of art, challenges any interpretation which ignores the cognitive sense of art. In his book *Francis Bacon: The Logic of Sensation* there are evident influences deriving from the phenomenological tradition, particularly Merleau-Ponty: the originality of the corporeal sensation, the centrality of the figure, the need to supersede the false dilemma between figurative and non-figurative, the hermeneutic role of Cézanne, and the suspicion towards an illustrative or narrative conception of the pictorial are all signs of this legacy. But here one also finds a new consideration of the relationship between sensation and figure, placed in an unintentional context, in which 'the figure is the sensible form related to a sensation'; 'it acts immediately upon the nervous system, which is made of flesh'. The reference to the flesh and to sensation is explicitly connected to a phenomenological (Heideggerian) Being-in-the-World, in virtue of which 'I *become* in the sensation and something happens through the

sensation, one through the other, one in the other' (Deleuze 2005, p. 85). But this encounter brings neither an intentional and descriptive stance nor an ontology. In fact, for Deleuze, the figure—the form attributed to the sensation—'is the opposite of the form related to an object'. This challenges the singular, global unity of Merleau-Ponty (the 'body synthesis') and instead brings us to *fragmentation*: to a sensation made up of multiple instincts, levels and intensities that lacks a defined centre.

For Deleuze, painting, particularly that of Cézanne, excludes the idea, often found in the preceding pages, of an ontological base. Rather, he argues, a unity based on a lived body is 'a paltry thing in comparison with a more profound and almost unlivable Power'. The unity of the bodily rhythm can be found only where 'the rhythm itself plunges into chaos, into the night, at the point where the differences of level are perpetually and violently mixed' (Deleuze 2005, p. 103). He makes reference, here, to the 'body without organs' of Artaud, which has only 'zones and levels' where sensation is the amplitude of waves, a 'hysterical' body facing the artwork's presence, beneath and beyond the representation.

In fact, this dark body, hysteric and cruel, has eyes everywhere and refuses to develop the temporal and formal moment of the organic encounter with the Being. The invisible forces which, according to a phrase by Klee also used by Merleau-Ponty, the art of painting grasps, are not comprised within a formative dynamics; they are not branches of the genesis of the Being; they are not even icons of transcendence, but rather of an intense and pulsive *obscurity*. They are screams that, unlike those of Laocoon, should not to be confused with the visible spectacle that makes you scream. They are forces of isolation, deformation and dissipation instead. In sum, these corporeal, obscure forces, even if not directly referring to sculpture, are primarily manual actions (as Herder first noticed): 'these manual signs, almost blind, mean to testify the intrusion of a different world into the visual world of figuration' (Deleuze 2005, p. 168).

The optical organization, destabilized by Merleau-Ponty through his criticism of linear perspective, but then restored on the basis of the organic unity of the living and sensing body, is now definitely surpassed by defining painting not as visual data but as an operational diagram. In contemporary art, this diagram has taken different routes: toward abstraction, when shapes 'belonged to a new, purely optic, space, which does not have to subordinate any manual or tactile elements to itself'; toward Abstract Expressionism (or formless art) where 'optical geometry falls apart to leave room for an exclusively manual line'; and moving on to the pure tactile Action Painting, in which the hand subjugates the eye. Most importantly, there is also another way, Bacon's, 'which is neither optic as abstract painting, nor manual as Action Painting' (Deleuze 2005, pp. 170-171).

This is the Egyptian way, which means, according to a definition by Riegl, a haptic way where painting becomes strictly associated with sculpture. The Western tradition in painting, often ignoring this plastic aspect of figurative art, has substituted a tactile-optic space for this primitive haptic vision and its spatiality. This new space can be defined as intentional, since 'it is no longer the essence, but rather the connection to express itself, that is to say the human organic activity'. When the eye takes on only the optical function, leaving behind the haptic, as one can see in Merleau-Ponty,

it ends up subordinating the tactile to itself, considering it a 'second power' (Deleuze 2005, p. 193). This originates either a pure optical space (described by Wolff, which leads to abstraction) or, as a reaction, 'a violent manual space', which takes place in what Worringer calls 'barbaric art', or gothic (as opposed to Byzantine art), and which today leads to formless art. Perhaps it was this alternative, presenting on one side the iconic-optic Byzantine, and on the other the Western-tactile (which leads to the praise of the hand, of the making of things, of the bodily *poiesis*)—these two having the common merit of challenging the rhetorical-narrative aspect of painting or, as Deleuze writes, 'of disintegrating the optical-tactile space of the so-called classic representation' (Deleuze 2005, p. 197)—it was this alternative, which fascinated but did not convince Herder, inducing him to search for those 'combinations and new and complex correlations' of which Deleuze speaks and which have constituted the authentic history of painting and of Western art itself. This 'third way', which Herder identifies with sculpture and Deleuze with colour, is what sets in motion the haptic function of sight.

But such an Egyptian function, embodied in Bacon's work and brought by Bacon himself toward catastrophe, cannot be traced back to an organic rapport between the eye and the hand. Herder's 'sensorium commune' need not be interpreted along the same lines as the eulogy of the hand by Focillon,[9] or Merleau-Ponty, since 'it is subject to dynamic tensions, logical upheavals, exchanges and organic substitutions' (Deleuze 2005, p. 227). The values of the hand are not organic: the digital, the tactile, the manual and the haptic have a complex relationship with the eye and among themselves. Taken all together they constitute the 'painterly fact', in which different shapes, all accidental, are comprised within one figure that does not tell any story (not finite nor infinite, not metaphorical nor symbolic) and 'does not represent anything other than its own movement, making apparently arbitrary elements gel together in a single continuous output' (Deleuze 2005, p. 232).

We are faced with an icon that is not a symbol but pure sensation, a presence which is not history nor representation, that unfolds under an eye that is part of the un-coordinated sensorial system. It is not a symbol of the organic unity of the body. Lessing's denial that figurative arts may be linkable to action and narration, and thus to the space of the body, is reaffirmed, on the condition that the organicity of the body be shattered in the multiple tactilism of the Figure, in which 'the hand, the touch, the grasp evoke this direct manual activity that traces the possibility of the fact' (Deleuze 2005, p. 232)

Painting itself embodies the difference that is the fact itself, the paradoxical foundation of a third eye that, as Herder maintained, no allegory can express and no ontology can embody: one haptic eye, which leads to a 'new clarity'—evidently neither Cartesian nor phenomenological—in which every dualism between tactile and optic is

[9] Henri Focillon (1881–1943) is the main exponent of the formalist stream of French art critique. In 1934 he published a successful book, *Life of Forms*, and subsequently a short essay titled *Eulogy*. The problem of rhythm is central to the investigations of French aesthetics at the beginning of the twentieth century. For a general survey of these issues, see Franzini (1984).

surpassed, as is every form of their ambiguous fusion, to inaugurate a 'logic of sensation'. In this logic there is no room for representing, and the figurative semantics of feeling are articulated in such a way that the centrifugal and centripetal rhythms of the body have dispersed the harmonic organicity of the form.

Deleuze not only redefines Herder's 'sensorium commune', but he also continues to advance toward illustrating the opacity of the presence, of the figure, that is to say, of the elements that a living body will never be able to reconcile in an organic vision (constituent or ontological), and which therefore have to be accounted for by a 'cruel body'. However, at the opposite end of the scale from Herder, and closer to the problems that today's art world presents, the haptics of the body refuse a symbolic consideration of the tactile form. This presents itself, in its substantial sensory presence, as indefinable, similarly to how it was described in Merleau-Ponty's ontology: the different clarity pursued by Deleuze does not investigate the symbolic opacity of the work as form, as an aesthetic reality whose condition of being a representation and an image holds an element of secret workings. Although this does not reduce it to the bare aesthetics of the form, nonetheless it cannot do without such aesthetics and without its frame.

Deleuze, in his complex diagrams that deconstruct the optic and the tactile, understands that in painting there is an event of such strength that it cannot be explained by simply linking it back to the Being (and perhaps this is the most violent break from the tradition that started with Neoplatonism). This event is made up of entities lacking a harmonic rapport with the body, so that the exchanges and reversible interactions that perception deploys are not immediately true options or tensions, but rather primarily facts, where what is at stake is the body, with all its tactile physicality. Even if he does understand clearly the difference of painting—or rather the thickness of this difference that characterizes painting—and its constant escape from allegorical or metaphorical substrates (Ricoeur 1981, p. 19), as in Herder—nonetheless he links the sublime opacity of the symbol to the ambivalences of the simulacrum, in which painting is only a multiplicity formed by differential elements, as expressed in *Difference and repetition* (1994, originally published in French in 1968).

IMPLICATIONS FOR A PHILOSOPHICAL APPROACH TO THE ARTS

Starting from this eulogy of roughness, of savagery, of formlessness or of cruelty, one can arrive at a conclusion, to which one is forced by the history of the aesthetic relationship between the visible and the invisible: there is no such thing as a system in the 'philosophy of art', and maybe in general it does not make much sense to talk about 'philosophy of art' (or of the single arts). Painting and sculpture simply

place us in front of 'entities'. These have the common characteristics of 'making us think', according to the Kantian definition of symbol, starting from their own aesthetics, from the layers of qualities that are articulated within them. A philosophical approach to arts does not consider them as a regional ontology to be resolved by description, and not even as an opening towards the Being or as a tool of *deconstruction*. Its 'objects' manifest images, representations, and forms, which are able to show the symbolic multiplicity of aesthetics, that is to say that it is not reducible, in its logic, into constituent operations. Painting presents 'things': one interrogates the general sense of this 'thing-ness', not the relationship with the being but the emerging of an intuitive sense through those things.

Some possible horizons for a philosophical investigation are: an investigation on the spatial sense of the artwork, on the surplus of its spatiality, on the aesthetic origin of the symbolic, on its perceptual coordination with the kinesthetic system of the body, on the opacity that operates within these processes of being intentional, and on the spiritual, historical and motivational meanings that upon these bases can build a particular non-causal and non-necessary (to the formal reality of the work) statute. These investigations need not become a system, a definition or a 'philosophy'. When we are confronted with an icon (or with a *tabula* or a *body*) we just ponder on its sentient nature, on the specificity of its form, on its relationship with other modes of knowledge, from language to voice. One can then revert to form, to the aesthetic and spatio-temporal meaning it has for our senses. This may be the only possible answer to the issues that have been raised since the eighteenth century: understanding that the tactile and spatial sense of the artwork leads to a question regarding time. It is within time that the whole meaning of the form, its sublime exposure as a reality that questions the 'limits' of the body, of its senses and of the senses' relationships when confronted to their immanent symbolic meaning that becomes explicit and tangible in the artwork.

In conclusion, painting and sculpture confront us with symbolic forms, with visible figures that allude to the far possibility of grasping that remains opaque, to a world of possibilities that is encompassed by the shape and its processes of construction, but it does not exhaust itself in its regulated and categorized vision. The iconophiles of Byzantium seemed to forget the existence of a type of painting that just wanted to be visible, without alluding to the invisible, offering itself to the pleasure of the gaze—that is, the type of painting which iconoclasts accepted, and, thus doing, they allowed the symbol to reside in the unchangeability of alluding signs. But they forgot that one cannot define the painting's meaning and, as Merleau-Ponty did, believe that this may always be a process of ontological transubstantiation or, as Deleuze, believe that this always manifests the deforming cruelty of the body. Whether it is an ontological symbol or a simulacrum, painting requires the senses to manifest an opacity that does not lead to an absolute horizon, but to those processes that render its symbolic product a reality that originates from movements of apprehension, from actions that present their constituent meaning even without exhausting it.

We started from the icon, from a mystical eulogy of a medium which, being visible pigment, is capable of linking with the secret truth of the invisible. The era of

the image has produced also illusory 'enlargements'—just think about the movie about the image, '*Blow up*', by Michelangelo Antonioni—which offer only the surface of things, in which the invisible blends into the illusion that destroys feeling and the sense of truth. Recently, Baudrillard observed that, in art, things fall into nothing, and iconoclasts seem to posthumously win, not by burning the images, but rather by multiplying them infinitely without worrying about their aesthetic reality and their spiritual meaning.

References

Burke E (1992). *Inchiesta sul bello e il sublime*. G. Sertoli and E Miglietta, eds. Aesthetica edizioni, Palermo Italy.

Deleuze G (1994). *Difference and Repetition*. Columbia University Press, New York.

Deleuze G (2005). *Francis Bacon: The Logic of Sensation*, DW Smith, trans. University of Minnesota Press, Minneapolis, MN.

Franzini E (1984). *L'estetica francese del '900. Analisi delle teorie*. Unicopli, Milan.

Herder JG (1994). *Plastica*. G Maragliano, ed. Aesthetica edizioni, Palermo Italy. Originally published in German (1778). For a translation in English, see Herder JG (2002) *Sculpture: Some observations on shape and form from pygmalion's creative dream*. University of Chicago Press, Chicago.

Lee RW (1974). *Ut pictura poesis. La teoria umanistica della pittura*. Sansoni, Florence Italy.

Merleau-Ponty M (1979). L'occhio e lo spirito. In F Fergnani, ed. *Il corpo vissuto*. Il Saggiatore, Milan.

Merleau-Ponty M (1968). *Fenomenologia della percezione*. A Bonomi, ed. Il Saggiatore, Milan. Originally published in French in 1945.

Ricoeur P (1981). *La metafora viva*. Jaca Books, Milan.

SCULPTURE AND TOUCH

FRANCESCA BACCI

This essay revolves around the crucial but deceptively simple question of whether a sculpture is an object designed to be touched. The fact that it belongs to the realm of three dimensions implies the physical possibility of touch. But many works, especially contemporary, are designed precisely to exclude touch, as we shall see later in this chapter. Bearing this issue in mind, I propose to explore it through the lens of cognitive neuroscience, motivated not by the pretence to provide an exhaustive answer, but rather by the possibility to add one further approach to this critical debate, while at the same time exposing the often unacknowledged complexity of touch and its interconnectedness with the other senses. I hope, through this paper, to raise the awareness that an answer to this question has repercussions on such diverse fields as, among others, museum policies and cultural heritage preservation, interpretation and critical analysis of artworks, didactic and cognitive approaches to sculpture, and, ultimately, on our cultural identity.

TOUCH AND SCIENCE

What is commonly referred to as 'touch' is a complex combination of the information coming from different receptors, including pressure on the skin and proprioception (which is the feeling of where our muscles and joints are in space). Touch is a sensorimotor

activity, since it involves an interaction between toucher and touched that goes beyond the physical aspect of nerve endings transmitting a signal to our brain.

Tactile objects are experienced as being on the body, whereas visual objects are experienced as being located at a distance. (...) Normal subjects orient attention away from the body during visual exploration and towards the body during tactile exploration. Therefore, touch may be linked more closely to personal space and vision may be linked more closely to peripersonal space. Integrating tactile and visual sensations may then help bind personal and peripersonal space (Vaishnavi et al. 2001).

It is interesting to note that touch influences the way that the human brain constructs representations of space. In fact, there are multiple representations, which include:

personal, peripersonal, and extrapersonal space. Personal space refers to the space occupied by the body. Peripersonal space refers to space surrounding our body within the reach of our limbs. Extrapersonal space refers to space beyond the reach of our limbs.

(Vaishnavi et al. 2001)

As further observed by cognitive neuroscientist Charles Spence:

objects within peripersonal space can be grasped and manipulated; objects located beyond this space (in what is often termed 'extrapersonal space') cannot normally be reached without moving toward them, or else their movement toward us. It makes sense, then, that the brain should represent objects situated in peripersonal space differently from those in extrapersonal space.

(Holmes and Spence 2004)

Thus, it is fair to say that tactile apprehension of an object adds an epistemological dimension that informs and to some extent modifies the visually-acquired percept. However, the role of touch has often being subjugated to that of sight, based at least in part on scientific theory. The question of whether it is touch to educate sight or vice versa has been long discussed in the scientific field. Synthesizing the history of the scientific exploration of this issue, Spence reminds us how Brewster showed experimentally the dominance of vision over the conflicting tactile/haptic sensations as early as 1832, and how scientists showed similar findings when, a century later, they conducted more rigorous experimental investigations on the influence of one sense on another (e.g. Gibson 1933; Rock and Victor 1964; Hay et al. 1965; Rock and Harris 1967).[1]

However, there have been two important changes in scientific theory, which have led to a re-evaluation of the question of touch and vision. First, scientists have also explored the idea that the sense of sight may learn to identify objects upon matching their visual features to sensory information from the other senses, in particular from touch experience. In 1866 the German scientist Hermann von Helmholtz had already described visual perceptions as unconscious inferences from sensory data

[1] See Charles Spence, Chapter 4 this volume, 'The Multisensory Perception of Touch', pp. 85–106.

and knowledge derived from the past (von Helmholtz 1866). More recently, following this line of enquiry, neuroscientist Richard Gregory (1997) proposed that:

knowledge is necessary for vision because retinal images are inherently ambiguous (for example for size, shape and distance of objects), and because many properties that are vital for behaviour cannot be signalled by the eyes, such as hardness and weight, hot or cold, edible or poisonous.

Moreover, 'perceptions are hypotheses, predicting unsensed characteristics of objects, and predicting in time, to compensate neural signalling delay' (Gregory 1997). Perception, especially vision, is not a passive window on the world, but requires intelligent problem-solving based on knowledge. Instructive in this regard is the experience of Gregory with a patient, Mr. Bradford, who acquired sight via corneal grafts after a lifetime of blindness. To his surprise, the man was immediately able to read the time on a wall-clock, despite having never seen one before—but having touched the clock's hands for a lifetime. Technically, the patient showed 'cross-modal transfer' from touch to vision, so he was able to solve the problem of the meaning of what he was seeing. Gregory (2004) wrote:

Vision was generally thought to be separate from the other senses and is still mainly studied in isolation; yet Bradford showed that exploratory touch – as well no doubt as taste, sound and other sensory experiences – gives richness and meaning to retinal images. For optical images are but ghosts, materialized into objects by perceptual experience of the non-visual properties of things.

These modern observations seem to partially confirm a very old hypothesis, dating from the thirteenth century. What Aristotle had called *sensus communis* was the part of the psyche responsible for binding the inputs of the individual sense organs into a coherent and intelligible representation. According to the philosopher and theologian Thomas Aquinas, the fundamental basis for the *sensus communis* is to be found in the sense of touch, as he wrote in his commentary to Aristotle's *De anima* (liber III, lect. 3. 602):

[Touch] is the first and in a way the root and foundation of all senses . . . This power is attributed to the sense of touch not as a proper sense, but because it is the foundation of all senses and the closest to the fontal root of all senses, which is common sense.

A second major change in the scientific view of touch has come from new models of how the senses interact. The idea of one sense dominating over the others has been superseded in favour of the more accurate view that our perceptual system combines the information coming from different sensory modalities in one unified percept. In everyday life, in fact, we receive correlated information from different senses about the same object. 'An extensive body of empirical research now demonstrates that visual, auditory and olfactory cues can all influence people's tactile perception of the substance properties (such as texture) of haptically explored objects and surfaces.'[2] One popular theory, which aims to predict how touch and vision combine in determining perception, comes from Ernst and Banks (2002). According to the so-called

[2] *Ibid.*

'maximum-likelihood' estimation account of sensory dominance, the brain weights the most precise sensory modality (i.e. the one which presents the least variance) more heavily than inputs from those modality estimates showing more variance.[3] Given that our knowledge of the world is formed through the integration of signals coming from our different senses, it appears undeniable that the lack of tactile access to sculpture determines an impoverishment of our percept, and thus of our aesthetic experience of the artwork.

Do touch the art . . . at least with your eyes

As we have seen in the previous section, haptic information constitutes effectively a layer of meaning that should be considered as indispensable to the sculpture's expressivity as colours to a painting. Unless otherwise indicated by the artist or by the placement and context for which the artwork has been conceived, it could be reasonably assumed that a sculpture's texture and surface treatment, but also temperature, hardness, and weight—all of which to be ascertained haptically—are rich sources of sensory stimuli and are vehicles for information that is important for the sculpture's aesthetic apperception. There are indeed concerns regarding the physical preservation of unique works of art from the past that determine the current restrictive museum policies, but the issue of tactile access to artworks is complicated by social and political factors as well, as Fiona Candlin, among others, has theorized in several of her papers.[4]

The time has come to seriously consider whether to privilege the physical integrity of artworks to the cost of their expressive power, or whether to find ways to guarantee the fullness of the experience of the aesthetic encounter with art. There are increasing numbers of institutions, such as the Victoria and Albert Museum in London, which strive to allow the public to touch selected exhibits in order to gain a haptic experience capable of enriching the understanding of the collection.[5] It is time to ask ourselves whether what we are preserving is our cultural identity, embodied by the object's integrity, or its monetary value. While sculptures have historically always been fondled and thus created in materials, such as bronze and marble, that could

[3] *Ibid.*, pp. 91–92.

[4] On this topic see Fiona Candlin's Touch and the Limits of the Rational Museum (2008). *Senses and Society*, **3** (3), 277–92; Museums, modernity and the class politics of touching objects. In Helen Chatterjee, ed. *Touch in Museums. Policy and Practice in Object Handling*. London: Berg, 2008; The dubious inheritance of touch: art history and museum access (2006). *Journal of Visual Culture*, **5** (2), 137–54.

[5] An issue that is worth briefly mentioning is that of the possibility of producing copies of original artworks for tactile apprehension. Would it feel the same as the original, to our hands, to touch a carefully crafted copy? Could we acquire a haptic knowledge that would enrich our visual experience of the original sculpture?

withstand this physical approach, the modern use of alternative, often ephemeral, media raises many questions regarding the willingness of the sculpture to meet our hands. Many contemporary works entrust their survival to their prescribed lack of haptic contact, a virginity that takes on an anthropological connotation and speaks volumes about the fragility, fear, mistrust, and isolation that characterises our touch-deprived society. It is meaningful that numerous artists are presenting works that are designed to incorporate their physical disintegration as a metaphor for death (such as Gonzales-Torres, *Portrait of Ross in L.A.*, made of sweets weighing as much as the artist's dead partner, which the public is invited to eat) or for the inevitable passage of time (Andy Goldsworthy's installations made of ice, wood, or leaves, left to be consumed by the natural elements). The survival of these sculptural installations is guaranteed in the form of video and photographic recordings, both printed and stored in digital format.

Even those sculptures built to endure the test of time, however, come to our attention primarily through the eyes, most often in the form of photographs. One can then consider photography of sculpture as one of the many possible ways to tell the story of the tactile relationship between sculpture and its perceiver. Since its beginnings, photography has portrayed sculptures as a favourite subject. Louis Daguerre's *The artist's atelier* (1837) and Hippolite Bayard's *Plaster casts* (c.1839) (Fig. 7.1) are probably the best-known examples of this early production.

This choice of subject was not only motivated by the obvious reason that sculptures did not move (a necessity determined by the long exposure times) but also by the fact that different textures combined with the whiteness of the marble played masterfully with the light, providing an astonishingly realistic representation. It is precisely this faithful rendering of tactile values that conferred a life-like quality to the image, differentiating it from its painted alternatives. In the last two centuries, sculpture has been depicted through the camera according to numerous and different stylistic approaches, each indicative of a specific critical, social and cultural attitude—photographs are, after all, 'woven in to the fabric of their own time'.[6] These images eloquently expose the different ways in which these artefacts have been perused.

One interesting fact is that, in photography, the image meaningfully registers the distance between the photographer's eye (hence his/her body) and the object. This provides the opportunity of reading photography of sculpture according to the distance between perceiver and perceived. This distance, far from being an accidental factor, largely determines our physical, hence intellectual, engagement with the artwork. There are photographers, such as David Finn for example, who have rejected the decorum of the arm's length view, pursuing inquisitive close-ups that are almost pornographic for their exaggerated anatomical exactitude. His shots of Renaissance masterworks offer an intimate vision of the sculptures photographed, one that

[6] Mary Bergstein, Lonely Aphrodites: On the Documentary Photography of Sculpture. *The Art Bulletin*, **74**(3) 475–98. On photography of sculpture, see also the excellent book by Geraldine Johnson (1999), *Sculpture and Photography: Envisioning the Third Dimension.* Cambridge University Press.

Fig. 7.1 Hippolite Bayard, *Plaster casts*, c.1839. (Source: http://
commons.wikimedia.org/)

presupposes emotion, possession, and sensual intimacy with the object, rather than
historical perspective and documentation. At this distance all of the background
disappears, and with it the context, thus the sculpture loses its temporal and mate-
rial dimension, almost becoming living flesh palpitating in an eternal present, read-
ily available for the observer's consumption.[7] Moreover, as detailed earlier, even the
cognitive relationship between perceiver and sculpture is quite different accord-
ing to the space occupied by the latter in the spatial map of the former (whether the
sculpture is in a person's peripersonal space or beyond it). In other words, objects that
are located at a distance shorter or equivalent to arm's reach offer the characteristic
of being potentially touchable, and this alone makes them different to perceive than
other objects.

One extremely popular photographic device that evoked the presence of an object
in peripersonal space is the stereoscope (Fig. 7.2).

[7] The use of zoom lenses can simulate a non-existent physical closeness between photographer
and object, but the observer of the photograph will still perceive this physical closeness as if it was
undoubtedly real.

Fig. 7.2 A stereoscope with photographic stereocards.

(Photograph: Peter Dent.)

Invented by Wheatstone in the 1830s, this device managed to create a dramati-
cally three-dimensional effect by reproducing the effect of binocular vision. This was
obtained by simultaneously viewing two photographs of the same subject taken from
slightly differing angles, thus imitating the information given by the differences in
the views of the two eyes. The invention worked to effectively trick our visual system
because binocular disparity is one of the most important cues for discerning depth,
especially in seeing near depth—while it is of little or no use in providing informa-
tion about the three-dimensionality of distant buildings or mountains. Thus, stereo-
photographers endeavoured to introduce foreground elements, where the effects
of depth were more pronounced. The stereoscope, which was commonly used for
didactic purposes and often pictured sculptures or academic nudes, testifies to the
struggle towards obtaining an image that would feel real to all the senses by convey-
ing a tactile sense of depth through the channel of sight. In the case of artworks, this
tool enriched the experience of seeing the concavities and convexities of the sculpted
shape, but it also created a potential conflict—like the close-up photograph—of
visually tantalizing the sense of touch by portraying depth in one's peripersonal
space that, frustratingly, could not be actually felt.

Some monumental sculptures, such as Richard Serra's *Fulcrum* (1987), manage
to almost enforce the public's touch by creating a bodily sensation of instability that
requires haptic verification (Fig. 7.3).

These works are so large that they offer an intriguing ambiguity as to whether one
is confronted with a work of sculpture or architecture. They cannot be understood

Fig. 7.3 Richard Serra, *Fulcrum*, 1987.

(Photograph: Oxyman, http://commons.wikimedia.org/)

unless one gathers a multitude of impressions by walking around and inside of them. This characteristic transforms the environment in which the sculpture is placed into a qualitatively new space, one in which the vestibular discomfort is compensated for by the tactile sensation of massiveness and stability. As Alva Noë (2000) aptly observed, Serra's sculpture:

enables us to catch ourselves in the act of perceiving and can allow us thus to catch hold of the fact that experience is not a passive interior state, but a mode of active engagement with the world (...) When one first encounters a piece, one is liable to be struck by the scale and the visually inscrutable orientations and distributions of weight. One not only notices these qualities, but one is disturbed by them. One puzzles: what stops these giants from falling over? To wander around or through a piece such as this can cause a loss of balance. In this way the works make us reflect on how we *feel*, perceptually, in their presence.

In light of these observations, we could rephrase our curatorial question (whether a sculpture is an object for touching or not) by asking whether sculpture provides the affordance of 'touchability', in other words whether the possibility of being touched is implicit in its sculpture-ness. The idea of 'affordance' was pioneered by J.J. Gibson in his 1977 article, when he discussed the presence of 'action possibilities' latent in the environment, directly dependent on the capabilities of the individual. For example, a hammer offers the affordance of beating a nail on the head (but not if the individual is an infant). In Gibson's view, perception and action are closely linked:

When in use, a tool is a sort of extension of the hand, almost an attachment to it or a part of the user's own body, and thus is no longer a part of the environment of the user. (...) This capacity to attach something to the body suggests that the boundary between the animal and the environment is not fixed at the surface of the skin but can shift. More generally it suggests

that the absolute duality of 'objective' and 'subjective' is false. When we consider the affordances of things, we escape this philosophical dichotomy.

(Gibson 1979, p.41)

It is here worth briefly mentioning that, similarly to Gibson's theory of affordances, in 1927 Martin Heidegger had talked of 'readiness-to-hand' (*Zuhandenheit*) and had discussed transcending the subject–object split (humans as 'being-in-the-world'). If one is to admit that a sculpture placed at arm's reach offers the affordance of 'touchability', then it logically follows that the embodied knowledge that one can acquire through touch, which as we have seen is primarily a sensory–motor and proprioceptive activity, constitutes a qualitatively new experience compared to looking from a distance—one in which the dichotomy subjective–objective loses its meaning in favour of a new way of being-with-the-sculpture.

CREATIVE AND EXPLORATORY TOUCH

In addition to the role of touch in the perception and appreciation and sculpture, the act of creating sculpture is, itself, deeply connected with touch. Sculptures, in fact, are most often the product of an act of touch directed by the *Kunstwollen* through the complex process of creation. In the act of sculpting, the gesture that imposes the shaping will to the unformed matter is both performing an action and receiving bodily feedback through the sense of touch. In the reaction of the matter to the strength of the gesture there is a great amount of information. As Aristotle had already noticed in the fourth century BC:

touch reaches in man the maximum of discriminative accuracy. While in respect of all the other senses we fall below many species of animals, in respect of touch we far excel all other species in exactness of discrimination. That is why man is the most intelligent of all animals.

(*De Anima*. Liber II, lect 9)

If this tactile and sensory–motor information is received by an experienced sculptor (that is, by an individual with an extensive knowledge of past interaction with clay, plaster, or stone), then it will sensibly modify and regulate every further action that the artist will undertake upon the medium. It is this accumulation of hand experiences with the material that, ultimately, influences greatly the artist's style.

This seldom-considered phenomenon appears evident to practising sculptors who work in traditional media such as wood, clay or marble, as American sculptor Malvina Hoffman (1887–1966) exemplarily reported.[8] One of the tenets of her

[8] She was a generous sculpture teacher, pupil of Rodin, and author of a useful and detailed instruction manual for young artists, titled *Sculpture inside and out.* W.W. Norton & Company, New York, 1939.

teaching method was the insistence with the students on extensive hours of practice as necessary to achieve mastery over the medium, to 'train their hands to obey their minds' (Hoffman 1939, p.82). This was encouraged not so that the students would become able to subjugate the matter to their own will, but in order to allow the expression of one's own style to flow freely, unobstructed by the incompetence of the hands. However, such style—and here comes the most surprising point—is largely determined by the medium of sculpture itself. She wrote:

It would be well for students to understand why they should carve directly in stone while they are studying the first principles of sculpture. (...) The resistance of the stone controls their minds; the appearance of forms as they emerge in the stone gives the carver a new demonstration of why the stone demands a solid form. Details and personal attributes are automatically subordinated to the basic needs of the material. Training that is limited to mod-elling in clay, for casting into bronze, is liable to lead the student into dangerous channels. He will probably become intrigued in the details of drapery, expression of the face, gestures of action, etc. The plastic consistency of clay is a temptation to model unessentials. (...) The discipline which stone and marble impose upon the artist, however, is unquestionably the best teacher that a student could have. Stone is a taskmaster that is unprejudiced, that presents the same obstacles to every student, old or young, archaic or modern, that commands undi-vided attention and tenacity of purpose, strong steady hands, and infinite patience.

(Hoffman 1939, pp. 157–8)

In other words, Hoffman reported the phenomenon of tactile acquisition of information during the carving of stone as responsible for the artist's stylistic choices. What expert hands have learnt to discern is 'the needs of the material' and 'the resis-tance of stone', it is this tactile learning that shapes the formal thinking of the sculptor. According to Hoffman, style would develop as a consequence of tactile interaction with the raw matter, and not, as more commonly held, as a visually-guided choice. Sight would eventually learn what the final appearance of the shapes (obtained by satisfying the conditions posed by the sense of touch) may be.

In the context outlined earlier, I would like to present the work of three contempo-rary sculptors as exemplars of how these scientific characteristics of touch are inter-twined with current artistic researches and practices. The work of sculptor Rosalyn Driscoll ties into the history of sculpture while, at the same time, posing entirely new questions.[9] Conceived specifically for tactile apprehension, these works recreate the original haptic, and somewhat intimate, relationship between perceiver and sculpture. Pushing Hoffman's thoughts to extreme consequences, the final visual appearance of Driscoll's sculptures is determined by the tactile sensation that the artist intends to communicate, and it is a direct consequence of the material's specific haptic require-ments. In so doing, these sculptures question the modern limits posed to our hands by our cultural institutions for preservation purposes. They also open up the rare possibility of expanding the discerning abilities of the sense of touch through the awareness of one's haptic exploration, either informed or uninformed by the sense of sight. Some of Driscoll's sculptures are so big to require continual bodily adjust-ments in order to be investigated, adding an intimate dimension of proprioceptive

[9] See her essay in this volume, 'Aesthetic Touch' (Chapter 5).

Fig. 7.4 Rosalyn Driscoll, *Lota*, 2008.

(Photograph: David Stansbury.)

self-perception occurring simultaneously with the stroking of the hands. The idea of training the sense of touch through practising running one's hand on an artistic-didactic object dates back at least to Marinetti's *Manifesto of Tactilism* (1921). The founder of Futurism sought to enhance the sensitivity of the skin, thought of as 'still a mediocre conductor of thought',[10] through the haptic experience of purposefully constructed tactile boards, called 'hand-journeys'.[11] Twelve years earlier, the influential Italian pedagogue Maria Montessori had theorized her educational method, which prescribed intensive sensory training in order to facilitate a faster mastery of reading, writing, and arithmetic (Montessori 1909). To this purpose, she often blindfolded the children performing her tactile exercises, in order to increase the perceptiveness of their sense of touch. Likewise, Rosalyn Driscoll regularly suggests that the public use a blindfold to first encounter her sculptures haptically before doing so through sight. This simple strategy highlights the gap between our impression of an unseen object gathered through touch and the form that then appears under our eyes. Her work *Lota* (2008), for example, explores the complexity of the human body, both as a physical apparatus and as a site of sensation (Fig. 7.4).

[10] F.T. Marinetti (1921). *Il Tattilismo*. Milano. Translated in English in Lisa Panzera and Cinzia Blum, eds. *La Futurista: Benedetta Cappa Marinetti*, pp. 54–6. Goldie Paley Gallery, Moore College of Art and Design, Philadelphia, PA, 1998.

[11] *Ibid*.

Fig. 7.5 Michael Petry, *Party Number 1*, 2007.
(Photograph: courtesy of the artist and Westbrook Gallery, London.)

The material encasing the copper and silver elements is rawhide. In touching it, we feel a skin that once could have felt us. Its translucent appearance is a visual reminder of its permeable and containing function—our body is a vessel encasing vessels (called 'lota' in Urdu and Hindi). Inside, a series of connecting tubes represents the pulsating motion and endless circulation of fluids necessary for life. Moreover, the chromatic contrast between these different materials takes on a symbolic meaning: 'inside us there are things that shine unexpectedly' says the artist, '*Lota* will change over time as people touch the metals, revealing the small, cumulative, and unconscious effects of touch that may not be apparent at this time'.[12]

Michael Petry's sculpture *Party Number One* (Fig. 7.5), which is meant to be handled, addresses the sensual aspect of touching. The sexual connotations of the sculpture, whose shape is evocative of human anatomical parts, suggest sensual manipulation of a lover's body, thus providing a reminder of the importance of touch as a primary physical and psychological site of non-verbal communication. In the artist's words, 'a seductively polished slice of Cedar of Lebanon is hanging in the space. The velvety smooth, horizontal piece of wood has many perfectly round holes cut into it that tempt the viewer to touch it or other viewers through it in the darkly lit space'. If we imagine stroking the wooden sculpture while looking at it or observing someone else performing this operation, this activity is liable to activate sensory–motor neuron signals in our brains via our fondling eyes.

Claude Heath's blindfold drawing series (some of which were presented in the exhibition 'Art and the Senses' concurrently with the conference that inspired this

[12] Personal communication with the author. London, October 31, 2008.

book) work precisely on exploring the gap and the sensory overlaps between sight and touch (Fig. 7.6).

Made while blindfolded, the artist had one hand engaged in touching a cast of a human head, and the other simultaneously busy tracing this touch-journey on paper. The artist could not look at the sculpture nor at the paper while working, using exclusively his sense of touch, proprioception, and 'body-centred' maps to draw. The resulting work is the graphic translation of an exploratory haptic strategy that is not concerned with the final aesthetic result, but rather with the development of the mental representation of the head as formed through the tactily-acquired information. To chart these stages in time, in some of the drawing from this series, Heath changed the colour of the pen that he was using in order to be able to understand, having regained his sight and viewing his work for the first time, which part of the picture he made first. Since he could not rely on the sense of sight, Heath used a small lump of Blu-Tak placed at the top of the shape to feel and another one on the upper part of the sheet on which he was tracing (which leaves a visible white spot on the drawing). This served as a reference point from which he could feel the relative distances of the different elements composing the object felt. Heath said:

There is often a disjunction between the images being shaped on the paper, the way I visualise them and the physical reality of the object itself. The disparity is healthy because it does not confine me to what I imagine, expect or desire to see.[13]

Fig. 7.6 Claude Heath, *Plaster Cast of Head* and *Drawing 138*, 1995.

(Photograph: Peter Dent.)

[13] Andrew Patrizio (2003). Perspicuous by their absence: the Wimbledon drawings of Claude Heath. In A Kingston, ed. *What is drawing?* p. 34. Black Dog Publishing, London. At the time of writing, available online at http://www.claudeheath.com/texts/article2.php.

This methodology of work betrays the artist's scientific intention. He empirically recorded his perceptions in order to better understand and become increasingly more sensitive to the acquisition of knowledge via haptic exploration. In this sense, these drawings are to be considered test results, maps charting the three-dimensional movements of the hand on the flat surface of the sheet.

An object seen always has a profile, a visible edge, the line of its shape as it stands out silhouetted against the world behind it. An object felt has any number of contours running over its surface, but none of them has the special status of this profile. (...) Drawing by eye always deals with these restricted visibilities. But drawing from touch has no such limits. It has no prejudice in favour of near side over far side, or in front of over behind. It deals indiscriminately with the whole tangible surface. On paper, all contours superimpose in confusion.

(Lubbock 2002)

The observer's difficulties in deciphering throughout the unfolding of this journey, which presents some areas of opacity, are similar to those experienced by the scientist, when trying to understand how the different spatial maps interact in the human brain in order to give a unitary percept.

This use of drawing as an instrument to capture tactility has an illustrious precedent in the work of the nineteenth-century national champion of French sculpture, Auguste Rodin (1840–1917). His working method was indeed different from that taught in fine arts schools worldwide. In fact, he used to keep his eyes fixed on the model and draw without looking at the paper and at the pencil that was leaving marks on it. He never lifted his pencil, once he had begun drawing, until he had completed the outline of the figure in one continuous sweep.[14] This technique allowed Rodin to haptically understand the shape that he would then render three-dimensionally in sculpture, almost as if the pencil, moving on the paper's surface, was 'a surrogate finger passing along the subject's contours' (Elsen 2003, p. 613). Rodin explained this procedure in a conversation with his secretary and friend Ludovici:

I have to incorporate the lines of the human body, and they must become part of myself, deeply seated in my instincts. I must become permeated with the secrets of all its contours, all the masses that it presents to the eye. I must feel them at the end of my fingers. All this must flow naturally from my eye to my hand. (...) Not a thought about the technical problem of representing it on paper could be allowed to arrest the flow of my feelings about it, from my eye to my hand. The moment I drop my eyes that flow stops.[15]

The drawing was a result of the hand motion rather than an attempt to perform a visually guided exercise. In 1906, Rodin made numerous works with this technique, portraying a group of Cambodian dancers who performed in Paris and Marseille. This is an ideal series to study, since both the drawings and the photographs of the master sketching are extant. In the latter, one can see that Rodin held the pencil in the correct way, that is between thumb and index finger, from the back, with his hand lifted from

[14] This working method is particularly well described in Anthony M. Ludovici, *Personal Reminiscences of Auguste Rodin*, pp. 135-40. John Murray, London, 1926. Ludovici served as Rodin's private secretary, and was an eyewitness of this methodology of drawing.

[15] Anthony M. Ludovici, *Personal Reminiscences of Auguste Rodin*, cit., pp. 138–9.

the paper. This technique is taught in art academies as the most convenient way to allow a free-flowing motion of the pencil when the work is visually controlled—if it is used while sketching without looking, though, this fluidity becomes an impairment, since the result is that:

the hand goes where it will: often the pencil goes off the page; the drawing is thus decapitated or loses a limb by amputation (...) It contains naturally some excessive deformations, unforeseen swellings, but (...) if the relation of proportions is destroyed, on the other hand, each section had its contours and the cursive schematic indication of its modelling.[16]

Instead, he can be seen in another photo using the aid of his little finger, firmly placed on the paper, when adding some visually guided strokes on a drawing, which evidently required a finest degree of precision and motor control (inv.Ph.6398, Cabinet des Photographies du Musée Rodin, Paris).[17] This way of anchoring the hand motion to a precise spatial point recalls Claude Heath's use of Blu-Tak, and expresses the need of carefully controlling the visual consistency and placement of the different marks, rather than the feel of producing them. Often, then, Rodin would tint his drawings with gouache and watercolours, in order to extract the salient features of the figure outlined, and to disambiguate the overlapping and misplaced lines. These drawings symbolize the complex relationship and interconnectedness between the two senses explored in this paper.

[16] This quote comes from the description of another eye-witness of Rodin's work. Clément-Janin, Les Dessins de Rodin, in *Les Maîtres du Dessin*, pp. 285–7. Paris, 15 October 1903.
[17] This picture can be seen on the back cover of the book by Claude Judrin, *Rodin: Hell and Paradise. Sculptor's drawings*. Paris: Musée Rodin, 2002.

REFERENCES

Aquinas T (1959). *In Aristotelis Librum de anima III.* Lect. 3. 602 (AM Pirotta ed.). Turin.

Elsen AE (2003). *Rodin's Art: The Rodin Collection of Iris & B. Gerald Cantor Center of Visual Arts at Stanford University.* Oxford University Press, New York.

Ernst, MO and Banks MS (2002). Humans integrate visual and haptic information in a statistically optimal fashion. *Nature,* **415,** 429–33.

Gibson JJ (1977). The theory of affordances. In R Shaw and J Bransford, eds. *Perceiving, Acting, and Knowing,* pp. 67–82. Lawrence Erlbaum, Hillsdale, NJ.

Gibson JJ (1979). *The Ecological Approach to Visual Perception.* Houghton Mifflin, Boston, MA.

Gregory RL (1997). Knowledge in perception and illusion. *Philosophical Transactions: Biological Sciences,* **352,** 1121–7.

Gregory RL (2004). The blind leading the sighted. An eye-opening experience of the wonders of perception. *Nature,* **430,** 836.

Hoffman M (1939). *Sculpture Inside and Out.* W. W. Norton & Company, New York.

Holmes NP and Spence C (2004). The body schema and the multisensory representation(s) of peripersonal space. *Cognitive Processing,* **5**(2), 94–105.

Lubbock T (2002). Don't look now. *The Independent,* 8 October.

Montessori M (1909). *Il Metodo della Pedagogia Scientifica applicato all'educazione infantile nelle Case dei Bambini.* Lapi, Città di Castello. (First published in English as *The Montessori Method,* 1912.)

Noë A (2000). Experience and experiment in art. *Journal of Consciousness Studies,* **7**(8–9), 123–35.

Vaishnavi S, Calhoun J, and Chatterjee A (2001). Binding personal and peripersonal space: evidence from tactile extinction. *Journal of Cognitive Neuroscience,* **13**(2), 181–9.

von Helmholtz H (1866/1962). Concerning the perceptions in general. In *Treatise on physiological optics,* vol. III, 3rd edn. (JPC Southall, trans. 1925 *Optical Society of America* Section 26). Reprinted Dover, New York, 1962.

CHAPTER 8

TOUCH AND THE CINEMATIC EXPERIENCE[*]

JENNIFER M. BARKER

WHEN we say we are moved by a film, that it touches us, or that we respond to it viscerally, we mean it in a more than metaphorical sense. These claims imply a distinctly tactile relationship between film and viewer that is a key factor in our attraction and response to the movies. Exploring cinema's tactility opens up the possibility of cinema as an *intimate* experience and of our relationship with the cinema as a *close* connection, rather than as a distant experience of observation, which the notion of cinema as a purely visual medium presumes. Vision and touch are married in the experience of cinema, as are mind and body. To perceive the world and to express one's perception of that world are not solely cognitive or emotional acts taken up by viewers and films, but always already *embodied* ones that are enabled, inflected, and shaped by a tactile engagement with and orientation toward others (things, bodies, objects, subjects) in the world.

The Quay Brothers' *Street of Crocodiles* (1986) dramatizes and literalizes the palpable connection between film and spectator that exists in all cinematic experiences but is rarely made so explicit. With its intense focus on material textures, miniature spaces and movements, and the ambivalent temporality of 'stop-motion' animation, the film is an object lesson of sorts, revealing the way films' meaning and significance emerge in the fleshy, muscular, and visceral encounter between films and viewers.

* This chapter is expanded on in *The Tactile Eye: Touch and the Cinematic Experience* ©2009 by the regents of the University of California, published by the University of California Press. Selections from this book are reprinted with permission from the University of California Press.

The film begins with a prelude, entitled 'The Wooden Oesophagus', that blends live-action cinematography with animation. In it, a museum caretaker enters a silent, cavernous auditorium, its chairs empty and its stage populated with apparently lifeless machinery. He whistles as he steps on to the stage, carrying a stage light. He sets the light on the floor next to one particular machine and walks out of the frame. A series of camera movements follows, in which the camera moves quickly down the surface of this machine, giving us glimpses (in black and white) of bits and pieces of the contraption: an eyepiece, a tiny crank, a small porcelain bowl of screws.

The man returns and peers through the viewfinder. Another jerky camera movement follows that takes us down into the machine's inner workings and then rapidly back up (this time in colour rather than black and white). The caretaker adjusts a magnifying glass that is attached to the machine and perched above a detailed map. He stands upright and, after a pause, spits slowly into the innards of the machine. There is a cut to a colour image of the machine's interior, where the saliva falls slowly from the top of the frame and sets into frantic motion a series of gears, pulleys, and unidentifiable mechanisms.

Amidst the mechanical whirrings, a little man-like puppet appears who will be our protagonist. His hand is attached by a thread to a pulley hanging above a doorway, and he tugs at the thread but is unable to move. The film cuts to a black-and-white image of the caretaker's hand reaching slowly into an opening in the side of the machine, holding a pair of scissors. As the puppet-protagonist continues to pull his arm to no avail, the caretaker reaches his scissors further into the machine and snips. Inside the machine, the scissors appear enormous now and in colour, emerging from the top of the frame to cut the thread holding the protagonist. A quick camera movement tracks up to the pulley as it spins out of control. Finally the protagonist moves jerkily out of the frame, free to wander the murky and maze-like space of this strange mechanical inner world.

The tactile engagement between the caretaker and the contraption and its resident puppet is, in some ways, analogous to the relationship between spectator and film[1]. The strange machine in this prelude invites the involvement of the caretaker's body; indeed, it cannot move without him. He brings the machine to life not just by *looking*, but by committing his entire body to its spectacle: he steps up to it, leans close, bends over the eyepiece, reaches into it, manoeuvres his fingers to cut the strings of the pulley, and finally spits into its inner workings. His preliminary contact with the apparatus at the surface of the body (both his and the machine's body) parallels a contact that occurs even deeper within him and the machine, a contact involving the muscular, mechanical workings and internal rhythms of each.

Likewise, the cinematic experience involves a mutual and distinctly tactile relationship between film and spectator that involves all dimensions of the body at once: surface, middle, and depth. Both films and spectators perform meaningful, embodied acts of perception and expression that, upon closer study, reveal corresponding tactile structures. These acts and their underlying structures manifest themselves as

[1] For an extended discussion of the role of tactility in the cinematic experience, see Jennifer M. Barker, (2009).

particular styles of surface contact (caressing, scraping, pricking, piercing, etc.), comportment (swaying, tugging, lurching, leaning, etc.), and internal rhythms (flowing, pulsing, skipping a beat, etc.). They occur in and across three regions of the spectator's body and the film itself, regions that I refer to as the skin, the musculature, and the viscera, which are related (but not limited) to materiality, spatiality, and temporality, respectively.

As a material mode of perception and expression, touch need not be linked explicitly to a single organ such as the skin. It is enacted and felt throughout the body, for, as phenomenologist Maurice Merleau-Ponty wrote, 'the body is borne towards tactile experience by all its surfaces and all its organs simultaneously, and carries with it a certain typical structure of the tactile "world"' (Merleau-Ponty 1962, p. 317). Cinematic tactility occurs not only at the skin or the screen, but traverses all the organs of the spectator's body and the film's body. As J.J. Gibson wrote, 'vision is kinaesthetic in that it registers movements of the body just as much as does the muscle-joint-skin system and the inner-ear system' (Gibson 1979, p. 183, cited in Rutherford 2002). Tension, balance, energy, inertia, languor, velocity, rhythm—all of these are 'tactile', though none manifests itself solely, or even primarily, at the surface of the body.

Cinematic tactility, then, is not just 'skin-deep'. It is a general engagement with cinema that the human body enacts in particular ways: haptically, at the tender surface of the body; kinaesthetically and muscularly, in the middle dimension of muscles, tendons, and bones that reach toward and through cinematic space; and viscerally, in the murky recesses of the body, where heart, lungs, pulsing fluids, and firing synapses receive, respond to, and re-enact the rhythms of cinema. The film's body also adopts toward the world and spectator a tactile 'attitude' of intimacy and reciprocity that is played out across its non-human body: haptically, at the screen's surface, with the caress of shimmering nitrate and the scratch of dust and fibre on celluloid; kinaesthetically, through the contours of on- and off-screen space and of the bodies (both human and mechanical) that inhabit or escape them; and viscerally, with the film's rush through a projector's gate and the 'breathing' of lenses.[2]

The skin, the musculature, and the viscera are not meant here metaphorically, but they *are* stretched beyond their literal, biological meanings to encompass their phenomenological significance. These categories helpfully lead us through a complicated terrain, but their boundaries are pliable and permeable. Sensations and behaviours constantly bleed, vibrate, dissolve, cut, infect, meander, or muscle their way from one dimension into the next.

This essay will use *Street of Crocodiles* to elucidate those three categories as they apply to both viewer's and film's embodied behaviour. It is in the dimension of skin that we find what Laura Marks has termed the 'haptic' qualities of cinematic perception: 'Haptic looking tends to rest on the surface of its object rather than to plunge into depth, not to distinguish form so much as to discern texture' (Marks 1999, p. 255). The musculature involves things like gripping, grasping, holding, clenching,

[2] For an elaboration of the 'film's body' as a concretely embodied entity whose visual and visible modes of perception and expression place it in a relationship of reciprocity and reversibility with its viewer, see Sobchack (1992).

and what Michael Taussig describes as a kind of 'sentient contact that is another mode of seeing, the gaze grasping where the touch falters' (Taussig 1993, p. 30), while the turbulent, pulsing rhythms of the viscera constitute yet another register of tactile perception and expression.

SKIN

Street of Crocodiles obscures its objects in a way that makes vision difficult and invites the viewer to *feel* rather than see the film. Objects and images are mysterious and murky, veiled by layers of dust and detritus and kept just out of visual range by camera movements that merely glance over their objects before the next shot. Film and viewer press against each other in a skin-to-skin contact: rather than look with a precise and penetrating gaze, the eye skitters along textures that 'make sense' only to the touch. Texture is something viewer and film engage in mutually, rather than something presented *by* the film *to* a passive and anonymous viewer. It is in the meeting of the film's skin and the viewer's skin that this film becomes meaningful.

The film thus invokes haptic visuality, in the sense that Marks describes: 'By engaging with an object in a haptic way, I come to the surface of myself' (Marks 1999, p. 184). In letting our gaze wander over the surface of the image, we *do* come to the surface of ourselves, feeling ourselves more keenly in the touch of our skin against the film's skin. This is a touch by which we and the film bring each other literally and sensuously into being. Indeed, as Marks writes, 'haptic images are erotic in that they construct an intersubjective relationship between beholder and image' (Marks 1999, p. 183).[3]

If we take 'skin' to mean the literal fleshy covering of a human or animal body, then to say a film has a skin would be quite a stretch. But if, as Merleau-Ponty has said of touch, 'skin' also denotes a general style of being in the world, and if skin is not merely a biological object but also a mode of perception and expression that comprises the surface of a body and the site where it meets the world of others and objects, then film can indeed be said to have a skin. Through its skin, the film is caught up in a reciprocal, intimate, and fundamentally erotic intersubjectivity with its viewer.

In a very particular way, stop-motion animation interacts with its viewer haptically, by way of textures that beg to be touched. *Street of Crocodiles* is filled with objects that, beyond carrying any narrative or symbolic value (although some do), address viewers primarily as organic objects of the world, reminding us of our own embodied existence in that world. Even the mechanical objects, and there are many, seem significant only by virtue of the dust particles and rust that accumulate on them, the saliva that propels them, and the dirt that surrounds them.

[3] For a discussion of the erotics of haptic visuality, see Marks (1998).

Street of Crocodiles takes very little in the way of narrative from Bruno Schulz's novella of the same name, but it does borrow the text's keen focus on texture and tactility. In Schulz's story, a character asks:

Can you understand the deep meaning of that weakness, that passion for colored tissue, for *papier mâché*, for distemper, for oakum and sawdust? This is . . . proof of our love for matter as such, for its fluffiness or porosity, for its unique mystical consistency . . . We love its creaking, its resistance, its clumsiness. We like to see behind each gesture, behind each move, its inertia, its heavy effort, its bearlike awkwardness.

(Schulz 1977, p. 62)

The scene in the film that corresponds to this passage revels in texture. The puppet-protagonist meets a tailor, a doll with a head of porcelain who, with three other porcelain dolls, welcomes the protagonist into his shop. The dolls fawn over and fondle their guest, running their tiny porcelain hands over his wiry hair and cracked, bewildered-looking features. After draping his body in rich, colourful fabrics, they replace his head with one like their own, stuff it with cotton, and pull tufts of cotton from the empty top, ears, and eye sockets.

At one point, the tailor stands at a table where he runs his hands over an exquisitely detailed map of Poland and magically produces from his fingertips a piece of raw meat that he lays over the map. He smoothes a sheet of dress-pattern tissue paper over the meat, whose moisture seeps through the tissue paper. An army of pins marches up the surface of the meat, sinking themselves into the glistening flesh as they fasten the tissue pattern to it. As the dolls continue to dress the now barely recognizable protagonist, the tailor cradles his detached head, running his tiny fingers through the coarse grey hair.

The tailor invites the protagonist to gaze through a window into a darker room beyond the tailor shop. Flanked by two dolls who caress his backside through his rough tweed coat, the protagonist peers through the grimy window. On the other side of the glass, another porcelain doll—a child—sits on a dirt floor, cradling in his arms a light bulb that is nearly as big as he is. As the protagonist and dressmakers look on, the child pulls a woollen hat from his head and gently covers the light bulb with it, the proximity of the camera emphasizing the wool fibres, the dirty surface of the glass bulb, and the doll's smudged features. In an extreme close-up, tiny screws on the floor surrounding the little boy raise themselves up, twirl deliriously through a layer of dirt so porous and dry that one can feel it under one's fingernails, and scamper off.

The tailor shop scene is characteristic of the haptic quality of the experience of this film, as well as the playful and perhaps disturbing way it probes the boundary between sexual and non-sexual touch and between pleasure and disgust. Like the caretaker and the puppet-protagonist, the porcelain dolls in the tailor shop experience this world tactilely rather than visually or cognitively, running their fingers voluptuously over every available surface, and the film invites its viewers to do the same. The textures here and throughout the film awaken the fingertips and call forth the sense of touch as a meaningful and complex mode of perception, communication, and emotional experience.

In this way, *Street of Crocodiles* seems to exemplify the physicality of the film experience, which Siegfried Kracauer described this way:

Film not only records physical reality but reveals otherwise hidden provinces of it, including such spatial and temporal configurations as may be derived from the given data with the aid of cinematic techniques and devices. The salient point here is that these discoveries . . . mean an increased demand on the spectator's physiological make-up. The unknown shapes he encounters involve *not so much his power of reasoning as his visceral faculties.* Arousing his innate curiosity, they lure him into dimensions where sense impressions are all-important.

(Kracauer 1965, p. 158)

MUSCULATURE

Beyond the notion that the film experience involves the senses at least as much as the intellect, I am interested here in the 'lure' Kracauer describes, which I would argue is not only visceral but also haptic and muscular. I will focus now on its muscular and spatial aspect and return later to the visceral and temporal one. This 'lure' is an invitation not only to press ourselves haptically against the film images but also to *inhabit* them. Film not only reveals 'hidden provinces' of physical reality but also actually incorporates the viewer's body into these configurations.

That films beckon us to inhabit their dimensions may seem paradoxical in the case of *Street of Crocodiles*, whose intensely miniaturized spaces do not correspond to human proportions. The film is dominated by extreme close-ups of tiny objects—screws, threads, straight pins, dandelion seeds, a leather shoelace—that swell to gigantic heights, and the caretaker's hand is mammoth in comparison to the tiny features of the puppet he sets free. And yet, this miniscule world becomes a thick, three-dimensional, and inhabitable space. How can that be? As Kracauer wrote, the viewing experience demands something of our physiological make-up: it requires (and enables) us to adapt our bodies to the measure of the screen.

Alexander Sesonske makes an apt description of this phenomenon:

While seated in the theater we can at the same time be taken (visually) into the space of the film, see the action as from inside the space, move through it at great or little speed, be rejected or excluded from it. Some of our most vivid experiences of film occur in scenes where we seem to be deep inside the action-space and wholly immersed within the events of the film.

(Sesonske 1973, p. 403)

Although for Sesonske, cinema space is a purely visual experience, it is not only visually but also tactilely 'vivid'. We don't entirely 'lose ourselves' in the film space, of course (we don't stop experiencing the press of our bodies against our seat, the chill in the theatre and other tactile aspects of our situation), but tactile sensations can be simultaneously provoked by one's own bodily situation *and* that of the film's body.

This is not to say that we aren't situated at all and are floating anchorless somewhere between our body and the screen. Rather, we are *doubly* situated: we exist in two places at once, even if we never literally leave our seats.

We are invited and encouraged, then, to commit ourselves to the film's space as well as our own, caught up 'there' and 'here' at the same time. If, as Merleau-Ponty attests, we comprehend space not objectively and theoretically, but by living in it sensuously, then if we are to comprehend filmic space at all, we must live quite literally in two places while watching a movie: our own and the film's. What Merleau-Ponty writes in another context may just as well apply to the film experience: 'I am borne wholly into the new spectacle and, so to speak, transfer my centre of gravity into it' (Merleau-Ponty 1962, p. 251). Psychologist and early film theorist Hugo Münsterberg described the sensual component of attention in the cinema in similar terms, saying, 'We feel that our body adjusts itself to the perception . . . We hold all our muscles in tension in order to receive the fullest possible impression with our sense organs' (Münsterberg 1916, pp. 36–7).

As Vivian Sobchack has made clear, the film/viewer relationship isn't anthropomorphic, for clearly my legs are not 'like' a dolly anymore than my eyes are 'like' a camera lens. But, like our body, the film's body 'uses modes of embodied existence (seeing, hearing, physical and reflective movement) as the vehicle, the '"stuff", the substance of its language' (Sobchack 1992, p. 5). We and the film exhibit likenesses in behaviour and comportment and in the way we use the muscular body as a means of perception and expression. Pushing, pulling, reaching, cowering, flinching, leaning forward, and pulling back, for example, all express in muscular terms one's 'attitudes' about one's relationship to the world and others in it. All these gestures can be performed by human bodies and film bodies, though we may use arms, legs, and spine to perform them, while the film might use tripod, crane, and zoom lens. In this way the film's body and the viewer's body are irrevocably related to one another, but neither identical nor completely divergent.

As with the definition of 'skin', then, the 'musculature' is not reducible to biology or mechanics; rather, a body's musculature is defined by its expressive and perceptive functions. In the case of both viewer and film, the musculature isn't a set of fleshy or mechanical 'parts' that we possess, but something through which we live and experience the world. If we can 'inhabit' cinematic space and experience movements in (and of) the film with our own theatre-bound bodies, as Sesonske described, this is because the muscular movements of both viewer and film express a particular interest in and attitude toward the world. They are counterparts, their muscular behaviours inspired, imitated, and sometimes resisted by one another.

The muscular relationship between film and viewer can be inflected in any number of ways; it might be tentative, playful, erotic, hostile, etc. Always, though, this reciprocal relationship is lived out by means of specific gestures. In *Street of Crocodiles*, perhaps the most dynamic of the film's muscular 'gestures' are the animated 'camera movements'. I set the term in quotation marks to indicate that at least some of these movements are probably fabricated in the stop-motion mode, while others move in real time over their objects, and it is difficult to tell how any given movement is made.

The camera movements are not only ontologically ambiguous, but also thematically ambivalent: they express, in muscular terms, the simultaneous but contradictory experiences of curiosity and claustrophobia, freedom and restriction, vitality and death. The pans and tilts and tracking shots are as tiny as the objects they explore: each one moves very quickly, sliding across intricate, richly textured surfaces like fingertips across Braille. This rapid movement, combined with the camera's extreme proximity to the objects of its attention, expresses an intense curiosity, a desire to explore the world of the film closely and intimately, and to 'take in' as much detail and information as possible with each fleeting instant. At the same time, though, the camera movements underscore a sense of restless and uneasy confinement. No camera movement lasts more than a second or two, and each one ends abruptly, so that the restless energy of the camera is constantly snuffed out. The camera moves almost obsessively in tiny increments as if struggling to work itself free from a cramped space. Ultimately, it fails: like the protagonist who is set free from his tether in the prelude only to wander endlessly through the small and twisted spaces of this cave-like world, the moving camera is paradoxically perpetually constrained.

Sesonske writes that, in the film experience, 'The slightest invitation will persuade us to abandon our ordinary lives and live wholly within the world of the film. Cinema space presents that invitation' (Sesonske 1973, pp. 399–400). These miniscule camera movements are the 'invitation' to inhabit the space of *Street of Crocodiles*, but at the same time they are the means by which we are 'rejected or excluded from it' (Sesonske 1973, p. 403), as the space is made to feel inhospitable, too close and too small for comfort. This ambivalence between inhabitability and inhospitality, and between movement and constraint, perhaps parallels the one that functions at the haptic level between pleasure and disgust: both involve a simultaneous attraction and repulsion, an ambivalent push/pull dynamic.

Like the materiality of its objects and spaces, then, the miniature scale and movements of *Street of Crocodiles* invite a tactile participation by the viewer that informs and shapes the viewer's intellectual and emotional experience of the film. We *feel for* the puppet-protagonist precisely because we *feel with* him, muscularly caught up in a not-yet-intellectualized but sensuous, muscular connection to the miniature world of the puppets, dolls, meat, metal, leather, and dust.

VISCERA

The tenuous, tactile connection between the film's and viewer's bodies exists as well in their depths, where a similar dynamic of attraction and repulsion is at play. The deeply felt but (ordinarily) scarcely noticed rhythms of the internal body can enact and express attitudes and emotions as dramatically as the skin and musculature. Like the skin and musculature, the viscera are here defined phenomenologically, not as individual inner organs but as that which keeps the body in motion, enables all conscious

activities, and regulates the body's rhythms, and yet does all this without drawing attention or being available to conscious control. This is touch as it is experienced and enacted in a dimension of the body that we rarely if ever see for ourselves, our attention diverted from it by our daily engagement with the 'world at hand'.

The work of the viscera is to mask a fundamental contradiction. Though we perceive our bodies' movement through the world to be smooth and continuous, the human body actually consists of a series of intermittent and separate motions. Every move we make involves the contraction and subsequent release of individual muscles, for example, and 'the lungs fill and collapse before they fill again. The valves of the heart open and shut, and both respiration and heartbeat are not continuous, but segmented, rhythmic activities. Yet, we do not consider ourselves in "intermittent motion"' (Sobchack 1990, p. 23). Likewise, the film's 'viscera' (constituted by sprocket-holes, film speed, and other mechanical aspects) regulates the film's movement through camera and projector in such a way as to encourage the illusion of continuous, rather than intermittent, motion.

Whereas movement in live-action cinema manages, for the most part, to convince us of its smooth continuity, stop-motion animation explicitly reminds us that the smooth motion of the objects on screen is an illusion, and that the movement of these images and objects is, in fact, intermittent and disjointed. For the duration of a stop-motion film, we are caught up in two inherently opposed modes of temporality: we simultaneously inhabit (more precariously than with a live-action film) the temporal structures both of *apparently* ceaselessly flowing 'real life' and of the lurching irregularity of the film-world.

Street of Crocodiles, even more than most stop-motion animation, exacerbates the tension between continuity and discontinuity in the internal rhythms of both bodies, cinematic and human. That tension is more pronounced and more profoundly meaningful because the film's tactile appeal to more accessible dimensions of the skin and the musculature in turn awakens us to the viscera. Because we feel a material and muscular investment in the film world and the film's body, our bodies are implicated in its temporality as well, and the film's visceral rhythms deepen the tactile connection in a way that may be seductive, startling, and even deeply unsettling.

Some viewers are bewitched by stop-motion animation precisely because it makes sensible to the viewing body, in cinematic form, a temporality that is not ordinarily sensible. However, some viewers express unease at watching *Street of Crocodiles*, which perhaps arises from the inability of the lived body to reconcile itself with the intermittence of the movement that characterizes this film and other stop-motion animation.

Street of Crocodiles winds up with a particularly striking image that reveals the complexities and subtleties of the temporal, as well as textural and muscular, engagement between the viewer and the film. Toward the end of the film, the tiny screws that appear in the prelude and tailor-shop scene have unscrewed themselves from the floorboards of a small, decrepit space behind the tailor shop and now scurry along its corridors. There is a cut to a small table on which lies a dusty and tarnished pocket watch. At the right of the screen, the screws appear at the edge of the table in extreme close-up and wiggle themselves toward the watch. When they reach it, they

leap up and disappear inside the watch, pushing themselves forcefully, almost violently, into its cracked and dirty face (which, interestingly enough, features letters rather than numbers, further destabilizing our ordinary sense of time). The watch shuts tight and spins around on the table, then falls open to reveal its inner workings, which consist entirely of glistening raw meat. The screws emerge again from these shockingly organic innards, wriggle their way out of the meat to fall on to the table again, and scurry away.

This remarkable sequence echoes the entire film in its attention to minuscule detail, its kinetic ambivalence, and the astonishing materiality of the watch's innards. More significantly, however, this meaty sequence also reminds us as embodied viewers of our carnal embeddedness in time itself. The film engages us in two different temporal modalities simultaneously, at once reminding us of our own discontinuous nature as beings in motion and of our own lived perception of our movement as continuous and smooth. By engaging our skin, our musculature, and our viscera with its own, the film entices us into a deeper relationship with it, by which we come to a palpable recognition that the inner clockwork of our bodies and the film's body are uncannily similar. Our tactile, visceral body grasps the implication immediately: like the cinema itself, our own robust vitality is an illusion, and our vital rhythms mark with every breath the perpetual possibility of stillness and death.

To say that we are touched by cinema indicates that it has significance for us, that it comes close to us, and that it literally occupies our sphere and shares something with us (materiality, muscular movements, rhythm), but the relationship between viewer and film is not anthropomorphic. Instead, it is a matter of shared styles of touch, and the differences between film's body and viewer's body in this respect are as important as the similarities. Particular structures of human touch correspond to particular structures of the cinematic experience, so that forms of tactility that filmgoers experience at the movies are taken up—in complex, not always comfortable ways—by both spectator and film.

Cinematic tactility comes to mean not simply contact, but rather a profound manner of being, a mode of perception and expression by which all parts of the body, both cinematic and human, commit themselves to or are drawn into an intimate and intersubjective contact with the other. Like the wriggling screws and the meaty pocketwatch, film and viewer are present to one another not only in the press of skin to skin, muscle to muscle, and viscera to viscera, but in a full-bodied opening on to one another that goes beyond surface, middle, and depth. We do not 'lose ourselves' in the film, so much as we exist—emerge, really—in the contact between our body and the film's body.

References

Barker JM (2009). *The Tactile Eye: Touch and the Cinematic Experience.* University of California Press, Berkeley CA.

Gibson JJ (1979). *The Ecological Approach to Visual Perception.* Houghton Mifflin & Co., Boston, MA.

Kracauer S (1965). *Theory of Film: The Redemption of Physical Reality.* Oxford University Press, New York.

Marks LU (1998). Video haptics and erotics. *Screen*, **39**, 331–47.

Marks LU (1999). *The Skin of the Film: Intercultural Cinema, Embodiment, and the Senses.* Duke University Press, Durham, NC.

Merleau-Ponty M (1962). *Phenomenology of Perception.* Routledge, London.

Münsterberg H (1916). *The Photoplay: A Psychological Study.* Dover, New York.

Rutherford A (2002). *Cinema and Embodied Affect, Senses of Cinema,* http://www.sensesofcinema.com/contents/03/25/embodied_affect.html

Schulz B (1977). *The Street of Crocodiles.* Penguin Books, New York.

Sesonske A (1973). Cinema Space. In D Carr and ES Casey, eds. *Explorations in Phenomenology.* Martinus Nijhoff, The Hague.

Sobchack V (1990). The active eye: a phenomenology of cinematic vision. *Quarterly Review of Film and Video*, **12**, 21–36.

Sobchack V (1992). *The Address of the Eye: A Phenomenology of Film Experience.* Princeton University Press, Princeton, NJ.

Taussig M (1993). *Mimesis and Alterity: A Particular History of the Senses.* Routledge, New York.

HEARING SCENTS, TASTING SIGHTS: TOWARD A CROSS-CULTURAL MULTIMODAL THEORY OF AESTHETICS

DAVID HOWES

INTRODUCTION

THIS essay opens with a review of recent advances in neuropsychological research on the multisensory organization of the brain. It goes on to critique that research from the standpoint of the anthropology of the senses. Crucially missing from the neuropsychological account of how the senses function is any recognition of the role that culture plays in the modulation of perception, as shown in the first section. The second section begins with an inquiry into the history of the Western concept of 'aesthetics'. This concept originally stood for the perception of 'the unity-in-multiplicity of sensible qualities' (Baumgarten), but the intersensoriality of this initial formulation was quickly lost from view. The third section presents a survey of the role

of the senses in the aesthetic practices of a range of non-Western cultures. The traditions covered all show a marked tendency to combine the senses (rather than separate them) for artistic and other purposes, most notably healing. This survey in turn lays the groundwork for the articulation of a cross-cultural multimodal theory of aesthetics in the final section, which recuperates some of the elements of the original definition. The essay concludes with a series of suggestions regarding how the disciplines of art history and neuropsychology might reconceptualize their engagement with the sensorium in a manner that is attuned to the historicity and interplay of the senses in art as in everyday life.

THE NEW MULTISENSORY PSYCHOLOGY
OF PERCEPTION

It is commonly assumed that each sense has its proper sphere (e.g. sight is concerned with colour, hearing with sound, and taste with flavour). This modular conception of the sensorium is reflected in the analytic orientation of most current research in the psychology of perception with its sense-by-sense (or 'one sensory modality at a time') approach to the study of perceptual processes. In recent years, however, a more interactive, relational approach to the understanding of how the senses function has begun to take shape as a result of the growing body of evidence that points to the 'multisensory organization' or 'integration' of the brain. As Calvert, Spence, and Stein write in their introduction to *The Handbook of Multisensory Processes* (the most authoritative work in this new field):

even those experiences that at first may appear to be modality-specific are most likely to have been influenced by activity in other sensory modalities, despite our lack of awareness of such interactions . . . [To] fully appreciate the processes underlying much of sensory perception, we must understand not only how information from each sensory modality is transduced and decoded along the pathways primarily devoted to that sense, but also how this information is *modulated* by what is going on in the other sensory pathways.

(Calvert et al. 2004, pp. xi–xii, emphasis mine)

Examples of such modulation include the well-documented fact that, in noisy surroundings, speakers can be understood more easily if they can be seen as well as heard. This finding is readily explicable in terms of the redundancy hypothesis of classic information theory: two pathways or 'information channels' are better than one.

However, the new multisensory psychology of perception probes deeper to explore the *relationships* among the component parts of a multisensory signal (e.g. Partan 2004). For example, in the case of animal and human communication, redundant multisensory signals can be subclassified into those that produce responses in the

receiver equivalent to the response to each unisensory component (*equivalence*), and those where the overall response is enhanced (*superadditive*). Multisensory signals may also be made up of stimuli that convey different (i.e. non-redundant) information. In such cases, the relationships between the component parts of the signal are often quite complex, and it takes a great deal of painstaking attention on the part of the researcher to sort them out.[1] For example, the relationship may be one of *dominance*, as in the case of the ventriloquism effect (where the seen lip-movements of the ventriloquist's dummy alter or 'capture' the apparent location of the speech sounds), or one of *concatenation*, as in the case of the reproductive behaviour of male oriental fruit moths (such moths 'need the visual presence of the female in combination with her pheromones before they will perform their most intricate courtship displays, and they need an additional tactile stimulus of a touch on the abdomen before they will copulate' (Partan 2004, p. 235). *Emergence*, as exemplified by the McGurk effect,[2] is a third possibility, and this typology could be extended further.

Many of the studies in the *Handbook* use modern neuroimaging techniques to reveal the multiple sites of multisensory processing in the brain, including many regions long thought to be modality-specific or 'primary sensory' areas as distinct from the so-called higher order, 'associative' areas traditionally assumed to be responsible for the formation of unified percepts out of the diversity of inputs. In addition to demonstrating the functional interdependence of the modalities, a number of these studies point to their functional equivalence or adaptability. For example, it is now clear that sensory-specific areas can be 'recruited' or 'remapped' by other sensory-specific areas in situations of sensory deprivation or intensive perceptual training. Thus, visual cortex in blind individuals has been found to show activation in auditory tasks while auditory cortex in deaf individuals can be activated by visual tasks.

Of note, the quality of sensation associated with activating the visual cortex in congenitally blind individuals, or the auditory cortex in congenitally deaf individuals, appears to derive from the nature of inputs. That is, visual inputs are perceived as visual even when auditory cortex is activated [in the case of the blind, while the reverse holds true in the case of the deaf] . . . Furthermore, even in normal, nondeprived humans, there is evidence for extensive multisensory interactions whereby primary sensory areas of the cortex can be activated in a task-specific manner by stimuli of other modalities . . . Common to these findings is the principle that inputs recruit pathways, cortical areas, and networks within and between areas that process the information, and the sensoriperceptual modality associated with the input is driven by the nature of the input rather than by the cortical area activated per se.

(Sur 2004, p. 690)

[1] Classic information theory remained blind to modulations of this sort due to the assumption that such 'interference' simply constituted so much 'noise'.

[2] In the version of McGurk's experiment with which I am familiar, the research subject watches a dubbed video of an actor's face pronouncing syllables. The seen lip-movements alter which phoneme is heard for a particular sound (e.g., a sound of /ba/ tends to be perceived as /da/ when it is coupled with a visual lip movement associated with /ga/). In this instance, the response to the multisensory signal is new, qualitatively different from the response to either of the unisensory components, and thus demonstrates *emergence*.

Such evidence of adaptive processing, or 'cross-modal plasticity', poses a serious challenge to the conventional model of the sensorium as consisting of five structurally and functionally distinct modalities. In light of this challenge, some researchers have proposed that the phenomenon of synaesthesia (i.e. the union or crossing of the senses, e.g. hearing colours, tasting shapes) might provide a more productive model for conceptualizing perceptual processes than the conventional sense-by-sense approach that has dominated research on the senses and sensations to date.

The model of synaesthesia

The condition of synaesthesia is typically understood to be quite rare. Estimates of its incidence vary from 1 in 200 to 1 in 2000 to 1 in 20 000 people (Baron-Cohen and Harrison 1997; Ramachandran et al. 2004, p. 868). The most commonly documented form is colour-grapheme synaesthesia in which written words or letters are perceived as having particular colours. To limit synaesthesia to a congenital condition, however, would be myopic.[3] Synaesthetic connections can be learned. Take the case of odour–taste synesthesia which, perhaps because it is such a common effect, has failed to attract much popular attention or scientific documentation. Yet the evidence is clear:

the majority of people appear to experience odor-taste synaesthesia. First, *sweet* is one of the most common descriptors applied to odors . . . [Furthermore,] when smelling an odor, most people can more easily recognize a taste-like quality such as sweetness than more specific qualities such as strawberry- or banana-likeness.

(Stevenson and Boakes 2004, p. 69)

This finding raises the question: when we speak of the odour of vanilla or strawberry as 'sweet', are we speaking in metaphor rather than reporting an actual olfactory sensation? Not according to Stevenson and Boakes:

The central argument of [their chapter in the *Handbook*] is that, as a result of eating and drinking, patterns of retronasal odor stimulation co-occur with oral stimulation, notably of the taste receptors, so that a unitary percept is produced by a process of either within-event associative learning or by a simple encoding as one event. Eating sweet vanilla-flavor ice cream will ensure that the retronasal odor of vanilla becomes associated with sweetness; on some later occasion the smell of vanilla will seem sweet, even if no conscious recollecton of eating ice cream comes to mind.

(Stevenson and Boakes 2004, p. 81)

The 'metaphor explanation' of synaesthetic perception is also rejected by V.S. Ramachandran, E.M. Hubbard, and P.A.Butcher in their chapter on 'Synesthsia, cross-activation, and the foundations of neuroepistemology'. Their objection rests on methodological grounds: 'Since very little is known about the neural basis of

[3] The ethnomusicologist Steve Feld once remarked to me that limiting synaesthesia to those who are congenitally susceptible to this effect would be like restricting music to those with perfect pitch. It cannot be so confined.

metaphor, saying that "synaesthesia is just metaphor" helps to explain neither synaesthesia nor metaphor and merely compounds the mystery' (Ramachandran et al. 2004, p. 868). The authors go on to tout the experimental procedures they have devised to determine whether an alleged synesthete's experiences are 'truly perceptual' or merely conceptual (an important distinction when it comes to selecting test subjects since only those in whom the effect can be shown to be involuntary are considered desirable), and then offer a physiological explanation for the effect having to do with the 'cross-activation of brain maps.' Such cross-activation may come about by two different mechanisms, namely: '(1) cross-wiring between adjacent [brain] areas, either through an excess of anatomical connections or defective pruning, or (2) excess activity in back-projections between successive stages in the hierarchy (caused by defective pruning or by disinhibition)' (Ramachandran et al. 2004, p. 872).

In the case of colour-grapheme synaesthesia—Ramachandran et al.'s chosen example—the brain areas corresponding to graphemes and colours are right next to each other in the fusiform gyrus, and the potential for excess cross-activation or 'hyperconnectivity' as a result of some genetic mutation in those individuals who naturally experience this effect is therefore strongly indicated. Ramachandran et al. conclude that:

far from being a mere curiosity, synaesthesia deserves to be brought into mainstream neuroscience and cognitive psychology. Indeed, [precisely because the neural basis of synaesthesia is beginning to be understood] it may provide a crucial insight into some of the most elusive questions about the mind, such as the neural substrate (and evolution) of metaphor, language and thought itself.

(2004, p. 881)

There is much to be said for Ramachandran et al's 'bottom-up' approach to the study of perceptual processes, but I find the physiological reductionism of their position unduly restrictive from my own perspective as a cultural anthropologist, and I think an equally valid case could be made for a 'top-down' approach. Such an approach would start by examining the cultural organization of the sensorium and descend via the psychological to the physiological level of brain organization. In point of fact, due to the selective focus of their discipline—neuropsychology—Ramachandran et al. never ascend in what they call 'the hierarchy' as far as the cultural level.[4] This oversight constitutes a serious lacuna, for as cultural psychiatrist Laurence Kirmayer observes concerning the hierarchical systems view of neural organization (which Ramachandran et al. presumably share):

Contemporary cognitive neuroscience understands mind and experience as phenomena that emerge from neural networks at a certain level of complexity and organization. There is increasing recognition that this organization is not confined to the brain but also includes loops through the body and the environment, most crucially, through a social world that is

[4] Ramachandran et al. are not alone. There is but one reference in the whole *The Handbook of Multisensory Processes* to cross-cultural variation in the modulation of perception: apparently, the McGurk effect is significantly weaker in Japanese than in American perceivers (Bernstein et al. 2004, p. 207).

culturally constructed. On this view, 'mind' is located not in the brain but in the relationship of brain and body to the world.

(Kirmayer 2007)

Ideally, Kirmayer states, 'we want to be able to trace the causal links up and down this hierarchy in a seamless way'.

Following Kirmayer's lead, let us imagine what a 'Cross-Cultural Handbook of Multisensory Processes' would look like. Instead of presuming sensory processes to be confined to the brain, it would start with the investigation of the culturally patterned 'loops' through the environment—that is, with the study of the relationship of brain and body to the world. Thus, a top-down approach to the study of synaesthetic perception would begin by drawing up an inventory of the range of cultural practices and technologies that generate different sensory combinations across different cultures and historical periods. For example, it is a good empirical question whether the incidence of colour-grapheme synaesthesia would be as high in an aural–oral society as it is in a visual–literate one, such as contemporary Western society.[5] In the latter, words and letters are experienced as quiescent marks on paper or a computer screen, which renders them available for colour-coding, whereas in the former, words (being experienced aurally) might not tend to be seen so readily as they would be felt or smelled as well as heard. In my own ethnographic research in Papua New Guinea, I found evidence of audio-olfactory synaesthesia. In many Melanesian languages, such as Kilivila (the language of the Trobriand Islands), one speaks of 'hearing a smell,' and this association is carried over in Pidgin English, 'mi harim smel'. The reason for this is that most communication takes place face-to-face (i.e. within olfactory range of the other) and odoriferous substances (e.g. anointing the body with oil, chewing ginger) are used to augment the power of a person's presence and words (Howes 2003).

It is also common in various African languages, such as Dogon (a language of Mali), to speak of 'hearing a smell'. According to Dogon conceptions, speech 'has material properties that . . . despite its invisible nature . . . are more than just sound . . . [It] has an 'odour'; sound and odour having vibration as their common origin, are so near to one another that the Dogon speak of "hearing a smell"' (Calame-Griaule 1986). The Dogon also classify words by smell: good speech smells 'sweet', and bad or impetuous speech smells 'rotten'—indeed, 'the mouth too ready to speak is likened to the rectum' (Calame-Griaule 1986, p. 320). This understanding is corporealized in, for example, the steps that are involved in a girl's 'education in speaking'. The first step occurs at age three with the piercing of a hole and the insertion of a metal ring in her lower lip so as to socialize her speaking. This is followed by the piercing of her ears at age six to socialize her hearing. Should the girl continue to make grammatical mistakes and/or utter impetuous remarks by age twelve, then rings are inserted in the septum and

[5] Or even earlier periods of Western culture. For example, a form of audio-grapheme synaesthesia has been described for the Renaissance: 'In a person's handwriting, Erasmus claimed, he could hear that person's very voice' (Smith 2004, 28).

wings of her nose (Calame-Griaule 1986, pp. 308–10). The nose-rings have the super-additive function of modulating both her hearing and her speech by promoting the reception and utterance of 'good-smelling words' and the deflection or repression of bad-smelling ones—all in accordance with the intrinsic connection the Dogon postulate between sound and odour.

These findings of audio-olfactory synaesthesia, familiar to scholars of sensory anthropology, would likely come as a surprise to most scholars of neuropsychology. For example, Stevenson and Boakes claim that: 'Odors display taste properties but do not elicit auditory or visual sensations' (2004, p. 73). On the contrary, in Mali as in Melanesia, sounds *do* elicit olfactory sensations, and vice versa. Thus, what Stevenson and Boakes take to be a physiological given actually rests on certain culturally-contingent (i.e. peculiarly Western) assumptions about the divisions of the sensorium and/or potential for cross-sensory activation. This example underscores the need for more cross-talk between the disciplines of neuropsychology and anthropology if contemporary cognitive neuroscience is to achieve a comprehensive understanding of the multiple possible forms of cross-talk between the senses. To put the matter another way, starting with cross-cultural examples such as these, which are *practical* (i.e. supported by cultural practices which form part of the 'loop' through which all sensations must pass) as well as metaphorical, neuroscientists could well be inspired to discover all sorts of heretofore unsuspected cross-linkages between the senses *wherever they may be localized in the brain.*[6]

AESTHETICS—THE SCIENCE OF
SENSE PERCEPTION

The concept of 'aesthetics' was coined by the philosopher Alexander von Baumgarten in the mid-eighteenth century. It is derived from the Greek *aisthesis*, meaning sense perception. For Baumgarten (1750), aesthetics had to do with the perfection of perception and only secondarily with the perception of perfection, or beauty. His new 'science of sense cognition' was to occupy an intermediary rung, as a 'science of the lower cognitive power' (sense perception) in contradistinction to 'the higher cognitive power' (reason). By limiting aesthetics to the perception of the 'unity-in-multiplicity of sensible qualities', as he put it, Baumgarten hoped to insulate it from being reduced to 'arid' intellection. He believed that the intellect or 'reason' was the poorer for the fact that it trafficked exclusively in 'distinct ideas', as opposed to the

[6] That is, proximity of brain areas would no longer be the determinative criterion (*pace* Ramachandran et al.), as indeed it is not given all the evidence of cross-modal activation, feed forward, and back-projection processes that has begun to emerge.

'confused and indistinct ideas' which were the commerce of the senses. For Baumgarten, therefore, the aesthetic was rooted in the body—specifically, in the disposition to sense acutely—and involved attending to the nature of sensory experience in itself, rather than trying to intellectualize sensation (Gregor 1983, pp. 364–65).

Baumgarten's new 'science' was quickly appropriated and just as quickly subverted by his contemporaries. They replaced his emphasis on the sensuous disposition of the aesthete with a taxonomy of 'the five arts' (architecture, sculpture, painting, music, and poetry). The scope and criteria of the various arts were delimited in terms of the dualism of vision (epitomized by painting) and hearing (epitomized by either music or poetry). The 'dark' or 'lower' senses of smell, taste, and touch were deemed too base to hold any significance for the fine arts. Theatre and dance were also excluded on account of their hybrid character, since they played to more than one sense at once (see Rée 2000)

Baumgarten's worst fears concerning the intellectualization of aesthetic perception were realized in Immanuel Kant's *Critique of Judgment* (1790). Kant attempted to transcend the dualism of vision and hearing and replace it with a fundamental division between the 'arts of space' (e.g. painting) and the 'arts of time' (e.g. music), accessible to 'outer intuition' and 'inner intuition' respectively (Rée 2000, pp. 58–60). It could be said that Kant rarefied aesthetics by divorcing it from perception and substituting intuition. After Kant, aesthetic judgment would be properly neutral, passionless and disinterested (see Eagleton 1990; Turner 1994). This definition of aesthetics guaranteed the autonomy of the enclave now known as 'art' but at the expense of sensory plenitude.

The disincarnation of aesthetics

In its modern incarnation (or more accurately, disincarnation), aesthetics has to do with the appreciation of the formal relations intrinsic to a work of art, and is divorced from that work's content. In one particularly influential characterization of the proper object of aesthetics, Robert Redfield offered the following analogy:

> Art . . . is like a window with a garden behind it. One may focus on either the garden or the window. The common viewer of a Constable landscape or a statue by St. Gaudens focuses on the garden. Not many people . . . 'are capable of adjusting their perceptive apparatus to the windowpane and the transparency that is the work of art'
>
> (Redfield 1971, p. 46 quoting Ortega y Gasset)

The implication is that it is only the uncommon viewer, capable of training his or her gaze on the windowpane itself, who is capable of enjoying a pure aesthetic experience, and of exercising the proper form of judgement.

Note how this characterization deflects attention from the focus on intersensory relations that was given in Baumgarten's concept of aesthetics as the perception of 'the unity in multiplicity of sensible qualities'. The idea of a windowpane effectively

silences any input from the non-visual senses, which are deemed to constitute so many distractions. Aesthetic perception thus depends on a dual process of sensory demarcation and the elision of non-intrinsic sensations so that the viewer may come to appreciate the 'organic unity' of a given work of art, be it a painting or a symphony. By way of illustration, consider the following passage from a Harold Osborne essay on 'The cultivation of sensibility in art education':

In the appreciation of a work of art we concentrate attention exclusively upon a selected region of the presented world. When listening to music we shut out so far as possible the sounds of our neighbours' coughing, the rustle of programmes, even our own bodily sensations. When reading a poem, looking at a film or watching a stage play we tend to be imperceptive and unmindful of sensations from outside. But within the chosen sector we are alert to the intrinsic qualities of the sense-impressions imparted rather than to their practical implications and we are alert to the patterned constructs formed by the relations in which these intrinsic qualities stand to each other . . . This is perception for its own sake, and represents the kernel of truth in the traditional formula 'disinterested interest'.

(Osborne 1984, p. 32; see further Elkins 2000, p. xi)

It should be noted that the aesthetic sensibility of which Osborne speaks is not only something that is cultivated by the viewer from within, it is also instilled in the viewer from without by the architectural design and codes of conduct (no touching, no chatting, no perfume, etc.) that obtain within the concert hall or art museum and other such spaces for the production of 'single-sense epiphanies' (Kirshenblatt-Gimblett 1998; see further, Drobnick 2004, on the sensory ideology behind the art museum as 'white cube').

There have been numerous attempts in the history of Western art since the eighteenth century to escape the straitjacketing of the senses that followed the rarefication of aesthetics perpetrated by Kant and his contemporaries. The poet Baudelaire, father of the Symbolist movement, celebrated the correspondence of the senses, rather than their separation. 'Who has not known', Baudelaire proclaimed, 'those admirable hours, veritable feasts of the brain, when one's heightened senses perceive striking sensations . . . when sounds ring out as in music, when colours speak, when perfumes tell us of worlds of ideas?' (whence his famous poem, 'Correspondences'). Baudelaire's counterpart in the visual arts was Gustave Moreau, whose paintings became Symbolist icons on account of the way they evoked textures, sounds, and scents through the representation of intricately patterned surfaces, musical instruments, and exuberant flowers (see Classen 1998, 109–18).

Marinetti and his Futurist confrères also experimented extensively with intersensoriality in their artistic works (see e.g. Marinetti 1989, 2004), though the emphasis in Futurism was more on producing a clash of sensations than the gently concatenating correspondences of the Symbolists (see Classen 1998, pp. 126–31) Both of these movements were, however, eclipsed by the relentless drive toward abstraction in art that unfolded over the course of the twentieth century. Abstract or 'non-representational' art is all windowpane, with no garden behind it—the logical culmination of the Kantian vision.

Healing arts of the Shipibo-Conibo Indians of Peru

In many non-Western societies, the aesthetic does not constitute a realm apart, but is rather an aspect of everyday and ritual practice, and the senses are not separated from each other but rather combine in specific ways to achieve specific purposes, such as healing. Consider the geometric designs of the Shipibo-Conibo Indians of Peru (see Fig. 9.1). These designs—which are said to originate in the markings of the cosmic serpent, Ronin—are woven into textiles, incised on pots and houseposts, painted on faces, and even recorded in books (see Illius 2002). However, their foremost use is in the context of Shipibo-Conibo healing rituals.

The Shipibo-Conibo understand medicine to be an art, literally, and their healing practices place a premium on synaesthesia in contrast to contemporary mainstream Western medical practice which is geared to the anaesthetization of the patient.

One important condition of [Shipibo-Conibo] therapy is the aesthetically pleasing [*quiquin*] environment into which the shaman and the family place the patient. He is carefully surrounded by an ambience designed to appease both the senses and emotions. Visible and invisible geometric designs, melodious singing, and the fragrance from herbs and tobacco smoke pervade the atmosphere, and ritual purity characterizes his food and each person with whom he has contact. The patient is never left alone in the mosquito tent during the critical

Fig. 9.1 Geometric design of the Shipibo–Conibo Indians.

time of his illness. This setting induces in the patient the necessary emotional disposition for recovery. But how is this indigenous concept of aesthetics [*quiquin*] to be understood?

(Gebhart-Sayer 1985, p. 161)

The Shipibo-Conibo term *quiquin*, which means both aesthetic and appropriate, is used to refer to pleasant auditory and olfactory as well as visual sensations. Let us follow how the shaman operates with *quiquin*-ness on these three sensory levels— visual, auditory, and olfactory—and how they are 'synaesthetically combined to form a therapy of beauty, cultural relevance, and sophistication' (Gebhart-Sayer 1985, p. 162).

At the start of a healing session (there will be five such sessions in all), the shaman, under the influence of the *ayahuasca* hallucinogenic vine, sees the body of the patient 'as if with an X-ray machine'. A sick person's visual body pattern appears 'like a very messy design', or mixed-up pile of garbage, and its pathological aura has a vile stench which is the mark of the attacking spirits (*nihue*) causing the illness. The healing ritual involves both the restoration of a healthy visual body pattern and the neutralization of the pathogenic aura through life-enhancing fragrance.

The shaman begins by brushing away the 'mess' on the patient's body with his painted garment and fanning away the miasma of the attacking spirits with his fragrant herbal bundle, all the while blowing tobacco smoke. He then takes up his rattle and beats a smelling rhythm: the air is now 'full of aromatic tobacco smoke and the good scent of herbs'. Following this, the shaman, still hallucinating, perceives whole 'sheets' of luminescent geometric designs, drawn by the Hummingbird spirit, hovering in the air, which gradually descend to his lips. On reaching his lips the shaman sings the designs into songs. At the moment of coming into contact with the patient, the songs once again turn into designs that penetrate the patient's body and, ideally, 'settle down permanently'. However, the whole time the healing design is being sung on to the body of the patient, the *nihue* will 'try to ruin the pattern by singing evil-smelling anti-songs dealing with the odor of gasoline, fish poison, dogs, certain products of the cosmetic industry, menstrual blood, unclean people, and so on' (Gebhart-Sayer 1985, p. 171), and thereby smudge or contaminate it. This is why it may take up to five sessions for the design to come out 'clear, neat, and complete,' and the cure to be finished. (If the design does not settle down permanently, the patient is unlikely to recover.)

Another strategy commonly employed by the evil *nihue* to prevent the cure from taking is to seek out the shaman's medicine vessel which contains all his design songs, and pry the lid off it. This causes the therapeutic power of the songs to escape. 'This power is imagined as the fragrance of the design songs or the aromatic gas fizzing from fermenting yucca beer' (Gebhart-Sayer 1985, p. 172). The design songs thus have an olfactory dimension, in addition to their visual one, as their power is understood to reside in their fragrance.

The synaesthetic interrelationships of the designs, songs and fragrances used in Shipibo-Conibo healing rituals are nicely brought out in the following lines from a shamanic healing song:

The (harmful) spirit pneuma
swirling in your body's ultimate point.

I shall tackle it right now
with my fragrant chanting.
. . .
I see brilliant bands of designs,
curved and fragrant. . .

 (Gebhart-Sayer 1985, p. 172)

An important point to note here is that, whereas we perceive these designs as visual abstractions, the Shipibo-Conibo perceive them as matrices of intersensory perception, since these geometrical abstractions are at the same time musical scores and perfume recipes. They resonate in each of the senses at once. They are not simply addressed to the eye.

Sensorial investigations

Let us now consider another non-Western aesthetic practice which gives the lie to the assumption that 'Odors display taste properties but do not elicit auditory or visual sensations' (Stevenson and Boakes 2004)—namely, the Japanese incense-guessing game or 'way of incense' (kōdō).[7] Osborne (1984) refers to this game approvingly as a way of cultivating the ability to make 'fine discriminations within a narrow range of sensory quality,' which is so important to art appreciation. He characterizes it as involving 'the competitive discrimination of scents of the incense type.' As we shall see, however, this characterization is altogether too unisensory, since the trick to this game lies in crossing sensory borders.

Hearing scents

The history of incense in Japan is as old as that of Buddhism, since the two were introduced from China together in the sixth century. To this day, Buddhist monks use incense to sacralize a space, as a vehicle of prayer, and as an aid to concentration. However, incense may also be enjoyed without any religious purpose, in which case it is called 'empty burning', a pastime which became especially popular among the aristocracy during the Heian period, who delighted in compounding incense and then guessing the ingredients when burnt. The 'way of incense' proper was codified in the fourteenth century, with different schools devising different rules. The tea ceremony (shoji) and the art of floral arrangement date from the same period. All three constituted essential accomplishments of the courtly class. The ceremony was taken

[7] This account of the Japanese incense ceremony is based on personal experience and the following key sources: Bedini 1994; Pybus 2001; Morita 2007.

over by other classes in subsequent centuries, but then fell into desuetude in 1861, only to be revived as a Japanese family game in the twentieth century.

Originally the grading of incense was by country of origin, since *jinko* (aloeswood) from various parts of the world differed in quality: Manaban (from the Malabar coast of southern India) was the coarsest and Rakoku (from Thailand) among the finest. There were six such categories in all. In the fourteenth century a gustatory lexicon was devised for grading purposes.

- *Sweet* honey or syrup-like aroma
- *Sour* unripe fruit aroma
- *Hot* spicy aroma
- *Salty* marine, ozonic, or perspiration aroma
- *Bitter* medicinal aroma

This gustatory ordination of incense makes sense, as Stevenson and Boakes would be quick to note, since the senses of taste and smell are so integrally linked. But the matter does not stop there, since this categorization also added a class dimension. The scent of Manaban, for example, is considered sweet, unrefined, and rather gritty whence the characterization of its demeanour as 'The Coarse Peasant', while the aroma of Rakoku, which is pungent and bitter, has the demeanour of a warrior and is known as 'The Samurai'.

Probing further, we discover that the Japanese do not smell or taste the woodsmoke but rather, as the saying goes, 'listen to the incense' (ko wo kiku). Various explanations have been offered for this turn of phrase. One authority notes that it translates the original Chinese phrase *wen xiang*, the pictograph for which resembles a person kneeling to pray and meditate. Another suggests that 'listening' more aptly conveys the concentration that is involved in kōdō than a term such as 'smelling' (or merely 'hearing'). Yet another authority stresses the cosmological dimension: everything is fragrant, like incense, in Buddha's world, including his words or teachings, which are therefore to be scented as well as heard. Finally, it is significant to note that many forms of the game involve the recitation or composition of poetry, and thus implicate the verbal arts.

The visual and haptic senses also play a role in odour-appreciation Japanese-style: the former in the way calligraphy is used to record the contestants' guesses and the latter in the way the master of ceremonies, the tabulator and all the contestants adopt a kneeling posture for the duration of the game. The ostensibly restricted role which the visual and haptic senses play in the practice of kōdō (e.g. having to kneel still, not being able to see the jinko since it is concealed in envelopes) is counterbalanced by the degree to which these senses are extended in the imagination. Consider the variant of the game called 'Shirakawa Border Station,' where the poem by the same names provides the ceremony with its structure—or rather, its map. The idea is to retrace the long journey (370 miles) from Kyoto to Shirakawa which the poet Nōin (who lived during the late Heian period) undertook by foot, taking two full seasons to complete.

I left the capital,
Veiled in spring mist

An autumn wind blows here,
At Shirakawa Border station.

The protocol of the game is as follows:

- Step 1. The master of ceremonies informs the guests that the three pieces of incense are called Mist in the Capital, Autumn Wind, and Shirakawa Border Station. Guests listen to the two sample incense pieces, Mist in the Capital first, and Autumn Wind second. (Shirakawa Border Station is not circulated during the tryout phase.)
- Step 2. The master of ceremonies shuffles the three pieces (one each of Mist in the Capital, Autumn Wind, and Shirakawa Border Station).
- Step 3. After the burning of each incense piece, guests indicate their listening by writing down the names of the incense on the tablet provided (Morita 2007).

Another variant is called 'The Three Scenic Spots.' In this game, one imagines a boat ride to each of the three famous sites: Matsushima (an archipelago), Amanohashidate (a white spit of land covered in pine tress) and Itsukusjima (with its famous Shinto red gateway).

The question arises: Why all this emphasis on travel? Perhaps it is because the aroma of incense transports you, literally. Also of note in this connection is the fact that it is easier to summon a visual image of a place to mind when you catch a whiff of some scent (e.g. that of fresh-mown hay) than it is to summon a scent to mind when staring at a postcard of a landscape (e.g. of a field of fresh-mown hay). Kōdō capitalizes on this asymmetry in the cross-modal activation potential of the senses of sight and smell, and by so doing enriches the field of vision without detracting from the pleasures of olfaction. Thus, Osborne is partially correct when he says that the incense ceremony cultivates the capacity to make fine discriminations within a narrow range of sensory quality (i.e. smell), but it would be more correct to say that it fosters the ability to forge intersensory connections.

Synaesthetic cosmos of the Desana Indians of Colombia

Perhaps the most notable practitioners of what I call 'cultural synaesthesia' (Howes 2006a) are the Desana people of the Colombian rainforest.[8] For the Desana, all sensory phenomena are interconnected, a perception heightened by their ritual ingestion of hallucinogenic plants. According to their understanding of the nature of the cosmos, the sun gives life to our world by infusing it with 'colour energies'. Each of these colour energies embodies a different set of values and potentialities. Red, for example, exemplifies the power of female fertility. Everything in the world contains a combination of these colour energies, which may be visible, as in the colours of flowers, or invisible, as in the rainbow of chromatic energies said to animate human beings. (Only the shaman is able to perceive the latter with the aid of the hallucinogenic vine and his special rock crystals.)

[8] This account of the Desana sensory order is woven together from the analyses presented in Classen (1993), Classen et al. (1994), and Howes (2003).

These life-giving colours form a primary set of sensory energies for the Desana. Secondary sets consist of such phenomena as temperatures, odours, and flavours. Odours are believed to result from a combination of colour and temperature, flavour, in turn, arises from odour.

The Desana understanding and use of these sensory phenomena or qualia is complex and extensive. As regards odour, the Desana are extremely attentive to the odours in their environment, calling themselves 'wira', which means, 'people who smell'. They hold that each individual has a 'signature' odour. This underlying odour can be altered by changes in emotional states, by lifecycle changes such as pregnancy, or by changes in diet. Tribes or extended kin groups are said to share a similar characteristic odour that permeates the area they inhabit. Even when this living space shows no sign of human habitation, the tribal scent is said to still be present. In fact, when travelling through their rainforest environment, the Desana will continually sniff the air in order to detect the scent of the peoples inhabiting the region, as well as the odours of different Amazonian animals and plants. As the Desana move through the environment they say that they lay down what they call 'wind threads', or scent trails, which can, in turn, be discerned by other people and animals.

Odours for the Desana are not simply indicators of presence, however, or of emotional state or dietary preference. Like colours, odours are believed to embody key values. One particular odour associated by the Desana with a range of items including deer and palm trees, for example, conveys the notion of male fertility. The odours of certain kinds of ants and worms, by contrast, are associated with feminine forces. Such perceived olfactory similarities make possible a variety of ritual substitutions. During certain ceremonies, for example, ants or worms may symbolize women, whose odour they share. They also necessitate an utmost attention to olfactory interrelations, as it is considered highly dangerous to combine odours (or colours) embodying contrasting forces indiscriminately. This is particularly emphasized in Desana cuisine in which great care is taken to blend food odours harmoniously, not in order to create pleasing dishes, but so as to preserve the proper order of the cosmos.

Desana artefacts, in turn, also contain multisensory meanings. The values associated with a Desana basket, for example, are manifested not only through its colours and patterns, but also through its texture, its odour, and even though the flavour of the particular vines of which it was made. (This, by the way, serves as a good illustration of how much sensory and aesthetic meaning may be suppressed when a multisensory artefact is turned into a purely visual display in a Western museum (see Classen and Howes 2006).)

The intensely multisensory nature of the Desana cosmic model means that every floral aroma, every bird song, every flutter of a butterfly suggests a particular cosmic value to the Desana and may be grouped together with other similar values in order to create a sensorial classificatory system that cuts across species' boundaries. The synaesthetic nature of the Desana cosmos means that one sensory phenomenon readily suggests another phenomenon in a different perceptual field, if not a whole train of sensations. An odour will bring to mind a colour; a colour, an odour, along, perhaps, with a temperature and a vibration. A particular design or arrangement of colours used in Desana art, for example, will evoke odours, flavours, and

other sensations customarily linked with those patterns and arouse a host of related cosmological values. A good example of this is the synaesthetic associations the Desana make with a certain kind of flute. The sound of the flute is said to be yellow in colour, hot in temperature, and masculine in odour. The vibrations it produces are said to remind people of correct child-rearing practices. I should emphasize that these synaesthetic, multimodal, associations are culturally shared and not simply the idiosyncratic perceptions of any particular individual. This form of synaesthesia transcends the domain of the neuropsychologist and involves those loops through the body, the environment, and the social world discussed earlier.

It must be noted, however, that the Desana do not themselves understand their synaesthetic world view as a cultural construct, but as plain reality. What is more, the Desana have their own theories of neuropsychology, and their brain science is highly aesthetic. The right hemisphere of the brain, they say, is concerned with practical and biological matters. This hemisphere is known as 'existence-first'. The left hemisphere has as its sphere divine, abstract ideals and is called 'abstract-first'. The right hemisphere perceives different sensory phenomena, the left translates them into underlying moral values. In another image, the brain is conceptualized as a buzzing beehive, with each hexagonal compartment containing honey of a different colour, flavour, or texture and relating to a different area of human life. As with the synaesthetic associations they reflect, such cerebral models are not the domain of specialized individuals, but are generally shared among the Desana.

As regards art, its primary role among the Desana is to employ iconic images in diverse sensory fields in order to assist individuals to be 'in tune' with the vibrating energies of the cosmos and the values these represent. Art, in fact, is a means of transcending the everyday realm of practical affairs and uniting oneself with the abstract ideals of the divine realm. The more sensory channels are involved in the process, the more complete the transcendence.

With the Desana we seem to have come as far afield as possible from Western notions of aesthetics and perception and entered a completely foreign realm or 'different reality'. Yet parallels may be found. One might think of the multisensory visions of the medieval mystics or of nineteenth-century efforts to create an 'omniart', which would engage all of the senses (see Classen 1998). Within the field of science there is the enigmatic 'pyschophysicist' Charles Henry who worked at the turn of the twentieth century. Sometimes known as the 'Symbolist scientist' for his influence on the Symbolist art movement (see Argüelles 1972), Henry argued that all of life was governed and unified by underlying cosmic 'rhythms'. Henry held that, as the cosmos itself was a unified whole, divisions and oppositions between the fields of science and art were artificial and counterproductive. Indeed, the highest goal of art, according to Henry, is to employ iconic images which will put people in touch with the basic rhythms of the universe and, by integrating all their sensory faculties, enable them to achieve a state of transcendence.

While the means by which Henry arrived at his 'scientific aesthetic', and the values he associated with different sensory phenomena, would no doubt be alien to the Desana worldview, nonetheless some correspondences are definitely there. Which leads

Fig. 9.2 David Howes delivering his paper at the 'Art and the Senses' conference (Oxford, 2006).

me to think that, when looking for bridges between science and aesthetics, as well as for relationships among the senses, one might be well advised to look not only across cultures but also at marginalized ideologies and practices within the West itself.

TOWARD A CROSS-CULTURAL MULTIMODAL THEORY OF AESTHETICS

In this essay I have described how, in modern Western culture, there is a strong tendency to *separate* the senses for scientific and aesthetic purposes. In many non-Western cultures, by contrast, the emphasis falls on the *intersection* of the senses,

or *transmutation* of one modality into another. I have further suggested that any theory of aesthetics, if it is to hold cross-culturally and not merely pertain to the West, will necessarily be multimodal, and that the same goes for any scientific theory of perception. Recent advances in neuropsychological research on the multisensory organization of the brain lend support to the latter proposition, up to a point. We have further seen that when a cross-cultural dimension is added to this theory, our comprehension of the multisensory organization of the brain stands to be increased a hundredfold, if not more, as a consequence of the revelation of all sorts of heretofore unsuspected cross-linkages between the senses in cultural practice, such as hearing scents (kōdō) and tasting sights (rasa). These practices represent so many 'loops through the environment' (in Kirmayer's terms) or ritualized 'extensions of the senses' (to borrow McLuhan's phrase) in the same way that television, for example, represents a techno-logical extension of the senses of sight and hearing.

Prior to this conference on 'Making Sense of Art, Making Art of Sense,' I held a dim view of neuropsychologists ever being able to imagine (never mind simulate experimentally) all of the possible interconnections of the senses that current research in the anthropology of the senses has brought to light and thus suggests may be latent in the human condition. This dim view was based on my perception of the absence of any meaningful cross-talk between the two disciplines. Now, after having seen Charles Spence perform on opening night, I have a much brighter view. In his pre-sentation together with Heston Blumenthal, as in the many ingenious experiments he has conducted in his Cross-Modal Research Lab, Spence has been systematically trying out every conceivable permutation in the kaleidoscope—or better, collideroscope (to borrow another McLuhan expression) of the sensorium. Indeed, Charles Spence strikes me as the Futurist scientist of our day, just as Charles Henry was the Symbolist scientist of his own time, with the difference that Spence is more interested in patterns of interference (than correspondence) and in the modulation (as opposed to the har-momization) of perception across the modalities.[9] The impressive scope of Spence's research into the multisensory integration of the brain (see e.g. Spence and McDonald 2004; Spence and Zampini 2006) leads me to think that he has brought us to the brink of a revolution in the sensory sciences which is as radical as the revolution in lin-guistic science inspired by de Saussure's *Course in General Linguistics* 1959, again with the difference that Spence's research crosses modalities whereas de Saussure confined his attention to the registration of discriminations in a single sensory field—namely, the sonic.

This paper has also attempted to recuperate the original idea behind the 'science of sense perception' as defined by Baumgarten. We have seen how his notion of aesthetics as the perception of 'the unity-in-multiplicity of sensible qualities' can be expanded through a consideration of the aesthetic practices of a range of non-Western cultures, while in the West this concept has been whittled down to fit within the discrete fields of painting, music, poetry, etc.. Here too, however, some of the more innova-tive practices of contemporary art show signs of recovering the sensory plenitude that

[9] Post-Futurist would perhaps be a more fitting appellation.

Kant sought to suppress.[10] I think of two works in the 'Art and The Senses' exhibition curated by Francesca Bacci: Oswaldo Macia's *Smellscape*, which translates the route described in Jules Vernes' *Around the World in Eighty Days* into scents in a manner reminiscent of the Shirakawa Border Station version of the Japanese incense cere-mony; and, Helen Ganly and Heather Peers' *The Radcliffe Camera as a Celebration Cake and Its Workbook*, which, when properly savoured, recalls to mind the practice of tast-ing sights which is so central to the Indian theatrical tradition. It is true that neither of these installations is as interactive or transformative as the non-Western examples to which I compare them here, nor are they rooted in social practice (that is, in a par-ticular lifestyle or culture), but they do open the perceiver to the experience of inter-sensoriality, and therein lies their value.

What is more, the works by Macia and Ganly and Peers help attune us to a dif-ferent way of perceiving art, of which art historians should take note. Rather than conceive of themselves as students of 'visual culture', art historians ought to expand their frame of reference to include the 'sensual culture' of which the visual is but one dimension. Our appreciation of the art of the Symbolists or Futurists stands to be enhanced considerably by adopting such a multimodal approach, as Classen (1998) has shown. And even the drive toward abstraction in the art of the later twentieth century is best understood using a multimodal approach, given that the impetus behind many of the earliest (and still finest) instances of non-representational art (e.g. the paintings of Wassily Kandinsky or Georgia O'Keefe) was the aspiration to create 'visual music'.[11] This brings me to my final point: when doing art history, whether one's passion is for painting or music or architecture, etc., it is surely advisable to cultivate (at least) two senses, rather than one.

ACKNOWLEDGEMENTS

I wish to thank my research assistant, Elena Papadakis, for supplying me with many sensational sources, and Constance Classen and Andrew Irving for their helpful comments on earlier versions of this paper. I am especially indebted to Francesca Bacci and David Melcher for organizing the 'Art and the Senses' conference, and creating such a stimulating forum for the exchange of ideas. This paper is based in part on research made possible by a grant from the Social Sciences and Humanities Research Council of Canada.

[10] If you think the critique of Kant presented here is overly harsh, see his withering critique and dismissal of any aesthetic vocation for the senses of smell and taste (Kant 2005).

[11] The history of synaesthesia in art and music since 1900 is traced by Brougher et al. in *Visual Music* (2005); for a multisensory critique of their argument see Howes 2006b.

REFERENCES

Argüelles JA (1972). *Charles Henry and the formation of a psychophysical aesthetic.* University of Chicago Press, Chicago, IL.

Baron-Cohen S and Harrison J, eds. (1997). *Synaesthesia: Classic and Contemporary Readings.* Blackwell, Oxford.

Bedini S (1994). *The Trail of Time.* Cambridge University Press, Cambridge.

Bernstein L, Auer E Jr, and Moore J (2004). Audiovisual speech binding: convergence or association. In G Calvert, C Spence, and BE Stein, eds. *The Handbook of Multisensory Processes,* pp. 202–23. The MIT Press, Cambridge, MA.

Brougher K, Strick J, Wiseman A, and Zilzcer J (2005). *Visual Music: Synaesthesia in Art and Music since 1900.* Thames & Hudson, London.

Calame-Griaule G (1986). *Words and the Dogon World,* D La Pin trans. Institute for the Study of Human Values, Philadelphia, PA.

Calvert G, Spence C, and Stein BE, eds. (2004). *The Handbook of Multisensory Processes.* The MIT Press, Cambridge, MA.

Classen C (1990). Sweet colors, fragrant songs: sensory models of the Andes and the Amazon. *American Ethnologist,* **17,** 722–35.

Classen C (1993). *Worlds of Sense: Exploring the Senses in History and Across Cultures.* Routledge, London and New York.

Classen C (1997). Foundations for an anthropology of the senses. *International Social Science Journal,* **153,** 401–12.

Classen C (1998). *The Color of Angels: Cosmology, Gender and the Aesthetic Imagination.* Routledge, London and New York.

Classen C and Howes D (2006). The Museum as sensescape: western sensibilities and indigenous artifacts. In E Edwards, C Gosden, and R Phillips, eds. *Sensible Objects.* Berg, Oxford.

Classen C, Howes D and Synnott A (1994). *Aroma: The Cultural History of Smell.* Routledge, London and New York.

Drobnick J (2004). Volatile effects: olfactory dimensions of art and architecture. In D Howes, ed. *Empire of the Senses: the Sensual Culture Reader.* Berg, Oxford.

Eagleton T (1990). *The Ideology of the Aesthetic.* Blackwell, Oxford.

Elkins J (2000). *How To Use Your Eyes.* Routledge, New York.

Gebhart-Sayer A (1985). The geometric designs of the Shipibo-Conibo in ritual context. *Journal of Latin-American Lore,* **11,** 143–75.

Gregor MJ (1983). Baumgarten's Aesthetica. *Review of Metaphysics,* **37,** 357–85.

Howes D (2003). *Sensual Relations: Engaging the Senses in Culture and Social Theory.* University of Michigan Press, Ann Arbor, MI.

Howes D, ed. (2004). *Empire of the Senses: The Sensual Culture Reader.* Berg, Oxford.

Howes D (2006a). Scent, sound and synesthesia: intersensoriality and material culture theory. In C Tilley, W Keane, S Küchler, M Rowlands, and P Spyer, eds. *Handbook of Material Culture,* pp. 161–72. Sage, London.

Howes D (2006b). Cross talk between the senses. *The Senses & Society,* **1,** 381–90

Illius B (2002). *Ventana hacia el infinito; arte shipibo-conibo.* Instituto Cultural Peruano Nortamericano, Lima.

Kant I (2005). Objective and subjective senses: the sense of taste. In C Korsmeyer, ed. *The Taste Culture Reader,* pp. 209–14. Berg Publishers, Oxford.

Kirmayer LJ (2007). On the cultural mediation of pain. In S Coakley and K Shelemay, eds. *Pain and its Transformations,* pp. 363–401. Harvard University Press, Cambridge, MA.

Kirshenblatt-Gimblett B (1998). *Destination Culture.* University of California Press, Berkeley, CA.

Marinetti FT (1989). *The Futurist Cookbook,* S Brill trans. Bedford Books, New York.

Marinetti FT (2004). Tactilism. In C Classen, ed. *The Book of Touch.* Oxford, Berg.

Morita K (2007). *The Book of Incense.* Kodansha International, New York.

Osborne H (1984). The cultivation of sensibility in art education. *Journal of Philosophy of Education,* **18**, 31–40.

Partan S (2004). Multisensory animal communication. In G Calvert, C Spence, and BE Stein, eds. *The Handbook of Multisensory Processes.* The MIT Press, Cambridge, MA.

Pinard S (1991). A taste of India: on the role of gustation in the Hindu sensorium. In D Howes, ed. *The Varieties of Sensory Experience.* University of Toronto Press, Toronto.

Pybus D (2001). *Kodo: The Way of Incense.* Turtle Publishing, Boston, MA.

Ramachandran VS, Hubbard EM, and Butcher PA (2004). Synaesthsia, cross-activation, and the foundations of neuroepistemology. In G Calvert, C Spence, and BE Stein, eds. *The Handbook of Multisensory Processes.* The MIT Press, Cambridge, MA.

Redfield, Robert (1971). Art and icon. In C Otten, ed. *Anthropology and Art.* Natural History Press, New York.

Rée J (2000). The aesthetic theory of the arts. In P Osborne, ed. *From an Aesthetic Point of View.* Serpent's Tail, London.

Saussure F de (1959). *Course in general linguistics,* W Baskin trans. McGraw-Hill, New York.

Schechner R (2001). Rasaesthetics. *The Drama Review,* **45**, 27–50.

Smith BR (2004). Listening to the wild blue yonder: the challenges of acoustic ecology. In V Erlmann, ed. *Hearing Cultures: Essays on Sound, Listening and Modernity,* pp. 21–41. Berg, Oxford.

Spence C and McDonald J (2004). The cross-modal consequences of the exogenous spatial orienting of attention. In G Calvert, C Spence, and BE Stein, eds. *The Handbook of Multisensory Processes.* The MIT Press, Cambridge, MA.

Spence C and Zampini M (2006). Auditory contributions to multisensory product perception. *Acta Acustica,* **92**, 1–17.

Stevenson RJ and Boakes R (2004). Sweet and sour smells: learned synesthesia between the senses of taste and smell. In G Calvert, C Spence, and BE Stein, eds. *The Handbook of Multisensory Processes.* The MIT Press, Cambridge, MA.

Sur M (2004). Rewiring cortex: cross-modal plasticity and its implications for cortical development and function. In G Calvert, C Spence, and BE Stein, eds. *The Handbook of Multisensory Processes.* The MIT Press, Cambridge, MA.

Turner B (1994). Introduction. In C Buci-Glucksmann, *Baroque Reason: The Aesthetics of Modernity.* Sage, London.

THE SCIENCE OF TASTE AND SMELL

TIM JACOB

INTRODUCTION TO TASTE AND SMELL

WHY are taste and smell such underrated senses? I hope I can put the record straight and convince you of their importance in this chapter.

Taste and smell are the 'chemical' senses, so-called because they respond to chemicals in our food, drink, and the air we breathe. They have been around for a long time in evolutionary terms and are older senses than vision and hearing. They still retain some of their primeval characteristics and functions, as we shall see. Both senses have access to more primitive and subconscious regions of the brain where they influence mood and emotion, and can evoke feelings of dèja vu—have you ever encountered that smell that takes you right back to childhood? These senses can also trigger involuntary reflexes—like vomiting when you really don't like the taste of something. The two senses, taste and smell, combine in higher brain areas (the cortex) to provide information about flavour. In simple terms our sense of smell is a hazard warning system, protecting us from danger, although as we will see there is much more to it than that. Our sense of taste drives our appetite for essential foods and is sometimes referred to as the body's 'last gatekeeper' for its role in preventing us from ingesting poisons.

SMELL

What is smell?

Smells, or more scientifically 'odorants', are airborne chemicals. We take them into the nose as we breathe and they dissolve in the mucus at the roof of the nostrils. In order to be detected by our olfactory system these odorants need to have certain properties. For instance, they must be small enough to be volatile (less than ~300 relative molecular mass) so that they can vaporize, get airborne, reach the nose, and then dissolve in the mucus. This tells us that smell, unlike taste, can signal over long distances,[1] enabling it to function as an early warning device. The olfactory system is an early evolutionary adaptation and hasn't changed much between the fruitfly (*Drosophila*) and mammals. The fly has an olfactory system with a very similar organization to that of the mouse. This similarity between the olfactory systems suggests that a very efficient solution to the problem of detecting and discriminating small molecules emerged over 500 million years ago, the evolutionary distance between these two species, and has not required much modification since.

Of course, the human olfactory system does more with the information it receives than the fly. Our nose samples our environment for information, continuously testing the quality of the air we breathe (this will alert us to potential dangers, e.g. smoke, decomposition) as well as informing us of other relevant information, such as the presence of food, the familiarity/novelty of the ambient smell and its congruency with the surroundings, or the identity of another individual.

How do we smell?

Once odorants have dissolved in the mucus they are carried by a protein 'taxi service' to their receptor. This taxi service is a class of protein, the odorant binding proteins (OBPs) that perform the vital function of first getting the odorants to their correct destination and, secondly, removing them for degradation so we are ready for the next smell. The receptors are situated in a region called the olfactory epithelium at the roof of the nostrils (Fig. 10.1). The receptors are expressed on the membrane surface of the cilia of the olfactory receptor neurons (ORNs). These cilia, which are non-motile, hang down into the mucus (Fig. 10.2). They are particularly vulnerable

[1] Pong in the air is 'Euro-whiff'. *BBC News, 18 April 2008*. A foul smell detected in parts of England and Wales is being blamed on easterly winds bringing farming or industrial smells across the Channel. Labelled 'Euro-whiff' by the Met Office, the source of the smell – alternately described as sulphur and manure – is under investigation. The Met Office said it had had hundreds of calls from the public looking for information about the odour. The BBC News website received more than 1,000 e-mails about the smell. The likely source according to the Met Office was either agricultural or industrial works in western Europe.

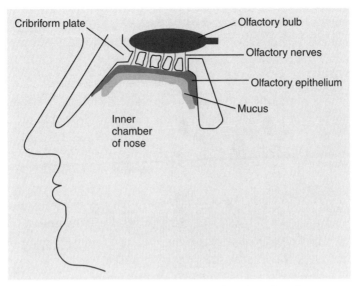

Fig. 10.1 A section through the nose showing the elements of the front end of the olfactory system. The olfactory epithelium contains olfactory receptor neurons (ORNs) as well as other cell types (see Fig. 10.3), which extend cilia into the mucus. ORNs have an axon that projects through the bone (cribriform plate) to the olfactory bulb.

(Source: http://www.cf.ac.uk/biosi/staffinfo/jacob/teaching/sensory/olfact1.html)

to damage from environmental exposure (to oxidizing agents, pollutants) and are replaced every 2 to 3 weeks. City-dwellers tend to have poorer senses of smell than country folk because of the damage done by pollution (e.g. sulphur and nitrogen oxides from car exhausts).

The importance of smell

The importance of smell can be appreciated by understanding what is lost by someone who loses their sense of smell later in life.[2] Smell permeates every aspect of our lives, it is the backdrop of our every waking experience and it contributes towards the pleasure of eating and drinking. The familiarity/novelty of smells in any situation relays information to us. If, for example, upon returning home you smell an unfamiliar smell you will be immediately alerted and investigate it in an attempt to identify the source. We look for congruency in smells—things should smell as we expect them to. Pleasant, familiar smells are relaxing and, under the right conditions, this can be

[2] Anosmia is the medical term.

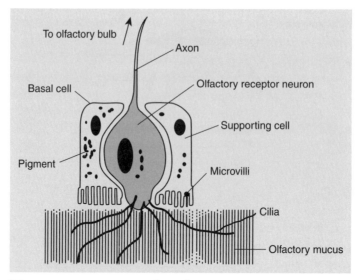

Fig. 10.2 Olfactory receptor neurons (ORNs) are embedded in the olfactory epithelium which also contains basal cells and supporting cells. The nasal epithelium contains some 10 million ORNs in humans (more in rats and cats) and certain dogs, e.g. bloodhounds, have as many as 250 million. The ORNs possess a terminal enlargement (a 'knob') that projects above the epithelial surface, from which extend the 8–20 olfactory cilia. Basal cells are stem cells for ORNs as well as other epithelial cells. Supporting cells contribute to the composition of the mucus layer as well as supporting the ORNs metabolically. The odorant receptors are situated on the cilia. The axon from the ORN projects to the olfactory bulb.

(Source: http://www.cf.ac.uk/biosi/staffinfo/jacob/teaching/sensory/olfact1.html)

used therapeutically. Smell is associated with memory, particularly with our emotional memory. It is integral to relationships—there are biological mechanisms at play which influence our choice of partner based on their smell, and smell is an important factor in sex. A loss of libido can follow loss of smell. We gain information about ourselves and others through the medium of smell. We communicate emotions (fear, happiness) via smell and many aspects of health are related to smell. We tend to avoid smells we find unpleasant and we find them unpleasant for good reason—they may be hazardous, poisonous, or warn us of death, decay, disease, and unhygienic conditions. Furthermore, there is the whole universe of perfume, fragrance, and the associated memories. Imagine a world without this olfactory dimension.

Where the nose leads the rest of us follows. More than any other sense our sense of smell determines the emotional tone of our every experience.

Smell and the brain

The sense of smell is often considered in isolation. We study the neuroanatomy of the olfactory system, its complex connections, and the perception of odours, and attempt

to understand how smell works. Consciousness is the result of integrated sensory input and smell is therefore an integral part of our consciousness, and, while the isolation of the olfactory system may make it simpler to study on its own, we may miss the point of its real contribution to our lives.

We respond in an involuntary way to smell—this is due to the wiring of the olfactory pathway. The olfactory nerves go first to a primitive region of the brain called the limbic system (Fig. 10.3). The limbic system is a collection of brain structures situated beneath the cerebral cortex that deal with emotion, motivation, and association of emotions with memory. Only after this relay has occurred does the information arrive in the higher cortical brain regions for perception and interpretation. Smell is unique among the senses in its privileged access to the subconscious. The limbic system includes such brain areas as the amygdala, hippocampus, pyriform cortex, and hypothalamus (Fig. 10.3). This complex set of structures lies on both sides and underneath the thalamus, just under the cerebral cortex. The limbic system is increasingly recognized to be crucial in determining and regulating the entire emotional 'tone'. Excitation of this, by whatever means, produces heightened emotionalism and an intensification of the senses. For instance, the voice of a loved one in a crowded room. The emotional salience of the stimulus increases the attention that is paid to this sensory input at the expense of other, less relevant information. The limbic system also has a lot to do with the formation of memories and this is the reason that smell and memory are so intimately linked. Think of the perfume/eau de cologne of your

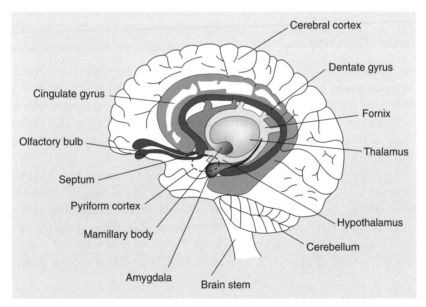

Fig. 10.3 A section through the brain showing the main structures of the limbic system (gray-shaded regions)—amygdala, cingulate gyrus, dentate gyrus, fornix, hippocampus, hypothalamus, mamillary body, pyriform cortex (outside the plane of this section) and septum. (© Tim Jacob 2007).

first girl/boyfriend, a smell that can take you right back and evoke a surprising amount of detail about the person as well as the emotions you experienced at the time.

TASTE

Introduction to taste

We have particular taste sensitivities to those foods and minerals for which we have an absolute requirement. Thus, we have a sweet receptor because we need carbohydrates for energy, an umami[3] receptor for amino acids (the building blocks for proteins) for growth and repair, and a salt receptor because we must have salt (sodium chloride). The appetite for a particular food, when satisfied, causes the brain to release a reward signal and also to suppress the desire for that food. This can explain why chocolate is so seductive. This reward system worked well in the past when *Homo sapiens* had to work hard to find carbohydrates, but now we are surrounded by them it encourages obesity.

The sour and bitter tastes evoke an aversive response and protect us by preventing ingestion of acids (sour) and poisons (most poisons taste bitter).

Taste mechanisms

The five tastes each have a receptor mechanism that has been identified genetically, and the mechanisms for translating taste into nerve impulses for the brain to interpret is becoming much better understood. Tastes are detected by taste cells within taste buds and these taste buds are situated on *papillae* distributed over the surface of the tongue (Fig. 10.4). Those little red dots scattered over the front of your tongue are taste papillae. Each taste bud contains a number of taste receptor cells, each expressing different receptors and they will therefore be sensitive to a number of different tastes. Although the 'taste maps' one sees in text books and reproduced in numerous articles are wrong,[4] it is true that we are more sensitive to bitter taste at the back of the tongue. It is for this reason that mums and dads try to spoon the unpleasant bitter-tasting medicine directly down the throats of their reluctant offspring— skipping the tongue altogether to avoid activating the bitter detectors. Bitter taste

[3] Umami (pronounced ōō-mä'mē) was first identified by Kikunae Ikeda at the Imperial University of Tokyo in 1909. It has only recently been adopted in the West following identification of its receptor.

[4] This myth originated from the misinterpretation of a PhD thesis written in German by Hanig in 1901. His thesis included a graph of tongue regional sensitivity with no scale on the y-axis. Another scientist later took the reciprocal of these values greatly exaggerating their differences.

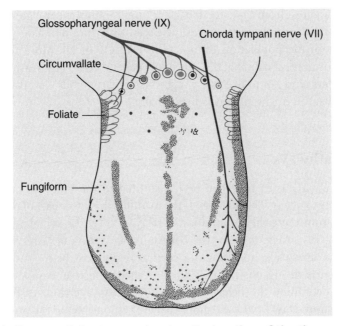

Fig. 10.4 A diagram of the tongue showing the location of the three main types of taste papillae. Fungiform papillae are located at the front of the tongue and appear as little red dots. Foliate and circumvallate papillae are situated at the back of the tongue and this region is more sensitive to bitter and sour tastes. The output from the papillae is carried to the brain by two separate nerves (cranial nerves 7 and 9). Cranial nerve 9 carries information about bitter and sour taste from the foliate and circumvallate papillae. There are no taste papillae in the central region of the tongue leading to a taste 'blind spot'.

(Source: http://www.cf.ac.uk/biosi/staffinfo/jacob/teaching/sensory/taste.html)

warns of danger and most drugs are poisons (especially at high concentrations) and taste bitter. However, all taste buds are sensitive to all tastes to some extent; for example, you can taste a coffee granule (bitter) on the front of your tongue. The fungiform papillae, so-called because they resemble button mushrooms in shape, are found mainly on the front of the tongue and, while they are sensitive to all tastes, they are predominantly sensitive to salt and sweet tastes. There is a bald patch in the centre of the tongue with no papillae. We are therefore 'taste blind' in this region but, when we swallow, food in this region is brought into contact with the roof of the mouth where there are more taste buds.

Supertasters

About 25% of the population, and more women than men, have a 'super-sensitivity' to the chemical n-propylthiouracil (n-PROP) (Bartoshuk et al. 1994). This has a

genetic basis and results in a greater density of fungiform taste papillae, and therefore taste buds, on the tongue which can easily be seen with the aid of a magnifying glass. Another 25% of the population cannot taste *n*-PROP at all. More recent studies (Lim et al. 2008) have shown that this sensitivity generalizes to other tastes (e.g. sweet) and supertasters tend not to like green vegetables or fatty foods, and there have been suggestions that this might influence dietary habits.

Central pathways

Information about taste must then be transmitted to the brain, in order for perception of taste to occur. The first stop is the medulla, the lower part of the brain stem in Fig. 10.3. From there the information is relayed to (1) the somatosensory cortex (postcentral gyrus in Fig. 10.5) for the conscious perception of taste, and (2) to the hypothalamus, amygdala, and insula (a cortical region just below and in from the postcentral gyrus in Fig. 10.5), giving the so-called 'affective' component of taste. These latter determine the behavioural response, e.g. aversion, gastric secretion, feeding behaviour. It is also these regions that are responsible for the protective function of taste—its 'last gatekeeper' role—and if we ingest poison a vomiting reflex is triggered.

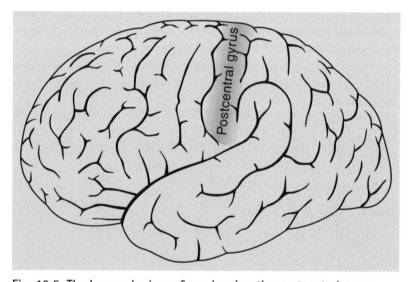

Fig. 10.5 The human brain surface showing the postcentral gyrus, one of the cortical regions where taste information is processed, the other being the insula, just down and in from this region, which is linked to the affective component of taste.

(©Tim Jacob 2007. Source: Wikipedia, with permission.)

Smell and taste receptors

We are sensitive to tens of thousands of different smells partly because we have hundreds of different receptors (~350), and lower mammals like rats and dogs have even more functional receptors than we do giving them a greater sensitivity. For instance, a bloodhound can intersect a person's trail and only requires two to five steps to know in which direction the person was heading.[5] Scientists are working out the structure and sensitivity of individual receptor molecules and, in the future, perfumes may be tailor-made to activate certain receptors. We have far fewer taste receptors— only five. These are the five basic tastes, salt, sour, sweet, bitter, and umami (savoury), for which there are known receptor mechanisms and, although other tastes such as fat, metallic, and astringent have been suggested, their receptor mechanisms remain obscure.

WHAT ARE SMELL AND TASTE USED FOR?

Smell and taste as warning systems

We have an innate response to tastes. In particular, human infants appear to be 'hard-wired' for tastes that affect survival such as sweet and umami tastes, which would indicate nutritious foods, and for bitter and sour tastes that would indicate potentially harmful substances. Sweet and sour tastes modulate the suckling behaviour of babies (Ganchrow and Mennella 2003) and have been shown to induce facial expressions suggesting 'acceptance' or 'aversion' in neonates (Steiner 1974). There also appears to be an innate mechanism maintaining salt (NaCl) balance, and salt is, of course, an essential part of our diet (Pfaffmann 1978). Interestingly, newborn babies do not have such a need and are indifferent or averse to saline solutions, developing a preference for saline from 6 to 24 months, and this mechanism may be dependent upon the later appearance of salt receptors on the tongue (Mistretta and Hill 2003). Generally children and adolescents prefer higher concentrations of sweet and salt tastes than adults (Ganchrow and Mennella 2003) but there appears to be an opposite response to bitter tastes, with adults being more tolerant (Murphy et al. 1997). If one considers the hazard detection function of the two senses, then smell warns us of danger at a distance while taste is much more proximal. Tasting requires ingestion of the substance and, if it is identified as potentially toxic, a vomiting reflex is triggered to prevent swallowing the hazard (Donnerer 2003).

Some research suggests that we appear to have an innate ability to detect bad, aversive smells. One-day-old babies give facial expressions that indicate rejection

[5] The dog detects the concentration of scent on the trail—the more recent, the more concentrated.

when given fish or rotten egg odour (Steiner 1977). This is an area of some controversy since it is difficult to assess the meaning of a day-old baby's facial expressions and they could just be responding to the intensity of the odour rather than the quality. The alternative hypothesis is that response to smell is learned—and there is much support for this idea including work that shows babies can learn odours *in utero* (Schaal et al. 2000).

Babies born to mothers eating 'anise' showed a preference for anise odour compared to those born to non-anise consuming mothers, which displayed aversion or neutral responses. However, one has to ask the question of what use exactly is a warning system in which one has to learn which are the hazardous odours? By the time one has learned it may be too late!

There are some cross-cultural differences in the appreciation of smell. Wintergreen is considered to be a pleasant smell in the United States whereas it is unpleasant in the United Kingdom (Cain and Johnson 1978). These cross-cultural differences extend to the odour of people; for instance Western Europeans, and in particular the British, are perceived by Hindus as smelling of butter/milk because of their large intake of dairy products. The Japanese have very few apocrine glands in their axillae (Kuno 1956, p.417) and the smell of body odour was, until recently, grounds for dismissal from the Japanese army. Europeans smell strongly of body odour to the Japanese although they are far too polite to say so.

Flavour

Many people mistake flavour for taste, indeed one chef misguidedly insured his taste buds for one million pounds. Flavour is mainly smell Although it does include contributions from the sense of taste (as well as touch (mouth-feel), temperature, pH,[6] and moisture) it is mainly smell (75–90%). Test this for yourself by eating or drinking something while holding your nose.

Smell is vital to our enjoyment of food and drink. Without smell the experience of eating and drinking is reduced to the five basic taste qualities, namely: sweet, salt, sour, bitter, and umami (savoury).

Smell is important to our appetite—when we are hungry, the brain sends information to the olfactory bulb, removing inhibition which acts to sensitize our noses to smells, and food smells are particularly attractive. However, the situation changes radically upon satiation. When our stomach is full, odours that we found pleasant a short while before, are now unpleasant or even repulsive to us.

[6] pH is a measure of acidity-alkalinity. Strong acids have a low pH.

Your unique smell

Our olfactory system is doing more than just giving us warnings. Amongst other possibilities, it serves a recognition function. We all have our own unique smell and can recognize and be recognized by our smell, and this is important for our social interactions. For a fascinating insight into the possible consequences of having no smell I recommend Patrick Suskind's book *Perfume*, whose protagonist, Grenouille, was born with no smell. There are two main determinants of our odour—in addition, of course, to personal hygiene. First, our individual smell, or odortype, is determined by our immune system. And, as we each have an unique immunotype—determined by our HLA (human leucocyte antigen) molecules (see next section)—so we all have an unique smell, with the exception of identical twins, although some dogs can tell identical twins apart if they are on different diets—the second major determinant of our personal smell. Because of this odortype we can recognize family members and distinguish them from non-family. Indeed we tend not to like the smell of our opposite gender siblings and parents, and this has been suggested to be an anti-incest device. It is interesting that a common insult in many cultures is 'you stink'. Artists have commented on the link between smell and identity on numerous occasions. Smell artist Clara Ursitti exhibited *Eau Claire*, a bottle containing her distilled body odour (Fig. 10.6).

Fig. 10.6 Clara Ursitti, *Eau Claire*, 1993.

(Photograph: courtesy of the artist.)

She also famously authored an installation called *Bill*, presented in the wake of the Monica Lewinski scandal, featuring an empty room filled with the scent of semen.

Mothers learn to recognize the smell of their babies; 90% of women tested identified their babies by smell alone after only 10 minutes to 1 hour's exposure to their baby (Kaitz et al. 2004). All of the women tested recognized their babies' smell after exposure periods greater than 1 hour. By as early as 3 days a baby can discriminate between a gauze pad worn by his or her own breastfeeding mother and that worn by another lactating mother used as a control. The smell of newborn babies always features in the top ten of the most popular smells in surveys. Babies need to use all means at their disposal to attract favourable attention from their mothers.

Communication using smell

Smell (odortype) and mate selection

Some people find other people's natural body odour repellent, while others they find attractive. A person's smell reveals information about their immune system. Increasing evidence indicates that the major histocompatibility complex (MHC) genes —called HLAs in humans—which control immunotype, influence odour and mating preferences in house mice and humans (Penn and Potts 1999). The more dissimilar the immunotype, the more attractive the smell (within certain limits). It has been shown that each person's unique smell, their odortype, is in some way related to their HLA genes (Eggert et al. 1999). Wedekind and colleagues (1997) demonstrated that women preferred male odours when their HLA differed from their own. The smell from men with similar HLAs was found to be unpleasant. Furthermore, the odour of HLA-dissimilar men reminded the test women more often of their own actual or former mates than did the odours of HLA-similar men, suggesting that the HLA genes influence human mate choice.

Men and women have different criteria for mate selection. Work by Herz and Inzlicht (2002) showed that women rank body odour as more important for attraction than 'looks' or any social factor except 'pleasantness'. So, guys, watch your smell! Moreover, in contrast to the response to fragrance use, liking someone's natural body odour was the most influential olfactory variable for sexual interest for both men and women. On the other hand men rated a woman's good looks as most desirable (men are so superficial!) and as more important than any other factor except pleasantness.

The combination of two different immunotypes (different HLA genes) would increase disease resistance and immunity in the offspring of such a marriage. Further illustrating the unconscious involvement of biology in our choices, marriages between people with identical HLA haplotypes are less frequent than expected and a high degree of HLA similarity between partners increases the chance of miscarriage (Ober 1999). An awareness of the importance of smell in mate selection is detectable in olfactory artwork. Designer James Auger devised a system, called *Smell + Apocrine gland secretion transfer system* (Fig. 10.7), which allows people to smell each other's

bodily scents before they actually meet. According to the artist this prototype, recently exhibited at MOMA's 'Design and the Elastic Mind' show, is a 'proposal is for a blind dating agency aimed at individuals wishing to meet a suitable partner for procreation. Olfactory communication is given precedence over visual stimuli.'

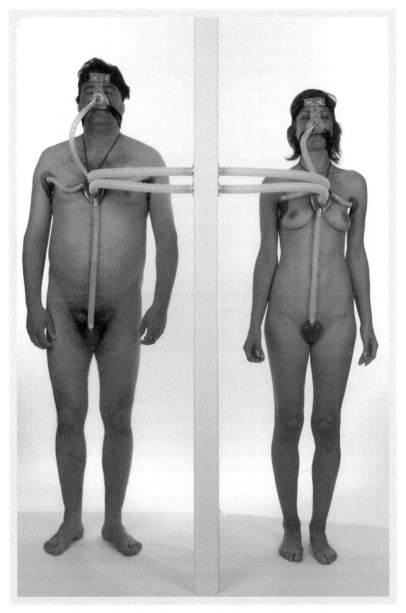

Fig. 10.7 James Augier, *Smell + Apocrine gland secretion transfer system*, 2007.

(Photograph: courtesy of the artist.)

Using smell to advertise your genes

In a study by Milinski and Wedekind (2001), 137 male and female students who had been immunotyped for their HLA were required to score their preferences for key perfume ingredients. It was found that there was a correlation between HLA type and choice of perfume ingredient. The authors' conclusion was that perfumes are selected 'for self' to amplify body odours that reveal a person's immunogenetics. This would imply that we use perfumes to advertise our HLA to attract an appropriate, genetically matched partner.

Menstrual synchrony

One of the most often-quoted examples of smell signalling in humans is menstrual synchrony. McClintock (1971) found that female college students, who spent significant amounts of time together, showed synchrony of their menstrual cycle, and attributed this synchrony to odours (pheromones). A few years later this finding was reinforced by another study (Stern and McClintock 1998). Sweat samples of five women with regular 29-day cycles were taken daily. These donor samples were applied to the upper lips of the female test subjects three times a week for 4 months. By the end of the test period, test subjects menstruated significantly more often at the same time as the donors than subjects in the control group. It was suggested that menstrual synchrony, which also is indicative of ovulatory synchrony, was controlled by pheromones. In a parallel study, the influence of male odours on the menstrual cycle was tested. Odour samples of male axillary secretions were again applied to the upper lips of female test subjects. Those who were not sexually active had irregular menstrual cycles at the beginning of the experiment. After 4 months the mean cycle length was 29.5 ± 3 days in a majority of the test subjects. This strongly suggested that male pheromones have a regulatory effect on the menstrual cycle.

Fear and happiness

Dogs and horses can smell fear in humans. Work by Chen and Haviland-Jones (1999) has demonstrated the ability of underarm odour to influence mood in others. Karl Grammer and colleagues have recently demonstrated that the smell of fear can be detected (by women) in the armpit secretions of people who watched a terrifying film (Ackerl et al. 2002). The implication of this work is that a chemical signal is secreted in sweat which communicates the emotion. So far, fear and happiness are the only two emotions to have been shown to be communicated in this way and women are more sensitive than men at interpreting the chemical signal.

Fittingly, artist Sissel Tolaas' best known work is titled *the FEAR of smell – the smell of FEAR* (2005 to present: Fig. 10.8). The installation presents synthesized human sweat pheromones microencapsulated and embedded in white paint on the gallery walls. These scents faithfully reproduce the bodily smells of (so far) nine men experiencing fear, with whom the artist has worked for 5 years. The odours are released manually, via scratch-and-sniff, by the visitors. With this work Tolaas intended to re-assert the social importance of the sense of smell in relation to the over-valued visual or auditory senses.

Fig. 10.8 Sissel Tolaas, *the FEAR of smell – the smell of FEAR,* 2005 to present.

(Photograph: courtesy of the artist.)

Smell indicates reproductive status

Humans are capable of discriminating between males and females by olfactory cues alone. These chemical cues are molecules derived from the sex hormones oestrogen and testosterone. Sex differences in the composition of human axillary (armpit) secretions may be the basis for such discrimination. In women, these compounds would be highest in those of reproductive age. Women's body odour is rated as more pleasant during ovulation and men tend to rate women more highly (i.e. more attractive) when they are exposed to secretions produced by ovulating women (Kohl et al. 2001). In lower mammals, one function of chemical communication is to produce properly timed mating, and oestrus is signalled by visual and odour cues. However, the situation in humans is more complicated and a woman's most fertile period, ovulation, is concealed. It has therefore been proposed that these secretions and odour changes that occur at ovulation are part of an elaborate and unconscious reproductive signalling mechanism (Kohl et al. 2001).

Changes in smell and smell sensitivity

Effect of hormones

Women's sense of smell peaks at ovulation, coinciding with a surge in the hormone oestrogen. It has been suggested that this enables them to be at their most sensitive to the smell of any potential mate (i.e. their suitability—see section 'Smell and mate selection') when they are at their most fertile (Kohl et al. 2001).

There have been many stories about smell changing during pregnancy when hormone levels are changing dramatically. Most pregnant mums have some recollection of strange alterations to smell and taste. Leslie Cameron (Cameron 2007) studied these effects and found that, consistent with previous reports, 90% of pregnant women reported that specific odours smelled less pleasant and 60% reported that some odours smelled more pleasant. Although nearly two-thirds of pregnant women rated their olfactory sensitivity to be enhanced during pregnancy and overall pregnant women's self-rated olfactory sensitivity was higher than that of controls, self-ratings did not correlate with measured scores. The results suggest that her findings and those of previous studies may reflect the fact that the effect of pregnancy on olfaction is small and inconsistent.

Changes in sensitivity to certain hormones

We can change our sensitivity to certain hormones (derived from testosterone and oestrogen) found in our sweat by repetitive exposure. This was first demonstrated by Wysocki et al. (1989) when one of the experimenters (C.J.W.), who was anosmic (unable to smell) for androstenone at the beginning of one of their previous studies, found himself becoming sensitive to it as the trial progressed. It was thought that certain people, who were unable to smell this compound, had a specific anosmia. However, they went on to demonstrate that this was a general phenomenon and people could 'learn' to smell it by repetitive exposure (sniffing a sample for 5 minutes three times a day). Jacob and colleagues (Wang et al. 2004; Jacob et al. 2006; Boulkroune et al. 2007) have shown that this also occurs with other related compounds and that, as sensitization occurs, the smell quality of the hormone changes and the electrical response of the brain increases in a gender specific manner. These compounds are not very volatile and we will only detect them on someone else by getting close to them. This will happen most often in between mothers and babies and couples. Because of this it has been suggested that these compounds may play a role in bonding in some presently unknown manner (Boulkroune et al. 2007).

Specific anosmias

Some people cannot smell skunks, others cannot smell fresias. These specific anosmias led John Amoore on a wild goose chase in the 1960s searching for the 'primary' smells from which all other smells were formed, analogous to vision where the colours of the visible spectrum are formed by the differential of activation of green, blue, and red cones. We now know that this is not how smell works, but these interesting anomalies remain. The current thinking is that smell receptors detect molecular features of odorants. One odorant will therefore activate a number of receptors and one receptor will be activated by many different odorants. The perceived smell is derived from the pattern of receptor activation.

Smell and health

Our smell changes when we are anxious or ill, and certain diseases have particular smells. Physicians used to speak of typhus as having a close, mawkish (sickly) odour; the smell of smallpox is very distinctive—at the end of the illness, skin lesions spread

into every bodily opening, including the mouth and eyes. When these lesions blackened and peeled off, they emitted a sweet and pungent odour known as the 'smallpox smell'; diphtheria has a mousy smell. An acid smell is indicative of acute rheumatism, and the sweet-smelling breath of diabetics is well known. Curiously a sweet smell was said to attend the plague, but what was counted as sweet then might not be so now. This phenomenon of disease-related odours is being used to advantage, and electronic noses have been developed that can smell tuberculosis bacteria on the breath.

There have been anecdotal reports of dogs spotting cancer in their owners, but now researchers have proved this phenomenon scientifically. In the United Kingdom, dogs have been trained to sniff out bladder cancer and the first controlled experiments verified the claim (Willis et al. 2004). In the United States, ordinary household dogs with only a few weeks of basic 'puppy training' learned to accurately distinguish between breath samples of lung- and breast-cancer patients and healthy subjects (McCulloch et al. 2006). Portuguese designer Susana Soares studied how bees can be trained to target a specific odour very easily, using Pavlov's reflex. She then produced *BEE'S* (2007), a series of glass objects that contain bees trained to detect a woman's fertility status through smelling her breath, and several other health conditions. These diagnostic instruments use insects as biosensors, while also being easy to use and aesthetically pleasing.

Smell and starvation

During starvation, fat gets broken down to ketone bodies which, in turn, get broken down to acetone. Ketone bodies are produced mainly in the liver and provide much of the energy for the heart and brain during starvation. Acetone, derived from the metabolism of ketone bodies, has a fruity smell and a sweet taste. During starvation the breath can smell fruity sweet due to the presence of acetone. Mediaeval mystics starved themselves to reach a state of altered consciousness. Reports that the mystics smelled sweet and experienced a sweet smell and taste comparable to honey are probably explained by this phenomenon. Pleasant smells have been associated with holiness as foul smells with sin. 'Heavenly scents' were said to have been emitted by Saint Teresa of Avila, Saint Thérèse de Lisieux (known as 'the Little Flower'), and Saint Maravillas of Jesus immediately after they had died. The smell of roses is said to have emanated from Padre Pio's stigmata. St. Casimir, Patron of Poland, died in 1483, and when his body was exhumed 120 years later, a sweet smell issued forth. One of the main ingredients of incense over the millennia has been sandalwood. This contains santalol which has a shape very similar to sex hormones.

Smell and memory

Smell and memory are intimately linked. The primary smell area in the brain (pyriform cortex) and the memory area (hippocampus) are next door to each other

and are interconnected by many nerve fibres. Odour exposure during a learning task has been shown to increase memory when the same odour is present at the recall stage (Herz 1997)—useful in exam revision!

It is a common experience to have a vivid recall, or *déjà vu*, evoked by a particular smell. The experience with smell-evoked memory is unique among the senses in the extent of the emotional, as well as factual, recall. The phenomenon has become known as 'autobiographical memory', or the Proust effect, after the account in *Swann's Way* of the memories conjured while savouring the taste (he didn't actually refer to smell!) of a petit madeleine dipped into his tea. He was transported back to his Aunt Leonie's house in Combray many years before and all the attendant memories. Artist Oswaldo Macia's *Smellscape*, presented at the 'Art and the Senses' exhibition (Oxford 2006), featured a series of scents that would have been encountered by the character Phileas Fogg during his circumnavigation of the globe in Jules Verne's novel *Around the World in Eighty Days* (Fig. 10.9). The installation comprised also of a map of the world where the place names were substituted by names of scents, whose memory had a strong association with the soul-deep identity of each place.

Smell can be used as a conditioned stimulus by reinforced association. This occurs by repeatedly pairing an odour with a situation or object. For example, learning to relax to a chosen smell (aromachemical) has been shown to reduce the frequency

Fig. 10.9 Oswaldo Macia, *Smellscape*, 2006.

(Photograph: Francesca Bacci)

of seizures in epileptics (Betts 2003), and the onset of seizures can be prevented by sniffing the conditioned smell. This is different from the Proust effect: Proustian associations tend to be few, idiosyncratic, and last a lifetime. In contrast, with reinforced associations one has some choice of the conditioning odour, and the effect, once formed, can be extinguished.

Smell conditioning

Smell conditioning can be used to modify behaviour. Rachel Herz and colleagues (Epple and Herz 1999) gave children an apparently simple, but insoluble, maze in the presence of an ambient odour. When the poor kids were later presented with other tasks to complete in the presence of the same odour, they performed worse than a comparable control group, indicating that the odour had influenced their behaviour. What a shame to use a smell to influence behaviour in a negative way! Perhaps also feeling this sentiment, Simon Chu (2008) gave underachieving schoolchildren the experience of unexpected success at a paper-and-pencil task in the presence of an ambient odour. When they later experienced the same odour again, performance on other tasks was superior to that of relevant control groups, showing that odours can be used to exert positive influences on human behaviour.

Smell loss

We lose our sense of smell temporarily sometimes during a bad cold. We can't taste anything because smell is such an important part of flavour (see 'Flavour' section). Our sense of smell can be also lost, sometimes permanently, from a traumatic head injury severing the olfactory nerves or a severe infection of the upper respiratory tract (e.g. bad cold or flu). A total loss of the sense of smell is referred to as 'anosmia' and partial loss as 'hyposmia'. Recovery following either head injury or infection damage occurs in approximately a third of cases and can take from one to five years.

As we age we lose smell sensitivity, men faster than women. On the basis of a smell identification test, this begins to happen in the 60s in men and the same loss occurs about a decade later in women. By the time we reach our 80s, three out of four people have some smell dysfunction (Doty and Laing 2003). However, this figure includes patients suffering from a variety of dementias that will affect olfactory ability. It is thought that if subjects are prescreened for nasal health and dementias, the differences between older and younger subjects are not that great (Murphy et al. 1997).

Libido and depression

The loss of smell may greatly alter quality of life. Many patients with olfactory disorders experience loss of pleasure in eating and sexuality, as well as an inability to detect dangers such as gas leaks. In two research questionnaires carried out by the Connecticut Chemosensory Clinical Research Center (CCCRC) in 1986 (Gent et al. 1986)

and the Warwick Olfaction Research Group (WORG) in 1999 (Van Toller 1999), problems with libido and relationships were found. Twenty-six per cent of the CCCRC respondents mentioned some disruption of their marital, sexual, and social relationships. In the WORG study, anosmics (those without a sense of smell) often stated that their interest in sex had dwindled.

The emotional consequences of smell loss are often underestimated, particularly in the medical community. Anosmics show varying degrees of depressive symptoms, such as feelings of helplessness, isolation in their condition, sad mood, loss of independence, and fatigue. Depression is common among patients with smell dysfunction. One-fifth of a sample of anosmics scored in the clinically depressed range on a depression measure, and one-third of anosmia patients reported extreme helplessness comparable to that seen among chronic illness samples such as arthritis patients (Ossebaard et al. 1999).

Smell loss and diet

Since the sense of smell contributes so significantly to flavour, loss of the sense of smell results in a loss of flavour for everything we eat or drink. This can have a profound effect on quality of life. A proportion of anosmics have been found to suffer from problems with food intake: some experience excessive weight gain while others experience an equivalent loss. These gains and losses would not be expected of healthy individuals. Eating correlates with olfactory ability and anosmics tend to eat less regularly. Left on their own they may forget to eat altogether. Eating becomes a refuelling exercise because they have lost the pleasure associated with food and drink. Eating is no longer a recreational activity for anosmics (Van Toller 1999).

Concluding remarks

Smell is the foundation of our waking lives and also continues to function as we sleep, influencing our dreams. We communicate though smell, consciously and unconsciously, choosing our partners by their smell, advertising our genes with our body odour as well as with applied perfume. Smells can relax us, help our memory, stimulate us and warn us of danger. Smell is integral to sex and, with taste, it exposes us to the vast array of sensory delights in food and drink. Both senses protect us from danger and warn us of disease, infection, poor hygiene, and health risks. And if you really want to know how important these senses are, ask someone who has lost them.

I would like to conclude with a reflection elicited by another artwork by Clara Ursitti. The artist made a video (*Untitled*, 1995, presented at the show 'Odour Limits' at Esther Klein Gallery in Philadelphia) where she is featured laying naked while perfumer and olfactory researcher George Dodd describes in great detail her odour in different body parts, while sniffing her from her feet to the genital areas, to her axillaries, and relating these scents to food and human behaviours (Fig. 10.10).

Fig. 10.10 Clara Ursitti, *Untitled*, 2005.

(Video still: courtesy of the artist.)

This footage eloquently exposes and summarizes the cultural taboos and lexical limits of our approach to odours. Despite their increasingly recognized importance to our well-being, as explained in this essay, scents are still an undervalued and somewhat unexploited resource to the average person.

REFERENCES

Ackerl K, Atzmueller M, and Grammer K (2002). The scent of fear. *Neuroendocrinology Letters*, **23**, 79–84.

Bartoshuk LM, Duffy VB, and Miller IJ (1994). PTC/PROP tasting: anatomy, psychophysics, and sex effects. *Physiology and Behavior*, **56**, 1165–71.

Betts T (2003). Use of aromatherapy (with or without hypnosis) in the treatment of intractable epilepsy – a two-year follow-up study. *Seizure* **12**, 534–8.

Boulkroune N, Wang L, March A, Walker N, and Jacob TJC (2007). Repetitive olfactory exposure to the biologically significant steroid androstadienone causes a hedonic shift and gender dimorphic changes in olfactory evoked potentials. *Neuropsychopharmacology*, **32**, 1822–9.

Cain WS and Johnson F Jr (1978). Lability of odor pleasantness: influence of mere exposure. *Perception* **7**, 459–65.

Cameron EL (2007). Measures of human olfactory perception during pregnancy. *Chemical Senses*, **32**, 775–82.

Chen D and Haviland-Jones J (1999). Rapid mood changes and human odors. *Physiology and Behaviour*, **68**, 241–50.

Chu S (2008). Olfactory conditioning of positive performance in humans. *Chemical Senses*, **33**, 65–71.

Donnerer J (2003). The emetic reflex arc. In J Donnerer, ed. *Antiemetic Therapy*, pp. 1–10. Karger, Basel.

Doty R and Laing DG (2003). Psychophysical measurement of human olfactory function, including odorant mixture assessment. In RL Doty, ed. *Handbook of Olfaction and Gustation*, 2nd edn., pp.203–28. Marcel Dekker, New York.

Eggert F, Muller-Ruchholtz W, and Ferstl R (1999). Olfactory cues associated with the major histocompatibility complex. *Genetica*, **104**, 191–7.

Epple G and Herz RS (1999). Ambient odors associated to failure influence cognitive performance in children. *Developmental Psychobiology*, **35**, 103–7.

Ganchrow JR and Mennella JA (2003). The ontogeny of human flavour perception. In RL Doty, ed. *The Handbook of Olfaction and Gustation*, 2nd edn., pp. 823–46. Marcel Dekker, New York.

Gent JF, Cain WS, and Bartoshuk LM (1986). Taste and smell measurement in a clinical setting. In HL Meiselman and RS Rivlin, eds. *Clinical Measurement of Taste and Smell*, pp. lo7–l6. Macmillan, New York.

Herz RS (1997). The effects of cue distinctiveness on odor-based context-dependent memory. *Memory and Cognition*, **25**, 375–80.

Herz RS and Inzlicht M (2002). Sex differences in response to physical and social factors involved in human mate selection. The importance of smell for women. *Evolution and Human Behavior*, **23**, 359–64.

Jacob TJC, Wang L, Jaffer S, and McPhee S (2006). Changes in the odour quality of androstadienone during exposure-induced sensitization. *Chemical Senses*, **31**, 3–8.

Kaitz M, Good A, Rokem AM, and Eidelman AI (2004). Mothers' recognition of their newborns by olfactory cues. *Developmental Psychobiology*, **20**, 587–91.

Kohl JV, Atzmueller M, Fink B, and Grammer K (2001). Human pheromones: integrating neuroendocrinology and ethology. *Neuroendocrinology Letters*, **22**, 309–21.

Kuno Y (1956). *Human Perspiration*. Blackwell Scientific Publications, Oxford.

Lim J, Urban L, and Green BG (2008). Measures of individual differences in taste and creaminess perception. *Chemical Senses*, **33**, 493–501.

McClintock MK (1971). Menstrual synchrony and suppression. *Nature*, **291**, 244–5.

McCulloch M, Jezierski T, Broffman M, Hubbard A, Turner K, and Janecki T (2006). Diagnostic accuracy of canine scent detection in early- and late-stage lung and breast cancers. *Integrative Cancer Therapies*, **5**, 30–9.

Milinski M and Wedekind C (2001). Evidence for MHC-correlated perfume preferences in humans. *Behavioral Ecology*, **12**, 140–9.

Mistretta CM and Hill DL (2003). Development of the taste system: basic neurobiology. In RL Doty, ed. *The Handbook of Olfaction and Gustation*, pp. 759–82. Marcel Dekker, New York.

Murphy C, Razani J, and Davidson TM (1997). Aging and the Chemical Senses. In AM Seiden, ed. *Taste and Smell Disorders*, pp. 172–203. Thieme, New York.

Ober C (1999). Studies of HLA, fertility and mate choice in a human isolate. *Human Reproduction Update*, **5**, 103–7.

Ossebaard CA, Tayer WG, Nicassio PM, and Cain WS (1999). A mediational model of depression in smell disordered patients. *Chemical Senses,* **24**, 607.

Penn DJ and Potts WK (1999). The evolution of mating preferences and major histocompatibility complex genes. *American Naturalist,* **153**, 145-164.

Pfaffmann C (1978). The vertebrate phylogeny of taste. In EC Carterette and MP Friedman, eds. *Handbook of Perception, VlA, Tasting and Smelling,* pp. 51–123. Academic Press, New York.

Porter RH and Winberg J (1999). Unique salience of maternal breast odors for newborn infants. *Neuroscience & Biobehavioral Reviews,* **23**, 439–49

Schaal B, Marlier L, and Soussignan (2000). Human foetuses learn odours from the pregnant mother's diet. *Chemical Senses,* **25**, 729–37.

Steiner JE (1974). Innate discriminative human facial expressions to taste and smell. *Annals of the New York Academy of Science,* **237**, 229–33.

Steiner JE (1977) Facial expressions of the neonate infant indicating the hedonics of food-related chemical stimuli. In JM Weiffenbach, ed. *Taste and Development: the Genesis of Sweet Preference,* pp. 173–88. US Department HEW Publications, Bethesda, MD.

Stern K and McClintock MK (1998). Regulation of ovulation by human pheromones. *Nature,* **392**, 177–9.

Van Toller S (1999). Assessing the impact of anosmia: review of a questionnaire's findings. *Chemical Senses,* **24**, 705–12.

Wang L, Chen L, and Jacob TJC (2004). Evidence for peripheral plasticity in the human odour response. *Journal of Physiology,* **544**, 236–44.

Wedekind C and Furi S (1997). Body odour preferences in men and women: do they aim for specific MHC combinations of simply heterozygosity? *Proceedings of the Royal Society (London) B,* **264**, 1471–9.

Willis CM, Church SM, Guest CM, et al. (2004). Olfactory detection of human bladder cancer by dogs: proof of principle study. *British Medical Journal,* **329**, 712–15.

Wysocki CJ, Dorries KM, and Beauchamp GK (1989). Ability to perceive androstenone can be acquired by ostensibly anosmic people. *Proceedings of the National Academy of Sciences,* **86**, 7976–8.

'SOUND BITES': AUDITORY CONTRIBUTIONS TO THE PERCEPTION AND CONSUMPTION OF FOOD AND DRINK

CHARLES SPENCE,
MAYA U. SHANKAR, AND
HESTON BLUMENTHAL

Eating is the only thing we do that involves all the senses. I don't think that we realize just how much influence the senses actually have on the way that we process information from mouth to brain.

Heston Blumenthal (*Tasting Menu,* http://www.fatduck.co.uk)

INTRODUCTION

WHEN thinking about the sensory systems that contribute to our perception and enjoyment of foodstuffs, people typically mention the senses of taste and smell. While it is certainly true that gustatory and olfactory (as these senses are more formally known) information contribute to our everyday food and beverage experiences (e.g. Rozin 1982), they alone do not constitute the whole picture. In fact, over the past 70 years or so, researchers have been able to demonstrate that our perception of food and drink is far more *multisensory* than many people had realized (see Duncker 1939; Moir 1936; Hall 1958; for early work in this area). Indeed, many researchers now talk about flavour perception in terms of perceptual gestalts (i.e. unified multisensory perceptual experiences), consisting of the combination of all of the available unisensory experiences, be they gustatory, olfactory, auditory, tactile, visual, and/or trigeminal (e.g. Delwiche 2004; see also Spence, Sanabria, and Soto-Faraco, 2007).[1] As Ferran Adrià, head chef at El Bulli (located near Barcelona), an establishment that is frequently rated as the world's best restaurant, puts it: 'Cooking is probably the most multi-sensual art. I try to stimulate all the senses' ('Does it make sense', 2007, p. 19). Indeed, some chefs are starting to create culinary sensations that are increasingly being referred to—in the press at least—as art (e.g. see Brooks 2008).

Vision, specifically in terms of the colour of food and drink, has been shown to play a dramatic role in modulating the perceived identity and intensity of flavour and aroma (e.g. Duncker 1939; DuBose et al. 1980; Morrot et al. 2001; Zampini et al. 2007; Levitan et al. 2008; Shankar, Levitan, and Spence 2009). Visual cues have also been shown to influence how rapidly we reach satiety when eating (Rolls et al. 1982; see also Raghubir and Krishna 1999), and can modulate our appetitive responses (e.g. Birren 1963; Wheatley 1973).[2] Similarly, the tactile attributes of food and drink, whether it be their temperature, texture, or viscosity have a profound influence on our experience of food as well (Green 2002; see Verhagen and Engelen 2006, for a recent review)—a concept without which one can hardly appreciate the visual pun of Meret Oppenheim's *Fur Covered Cup*, 1936. Finally, it is important to note that flavour perception is also modulated by the stimulation of the trigeminal sense (see Green 1996; Delwiche 2004; Verhagen and Engelen 2006); here, one need only think of the tingle of carbon dioxide bubbles in a carbonated beverage, or the pleasantly painful burning sensation associated with eating a chicken vindaloo at the local curry house.

[1] Marinetti's *Futurist Cookbook* (1930/1989) advised readers that to stimulate the senses during eating, people should try wearing pajamas made of differently textured materials such as cork, sponge, and felt. Marinetti also suggested eating without the aid of knives and forks by simply burying one's face in the plate to enhance the tactile sensations.

[2] Indeed, those attendees who went to the conference dinner at the 'Art and the Senses' meeting in 2006 were treated to a starter of blue soup (while listening to Miles Davis' 'A kind of blue') followed by green chicken and mashed potatoes. As one might imagine, these were not always the easiest of dishes to consume. . .

Interestingly, numerous artists have used food preparation as their art form or to theorize the totality of their artistic movement; or they have charged food consumption with symbolic meanings as an integral part of their work (see Goldberg 1979). Looking into the less recent history of modern art, one can think about some classic works such as Duchamp's chocolate grinder (used as a metaphor of the ties between food and sex), Piero Manzoni's 1960 performance (where he ate a series of eggs previously cooked and signed with fingerprints by the artist, to comment on how art is consumed by the public while being experienced, and on the equivalence of physical and spiritual food), Mario Merz's spiral tables with fruit (dealing with the dichotomy of perfection vs. decay, and using food as a metaphor for the stages of life), Andy Warhol's packaged food, and Claes Oldenburg's fictional giant food items (which provided a final poignant comment on how packaging comes to represent the identity of the food itself).

Even among the many possible examples from contemporary art, considering the work of the following artists may give a sense of the variety of approaches presently adopted to explore the sensory and conceptual complexity of food: Rirkrit Tiravanija (who has cooked meals for gallery-goers as a form of installation art since the 1990s); Sonja Alhauser (famous for her edible sculptures to be consumed by the public, within a certain time frame, exploring the issue of eating as an aesthetic experience); Jana Sterbak (her *Vanitas: Flesh dress for albino anorectic* expands on the idea of food as tied into the perception of self); Wim Delvoye (designed a machine that eats, digests, and excretes, reflecting on mindless eating as a mechanical experience); Tania Bruguera (in her *Poetic Justice*, 2002, she tackled issues of exploitation and colonialism through the display of two extensive wall surfaces coated in used tea bags).

Our understanding of food as a multisensory experience has made its way into our culinary experiences through restaurants like the L'Esguard de Sant Andreu de Llavaneres, in Barcelona, Spain. The proprietor and chef, Miguel Sánchez Romera, combines his knowledge of cognitive psychology (which he acquires by day in his job as a neuroscientist), and his experience of flavour (which he acquires by night as chief chef and proprietor of a very successful restaurant), in order to produce eating and dining experiences that more effectively stimulates the senses (see Sánchez Romera 2001). Similarly, Heston Blumenthal works to manipulate different aspects of the consumer's dining experience by modulating different sensory and contextual aspects of food and drink, in order to optimize the overall likeability and enjoyment of his dishes at The Fat Duck restaurant in Bray, England. As he notes, there is no food that is intrinsically disgusting, otherwise no one would eat it. Eating a live crab is difficult for a Westerner, while a Japanese diner might be appalled at a sweet rice pudding. Even changing a food's name, from 'frozen crab bisque' to 'crab ice cream' can affect the perceived saltiness and flavour of the dish (Yeomans et al. 2008; see also Wansink 2002).

Our focus in the present chapter is to examine the sense that is most often overlooked when people think about their culinary experience, namely the sense of hearing (see Srinivasan 1955). Perhaps surprisingly, the relationship between hearing and flavour perception and between hearing and culinary experiences/behaviours more generally

has, to date, remained relatively unexplored (as compared to other multisensory inter-actions in the domain of food and drink). In fact, some researchers have even gone so far as to assert that interactions between sound and the chemical senses are, a priori, unlikely (see Delwiche 2004, p. 142). Indeed, in their comprehensive recent review of the multisensory contributions to flavour perception, Verhagen and Engelen (2006) devote less than one page of their 37-page article to any consideration of multisensory interactions involving the auditory system.

It is our aim, therefore, in this chapter to try and correct this imbalance; in par-ticular, we bring together and critically evaluate the emerging (if widely distributed) body of empirical evidence from research fields such as cognitive and environmental psychology, food science, neuroimaging, marketing, and psychophysics that has recently started to illustrate just how important what we hear is to our everyday food and drink experiences. For example, researchers have now shown that what people hear can influence everything from which foodstuffs they choose to purchase (e.g. North et al. 1997), how much money they spend on the items that they choose (e.g. Areni and Kim 1993; North and Hargreaves 1998), what these food items taste like (e.g. Srinivasan 1955; Holt-Hansen 1968, 1976; Rudmin and Cappelli 1983; Zampini and Spence 2004; Reid 2008), how rapidly people consume them (e.g. Roballey et al. 1985; Guéguen et al. 2008), and how much they consume (e.g. Guéguen et al. 2004).

Taken together, these findings demonstrate just how profoundly what we hear, be it the sound of the environment in which we eat, the sound of the food as we are eating or drinking it, or even the sounds of the opening of the packaging in which that food is presented (see Spence and Zampini 2006) affects people's eating/dining experiences. Interestingly, these crossmodal influences appear to occur no matter whether people are aware of them or not. In fact, the evidence actually points to the fact that people are very often unaware of them (see Milliman 1982; Roballey et al. 1985; North et al. 1997). It is our belief that by gaining a better understanding of the mul-tisensory contributions to the perception of food and drink (in particular, here, the contributions of what people hear), we can start to design food and drink experiences that will more effectively stimulate the senses of the consumer/diner.

In the sections that follow, we review the extant research investigating the role of auditory cues on the various aspects of our food experiences/behaviours. In the first two sections we highlight the influence of background music on people's food and drink selections, and on the rate at which they are consumed. In the following two sections we focus on the influence of the sounds that people actually make when consuming food and drink, and on the sounds made by certain kinds of food pack-aging on their experience of flavour. In the last section, we report on the results of several new experiments designed to show how auditory stimuli can be used to enhance people's perception of the identity and pleasantness of various food items.[3]

[3] It is also important to note, though, that certain of the effects of tempo, or musical type, and even loudness on people's behaviour might simply be explained by people's preference for the particular music being played (Herrington and Capella 1996; Caldwell and Hibbert 2002). In fact, to date, it seems far to say that many researchers have underestimated the effects of pleasantness.

The results of these experiments illustrate how changing what people hear can influence (or change) their perception of foods. Where appropriate, we also highlight the various mechanisms that have been put forward to account for these effects.

AUDITORY CONTRIBUTIONS TO THE SELECTION OF FOOD AND DRINK

A large body of empirical research now shows that the atmosphere of an environment can play an important role in determining which foods and drinks we choose to purchase, and how much we enjoy them (e.g. Green and Butts 1945; Meiselman et al. 1988; Rozin and Tuorila 1993; Bell et al. 1994; Pine and Gilmore 1998; Edwards et al. 2003). Compelling evidence for the existence of such contextual effects comes from a study by Bell et al. (1994) in which the researchers examined whether it is possible to alter how 'ethnic' various foods were judged to be, without modifying the foods themselves. In Bell et al.'s study, a British restaurant (the *Grill Room* at Bournemouth University) offered both Italian and British foods on four consecutive days. For the first two days of the experiment, the food was served with the restaurant decorated normally. For the second two days, identical foods were served, but now the restaurant was given an Italian theme (see Table 11.1). The foods were also described on the menu using 'ethnic names' (e.g. *maccheroni al formaggio* in the Italian condition vs. *macaroni and cheese* in the British condition). After having made their food choices, the customers (N = 138) were given a questionnaire in which they were asked to rate the perceived ethnicity and acceptability of the food items that they had just selected.

Table 11.1 Decorations used in the Grill Room restaurant in order to elicit either an Italian or British (normal) theme (atmosphere)

Italian	British
Red-checked tablecloths	White tablecloths
Italian flags on walls	No flags
Chianti bottles on tables	No bottles
Italian menu names	British menu names
Italian travel posters	No travel posters

Source: Bell et al. (1994).

Bell et al. (1994) found that when the restaurant was given an Italian theme, the customers were more likely to select pasta and eat Italian desserts (e.g. ice cream and zabaglione), while they chose fewer fish items (such as trout; see Fig. 11.1). They also found that the Italian restaurant theme significantly increased the customers' ratings of the perceived Italian ethnicity of the pasta items and increased the perceived ethnicity of the meal as a whole. These results therefore provide a powerful demonstration of how the perceived ethnicity of a dish can be altered merely by manipulating the sensory attributes of the environment. While Bell and colleagues' study focused on the effects of changing the visual attributes of the environment, a number of other researchers have shown that people's selection of food and drink can be modified by manipulating the auditory aspects of the environment as well. For example, researchers have shown that altering the music that people hear can also have a profound effect on people's food choices (North et al. 2003). These findings are particularly important in the context of the service/retail setting, given that this aspect of the environment is both easy and relatively inexpensive to control (Herrington and Capella 1994; Caldwell and Hibbert 2002; Treasure 2007).

For example, North, Hargreaves, and McKendrick (1997) have demonstrated that the music played in a store can have a marked influence on customers' wine purchasing decisions. In their study, four French wines and four German wines (matched between countries for cost and dryness/sweetness) were displayed in the drinks section

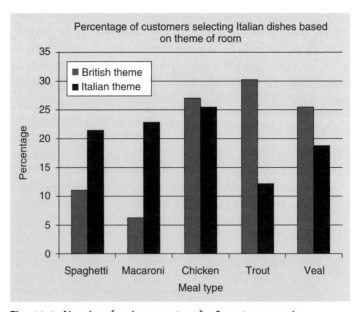

Fig. 11.1 Number (and percentage) of customers who selected Italian vs. British dishes based on visual theme (or atmosphere) of the restaurant.

Source: Bell et al. (1994).

of a supermarket. One French wine and one German wine were placed on each of four shelves, and each wine was accompanied with its corresponding national flag. On alternating days, either French accordion music or German Bierkeller music was played in the background. North and his colleagues found that when French music was played, customers purchased more French wine than German wine, while the reverse was true when German music was played (see Fig. 11.2). Crucially, when the customers were stopped and questioned about their purchasing decisions shortly after leaving the till, only 6 of 44 shoppers asserted that their decisions may have in some way been influenced by the music playing in the background. These results therefore demonstrate that what people hear can contribute to the food and drink choices that they make, no matter whether they realize it or not (see also North et al. 1999).

It is worth nothing here that a number of other studies have also looked at the effects of playing music on people's behaviour in supermarkets and other retail outlets (e.g. Smith and Curnow 1966; Yalch and Spangenberg 1990; Areni and Kim 1993; Herrington and Capella 1996; Wilson 2003). For example, in one particularly interesting study, Areni and Kim reported that the customers in a wine store bought more items and selected more expensive drink items when classical music was played in the background than when 'Top 40' music was played instead: the customers spent an average of $7 when listening to classical music versus $2 when listening to 'Top 40' hits (see also Yalch and Spangenberg 1993). Meanwhile, other researchers have shown that changing the tempo of the background music can affect how rapidly people move down the aisles in the supermarket (e.g. Milliman 1982), hence indirectly affecting customers' purchasing behaviour. More specifically, Milliman observed that the traffic flow in a grocery store was significantly slower when slow-tempo music was played than when fast-tempo music was played. Milliman also reported a 38% increase in sales when the slow music was played. In another early study, Smith and Curnow varied the loudness of the music in two supermarkets and reported that the

	French accordion music	German Bierkeller music
Bottles of French wine sold	40 (77%)	12 (23%)
Bottles of German wine sold	8 (27%)	22 (73%)

Fig. 11.2 Number (and % in brackets) of bottles of French vs. German wine sold as a function of the type of background music played.

Source: North et al. (1997).

customers spent significantly less time in the shop playing the louder music (though see Herrington and Capella 1996).

AUDITORY CONTRIBUTIONS TO THE RATE AT WHICH PEOPLE CONSUME FOOD AND DRINK

Many researchers have investigated whether the rate at which people consume food and drink, as well as the total amount consumed, is influenced by what they happen to be listening to (e.g. Bach and Schaefer 1979; Roballey et al. 1985; McCarron and Tierney 1989; Drews et al. 1992; Ragneskog et al. 1996; Guéguen et al. 2004). For example, McCarron and Tierney reported a laboratory-based study involving 30 students in which they demonstrated that increasing the loudness of the background music (from no music to music playing at 70 or 90 dB) resulted in a significant increase in the consumption of soft drinks during a 25-minute period, while students sat passively in the laboratory.

Meanwhile, Guéguen et al. (2004) conducted a more ecologically valid study in two bars (one located in an urban area and the other in a rural area), in which the loudness of the background music (Top 40 music, as normally played in the bars under study) was also varied. Their results showed that the customers (N = 120 participants) ordered significantly more drinks when louder music (88–91dB) was played than when the music was played at its normal quieter level (72–75dB). In their latest research, Guéguen et al. (2008) have reported that playing loud music can affect the drinking behaviour of young men (in the 18–25-year age range; see also Smith 2008). The young men in Guéguen et al.'s study drank 3.5 drinks in venues with loud music vs. 2.6 drinks in venues playing quieter music. They also drank their beer faster (11.5 vs. 14.5 minutes; see 'Loud music in the pub "makes you drink more"' 2008).

In another oft-cited early study, Milliman (1986) manipulated the tempo (i.e. the number of beats played per minute, or bpm) of the music played in a restaurant, and assessed its effect on the patrons' consumption of food and drink. The customers in this study ate more quickly when fast music was played (M = 108 bpm) than when slow background music was played (M = 56 bpm). Although there was no effect of musical tempo on the amount of money spent on food, there was a marked difference on the final bar bill, with those in the slow music condition spending 40% more. Similarly, McElrea and Standing (1992) have reported that drinking time decreased significantly when background piano music was played at 132 bpm as compared to when it was played at 54 bpm. Note that the participants (N = 40) in this laboratory-based study were simply asked to drink a can of soda with the stated aim of rating its flavour. McElrea and Standing's results are consistent with those from a study by Roballey et al. (1985) in which fast-tempo instrumental, non-classical background

music (M = 122 bpm) resulted in consumers (N = 11) taking significantly more bites per minute in a cafeteria, as compared to when a slow-tempo piece (M = 56 bpm) was played (4.4 vs. 3.2 bites per minute, respectively).

More recently, Jacob (2006) has shown that it is not only the tempo, but also the style of background music that is played that is important. She investigated whether the music played in a bar in a seaside resort town in France influenced how long the patrons spent there. The drinkers in her study (N = 93) were found to spend significantly more time and money when 'drinking' music (e.g. 'The Drunken Sailor Song' or any one of a number of other festive songs that had lyrics pertaining to food and alcohol) was played (at 70 bB) than when 'Top 40' music (the music usually played in French bars), or 'cartoon' music (e.g. 'Some day my Prince will come' or any other type of music played in animated films) was played instead. It should, of course, be noted that the most appropriate/liked music will also depend to a large extent on the age/demographic make-up of the customers in a given retail or service setting (see Herrington and Capella 1994; Caldwell and Hibbert 2002).

Taken together, the studies reported in this section therefore show that auditory environmental (or situational; Edwards et al. 2003) factors can have a significant influence on the rate of consumption of food and drink and on the overall amount that people consume. The research that has been published to date has shown that the loudness, tempo, and type of music can all exert a significant influence on consumer decision-making and purchasing behaviour in a variety of different everyday settings. Researchers have put forward a number of different accounts to try and explain why/how background music might modulate people's behaviour in this way. One popular suggestion has been that changing the background music may simply affect people's perception of the passage of time (see Linsen 1975; Kellaris and Kent 1992; Kellaris et al. 1996; see also Wansink 1992; Yalch and Spangenberg 2000; though see Caldwell and Hibbert 2002). The idea here is that if a certain piece of music happens to make people perceive that the time is passing more slowly then they might well end up spending longer in whatever environment they happen to be in, and hence possibly eating, drinking, and ultimately, spending more.

A second account of how listening to music can modulate behaviour is that it may result in a change in the level of arousal, and it is this that influences people's eating/drinking behaviours (e.g. Roballey et al. 1985; Guéguen et al. 2004, 2008; cf. Smith and Curnow 1966). Third, according to environmental psychologists, environmental stimuli, such as sounds and music (see Guéguen et al. 2008), as well as visual and olfactory cues, can elicit emotional responses, such as pleasure, arousal, and dominance, which may in turn mediate a variety of 'approach-avoidance' behaviours (e.g. see Mehrabian and Russell 1974; Holbrook and Anand 1990; Konečni 2008). Thus, music may serve to enhance a person's mood and/or the pleasantness of the atmosphere (see also Alpert and Alpert 1990; Bruner 1990; Drews et al. 1992; Jacob 2006). Fourth, music may simply act as a form of distraction. Note here that both adults and children have been shown to snack more when watching TV (Wansink 2002). Similarly, Bellisle and Dalix (2001) have shown that people who eat their lunch while listening to the radio consume 15% more food than those who eat in silence.

A final possibility here is that listening to pleasant music might actually affect people's perception of the taste/flavour/pleasantness of the food or drink itself (though see McCarron and Tierney 1989). Related to this latter suggestion, Kristian Holt-Hansen (1968, 1976) conducted studies in which the frequency at which people experienced (synaesthetic) 'harmony' (or unity; see Vatakis and Spence 2007, 2008) between taste and sound (pure tones) while consuming beer (Carlsberg) was initially established. The participants reported that the beer tasted better (e.g. more full-bodied) when the pitch of the sound was 'harmonized' with it (known as the 'pitch of fit'; see also Bronner et al. 2008).[4] By contrast, when the pitch of the sound was changed, the participants no longer experienced such 'harmony' and reported that the taste and sound were now experienced separately (one might say that the 'unity assumption' had been broken; see Vatakis and Spence 2007). Under such conditions, the participants tended to report that the beer tasted weak, thin, strong, watery, bitter, acrid, and/or nauseating! What is more, some of the participants also experienced rhythmic sensations in their heads, as well as tickling sensations in their jaws and mouth.

In a follow-up study, Holt-Hansen (1976) reported that three of the (nine) participants had a range of 'extraordinary' experiences after having been trained to taste one of six lager beers/ales while listening to a rhythmic sound, a sound whose pitch was varied. These participants reported experiences that apparently resembled those of people under the influence of drugs, such as mescaline, LSD, and cannabis (see also Beeli et al. 2005; Day 2005). For example, one participant reported the following experience at the 'pitch of harmony': 'My right hand with the glass of beer in it trembled so violently that I was suddenly afraid of dropping the glass. I felt as if I was floating in the air. The tone was intensified to such a degree that it sounded like a symphony orchestra and the room was filled with it. My jaws were moving in and out with the rhythm of the tone.'[5]

In another laboratory-based study, Ferber and Cabanac (1987) found that the hedonic valence of sucrose (but not of sodium chloride) solution could be elevated by exposure to noise and loud music (McFadden et al. 1971). And, in what was perhaps the first study to look specifically at the role of the ear in flavour perception, Srinivasan (1955) observed that people's perception of the saltiness of common salt and the sweetness of cane sugar could be altered by putting the palms of their hands or their fingers against their ears. When the participants closed their ears in this way many reported either the enhancement or the suppression (depending on the participant) of the odour of strongly-smelling substances such as asafoetida (see also Petit 1958).[6]

[4] The pitch of harmony for Carlsberg lager was in the range of 510–520 Hz, while Carlsberg Elephant beer was found to have a pitch of harmony in the range of 640–670 Hz.

[5] Not bad on 12 fluid ounces (i.e. 360 millilitres) of regular beer! More seriously, however, these results presumably speak more of the dangers of relying too much on subjective report (see also Srinivasan 1955), rather than of the miraculous effects of drinking beer *per se* (see also Rudmin and Cappelli 1983).

[6] The absence of any statistical analysis of these data, however, makes it difficult to draw any firm conclusions regarding the actual effect, if any, of closing the ears on flavour perception across the population.

More interestingly, the latest (as yet unpublished) research to be conducted by Adrian North (and funded by Aurelio Montes, the Chilean wine producer), investigated whether listening to different kinds of music would affect people's (N = 280 students at Herriot Watt University, Scotland) judgements of wine. North showed that when 'heavy' background music was played, people judged certain wines as tasting 'heavier' (see 'Music can enhance wine taste', 2008; Reid 2008). So, for example, when a powerful, heavy piece of music, such as 'Sweet Child O'Mine' by Guns 'N Roses, was played, people rated a cabernet sauvignon (a red wine) as tasting 60% more robust than when the wine was tasted in silence (see Table 11.2). These results led Dave Williams, the editor of *Wine and Spirit* magazine, to suggest that we might soon find 'music lists' in Michelin-starred restaurants (Reid 2008). Alternatively, innovative restaurateurs may soon start coordinating the background music played in their restaurants to the wines chosen by the patrons, in the same way that they currently match specific wines to particular dishes.[7]

What is more, the recent development of hyper-directional loudspeakers means that specific soundtracks could be directed to specific diners in a restaurant setting, without having to worry about any auditory information from the next table giving them indigestion and without the need for the use of headphones. In fact, it should be possible using such loudspeakers for each person on a given table to have their very own soundtrack coordinated with their specific meal choices.

Table 11.2 Music recommendations to enhance the flavour of particular wine varieties

Cabernet Sauvignon	All Along The Watchtower (Jimi Hendrix), Honky Tonk Woman (Rolling Stones), Live And Let Die (Paul McCartney and Wings), Won't Get Fooled Again (The Who)
Chardonnay	Atomic (Blondie), Rock DJ (Robbie Williams), What's Love Got To Do With It (Tina Turner), Spinning Around (Kylie Minogue)
Syrah	Nessun Dorma (Puccini), Orinoco Flow (Enya), Chariots Of Fire (Vangelis), Canon (Johann Pachelbel)
Merlot	Sitting On The Dock Of The Bay (Otis Redding), Easy (Lionel Ritchie), Over The Rainbow (Eva Cassidy), Heartbeats (Jose Gonzalez)

Source: Montes wines.

[7] Note though, that as yet, there is no evidence to support Mr Montes' contention that serenading his maturing wines with music improves their quality. He states that 'I've always believed that playing Gregorian chants aids the angelic maturation of our wines and is an important step in our wine making process.'

THE SOUND OF FOOD AND DRINK

Researchers have also looked at the effects that the self-generated sounds people make while consuming food and drink have on their perception of foodstuffs. It should be noted that many foods elicit unique (or characteristic) sounds when they are consumed, particularly dry food products such as biscuits, crisps, and cereals (Drake 1965). These sounds often serve as good indicators of the expected flavour and quality of what is being eaten. For instance, several studies have now shown that people's hedonic ratings of a variety of different foods can be influenced by the sounds produced by people when chewing (or crunching) on them (e.g. see Drake 1970; Vickers and Bourne 1976; Vickers 1981, 1983; Dacremont and Colas 1993). For example, many years ago, Zata Vickers (1981) demonstrated that people's judgements of the crispness, crunchiness, and hardness of a variety of foods (such as celery, turnips, and Nabisco saltines) that were based on purely auditory cues (i.e. on the recorded sounds made when participants bit or chewed a food) were similar to their judgments when based on oral-somatosensory cues (see also Christensen and Vickers 1981).

In another study, Zampini and Spence (2004) examined whether people's perception of the crispness and staleness of potato chips (or crisps) would be affected simply by modifying the sounds that they heard when biting into them. The participants ($N = 20$) in this study had to bite into a large number ($N = 180$) of Pringles potato chips (all more or less identical in shape, size, and weight—hence ideal for psychophysical investigation), and were instructed to rate each one in terms of its crispness and freshness using a visual analogue scale presented on a computer screen. During each bite, the participants received real-time auditory feedback of their own crisp-biting sounds over headphones. This feedback was sometimes altered in terms of its overall loudness and/or frequency composition. Zampini and Spence found that the participants rated the crisps as tasting both significantly crisper and significantly fresher when the overall sound level was increased and/or when just the high frequency sounds (those above 2 kHz) were amplified (see Fig. 11.3). By contrast, the participants rated the crisps as being both staler and softer when the overall intensity of their food-eating sounds was reduced and/or when the high frequency sounds were attenuated instead. These results therefore highlight the significant role that food-related biting sounds can play in modulating people's perception and evaluation of inherently 'noisy' foods. Vickers and Wasserman (1979) have also highlighted how the temporal qualities of food sounds—such as how uneven or discontinuous they are—can influence how 'crispy' people perceive them to be, a cross-modal (or multisensory) influence that has recently been confirmed by other researchers (e.g. Chen et al. 2005, 2006; see also Zampini and Spence 2005).

In a subsequent study, Zampini and Spence (2005) went on to investigate the role of auditory cues on people's perception of carbonated water (cf. Vickers 1991; Harper and McDaniel 1993). The participants in this experiment had to rate a series of carbonated beverages while receiving auditory feedback of the sound emitted by the popping of the bubbles in the cup. The loudness and frequency composition of the

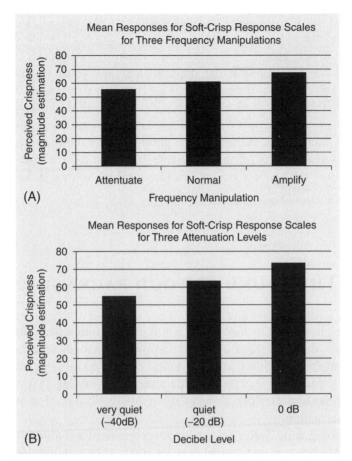

Fig. 11.3 A) Participants' mean *crispness* ratings when listening to auditory feedback incorporating one of three different high–frequency (i.e. those frequencies above 2kH) manipulations (attenuate, normal, or amplified high–frequency components). B) Mean *crispness* responses with auditory feedback of three different loudness attenuation levels (0 dB, –20 dB, or –40 dB).

Source: Zampini and Spence (2004).

sounds were once again manipulated in real-time. The participants judged the water samples in cups of carbonated water that they held in their hand as being significantly more carbonated when the overall level of the carbonated water sound was increased and/or when the high frequency components were amplified.

These findings are also supported by a nice anecdotal example reported by Jon Prinz, a food researcher based in the Netherlands. He describes a situation in which people were trained to bite rhythmically into a food (by trying to keep pace with the sound of a metronome playing in the background). If, during the course of the biting action, the experimenter played the sound of glass breaking, people's jaws would often freeze up—it was as if they could no longer eat.

Hashimoto and his colleagues in Japan have taken the idea of playing with the sounds of food one stage further via their recently developed straw-like user interface (see Hashimoto et al. 2007). Users of the device are instructed to place the straw over a food of their choice (with different foods pictured on different plates) and then to suck ('drink') on the straw. The device gives a surprisingly convincing virtual impression that one is sucking up one of a range of different foods through the straw. This impression is achieved simply by combining tactile and auditory cues as the user sucks on the straw. So, for example, juice appears to enter the straw with little resistance, while sucking up jelly through the straw gives rise to intermittent resistance. The impression here is, of course, entirely illusory since no food is, in fact, actually delivered.

THE SOUND OF FOOD PACKAGING

It is, however, important to note that it is not just the sound that a food makes as we consume it that modulates our perception of noisy foods (such as crisps and carbonated beverages). In fact, even the sound of the packaging in which the food happens to be presented (e.g. think of the noise of the rattling of the crisp packet whenever eating a bag of crisps) can have a subtle, but significant, effect on our perception of the food within.

Amanda Wong and Charles Spence recently conducted a study in which 20 participants had to bite into 40 Original Pringles potato chips, while either listening to white noise or to the sounds associated with the opening/manipulation of one of three different crisp packets. The participants in this experiment were given an assortment of fresh potato chips (from a newly opened pack) and stale potato chips (from a packet that had been opened and then left out for several days).[8] Before starting the experiment proper, the blindfolded participants were given a sample crisp to taste, which they were informed had a crispness rating of 5 on a 10-point crispness scale, with 10 being 'very crispy'. During the experiment itself, the participants were instructed to bite into each potato chip with their front teeth and give a verbal estimate of the 'crispness' of the chip on the 10-point scale. During each trial, one of four different sound clips was played to the participant over a pair of closed ear headphones. The four auditory soundtracks consisted of: (1) the sound made by the rattling of a packet of Walker's crisps (25-g bag composed of two layers of polypropylene, one metallic layer and the other with the print on the outside); (2) the rattling sounds made by

[8] The participants were given potato chips of different staleness levels in order to make sure that they were actually performing a meaningful discrimination. On average, participants rated the stale potato chips as a 5.0 on the scale, whereas the potato chips from the newly-opened packet were given a higher rating of 6.7, as one would expect.

a packet of Kettle's crisps (28-g, form-fill-seal bags made from a coated-paper sub-strate); (3) the popping sound associated with the opening of a tube of Pringles potato chips (170-g cardboard tube with a paper liner and a foil liner made of aluminium foil and polyethylene); and (4) continuous white noise presented at 91 dB (cf. Kupfermann 1964; McFadden et al. 1971). The various auditory conditions were presented in a random order. The results showed that participants' perception of the crispness/stale-ness of the potato crisps was affected by the particular soundtrack that they happened to be listening to (see Fig. 11.4). In particular, the participants rated the crisps that they bit into when listening to the rattling of a bag of Kettle's or Walker's crisps (M = 6 for both) as being significantly crispier than when they listened to the recording of a tube of Pringles crisps being opened (M = 5.5; t(17) = 3.48, p <0.005, by post hoc t-test for the comparison between the Pringles soundtrack and both the Kettle's and Walker's crisp rattling soundtracks).

That what we hear (even when it is the sound of a rattling crisp packet) can have a significant effect on our perception of food should perhaps not come as such a surprise when one considers the animal literature. For one need think only of Ivan Pavlov's (1927) early demonstration that dogs can be conditioned to salivate in response to the presentation of a sound that has previously indicated the arrival of food. In fact, even fish can be trained to engage in food expectancy behaviours in response to sound, as in Frolov's classic report of the various species of carp whose food-approach behaviours had been conditioned to the sound of a telephone ringing (Frolov 1924/1937, p. 66; see also 'The fish with a memory who knows when it's time to eat', 2008). Meanwhile, Kupfermann (1964) reported that a variety of eating behaviours in rats result from the mere presentation of white noise to the animals. Given that the sound

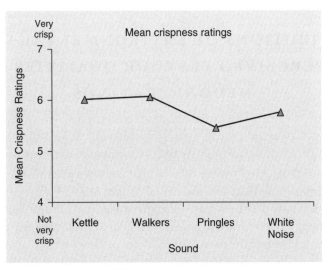

Fig. 11.4 Participants' ratings of the crispness/staleness of Pringles potato chips, as influenced by the particular soundtrack (Walkers, Kettle's, Pringles, or white noise) heard while biting into the potato chips.

of food packaging, which normally precedes the consumption of a particular food item (as in the sound of the rattling of a crisp packet preceding the consumption of a particular type or brand of crisps), should have such an effect on people's perception of the crispness of crisps may perhaps just represent a form of conditioning (see also Gorn 1982; Rozin and Tuorila 1993; North and Hargreaves 1996b), and/or expectancy effect (Tuorila et al. 1994; Lee et al. 2006; Stevenson and Oaten 2008; Shankar et al. 2009, 2010). In a related vein, other researchers have shown that simply seeing, or smelling a liked food, can both increase reported hunger and also stimulate salivation (Hill et al. 1984; Rogers and Hill 1989).

The relationships between food packaging, consumption, instant gratification and addiction have been addressed by several artists and designers. The design firm M-A-D, for example, created the Doritos project for the exhibition *Value Meal: Design and (over)eating* in the International Design Biennale in Saint-Etienne, France (6–14 November, 2004). Reflecting on the typical compulsive consumption of this food, Philip Foeckler designed a safety-jacket made of Doritos bags fastened together, which come inflated to protect the product inside. This wearable device 'saves' the wearer from lacking his/her favourite snack in times of need, while at the same time making a worrisome visual simulation of the fattening effects resulting from the overconsumption of this particular food. Within the same project, Gregory Cowley programmed a video presenting a time-measuring device called *Adoriction Clock*, in which a digital clock ticks in tempo with the crunching of chips (regularly occurring every second), while a woman rhythmically inhales and exhales into a Doritos bag, once per minute. Again, this is presented as a reflection on time measured by intervals between meals.

CONTRIBUTIONS OF ENVIRONMENTAL SOUNDS TO PERCEIVED FLAVOUR QUALITIES AND HEDONIC RATINGS

Charles Spence and Heston Blumenthal conducted two experiments together with the members of the audience who attended the opening session of the 'Art and the Senses' conference held in October of 2006 that were designed to examine whether (and/or to demonstrate that) environmental sounds would influence people's perceptions of the foods that they were eating (see Fig. 11.5). In the first experiment, 40 audience members were asked to taste two samples of 'bacon and egg' ice cream, one after the other, and to rate the flavour of each scoop. They were instructed to rate the relative strength of the bacon and egg flavours by making a mark on a scale provided on a sheet of paper (see Fig. 11.6). A different soundtrack was played in the background while the members of the audience consumed each of the ice creams: one soundtrack consisted of what sounded like bacon sizzling in a frying pan, while the other consisted of the clucking sounds of farmyard chickens. The ice cream was served with the

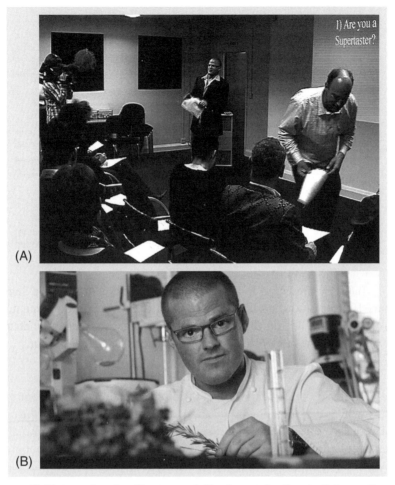

Fig. 11.5 A) Picture showing Heston and Charles at the front of the audience at the 'Art and the Senses' conference (Oxford, 2006). B) Picture showing Heston Blumenthal in his kitchen.

(a) Photograph: Francesca Bacci b) ©Heston Blumenthal

farmyard soundtrack and a yellow plastic spoon (e.g. consistent with the colour of eggs) while the other sample was presented with a blue spoon.

The results showed that the audience rated the ice cream tasted in the presence of the sizzling bacon soundtrack as having a significantly more *bacony* flavour than the ice cream sample that was tasted in the presence of the farmyard chicken sounds $(t(39)= 4.0, p <0.001$, by paired-samples t-test; see Fig. 11.7). Interestingly, however, both scoops of ice-cream had come from the same batch—that is, the flavours were actually identical. These results show that auditory cues can be used to bias people's perception of the relative strength of two competing flavours in a food.[9]

[9] Note that when the bacon and egg-flavoured ice cream is served at The Fat Duck restaurant, a piece of fried bread is also presented on the plate. Adding this crispy component to the dish really makes the dish work. Informally, it seems that the fried bread provides the texture appropriate to the

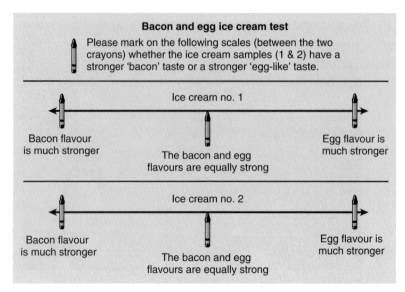

Fig. 11.6 The scale presented to audience members at the 'Art and the Senses' conference (Oxford, 2006) during the bacon and egg ice cream experiment. They were asked to mark a line on each scale after tasting each sample, to indicate their perception of the relative strength of the 'bacon' and 'egg' flavour.

More generally, it should be noted that the disambiguation of the flavour of a food dish can be achieved by a number of means: either visually, by changing the colour of the food, verbally by means of labelling (Meiselman and Bell 1992; Wansink et al. 2000), by presenting pictures or other cues on the packaging (see Demattè et al. 2009), and/or by the presentation of auditory cues, as described in the present study. Furthermore, even saying the word 'cinnamon' has been shown to activate the olfactory cortex (i.e. the part of the brain that processes smells; see González et al. 2006). Playing the sizzling bacon soundtrack at the 'Art and the Senses' conference may therefore have influenced the audience's perception of the bacon flavour in the ice cream simply by making them think of bacon. All provide putative explanations of how listening to the sound of frying bacon might make bacon and egg ice-cream taste more bacony! It is at present an open question as to whether simply writing the word bacon on the screen in the front of the auditorium would have had the same effect (see Sakai et al. 2005; Demattè et al. 2009). The soundtracks were presented at a clearly audible level in this study and some of the audience members could feel that their flavour perception was being changed by the soundtrack; a few even tried to override this form of auditory manipulation by repeating the word 'bacon, bacon, bacon. . .' to themselves

taste of 'crispy' bacon. Consequently, the bacon and egg flavours seem to separate in the mouth as the bacon taste delivered by the ice cream is actually mislocalized (or ventriloquized) to the texturally appropriate but bland fried bread, while the eggy flavour remains in the ice cream (which has more the smooth consistency of an actual egg; see Green 2002; von Békésy 1963).

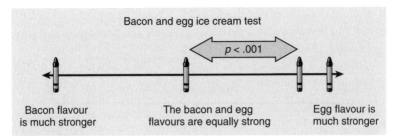

Fig. 11.7 Results of the bacon and egg cream ice cream experiment. The participants rated the ice cream sample tasted in the presence of the sizzling bacon soundtrack as having a significantly more pronounced bacon flavour than the ice cream sample tasted in the presence of the farmyard chickens soundtrack.

like a mantra when listening to the farmyard chickens clucking away, but to little avail. One suggestion is that environmental auditory stimuli may activate superordinate knowledge structures and hence prime related stimuli (see Martindale and Moore 1988; North et al. 1997).

In a second study, 33 members of the audience were asked to taste and rate two oysters in terms of their pleasantness and intensity of their flavours using the scales shown in Fig. 11.8. One oyster was served in the shell from a wooden basket (of the

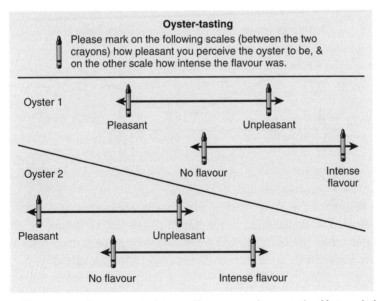

Fig. 11.8 The two scales presented to audience members at the 'Art and the Senses' conference (Oxford, 2006) during the oyster-tasting experiment. They were asked to mark a line through each scale after tasting each oyster, depending on how 'pleasant' and 'intense' they found the flavour of each oyster to be.

type that one commonly sees at the seaside). The other oyster had been removed from the shell and was served in a petri dish instead. The first oyster was served while the audience listened to the 'sounds of the sea' soundtrack in the background (this consisted of the sound of seagulls squawking and waves crashing gently on the beach), the second while they listened to the 'farmyard noises' used in our first experiment.[10] The results revealed that the audience rated the oyster that they had consumed while listening to the 'sound of the sea' as tasting significantly more pleasant than the oyster that had been tasted while they listened to the farmyard noises instead ($t(32)=2.34$, $p<.05$, paired sample t-test; see Fig. 11.9). Interestingly, however, no such effect was found for the intensity ratings (see Fig. 11.9). That is, changing the sound had no effect on people's perception of the intensity of the flavour of the oysters.

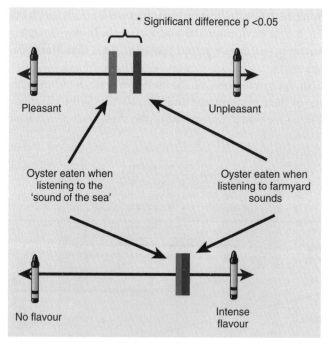

Fig. 11.9 Results of the oyster-tasting experiment. The participants rated the oyster consumed while listening to the 'sound of the sea' as tasting significantly more pleasant than the oyster tasted while listening to the farmyard sounds instead. No such effects were seen on the ratings of flavour intensity.

[10] Note that we counterbalanced the order of presentation of these two conditions, that is, one group of audience members hear the sound of the sea first, and the farmyard noises second, while the order of presentation of the sounds with the oysters was reversed for the other group of participants.

Taken together, the results of these two experiments, conducted at the 'Art and the Senses' conference, highlight just how dramatically environmental sounds can influence (or bias) people's perception of the foods they consume. Interestingly, these results led directly to the introduction of the 'Sound of the Sea' seafood dish on the tasting menu of The Fat Duck restaurant in Bray (see Fig. 11.10). With this dish, diners are presented with a plate of food that is reminiscent of a beach (with foam, sea-weed, and sand all visible on their plate). The diners are also presented with a mini iPod hidden inside a sea-shell, with only the earphones poking out. The diners are encouraged to put on the headphones (whereupon they hear the 'sounds of the sea' soundtrack) before starting to eat the dish placed in front of them. The response of diners on the tasting menu has been very positive. The diners appear to really enjoy the dish. In fact, it has become a signature dish at the restaurant. The dish appears to work at several levels: by getting the diners to think about the role of hearing in eating and by helping to illustrate the importance of sound to the appreciation of food. Second, we believe, on the basis of the evidence reported here, that the dish is so successful because the soundtrack serves to intensify the flavour of the dish. That is, it heightens the flavour (see 'Fat Duck dons an iPod', 2007). It is also worth noting that wearing the headphones has the originally unanticipated additional effect of concentrating the diners' attention on the dish since it becomes difficult to converse with one's dinner partners while listening to the seaside sounds (see Marks and Wheeler 1998).

Fig. 11.10 The signature 'Sounds of the sea' seafood dish, now served with headphones at The Fat Duck restaurant in Bray by Heston Blumenthal.

Finally, it is worth thinking about the effect of the sound of the dish's name itself. As Gerard Samper, the effete Englishman and ghostwriter to the stars puts it in James Hamilton-Patterson's novel, *Cooking with Fernet Branca*: 'I sometimes wonder if one is not more seduced by the mellifluous *sound* of a dish than by how it would actually taste' (Hamilton-Patterson, 2004, p. 67). While one might not necessarily agree with the claim, the latest evidence nevertheless does suggest that certain food attributes/ qualities really are better matched with particular food names, or rather with particular speech sounds. In fact, this research represents an extension of one of the best-known early results from the study of experimental psychology: namely, the finding that if people are shown two shapes, one angular and the other curvy, and are asked which of the two shapes is a 'kiki' and which is a 'bubu', the majority will say that the angular shape is the 'kiki' whereas the more curvaceous shape is the 'bubu' (see Köhler 1929; Sapir 1929; Ramachandran and Hubbard 2001).

The results of the latest research from the Crossmodal Research Laboratory in Oxford have extended this idea by showing that certain foods (such as a soft and creamy Brie cheese) are more naturally associated with more rounded/softer-sounding words whereas other foods (such as sharp and acidic cranberries) are associated with sharper-sounding words (Gallace et al. in press). The results suggest that there might be a systematic link between the taste of foods and the kinds of sounds that match, or are synaesthetically congruent with them. Such results are now beginning to be used by the most innovative chefs and food manufacturers in order to ensure that the sound of the names of their food dishes are matched synaesthetically to the tastes that consumers are about to experience (see also Klink 2000; Bertolli 2003; Yorkston and Menon 2004).

CONCLUSIONS

In conclusion, the evidence reviewed in this chapter illuminates just how impor-tant what you hear is to your everyday experience of food and drink. We believe that the research that has been published to date now unequivocally shows that auditory cues can (and do) influence many different aspects of our eating/dining experiences— despite people's intuitions to the contrary. What we hear influences everything from what we choose to eat, the rate at which we eat it, the perceived pleasantness of the food in our mouths, and the flavour profiles of wine, beer, and presumably any other drink that we might have a predilection to consume (see Petit 1958; Holt-Hansen 1968, 1976; Rudmin and Cappelli 1983; Bronner et al. 2008; Reid 2008).

The results of the research outlined in this review have been published in a variety of disparate research areas, including human psychophysics, food science, market-ing, functional neuroimaging, and animal behaviour. This may help to explain why,

to date, the topic of the influence of hearing on eating, drinking, and perception has not received the serious scientific attention that it deserves. Several potential mechanisms (both physiological and psychological) have been put forward to try and explain the various ways in which what people hear influences their food perceptions and behaviours. These include physiological/autonomic effects on a person's level of arousal (e.g. Smith and Curnow 1966), multisensory perceptual interactions resulting from the modulation of food-related sounds (e.g. Zampini and Spence 2004, 2005), putative conditioning effects resulting from the sounds made by our interactions with the packaging of food (and possibly also the environment; see Gorn 1982; Rozin and Tuorila 1993) on the pleasantness of the food or drink itself (Jacob 2006). Researchers have also shown that auditory cues can help to bias people's identification of the identity/flavour of a food, especially under conditions of perceptual uncertainty (see the 'bacon and egg ice cream' experiment reported earlier). Thus, it would appear that the food or drink (i.e. the product), its packaging (Spence and Zampini 2006), and even the environment (i.e. the place; see Pine and Gilmore 1998), are all seamlessly integrated to give rise to our overall perception of/responses to food and drink.

That the 'atmospherics' (see Kotler 1974) of the environment can and does influence our perception of food and drink should come as little surprise to anyone who has purchased a cheap bottle of plonk (wine) while on holiday. On the basis of informal questioning, it would appear that most people (at least those living in the United Kingdom) have had the experience of drinking wine that tastes so nice when it is consumed at a restaurant by the sea (preferably somewhere in the Mediterranean), with the sun beating down on your back, and, of course, listening to the sound of the sea, only to open the very same wine once safely ensconced in the middle of a dark winter's evening back at home, and to find, with disappointment, that it no longer tastes the same. The fact that this experience is common to so many of us provides further, albeit anecdotal, support for the claim that the atmospherics in which we consume food and drink have a profound effect on our perception and appreciation of them (see also Byrne and Clore 1970; North and Hargreaves 1996a,b; Pine and Gilmore 1998). Given the results reported in this chapter, one obvious solution to the 'plonk paradox' (why cheap wine tastes good on holiday but terrible at home) would be to try and recapture some of these sensory impressions in one's own living room, in order to enhance the flavour/pleasantness of the wine-drinking experience (and turn that horrible tasting wine into something that tastes really rather nice), and to elucidate the respective contributions of contextual effects on hedonic ratings.

While it would probably be most sensible to retain a degree of scepticism with regard to certain of the more outlandish findings that have been reported in the literature (e.g. see Holt-Hansen 1968, 1976; especially given the possible role of expectancy effects, e.g. see Holt-Hansen 1968, p. 61; Rudmin and Cappelli 1983), at least until they have been independently verified, the weight of empirical evidence on the effects of auditory stimulation on our eating experiences now unequivocally support the claim that what people hear can modulate their experience of food and drink. When

trying to deliver the most satisfying eating and drinking experiences, the loudness, tempo, and type of music played in the background, the particular sounds made by food as we eat and drink it (e.g. Zampini and Spence 2004, 2005), the sound of the packaging or container in which the food happens to be served or presented (see Spence and Zampini 2006), and even the atmospherics of the environment in which that food is consumed, should all be considered (see Kotler 1974; Mehrabian and Russell 1983; Pine and Gilmore 1998; Turley and Milliman 2000; Spangenberg et al. 2005).[11] Of course, when thinking about the use of sound in service settings (retail environments) one must be careful not to go so far as to annoy the consumer/customer (e.g. see Englis and Pennell 1994; Spence 2002).

We believe that the cognitive science-inspired approach to the design of food and drink outlined here offers a promising means of enhancing the eating experience in the years to come (see 'Fat Duck dons an iPod', 2007; Reid 2008; Spence 2008). In fact, the future may look very much like the Futurists predicted a century ago (see Marinetti 1930/1989). While Marinetti suggested that we could enhance the dining experience by implementing what we know about contextual effects, our growing understanding of the cognitive neuroscience is already providing some important practical interventions that may make flavour more appealing. Indeed, recently, the press has even started to refer to specific dishes, and even entire menus, as 'works of art'. Moreover, some of the world's top chefs are increasingly being described as artists, rather than simply as cooks! For example, Alison Knowles, an American experimental artist, recently prepared a giant salad and dished it up for over 300 people at Tate Modern in London. The coordinating of the salad was set to the music of Mozart, in a 'performance designed to blur the line between art and everyday activity' (Brooks 2008, p. 9). The event's curator, Kathy Noble, said, 'It's a participatory event in every sense. The work of the chefs, the observation of the audience and then their chance to eat what they have seen put together' (Brooks 2008, p. 9).

..

[11] However, there is little evidence that many companies are currently exploiting these findings (i.e. by turning up the volume to increase drinks sales, for example). Similarly, adverse effects of 'elevator' music have, to date, remained fairly limited (see Englis and Pennell 1994; Spence 2002). That said, companies such as SoundAlert (see Treasure 2007) are now offering to provide specific soundtracks to particular retail environments. Those of you who have passed through Glasgow airport recently might well be familiar with the nature soundtrack that greets people in this oftentimes stressful environment (see also Smith 2008). Of course, whatever the music, it is important to make sure that it matches customer preferences (see Caldwell and Hibbert 2002; see also Pine and Gilmore 1998; and 'Loud music in the pub "makes you drink more"' 2008).

ACKNOWLEDGEMENTS

We would like to thank Melissa Lyons for making sure that everything ran so smoothly with the demonstrations at the 'Art and the Senses' conference. Maya Shankar would also like to thank the Rhodes Trust, which funds her research.

REFERENCES

Alpert JI and Alpert M (1990). Music influences on mood and purchase intentions. *Psychology and Marketing*, 7, 109–33.

Areni CS and Kim D (1993). The influence of background music on shopping behavior: Classical versus top-forty music in a wine store. *Advances in Consumer Research*, 20, 336–40.

Bach PJ and Schaefer JM (1979). The tempo of country music and the rate of drinking in bars. *Journal of Studies on Alcohol*, 40, 1058–9.

Beeli G, Esslen M, and Jäncke L (2005). When coloured sounds taste sweet. *Nature*, 434, 38.

Belk RW. (1974). An exploratory assessment of situational effects in buyer behaviour. *Journal of Marketing Research*, 11, 156–63.

Bell R, Meiselman HL, Pierson BJ, and Reeve WG (1994). Effects of adding an Italian theme to a restaurant on the perceived ethnicity, acceptability, and selection of foods. *Appetite*, 22, 11–24.

Bellisle F and Dalix AM (2001). Cognitive restraint can be offset by distraction, leading to increased mean intake in women. *American Journal of Clinical Nutrition*, 74, 197–200.

Bertolli P (2003). *Cooking by Hand*. Clarkson Potter, New York.

Birren F (1963). Color and human appetite. *Food Technology*, 17 (**May**), 45–7.

Bronner K, Bruhn H, Hirt R, and Piper D (2008). *Research on the interaction between the perception of music and flavour*. Poster presented at the 9th Meeting of the IMRF, 15–19 July. Hamburg, Germany.

Brooks R (2008). Tate tosses up super-salad as art. *The Sunday Times*, **March** 16 (News), 9.

Bruner GC (1990). Music, mood, and marketing. *Journal of Marketing*, 54, 94–104.

Byrne D and Clore GL (1970). A reinforcement model of evaluative responses. *Personality*, 1, 103–28.

Caldwell C and Hibbert S (1999). Play that one again: The effect of music tempo on consumer behaviour in a restaurant. *European Advances in Consumer Research*, 4, 58–62.

Caldwell C and Hibbert SA (2002). The influence of music tempo and musical preference on restaurant patrons' behavior. *Psychology and Marketing*, 19, 895–917.

Chen J, Karlsson C, and Povey M (2005). Acoustic envelope detector for crispness assessment of biscuits. *Journal of Texture Studies*, 36, 139–56.

Chen J, Karlsson C, and Povey M (2006). Crispness assessment of roasted almonds by an integrated approach to texture description: Texture, acoustics, sensory and structure. *Journal of Chemometrics*, 20, 311–20

Christensen CM and Vickers ZM (1981). Relationships of chewing sounds to judgments of food crispness. *Journal of Food Science*, 46, 574–8.

Dacremont C and Colas B (1993). Effect of visual clues on evaluation of bite sounds of foodstuffs. *Sciences des Aliments*, 13, 603–10.

Day S (2005). Some demographic and socio-cultural aspects of synesthesia. In LC Robertson and N Sagiv, eds. *Synesthesia: Perspectives from cognitive neuroscience*, pp. 11–33. Oxford University Press, New York.

Delwiche J (2004). The impact of perceptual interactions on perceived flavor. *Food Quality and Preference*, 15, 137–46.

Demattè ML, Sanabria D and Spence C (2009). Olfactory discrimination: When does vision matter? *Chemical Senses*, 34, 103–9.

'Does it make sense?' (2007). *Contact: Royal Mail's magazine for Marketers*. Redwood, London.

Drake B (1965). Food crushing sounds: Comparisons of objective and subjective data. *Journal of Food Science*, 30, 556–9.

Drake B (1970). Relationships of sounds and other vibrations to food acceptability. *Proceedings of the 3rd International Congress of Food Science and Technology*, pp. 437–45. 9–14 August, Washington DC.

Drews DR, Vaughn DB, and Anfiteatro A (1992). Beer consumption as a function of music and the presence of others. *Journal of the Pennsylvania Academy of Science*, 65, 134–6.

DuBose CN, Cardello AV, and Maller O (1980). Effects of colorants and flavorants on identification, perceived flavor intensity, and hedonic quality of fruit-flavored beverages and cake. *Journal of Food Science*, 45, 1393–9.

Duncker K (1939). The influence of past experience upon perceptual properties. *American Journal of Psychology*, 52, 255–65.

Edwards JSA, Meiselman HL, Edwards A, and Lesher L (2003). The influence of eating location on the acceptability of identically prepared foods. *Food Quality and Preference*, 14, 647–52.

Englis BG and Pennell GE (1994). 'This note's for you. . .': Negative effects of the commercial use of popular music. *Advances in Consumer Research*, 21, 97.

'Fat Duck dons an iPod' (2007). *Manchester Evening News*, 16 April.

Ferber C and Cabanac M (1987). Influence of noise on gustatory affective ratings and preference for sweet or salt. *Appetite*, 8, 229–35.

Frolov YP (1924/1937). Fish who answer the telephone, and other studies in experimental biology, S. Graham, trans. Kegan Paul, London.

Gallace A, Boschin E, and Spence C (in press). On the taste of 'Bouba' and 'kiki': An exploration of word-food associations in neurologically normal participants. *Cognitive Neuroscience*.

Goldberg RL (1979). *Performance art: From Futurism to the present*. Thames & Hudson, London.

González J, Barros-Loscertales A, Pulvermüller F, Meseguer V, Sanjuán A and Belloch V (2006). Reading cinnamon activates olfactory brain regions. *NeuroImage*, 32, 906–12.

Gorn GJ (1982). The effects of music in advertising on choice behavior: A classical conditioning approach. *Journal of Marketing*, 46, 94–100.

Green BG (1996). Chemesthesis: Pungency as a component of flavor. *Trends in Food Science and Technology*, 7, 415–24.

Green BG (2002). Studying taste as a cutaneous sense. *Food Quality and Preference*, 14, 99–109.

Green DM and Butts JS (1945). Factors affecting acceptability of meals served in the air. *Journal of the American Dietetic Association*, 21, 415–19.

Guéguen N, Jacob C, Le Guellec H, Morineau T, and Lourel M (2008). Sound level of environmental music and drinking behavior: A field experiment with beer drinkers. *Alcoholism: Clinical and Experimental Research*, 32, 1–4.

Guéguen N, Le Guellec H, and Jacob C (2004). Sound level of background music and alcohol consumption: An empirical evaluation. *Perceptual and Motor Skills*, 99, 34–8.

Hall RL (1958). Flavor study approaches at McCormick and Company, Inc. In AD Little Inc, ed. *Flavor research and food acceptance: A survey of the scope of flavor and associated research, compiled from papers presented in a series of symposia given in 1956-1957*, pp. 224–40. Reinhold, New York.

Hamilton-Paterson J (2004). *Cooking with Fernet Branca*. Faber and Faber, London.

Harper SJ and McDaniel MR (1993). Carbonated water lexicon: Temperature and CO_2 level influence on descriptive ratings. *Journal of Food Science*, **58**, 893–8.

Hashimoto Y, Nagaya N, Kojima M, et al. (2007). Straw-like user interface: Virtual experience of the sensation of drinking using a straw. *Proceedings World Haptics 2007*, pp. 557–8. IEEE Computer Society, Los Alamitos.

Herrington J and Capella L (1994). Practical applications of music in service settings. *Journal of Services Marketing*, **8**, 50–6.

Herrington JD and Capella LM (1996). Effect of music in service environments: A field study. *Journal of Services Marketing*, **10**, 26–41.

Hill AJ, Magson LD, and Blundell JE (1984). Hunger and palatability: Tracking ratings of subjective experience before, during and after the consumption of preferred and less preferred food. *Appetite*, **5**, 361–71.

Holbrook M and Anand P (1990). Effects of tempo and situational arousal on the listener's perceptual and affective responses to music. *Psychology of Music*, **18**, 150–62.

Holt-Hansen K (1968). Taste and pitch. *Perceptual and Motor Skills*, **27**, 59-68.

Holt-Hansen K (1976). Extraordinary experiences during cross-modal perception. *Perceptual and Motor Skills*, **43**, 1023–7.

Jacob C (2006). Styles of background music and consumption in a bar: An empirical evaluation. *International Journal of Hospitality Management*, **25**, 716–20.

Kellaris J and Kent R (1992). The influence of music on consumers' temporal perceptions: Does time fly when you're having fun? *Journal of Consumer Psychology*, **1**, 365–76.

Kellaris J, Mantel S, and Altsech MB (1996). Decibels, disposition, and duration: A note on the impact of musical loudness and internal states on time perception. In *Advances in Consumer Research*, **23**, 498–503. Association for Consumer Research, Provo.

Klink RR (2000). Creating brand names with meaning: The use of sound symbolism. *Marketing Letters*, **11**, 5–20.

Köhler W (1929). *Gestalt psychology*. Liveright, New York.

Konečni VJ (2008). Does music induce emotion? A theoretical and methodological analysis. *Psychology of Aesthetics, Creativity, and the Arts*, **2**, 115–29.

Kotler P (1974). Atmospherics as a marketing tool. *Journal of Retailing*, **49**, 48–64.

Kupfermann I (1964). Eating behaviour induced by sounds. *Nature*, **201**, 324.

Lee L, Frederick S, and Ariely D (2006). Try it, you'd like it: The influence of expectation, consumption, and revelation on preferences for beer. *Psychological Science*, **17**, 1054–8.

Levitan C, Zampini M, Li R, and Spence C (2008). Assessing the role of color cues and people's beliefs about color-flavor associations on the discrimination of the flavor of sugar-coated chocolates. *Chemical Senses*, **33**, 415–23.

Linsen MA (1975). Like our music today, ms. shopper? *Progressive Grocer*, **October**, 156.

'Loud music in the pub "makes you drink more"' (2008). *Daily Mail*, **July 19**, 26.

Maller O, DuBose CN, and Cardello AV (1980). Consumer opinions of hospital food and foodservice. *Journal of the American Dietetic Association*, **76**, 236–42.

Marinetti FT (1930/1989). *[La Cucina Futurista] The Futurist Cookbook*, S Brill, trans. Bedford Arts, San Francisco, CA.

Marks LE, and Wheeler ME (1998). Attention and the detectability of weak taste stimuli. *Chemical Senses*, **23**, 19–29.

Martindale C and Moore K (1988). Priming, prototypicality, and preference. *Journal of Experimental Psychology: Human Perception and Performance*, **14**, 661–70.

McCarron A and Tierney KJ (1989). The effect of auditory stimulation on the consumption of soft drinks. *Appetite*, **13**, 155–9.

McElrea H and Standing L (1992). Fast music causes fast drinking. *Perceptual and Motor Skills*, **75**, 362.

McFadden D, Barr AE, and Young RE (1971). Audio analgesia: Lack of a cross-masking effect on taste. *Perception and Psychophysics*, **10**, 175–9.

Mehrabian AR and Russell JA (1974). *An Approach to Environmental Psychology*. MIT Press, Cambridge, MA.

Meiselman HL (2008). Dimensions of the meal. *Journal of Foodservice*, **19**, 13-21.

Meiselman HL and Bell R (1991/2). The effects of name and recipe on the perceived ethnicity and acceptability of selected Italian foods by British subjects. *Food Quality and Preference*, **3**, 209–14.

Meiselman HI, Hirsch ES, and Popper RD (1988). Sensory, hedonic and situational factors in food acceptance and consumption. In DMH Thomson, ed., *Food acceptability*, pp. 77–87. Elsevier Applied Science, San Francisco, CA.

Milliman RE (1982). Using background music to affect the behavior of supermarket shoppers. *Journal of Marketing*, **46**, 86–91.

Milliman RE (1986). The influence of background music on the behavior of restaurant patrons. *Journal of Consumer Research*, **13**, 286–9.

Moir HC (1936). Some observations on the appreciation of flavour in foodstuffs. *Journal of the Society of Chemical Industry: Chemistry and Industry Review*, **14**, 145–8.

Morrot G, Brochet F, and Dubourdieu D (2001). The color of odors. *Brain and Language*, **79**, 309–20.

'Music 'can enhance wine taste'' (2008). Downloaded from BBC News website: http://news.bbc.co.uk/go/pr/fr/-/1/hi/uk/7400109.stm on 14 April, 2008.

North A and Hargreaves D (1996a). Responses to music in a dining area. *Journal of Applied Social Psychology*, **26**, 491–501.

North A and Hargreaves D (1996b). The effects of music on responses to a dining area. *Journal of Environmental Psychology*, **16**, 55–64.

North A and Hargreaves D (1998). The effects of music on atmosphere and purchase intentions in a cafeteria. *Journal of Applied Social Psychology*, **28**, 2254–73.

North A and Hargreaves D (2008). *The social and applied psychology of music*. Oxford University Press, Oxford.

North A, Hargreaves DJ, and McKendrick J (1997). In-store music affects product choice. *Nature*, **390**, 132.

North A, Hargreaves D, and McKendrick J (1999). The influence of in-store music on wine selections. *Journal of Applied Psychology*, **84**, 271–6.

North A, Shilcock A, and Hargreaves D (2003). The effect of musical style on restaurant customers' spending. *Environment and Behavior*, **35**, 712–18.

Pavlov IP (1927). *Conditioned reflexes: An investigation of the physiological activity of the cerebral cortex*, GV Anrep, trans. and ed. Oxford University Press, London.

Petit LA (1958). The influence of test location and accompanying sound in flavor preference testing of tomato juice. *Food Technology*, **12**, 55–7.

Pine II BJ and Gilmore JH (1998). Welcome to the experience economy. *Harvard Business Review*, **76**, 97–105.

Raghubir P and Krishna A (1999). Vital dimensions in volume perception: Can the eye fool the stomach? *Journal of Marketing Research*, **36**, 313–26.

Ragneskog H, Brane G, Karlsson I, and Kihlgren M (1996). Influence of dinner music on food intake and symptoms common in dementia. *Scandinavian Journal of Caring Science*, **10**, 11–17.

Ramachandran V and Hubbard E (2001). Synaesthesia – a window into perception, thought and language. *Journal of Consciousness Studies*, **8**, 3–34.

Reid M (2008). How Guns and Roses can change your tune on wine. *The Times*, **May 13**.

Roballey TC, McGreevy C, Rongo RR, et al. (1985). The effect of music on eating behavior. *Bulletin of the Psychonomic Society*, **23**, 221–2.

Rogers PJ and Hill AJ (1989). Breakdown of dietary restraint following mere exposure to food stimuli: Interrelationships between restraint, hunger, salivation, and food intake. *Addictive Behaviors*, **14**, 387–97.

Rolls BT, Rowe EA, and Rolls ET (1982). How sensory properties of foods affect human feeding behaviour. *Physiology and Behavior*, **29**, 409–17.

Rozin P (1982). 'Taste-smell confusions' and the duality of the olfactory sense. *Perception and Psychophysics*, **31**, 397–401.

Rozin P and Tuorila H (1993). Simultaneous and temporal contextual influences on food acceptance. *Food Quality and Preference*, **4**, 11–20.

Rudmin F and Cappelli M (1983). Tone-taste synesthesia: A replication. *Perceptual & Motor Skills*, **56**, 118.

Sánchez Romera M (2001). *La cocina de los sentidos* [The kitchen of the senses]. Editorial Planeta 2003, Barcelona.

Sakai N, Imada S, Saito S, Kobayakawa T, and Deguchi Y (2005). The effect of visual images on perception of odors. *Chemical Senses*, **30**(Suppl 1), i244–i245.

Sapir E (1929). A study in phonetic symbolism. *Journal of Experimental Psychology*, **12**, 225–39.

Shankar MU, Levitan CA, Prescott J, and Spence C (2009). The influence of color and label on the perceptions of flavor. *Chemosensory Perception*, **2**, 53–8.

Shankar MU, Levitan CA, and Spence C (2010). Grape expectations: The role of cognitive influences in color-flavor interactions. *Consciousness & Cognition*, **19**, 380–90.

Smith PC and Curnow R (1966). 'Arousal hypothesis' and the effects of music on purchasing behavior. *Journal of Applied Psychology*, **50**, 255–6.

Smith R (2008). The louder the music, the faster men drink beer. *The Daily Telegraph*, **July 19 (News)**, 12.

Spangenberg ER, Grohmann B, and Sprott DE (2005). It's beginning to smell (and sound) a lot like Christmas: The interactive effects of ambient scent and music in a retail setting. *Journal of Business Research*, **58**, 1583–9.

Spence C (2002). *The ICI report on the secret of the senses*. The Communication Group, London.

Spence C (2008). Multisensory perception. In H. Blumenthal, *The Big Fat Duck Cookbook*, London: Bloomsbury.

Spence C, Sanabria D, and Soto-Faraco S (2007). Intersensory Gestalten and crossmodal scene perception. In K Noguchi, ed. *Psychology of Beauty and Kansei: New Horizons of Gestalt Perception*, pp. 519–79. Fuzanbo International, Tokyo.

Spence C and Zampini M (2006). Auditory contributions to multisensory product perception. *Acta Acustica united with Acustica*, **92**, 1009–25.

Srinivasan M (1955). Has the ear a role in registering flavour? *Bulletin of the Central Food Technology Research Institute Mysore (India)*, **4**, 136.

Stevenson RJ, and Oaten M (2008). The effect of appropriate and inappropriate stimulus color on odor discrimination. *Perception & Psychophysics*, **70**, 640–6.

'The fish with a memory who knows when it's time to eat' (2008). Downloaded from MailOnline at: http://www.dailymail.co.uk/sciencetech/article-511706/The-fish-memory-knows-time-eat.html on 25 June, 2008.

Treasure J (2007). *Sound Business*. Management Books 2000 Ltd, Cirencester.

Turley LW and Milliman RE (2000). Atmospheric effects on shopping behavior: a review of the experimental evidence. *Journal of Business Research*, **49**, 193–211.

Vatakis A and Spence C (2007). Crossmodal binding: Evaluating the 'unity assumption' using audiovisual speech stimuli. *Perception and Psychophysics*, **69**, 744–56.

Vatakis A and Spence C (2008). Evaluating the influence of the 'unity assumption' on the temporal perception of realistic audiovisual stimuli. *Acta Psychologica*, **127**, 12–23.

Verhagen JV and Engelen L (2006). The neurocognitive bases of human multimodal food perception: Sensory integration. *Neuroscience and Biobehavioral Reviews*, **30**, 613–50.

Vickers ZM (1981). Relationships of chewing sounds to judgments of crispness, crunchiness and hardness. *Journal of Food Science*, **47**, 121–4.

Vickers ZM (1983). Pleasantness of food sounds. *Journal of Food Science*, **48**, 783–6.

Vickers Z (1991). Sound perception and food quality. *Journal of Food Quality*, **14**, 87–96.

Vickers Z and Bourne MC (1976). A psychoacoustical theory of crispness. *Journal of Food Science*, **41**, 1158–64.

Vickers ZM and Wasserman SS (1979). Sensory qualities of food sounds based on individual perceptions. *Journal of Texture Studies*, **10**, 319–32.

von Békésy G (1963). Interaction of paired sensory stimuli and conduction in peripheral nerves. *Journal of Applied Physiology*, **18**, 1276–84.

Wansink B (1992). Listen to the music: Its impact on affect, perceived time passage and applause. In J Sherry and B Sternthal, eds. *Advances in Consumer Research*, **19**, 715–18. Association for Consumer Research, Provo.

Wansink B (2002). Changing eating habits on the home front: lost lessons from World War II research. *Journal of Public Policy and Marketing*, **21** (**Spring**), 90–9.

Wansink B, Park SB, Sonka S, and Morganosky M (2000). How soy labeling influences preference and taste. *International Food and Agribusiness Management Review*, **3**, 85–94.

Wansink B, van Ittersum K, and Painter JE (2005). How descriptive food names bias sensory perceptions in restaurants. *Food Quality and Preference*, **16**, 393–400.

Wheatley J (1973). Putting colour into marketing. *Marketing*, **October 24–29**, 67.

Wilson S (2003). The effect of music on perceived atmosphere and purchase intentions in a restaurant. *Psychology of Music*, **31**, 93–112.

Yalch R and Spangenberg E (1990). Effects of store music on shopping behavior. *Journal of Services Marketing*, **4**, 31–9.

Yalch R and Spangenberg E (1993). Using store music for retail zone: a field experiment. *Advances in Consumer Research*, **20**, 632–6.

Yalch RF and Spangenberg ER (2000). The effects of music in a retail setting on real and perceived shopping times. *Journal of Business Research*, **49**, 139–47.

Yeomans MR, Chambers L, Blumenthal H, and Blake A (2008). The role of expectancy in sensory and hedonic evaluation: the case of smoked salmon ice-cream. *Food Quality and Preference*, **19**, 565–73.

Yorkston EA and Menon G (2004). A sound idea: phonetic effects of brand names on consumer judgements. *Journal of Consumer Research*, **31**, 43–51.

Zampini M and Spence C (2004). The role of auditory cues in modulating the perceived crispness and staleness of potato chips. *Journal of Sensory Science*, **19**, 347–63.

Zampini M and Spence C (2005). Modifying the multisensory perception of a carbonated beverage using auditory cues. *Food Quality and Preference*, **16**, 632–41.

Zampini M, Sanabria D, Phillips N, and Spence C (2007). The multisensory perception of flavor: Assessing the influence of color cues on flavor discrimination responses. *Food Quality and Preference*, **18**, 975–84.

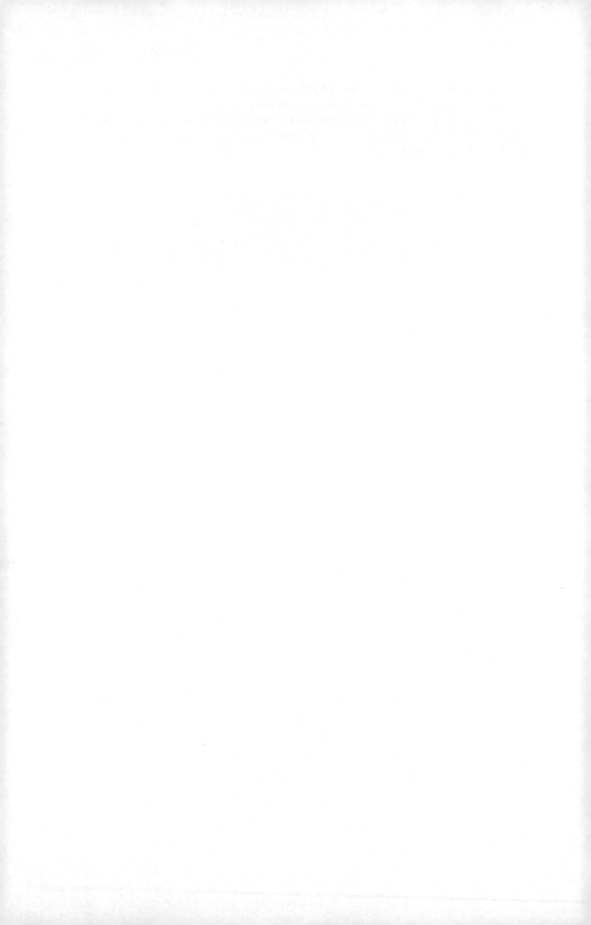

THINKING MULTISENSORY CULTURE*

LAURA U. MARKS

VISUAL and cultural studies were founded with the intention to correct the apparent elitism and disciplinary narrowness of art history and related disciplines. However, the turn toward visual culture has left in place the sensory hierarchy that subtends Western philosophy, in which only the distance senses are vehicles of knowledge, and Western aesthetics, in which only vision and hearing can be vehicles of beauty. It seems that the democratization of the object of aesthetic study to include high and low or popular arts has not really extended to non-visual objects, except for the audiovisual arts such as cinema.

The neglect of touch, smell, and taste (and, to some extent, hearing) in visual culture descends particularly, of course, from art history, and generally, from the tendency to dismiss the proximal senses as inferior that underpins Western thought.

To include sense experience in our cultural analysis, we need to revisit the sensory hierarchy—while trying to retain the capacity for aesthetic judgement, knowledge, and ethics associated with the 'higher' senses. And we have to do it before the new marketing of all sense experience does it for us. Recent questions of the affective dimension of sensuous experience permit new dimensions of epistemology and ethics that are immanent, grounded in the particularity of experience. Sense experience operates at a membrane between the sensible and the thinkable, and, as Jacques Rancière argues, art exacerbates this relationship: 'The place of art is the place of an adequation between a sensible different from itself and a thought different from itself' (Rancière 2000).

*This chapter was originally published in 2008 in *Paragraph* and is reprinted here with permission of Edinburgh University Press.

Thus a de-hierarchized aesthetics such as I am proposing would understand any sense experience as capable of opening in two directions, both potentially infinite: 'outward' to thought and 'inward' to the material (Deleuze 1990; Deleuze and Guattari 1994).

This essay is illustrated with smells, which of course cannot be reproduced. Ideally, so that you can undergo the olfactory experiment on which my argument rests, you should be able to smell these 'illustrations' without knowing what they are. Ask a friend to gather and number the olfactory items listed in this footnote,[1] but do not read the footnote yourself. For each example, smell the substance but avoid touching it or looking at it. Note how it smells and any associations you might have with it. For the moment, deal with the slight discomfort of having molecules up your nose without knowing what they are.

Now, please smell substance number one.

Smell receives a variety of attention in the history of Western philosophy: Aristotle the empiricist included smell, but not touch and taste, among the 'noble' senses. Islamic *kalam* philosophers counted touch and sight as the senses providing reliable knowledge, while the other senses perceive only 'accidents' (Dhanani 1994). The term *aesthesis* was introduced into philosophy relatively late, by Baumgarten in the eighteenth century, and it was Lessing who defined aesthetics as the connection between the arts and the senses—but only the higher senses of vision and hearing.

In transcendental philosophy, knowledge (in Baumgarten's term, *noeta*, epistemology) must be emancipated from the senses, even though it may arrive through perception. The object of a sense perception (Baumgarten's term *aestheta*, perception) can be called beautiful, as long as it is a distance sense—vision or hearing. Kant and Hegel both developed a hierarchical relation between the two remaining senses deemed capable of aesthetic experience, with hearing, the inner, temporal, and more spiritual sense being above vision, the outer, spatial, and more physical sense (Rée 2000). For Kant, the bodily senses were capable of agreeable sensations, but not of beauty. Hegel argued that aesthetics is the transcendent rise from a sensuous particular to a universal truth, and was only possible through the distance senses:

Smell, taste, and touch have to do with matter as such and its immediately sensuous qualities . . . For this reason these senses cannot have to do with artistic objects, which are meant to maintain themselves in their real independence and allow of no *purely* sensuous relationship. What is agreeable for these senses is not the beauty of art.

(Cited in Korsmeyer 1999)

The place left for sensuous refinement is pleasure—the proximal senses are *hedonic*.

I propose that the proximal senses—touch, taste, and smell—are not only hedonic but may also be senses of knowledge (epistemology), vehicles of beauty (aesthetics), and even media of ethics. In this essay my examples focus around smell—somewhat artificially, since most sensory events combine the experience of several senses simultaneously, but for purposes of argument. Why smell in particular? Because smell often brings with it a freight of personal affect: it seems to be the least translatable

[1] 1) Truffle oil. 2) Jasmine oil.

and most personal of all the senses. Smells can be semantically coded, but less easily than other sense perceptions for this reason. If smell can be a medium of shared knowledge, then I'd argue any sense can. I also note that smell may be the sense that best shows the mutual limits of psychoanalysis and non-psychoanalytic affect theory, in that the former pays little attention to the singularity of sense experience, while the latter does not have a concept of repression, both of which are important in the experience of smell.

What you have been smelling is oil of truffles, which many people find has a provocatively, even unbearably gamey smell. Note how it's reassuring to have a name associated with what you smelled. In fact, you may be able to smell it better now: studies show that an odour smells stronger when the smeller knows what it is. When you smelled what turned out to be truffles, you may well have thought you smelled human body odour, or some other organic smell that many people find noxious. Though semantically identifying the source of the smell probably makes it less noxious, you were in a sense right. Truffles have a chemical fingerprint that's close to human body odour. This is why female pigs are used to hunt truffles. Truffles secrete a steroid, 5-alpha-androstenol, which is the same steroid that male pigs secrete to advertise their sexual availability; it's also in human male perspiration and female urine.

This three-part smell story—smelling, associating, knowing—shows that the ideal semantic window for perceiving smells may be in the middle of their signifying spectrum. When we know too little, or too much, about a smell, it moves beyond the *heimlich*: it ceases to communicate humanly. The smell of truffle reminds us of what we have in common with other desiring creatures. It does *not* reveal the fundamental naturalness of smell; it shows that cultivated odours operate across a membrane from the material to the symbolic, the asocial to the communal. The base notes of perfumes, similarly, are often sexual or animal odours that we have learned to find noxious in themselves, yet are seductive when masked. A fine meal or elegant perfume both recalls and refines our animal and *vegetable* nature. Smell, the chemical communication, is uncanny because it reminds us what we have in common with pigs—and with fungi.

If sense experience is to be analysed culturally, it must be communicable; we can ask, to what degree is sense experience culturally coded, to what degree is it asocial? I argue that all sense perceptions have aspects of both. The proximal senses are eminently teachable. Witness the cultivation of sense knowledges across cultures, as well as in the life of an individual learning archery, auto mechanics, Thai cooking, perfumery, or another multisensory skill. This educability of the sense extends to the level of neural plasticity. The educability of the proximal (indeed all) senses indicates that they can be means of communication, and thus of knowledge and aesthetics.

There is an aspect of smell experience that is learned but not communicable: namely, those olfactory events that are important in an individual's life but repressed as part of general socialization. Smell populates the imaginary, for it has intense personal associations that are difficult to communicate. Freud himself seems to have repressed the importance of smell, harshly criticizing his friend Wilhelm Fleiss who argued for fundamental connections between olfaction and sexuality. Recent findings in neuroscience support the psychoanalytic argument for links between olfaction and

intense emotional experience, including repressed experience. The power of smell to elicit memory has partly to do with the unique 'wiring' of olfaction directly to neural centres for emotion and memory (the amygdala and the hippocampus), before it connects to cognition (the cortex) (Stopfer and Laurent 1999). Emotionally intense experiences (not all experiences) are likely to cement an association between the emotion and the odour associated with the event (hence the olfactory imaginary), even if the event itself is forgotten. We may think of such events as lodged in a *sensuous unconscious*, which may be brought to consciousness, and its stories with it—as in the stories that tumbled from Proust's fragrant encounter with a madeleine dunked in a tisane of *tilleul*.

Thus the phylogenetic leaving-behind of smell that Freud posited in human history—where, in standing up, humans distanced themselves from each other's bodily smells and the knowledge that they provided—is recapitulated in individual human experience. Such a repression has occurred in recent histories of civilization as well: for example, Alain Corbin (1986) describes the eradication of 'unpleasant' smells as part of the construction of bourgeois experience in eighteenth- and nineteenth-century France—smells of sewage, rot, corruption, body odour, in short the smells connected with death and impermanence were censored from bourgeois life and replaced by sweet, 'clean' smells. In the resulting deodorized environment, smell ceased to be useful as an epistemological sense and became simply a sense for pleasure—and a very limited palette of pleasures at that. Smell ceased to be a means of knowledge, especially of knowledge to do with death and danger.

Smell is thus triply repressed. Smell is so strongly associated with excrement, sexuality, filth, poverty, and other repressed contents of both individual and cultural history, that even innocent smells have a taboo, or at least asocial dimension. We have more smell experience than we are able to talk about, because smells are inextricable from bodily events that are repressed. Smelling in public, or even talking about smell, seems to violate a private realm, the olfactory imaginary. Finally, there is an aspect of sense experience that is neither educable nor communicable, not associated with repressed experience, and indeed has little association at all. The 'wild', uncoded dimension of smell shows that the senses can be vehicles of intensity that remains free, but that cannot communicate. Across the membrane between communicability and incommunicability, the proximal senses build an intensity that is not social but is the meaningful lining of experience.

The sensory hierarchy is not only a Western phenomenon: most cultures maintain some version of sense hierarchy, usually with vision or hearing at the top; but what is interesting is the way in which certain constellations of sense knowledge are cultivated. Anthropologists are perhaps most aware of the variability of sensuous knowledges in different cultures, as in David Howes's (2003) account of the complex auditory and olfactory epistemologies of Melanesian people. In a relatively Western genealogy of the senses, classical Islamic civilization cultivated a multisensory aesthetics, the latter especially in the luxurious courts of the 'Abbasid caliphate in Baghdad. Arabic philosophers tended to adopt the Aristotelian conception of the body as integral to human happiness, and thus valued bodily pleasures in moderation. Al-Kindi's

(d. 866) writings on music adopted the Greek doctrine relating elements and humours to notes and rhythms. He developed a kind of multisensory therapy combining music, colours, and perfumes (Behrens-Abouseif 1998). Islamic aesthetics generally created a place for all the senses, as when Ibn Al-Haytham (d. 1039), author of the *Optics*, described perception to consist of a compound of sensations that are mentally compared, as in the sight, sound, and smell experienced by a man sitting on a river-bank listening to music and admiring lovely women (Nasir 1969). Arab cultivation of olfactory knowledge and pleasure remains in customs like offering perfumes to guests, maintaining an interpersonal distance close enough to allow both parties to smell each other, and the cultivation of fragrant gardens as terrestrial reminders of paradise. And of course, Arab and Indian olfactory pleasure was adapted by European wealthy classes of the Middle Ages, whose eagerness for pepper, cinnamon, cardamom, and myrrh spurred explorers to discover continents.

Recent scholarship is beginning to develop a multisensory Archaeology of Knowledge. Currently this is the domain mainly of sensory anthropology descending from Marshall McLuhan and Walter Ong, as in the work of historian Constance Classen and anthropologist David Howes. Scholars of 'visual culture' and cultural history can pursue the questions: what are the cultural, epistemological, economic currents that inform the development of some sense knowledges, the repression of others, and relations among them?

ODOUR REVALUED, AT A COST

The body and its senses have been embraced in scholarship and art practice, for a variety of laudable motivations. Non-dualist philosophies in the nineteenth century already twisted the sense hierarchy, as in Nietzsche's valuing of 'flair' or instinct and the inclusion of olfactory experience in C.S. Peirce's (1955) semiotic theory. Emerging from critiques of dualism and idealism, contemporary materialist, feminist, and inter-cultural theories practically reverse the values ascribed to the sensory hierarchy by traditional aesthetics. While vision and hearing can be experienced as bodily senses, as we've 'seen' they are strongly associated with abstraction and transcendence because of their ability to seem independent of the body. The embodied nature of the close senses of touch, taste, and smell is more evident, and thus they link us to the material world, indeed bringing it close to or into our bodies. An understanding of sense experience as embodied resists transcendentalism, for it links perception and the perceived material world. Embodied perception, including the experience of all the senses, acknowledges the inextricability of perceiver from perceived and the groundedness of knowledge in local experience. The close senses, which index both the material world and the materiality of the body that perceives with them, insist upon *mortality*. Thus, a materialist aesthetics can find value in the close senses precisely

for their grounded, provisional, and ephemeral character. The immanence and materiality of the proximal senses can thus be the ground of aesthetics, knowledge, and indeed ethics.

However, the contemporary 'bodily turn' in scholarship raises new problems. An inversion of the sensory hierarchy with the bodily senses at the top is not necessarily any more conducive to knowledge or justice than the old hierarchy. Carolyn Korsmeyer writes, 'One cannot simply add taste and the other bodily senses to philosophy as it has evolved and correct theories accordingly to be more comprehensive in their treatment of sensory worlds' (Korsmeyer 1999, p. 37). Instead we must ask, what are the particular pleasures and knowledges we can get from different kinds of sensory experience?

Second, since the knowledge and pleasure gained by the distance senses are associated with transcendence, critical theory seems to have thrown aesthetics (and its presumption of a subject capable of transcendent experience) out with the bath water of dualism. Contemporary critical theory seems to have a lot of unease and bad faith about whether we can still speak of aesthetic objects. There is a certain theoretical squeamishness around the senses' ability to function epistemologically, as well as aesthetically. For contemporary visual studies, Hegel's dictum could almost be reversed: artistic objects *are not* meant to maintain themselves in their real independence from the material world and *can only* allow of a purely sensuous relationship. Bourdieu's semiotic revaluation of taste translates aesthetic pleasure into economic and social terms alone. Contemporary theory can speak of pleasure (considered subjective), and of politics, but not of beauty. Just when the proximal senses have been redeemed, there seems little for them to do—except go shopping (of which more in a moment). So it is still necessary to argue that the senses are means of knowledge and ethics as well as pleasure.

The contemporary popular tendency to reverse the sense hierarchy and reject the transcendental is not the answer. We still need to be able to ask, what knowledge am I gaining from sensuous experience? How can it make life worth living?

Charles Fourier, writing during the Industrial Revolution (1851), believed a society could be judged by the degree to which it gratified and developed the senses of its citizens. The current stinking state of the world was a far cry from the multisensory order that Fourier imagined for the cosmos, where each planet corresponds to a musical note and to a fragrance: Earth emanates the odour of violet, Jupiter, jonquil, Mercury, rose (Classen 1998). Fourier's utopia is idealist, in its eradication of unpleasant odours, but it is decidedly corporeal in its appeal to embodied pleasure and knowledge. Marx adapted from Fourier the ideal of liberation of the senses that are abused and impoverished in the capitalist system of labour, such as the factory workers suffer from noise, heat, smell, and immiseration: 'the worker loses all notion of sensory refinement' and 'no longer knows any need . . . but the need to eat (cited in Howes 2003, p. 206).' As Howes notes, Marx had little interest in the sensuous dimension of life, but his call for humans to be able to cultivate our sensory capacities gave a political immediacy to Fourier's fragrant idealism. Sensuous experience can make life worth living by liberating *capacities* that are not contained by instrumental purposes. But where, and how?

There is a current popular tendency to embrace feeling over thinking, which seems to be especially embraced on the West Coast (of North America): it descends from feminist and other critiques of mind-body dualism and instrumental rationality, but has devolved into an anti-rationalism that is positively lazy. I am not sure how widespread this tendency is, but in my west-coast city of Vancouver 'Feel, don't think!' (like 'No worries'—when surely there are things we should be worrying about) is considered a positive slogan.

Fashionable anti-rationalism plays into the commercial *capture* of sense experience: the senses are being sold back to us as means not of knowledge but of pleasure. Consumer capitalism is conquering the bodily senses from nose to toes. Fourier's utopia is here, though not in the way he anticipated. The well-to-do people of the world are both educated and gratified in their senses—but for hedonic, not epistemological reasons. That is, contemporary post-industrial society affords its consuming classes an overwhelming wealth of sense experience and the means to refine our appreciation of them. Meanwhile the world's poor live in sensuous poverty not so different from that bemoaned by Fourier and Marx. Among the many inequities resulting from the global division of classes into the very rich and the very poor is an inequity of sense experience.

We, the well-to-do of the Western and Westernized world, still live in the deodorized bubble associated with the rise of the bourgeoisie, both European and global. Smell is an impoverished sense. We still use smell for survival reasons—to check for the presence of rotting meat, mould, infection, sewage, gas leaks, and other things that pose a danger. Smell knowledge is arguably most useful for distinguishing different kinds of car trouble—oil burning, brake friction, coolant leaks. Poor people are more likely to live with odours that index real events, including danger—and thus are objects of knowledge. But these are the few opportunities that smell has to exercise its epistemological potential.

After the olfactory whitewashing of Westernized middle-class life, pleasing new odours flooded the blank canvas. In the past couple of decades the use of smell, and the other bodily senses, for pleasurable and refined consumption has accelerated. The tasteless processed foods that signified modernity in the 1950s and 1960s (Belasco 2005) have given way to a great variety of fresh produce, often locally grown, as well as exotic imports, because of industrial diversification and faster shipping methods. The canned Maxwell House of 20 years ago has given way to a dazzling array of specialty coffees, a marvel of niche marketing—North Americans drink less coffee than they did in the 1960s but they spend more on it. Wine, which those of us who were alive in the 1970s knew in the categories red, white, and rosé, is now produced and marketed in bewildering variety, requiring middle-class consumers to become, or act like, connoisseurs. Dish-soap comes with aromatherapeutic promises, soothing or stimulating, etcetera.

The reason for this explosion of sensuously pleasing products is, of course, the exhaustion of markets and the need of corporations to induce consumers to continue to spend. Multisensory products promise to enhance individuality—consumers are encouraged to design signature scents, express themselves through gourmet

cooking, etc.—confer cultural capital—connoisseurship of wine, coffee, chocolate, 'artisanal' bread, and other luxury goods and the concomitant opportunity for snobbism—and enhance sensuous pleasure. This they probably do: it is a great thing to savour good wine, choose among many varieties of international tasty food, inhale stimulating fragrances in the hurried morning shower, and bury one's nose in Dove cleansing pads for a brief respite from screaming children, holiday in-laws, and airport delays (scenarios provided by Dove advertisements).

However, as these descriptions of pleasure begin to indicate, multisensory products are conceived to defray the pressures of contemporary life, where most people, even middle-class people, are working too hard and have too little time. Many aromatherapy products and bath products emphasize the *time* of consumption, 'time for me'; they sell a product in the name of creating free time, and their principal target seems to be harried, hard-working women.[2] Sensuous pleasure is sold to us fundamentally to ensure that we get back to work—relaxed, refreshed, and ready. Thus one of the most cynical promises of the new sensuous commodities is that they will give people more time.

Sensuous refinement now serves mainly hedonic ends; the aesthetic, epistemological, and *ethical* dimensions of sensuous experience are far from the commodity landscape. The 'emancipation of the senses' envisioned by Fourier is only a further enslavement if our senses are marshalled only for the purposes of consumption. The proximal senses, in their intimacy, relation to memory (especially smell), and affective intensity, are the very senses most resistant to mass communication. Sensory commodities that invade and encode the private space of the proximal senses are threatening this resistance.

ODOUR'S AFFECTIVE SPACE

Please turn to your olfactory illustrations and smell substance number two.

Two years ago I returned to the Souk al-Hamadiya in Damascus. This souk, where people have plied their trades in carpets, silks, blown glass, hammered brass, and other handcrafted goods, has expanded its focus with the changed direction of global trade, as well as the vast expansion of the Syrian factory economy. You can get everything there—cheek by jowl with the metalworkers' souk are now the plastic kitchen equipment souk, the imported biscuit souk, and the outrageous ladies' underwear souk. But I was confidently in search of essential oils: the attar of rose, jasmine, amber, *fil* (a tiny flower with overpowering scent), and other locally extracted scents that perfumers have imported from the Orient for hundreds of years. You are now

[2] I thank Suzanne Lindgren, a student in Art and Culture Studies at Simon Fraser University, for pointing out this temporal-olfactory paradox.

smelling jasmine, which just possibly might come from the Souk al-Hamadiya. This time I noticed that the expert Syrian knockoff artists, who have flooded Arab markets with camouflage Nike and misspelled Calvin Kline garments, now include 'noses' capable of discerning the elements of a composite perfume—for it is possible at the fragrance souk to buy reasonable facsimiles of Coco Chanel, Tommy Hilfiger, Hugo Boss, and other commercial fragrances for a tiny fraction of the price. Indeed it's my research dream to visit a Syrian perfume factory and meet the great 'nose'—but given the Bush administration's practice of bombing Iraqi perfume factories during the last Gulf war, this is probably not likely any time soon. The perfume monger fills the little vials with a syringe of precious oil, then in a jolly manner sprays the remaining drops at customers, who spread out their arms to be engulfed by fragrance. It's a social atmosphere of shared smelling.

This time I happened to look at the vat from which the vendor syringe-extracted the precious oil of jasmine that is so typical of this part of the world. It—this jasmine you are perhaps smelling—was a German synthetic. Complex original smells are being replaced by synthetic smells at what ought to be the centre of original smells, the library of real smells, the Damascus perfume souk. Synthetic jasmine is like a photocopy of jasmine, approximating its complexity with a compound of a few chemicals and a strong base note of petroleum. (By contrast, it seems to me that real jasmine has a base note of excrement, which is perhaps why jasmine is planted outside lavatories.) Such economically driven smell replacements worry me the way a film archivist would be worried if all the 35mm reels were replaced by MPEGs. What will we study in the future; with what will we enrich and educate our senses?

Yet the socialness of the perfume souk at Hamadiya involves another dimension of smell experience that is perhaps more durable than smell itself.

I have mentioned a few times the ethical dimension of multisensory experience, and it is high time to explain this seeming oxymoron. It has to do with the position of the proximal senses on the membrane between shared and private, codified and uncodable experience—on the middle bandwidth of sense experience. Korsmeyer, a philosopher, argues (against Bourdieu) that the philosophical baby can indeed be retained when we toss out the bath water of purist aesthetics: the issue is what kinds of philosophical treatment do the close senses invite? (Korsmeyer 1999, p. 66). Her answer involves the nature of the proximal senses as both objective and subjective: capable of being directed outward (epistemological), and inward (hedonic) within a set of bodily and cultural limitations (Korsmeyer 1999, pp. 94–8). Thus, the proximal senses operate at the literal border between the intimate and the communal. Knowledge and communication that makes use of them may lose in 'objectivity' but they gain in depth, trust, and sociality.

Recall that incommunicable dimension of sensuous experience, which I qualified as comprising an olfactory unconscious. We might refer to this incommunicable dimension, adapting Spinoza's ethics, as *affect*. Between passive and active, affect is a *passion* (Spinoza): an intensity, an 'excess,' a suspension of the linear progress of narrative (Massumi 2002, p. 26). As in the affection-image of Deleuze, it is a moment of gathering force, which may or may never be acted upon. This is a volatile moment.

It's when a person feels the great pressure and potential of the virtual—of the broad realm of possibilities, one of which can be summoned into being. It is not yet communicable.

To what degree can affect be experienced in common, socially? The concept of excess from film theory, for example, shows that affect is marshalled around a common image, as when audience members all cry at a movie like the classic 'weepie' *Stella Dallas*, salivate emotively during *Chocolat*, or feel the urge to slay Persians while watching *300*. However, I would argue that affection-images allow people to respond *as they will*—not necessarily all in the same way. What the participants in an affective situation have in common is that some affection-image stimulated their affective response—this intensity, this passion, not yet bound as emotion, and *not yet communicable*—and they had the response together. So they would attribute to the affection-image, be it *Stella Dallas*, *Chocolat*, *300*, or a sudden rush of jasmine, the ability to arouse affect in them. This is Brian Massumi's reasoning when he argues that the television addresses of former President Reagan unleash affect, which makes people feel good, and vote for the man, even without knowing why (Massumi, 2002, pp. 39–42).

Affect arises from a break in the continuity of experience, a shock in Walter Benjamin's sense. It may thus have the critical ability to disrupt the clichéd narrative of daily life. For example, I'm working at my crummy telemarketing job and someone passes wearing the perfume my mother wore when she used to kiss me goodnight years ago. I feel the giddy vertigo of travel, between actual and virtual, then a resurgence of the original emotion (love? safety? excitement? jealousy?) *before* the memory resolves itself. For this is how smell memory works—first you experience the disruption, then you feel the emotion, then you identify the source. Such an experience could well make me burst into tears in my nasty little cubicle *and* remind me of the vast powers of the virtual hovering below the surface of my crummy actual life.

The closer the sense, the stronger the effect: smell seems to be the perception capable of the most powerful affection-image, though I note that music seems to have an effect exactly analogous to smell—a heard fragment of an old song arouses piercingly specific memories in just the same way as a whiff of a scent from long ago may. Physical gestures, tastes, and colours can also sometimes call up intensely embodied emotional memories, though less often than smell and music.

In an essay titled 'The Logic of Smell' I argued that smell cannot be a basis of communication (Marks 2002). I still believe that smell's asocial nature is a great virtue of this sense. The charged individual responses that *may* gather around particular smells protect olfaction from ever being completely culturally coded. This is a value in an economy that is forever finding new ways to encode meaning in sensory experience in order to eke out more profit.

However, smell is also, like the other senses, a social sense. As Korsmeyer points out, taste is a social sense because one brings one's memories associated with particular foods to the present encounter. Smell functions similarly. Being in the presence of smells familiar from the past sometimes has the quality of socializing with a

community, even if others are absent. Such associations are a virtual presence that may be actualized. So too, smell, though it is even less codifiable than taste, can be a social sense as the virtual experiences it evokes are actualized, and communicated, by the smeller. What's rich about these experiences is their *virtual depth*: the degree to which more is going on, more is potentially present, to each individual and to the group. The thickness of communication includes what is *not* communicated, what may not even be identified as more than a potentiality. Affect is incommunicable *per se*, and that is its virtue. People may respond in common, but that response will be enriched and complexified by a core of absolutely individual and relatively incommunicable experience. People cry at the movies, even happy movies, because the passage from virtual to actual is exquisite—it is painful. I cried once when an unanticipated smell (freon, melted plastic and cigarette smoke) reminded me of my grandfather, because the love he gave me has slipped forever back into the virtual. Affect reminds people of missed appointments with love.

In its autonomy, affect is the foundation of an ethics. Massumi writes, 'The autonomy of affect is its participation in the virtual' (2002, p. 35). Even when affect is expressed as emotion, 'Something remains unactualized, inseparable from but unassimilable to any *particular*, functionally anchored perspective [original italics]' (2002, p. 35). Affect, to the degree to which it remains free, is the force underlying emotion and action.

In certain ways the protection of the freedom of affect is a conservative goal. Its result is not, for example, social action, but a retaining of the quality of life. Any social or political effect comes later and not necessarily. If people could believe that the virtual powers with which they came into contact through affect could really be actualized in the social, they would not just weep, they would proceed to fight.

Let us conclude with another look at that sensory hierarchy and the dualism it subtends. I've mentioned that we may think of sense experience, and the affect that it sometimes brings forth, as a membrane between several pairs: between social and private, between communicability and incommunicability, between codified experience and uncodifiable experience. In a certain way this membrane reinstates a duality, not between matter and spirit but between actual and virtual. Sense experience is one of the ways of traversing this duality. Smell (which, as the ancients remarked, was the only perceptible object that actually comes into contact with the brain itself) could be the mascot of that creative traversal.

Acknowledgements

I thank two groups of listeners for their helpful responses to this paper, at Project for the Study of Visual Culture of the University of Southern California, and the Faculty of Modern and Medieval Languages at Cambridge University.

REFERENCES

Behrens-Abouseif D (1998). *Beauty in Arabic Culture.* Markus Wiener, Princeton, NJ.

Belasco W (2005). Food and the counterculture: a story of bread and politics. In Watson JI and Caldwell ML, eds. *The Cultural Politics of Food and Eating*, pp. 217–34. Blackwell, Oxford.

Classen C (1998). *The Color of Angels: Cosmology, Gender, and the Aesthetic Imagination.* Routledge, New York.

Corbin A (1986). *The Foul and the Fragrant: Odor and the French Social Imagination*, M Kochan, Porter C, and Prendergast R, trans. Oxford University Press, Oxford.

Deleuze G (1990). The Simulacrum and Ancient Philosophy, Lester M trans. In CV Boundas, ed. *Logic of Sense*, pp. 253–79. Columbia University Press, New York.

Deleuze G and Guattari F (1994). What is a concept? In *What Is Philosophy?*, Tomlinson H and Burchell G, trans. pp. 15–34. Columbia University Press, New York.

Dhanani A (1994). *The Physical Theory of Kalam: Atoms, Space and Void in Basrian Mu'tazili Cosmology.* Brill, New York.

Howes D (2003). *Sensual Relations: Engaging the Senses in Culture and Social Theory.* University of Michigan Press, Ann Arbor, MI.

Korsmeyer C (1999). *Making Sense of Taste: Food and Philosophy.* Cornell University Press, Ithaca, NY.

Marks LU (2002). The logic of smell. In Tiarks LU *Touch: Sensuous Theory and Multisensory Media*, pp. 113–26. University of Minnesota Press, Minneapolis, MN.

Massumi B (2002). The autonomy of affect. In *Parables for the Virtual: Movement, Affect, Sensation*, p. 46. Minnesota University Press, Minneapolis, MN.

Nasir NA (1969). Ibn Al-Haitham and his philosophy. In Said HM, ed. *Ibn Al-Haitham*, p. 85. Hamdard National Foundation, Karachi.

Peirce CS (1955). The principles of semiology. In Buchler J, ed. *Philosophical Writings of Peirce*, pp. 74–97, Dover, New York.

Rancière J (2000). What aesthetics can mean (Holmes B trans.). In Osborne P, ed. *From an Aesthetic Point of View: Philosophy, Art and the Senses.* Serpent's Tail, London.

Rée J (2000). The aesthetic theory of the arts. In Osborne P, ed. *From an Aesthetic Point of View: Philosophy, Art and the Senses*, pp. 57–9. Serpent's Tail, London.

Stopfer M and Laurent G (1999). Short-term memory in olfactory network dynamics. *Nature*, **402**, 664–8.

CHAPTER 13

..

SIGHTING SOUND: LISTENING WITH EYES OPEN

..

SIMON SHAW-MILLER

THERE are an increasing number of researchers working in the humanities whose work, like mine, claims to be interdisciplinary. But interdisciplinarity is not a simple concept. As Roland Barthes has put it, it 'is not to be accomplished by the simple confrontation of specialist branches of knowledge. Interdisciplinarity is not the calm of an easy security; it begins effectively . . . when the solidarity of the old disciplines breaks down . . . ' (Barthes 1982). It is, therefore, a concept that needs some unpacking before we can proceed. Often the term is used when cross-disciplinarity or multi-disciplinarity would be more apposite. Similarly, these concepts are often used as synonyms. In fact, they are concerned with very different theoretical paradigms. My work continues to develop models and to test them against practice, but I would propose the following characterizations:

- Interdisciplinarity is concerned with synthesis, and unification, where two (or more) things merge to become a third. Relationships are concordant although identity is transformed.
- Cross-disciplinarity is concerned with unstable transformations, where the character of one thing dominates and modifies the other(s). Such relationships are often conflictual.
- Multidisciplinarity is concerned with coexistence, with parallelism. Mutual, non-dominant coexistence characterizes these relationships, where concord predominates.

The prefix 'inter' means 'between' or 'within', and I am especially interested in the relationship between this 'between' and 'within' in art and music. In other words, and I am well aware that words are different from the material I analyse, my work addresses the identities and interstices between the sounding of music and the vision of art. I am not principally interested in the categories of vision and audition. Rather, I address art and music as cultural practices with specific histories. While vision and audition undoubtedly have histories, they are not equivalent to art and music. Art and music are composed as part of a cultural continuum; it is at the 'outer' historical and cultural edge of music and art that they contact each other, indeed, in places overlap.

We can think of music as the cultural enactment of framing sound, an enactment that is visual, tactile, and sonoric. The experience of music is complex; listening is not passive consumption, for our encounter with music is emotional, intellectual, and physical, as well as social and historical. To listen and to see is also to think, and our thinking structures our listening and seeing. Music occurs as sight and sound, and its meaning, in enactment, is a result of mediations between eye and ear, as much in performance, listening, and composition. Music is always more than sound, it is a point of focus for a multisensory experience that centres on sound, but is not solely defined by it. Analysis, interpretation, performance, and composition are in intricate dialogue with each other and with the sensorium. Music is, in short, an activity—an embodied, social, and historical event.

The 'faculties' of the university separate the visual arts from the literary and sounding arts, as well as they do the humanities and the sciences. Sophisticated methodologies and historiographies have developed to provide tools for visual and aural analysis. But we are only now beginning to forge ways of thinking in the gaps between disciplines and describing what we find there. Hybridity is still often thought of as undesirable, it carries with it the ideas of contamination, weakness, even the potential for chaos and disarray.

There is a long history of music being defined as opposite to this, as abstract, pure sound. It is, in part, this perception that allowed music to act as the art to which all arts might aspire, to paraphrase the words of Walter Pater: music as an art of formal abstraction and theoretical sophistication, not contamination and chaos. My contention is, however, that precisely because musical sound is abstract, the visual experience of its production is crucial in locating it within history, society, and culture, even when technology liberates the mind's eye. Music-making, for performers and listeners, is social; it involves communication (in many directions) between composer, performer, and listener. Sight, together with sound, locates this activity and gives it meaning (see also Leppert 2004).

As an aside, we don't have an equivalent of music analysis in art history. Indeed, it is fairly unique in the humanities to have a practice that claims such a detailed and complex set of methodologies to analyse the essential material (the 'music' in music analysis), and that is relatively separate from questions of history.

To return to the notion of pure music: I have traced this history elsewhere, so here it will be enough to briefly summarize (Miller 1993).

One way of telling the story would be to say that art music (I prefer this term to the more stylistically circumscribed 'classical music') developed through a movement away from utility. There was a gradual and slow modulation of its terms of address, from an accompaniment to life and tasks, to a consideration, analysis, and perception of itself as organized sounds. This is not a simple process, for no such total escape is ever possible; indeed, music has meaning because it serves a cultural purpose. So the question is primarily one of aspiration, a relative achievement, for as music aspired to escape strict social function, it came to be admired in terms of the development of its own form *as* form, rather than as fit to a purpose outside the appreciation of formal concerns. A key term coined for this process has its origins with Richard Wagner: 'absolute music', a term easier to characterize negatively (as Wagner indeed first used it). It is most often used, for example, to mean music without words, or the absence of 'programmatic' content; it is harder to define positively. The musicologist Carl Dahlhaus has, not unproblematically, described absolute music in Kantian terms, as music without a 'concept, object, and purpose' (Dahlhaus 1989). It is a term which also becomes embroiled in its opposite, in the work of the man who coined it: Wagner and the concept of the *Gesamtkunstwerk.*

Through this process of abstraction, music changes its nature, but it also becomes, I would argue, a new kind of object. It becomes a 'work-concept' (in Lydia Goehr's helpful terms), an identity that exists, rather like the idea of the soul, as something separate from the material world (Goehr 1992). A work functions as a fixed system of relationships, formal identity being sustained beneath the surface of transcription; a five-part choral work, for example, reconceived for the six strings of a lute, must maintain its formal identity in order to be recognized as a transcription and not a variation. Notation is central to the development of the work, and it is worth emphasizing that notation is a visual code. (This is not to say that Braille notation, as a touch code, is not also significant.) Notation is so important that it makes it almost impossible to conceive a musical 'idea' independently from its realization in notation, in visual code. Certainly this is the case in the work-concept, where musical relationships are organized over large spans of time and in intricate, inter-related ways. The musical idea or gesture comes to the imagination already contaminated with the rhetoric of notational conventions and innovations, presenting itself to the eye, as it becomes a musical object.

Around 1800, a shift occurred in what was to be understood as musical meaning, from centre to periphery. There was a move, from what was thereafter described as 'extra musical', to what was definitive as 'purely musical': absolute music. Prior to this shift, music was defined and regulated as much by context as it was by text. Music now aspired to a form of emancipation from context, to become an autonomous, absolute practice that ultimately depended on nothing but itself. Through this process, music emerged as a signifier free from fixed signification, and thus mutable and malleable in its subsequent rejoining to subjects. As Goehr describes this process, 'Such ideas affected everything musical . . . Usually [ideas about music] were shaped by the functions music served in powerful institutions like the church and

court . . . after 1800 [the extra-musical] was marginalized by and incorporated into a new understanding' (Goehr 1992, p. 122).

Dahlhaus has shown that this shift to absolute music coincided with the absorption of religious sensibilities into the musical realm, and the development of sensibilities that allowed the aesthetic contemplation of absolute music, and the ascension of word-less music to a position above words. He quotes Wackenroder (through the character of Joseph Berglinger):

When Joseph was at a big concert, he would sit down in a corner and listen with just the same devotion as though he were in church . . . In happy and delightful symphonies in full voice, which he loved above all, it seemed to him as though he saw a frolicking chorus of youths and maidens dancing in a pleasant meadow . . . All these meaningful sentiments thus always brought forth corresponding images and new thoughts in his soul: a wonderful gift of music . . .

(Dahlhaus 1989, p. 81)

Listening to purely instrumental music thus became a secular religious experience. And, significantly, once words were lost, a host of free images could flow forth to take their place.

The modulation of music into 'fine art' happened against a general backdrop of aesthetic secularization. By the end of the eighteenth century, the arts had even cut themselves free from the everyday and ordinary; as Goehr argues, 'The essence of fine art comprised the basic idea of severance from anything associated with . . . [the] contingent world of mere mortals.' Joshua Reynolds argued in his 13th Discourse, 'Whatever is familiar, or in any way reminds us of what we see and hear every day perhaps does not belong to the higher provinces of art . . . ' (Reynolds 1961, p. 207). Music becomes an even more special case of this a little later for Wackenroder, who wrote in 1799, 'the spirit can no longer use [music] as a vehicle, as a means to an end, for it is substance itself and this is why it lives and moves in its own enchanted realm.' The idea of music inhabiting an 'enchanted realm' outside the mundane world is taken up by Schopenhauer 20 years later. He enacts an even more radical removal of sound from the site of things and the labour of its making, allowing sound to become the sole agent of meaning, divorcing it from production, and even reception;

music, since it passes over the Ideas, is also quite independent of the phenomenal world, positively ignores it, and, to a certain extent, could still exist even if there were no world at all, which cannot be said of the other arts . . .

(Schopenhauer 1818/1969, Vol. 1, bk. 3, sec. 38).

The refinement of music to an absolute medium also affected its means of consumption. Classical concerts became ritual event. Religious sensibilities migrated from the church to the concert room. New conventions and codes of practice developed. The sites of musical consumption were modified. The horseshoe shape of eighteenth-century opera houses functioned as more than just an ambient chamber for sound projected from the stage; they provided sites for the aristocratic audience to display and disport itself, allowing the latest fashion and social gossip to be broadcast (with the aid of lorgnettes) (Fig. 13.1).

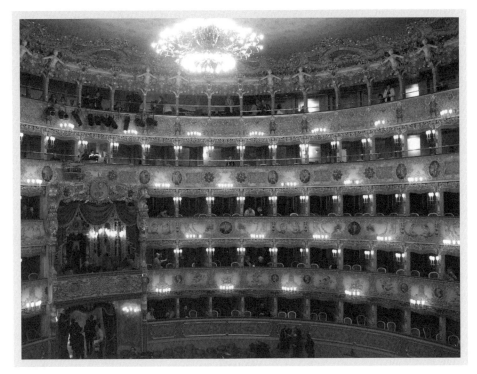

Fig. 13.1 An example of an eighteenth-century opera house: the auditorium of Teatro La Fenice, Venice

(Photograph: Andreas Praefcke.)

The bourgeoisie presented a different agenda, for in the nineteenth century the instrumental concert hall flattened out the audience's address to the stage, with more people directly facing the performers (Fig. 13.2). Social display, of course, did not disappear with this democratization, although it was reduced to peripheral spaces, such as the interval bar and entrance foyer. The most significant development in concert hall design was to be found, however, in the attention given to acoustic precision and control, to enhancing frequency range and controlling the decay of sound. These changes went hand-in-hand with the development of the Romantic symphony and tone poem as a vehicle of expression. Here the spectacle of massed choirs and hundreds of instrumentalists was clearly coordinated in space and time.

The disposition of the players in this space also changed during the eighteenth and nineteenth centuries. From an intimate arrangement around a keyboard, or concealed in a pit, the sartorially coordinated orchestra now emerged on to a raised stage, with massed strings—the most visually coordinated section—in the foreground. Originally, first and second violins faced each other on opposite sides to aid contrapuntal separation, but now they were more commonly neighbours, with violas to the left, cellos opposite the first violins, and double basses behind the cellos. Bowing became synchronized. In the middle ground came first the woodwind and then the

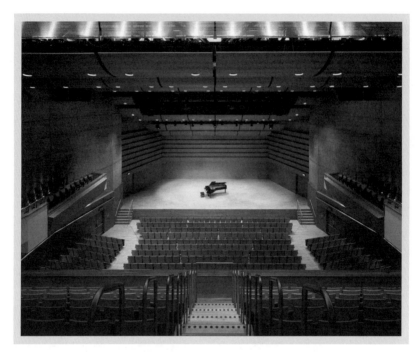

Fig. 13.2 A modern instrumental concert hall. Notice the seating disposition, allowing the public to directly face the performers.

brass, with the percussion raised along the back. Any choir would have been tiered up at the back of the orchestra.

This new arrangement was anchored around the conductor. The introduction of the baton (usually credited to Louise Spohr in the 1820s), to coordinate and control the expressive emoting of hundreds of different musicians, ushered in a new language of vision in a repertoire of gestures ranging from flying arms to smaller, controlled movements; the act of interpretation took on a new impetus (Fig. 13.3). At first, the composer was often the conductor: virtuosi like Nicolo Paganini and Franz Liszt were masters of display as well as of their instrument, thus satiating the audience's desire for dramatic spectacle. The emergence of the 'star conductors' (Fig. 13.4) came more slowly, chiefly because they were less visible. With their backs to the audience, they did not, initially, engage them in the same way. But gradually they became the locus for the look of the audience (and later camera), the gestures and body-language of conductors coming to embody their reading of the music. The audience in the modern concert hall, still and quiet, live out the life of the music, imaginatively projected through the sights and sounds of the performers.

The notion of absolute music was co-emergent with the virtuoso and star conductor. Let us briefly return to the example of Liszt, mentioned earlier. In 1835 Liszt wrote:

In the name of all musicians, of art, and of social progress, we require: . . . the foundation of an assembly to be held every five years for religious, dramatic and symphonic music, by

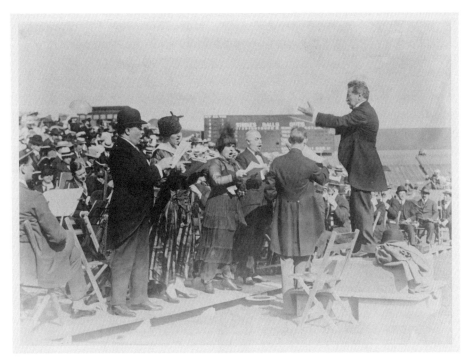

Fig. 13.3 Verdi's *Requiem* being emphatically directed in an outdoor performance at the Polo Grounds, New York City (1916).

(Photograph: Library of Congress.)

which all the works that are considered best in these three categories shall be ceremonially performed every day for a whole month in the Louvre, being purchased by the government, and published at their expense . . . we require the foundation of a musical Museum.

(quoted in Goehr 1992, p. 205)

This is both a plea for the fixing of musical works as absolute objects and for their subsequent display. In this way, value would be socially inscribed and the work's identity reinforced. But there is a potential problem with the idea of Liszt championing the notion of absolute music and requiring the autonomy of the aesthetic space of the museum to set it apart from the social space outside. Liszt was in part driven to this position because he regarded music programme music as equal in rank to poetry and painting, so deserving of the status of 'fine art'. But programme music was regarded by many as antithetical to music's absolute status, because of its relationship to painting and poetry. Eduard Hanslick, a key figure in the ideology of absolute music, famously dismissed Liszt's symphonic poems as denying 'music more completely than ever before its independent sphere, and [dosing] the listener with a kind of vision-promoting medicine' (Hanslick 1891, pp. 5–6).

Vision is here regarded as linked both to religiosity and imaginative sight; both are for Hanslick undesirable in keeping music alone. But for Liszt, and many other composers, the distinction between programme and absolute music was not one of

Fig. 13.4 Poster of the farewell tour of Austrian star-composer Eduard Strauss (1835–1916), Imperial Court musical director, and his famous orchestra from Vienna.

opposites, but rather one of common vision: they were competing concepts for the same ground: spiritually meaningful expression.

Liszt's position as a virtuoso, perhaps *the* virtuoso, also placed him in an ambivalent situation. He was, above all, a visually arresting performer, as Robert Schumann remarked: 'If Liszt played behind the scenes, a great deal of poetry would be lost' (Schumann 1840/1965, p. 158). Liszt in many ways defines the virtuoso and sets the scene and syntax for all subsequent 'star' performers (Fig. 13.5). But as well as representing transcendental expressiveness, he could also be perceived as flashy and brash.

Liszt demonstrated his mastery of his instrument by dominating it visibly as well as musically, as one of his French critics remarked: 'Liszt's attitude at the piano, like that of a pythoness, has been remarked again and again. Constantly tossing back his long hair, his lips quivering, his nostrils palpitating, he swept the auditorium with the glance of a smiling master' (Ernest Legouvé, quoted in Huneker 1911, p. 285). He controlled the piano by encompassing the instrument (and the pythoness simile is interestingly feminine). His hair, a signifier of visual excess, is constantly in motion,

Fig. 13.5 Caricature showing Franz Liszt playing the Piano.

like his supernatural fingers (in some caricatures he is depicted with extra large hands and sometimes more than ten fingers!). All performances, but especially virtuoso performances, are driven by the dynamic interplay between the visuality of enactment and the sound of the music. Again, Schumann implicitly understood this when he said of Liszt's *Etudes*: 'One ought to see the composer play them, for just as the sight of any virtuosity elevates and strengthens, so much more does the immediate sight of the composer himself struggling with his instrument, taming it, making it obey' (Schumman 1946, p. 150).

Another element of this mix is the sexual magnetism of the performer, sometimes overt, sometimes hovering just below the surface, in this power-play of musical dominance. The sexualized performer constitutes another destabilizing element in

the goal for absolute music, for it reminds us of the physical, effortful body, the grimac-ing face of the performer, and the erotic potential of music, noted since Plato.

Theatricality is at the heart of Liszt's performance—a notion decried by all sup-porters of absolute music, as of modernist art, which itself used absolute music as a paradigm in the development of abstraction. I am thinking here of Michael Fried, who sees theatricality as the opposite of art (Fried 1967). In acknowledging the site of reception (and the presence of listeners/viewers), theatre, in this sense, surrenders absolute and independent cultural authority. Absolute music, on the other hand, would prefer not to be passed through the hands of sweaty musicians, and the eyes as well as the ears of the audience: theatre debases music by associating it with the visual and the physical. Absolute music would prefer to sound alone. Above and apart from the particulars of reception and the crowd, it hopes for the ideal universal.[1] In other words, and there is, I believe, a dialectical relationship at work, Liszt is guilty of both theatrical music and theatrical performance, which are antithetical to the emerging paradigm of absolute music.

But even without specific recourse to a programme, music can still provoke visions. As the poet Heinrich Heine expressed it:

I avow . . . how very fond I am of Liszt, but his music does not affect my mind agreeably, the more so that . . . I see the ghosts that other people only hear, so that every tone his hand strikes from the piano raises a corresponding sound-image in my spirit, in short, the music becomes visible in my inner eye.

(Quoted in Bernstein 1998, p. 73)

This is, as we have seen, just how Wackenroder described Joseph Berglinger's experience of listening.

Although the ideology of absolute music tried to expunge the visual, it continues to seep out, emerging in the site and sights of enactment: notation, performance, and reception.

Another way of describing this normative shift would be to regard it as a move from an understanding of the concept of music as a discourse (in Foucault's terms: see Foucault 1972) in the context of non-absolute music, to a formalist understand-ing best suited to pure, absolute music. The discursive conception of music allows issues of meaning to be located more widely, both ideologically and historically. After all, all composers of music, absolute or otherwise, are bound up in a web of tradition and influence, in which they consciously situate themselves. This is largely what differentiates music from sound.

The composer John Cage was part of this history. But he is of particular interest here, because he aspired to an art of non-translation or non-mediation. His art attempted contact with the other, through techniques that aim to have little effect on musical material beyond the act of reframing. But it is precisely this reframing that

[1] This point is related to the notion of unplayable works, as it separates off the notion of the music from its performance. Schoenberg once remarked of his violin concerto, 'I am delighted to add another unplayable work to the repertoire'.

allows us to define his activities *as* music; his activities become part of music's identity and its history. Cage is a good example because, through the pursuit of his radical aesthetic of 'letting sounds be themselves', his work challenged the view that art music is divorced from worldly associations and its physical environment. In pursuing sounds in themselves, he opened up the concept of music to its physical environment: the music of 4'.33" is its physical environment, its sights and site.

So far, I have discussed the divorce of music from the 'extra-musical', but with Cage I want to dwell briefly on the technological issues subsequent upon this divide and its reunion.

Recent reproduction technologies have aspired to divorce music more literally from site (and sight), allowing the dislocation of music from its origins in production and performance. Digital technologies have made music's origin and its site of production potentially virtual. In this history, radio was one of the first devices to dematerialize music, and radio was an abiding interest of John Cage. But even here, music cannot escape the visual.

The radio embodies the notion, outlined earlier, that music represents an absolute, even heavenly realm. The conceit is that this celestial realm can now be 'tuned into' through technology. As a medium, radio has tended to remain (like the music itself) invisible, merely an agent of dissemination, not perceived as affecting the nature and experience of the music itself. I shall conclude this paper by reference to two works by John Cage that employ radios from his series, "Imaginary Landscapes"[2] (nos. 1 and 4).

"Imaginary Landscape" No. 1 (1939) was composed for two variable-speed turntables, frequency recordings, muted piano, and cymbal. It was first performed at the Cornish School's radio studio. The score also states that the work should be performed as a recording or broadcast, not as, or in, a concert. It is thus sited as radio. The score is fairly conventional, in 6/4, with four staves for the four players, and is organized in four large sections, each one lasting 15 bars, with the final phrase of each one increasing progressively from one to four bars in length, manifesting a deliberately symmetrical rhythmic organization. Pitch is very limited. The piano is played by 'sweeping the bass strings with a gong beater', and more conventionally in repetitive figures (mainly triplets and semi-quavers), within a compass of a diminished 3rd (b-d flat). The rest of the pitch content is limited to simple prerecorded tones. However, the work is not ultimately about auditory relationships, let alone diatonic ones; like much of Cage's music it is about the relationships between sounds and their sources. Cage used test-tone records (Victor frequency and Constant note records) on two turntables, changing speeds between 33 1/3 and 78rpm, and thus varying the pitch. These recorded sounds are conventionally used by sound engineers to standardize broadcast equipment and on-air signals. They work in this way because the sounds are constant. Cage destabilizes them by changing speed to affect pitch. As sound, they are also hard to locate spatially or to assign to a point of origin. This is because they are

[2] "Imaginary Landscape" nos. 1, 3, 4, 5 (1939, 1942, 1951, 1952; no. 2 was withdrawn).

not sonic objects locatable in space, as the piano is (which is separately microphoned, like the cymbal), but their sound is directly reproduced and emanates from the radio itself. In this way they are identified totally with the medium. Hence, not only is the recording studio perceived as a musical instrument, but so, too, is the radio; through this process it becomes visible in its objecthood.

In 1951, with "Imaginary Landscape" No. 4, Cage developed further this notion of the radio as an instrument or sound source in its own right. "Imaginary Landscape" No. 4 is scored for twelve radios, to be operated, or performed, by 24 people, two for each radio, one to control the tuner and one to control the volume and tone controls. The score is, like no. 2, relatively conventional in its notation, with detailed indication of duration, station-tuning, and dynamics, shown as numbers ranging from 3 to 15. All these performance parameters were determined by chance operations expressed in charts, with direction to be given by a conductor. Here, what is broadcast at the time of performance becomes the sonic material of the music, and it might be anything, including the white noise between stations. At the first performance it was marked by subtle sounds rather than a cacophony, which is what you might expect from 12 radios. This is due, in the main, to the low dynamics and the frequent use of silence. Silence is central to Cage's aesthetic and is a device for emphasizing the visual in performance. At the première, some thought the quietude an accident of the late hour of the performance, and therefore the paucity of broadcast radio sources, and a consequent misjudgement of volume levels on Cage's part. But as James Pritchett has pointed out, all these characteristics are entirely consistent with other works Cage was composing at this time (Pritchett 1983).

"Imaginary Landscape" No. 4 not only brings the site of other performances, *via* the radio, into the concert space, recontexualizing them. It is also visually determined by, and embodied in, the design of radios and the actions of performers. In the case of the first performance, the radios were probably the gloriously named RCA Victor Golden Throat radio (Fig. 13.6). Like other musical instruments, the radio is a designed object, as deliberated over in terms of its looks as its sound. Like musical instruments, the radio is therefore a nexus of sight and sound, of technology and history.

The imaginary landscapes produced by these works are no less visual than any other enactment of music. The psychologist Rudolf Arnheim was one of the first to recognize this in his celebrated 1936 essay on radio, a medium, he felt, that had the possibility to change perceptions. This was to be achieved, in part, through its utilization of a wide variety of sounds, and in so doing, radio had the potential to suggest images 'more directly, objectively and concretely than on the printed page' (Arnheim 1936/1971). The fact that radio, as the ideal vehicle for absolute or disembodied music, should be so suggestive of images is less ironic when we consider the origin of the word radio itself. It comes from the Latin *radius*, a ray; *radians*, beaming, filled with light; *irradiatus*, to illuminate, to enlighten intellectually. The word is, therefore, indicative of the fluid space that exists, as I said at the outset of this paper, on the 'outer' historical and cultural edges of music and art, at the site where they converge.

Because, as I have argued, music is abstract, the visual is critical to us as producers and consumers in locating and communicating with it. The tension between the

Fig. 13.6 The RCA Victor Golden Throat Radio.

(Photograph: Ronald J. Binon.)

physical activity of making music and the abstraction of musical sound is resolved in sight. It is not an accident that we often say we are going to 'see' a concert. Musical meaning is embodied in performers and consumers, in objects and history. Music is an art of objects, performances, texts and contexts; sights and sounds.

REFERENCES

Arnheim R (1936/1971). *Radio*. Arno Press, New York.

Barthes R (1982). *Image-Music-Text*. Fontana, Glasgow.

Bernstein S (1998). *Virtuosity of the Nineteenth century: Performing Music and Language in Heine, Liszt and Baudelaire*. Stanford University Press, Stanford CA.

Dahlhaus C (1989). *The Idea of Absolute Music*. The University of Chicago Press, Chicago, IL and London.

Foucault M (1972). *The Archaeology of Knowledge*. Routledge, London.

Fried M (1967). Art and objecthood. In C Harrison and P Wood, eds. *Art in Theory, 1900-1990: An Anthology of Changing Ideas*, pp. 822–34. Oxford University Press, Oxford.

Goehr L (1992). *The Imaginary Museum of Musical Works: An Essay on the Philosophy of Music*. Clarendon Press, Oxford.

Hanslick E (1891/1957). *The Beautiful in Music*, G Cohen trans. Bobbs-Merrill Co, Indianapolis, IN.

Huneker J (1911). *Franz Liszt*. Scribners, New York.

Leppert R (2004). The social discipline of listening. In J Drobnick, ed. *Aural Cultures*. YYZ Books, Toronto.

Miller S, ed. (1993). *The Last Post: Music after Modernism*. Manchester University Press, Manchester.

Pritchett J (1983). *The Music of John Cage.* Cambridge University Press, Cambridge.

Reynolds J (1961). *Discourses on Art.* Yale University Press, London.

Schopenhauer A (1818/1969). *The world as will and representation,* EF Payne, trans. Dover Publications, New York.

Schumann R (1840/1965). Franz Liszt: Concerts in Dresden and Leipzig. In *Schumann on music: a selection from the writings,* p.158, H Pleasants, trans. Dover Publications, New York.

Schumann R (1946). *On Music and Musicians,* p.150, K Wolff ed., P Rosenfield trans. WW Norton, New York.

Wackenroder WH (1799). *Phantafien über die Kunst, Für Freunde des Kunst,* L Tieck ed., Friedrich Ferthes, Hamburg.

THE SIGHT AND SOUND OF MUSIC: AUDIOVISUAL INTERACTIONS IN SCIENCE AND THE ARTS

DAVID MELCHER AND MASSIMILIANO ZAMPINI

In this essay, we examine the interaction between visual and auditory information: in the real world, in the laboratory and in the arts. We review both classic and more recent studies on audiovisual integration and describe research that is beginning to uncover how the human brain is 'wired for sound' and, intriguingly, predisposed for visual–auditory interactions. The final section examines some examples of contamination between visual and auditory stimuli in the arts. In particular, we re-examine the building blocks of music in terms of natural and social events which are typically multisensory.

The overall goal is to break down the artificial barriers between sound and vision, acknowledging the interplay between these two senses. The theory of 'pure vision' or 'pure sound' turns out to be problematic, even in traditionally unisensory art forms such as music or painting.

AUDIOVISUAL INTERACTIONS
IN THE LABORATORY

The cues that simultaneously impinge on our different senses provide us with convergent and partially redundant information about the same object or event. For example, during face-to-face conversation, our understanding of speech is reliably improved by what we see (i.e. from lip movements, facial expressions, and gestures), particularly in a noisy situation. Also, this influence is usually outside the observer's awareness, it becomes apparent when auditory and visual information are somewhat incongruent. One example is when in a poorly dubbed movie the movements of the actors' lips fail to match with the temporal pattern of the sounds. The comedic value of intentionally incongruent dubbing was first demonstrated by the series 'Fracture Flickers' (1961) and later exploited by Woody Allen in his first film *What's Up, Tiger Lilly* (1966), but is more generally distracting or unpleasant.

However, in most everyday situations auditory and visual information are congruent. This natural synchronization, which is taken for granted, has made it difficult for scientists to assess the relative contribution of each of our senses to perception and to understand how people integrate information from the different senses. One method has been to present conflicting information from the different senses. Two of the best-known examples of this audiovisual competition are the *McGurk illusion* and the *ventriloquism illusion*.

Illusions in auditory perception caused by vision

What is now called the *McGurk effect* (see Ward, Chapter 24, this volume) was first reported by McGurk and MacDonald (1976). In their seminal study, they presented auditory syllables synchronously dubbed with discrepant visual syllables. For instance, participants could hear a voice repeatedly uttering a particular syllable 'ba' while they simultaneously saw a synchronized video recording of a face whose lip movements were associated with a different syllable, 'ga'. In such a case, most people report hearing the new, completely different syllable 'da': a percept intermediate between the auditory and visual stimulus. This audiovisual effect clearly demonstrated the combination of visual and auditory inputs to provide a single percept most consistent with both sources of information. The McGurk effect is so robust that it remains strong even when participants are instructed to report only the auditory information while ignoring the visual information (Massaro 1987), or even when participants know that the auditory and visual syllables might be combined inappropriately (Manuel et al. 1983). These findings suggest that the audiovisual integration in speech perception is automatic (i.e. without the need for attention or concentration). Surprisingly, the effect even occurs when a male voice is paired with a female face (Green et al. 1991).

Another example of the influence of the visual information on auditory perception is the *ventriloquism effect* (Howard and Templeton 1966). When we watch a ventrilo-quist's performance, we have the illusory perception that the voice we *hear* is coming from the mouth of the puppet we *see* moving, because it *looks* as if the dummy was speaking. This art of tricking people by making one's voice emanating from elsewhere was used in Greek and Roman times by oracles (Connor 2000). In the early eighteenth century, it was suggested that performers manipulated the physical properties of the sound, making it appear to come from their puppets. However, it is not necessary to attend a ventriloquist's show to experience this audiovisual illusion: we regularly experience it in everyday situations. Whenever we watch a movie at the cinema, the spoken soundtrack seems to emanate from the lips of the actors seen on the screen, despite the fact that the sounds are actually presented from loudspeakers positioned elsewhere. Of course, the ventriloquism effect is not limited to speech, but happens for sound effects or when hearing music coming from the instrument being played by the musician rather than the loudspeakers.

Illusions in visual perception caused by sound

Many explanations for the ventriloquist effect have assumed that vision dominates sound, and somehow captures it (Warren et al. 1981). In other cases, however, what we hear can change what we see. In a real-world situation, when two objects move toward one another along the same linear pathway they will collide. However, the same situation can be made more ambiguous when explored under experimental conditions. For example, if you look on a computer screen at two identical objects (e.g. two black discs) moving toward each, overlapping, and then moving apart, two different events can be perceived. Either the objects can be perceived to follow the same trajectory (i.e. to cross each other's trajectory), or else to reverse their direction (i.e. to collide and bounce back). The situation can be made less ambiguous by presenting a sound at the exact moment of overlap (Sekuler et al. 1997). In that case, the number of times that people report that the two objects are bouncing off one another significantly increases. This audiovisual effect clearly shows that auditory information (not necessarily a realistic collision-like sound) can influence the perception of a visual event when pre-sented at a significant moment.

Another example of changes of visual perception by auditory stimuli is provided by the 'sound-induced flash illusion' (Shipley 1964; Shams et al. 2000; see also Gebhardt and Mowbray 1959). In Shams et al.'s study, people fixated the centre of the screen and were asked to judge the rate at which a white disc was flashed on the periphery of the screen. People were very accurate in reporting the number of flashes (i.e. 1–4) when the white disks were presented without any sound. However, when multiple auditory beeps (i.e. fluttering) were presented with the flashing light, an increase or decrease in the flutter rate of the sound could cause the apparent flicker rate to increase or decrease. Studies suggest that this is a truly perceptual illusion (Shams et al. 2004),

not just a cognitive bias: the illusory double flash is perceptually similar to a physical double flash. Importantly, the reverse is not true; the illusory beeping of a single sound cannot be induced simply by coupling it with a single flashing light.

One explanation for the relative dominance of audition in temporal events is that audition has better temporal acuity than vision. However, Saldaña and Rosenblum (1993) showed the influence of vision on audition in rating whether a heard note was bowed or plucked on a cello. In their study, a single note (the note G; −98Hz) was played by bowing or by plucking on the same cello string, and participants could both see (i.e. on a computer screen) and hear the played note. The audiovisual pairings could be congruent (in both the note was plucked or bowed) or incongruent (in one the note was plucked and in the other was bowed). The visual stimulus significantly affected the identification of the auditory stimulus, suggesting that sensory dominance in audiovisual interactions depends at least partly on the structure of the stimuli.

Theories of cross-modal integration

These examples of audiovisual conflicts show that vision and audition might show dominance over each other under different conditions. One possible account suggests that our perception relies more upon the sense that typically provides the more accurate information for the task at hand (Welch and Warren 1980; Ernst and Banks 2002). Hence, vision has the best spatial acuity, and so dominates audition when spatial judgements are requested (e.g. stimuli localization). By contrast, when we are involved in temporal judgements tasks (e.g. rhythm evaluation), we trust more our auditory modality because it has much better temporal resolution than the visual modality.

However, in many everyday situations, we have to integrate coherent (i.e. not conflicting) sensory signals reaching our senses at one time. A considerable body of empirical research has investigated the principles governing multisensory integration and cross-modal interactions (see the chapters in Calvert et al. 2004, for recent reviews). Spatial colocation and temporal coincidence are two of the most important cues that are used by the brain to determine whether or not sensory stimuli should be bound together. However, the detection of sensory synchrony is no simple matter for the nervous system to solve. Auditory and visual information are propagated through air at dramatically different rates. Light travels at a much faster rate (300 000 000 metres per second) than sound (300 metres per second). Therefore, visual information from the same event will arrive to our eyes before auditory information reaches our ears. In the brain, however, auditory information arrives to the brain from the ear more rapidly (i.e. 1–2 milliseconds) than visual information (20–30 milliseconds from the retina to the brain). Thus, the brain has to combine auditory and visual signals from the same location and same temporal event despite these basic differences at the level of physics and physiology.

It seems that our brain has a relatively wide window for the temporal integration of multisensory stimuli. Experimental evidence supports the claim that a strict temporal

overlap is not necessary, as the perceptual system can accommodate some degree of asynchrony. We are relatively insensitive to small differences in the arrival time of auditory and visual inputs to the brain. For instance, it has been shown that visual correlates of speech have to precede auditory speech by more than 250 milliseconds for the asynchrony between the two different sensory signals to be perceived. Moreover, the McGurk illusion can also be perceived when the auditory syllable lags (by up to 240 milliseconds) or leads (by up to 60 milliseconds) the visual syllable. Perception of when a stimulus occurred in time may also depend upon the allocation of selective attention. A sensory signal will be perceived as occurring earlier in time (relative to another stimulus) if we are paying attention toward the former stimulus–the law of prior entry proposed by Titchener (1908). Zampini and colleagues recently demonstrated that attending to a sensory modality (audition or vision) can speed up the relative perception of stimuli in that modality, compared to a stimulus in another modality (Zampini et al. 2005). The allocation of attention influenced the interval between an auditory and visual stimulus that would allow for perceived simultaneity. It is interesting to note that this temporal window of synchrony perception is not limited to highly related, complex audiovisual stimuli: it also includes relatively simple and non-related stimuli like a tone and light pair. Moreover, the temporal window for audiovisual multisensory integration appears to be quite flexible. For example, it is possible to induce a general temporal recalibration between audition and vision by exposing the participants to an asynchronous stream of complex audiovisual stimuli (such as speech or a recording of a hand playing a piano: Navarra et al. 2005). In particular, the temporal window for audiovisual integration can become wider as a result of monitoring the asynchronous speech or music stream. A similar pattern of results can be found in both speech and music stimuli.

The 'cost' of audiovisual integration

The discussion of audiovisual interactions would not be complete without considering perception when one sense is lost. One common folk belief is that those who lose the sense of vision (i.e. blind people) develop better capacities in perceiving auditory information. Recent evidence seems to suggest that this is indeed the case (see Röder and Rösler 2004, for a review). For example, blind individuals are better able to localize sound sources, which is obviously quite useful given that they cannot rely upon any visual cue. However, these enhanced auditory skills can also be extended to other auditory domains, such as listening to speech or music. In fact, blind individuals are faster in processing auditory language stimuli than their sighted counterparts.

One interesting example comes from studies showing differences in the prevalence of 'absolute pitch' between blind and sighted musicians. Absolute pitch, or perfect pitch, is the ability to name or reproduce a particular pitch without the aid of a reference tone. This skill is relatively infrequent even in expert musicians, although early musical training might facilitate its acquisition. Some of the musicians that had/have

this ability include: Ludwig van Beethoven, Wolfgang Amadeus Mozart, Charlie Parker, Miles Davis, and Ray Charles. Studies on absolute pitch in blind musicians have shown that the presence of absolute pitch is more frequent among blind than sighted musicians. This is surprising, considering that, on average, musical training with blind musicians with absolute pitch occurs later in time than in age-matched sighted musicians. This difference might be explained by the results of studies investigating the neural correlates of this ability in blind and sighted participants (e.g. Hamilton et al. 2004). Brain regions that are normally involved in processing visual information in sighted people can be 'recruited' by the blind to aid their auditory performance. By contrast, sighted people cannot rely on additional brain areas but are dependent only on auditory areas. In other words, if one sense is absent, another sense can take over and involve the neurons in those areas associated with the non-functioning sensory modality. This cortical plasticity may help to explain why blind people have increased auditory (but also tactile) abilities when compared to sighted people.

It is tempting to speculate on whether the special sensitivity of the blind towards music might partially explain the long tradition, across many cultures, of blind musicians (and in Western Europe, blind piano tuners). It is interesting to note the large number of blind musicians who have played an important role in the development of jazz, country and blues music. Examples include: Ray Charles, Blind Lemon Jefferson, Blind Willie Johnson, Rahsaan Roland Kirk, Blind Willie McTell, Ronnie Milsap, George Shearing, Art Tatum, Sonny Terry, Lennie Tristano, Doc Watson, and Stevie Wonder. Indeed, 'Blind' was such a common nickname in American blues music that the sighted musician Eddie Lang used the moniker 'Blind Willie Dunn' when recording blues records with Lonnie Johnson. While cultural factors have indeed played a role, including limits on career choices that were available to the blind, it might also be the case that the absence of audiovisual integration in those with visual deprivation has provided extra resources for musical ability. In sum, audiovisual integration has a cost for sighted musicians, in addition to a benefit: it may slow down (and perhaps, make less sensitive) our auditory perception of musical pitch.

AUDIOVISUAL NEURONS: HOW THE BRAIN PROCESSES MEANINGFUL SOUNDS

Does integration occur 'early' in neural processing?

Given the ubiquity of audiovisual interactions, it is perhaps not surprising that recent scientific evidence has shown that our brains are wired for sight–sound interactions. Traditionally, the areas of the brain's cortex that first process sensory inputs have been considered unisensory. Area A1, for example, is an area in the brain's temporal

lobe, which is the first stage in the cortex which processes sounds for identification and localization. Surprisingly, a number of studies have demonstrated that neurons in A1 respond to visual and somatosensory stimuli as well (Werner-Reiss et al. 2003; Brosch et al. 2005; Ghazanfar et al. 2005). Functional magnetic resonance imaging with humans has shown that the responses in A1 are modulated by the visual input accompanying an auditory signal (Calvert et al. 1999). Thus, the primary sensory cortices do not seem to be as unisensory as we once thought. This raises two important questions: (1) what are the anatomical connections that allow this early sensorial promiscuity to occur?; (2) how does our anatomy constrain the interactions between the senses?

In general, there are three main ways (which are not mutually exclusive) in which a primary sensory area like A1 could receive inputs from the other senses. First, the mixing could occur early at a more basic, sub-cortical[1] level, prior to the arrival in cortical area A1. A second idea is that neurons in area A1 might directly integrate relevant visual or somatosensory information into their processing of auditory stimuli. Finally, the multisensoriality of A1 might result from a feedback loop, in which information from multisensory integration regions is passed back down (in a second pass through the sensory system) to modulate A1 activity. So far, there is evidence in support of all three hypotheses, at least in animals. However, further study is required to understand whether these three pathways, which differ in the latency at which the non-auditory information would reach A1, carry different types of information (for review, see: Brosch et al. 2005). Audition is used for a variety of purposes: localizing sounds, decoding speech, detecting a danger, hearing our own footsteps and so on. Thus, these different mechanisms might, in theory, be involved in different aspects of audiovisual integration.

In addition to the multisensory influences on the initial cortical processing of stimuli in primary sensory cortices, there are a large number of multisensory areas which are involved in the integration of multiple sensory inputs into a complex percept. An area in the superior temporal lobe known as STS (superior temporal sulcus) appears to play an important role in integrating auditory and visual information in order to understand some physical events. In particular, STS is reliably activated by biological motion such as walking or face movements, suggesting that this region serves as a multisensory social event processor rather than a general-purpose multisensory integration area.

As reviewed earlier, there is evidence that certain visual and auditory stimuli fit together based upon shared spatial and temporal information. Other audiovisual associations, such as in synaesthesia (see van Campen, Chapter 25, and Ward,

[1] Both audition and vision involve not only cortical pathways, but also subcortical pathways. Thus, patients without a visual cortex may still have 'blind sight' based on information routed through the superior colliculus, and damage to auditory cortex does not eliminate the startle response to a sudden loud noise. Neurons in the superior colliculus respond to auditory, somatosensory, and visual stimuli. In addition, there is evidence for direct links between the thalamus and areas of the limbic system.

Chapter 24, this volume) or more 'metaphorical' similarities, are less straightforward to explain. One example is the mapping between visual shapes and the sound of certain words first demonstrated by Wolfgang Köhler (1929/1947). Köhler showed that people presented with a curvaceous or a pointy shape and a pair of words ('takete' and 'maluma') consistently paired maluma with the curved shape and takete with the pointy one. Even young children (2.5 years of age) show this tendency (Maurer et al. 2006) and it does not depend on exposure to the English language (Davis 1961). One speculation is that the shape representation is generalized between mouth movements (open versus narrow) and visual shape, but further research is required to test this hypothesis (Ramachandran and Hubbard 2001). Many artists, such as Wassily Kandinsky, have argued for a correspondence between particular visual features—such as colour and shape—and sounds (Fig. 14.1).

Although these links can be quite personal for specific artists (see Ward, Chapter 24, this volume), the link between visual and auditory features is made explicit in the performances of the artist Mark Rowan-Hull. Figure 14.2 shows a painting by the artist produced during a performance of Stravinsky's 'Concertino' performed live by the Coull Quartet.

The role of the planum temporale

One of the brain areas involved in audiovisual integration for complex stimuli is the planum temporale (PT). This triangularly shaped brain region occupies the superior temporal plane just posterior to A1 (primary auditory cortex). It is considered a portion of 'Wernicke's area', an area of the human brain specialized for language with a particular involvement in the comprehension of spoken language. Traditionally, PT has been considered to have exclusively auditory functions. However, Calvert and co-workers (1997) found overlapping activations of PT for heard speech and silent lip-reading. In particular, they have shown that the sight of lip movements directly activates the PT in the absence of any auditory speech sounds. These findings strongly support the claim that PT has a role for integrating auditory and visual information (perhaps the types of integration measured in the McGurk effect described earlier). It is interesting to note that PT was not engaged in the task when participants were watching visual stimuli (i.e. a mouth moving) without any plausible interpretation in terms of spoken language. This suggests that PT has a role for helping us in interpreting speech stimuli by integrating auditory and visual inputs. For instance, we know that auditory perception of speech can be improved by watching our conversation partner's lips during a face-to-face conversation in a noisy environment. The multisensory role of PT in audiovisual integration has been confirmed by studies on deaf individuals that do not show the same activation pattern (MacSweeney et al. 2002).

Given that similarities between language and certain aspects of music have been noted for centuries (Steele 1775), one might wonder whether PT is also involved in audiovisual integration for music perception. Indeed, this seems to be the case, at least for reading music scores (Nakada et al. 1998). Sight-reading music requires matching

Fig. 14.1 Wassily Kandinsky, *Rot in Spitzform*, 1925. Watercolour. © ADAGP, Paris and DACS, London 2011. Kandinsky suggested that colours have an 'interior sound' that awakens the spirit. (See Colour plate 3)

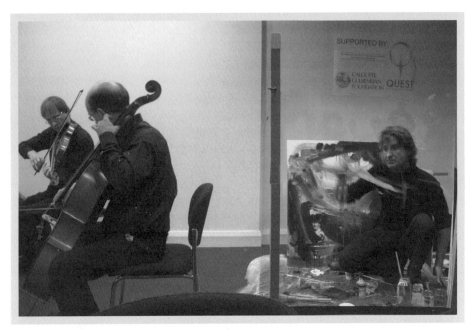

Fig. 14.2 Mark Rowan-Hull, *Untitled*. Acrylic and liquitex medium on perspex, 27th October 2006. (Photograph: Ella Clocksin.) Painted live on stage at the opening of the conference 'Art and the Senses'. Produced in response to Igor Stravinsky's 'Concertino' performed live by the Coull Quartet. Mark Rowan-Hull was influenced initially by both Abstract Expressionism and contemporary improvised and classical music. Rowan-Hull consistently seeks to extend the ideas associated with action, improvisation and music through colour and gesture. His creative process continues to fuse musical and visual concerns in order to explore the limits of artistic practice and performance and to explore where the two forms join. Throughout his career, Rowan-Hull has produced site-specific installations that relay a preoccupation with the process involved in composition, both visual and musical. Rowan-Hull's concerns are not so much about the final product but the conceptual and performed efforts entailed in pushing painting and image making out of its frame. Rowan-Hull's installations and performances reiterate his approach towards this transitory and ephemeral process of making art and music.

visual symbols with the corresponding sounds, based on experience and training. The finding that PT is involved in reading words and also musical scores suggests that this brain region is involved when there is a communicative goal (e.g. music and speech). Evidence for the importance of PT in meaningful audiovisual interactions comes from a recent study by Hasegawa and colleagues (2004). In their study, piano players of varying levels of training (untrained naïve participants, relative beginners, or players with at least eight years of training) were shown a video showing hands playing music pieces on a piano in the absence of any piano-related sounds. Participants had

to identify the piano pieces by watching the key-touching movements of the hands. Well-trained pianists were better in recognizing familiar pieces than the remaining two groups of participants. Although unfamiliar music and random sequences did not show the same pattern of results, all the conditions (i.e. familiar music, unfamiliar music, and random sequences) showed the same activation of the PT in well-trained piano players. Naïve and less-trained piano players did not show such activation. Hasegawa and colleagues suggested that PT is engaged in transforming the visual stimulus of hand movements into a sequence of sounds, at a stage occurring prior to identification of music.

Auditory art: the sound (and sight) of music

The basic components of music

As described earlier, there are particular patterns in auditory stimuli that are relevant for perceiving the location and identity of events, as well as for speech perception. All forms of music require the sensitivity to a particular set of regularities in sound, all of which are found in natural and social events. The basic aspects of musical sounds are: pitch, timbre, contour, loudness, reverberation, rhythm, and tempo. These are called 'separable' components to indicate that a musician can manipulate any of these features individually to create a new piece of music as, for example, with taste, the features of sweet, sour, salty, and umami are separable and independent. These are the regularities of sound to which our brains happen to be finely tuned.

Pitch is the perceived frequency (such as 'middle C') of a sound. Interestingly, pitch exists only in our mind: it takes into account contextual information (such as position within a musical scale) in addition to the pure information about frequency. Playing a particular pitch is, in a deep sense, 'playing the brain': the frequency at which neurons fire in areas of auditory cortex is probabilistically related to the frequency of the sound wave itself. Contour describes the way that pitches go up or down in a sequence. It is the contour of the sounds that is best remembered: we might all start singing the birthday song from a different note, but we will tend to follow the same contour. In both speech and music, contour conveys meaning and is used to create expectations (see Krumhansl and Lerdahl, Chapter 16, this volume). In the English language, for example, when asking a question the pitch should 'go up' at the end of a phrase. In the context of music, a melody is the shape, or contour, of a set of notes.

Timbre is the hard-to-define aspect of a sound that allows us to distinguish a female voice singing middle-C from a saxophone playing the same note. Natural sounds

are always a combination of different frequencies (called overtones) that depend on the material which happens to be vibrating. Natural objects do not make pure tones. Instead, each material has a signature pattern of tone and overtones that your brain has learned to interpret through practice. Our understanding of overtones has now allowed us to synthesize these patterns: hence the term 'synthesizer' to describe a keyboard instrument that can play tones that sound like a particular instrument, and, more generally, that have 'natural' properties although they do not sound like any acoustic instrument.

Loudness is easily understood as the property of sound that is influenced by turning up or down the volume knob. Many people like large amplitude sounds— firecrackers, rock concerts, and so on—and it is generally the case that such a sudden increase in amplitude is arousing (rather than soothing). Reverberation describes the way that sounds echo off of obstacles, creating a pattern of 'delays' as each sound wave hits the ears. The brain uses the physical properties of this echo to estimate the environment in which the sound occurs, and this generates a different 'feeling' for that sound.

Rhythm reflects our mind's grouping of sounds (beats) in time. Each period of time is divided into notes of a certain duration and (relative) silence. Typically, musical rhythm is divided into units such as measures, but even without regular measures we tend to hear regularities in music as part of our natural tendency to group sounds in time. In music with a strict rhythm, the pattern of accented and non-accented beats remains relatively constant within a particular piece of music, giving it a 'good rhythm' (although experimental music in the twentieth century saw the breakdown in strict rhythm in Western music, with the experimentation of Wagner, Schoenberg, Messaien, and others, which mirrored the dissolution of tonality in modern classical music). The pattern of beats—rhythm—moves at a certain speed, reflecting the number of times that a percussive event occurs (such as two objects colliding or someone hitting a drum). Tempo describes the speed at which these events occur: in other words, would it require many or few movements per second to tap along?

In sum, the brain is constantly searching for patterns in the incoming stream of sensation: in the case of music, the seven separable features reflect these patterns in the auditory stimulus (Fig. 14.3). In a sense, 'all the rest is noise', in that sounds can only be organized when our minds are sensitive to the underlying order in the temporal pattern of wavelengths transmitted as sound. Although noise is, by definition, a random nuisance that obscures a target signal, we often hear patterns even in random noise (see Muniz and Melcher, Chapter 18, and Melcher and Cavanagh, Chapter 19, this volume, for further discussion of the visual equivalent of this phenomenon).

This ambient background noise in a musical performance was made clear by John Cage's work 4'33" (1952), in which the pianist sat silently rather than playing any notes on the piano. In addition, mechanical or environmental sounds have been used within musical compositions. One early example is the use of the organ to mimic natural sounds. The Futurist Luigi Russolo was among the first to theoretically formulate a music of industrial noises, wishing to 'play the city' itself, while Edgar Varèse

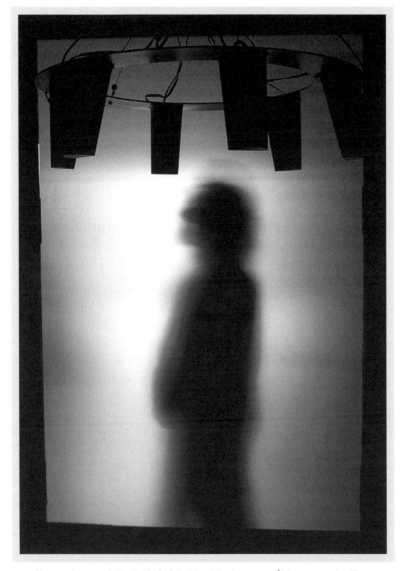

Fig. 14.3 Simon Longo DITHERNOISE, *Untitled*, 2006. (Photograph: Francesca
Bacci.) This sound piece reflects Simon Longo's investigation of the way that
sound patterns can combine into unique percepts. The composition consists in
sound elements such as beating frequencies, harmonics, noise, field recordings,
and tribal rhythms organized on three sets of CD audio tracks. These tracks differ
in duration, from 40 minutes to 1 hour, so that when played simultaneously
and continuously they recombine in different variations every time they loop.
Furthermore, the pattern changes depending on the position and movement of the
observer. By standing in the centre of the installation, the listener perceives the
indeterminacy of the composition as an ever-changing soundscape.

used high and low pitched sirens and a 'lion's roar' membranophone (a friction drum) in his composition 'Ionization' (1931). Moreover, composers and musicians have explored the role of chance, in which meaningful patterns of sound (for expert listeners) emerge out of unscripted interactions between sounds (see Iyer 2006). Such exercises might be similar to Leonardo's recommendation to painters to seek inspiration from random patterns in nature, as well as to the techniques used by scientists to uncover basic features in visual perception by looking at patterns of human responses to noise ('reverse correlation', see for example: Jones and Palmer 1987; Neri et al. 1999). In sum, looking at how the mind seeks regularities in noise, whether in the laboratory or the concert hall, provides insight into the musical brain.

Music and the perception of social and emotional events

Music has been famously defined by Edgard Varèse as 'organized sound', reflecting the modernist fixation on 'pure sound' or 'pure vision'(see Shaw-Miller, Chapter 13. this volume). However, music's divorce from accompanying visual information is historically recent. Before the advent of popular recording techniques, developed in 1877 with Thomas Edison's phonograph, music was never physically removed from the event that produced it. In the real world, patterns of sound have meanings in terms of physical and social events, with many auditory stimuli related to other sensory stimuli involved in the same event. As described earlier, our interpretation of sounds occurs within a multisensory context in which visual information plays an important role.

Theorists often distinguish between the sound ('sensation') and the recognition ('reference') of a particular object or event (see, for example, G. Frege, *On Sense and Reference*, 1892/1952). As Heidegger (1927/1996) noted, it is difficult to perceive pure noise. Instead, we hear a motorcycle coming down the street or a door slamming shut. Musical sounds, therefore, have both a subjective experiential quality and a property of recognition that calls to mind the source of the sound. The experiential aspect of sound is certainly important to music (see Noë 2000), and music, like other forms of art, can make us more aware of our own perceptual processes (see Muniz and Melcher, Chapter 18, this volume). However, it is useful to consider auditory stimulation within the context of the primary mission of sensation, which is to yield information about the sources of events. Indeed, such an analysis might go some way in helping to explain our emotional and embodied reactions to music, as well as to guide our understanding of how visual stimuli can interact with certain aspects of music.

The first two separable components of music, pitch and timbre, tell us something about the nature of the object making the sound. When combined, these two features can reveal, for example, whether the speaker is a male or female or even a particular person that you know. In the case of physical events, these features of sound inform us whether a solid object has banged against a wall or, instead, if there was a

shattering of glass. In a basic sense, timbre reflects a perceptual hypothesis about the *materials* involved in a particular auditory event, similar to texture and colour information in the visual modality. Of course, timbre is typically combined with other auditory cues in refining our perception. In particular, the attack and sustain of a sound—which depend on the time course of loudness and timbre—are particularly important for the identification of sound sources. While most of us can tell apart the same tone played by different instruments, with enough practice experts learn to tell apart one make or model of instrument from another and can even discriminate, based purely on timbre, the sound of one musician playing from another. Timbre is part of a musician's 'voice' and forms the auditory fingerprint of a particular instrument.

Our sensitivity to pitch and timbre reflect 'natural harmonics': the way that the physical objects happen to vibrate on our planet. For example, the first three intervals of the series of overtones are the 'perfect' intervals: the octave, the perfect fifth, and perfect fourth. It is interesting to note how the development of Western music, with harmonic and melodic systems based on the octave and the perfect fifth, is directly related to the overtones series and, thus, reflects a physical property of the world. Although it is certainly not the only way to construct music, it is far from arbitrary (the ancient Greeks described intervals as 'perfect' because they were created by nature). Recent studies of child development show an innate sensitivity to these classic intervals (for reviews, see: Trehub 2003, 2006) and a preference for consonance (Trainor et al. 2002). While we can be trained to be sensitive to other sound patterns, the intervals in Western music may take advantage of what is easiest for our musical brains to understand. Indeed, there is a general agreement, among listeners, about the general 'feeling' (described by words or by body movements) communicated by particular intervals (Krantz et al. 2004, 2006). Such differences may reflect the way that tonal processing occurs in the brain, based on evidence from neural responses and preferences of other animals exposed to musical sounds (for review, see Hauser and McDermott 2003).

When combined with pitch and timbre, the musical contour provides important information about physical and social events. In particular, these aspects of sound are critical for understanding the social meaning of a stimulus. Caregivers make a special use of contour, known as 'motherese' when speaking to infants, in a type of proto-music (for review, see: Trevarthen 2008). In particular, this proto-music is used to guide the infant's attention or to change emotional state, such as by calming a fussy baby or helping her to fall asleep. Combined with timbre, the contour of pitches provides a strong cue to communicative intent—differentiating, for example, between a question and a command. The contour and timbre provide an important clue to emotional expression. In other words, it is not just *what* you say, but *how* you say it ('prosody') that caries meaning. Verbal prosody and dynamic facial expressions interact in communicating emotions, and our perceptions tend to combine information from both sources (see for example: Walker and Grolnick 1983; Ethofer et al. 2006). Thus, music can use the same clues to emotion that are involved in emotional

speech, without speech getting in the way (for a review of music and emotion, see: Juslin and Sloboda 2001). As the composer Felix Mendelssohn argued 'It's not that music is too imprecise for words, but too precise . . . ' (cited in Kruse 2007).

Music, like prosody in speech, may tap into neural mechanisms that help us to attend to the important aspects of sound and to keep that information active in working memory (Patel et al., 1998). Interestingly, the mnemonic power of melodic contour can even be used to help treat aphasic stroke victims who have lost the ability to speak. 'Melodic Intonation Therapy' pairs useful phrases (such as the patient's name or 'example') with song-like patterns (combining both melody and rhythm) and has been successful in bringing back speech, perhaps by re-activating language areas via the route of musicality (Belin et al. 1996). Many music therapy approaches are based on the idea that musicality is a deep, fundamental and prelinguistic capacity that supports communication and the development (or rehabilitation) of language.

Contour also provides an important cue about physical events: a pattern of rising notes provides a different interpretation from a 'bouncing' or 'falling' contour of notes. Numerous studies have shown that music that 'goes up' in pitch is understood in spatial terms (see Ward, Chapter 24, and van Campen, Chapter 25, this volume on synaesthesia). Independent contours can be segregated in polyphonic music, allowing different 'objects' to interact. This allows the different melodic streams to be segregated (either by instrument or across instruments by following the melody). Examples include the 'call and response' in gospel and jazz music or the way that the soloists in a Mozart piano concerto seem to 'converse', or at least react and interact, with the rest of the orchestra.

The social power of music is particularly clear when examining the joint performance of music. Musicians lock into shared melodic and temporal structures. The importance of a shared 'groove' is clear in more improvisational music (see Madison, Chapter 17, and the interview with jazz musicians Greg Osby and Skip Hadden, Chapter 15, this volume), but even composed music requires temporal and tonal synchronization. The mechanisms underlying this cross-individual synchronization are just beginning to be studied, but there is preliminary evidence that brain patterns show greater synchrony when musicians are playing together (Lindenberger et al. 2009).

Sound localization: musical space

The next two separable components of music—loudness and reverberation—provide clues about our physical relationship to a sound-producing event. Loudness depends both on the amplitude of the vibrations at the source (the intensity, frequency, and duration of the sound produced by the event) and our distance from the event (Zahorik and Wightman 2001). Thus a change in loudness only could reflect either a larger event (hitting something with more force, for example) or that our distance to that event has decreased.

Loudness has correlates in the other senses, given its correlation with 'collision', 'increasing', and 'approaching'. The visual correlates of increased loudness are

increases in size and/or moving closer to the observer, and, in fact, our perception of auditory and visual cues about size and distance interact with each other (Kitagawa and Ichihara 2001). Thus, it is not just loudness *per se*, but also changes in volume that are important in physical event and social perception. In many cultures, raising one's voice is an important cue in communication. Loudness is generally arousing but, at the extreme, loud sounds can physically hurt us. Indeed, loudness for its own sake in the music of some rock bands has lead to permanent damage to the hearing system in some musicians and listeners.

Reverberation provides a vital clue about the environment in which the sound is produced. The mind interprets the pattern of echoes in terms of the physical properties of the environment. Reverberation can give us cues about the size of the space and the materials of the walls (such as carpet versus wooden floors). Many musicians manipulate the reverberation of their instrument on stage using various devices like a stomp box, signal processor, or reverberation knob on the amplifier. Modern sound engineers artificially manipulate sounds to recreate an enormous concert hall or a padded room for listeners who use earphones (that of course, cannot produce natural reverberation themselves). In fact, engineers can now produce reverberation that is not actually consistent with any physically possible environment. In practice, reverberation and loudness work together in creating the perception of auditory space giving subjective reports of 'open' space or more closed 'intimate' (or claustrophobic) space.

Loudness and reverb, when combined, provide a powerful tool for musicians who wish to move the sound in audiovisual space. Examples include the 'far off' sound of a trumpet call in a symphony or the sound of instruments separated by stereo sound (particularly with headphones). One dramatic example, in club music, is the perception of the 'approach' of a sound, which dramatically builds tension in the anticipation of its arrival. Then, when the sound finally arrives, this moment of climax is emphasized by the entrance of a deep, pounding bass beat (Clark 2001). This provides another example of how music, often considered 'pure sound' or 'abstract', taps into our mind's search for meaningful patterns which reflect social and physical events.

Embodied music

The last two components—rhythm and tempo—inform us about the precise timing of events. As described earlier, sound provides a precise source of information about collisions between objects that is more precise than the visual correlates of the same events. In the case of music, however, it is important to note that percussive sounds have been, up until relatively recently, human-made. More generally, patterns in music happen over different timescales, which can be compared to the rhythms and tempo of the body (Iyer 2004). Over a timescale of seconds, there are dynamic swells that correlate with bodily activities such as 'breathing, arm gestures or body sway' (Iyer 2004, p. 396). The musical correlates of these dynamic swells are

'phrase, meter, harmonic rhythm and vocal utterances'. In a timespan of a third of a second to one second (60–180 beats per minute), we find 'heartbeat, walking and running, sexual intercourse, head bobbing and toe tapping', which have music correlates in 'pulse, walking baselines and dance rhythms' (Iyer 2004 p. 396). At the shortest timescale, hundreds of milliseconds (3–10 notes per second) corresponding to the musical features of 'fast rhythmic activity and bebop melodies', the motor actions include speech articulation and rapid body movements such as finger motion. These links between musical timing and human timing become clear when listening to musicians performing: for example, in the phrase lengths of wind instruments (which are constrained fundamentally by breathing in most cases), even artificial percussion calls to mind the body rhythms that it hopes to provoke by compelling the listener to dance or at least to 'feel' the beat. Thus, Shove and Repp describe music as 'audible human motion' due to this fundamental link between the timing and range of sounds and the body movements that (for most of human history) generate those sounds (1995).

The subjective impression of the 'beats' in music has been studied by scientists using a variety of paradigms, including the seemingly simple task of tapping along to music (for review, see Repp 2005) One key finding is that our perception of the timing of music (the combination of tempo and rhythm) involves neural regions involved in generating movements. Overt manifestations of this embodied perception of 'the beat', such as tapping one's fingers, reflect a covert motor response going on in our brains when perceiving rhythm and tempo. Temporal entrainment to auditory beats is a well-known phenomenon (whether in military marching or in a tribal dance). Interestingly, entrainment to tempo (the phenomenon in which people spontaneously nod their head or tap their toes to music) has also been shown with vocal learning birds (Schachner et al. 2008; Patel et al. 2009). Parrots, which imitate speech and other sounds are, so far, unique examples in the animal kingdom of entrainment to auditory beats (entertaining videos of the cockatoo 'Snowball', which have been viewed by millions of people, can be found on YouTube and at researcher Adena Schachner's website: http://www.wjh.harvard.edu/~amschach/videos.html). The world's first bird dance contest was recently held at BirdChannel.com. At the same time, there is undoubtedly an influence of personal experience on synchronization to musical tempo. Drake and Ben El Heni (2003), for example, compared finger tapping in Tunisian and French listeners and found that temporal synchronization occurred over a wider range of tempos and at a higher hierarchical level (rhythmic complexity) when participants listened to music from their own culture. Thus, it seems that acculturation and expertise strongly influence the function of embodied mechanisms for perception of rhythm and tempo (see Iyer 1998, 2002, 2004b).

Taken together, all of the evidence from physics, physiology, and psychological research demonstrates that, despite the fact that the various sensory cues emanating from an object may actually occur at the same time, it is quite unlikely that the auditory and visual information reach our brain exactly at the same time. Hence, our brains must resynchronize, or adapt to these various sensory asynchronies in order for us to interact adaptively with our environments, and deliver the rich multimodal percepts we

experience in everyday life. In other words, our brain must continually solve the problem of synchronicity (Madison 2003, 2006). The attribute of music known as 'groove' appears to be particularly important for collaborative, improvisational music in both Western and non-Western music (Iyer 1998, 2002; McGuiness 2005). Specifically, groove plays a role in improvisation, which involves an embodied synchrony between musicians, such as in rock or jazz music, based on a shared understanding of the current state of the music and its future possibilities. Often, music with groove (for example the music of James Brown) explicitly shifts the pattern of rhythm across different instruments, making the temporal synchronization of the musicians apparent to the listener as well. Thus, the listener might experience, perhaps through their own sensorimotor system, the entrainment occurring among the musicians performing. In the case of a live concert, this relationship between the performers and the audience becomes more interactive and develops—in Christopher Small's terminology—into the shared activity of 'musicking' (1987).

Human response to sounds, and particularly to music, is a complex phenomenon (for an extensive treatment of the topic, see: Juslin and Sloboda 2001). The link between sound and motivation (rewarding behaviours that lead to survival and reproduction) may play a part in its emotional power. Pleasant visual stimuli, for example, are rewarding in the classical sense of the word, since faces can be used to classically condition a response (Bray and O' Doherty 2007). In the case of olfaction, recent studies suggest that there is an innate component—which can, of course, be shaped by experience—of olfactory pleasantness, which is directly related to the discriminability of the odorant molecules at a physiochemical level: the molecular weight and extent of the odorant (Khan et al. 2007). It is easier to say whether we *like* a smell than to identify it, and the same might be true of music.

The influence of a certain pattern of sounds on a particular individual will be a product of her or his entire past. Musical training influences the sensitivity to certain patterns of sounds, just as an expert wine taster learns to discriminate different components of the smell and taste of wine and to give these a name. Moreover, the response of the ear itself changes over time, due to development, aging-related changes in sensitivity, or even damage caused by exposure to loud events. Thus, our brain retunes its processing based upon the statistical regularities of our auditory world. We do, in a real sense, learn to hear differently.

Thus, the communication of ideas and feelings involves the stimulus itself—the pattern of sound—as well as the context and the individual's personal experience. Artists can manipulate the sounds and the context, and try to address the personal and cultural history of the listener. In the context of a religious ceremony, for example, a certain set of sounds might inspire spiritual feelings, while quite similar patterns of sounds in a dance club or concert hall would be interpreted in non-religious ways. Today, many listeners would tend to attribute the beauty of J.S. Bach's religious music, even if played in a cathedral, to the genius of the artist rather than to the power of God. Thus, music can only suggest a particular idea or feeling. Context and appraisal play a role in the interpretation of the meaning of what is suggested by the musical sounds themselves.

AUDIOVISUAL INTERACTION IN THE ARTS

Adding sight to sound

Auditory and visual stimuli can interact in different ways, providing different tools that can be used by artists. In this section, we will look at specific examples of how our audiovisual perception, trained in the real-world, can be used in the arts. First, images can be added to complement auditory stimuli. Traditionally, music has been performed in groups of players and dancers, not—as in Western culture—consumed passively by a stationary audience. It is not surprising, then, that the development of new media has favoured the re-establishment of audiovisual experiences. One obvious example is the music video. As presciently foreseen by the Buggles in their 1979 song (and music video) 'Video killed the radio star', often today the experience of a song is inextricably linked to a specific video. Thus, the images and sounds are bound in a unique multisensory event, returning music from its rarified (and reified) heights as 'pure sound' to its origins as part of a multisensory, embodied and situated activity (see Iyer 2002, 2004b).

David Byrne's *Playing the Building* installation at the Battery Maritime Building in New York (2008) provides an example of how visual information can heighten the interpretation of each sound in terms of a physical event. Byrne attached sound-making devices to the building structure itself, to create three types of sounds: wind, vibration, and striking. Playing a keyboard caused parts of the building (beams and pillars, heating and water pipes) to resonate, vibrate, or oscillate, thus producing a sound in the space.

More generally, any live musical event that maintains the transparency of the relationship between auditory and visual stimuli takes advantage of this synergy. But musicians have invented additional visual cues—ranging from choreographed dancing to laser light shows—to bring new associations between auditory and visual stimuli. Abstract visual stimuli such as flashing lights can be synchronized with 'colorations' of the music or emphasize certain moments or structures within the musical performance.

Visualizing sound

One reason for the power of visual images in history is the ability to create relatively long-lasting representations through sculpture, etching, drawing, painting and other techniques. Certainly, one can tell an art history based on visual representation of visual phenomena, but there is an equally interesting story of the use of visual representation of the other senses (see Melcher and Cavanagh, Chapter 19, this volume). If auditory and visual information tend to interact in particular ways, then one might expect certain aspects of auditory events to be translated into visual cues. One example is the way that sound waves radiate outwards from the source (like ripples on the

surface of the water). This provides a natural convention for portraying sound, in a visual image, as waves or as a set of radial lines. 'High' and 'low' or coloured sounds also have visual equivalents (see chapters by Ward, Chapter 24, and by van Campen, Chapter 25, this volume).

Visual art is now used as an integral part of the experience of music by the inclusion of album/CD covers that match the music, or an existing artwork based on some perceived similarity. A pastoral piece of classical music might show a nice pastoral scene on the cover, while abstract modern music would be better served by an abstract artwork. Following pioneering work by artists such as Alex Steinwess (including album covers for Igor Stravinsky, Louis Armstrong, and Duke Ellington), S. Neil Fujita (whose painting is on the cover of 'Take Five' by the Dave Brubeck Quartet and 'Mingus Ah Um' by Charles Mingus), and Reid Miles (artistic director for Blue Note records), music was no longer sold in a plain brown wrapper but with specially designed and commissioned 'album cover art' (Steinweiss and McKnight-Trontz 2000). Jazz, in particular, called for abstraction and stylization, while classical music often showed performers or figurative artworks (Heller 2007). In addition to graphic designers, well-known visual artists including Andy Warhol, Robert Mapplethorpe, Al Hirschfeld, Mati Klarwien, and Vik Muniz have created original album cover art. There have been numerous recent museum and gallery shows of artworks created specifically as album covers.

Exit music (for a film)

There was a tremendous commercial push for 'moving pictures' to become 'talking pictures', with *The Jazz Singer* (1927) as the first feature-length 'talkie'. The success of Hollywood, which embraced the commercial possibilities of films with soundtracks, led the way, while many European and Asian film-makers maintained the aesthetic of silent films. For example, the Russian Formalist theorist Viktor Shkovsky argued that 'Talking film is as little needed as a singing book' (quoted in Kenez 2001, p. 123). Movies include speech and sound effects, which both take advantage of the ventriloquist effect described earlier. Video artists such as Tony Oursler have taken advantage of the power of the ventriloquist effect to give 'presence' to images. Oursler projects faces on to inanimate objects and lets them 'speak'. Although in the work *Machine* (2000) the artist's projected face on a maquette declares, 'I am not a talking head', the ventriloquist effect gives arise to exactly this uncanny perception.

There are at least three ways in which music can influence the experience of watching a film or video. First, it can suggest a mood that is congruent with an emotional event in the film (Smith 2003). Since both visual and musical cues to emotional events can be imprecise, combining the two sources of information can create an audiovisual additivity that heightens the effect. Second, the music could serve as a cue which helps us to interpret a potentially ambiguous event (Smith 2003). For example, playful music might tell us to laugh at an unfortunate event that befalls the protagonist, while dramatic and sad music might increase our sympathy for the same

unfortunate character. The *'Danube Waltz'* played as spaceships twirl through space emphasizes the dance-like movement of the spaceship in Stanley Kubrick's *2001* (1968). Finally, music is a powerful tool to increase the general arousal, such as by creating tension which is, itself, ambiguous. Even a simple 'drum roll' could, in a film, herald the arrival of a happy event or a scary monster. In the film *2001*, for example, the use of *'Thus Spake Zarathustra'* effectively builds tension to inform us of the monumental nature of the events unfolding on screen. The ostinato was used effectively in *Psycho* (1960) and *Jaws* (1975) to heighten tension, showing the strength of fear conditioning. It is interesting to note that studies with animals suggest that fear conditioning to a sound can bypass the auditory cortex and make a direct, subconscious link between stimulus and fear response, which is later modified by the slower, cortical input.

One powerful illustration of the power of both the musical score and the sound effects in film perception is the refusal by the British Board of Film Classification

Fig. 14.4 Fortunato Depero, *Sketch for a Plastic-Motor-Noise Apparatus with Coloured Lights and Spray Mechanism*, 1915. MART Museum, Rovereto.

to grant the requested 12A (for children 12 years or older) rating for the 2007 movie adaptation of *The Da Vinci Code*. The film board complained that the film's musical score created tension and anxiety: 'Everyone was full of praise for the score but the BBFC felt that the way it was being used to build up the tension was simply too much for very young children.' Also, the sound effects enhanced the visceral nature of the violence: 'The BBFC also thought that the film had a very high 'crunch factor'. You didn't just see the fight scenes, you heard the bones break' (Hastings 2006). It was only after making the changes to the audio content—while leaving the violent images intact—that the film was granted the desired 12A rating.

While cinema and video are obvious exemplars of truly multimodal, audiovisual forms of art, another case in point comes from objects that are designed to be both seen and heard. In this situation, the materials and mechanics of the object may allow for a truly multisensory experience (or, alternatively, the object may be designed to hide the relationship between visual and auditory event). Futurist artists such as Fortunato Depero (Fig. 14.4) and Luigi Russolo designed audiovisual art objects, essentially machines, which were used for creating multisensory artistic performances.

Figure 14.4 shows a design sketch by Depero for a machine that would make a combination of sounds and colours (coloured lights, smoke, and water). Russolo built a series of machines, which he called 'intonarumori' (noise players), to sample different industrial sounds as part of a performance.

The sound sculptures of Harry Bertoia (1915–1978), created in the 1970s, make the nature of audiovisual interactions transparent, as the pattern of sound reflects both the material properties of the objects and also the event that acts upon that object, such as a breeze or human touch (Fig. 14.5). Bertoia used the term 'sonambient' to describe the multisensory environmental effects of his sculptures, which included patterns of metal rods or sculptures shaped as gongs that were meant to be struck. The event that initiates the sound, by displacing in space one or more rods, as well as the continued reverberation of the rods, is a true audiovisual stimulus, bringing this discussion of audiovisual perception and the arts full circle, back to the main theme of this review: the integration of audio and visual information is critical for the perception of social and physical events.

CONCLUSIONS

In sum, interactions between audition and vision increase our ability to localize and understand physical and social events. The neural substrates of these interactions are wired into our brains, but also, importantly, are modified by experience. There are specialized multisensory regions as well as direct connections between unisensory areas. Our perceptions reflect a fundamentally multisensory understanding of the

Fig. 14.5 Harry Bertoia, *Untitled (Sonambient)*, 1970s. Sound sculpture, beryllium–copper rods with brass top and base, Sculpture Garden of the Huntington Library (California).

(Photograph: Van Swearingen.)

world in terms of what and where (physical events) and in terms of communication (social events): the audiovisual percept is more than the sum of its sensory parts.

These audiovisual interactions can influence our reaction to the arts. Music, for example, takes advantage of the natural properties of the sounds that occur in physical events and in human speech. Our sensory receptors and brains have developed to pick up the most useful information for our survival, and these sensory experiences tend to motivate us to behave in particular ways. Although sound stimuli, in particular musical sounds, are often studied in isolation, audition is deeply linked to the other senses including vision and touch (the body senses). These audiovisual interactions, honed in everyday life, are transported into the museum or theatre as part of our experience of the arts. Artists can take advantage of these interactions through multisensory congruency or, instead, pit our senses against each other for dramatic effect.

REFERENCES

Belin P, Van Eeckhout P, Zilbovicius M, et al. (1996). Recovery from nonfluent aphasia after melodic intonation therapy: a PET study. *Neurology*, **47**, 1504–11.

Bray S and O'Doherty J (2007). Neural coding of reward-prediction error signals during classical conditioning with attractive faces. *Journal of Neurophysiology*, **97**, 3036–45.

Brosch M, Selezneva E, and Scheich H (2005). Nonauditory events of a behavioral procedure activate auditory cortex of highly trained monkeys. *Journal of Neuroscience*, **25**, 6797–806.

Calvert GA, Brammer MJ, Bullmore ET, Campbell R, Iversen SD, and David AS (1999). Response amplification in sensory-specific cortices during crossmodal binding. *Neuroreport*, **10**, 2619–23.

Calvert GA, Bullmore ET, Brammer MJ, et al. (1997). Activation of auditory cortex during silent lipreading. *Science*, **276**, 593–6.

Calvert GA, Spence C, and Stein BE, eds. (2004). *The Handbook of Multisensory Processes*. MIT Press, Cambridge, MA.

Clark E (2001). Meaning and the specification of motion in music. *Musicae Scientiae*, **5**, 213–34.

Connor S (2000). *Dumbstruck: A Cultural History of Ventriloquism*. Oxford University Press, Oxford.

Davis R (1961). The fitness of names to drawings: a cross-cultural study in Tanganyika. *British Journal of Psychology*, **52**, 259–68.

Drake C and Ben El Heni J (2003) Synchronizing with music: intercultural differences. *Annals of the N Y Academy of Sciences*, **999**, 429–37.

Ernst MO and Banks MS (2002). Humans integrate visual and haptic information in a statistically optimal fashion. *Nature*, **415**, 429–33.

Ethofer T, Pourtois G, and Wildgruber D (2006). Investigating audiovisual integration of emotional signals in the human brain. *Progress in Brain Research*, **156**, 345–61.

Frege G. (1892/1952) On sense and reference. In PT Geach and M Black, eds. *Translations from the Philosophical Writings of Gottlob Frege*, pp. 56–78. Blackwell, Oxford.

Gebhardt JW and Mowbray GH (1959). On discriminating the rate of visual flicker and auditory flutter. *American Journal of Psychology*, **72**, 521–9.

Ghazanfar AA, Maier JX, Hoffman KL, and Logothetis NK (2005). Multisensory integration of dynamic faces and voices in rhesus monkey auditory cortex. *Journal of Neuroscience*, **25**, 5004–12.

Green KP, Kuhl PK, Meltzoff AM, and Stevens EB (1991). Integrating speech information across talkers, gender, and sensory modality: Female faces and male voices in the McGurk effect. *Perception & Psychophysics*, **50**, 524–36.

Hamilton RH, Pascal-Leone A, and Schlaug G (2004). Absolute pitch in blind musicians. *Neuroreport*, **15**, 803–6.

Hasegawa T, Matsuki K, Ueno T, *et al.* (2004). Learned audio–visual cross-modal associations in observed piano playing activate the left planum temporale. An fMRI study, *Cognitive Brain Research*, **20**, 510–18.

Hastings C (2006). Da Vinci Code music—not the killing—is too scary for children, say censors. *The Daily Telegraph*, **6 May**.

Hauser MD and McDermott J (2003). The evolution of the music faculty: a comparative perspective. *Nature Neuroscience*, **6**, 663–8.

Heidegger M (1927/1996). *Being and Time: A Translation of Sein und Zeit*, J Stambaugh trans. State University of New York Press, Albany NY.

Heller S (2007). Waxing chromatic: an interview with S. Neil Fujita. *Voice: AIGA Journal of Design* (September 18, 2007). http://www.aiga.org/content.cfm/voice

Howard IP and Templeton WB (1966). *Human Spatial Orientation.* Wiley, New York.

Iyer V (1998). 'Microstructures of feel, macrostructures of sound: Embodied cognition in West African and African-American Musics.' Unpublished PhD thesis. University of California, CA.

Iyer V (2002). Embodied mind, situated cognition, and expressive microtiming in African-American music. *Music Perception*, **19**, 387–414.

Iyer V (2004a). Exploding the narrative in Jazz improvisation. In R O'Meally, B Edwards and F Griffin, eds. *Uptown Conversation: The New Jazz Studies.* Columbia University Press, New York.

Iyer V (2004b). Improvisation, temporality, and embodied experience. *Journal of Consciousness Studies*, **11**, 159–73.

Iyer V (2006). Sangha: collaborative improvisations on community. *Critical Studies in Improvisation / Etudes critiques en improvisation*, **1**, 1–18.

Jones JP and Palmer LA (1987). The two-dimensional spatial structure of simple receptive fields in cat striate cortex. *Journal of Neurophysiology*, **58**, 1187–211.

Juslin PN and Sloboda J, eds. (2001). *Music and Emotion.* Oxford University Press, Oxford.

Kenez P (2001). *Cinema and Soviet society from the revolution to the death of Stalin.* I.B. Tauris, London and New York.

Khan RM, Luk CH, Flinker A, et al. (2007) Predicting odor pleasantness from odorant structure: Pleasantness as a reflection of the physical world. *Journal of Neuroscience*, **27**, 10015–23.

Kitagawa N and Ichihara S (2001). Hearing visual motion in depth. *Nature*, **416**, 172–4.

Köhler W (1929/1947). *Gestalt Psychology*, 2nd edn. Liveright Publishing, New York.

Krantz G, Merker B, and Madison G (2004). Subjective reactions to musical intervals assessed by rating scales p. 22. In *Proceedings of the Eighth International Conference on Music Perception and Cognition.* North Western University, Evanston. IL.

Krantz G, Madison G, and Merker B (2006). Melodic intervals as reflected in body movement. In M Baroni, AR Addessi, R Caterina and M Costa, eds. *Proceedings of the 9th International Conference on Music Perception and Cognition*, pp. 265–8. Alma Mater Studiorum, University of Bologna, Italy.

Kruse F (2007) Is music a pure icon? *Transactions of the Charles S. Peirce Society: A Quarterly Journal in American Philosophy*, **43**, 626–35.

Lindenberger U, Li SC, Gruber W, and Muller V (2009). Brains swinging in concert: cortical phase synchronization while playing guitar. *BMC Neuroscience* **10**, 22.

MacSweeney M, Calvert GA, Campbell R, et al. (2002). Speech-reading circuits in people born deaf. *Neuropsychologia*, **40**, 801–7.

Madison G (2003). Perception of jazz and other groove-based music as a function of tempo. In R Kopiez, AC Lehmann, I Wolther, and C Wolf, eds. *Proceedings of the 5th triennial ESCOM conference*, pp. 365–7. School of music and drama, Hannover, Germany.

Madison G (2006). Experiencing groove induced by music: consistency and phenomenology. *Music Perception*, **24**, 201–8.

Manuel SY, Repp BH, Liberman AM, and Studdert-Kennedy M (1983). 'Exploring the 'McGurk Effect'. Paper presented at the 24th Annual Meeting of the Psychonomic Society, San Diego, CA.

Massaro DW (1987). *Speech perception by ear and eye: A paradigm for psychological inquiry.* Lawrence Erlbaum, Hillsdale, NJ.

Maurer D, Thanujeni P, and Mondloch CJ (2006). The shape of boubas: sound-shape correspondences in toddlers and adults. *Developmental Science*, **9**, 316–22.

McGuiness A (2005). 'Microtiming deviations in groove.' Master's thesis, Centre for New Media Arts, The Australian National University.

McGurk H and MacDonald J (1976). Hearing lips and seeing voices. *Nature*, **264**, 746–8.

Nakada T, Fujii Y, Suzuki K, and Kwee IL (1998). 'Musical brain' revealed by high-field (3 Tesla) functional MRI. *Neureport*, **9**, 3853–6

Navarra J, Vatakis A, Zampini, M, Soto-Faraco S, Humphreys W, and Spence C (2005). Exposure to asynchronous audiovisual speech increases the temporal window for audiovisual integration of non-speech stimuli. *Cognitive Brain Research*, **25**, 499–507.

Neri P, Parker AJ, and Blakemore C (1999). Probing the human stereoscopic system with reverse correlation. *Nature*, **401**, 695–8.

Noë A (2000). Experience and experiment in art. *Journal of Consciousness Studies*. 7, 123–36.

Patel AD, Iversen JR, Bregman MR, and Schulz I (2009). Experimental evidence for synchronization to a musical beat in nonhuman animal. *Current Biology*, **19**, 827–30.

Patel AD, Peretz I, Tramo M, and Labrecque R (1998). Processing prosodic and musical patterns: a neuropsychological investigation. *Brain and Language*, **61**, 123–44.

Ramachandran VS and Hubbard EM (2001). Synaesthesia –a window into perception, thought and language. *Journal of Consciousness Studies*, **8**, 3–34.

Repp BH (2005). Sensorimotor synchronization: a review of the tapping literature. *Psychonomic Bulletin & Review*, **12**, 969–92.

Röder B and Rösler F (2004). Compensatory plasticity as a consequence of sensory loss. In GA Calvert, C Spence, and BE Stein, eds. *The Handbook of Multisensory Processes*, pp. 719–48. MIT Press, Cambridge, MA.

Saldaña HM and Rosenblum LD (1993). Visual influences on auditory pluck and bow judgments. *Perception & Psychophysics*, **54**, 406–16.

Schachner A, Brady TF, Pepperberg I, and Hauser M (2008). 'Spontaneous entrainment to auditory rhythms in vocal-learning bird species.' Poster presented at *The Neurosciences and Music III*, Montreal, Canada.

Sekuler R, Sekuler AB, and Lau R (1997). Sound alters visual motion perception. *Nature*, **385**, 308.

Shams L, Kamitani Y, and Shimojo S (2000). What you see is what you hear: sound induced visual flashing. *Nature*, **408**, 788.

Shams L, Kamitani Y, and Shimojo S (2004). Modulations of visual perception by sound. In GA Calvert, C Spence, and BE Stein, eds. *The Handbook of Multisensory Processes*, pp. 27–33. MIT Press, Cambridge, MA.

Shipley T (1964). Auditory flutter-driving of visual flicker. *Science*, **145**, 1328–30.

Shove P and Repp BH (1995). Musical motion and performance: Theoretical and empirical perspectives. In J Rink, ed. *The Practice of Performance*, pp. 55–83. Cambridge University Press, Cambridge.

Small C (1987) *Music of the Common Tongue: Survival and Celebration in Afro-American music.* Calder, London.

Smith G (2003) *Film Structure and the Emotion System.* Cambridge University Press, Cambridge.

Spence C and Squire SB (2003). Multisensory integration: Maintaining the perception of synchrony. *Current Biology*, **13**, R519–R521.

Steele J (1775). *An essay toward establishing the melody and measure of speech to be expresses and perpetuated by peculiar symbols.* Bowyer & Nichols, London.

Steinweiss A and McKnight-Trontz J (2000) *For the Record: The Life and Work of Alex Steinweiss.* Princeton Architectural Press, Princeton, NJ.

Titchener EB (1908). *Lectures on the elementary psychology of feeling and attention.* Macmillan, New York.

Trainor LJ, Tsang CD, and Cheung VHW (2002). Preference for consonance in 2-month-old infants. *Music Perception*, **20**, 185–92.

Trehub SE (2003). The developmental origins of musicality. *Nature Neuroscience*, **6**, 669–73.

Trehub SE (2006). Infants as musical connoisseurs. In G McPherson, ed. *The Child as Musician*, pp. 33–49. Oxford University Press, Oxford.

Trevarthen C (2008). The music art of infant conversation: narrating in the time of sympathetic experience, without rational interpretation, before words. *Music Scientiae, Special Issue*, 15–46.

Walker A and Grolnick W (1983). Discrimination of vocal expressions by young infants. *Infant Behavior and Development*, **6**, 491–8.

Warren DH, Welch RB, and McCarthy TJ (1981). The role of visual-auditory 'compellingness' in the ventriloquism effect: implications for transitivity among the spatial senses. *Perception & Psychophysics*, **30**, 557–64.

Welch RB and Warren DH (1980). Immediate perceptual response to intersensory discrepancy. *Psychological Bulletin*, **3**, 638–67.

Werner-Reiss U, Kelly KA, Trause AS, Underhill AM, and Groh JM (2003). Eye position affects activity in primary auditory cortex of primates. *Current Biology*, **13**, 554–62.

Zahorik P and Wightman FL (2001). Loudness constancy with varying sound source distance. *Nature Neuroscience*, **4**, 78–83.

Zampini M, Shore DI, and Spence C (2005). Audiovisual prior entry. *Neuroscience Letters*, **381**, 217–22.

CHAPTER 15

..

IMPROVISATION IN TIME: THE ART OF JAZZ

..

DAVID MELCHER INTERVIEWS GREG OSBY AND SKIP HADDEN

INTRODUCTION

..

WATCHING a jazz performance provides the opportunity to observe the creative, artistic process unfold over time. Jazz is a music based on both individual improvis- ation and the complex interplay of individuals within a group. It balances the most popular and the most academic aspects of art: jazz can link the embodied urge to dance with complex cognitive structures and unexpected twists and turns. Jazz is widely considered one of the major art forms to develop in twentieth-century America and it has greatly influenced other art forms including dance, visual art, and cinema (Cooke 1999; Kirchner 2005; Shipton 2007). The development of this creative improvis- ational music reflects the multicultural, social, and political history of America itself. Although its origin comes from African and Afro-Caribbean music, evident in the basic ingredients of blues, swing, poly-rhythms, and syncopation, jazz has devel- oped within the context of popular American music and has been greatly influenced by South American and European musical traditions.

This essay contains excerpts from interviews with two jazz musicians. We dis- cussed many of the major themes raised in this book, including how music allows for communication, the relationship between music and other art forms, the nature of composition and improvisation, cultural and historic aspects of jazz, and the role of

learning and expertise in listening to music. Both musicians, in addition to playing at the highest level in their profession, are dedicated teachers and writers. Greg Osby (Fig. 15.1) is a composer, saxophonist, producer, and educator. Among his many accomplishments, he has led 15 recordings for the prestigious Blue Note label. In 2008, he launched his own record label, 'Inner Circle Music' which continues his commitment to innovation and to developing the careers of new artists. Skip Hadden (Fig. 15.2) is a drummer, author, and educator. His books include *World Fusion Drumming*, *The Beat, The Body & The Brain II*, and *Profiles in Jazz Drumming*. He has played with many jazz greats and his recorded output includes playing drums on the seminal album *"Mysterious Traveler"* by the group Weather Report.

MUSICAL COMMUNICATION

David Melcher (D.M.): Each instrument can play a different range of notes. Alto and tenor saxophones, for example, have a range that overlaps—but not entirely—with the human voice. As a bandleader and composer, working with different instruments, including singers, how do you use the expressive power of each instrument?

Greg Osby (G.O.): My experience—and deep experimentation—has shown me that you can elicit an array of responses from people with the deliberate and artful juxtaposition of instruments, the 'coupling' of instruments as we say, and people respond to ranges and frequencies and different types of combinations in a variety

Fig. 15.1 Greg Osby.

Fig. 15.2 Skip Hadden.

(Photograph: Stefano Gislon)

of ways. A controlled acknowledgement of these responses gives you a broader pal-ette because then you can 'push buttons' in the listener. The combination of these sounds, for example, might make people anxious or angry, while another combina-tion offers a calming compound. This is an aspect that many musicians do not readily acknowledge or may not be interested in, but it has fascinated me since the beginning of my career. How can I draw people in, more deliberately, not only with compositions but with a focus on the means within those compositions?

D.M.: How is it possible to communicate emotions, colours, and feelings, with drums, which—in essence—involve hitting something with your hands or a stick?

Skip Hadden (S.H.): Well, it is hard. I learned by studying expression in general, not just in music. So, for example, I bought a book on photography to see what techniques were used: colour, shape, patterns, and subdivisions of lines and patterns. There are interesting parallels with drumming.

I teach a class on basic time and pulse, which is about playing colourings and feel-ings on the drum set. It is experiential. I start with a piece of American contemporary classical music, by Charles Ives, played by the Boston Symphony Orchestra. The stu-dents listen. Then their assignment is to make the drum set their orchestra, to focus on what they felt and what they got out of listening to the music. It is a great exercise to help them to move inside the music.

All of the aspects of drumming—the tempo, rhythm, tone, dynamics—can be used. The idea is to have them focus on the emotion in the music and to learn to communicate their intent. I ask them: what is your intent? They look up the meaning of 'intent', to make their ideas concrete, which is not just important for drummers but for all musicians.

With drums, the vocabulary of sounds is enormous, because each drummer sets up the instruments differently: the tuning of the drums, the drum sizes, the sticks they use (the tip sizes and shapes make the sound different), and the energy with which they play. All of these elements have a big influence on the final sound effect. Musical sounds modulate over time: attack, decay, sustain, release. Because drumming involves striking something, it is all about the attack (how quickly the sound reaches full volume). The sustain (the level period of sound after the attack and decay) is secondary, because it can get in the way of the next note. You are playing lots of notes, and you must articulate each note or it becomes a blur of sound. However, cymbals can be used to create a sonic atmosphere, a ringing, based on the sustain, if this atmosphere is compatible with what the rest of the ensemble is doing. Drums, just like any other instrument, can be out of tune with the rest of the group.

D.M.: How is it possible to communicate colours and feelings with a saxophone?

G.O.: The science behind the arrangement of music involves waves, sound energy, moving air mass—and then these create physical effects and reactions in people. Melody is the modification of one note at a time; the intervals that make up a melody of course make people respond in certain ways. But when you are dealing with chords, harmonies, progressions, and different types of logic and you put all of that together in a controlled frame, a composition, then you can enter into this composition process with a whimsical attitude or you can try to be constructive, thinking that 'I want people to emerge from this performance feeling like this', or, 'I am trying to evoke this'.

D.M.: Historically, some musical forms have developed from imitation of the natural world and the rhythms of the body (like walking, breathing, heartbeat). Where does your music come from?

S.H.: That physicality, related to the body and the natural world, may be one reason why the drums, after the voice, were the next instrument to produce music. There are rhythms all around. If you listen to works by Messiaen, for example, there is the influence of natural sounds, like birds, all of which enters into it. I live near the ocean, and one morning I heard foghorns, waves, rhythms, birds, and I jumped up and started writing it down. It was ten minutes of music, all of which was rhythms of the natural world. Birds, a truck going by, foghorns, the waves, all of these were pitches and rhythms that needed to be articulated in the music. And I could also see colours in the music; it was almost like a Mondrian, with the boxes of colours. I could see the balancing of these sounds as colours on a canvas.

G.O.: It is hard not to use the term 'organic' here—it has been over-used and bastard-ized—everyone wants to be organic, but I do seek connections with what interests me at the time. This could be experiences or studies, and they serve as the compounds that inform the work. I try to have my work be a vivid and direct reflection of those experiences and those trials. So if I happen to be studying some mathematical equations, or some properties of organic chemistry, or the behaviour of children or different social attitudes, then maybe the music will mirror those interests.

D.M.: Some intervals are consonant, and the tri-tone has been called the devil's music. Why is some music 'harder' for people to like?

G.O.: Well, the tri-tone sounds beautiful to me. I think that it is the experience: everything can be tolerated through association. If you are not familiar with some-thing, such as a particular type of folk music or indigenous music, it is going to be trying on your senses, since you are not familiar with the array of constructs within the music. The unfamiliarity is usually a generator for rejection, because human beings tend to be intolerant by nature unless they are conditioned to respond favour-ably to something. People do need to be more open, but that is easier said than done.

D.M.: Some music seems to lock you into a groove, to make people dance or move. What is it about certain rhythms that swing or groove?

G.O.: Groove is impossible to define. It is an innate ability to feel and to project that feeling through music. You know when it is not there—things are stiff or robotic, rather than organic. Music without groove lacks that humanity, it is technical and staid and regimented. It is the same with food. You say that 'this cake tastes good', while another piece of cake that has the same ingredients just does not taste as good. So the first cake is 'grooving' while, for the second cake, it is just not happening (*laughs*).

S.H.: Everyone gets in synchronicity, like a form of entrainment. It goes back to the development of the word in the seventeenth century by a Dutch scientist, which put a name to it.[1] In the agrarian cycles, this goes way back with synchronizing with the seasons and the stars in planting. During the year, farmers go to the fields and come back together in synchrony. In Korea, there is a folkloric tradition, linked to the farmers, of drum playing. They accompany the farmers to the fields, at different times of the year, with specific rhythms. It is part of the military tradition, in marching.

[1] The term 'entrainment' was coined in 1666 by the Dutch physicist Christian Huygens, who described how pendulum clocks stabilized into the same rhythm, but in antiphase. This phenomenon, which may be related to resonance in physics, has also been applied to sociology, neuroscience, and other fields of study. For example, biological cycles, such as the sleep–wake cycle or menstruation, tend to become synchronized in groups. Musical entrainment describes the tendency to synchronize based on rhythm or melody.

In the folkloric sense, it is still going on: drumming to bring on the sun and the rain, or to tell people when to go to the fields.

D.M.: The speed and loudness of the music seems to affect people—it can make then eat and drink more when they listen to louder and faster music (see Spence et al., Chapter 11, this volume). How do you use these differences in performance?

G.O.: When we perform in clubs and other venues where you can see the audience—as opposed to concert halls or other places where you are far removed—then we use a process called 'reading the audience'. Before starting, we programme the set with 'hot' and 'cold', fast and slow pieces, shadings and opposites that embrace different parts of the spectrum. But then, if you feel that you are not getting a rise out of people, if they are not being attentive—you are losing them, they are bored or even reject what you are doing—then you have to make a sudden alteration in your programme. The tempos, the level of dynamics and volume in these songs are designed to elicit emotions, even to jump start or shock these emotions, because otherwise you can feel people slipping. Only the most self-indulgent musicians say 'they are not elevated to my level, they are not meeting me at my terms so I am not changing a note'.

D.M.: What is the role of expectations and challenging expectations? Can a certain rhythm be too boring, or, conversely, too challenging for the listener?

S.H.: It depends on the artist and the audience. Even for me, when I hear certain beats such as 'bum TA, bum bum TA'—over and over—I would say 'oh no, not that again', because there was a time when all the drum machines were playing this. But it depends. Even the well-known jazz drummer 'Ndugu' Chancler played that rhythm on Michael Jackson's song 'Billie Jean' (1983) and that worked great for that pop song, even though there is nothing to it. That rhythm is going to make you move. And that is something that heightened his career, this ability to take things right to their essence—to play time like that. There are other styles of music, but the key is to reach a place where it appeals to and touches everyone. It may not be a 2/4 beat, but there is enough motion in there that they get emotions from it. Maybe they connect at the roots.

G.O.: People often take the easy route. There is an overwhelming laziness that abounds in every strata of music: classical, jazz, pop music. They allow some daredevil or maverick to take the lumps for being first, and then they see if that person sinks or swims. If that person prevails, then the others adopt those techniques, jump on the bandwagon. I favour the trailblazers and think that everyone has that potential. Of course we cannot have bastions of people with all-new ideas because then there would be no coherence. There must be some threads that hold it all together. You can't have a wall of all bricks with no mortar. There must be something to hold everything together. And you also need a strong foundation. Some people embark on these new

ideas, playing far-out conceptual compositions but they don't have the basics—the blues, soulfulness, the feelings. It is all limited, intellectual, and left-brained.

D.M.: Can music put people into a trance? Repetition is a key feature of prayer, a good example of which is Buddhist chants or reciting the rosary beads. These practices are aimed at transporting the listener to another dimension.

S.H.: Well, if the field recordings of African music are true to the original ancient music, they show that often there was the same rhythm—whether it was simple or complicated in structure—repeated over and over and over again, over a period of days, not hours—what that did was to move people to ecstasy, move them out of their normal frame of thinking. Maybe it is similar to that trance-like state we were talking about before and that is where it may fit into religious music.

G.O.: This music is a tool. It is a functional music, some of which is designed to lull people into a semi-trance state, a state of passivity or release so that they can be affected. Because if you are 'uptight' then you are resistant, you will not respond, you are wearing armour. Meditative and ritualistic music used repetition to release, like an aural message. It gets past the barrier, although some people are impenetrable.

D.M.: It has been suggested that music can play a role in creating group cohesion, beyond the individual. Which aspects of music are social and which ones are individual?

G.O.: Fundamentally, any kind of ensemble or combo is the best example of a mini democracy. The leader, whose composition you should be playing—maybe he is like the president—there is the whole cabinet, the whole cast working with the rules of the music who are called upon to be free and to input, as specialists, something that will add some instability, which is an important propellant. We need that.

S.H.: With music, there is also the social aspect of seeing music live. In a stadium with 100 000 people it is not just your personal relationship with the music, which you would get more with stereo and headphones.

One purpose of music is to be inclusive; otherwise you would not bother to record it. You would just be in your basement, playing. There are probably some really good players out there, just like that, for whom reaching out is not their interest. The music may just be about your own self. For example, there is a great recording 'The Melody at Night with You' by Keith Jarrett (1999), after he had recovered from an illness, which he did in his home studio as a gift for his wife. He finally felt well enough to play, and, it is amazing, he just did melodies. When his wife heard it, she said: 'this is not just for me, you have to share this with everyone'. And it is magical, it is inspirational. It is a challenge for a drummer—how can you do 'love' with something you are hitting? You have to transcend the instrument. Your message must be greater than the limitations of the instrument. Not that I can do that, but that is a goal

worth pursuing. If nothing else, people should hear that I love playing the instrument. By offering the music up—it is outside of me—I am offering it up to a higher place beyond where I am sitting and playing. Other musicians, then, can join into that together as a group, and the listeners are more involved by the music.

Parallels and interactions between jazz and other forms of art

D.M.: Are you inspired by other art forms, such as dance or painting?

G.O.: Definitely. The aesthetics of other art forms play into my music. I collaborate with a variety of artists, including visual artists, spoken word artists, choreographers, and others, because these collaborations are the purest, rawest form of artistic expression, People meet and find the commonalities which serve as generators for creativity. So I seek that out, because it is motivating and inspiring.

S.H.: Many years ago, one of the main inspirations for my playing was Max Ernst. I had seen his artwork and I thought: I can do this with my music. I can create a framework, to be the frame of the canvas in which to put the colours, and be the backdrop to those lines and colours. I went to a retrospective of his work at the Guggenheim in the 70s, and I was totally blown away when I saw them live, it was a most intense experience ('Max Ernst: a Retrospective', Guggenheim Museum, New York, February–April 1975).

D.M.: Do you see any synaesthetic connections between the arts?

G.O.: A lot of musicians see colours when they compose. Musicians try to fashion a 'movement' in the compositions. Just like a painter will determine a palette, in terms of shades and gradations, before we begin to compose we make decisions about which musicians, instruments and environment will be used—what the whole 'landscape' will be.

S.H.: When I am comfortable within the music, I am painting with sound. I actually 'see' the themes and try to play those. I don't tell people what the theme is, but the other players understand. One time I was playing with a piano trio, Kenny Werner and Ratzo Harris, in New York and I was the ocean, I was trying to create waves with rising and falling dynamically and different colours. At the end, the piano player, Kenny, said to me 'I am all wet' . . . not because he was sweating, but because he got the intent.

There are so many parallels, for dancers, chefs, painters, who are all trying to get to a place where they can express their intention. If artisans can get in touch with why they are doing what they are doing, then they can fulfil that function.

Mark Orfaly,[2] a famous chef here in Boston, was a student of mine. He says, 'I used to play the drums, now I play music with tastes'. There is an interesting story I just read about diners at a London restaurant who had ordered a favourite dish from their home country of Pakistan, which they had left many years earlier (Aslam 2008). They were amazed that it tasted just like the way their aunt had cooked for them 20 years ago, and the aunt had been dead for ten years. The spices, aromas, the texture were unmistakable. They peeked into the kitchen and found, to their surprise, that it was their cousin—the daughter of their aunt—who was the chef. In tasting the same recipe, the same message, they got the essence of that direct communication of their personal history and their culture. In the same way, certain sounds, like the smells and tastes, can carry the information of the culture in which they originated.

COMPOSITION

D.M.: How do you compose music?

G.O.: With composition, I don't do anything that other musicians have not done before, maybe better. Many composers can get stuck in a rut by starting with the same germ. The germ of the idea is the catapult, so if you always start at the same point then your songs will begin to implode, to sound the same. If you always start with the same instrument, piano or saxophone, then this happens. So, first, it is important to start with a different initiate. Second, the components for the composition have to be dramatically different and full of charge. It must be not just to meet a deadline but divinely inspired, where you jump out of bed at 3 a.m. because something comes to you, maybe in a dream. I don't know where it comes from, but I have to document it while it is still fresh in my mind.

I want the music to be informed by my most recent experiences. I want my most current work to be reflective of everything I went through since my last recording: the interesting people that I meet, the books that I read, and the research. I don't want the music to be a technical manual on CD—I have been criticized for being too analytical, too intellectual. But I don't know any musician who just woke up as a

[2] Marc Orfaly was listed in *Food & Wine Magazine*'s 10 Best New Chefs in 2004. At the time of this interview, he was chef/co-owner of the Pigalle and Marco's restaurants in Boston. His career in cuisine began when, in order to earn money to pay for his drum kit, he took a job as a short-order cook.

virtuoso, it is born of sacrifice—you must sequester yourself to do anything interesting as an artist, and this is true not just of artists.

My compositions have to make a point. Each composition has a point—rhythmic, harmonic, or structural—that I'm trying to make. But I am always trying to mould these theorems into something musical, because otherwise it sounds solely technical, left brain, and analytical.

I am working on a set of structures, of intervals, on a particular concept, study, or research. Or some innocent children that I have met, I am trying to elicit the feeling I had talking to these people who have no inhibitions, or talking to someone in another country through an interpreter. When I travel, I tell the promoters that I want to talk to certain people, because they have some information that is useful and I can transcribe it. Composition is deeper than just: 'these are some cool tunes, it's grooving, it's swinging, it feels good, it sounds great and makes me want to tap my feet'. That is all good, but at the base level there is a reason behind *why* I want to tap my feet.

Not everything has to be exploited, broken down into individual atoms, because that can take the fun out of things. Some things are completely risk taking, a role of the dice. I will juxtapose one element with something completely different that I learned a year ago: maybe Bulgarian folk music with the drum chants of Ghana, and combine that with communicative drumming from the Caribbean. I might combine music from the African Diaspora with five-tone scales from Japan that are tuned differently. It is like a soup and you try to expand the ingredients. Sometimes it is a dismal failure, sometimes you only learn only that these ingredients should not be combined. The proportion of those ingredients is important. Some people may use all the ingredients, but use them differently. Some people might be heavy-handed with the salt, others might not use that much salt, or might use only some of the ingredients.

Some compositions have a primary means of focus, for example a dominant rhythm that is recurrent. It is not looping or repetitious, but it is referred to liberally and deliberately at structural points within a composition. It is the thread that holds it together, the underlying structure or 'centre'. That can be intervallic, or it can be a melody. In classical music, it is called a recapitulation. There is a melodic theme, followed by a restatement of the theme with variations built upon it. At key points, the theme is modulated and taken into other areas; it is almost obscured but it is still there. And then the recapitulation involves a restating at the end. There is a thread that is weaved through the music.

Structurally, you can set up the composition almost like an architectural blueprint. For example: 'for eight bars I am going to do this and then for sixteen bars do something else'. You are effectively 'building' a composition, using instruments as building blocks and constructions such as a crescendo, then a spreading out of the instruments or a solo flight with one instrument. There is support: a second instrument can come in, and then there are two voices crossing each other. There could be an improvisational section. There are other structures that more

closely simulate or imply a geometry. There are different directions: playing vertically with the information ascending and different elements cascading, along with other support elements under it so that it is not out there alone.

Other elements may be stark and unsuspected, like a narrative: a play or an opera. Each of the instruments in the combination is role-playing. They each fit into the story, in terms of melodic structures, moving the tonal centres, chord progressions, all of those things. Of course, it can be more intuitive. Some people are not as deliberate: but there is still the structure, even if they are not aware of it.

IMPROVISATION

D.M.: How do people stay in sync during improvisation? Is improvisation based on understanding the musical structure, paying attention to visual cues or feeling the rhythm in your body?

G.O.: We are playing within forms. Each song has a certain form and structure; it has a certain number of guidelines, although you have choices that you can make. There are directions, but you are only limited by your imagination and your fearlessness. I think that it is essential that musicians develop their improvisational prowess, because that is the most honest and genuine detailing of who they are. You can play a composition—yours or someone else's—but when you improvise you are walking the tightrope. Some people are very adept at improvisation, but for others it is 'total recall': they have memorized a host of variables and then when they get on stage they recall that. For many, there is a proportion of about 50% to 60% memorization and the rest is true spontaneous inspiration.

S.H.: Everyone knows where they are, and where everyone else is, if they are good players. This may allow more freedom for the drummer to 'comment' musically on what is being played, as opposed to just keeping time. In jazz, you keep time with the cymbal and the high-hat, with the repeated ostinato (a repeated pattern). Then you can use the other hand and your feet to comment on the musical conversation as it is moving along, and you can help move it along. The drummer can become, by themselves, the entire rhythm section: piano, bass, and drums. I can keep time with the right hand, and then play commentary on the chords with the left hand around the snare on the drum set, and the base line with the base drum, playing all those parts within the music.

You do not need to directly answer every comment, just as repeating back exactly the same phrase makes no sense in a conversation. However, it needs to be in the same style, not changing the topic of the conversation. It is the same thing in music.

If the music is totally improvised, you may not play tunes. Playing with Wayne Shorter, for example, you must be open to whatever the conversation might be. And if you are talking to him, he has favourite subjects that he likes to respond to, like talking about music, books, or food, so that he is thinking of something outside of just melody.

More often, in jazz, there is a melody or form that people are playing over, that you can return to in the music. Rhythm, harmony, and form can be the foundations for improvisation, but you can also open it up to other forms or sounds. Starting with 60s avant-garde music, for example, the tonal centre of the music could move within the piece. Some artists, such as John Coltrane, began to use a second drummer, bringing in Rashid Ali, in addition to Elvin Jones, to have the energy of two drummers.

D.M.: A recent neuroimaging study (Limb and Braun 2008) suggests that improvisation differs in many ways from playing a set composition, particularly in terms of changes in attention and awareness. During improvisation, there also seemed to be a deactivation of areas involved in monitoring and censoring behaviour. The study suggests similarities between improvisation and forms of altered awareness like meditation or REM sleep. What is the relationship between thinking and intuition in improvisation? Do you think when you improvise?

S.H.: For the most part, you can't think while you improvise playing music. Otherwise, the best that you can do is to play the instrument. What you need to do, instead, is to play the music. The drums, in this case, are like your pen or the computer keyboard, something that is used only to articulate the larger ideas and feelings. It is a language that you are using. The combination of sounds is used, rather than words, to communicate your intention.

G.O.: Intuition and instinct are critical. You are responsible for more, personally, because when you work with memorized material the audience is familiar with and accepts that material. When you are improvising, as they say in hip hop 'coming off of the dome', that responsibility leads to a freeing up of the inhibitions and impasses that come naturally when you try to satisfy people. It is liberating and honest. There is also no true way to grade it: there is some bad improvisation, when it is done recklessly without any concern for or adherence to the parameters that have been set up: otherwise, there is total cacophony. There is plenty of that (*laughs*).

D.M.: So what makes for a good saxophone solo?

G.O.: First, having a good tone, a tone that is as distinctive and individual and provoking as someone's voice. When you hear someone speak, the patterns make it clear with one word who that is. For me, that is the bottom line. I don't care how many notes they play, if it is technical and virtuosic, with all this dexterity and jumping around, if they sound human than they can't go wrong.

Also important is an adherence and acknowledgment to the precedent that has been established, in terms of the lineage of the music—the great saxophone players.

You should be able to hear the contribution that these great players have made, but without it being patronizing or directly mimicking what they did, because then it would be a caricature. There is a fine line between acknowledgment and copying. Rather than a copyist, I would rather hear someone who channels this history into a personal reflection of who they are based on their own experiences and aspirations as an artist.

D.M.: What makes for a good drum solo?

S.H.: I try to get students to learn the melodies and then embellish those. You play the melody on the drum kit as if you were a trumpeter or saxophonist, with control over the dynamics. And then embellish that melody. But by coming, first, from the music side, then you end up with 'music', not just drums. And that is where it reaches people, when it is not just limited to rhythm. However, from the beginning of time, drums have been used as a motivational force, in order to move people. The primary instrument was voice, with the melodic content that preceded and accompanied drums.

D.M.: In every type of performance, there are going to be good nights and bad nights. For improvisation, what makes it all go right or go wrong?

S.H.: I think that things go wrong when everybody, collectively, gets in the way of the music. With playing, you need to get out of your way, out of everyone else's way, so that you are all moving towards the same direction. It is only when everybody is moving, in a supporting role, that anyone can step out successfully as an individual within the group. Because when you are not thinking, then everyone can be the leader, can be the lead voice. Your function is to find grace in that supporting role, not always being out front.

G.O.: It is a good night when—to use a cliché—everything is in sync. People are responding, the musicians are making wise choices, artful choices that are complementary to the ensemble and elevate the music beyond the familiar. The most familiar version of the piece will likely be the recorded one—this is the model. But hopefully at the conclusion of those performances, those compositions will have regressed and may barely resemble the recorded version. People are more tentative and conservative when recording. No one wants to make a mistake and blow the take.

The venue and context are important, too. In a live performance, when you are 'vibing with the audience', then you can see that they are with you. Sometimes you cannot even see them, the venue is set up that way, or you can't hear because the instruments are too far apart. There might be too much reverberation, so that the drums obscure everything.

A great performance is when everything that you wanted to say with your instrument, you are able to execute with ease. If you hear something and you can play it and it is complementary and it inspires someone else to respond in turn, then there is a volleying of intent. When you speak with someone, you want to say something new.

It is more interesting, for example, if in an interview, you do not have to come up with new ways to answer the same old question. This interview is a good change, because I do not know the next question, I do not know what you are going to ask.

HISTORY AND CULTURE

D.M.: Art is often a response to the cultural context and changes in society. In the early twentieth century, the Futurist Luigi Russolo (1885–1947) wanted to incorporate the sounds of industry, to 'harmonize noises' and play the city as a giant instrument—using the noise produced by trains, factories, and automobiles as sounds. John Cage, in his composition 4'33", makes us heart the ambient noise. Similarly, there was a recent installation by David Byrne, *Playing the building* (2008), using a big industrial space in which the elements of the building itself made all of the sounds. There is a category called 'urban music', but so much of music in the twentieth century might be considered urban, as the city plays such a role in people's lives. Does jazz music reflect this urban influence?

G.O.: Urban areas, as opposed to more remote areas, progress more rapidly. There is a flux of ins and outs, transitory elements, with people moving in who affect the situation with their character, habits, and traditions, and then people move on. Since it evolves rapidly, I would like to use that as a pool of inspiration, rather than a place that never changes. That is why you have more contemporary and progressive artistic movements happening in these so-called urban areas, as opposed to outlying areas which are more favourable to folk musical forms which change more slowly.

D.M.: Music is categorized in certain styles. Some of this is labelling or pattern recognition. Even a music novice can tell if a piece sounds like a waltz or sounds 'Latin'—is there something essential about the music reflected in that label or is it entirely a cognitive association?

S.H.: Well, Latin sounds are the product of a particular culture, so people would relate to the sounds from their background. In Brazil, for example, the sounds that they are playing stems from that produced by the birds, animals, or insects—so all those elements are influencing what's happening with the music. We would not necessarily know about that from here, but we would get that laid-back feeling—regardless of how fast or slow the music was—because it lays back on the beat more. When you come further north, even to the Caribbean, then the music has much more staccato, is much more 'on top'. The Brazilian stuff is 'down the middle', or even behind the beat. As you come up to New York City, it is even quicker and faster. Everybody is playing more notes. And the technology plays a role, so that people can play more notes

per second, articulate more, and still have it be heard. Even older instruments, like the trumpet or saxophone, need to keep up, so that technology is influencing the way even those instruments are played.

G.O.: Jazz in and of itself is the result of many levels of fusion. It is built on indigenous music, it is a regional music full of regional 'dialects', just like people talk differently in different regions within the US—New Orleans and Boston for example. But the styles, in terms of their names, are commercial affectations to compartmentalize the music to sell it. To put it in a bin makes it easier for people to file it. Musicians don't necessarily name their music like that.

D.M.: How has contemporary culture and technology changed the way that improvisational music is heard?

S.H.: One big difference is the development of the drum set, which everyone around the world is hearing through pop music. But the basis is hand rhythms, folkloric music. The drum set is like the piano, in that you can articulate with both hands and feet. In Carnatic music,[3] from thousands of years ago, it was simply played with the two hands because people were sitting down, with the heavy drums in their lap. The recent John McLaughlin album, *The Floating Point* (2008) has a rhythm section of Indian drummers, including a young drummer (Ranjit Barot) who plays, on the drum kit, traditional rhythms going back to ancient sources—which is exciting. And, of course, the recording techniques now enable us to hear every beat.

G.O.: With the internet, music is more accessible. It makes the world smaller. But it also opens the floodgates to mediocrity; anyone with a recording device can be on the web. You need a machete to hack through the jungle of disposable content to get to the gems, and you might never get to it. There used to be more discretion. Artists who have stories to tell have been displaced.

 Was there ever a time when the balance was right? In the early 1960s, for example, between 1959 and 1965, there was so much individualism. No one pandered to any one ideology. The scene abounded with energy. In the early 1990s, I was doing a series of dual concerts with Jackie Byard—famed pianist, innovator, conceptualist, icon, and sage—and when we were rehearsing at his house he had, on his wall, a marquee from The Village Gate (a club in New York) where there were double-bills each night, one upstairs and one downstairs. On this marquee, there was, all at the same time, his group with other artists, such as Eric Dolphy, Rahsaan Kirk, maybe Cecil Taylor, whoever, four different artists who sounded worlds apart but all great groups that had arrived with a strong statement. And they thrived in the same venue, on the same night. I asked Jackie, what was the patronage, and he replied 'We were killin'em. There

[3] Carnatic music is the classical music of South India, some 4600 years old. Ancient texts describe this music as based on the sounds of animals and birds and it has religious roots. The music is based on compositions but includes room for improvisation.

were lines down the street'. I had an overwhelming feeling of being born late, because that is when jazz really flourished.

Things happen in cycles, it is inevitable. There will be another 'Jazz Age', another Renaissance: history has shown it. After WWII, Vietnam, Korea, after these wars or a political malady, once the situation stabilizes, the musicians who were forced out of work—who had to get the day job—have been in the lab tooling for something that will be their marker once the dust settles. Right now, as we speak, there are a great number of musicians on the threshold of new discoveries. The venues will open up, the economy will flourish, and people will have disposable income to pay to see these musicians, and then it happens again. I am looking forward to that.

Expertise and learning

D.M.: How is listening to music different, as a professional musician?

S.H.: First, I try to get past the first level, of what the drummer and the other musicians are doing, to listen to the music itself: the total experience, the energy of that music. But if something is out of tune, out of time, it jumps out to me, of course. I heard someone play recently, someone whose playing I really enjoy, but the cymbals were out of tune with the rest of the music, and I almost had to leave the hall. I had to move beyond that.

G.O.: Sometimes I have to divorce myself from my professionalism in order to enjoy a performance. I have ruined performances for the people that I am with by sitting there wincing, grimacing, and groaning, because I am hearing a lot of mistakes or decisions that I would have made differently. In order to enjoy it, I need to listen as a lay person.

Other times, like at school, I need to listen critically but also be supportive, to deal with the music in a more academic fashion. It is difficult not to analyse, break things apart in your own mind. I am good friends with doctors, for example, and they are often talking about medical things. My cousin is a surgeon, and at Thanksgiving, when cutting the turkey, you don't want to hear about surgery, that makes people lose their appetite.

D.M.: What can and cannot be taught? There is a debate in cognitive science about whether talent exists, or, instead, if some people just pay more attention and practise more.

G.O.: With enough practice, then people who have marginal talent can become proficient. But they may not become the most creative artists. The innovative musicians

have a level of fearless and a keen intuition—an awareness and a quick response to the environment. There are a lot of proficient musicians who cannot respond quickly to transitions. They have to be prepared to know what is going to happen. The most instinctive musicians only need a blueprint and an idea. They have what we call 'elephant ears': they can hear around corners, they can anticipate what is going to happen and they are ready for it. These people become the prodigies, with less training they pick up on things and their response time is shorter.

Music must be 'artful', otherwise there is chaos. If everyone is doing their own thing, what is the delineation between people who have learned, studied, and become accomplished and other people who have been playing for two weeks? There is a Zen parable in the art of the Bushido swordsman. After learning all the techniques, organizing their life around their sword, their 'instrument', they say that ultimate achievement involves 'unlearning what you have learned'. You must first go through all the practice, all the sacrifice: only then can you enter into something creative with a blank slate, with the innocence of a child—that is when you are the most pure. The rules are the glue that binds it together, but you are not bound by the rules. It is almost like a paradox. I have rules but no rules. I am thinking non-thinking. You have to learn in order not to be bound by your learning.

S.H.: I found that I cannot tell who, among my students, are going to be the most successful later on, who you are going to read about in the magazines. Every one of them is a potential master. There are limits. What teachers can do—what I try to do—is to present musical postcards. Do you want to go here? Or go here? I can help you to do that. Even if you never play drums again, you can use the process in other areas of your life.

REFERENCES

Aslam N (2008). The homesick restaurant. *The New York Times*, **November 28**.

Cooke M (1999). *Jazz*. Thames and Hudson, London.

Hadden S (1993). *World Fusion Drumming*. Alfred Music Publishing Los Angeles. CA.

Hadden S (1995). *The Beat, The Body, & The Brain II*. Who's Counting? Gloucester, MA.

Hadden S (2005). *Profiles in Jazz Drumming*. Who's Counting? Gloucester, MA.

Kirchner E (2005). *The Oxford Companion to Jazz*. Oxford University Press, New York.

Limb CJ and Braun AR (2008). Neural substrates of spontaneous musical performance: An fMRI study of jazz improvisation. *PLoS ONE*, **3**, e1679.

Shipton A (2007). *A New History of Jazz: Revised and Updated Edition*. Continuum, New York.

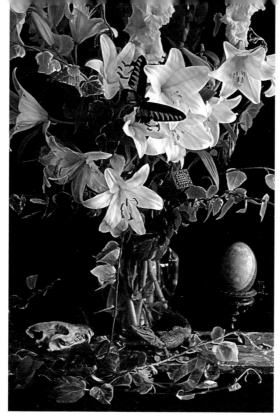

Plate 1 Jane Wildgoose, *Vanitas Still Life at the Wildgoose Memorial Library*, 2005. (See Fig. 1)

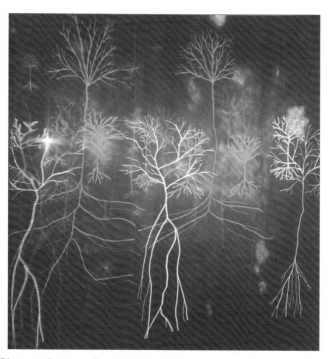

Plate 2 Andrew Carnie, *Magic Forest*, 2001. (See Fig. 2)

Plate 3 Wassily Kandinsky, *Rot in Spitzform*, 1925. Watercolour. © ADAGP, Paris and DACS, London 2011. Kandinsky suggested that colours have an 'interior sound' that awakens the spirit. (See Fig.14.1)

Plate 4 Vik Muniz, *Picture of Junk: Atalanta and Hippomenes, after Guido Reni,* 2005–6. Rovereto, Mart Museum. (See Fig.18.1)

Plate 5 Gino Severini, *Ritratto di Madame M.S.,* 1913–15. (See Fig.19.3)

(Mart Museum, Rovereto)

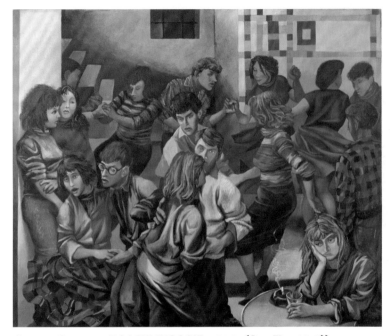

Plate 6 Renato Guttuso, *BOOGIE WOOGIE*, 1953. (See Fig. 19.8))

(Mart Museum, Rovereto)

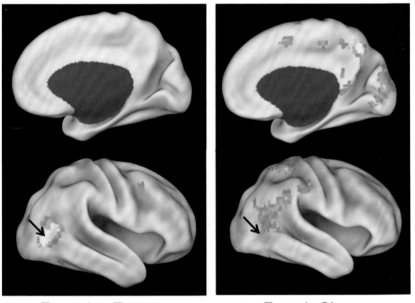

Everyday Events French Cinema

Plate 7 Evoked responses at event boundaries in laboratory-made movies of everyday events, and in a narrative French art film (Lamorisse 1956). Data from (Zacks et al. 2001, left) and (Zacks et al. 2006b, right). Arrows indicate the approximate location of area MT+. (See Fig. 21.3)

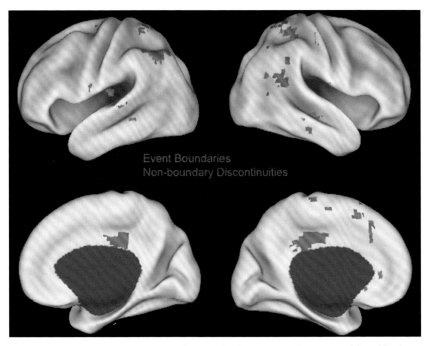

Plate 8 Brain regions that increased selectively at cuts that were identified as event boundaries (blue) or points in time that were discontinuous in space or time but were not identified as event boundaries (red). Data from (Magliano et al. 2007). (See Fig. 21.4)

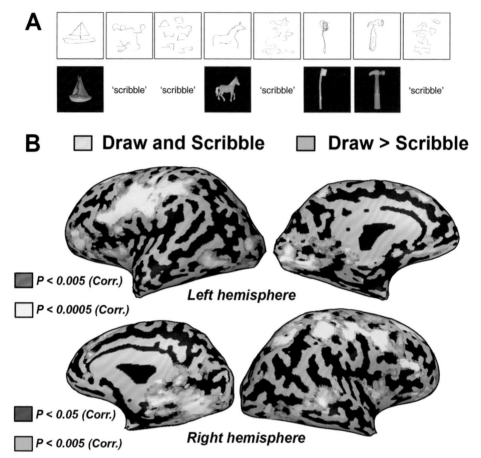

Plate 9 Neuroimaging data of subject EA for drawing and scribbling objects.
A) Example of behavioural data collected from a scanning run. Subject E.A.'s
sketches (above) are shown compared to the object tactilely explored or in
response to the control scribble condition (below). B) Activation patterns
associated with the contrast of drawing versus scribbling presented on a full
inflated cortical reconstruction of E.A.'s brain (lateral and medial views). Most
striking is the activation seen in the occipital areas localized around the calcarine
sulcus (identified by cyan arrows). The calcarine sulcus anatomically corresponds
to early visual areas (V1 and V2) in normally sighted individuals. In EA, these
areas are active for drawing. (See Fig. 23.2)

Adapted from Amedi et al. (2008).

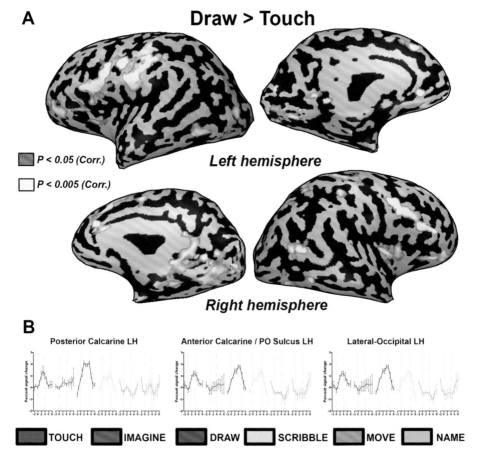

Plate 10 Neuroimaging data of subject E.A. for a direct comparison of drawing versus tactilely exploring objects. A) The contrast of drawing versus touching objects is presented on a full inflated cortical reconstruction of E.A.'s brain (lateral and medial views). Note again the robust activation in several posterior ventral occipital areas. Activation for drawing was strong and selective even in the calcarine sulcus. See also (B) for the time courses and magnitude of activation from this area. The time courses are depicted by the following colour index: tactile objects (red), mental imagery (brown), drawing (blue), scribbling (cyan), motor control (orange), and naming/verbal memory (green). (See Fig. 23.3)

Adapted from Amedi et al. (2008).

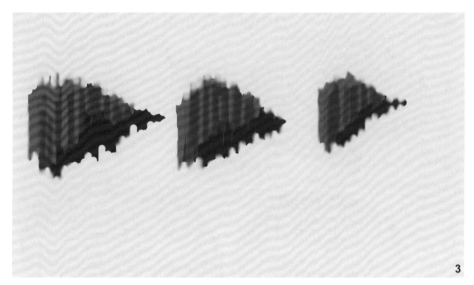

3

Plate 11 An example of a complex synaesthetic visual experience (also consisting of movement) induced by a simple sound (F# on the cello). (See Fig. 24.1)

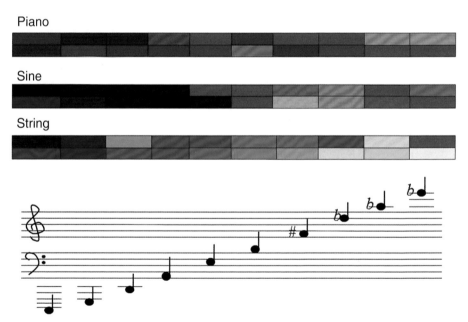

Plate 12 An example of a synaesthetic participant's choice of colours for 10 different musical notes that were either pure tones (sine wave), or from piano or strings. The synaesthete chose each colour on two different occasions and the Figure shows that similar colours tend to be chosen over time. (See Fig. 24.2)

Plate 13 Still taken from an animation created by the Music Animation Machine, representing the first ten bars of Johann Sebastian Bach's organ work *In Dulci Jubilo.* (See Fig. 25.7)

(with permission from Steven Malinowski, www.musanim.com).

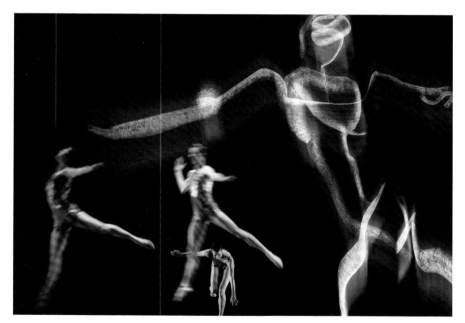

Plate 14 Merce Cunningham, *Biped* (1999). Projected onto a scrim pencil-drawn figure of a dancer. (See Fig. 26.1)

(Photograph: Stephanie Berger.)

MUSICAL TENSION

CAROL L. KRUMHANSL AND FRED LERDAHL

INTRODUCTION

THE arts offer a rich and largely untapped resource for the study of human behaviour. This collection of essays points to the potential of studying the various art forms from a variety of disciplinary perspectives. The present essay describes a project involving a music theorist-composer and a cognitive scientist who conducts empirical research on music.

From a psychological point of view, the arts can extend our understanding of the physical, sensory, and perceptual processes that enable us to apprehend the world around us. Art works are special cases that, at a somewhat higher level, can yield insights into processes such as memory and attention, and show how knowledge shapes our interactions with, and interpretations of, artistic objects. At a still higher level, they raise questions about emotional, social, and cultural factors at work in the aesthetic realm. Finally, perspectives from neuroscience, genetics, and evolutionary theory illuminate questions about the underpinnings of artistic creativity.

Over the last 30 years, the cognitive science of music has become a mature field with different branches. One important impulse has come from the intersection of music theory and experimental psychology. Empirical studies have demonstrated that music theory provides a description not only of structural regularities in music, but also of the way music is perceived, organized, and remembered by listeners. Descriptions of music employ a set of terms such as scale, chord (harmony), key (tonality), melody, and melodic contour. These terms are defined in the glossary at the end of this chapter (Thompson 2009; see also Melcher and Zampini, Chapter 14, this volume).

With the development of music cognition, these questions have moved from well-established theoretical concepts such as harmony and tonality (see, for example, Krumhansl 1990, *Cognitive Foundations of Musical Pitch*; abbreviated CFMP) to newer music-theoretic proposals (Narmour 1990; Lerdahl 2001: *Tonal Pitch Space*, abbreviated TPS). For these, empirical research acts not only to test a theory but also to suggest modifications that more accurately describe how the music is perceived. Before we present one such theory and one of its tests, we provide some background on how this project relates to more general concerns.

MUSIC AND EMOTION: EXPECTATION AND TENSION

The first question that anyone who engages with music in any way (and that is most everyone) asks is why music has such a powerful emotional effect. This is a question discussed widely in philosophy and musicology, cognitive and biological science, evolutionary theory, and psychoacoustics (the branch of auditory research concerned with physical properties of sound and its sensory processing).

One line of argument, from psychoacoustics, is that musical sounds are inherently pleasing because of the intervallic relationships that produce consonant sounds. Another position is that music has an emotional effect because it has been paired previously with significant events in an individual's life. Yet another is that music has characteristics such as tempo, amplitude, and contour that are also found in emotional speech. Still another thread speculates about how music might have evolutionarily advantages as a means to increase group cohesion and enhance courtship and religious ceremonies, with consequent emotional effects (see Madison, Chapter 17, this volume). A full explanation of musical emotion likely includes all these elements and others.

A somewhat different perspective comes from Leonard Meyer's *Emotion and Meaning in Music* (Meyer 1956). This seminal book has stimulated considerable experimentation. One attraction to psychologists is that it builds on important theoretical concepts in psychology, particularly *Gestalt principles of organization*[1] and *information theory*[2]. The theory makes the important shift from the question, 'Why does

[1] Gestalt principles of perception describe our tendency to group elements so that they provide 'good form', including principles such as grouping by similarity or proximity. Many of these principles apply in both visual and auditory modalities and may interact in audiovisual perception.

[2] Information theory, developed by Claude Shannon (*A Mathematical Theory of Communication*, 1948), is a set of theories and principles developed to describe the transmission of a message. These ideas, which came out of work in Bell Labs during studies of the transmission of signals over telegraph or telephone wires, have been expanded upon and used in a variety of applications, ranging from psychology to data compression (such as MP3s).

music produce emotions?', to 'How does music produce emotions?' This step draws attention to the way music is constructed. The question thus becomes more focused; it asks what patterns in music produce emotion. Also, the perceptual response that becomes of interest is the moment-to-moment experience of the ongoing flow of the music, rather than generalized 'real-life' emotions such as happy, sad, and tender that are engendered by passages or entire pieces of music.

The essential claim of Meyer's theory is that music produces emotions because the listener actively responds to music (mostly unconsciously) by *generating expectations* for what is to follow. Meyer emphasizes three sources of expectation, although he does not claim that they are exhaustive. The first is the listener's knowledge of the styles, sometimes called extra-opus knowledge (Meyer 1956, 1989; Narmour 1990). These are patterns that are characteristic of a musical style, as the first phrase of the familiar song 'Over the Rainbow', shown in Fig. 16.1, will illustrate.

Expectation as extra-opus knowledge is exemplified in bars 7–8 by the V-I (or V^7-I) cadence in the tonic key of C major. The pattern I . . . V-I appears in a large percentage of phrases in tonal music. A further extra-opus feature of this phrase is its internal grouping structure, shown by the brackets beneath the music: two bars of statement and two bars of counterstatement, followed by a four-bar continuation and cadence. This so-called 'sentence form' is common in a variety of tonal styles.

For knowledge of this sort, Meyer draws on information theory and its use of probabilities. 'We have stated that styles in music are basically complex systems of probability relationships in which the meaning of any term or series of terms depends upon its relationships with all other terms possible within the style system' (Meyer 1956, p. 54). Empirical studies demonstrate that listeners can use information about patterns that appear with high probability to orient themselves to a novel style (e.g. Castellano et al. 1984; Krumhansl et al. 1999, 2000), and recent music theory has discussed how probabilities function in learning and recognizing musical patterns (Huron 2006; Temperley 2007).

The second source of expectation comes from the experience of a particular piece of music, called intra-opus knowledge. These are expectations that depend on the characteristics of that work. Even on first listening, a listener might expect that if a particular motive or theme appears early in the piece, the same motive or theme will recur

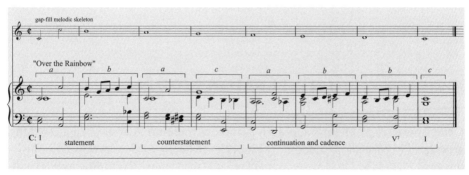

Fig. 16.1 The first phrase of 'Over The Rainbow'.

later in the piece, or reappear in variation. Figure 16.1 illustrates intra-opus knowledge of 'Over the Rainbow' by its motivic structure, shown above the music by the labelled brackets. The succession 'a' to 'b' in bars 1–2 creates the expectation that this pattern will follow later in the phrase. After the varied repetition of 'a' in bar 3, however, the whole note G in bar 4, marked 'c,' belies this expectation. Bars 5–7 compensate for this move by stating 'a' again and following it by two 'b's' before the music comes to rest in bar 8 on 'c'.

Meyer's third source is the role that Gestalt principles of organization play in generating expectations. These principles are assumed to function in all individuals, not based on specialized training, and only rarely influenced by prior experience. Some consequences of these principles are that a simple well-organized melody will be remembered better than an irregular one, that a pattern will be expected to continue in a manner similar to how it began, and that a large pitch jump will lead to an expectation that the next pitch will fill in the gap. In this tradition, Narmour (1990) proposed five principles for melodic expectations that have been tested using a fairly wide variety of musical styles and listeners in different cultures (e.g. Krumhansl 1995; Thompson and Stainton 1998; Krumhansl et al. 1999, 2000).

'Over the Rainbow' is a classic example of a gap-fill melody. Figure 16.1 shows this by the small notes in the top staff, which strips away relatively ornamental pitches to reveal the phrase's melodic skeleton. After the opening upward leap from C to C an octave higher, the melody slowly descends down the C major scale until the original C is reached.

According to Meyer, these various kinds of expectation lead to waves of tension caused by the relationship between the expectations and what actually occurs in the music. 'Thus in a very general way expectation is always ahead of the music, creating a background of diffuse tension against which particular delays articulate the affective curve and create meaning' (Meyer 1956, p. 59). If the expectation is fulfilled, no strong response occurs. However, when the expectations are not fulfilled, this produces a feeling of tension. Or, in the words of the then contemporary behavioural psychology, 'emotion and affect is aroused when a tendency to respond is arrested or inhibited' (p.14). The feeling of tension is not necessarily negative, nor is the feeling of resolution necessarily positive. Rather, the response depends on the particular way expectations are fulfilled, perhaps in an especially artful way or through an unexpected delay.

THE TENSION MODEL

Complementary to Meyer's approach is another tradition, that of pitch attractions, articulated in psychological terms by Bharucha (1984, 1996) and developed in music-theoretic models by Larson (2004) and Lerdahl (1996, 2001). According to this tradition, which in music theory can be traced back to the early nineteenth century, some pitches or chords seem to want to go to other pitches or chords, such as the leading tone

to the tonic pitch. This tonal urge elicits an expectation: a dominant seventh chord is expected to resolve to the tonic chord, for example, and motion to another chord is felt as a denial of that expectation. A strong attraction-expectation can also be expressed as a kind of tension.

Thus each event in 'Over the Rainbow' generates some degree of expectation felt as a kind of attractive tension. The strongest attraction in Fig. 16.1 occurs in bar 7 at V^7, which 'wants' to resolve to the tonic I. Specifically, the pitches D and B are strongly attracted to C, F is strongly attracted to E; and G is strongly attracted to C, expressing the urge for V^7 to resolve to I. These resolutions indeed take place (with the B surreptitiously displaced to G).

Figure 16.2 illustrates another kind of tension based on tonal stability and instability. The tonic is stable and relaxed, whereas a pitch or chord distant from the tonic is experienced as unstable and tense. Suppose, for the latter case, that 'Over the Rainbow' resolved away from the tonic, creating tension through instability. In Fig. 16.2, the melody moves to C, as before, but C is supported by an unstable harmony, V^7/V (that is, the D-F#-A-C form a dominant-seventh chord in the key of the dominant, G major). Such a 'deceptive' cadence away from the tonic would create tension and the expectation for a further continuation that would bring the expected tonic close.

Intuitions of tension based on attraction and stability both depend on the structural schemas of tonality uncovered in CFMP and related empirical studies. TPS provides a music-theoretic account of both. The schemas address a specific, learned level of cognitive organization. At present, it is an open question as to whether these structural schemas can be learned through extra- and intra-opus probabilities as proposed by Meyer.

THEORY AND EXPERIMENT

We have collaborated in an empirical study (Lerdahl and Krumhansl 2007) to test this double account of tonal tension. It is important, in this connection, that the

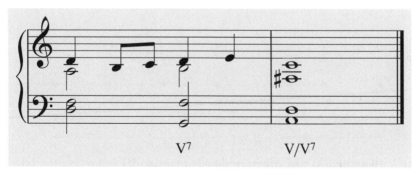

Fig. 16.2 A deceptive cadence for the 'Over The Rainbow' phrase.

TPS model makes quantitative predictions, so that these can be compared with experimental observations, which most often take quantitative form. Because of the variability of human behaviour, the quantitative data need to be processed by statistical techniques to uncover the underlying regularities and assess whether these regularities conform to predictions.

In general terms, the stability-tension theory creates a tree-structure that describes the hierarchical structure of the music—it is somewhat like diagramming a sentence in terms of nouns, verbs and adjectives. It builds, first, on what is called the *prolongational component* in Lerdahl and Jackendoff's *Generative Theory of Tonal Music* (1983; abbreviated GTTM) and, second, on the theoretical and empirical measures of distances between musical elements (tones, chords, keys) described in CFMP. These two factors combine (together with two other theoretical components briefly described later) to produce precise predictions about the relative tension and relaxation of each event in a musical passage. This is a complex theory, and only a few of its essential elements are presented here; but it is important to note that musical complexity necessitates theoretical complexity and that empirical methods are available to test such subtle and precise theoretical predictions.

GTTM considers prolongational organization as a psychological phenomenon that consists of nested patterns of tension and relaxation. These nested patterns are depicted in an inverted tree notation, illustrated abstractly in Fig. 16.3. Right branches stand for a tensing motion (or departure from stability), left branches for a relaxing motion (or return to stability). At a local level, Event 1 tenses into Event 2, Event 3 relaxes into Event 4, and Event 5 relaxes into Event 6. At a higher level, Event 1 tenses into Event 4, Event 6 relaxes into Event 7, and Event 1 relaxes into Event 7.

Added to the tree structure is a method to compute distances between any pitch or chord in one key and any pitch or chord in the same or any other key. The hypothesis is that greater distances between events contribute to greater experienced tension.

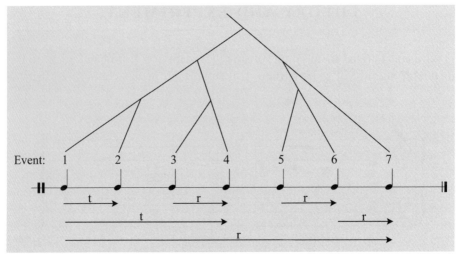

Fig. 16.3 Hypothetical tree structure showing tension (t) and relaxation (r).

CFMP summarizes experiments investigating the perceived distances between tones, chords, and keys[3]. These results have been replicated in several laboratories, using a range of musical contexts, participants with varied training, and different task instructions.

One empirical result of interest in connection with the TPS model is the tone profiles of Krumhansl and Shepard (1979) and Krumhansl and Kessler (1982). Those experiments found a hierarchy of tones headed by the tonic, followed by the fifth and third degrees of the scale, then the remaining scale tones, and finally the non-scale tones. TPS proposes a similar, theoretically motivated, tone hierarchy, called the basic space, shown in Fig. 16.4. The basic space and its transformations represent the levels of pitch, chord, and key and their distances within a unified and quantified formalism.

These two components of the TPS model, the prolongational tree structure and operations on the basic pitch space, are combined in the following way. A prolongational tree for a segment of music is constructed based on a number of precise principles or rules (GTTM and TPS). This tree structure determines which distances are computed. The distance of any given event is computed from the event that is superordinate to it in the tree. For example, in Fig. 16.3 the distance for Event 1 is computed from Event 7. When an event has two or more superordinate events, its distance is the sum of the distances along the paths leading to the root of the tree. For instance, Event 2's distance is first computed from Event 1, and then it inherits the distance from Event 1 to Event 7. Generally, an event that is deeply embedded in the tree—that has many superordinate events—will have a large tension value associated with it.

These distances are combined with two other components of the theory. Briefly, one is a treatment of surface or sensory dissonance. This measure is largely psychoacoustic: the interval of a seventh is more dissonant than a sixth; a non-scale tone increases dissonance, as does a chord not in root position; and so on. The other component in the model is the tension caused by attraction, as mentioned earlier. Listeners experience the relative pull of pitches toward other pitches in a tonal context, especially more stable pitches that are nearby. The factors of proximity and relative stability together generate a quantitative prediction of the degree of tension caused by

(a) octave (root) level:	0											(0)	
(b) fifths level:	0						7					(0)	
(c) triadic level:	0			4			7					(0)	
(d) diatonic level:	0		2		4	5		7		9		11	(0)
(e) chromatic level:	0	1	2	3	4	5	6	7	8	9	10	11	(0)

Fig. 16.4 Diatonic basic space, set to the tonic of
C major. 0 = C, 1 = C#, and so on.

[3] Theoretically consistent patterns have been found on these three levels of musical structure (e.g. Krumhansl and Kessler 1982, for tones and keys; Bharucha and Krumhansl 1983, for chords).

attraction for each event in the passage analysed. These are then compared with the judgements of tension that listeners make in the experiments.

Testing the model

To study the rise and fall of tension, real-time measures have been developed in which listeners move a device to indicate the amount of tension they experience throughout the course of a piece (e.g. Nielsen 1983; Fredrickson 1995; Krumhansl 1996). In some preliminary results (Krumhansl 1996) these judgements were found to be quite consistent across listeners, independently of musical training and of degrees of familiarity with a piece.

We undertook a series of experiments to provide a quite comprehensive test of the model's predictions over a range of musical styles. The participants made tension responses for Wagner's Grail theme from Parsifal in both its diatonic and chromatic versions, a Bach chorale, Christus, der ist mein Leben, Chopin's E Major Prelude, and the opening of the fifth movement of Messiaen's Quartet for the End of Time. (The beginning of the first movement of the Mozart Piano Sonata, *K. 282* was also analysed similarly; see Krumhansl 1996; Lerdahl 1996.) We present here only the experiment using the Chopin 'Prelude;' the other experiments are described in Lerdahl and Krumhansl (2007).

Chopin's *E* major Prelude was analysed in Chapter 3 of TPS. It divides into three phrases corresponding to Figs. 16.5–16.7. It is a highly chromatic nineteenth-century piece; the degree of chromaticism is reflected in the number of sharp, flat, and natural signs in the score, especially in the second and third phrases. As such, it presents analytic and perceptual complexities that make it an interesting test case. One complexity that we decided to avoid in the experiment is the textural ornamentation in the melody. Thus, the prelude was presented in block chords as shown. The chords were presented at a slow rate of one chord per two seconds, giving listeners ample time to respond to each event.

Following are some technical details of the TPS model applied to the Chopin Prelude. Readers may prefer to continue reading from the 'Summarizing the findings' section.

Details of the TPS model applied
to the Chopin prelude

Figs. 16.5–16.7 each contain a number of different kinds of information. Events are numbered in order above the staves. Between the staves are *Diss.*, which refers to

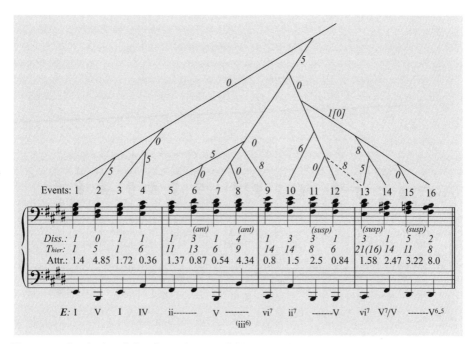

Fig. 16.5 Analysis of the first phrase of Chopin's E major Prelude.

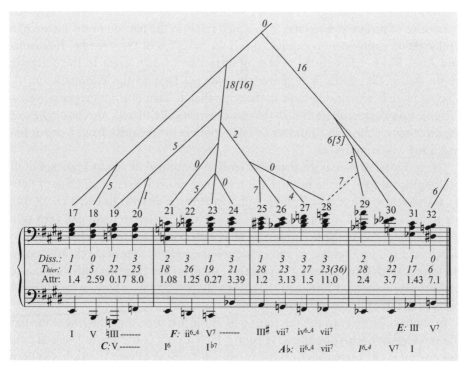

Fig. 16.6 Analysis of the second phrase of Chopin's E major Prelude.

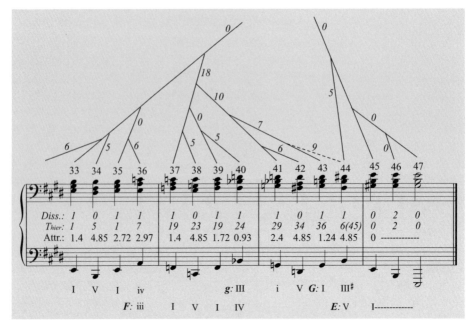

Fig. 16.7 Analysis of the third phrase of Chopin's E major Prelude.

the degree of surface dissonance, T_{hier}, which refers to the tension in the hierarchical prolongation component computed down the branches of the tree plus dissonance, and *Attr.*, which refers to the degree of attraction of each event to the successive event. Below the staves is a harmonic analysis. Despite the chromaticism, the Chopin prelude remains diatonic in the sense that its harmonic progressions refer to diatonic scale degrees, even though they are chromatically altered. Also, as can be seen, the piece moves through a number of different keys (or regions), from E major to C major to F major, and so on.

Of most interest here is the degree of tension computed down the branches of the prolongational tree. At the most global level (not shown), Event 1 attaches to Event 47, then Event 17 attaches to Event 1, and then Event 33 attaches to Event 17. All these are tonic chords in E major, so there is zero distance between them and zero sums down the branches to the beginning event of each phrase. To this is added the dissonance value of 1 for Events 1, 17, and 33 because the melodic note of the chord is not on the tonic scale degree, giving $T_{hier} = 1$ for these three events. Together with the presence of the closely associated dominant (V) chords, the predictions of tension for the beginnings of all three phrases are relatively low.

In contrast, let us consider the section of music just preceding the end of the final phrase (Fig. 15.7), where predicted tension is high. Event 43 attaches to Event 41 (with distance 7); Event 41 attaches to Event 37 (with distance 10); Event 37 attaches to Event 33 (with distance 18); and (as before) Event 33 attaches to Event 45 (with distance 0).

The sum of these distances is $7+10+18+0 = 35$, to which a dissonance value of 1 is added giving a total of $T_{hier} = 36$.

Before considering how well the predictions fit the tension judgements made by listeners, one aspect of the predictions should be mentioned. At three places in the prolongational component (Events 13, 28, and 44) two alternatives are indicated (with one indicated by a dashed line in the tree). These alternatives are both consistent with the TPS model. In these cases, the question is whether the event is heard with respect to the preceding event or the following event. The data can be used to select between the alternatives. The data suggest that Event 13 is heard with respect to Event 12; that Event 28 is heard with respect to Event 29 (giving a sharp peak in predicted tension); and that Event 44 is heard with respect to Event 45 (the familiar dominant-tonic progression). In this way, theory and data interact resulting in a more accurate formulation of how the TPS analysis corresponds to the perceptual data.

Summarizing the findings

Figure 16.8 plots the predicted tension (dashed line) and the judged tension (solid line). The disparity at the beginning of the piece reflects the fact that the slider listeners use to make the tension judgements is initially set to 0, so it took a few events before the listeners' judgements reached the level of the predictions. It should also be noted

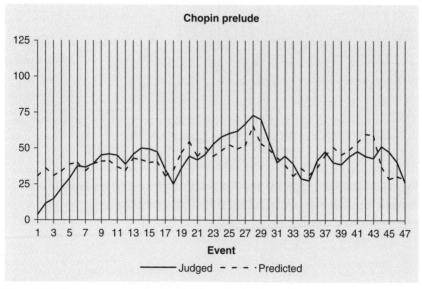

Fig. 16.8 Tension graph for the TPS analysis of the Chopin Prelude.

that the scale of the predicted values in this graph is adjusted so that it matches the tension judgements as well as possible. Nonetheless, it can be seen that the predictions for the second phrase are generally below the judgements and the predictions for the third phrase are generally above the judgements.

This discrepancy suggests that the model is missing an important factor. Observe that in the first two phrases the judged tension rises and falls in waves that correspond to the rise and fall of the melody (its contour). In this case the melody consists of the highest tones. Although the harmony here is complex, the shape of the melody is simple. To add the factor of melodic contour to the analysis, we quantified it and used it as an additional predictor to the statistical analysis. The results are shown in Fig. 16.9, with a clearly better match between prediction and data (which is substantiated by statistical tests that evaluate how well the data match the predictions).[4]

This example illustrates the process through which listeners' experience of tension and release of tension can be modelled precisely in terms of a specific music theoretic model. The other examples we tested each raised a number of interesting issues that arose in the interaction between theory and data. Various alternative hierarchical analyses were tested, leading to a better understanding of which choices, within the constraints of the TPS model, more accurately describe listeners' responses.

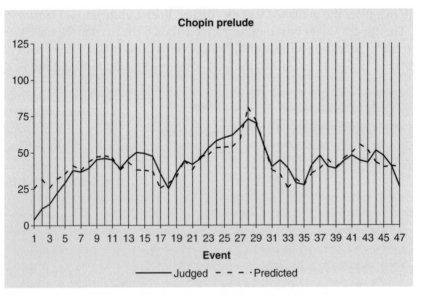

Fig. 16.9 Tension graph for the TPS analysis of the Chopin Prelude after melodic contour was added to the statistical analysis.

[4] The statistical analysis describes how much of the data (ratings by the listeners) could be predicted by the theory. A basic assumption in psychology is that a theory is more likely to be correct if it can successfully predict human behaviour.

DISCUSSION AND CONCLUSIONS

The degree to which the TPS model proved successful in its various tests suggests that it provides a largely adequate account of how complex interactions between the sounded events and the listeners' cognitive system give rise to the experience of tension. In part because of Meyer's (1956) emphasis on how expectations produce continually varying degrees of tension, we have emphasized the component of the TPS model that makes the largest contribution to predicting tension, the hierarchical prolongational component.

The tree representation in this component shows many branches connecting to events that are not adjacent. In other words, the theory proposes that listeners hear each event not only in relation to immediately adjacent events, but also in relation to events at a distance. In language, such relationships are called non-adjacent dependencies and are held to be a special aspect of language structure and unique to humans (Chomsky 1957: Hauser et al. 2002; Fitch and Hauser 2004). Although the present results are neutral with respect to the question of whether hierarchical structure is unique to humans, they suggest that music and language are similar in their hierarchical organization.

Just as people are not often aware of the hierarchical structure of language, even though they implicitly use this knowledge in understanding and producing language, it is likely that listeners are not aware of the complex hierarchies in music: they only feel the tensions created by the structure in the music. By asking participants to rate the tension in music, rather than asking for their explicit knowledge of the structure of the music, our method was able to uncover important aspects of the underlying structure of the music.

Effects of expectation and tension in music have also been found in other indirect measures, such as changes in emotion physiology. Some of these physiological changes (such as changes in heart rate, breathing, and sweaty palms) are associated with 'real-life' emotions, although the correspondences are far from perfect (Cacioppo et al. 1993). This raises the possibility that emotion physiology may suggest some connection between patterns of tension and relaxation and the more everyday emotions. However, the connection is likely to be complex, especially given the different time scales of the moment-to-moment variations in tension and the more sustained moods associated with other emotional events.

One study reporting physiological reactions to music was Sloboda's (1991) questionnaire study in which respondents reported specific physiological reactions. These occurred at points in the music, selected by the respondents, where they reported especially strong reactions. Sloboda found that different physiological reactions corresponded to different kinds of expectancy violations as analysed in music-theoretic terms. For example, he found that tears were associated with an extended melodic and/or harmonic sequence, shivers down the spine with a sudden change of dynamic (loudness) or timbre (the characteristic sound of an instrument), and heart racing with a prominent event arriving earlier than expected.

In an exploratory study with real-time measures, judgements of tension in the study of Krumhansl (1997) correlated with changes in emotion physiology over time. In addition, the tension judgements correlated with real-time judgements of fear, but judgements of happy and sad also made contributions. Changes in emotion physiology showed a similar pattern. This suggests that tension is a multivalent quality with contributions of different reported emotions. Supporting this, another study (Krumhansl and Schenck 1997) showed tension judgements were virtually identical with judgements of the total amount of emotion. Krumhansl (2002) summarizes additional studies relating real-time measures to emotion responses. Thus, tension does not map uniquely to a single emotion (see essays by Melcher and Zampini, Chapter 14, and by Madison, Chapter 17, this volume).

A growing number of studies using measures of neural activity[5] have shown brain responses when musical expectancies are violated. For example, a functional magnetic resonance imaging (fMRI) study by Koelsch et al. (2005) found responses to unexpected chords. In another fMRI study, areas of secondary auditory cortex were active when listeners heard violations of expectations for pitch and rhythm (Krumhansl 2005), even when the listeners were not performing a task, suggesting that the responses to expectations are automatic. Studies using electroencephalography (EEG) (Besson and Faita 1995; Janata 1995) have found early event-related correlates of the degree to which expectations are violated, a result replicated in other studies (e.g. Koelsch et al. 2000).

Some studies also suggest that music can activate the same brain structures that are involved in emotional responses in other situations. In the Koelsch et al. (2005) study cited earlier, the unexpected chords elicited orbital frontolateral cortex activation, an area known to support emotional processing (see Calvo-Merino and Haggard, Chapter 27, this volume, for the role of this brain region in 'rewarding' behaviours such as listening to music, looking at preferred visual artworks or even eating chocolate). Blood and Zatorre's (2001) PET study showed brain responses at specific listener-identified moments of strong emotions, as well as other physiological changes. And, finally, a recent study (Steinbeis et al. 2006), found tension, subjective emotionality of the music, early negativity event-related potential (ERP) response, and electrodermal activity (EDA) increased with harmonic unexpectedness, thus demonstrating connections between all four kinds of responses.

In summary, empirical evidence, using a variety of behavioural and neurocognitive measures, strongly supports the idea that listeners develop constantly changing expectations while listening to music, and these give rise to waves of tension and relaxation. Here we described one music-theoretic model that is able to identify musical patterns that give rise to tension. At present, however, it appears that these moment-to-moment responses do not map in a simple way on to the traditional emotional states studied within psychology. Although the emotions evoked by music

[5] Techniques to indirectly measure the activity of groups of neurons in the brain include EEG (including event-related changes in EEG activity called ERPs), positron emission tomography (PET), and fMRI.

may be different or more complex than 'real-life' emotions, they are fundamental to the musical experience.

Glossary[6]

- Chord: in a musical context, a chord is a collection of tones that are played simultaneously or near simultaneously. The most common chords in Western music are major and minor chords (called *triads* because they consist of three tones).
- Chord (or harmonic) hierarchy: the hierarchical stability of chords established by the key. The most stable chord is the chord built on the first scale tone (the tonic chord, I), followed by the chord built on the fifth scale tone (the dominant chord, V), and then the chord built on the fourth scale tone (the subdominant, IV). These are also usually the most frequent chords in a musical composition. Common sequences of chords that mark the end of phrases are called cadences.
- Key: a concept describing the organization of a passage of music. A sense of key is determined by the establishment of two features: a scale and a tonal centre.
- Melody: the melody is the change in pitch in a passage of music. If it is organized according to musical conventions and perceptual principles, it is well remembered.
- Pitch: the psychological quality of periodic sounds that extends from low to high (pitch height). In the context of music it is called a *tone* and when it is written down it is called a *note*.
- Scale: the set of tones that represent a musical composition, and from which most or all tones in the music are drawn. In Western music, the most common scale is the major (seven-tone) diatonic scale.
- Tonality: the quality of music that involves the use of a key or keys. Its perception involves sensitivity to a complex system of relationships, including the relationships between tones, chords, and keys and the tonal and harmonic hierarchies.
- Tonal centre (or tonic): the tone that functions as a point of maximum stability and minimum tension. It often appears most frequently in the music and gives the name to the scale, e.g. C is the tonal centre for the key of C major.
- Tonal hierarchy: the hierarchy of stability of tones established by the key. The most stable tone in a major key is the first tone of the scale (the tonic), followed by the fifth tone of the scale (dominant), and the third tone of the scale (mediant); the tones that are not in the scale are the least stable.

[6] The following definitions are taken in large part from *Music, Thought and Feeling* (Thompson 2009) which can be consulted for additional information.

References

Besson M and Faita F (1995). An event-related potential (ERP) study of musical expectancy: Comparison of musicians with nonmusicians. *Journal of Experimental Psychology: Human Perception and Performance*, **21**, 1278–96.

Bharucha JJ (1984). Anchoring effects in music: The resolution of dissonance. *Cognitive Psychology*, **16**, 485–518.

Bharucha JJ (1996). Melodic anchoring. *Music Perception*, **13**, 383–400.

Bharucha JJ and Krumhansl CL (1983). The hierarchical representation of harmonic structure in music. *Cognition*, **13**, 63–102.

Blood AJ and Zatorre RJ (2001). Intensely pleasurable responses to music correlate with activity in brain regions implicated in reward and emotion. *Proceedings of the National Academy of Sciences*, **98**, 11818–23.

Cacioppo JT, Klein DJ, Berntson GG, and Hatfield E (1993). The psychophysiology of emotion. In M Lewis and JM Haviland, eds. *Handbook of emotions*. Guilford, New York.

Castellano MA, Bharucha JJ, and Krumhansl CL (1984). Tonal hierarchies in the music of North India. *Journal of Experimental Psychology: General* **113**, 394–412.

Chomsky N (1957). *Syntactic structures*. Mouton, The Hague.

Dibben N (1994). The cognitive reality of hierarchic structure in tonal and atonal music. *Music Perception*, **12**, 1–26.

Fitch WT and Hauser MD (2004). Computational constraints on syntactic processing in a nonhuman primate. *Science*, **303**, 377–80.

Fredrickson WE (1995). A comparison of perceived musical tension and aesthetic response. *Psychology of Music*, **23**, 81–7.

Hauser MC, Chomsky N, and Fitch WT (2002). The faculty of language: What is it, who has it, and how did it evolve? *Science*, **298**, 1569–79.

Huron D (2006). *Sweet anticipation: music and the psychology of expectation*. MIT Press, Cambridge, MA.

Janata P (1995). ERP measures assay the degree of expectancy violation of harmonic contexts in music. *Journal of Cognitive Neuroscience*, **7**, 153–64.

Koelsch S, Fritz T, Schulze K, Alsop D, and Schlaug G (2005). Adults and children processing music: An fMRI study. *Neuroimage*, **25**, 1068–76.

Koelsch S, Gunter TC, Friederici AD, and Schröger E (2000). Brain indices of music processing: 'Non-musicians' are musical. *Journal of Cognitive Neuroscience*, **12**, 520–41.

Krumhansl CL (1990). *Cognitive foundations of musical pitch*. Oxford University Press, New York.

Krumhansl C.L (1995) Music psychology and music theory: Problems and prospects. *Music Theory Spectrum*, **17**, 53–80.

Krumhansl CL (1996). A perceptual analysis of Mozart's Piano Sonata, K. 282: Segmentation, tension and musical ideas. *Music Perception*, **13**, 401–32.

Krumhansl CL (1997). An exploratory study of musical emotions and psychophysiology. *Canadian Journal of Psychology*, **51**, 36–52.

Krumhansl CL (2002). Music: A link between cognition and emotion. *Current Directions in Psychological Science*, **11**, 45–50.

Krumhansl CL (2005). The cognition of tonality – as we know it today. *Journal of New Music Research*, **33**, 253–68.

Krumhansl CL and Kessler EJ (1982). Tracing the dynamic changes in perceived tonal organization in a spatial map of musical keys. *Psychological Review*, **89**, 334–68.

Krumhansl CL, Louhivuori J, Toivianinen P, Järvinen T, and Eerola T (1999). Melodic expectancy in Finnish folk hymns: convergence of behavioral, statistical, and computational approaches. *Music Perception*, **17**, 151–96.

Krumhansl CL and Schenck DL (1997). Can dance reflect the structural and expressive qualities of music? A perceptual experiment on Balanchine's choreography of Mozart's *Divertimento No. 15*. *Musicae Scientiae*, **1**, 63–85.

Krumhansl CL and Shepard RN (1979). Quantification of the hierarchy of tonal functions within the diatonic context. *Journal of Experimental Psychology: Human Perception and Performance*, **5**, 579–94.

Krumhansl CL, Toivanen P, Eerola T, Toivianinen P, Järvinen T, and Louhivuori J (2000). Cross-cultural music cognition: cognitive methodology applied to North Sami yoiks. *Cognition*, **76**, 13–58.

Larson S (2004). Musical forces and melodic expectations: comparing computer models and experimental results. *Music Perception*, **21**, 457–98.

Lerdahl F (1996). Calculating tonal tension. *Music Perception*, **13**, 319–63.

Lerdahl F (2001). *Tonal pitch space*. Oxford University Press, New York.

Lerdahl F and Jackendoff R (1983). *A generative theory of tonal music*. MIT Press, Cambridge, MA.

Lerdahl F and Krumhansl CL (2007). Modeling tonal tension. *Music Perception*, **24**, 329–66.

Meyer LB (1956). *Emotion and meaning in music*. University of Chicago Press, Chicago, IL.

Meyer LB (1989). *Style and music: theory, history, and ideology*. University of Pennsylvania Press, Philadelphia, PA.

Narmour E (1990). *The analysis and cognition of basic melodic structures: The implication-realization model*. University of Chicago Press, Chicago, IL.

Nielsen FV (1983). *Oplevelse af musikalsk spænding* [The experience of musical tension]. Akademisk Forlag, Copenhagen.

Schenker H (1935/1979). *Free composition*, E Oster trans. Longman, New York.

Serafine ML (1987). *Music as cognition: the development of thought in sound*. Columbia University Press, New York.

Sloboda JA (1991). Music structure and emotional response: some empirical findings. *Psychology of Music*, **19**, 110–20.

Steinbeis N, Koelsch S and Sloboda JA (2006). The role of harmonic expectancy violations in musical emotions: evidence from subjective, physiological, and neural responses. *Journal of Cognitive Neuroscience*, **18**, 1380–93.

Temperley D (2007). *Music and probability*. MIT Press, Cambridge, MA.

Thompson WF (2009). *Music, thought, and feeling: understanding the psychology of music*. Oxford University Press, New York and Oxford.

Thompson W and Stainton M (1998). Expectancy in Bohemian folk song melodies: evaluation of implicative principals for implicative and closural intervals. *Music Perception*, **15**, 231–52.

CHAPTER 17

CAUSE AND
AFFECT:
A FUNCTIONAL
PERSPECTIVE
ON MUSIC AND
EMOTION

GUY MADISON

Music remains a curiously enigmatic companion of mankind. The character and purpose of music has been the object for debate and disagreement at least since the days of our earliest written sources. Even today, after more than a century of empirical study, we cannot explain why we have music or even give it a precise definition. Following a long period of disrepute, the study of emotion has recently come into vogue, raising the classical theme of the relation between music and emotion (e.g. Aristotle 1932). It is generally accepted that music 'has something to do with' emotions, but exactly what and why remains elusive. Nevertheless, this idea is pervasive in folk psychology and has guided much empirical work, in particular during the last decades' surge of interest in music from many different branches of science. The reader unfamiliar with this field can find introductory and review papers in the special issues of *Musicae Sciaentiae* and in several edited books (Deutsch 1999; Wallin et al. 2000; Zatorre and Peretz 2001; Avanzini et al. 2003, 2005),[1] and other works focused on

[1] See also specialist journals like *Journal of New Music Research*, *Leonardo*, *Music Perception*, *Psychology of Music*, and *Psychomusicology*. Other sources are occasional papers in *Annals of the*

music and emotion (e.g. Rigg 1964; Budd 1985; Åhlberg 1994; Scruton 1997; Juslin and Sloboda 2001; London 2001; Gabrielsson and Juslin 2002; Kivy 2002; Scherer 2004).

Although many different ideas about the relationship between emotions and music have been proposed in the last 2500 years, there is yet no inkling of consensus. Three related reasons in particular should be mentioned. Firstly, music is not one thing, but a multifaceted phenomenon that may serve more than one function (Fitch 2006). A number of different levels of analysis may therefore be appropriate, such as the individual, cultural, and evolutionary. However, a literature that cuts across different functions that music is assumed to serve, across mundane and peak experiences, and across explanatory perspectives ranging from the humanities to the sciences, will necessarily be heterogeneous and unlikely to reveal any consistent patterns. Secondly, the function of emotions is primarily to guide action. From this it would seem to follow, as will be elaborated in the next section, that a plausible link between emotion and music might involve adaptive benefits. However, the adaptive value of music is itself a difficult, controversial, and as yet unresolved issue. Since these issues are so intimately connected, researchers have likely been wary to commit themselves theoretically on one issue until the other has become more elucidated. Thirdly, both music and emotions are prevalent in everyday life, and their close connection with our individual lives may make it difficult to assume a perspective above and beyond culture, geography, and history.

Rather than review the literature on music and emotion, which has been done repeatedly and competently before (see references listed earlier), I will adopt a functional perspective on the relation between emotion and music, focusing on such functions that may be considered general or important enough to account for the ubiquity and universal nature of music. A main thrust of the functional perspective is to create patterns of predictions, and I will suggest that predictions concerning the type and content of affective responses differ with respect to the different functions attributed to music. This can be helpful in assessing the plausibility of causal relations between these functions, and for formulating empirical hypotheses. The structure of the chapter is as follows. I will first introduce the affective categories *emotion, feeling, mood, and affect*, and then review a few *biological and universal aspects of music*, thus setting the stage for discussing the *adaptive value and function of music*. Having considered function in relation to both emotion and music, I proceed to discuss *cause and affect in the context of music*, and find a number of theoretical objections to the idea that emotions are the point of music. That affective responses emerge from the motivational logic for engaging in music seems, in contrast, to provide the best agreement with empirical data and everyday experience. I conclude with some *reflections on music experience and practice* about the perceived meaning of music, the

New York Academy of Sciences, Bulletin of Music Education, Cognition, Cognition and Emotion, Cognitive Psychology, Computer Music Journal, Contemporary Music Review, Empirical Studies of the Arts, Interface, Journal of the Acoustical Society of America, Journal of Cognitive Neuroscience, Journal of Experimental Psychology: Human Perception and Performance, Memory and Cognition, and *Perception & Psychophysics.*

effort put into creating still new and more sophisticated music, and the rise and fall of the musical genius.

EMOTION, FEELING, MOOD, AND AFFECT

These are terms that tend to overlap somewhat in everyday usage. There is some consensus among researchers, however, that they constitute distinct functional and experiential categories (e.g. Oatley and Jenkins 1996).

An emotion is relatively fast, brief, and transient, has an apparent cause, and involves physiological reactions and often also expressive behaviours. Emotions are biologically embedded in terms of being, to some extent, built into the neural system, which in turn implies that they have a direct adaptive value and are less subject to modification by cognitive processes. That they are part of our basic biological equipment implies a limited set of so-called basic or fundamental emotions (Ekman 1992; Plutchik 1994). Emotions work by invoking action or action readiness, especially in emergent situations where prior knowledge or a rational solution is not available. For example, a loud, unexpected sound causes a start, a dilation of the sweat glands, and increased heart rate, regardless of the source of the sound. Evaluating whether the sound is associated with danger or not requires cognitive evaluation of the event, which takes considerably more time than to just react in a preset, stereotypical way to the sound. Thus the organism is preparing for immediate fight or flight in response to a potentially dangerous event, even before an evaluation of that danger has been completed. There is reasonable consensus among researchers that happiness, sadness, anger, fear, and disgust constitute biologically distinct emotions, often called basic emotions (Plutchik 1994; Power and Dalgleish 1997). Of course, emotions may also be induced by cognitive processes rather than by physical events. Remembering that one yesterday addressed a friend with someone else's name might induce shame (another likely basic emotion), and realizing that one has successfully completed a demanding task might induce a sense of joy or happiness. In any case, an emotion can be defined as an episode exhibiting coordinated changes in physiological arousal, motor activity, and feeling, according to the component process model (Scherer 2004; cf. Kleinginna and Kleinginna 1981).

Feelings include the cognitive and conscious recognition of emotions, but also a wide range of evaluative and motivational sensations that are not emotions proper. It is conceivable that many evaluations and other cognitive processes manifest themselves as feelings, either because the underlying processes or information is consciously unavailable or because one experiences a relatively high level of uncertainty about them. One may, for example, feel that something is good, bad, unnecessary, or too early, without being able to account for why this is. This means that feeling is a very broad concept that may cover the range from biologically based sensations, such as

excited, tired, and bored, to more cognitive ones such as confident, solemn, suspicious, triumphant, ugly, or even Machiavellian.

Affect is commonly attributed the sensation of valence, in other words an evaluation on a good–bad or positive–negative continuum. There are numerous studies indicating that valence is the most common and general dimension applied by humans. This makes sense from an adaptive perspective, since virtually everything may effectively be valued as good, bad, or neutral with respect to survival and reproduction (cf. Batson et al. 1992; Oatley et al. 1996).

Moods are diffuse affective states. In contrast to emotions, moods are slow, persistent, and have often no apparent cause. One could argue that moods may reflect endocrine levels, or be the outcome of a cognitive appraisal of persistent situational factors, such as unemployment, good or poor social relations, and so forth. Mood can probably be induced by anything that induces emotions, feelings, and affects, although some factors more than others are more likely to play a role. Functionally, one can say that moods influence the way we think, while emotions, in contrast, influence action (Davidson 1994).

Emotions, feelings, affects, and moods are, in practice, often difficult to distinguish from each other, for example because all information is not available in a real-life or laboratory situation. We may not be aware if the feeling reported by a listener was in fact preceded by a physiological response, in which case it should have been categorized as an emotion. I will therefore use the overall concept *affective responses* (Grewe et al. 2007) whenever the precise affective category is unknown or irrelevant. Since feelings involve labelling of the content or quality of both emotions and other affective responses, I will refer to feelings as the category of quality, such as happiness and anger, good or bad, and so forth.

Biological and universal
aspects of music

If we were not equipped with the specific neural circuitry for it, no human could acquire the ability to distinguish two pitches from each other, to produce a series of sounds in synchrony with someone else, or to remember a melody from one day to the next (cf. Peretz 2006). This circuitry may to some extent be dedicated to musical processing and reside in specific brain areas (Zatorre and Halpern 1993; Falk 2000). Temporal entrainment is the key feature underlying both the ability to synchronize and the temporal structure of music in terms of the isochronous beat or *tactus* (Merker et al. 2009). Only a few species are known to synchronize, for example fireflies (Pteroptyx) and crickets (Mecopoda), and this behaviour is predominantly used by males to attract females (Greenfield 1994). With the notable exception of humans,

primates and mammals in general do not synchronize, which means that they either lack the ability or the motivation to do it.

All tonal systems feature octave generalization, which means that tones spaced one octave ($f = f2^{\pm 1..x}$) are considered to have the same pitch identity (chroma), or, more generally, to be more similar than tones with any other spacing. This corresponds to the fact that we also perceive tones this way, a feature shared with Rhesus monkeys (Wright et al. 2000) and hence probably with most mammals. Moreover, musical scales in different cultures share striking similarities in gross structure, for example, the order of relatively large and small intervals with respect to consonant intervals (Burns 1999). These structural properties are well accounted for by theoretical models based on information-processing efficiency with respect to audition and cognition (e.g. Balzano 1982; Tymoczko 2006). This also puts a limit to the number of scale tones within the octave, which is typically less than eight.

An even more fundamental characteristic of music is that its constituents—like those of human language—are discrete and non-blending, and thus conform to the so-called particulate principle (Merker 2002). This means that although the sets of pitches and durations may be, and typically are, small, they can be combined in almost any configuration without information loss, yielding a virtually infinite number of possible unique combinations. As a consequence, any individual can quickly learn the specific sets of a foreign culture and partake in its musical behaviours, the level of sophistication being limited only by his/her cognitive skills in terms of remembering, reproducing and recombining. Even if all members of the sets were novel, it is conceivable that learning a foreign spoken language would be several orders of magnitude slower (cf. the later discussion of costly signalling and pattern elaboration in songbirds).

These are but a few examples of features of music that on the surface level may appear to be culturally determined, but which in their principal characteristics are biologically determined. Although samba and reggae utilize different rhythmical patterns, both build their patterns on integer multiples and subdivisions of a continuous isochronous beat. Examples of music that seem to overstep these neural settings can always be found, but they are rare cases when cultural evolution has for some reason taken the narrow path away from nature. When Arnold Schoenberg decided to make all twelve tones equal (instead of subordinate to each other, as in the Western tonal system), he meant to create a more refined and artistically free music. The idea, however, was purely intellectual. In disregarding the neural substrate of the listener, the result was deemed obscure and unattractive by all but a few devotees.

More complex and higher-level processing of music also exhibits high consistency across individuals from different cultures, across infants and adults, and across levels of musical experience. A closer description of musical universals is outside the present scope (but see Krumhansl and Lerdahl, Chapter 16, this volume)—the point being, however, that all humans share a genetic disposition that is necessary and may be sufficient to make music a human universal. It should also be noted that these central, defining design features of music are those that are common to the world's musics, whereas cultural differences are found for features that can be considered 'free parameters' with respect to the processing of musical patterns by the neural system.

ADAPTIVE VALUE AND FUNCTION OF MUSIC

That music is biologically based and universal suggests that it could have been selected for at some point in our evolutionary history. There are other possibilities, of course, for example, that music is a cultural invention that opportunistically draws on capabilities that were selected for some entirely different function (cf. Brown et al. 2000; Fitch 2006; Peretz 2006). This exemplifies the uneven interface between function, traits, and adaptive value, in contrast to the apparent uniformity that obtains for behaviours with direct biological value, such as eating. These are difficult issues, constantly a matter for debate, as mentioned, and this is no place to enter into this controversy. Instead, I will briefly delineate what I see as four main themes in the literature, which all allude to evolutionary mechanisms but differ in their evolutionary logic:

1) The claim that seems to be implied by many theorists is that induction and communication of emotion constitutes a function of music and a reason why we are attracted to it; in other words, no less than an explanation for the very existence of music. Emotions and their expressive behaviours are innate, which provides a general, on-board, ready-to-go detector of their associated expressive features. That emotions themselves have an obvious adaptive value could further buttress and qualify this claim by indirectly endowing the musical experience with a connection to innate biological mechanisms. The evolutionary significance of this *emotion hypothesis* is, however, that musical capacities themselves were not directly selected for. One could argue that once they were in place for other reasons, the ensuing interpersonal emotional communication or self-regulation might have assumed adaptive value, for example in terms of preverbal communication between infants and their caregivers, along the lines suggested by Hodges (1989) and Roederer (1984).

2) Charles Darwin (1871) was the first to propose that human music evolved as a sexually selected courtship display. A widely accepted account for such selection is the handicap principle, exemplified by the peacock's tail. The main idea is that the display itself is costly and therefore cannot be afforded by an individual of poor quality. The learning and production of complex patterns in animal song is costly in terms of resources, and serves therefore as *costly signalling* of mate quality in birds (Marler 2000; Slater 2000) and humpback whales (Payne 2000). Songbirds invest energy to grow and maintain neural tissue dedicated to singing, in addition to the time spent learning and practising song patterns, resources that might have been spent on nutrition or some other direct adaptive value (Catchpole and Slater 1995). In addition, the sound they produce reveals their position to predators and increases their risk of becoming prey. The fact of surviving despite such handicaps is a mark of quality. Miller (2000) provides many arguments why sexual selection should be considered the evolutionary null hypothesis, and notes, for example, that music making is predominantly an activity of young males.

3) The *social bonding* hypothesis asserts that music as a cooperative activity may have an important bonding effect, and may facilitate social organization (Roederer 1984; Freeman 2000; Ujhelyi 2000). Inasmuch as such changes to social organization would entail increased adaptive value for the individual, they would be favoured by natural selection. Freeman gives particular significance in this regard to the synchronization of bodily movement by means of pulse, the foundation of musical rhythm, a trait that may have occurred during the period of speciation between chimpanzees and early hominids (Merker 1999, 2000). Incidentally, Merker's scenario is limited to temporal entrainment and to a critical period in evolution, and is therefore unlikely to bear on affective responses to full-blown music.

4) The *language hypothesis* refers to the idea that human language and music have been cooperative during some period of their common evolutionary history (Brown 2000; Molino 2000; Richman 2000; Mithen 2005). Music was either a necessary transitional stage towards language that has remained with us since then, or it relies on the same capabilities that were selected for language. In both cases music would be a side effect of a true adaptation, a so-called spandrel (Gould and Lewontin 1979), or, if music has assumed some other adaptive value at a later stage, an exaptation, meaning that a trait originally selected for one purpose is switched to another (Gould and Vrba 1982).

I will now discuss functions of affective responses in relation to each of these hypotheses.

Cause and affect in the
Context of music

The function of emotions and affective responses in general is to guide action, and each different feeling signifies different action tendencies (Frijda 1986). Basically, negative feelings direct us away from that which may ultimately threaten well-being, and positive feelings direct us to that which may ultimately facilitate well-being. Of course, the complexity of modern society entails many examples of non-adaptive outcomes of our affective processes.

Outside the narrow confines of adaptive hypotheses a wide variety of theories and ideas have been proposed and subsumed under different labels, such as absolutist, cognitivist, expressionist, formalist, and referentialist (for reviews, see Budd 1985; Davies 2001; London 2001). These theories encompass issues such as whether affective responses to music are different than those evoked by everyday events, what it is about musical expression that we react to and why, how formal musical knowledge contributes, and so forth. These distinctions tend in some cases to be conceptually

fine-grained to the extent that evaluation in practice becomes impossible. More importantly, theories that cannot distinguish between innate and acquired relations lack the power to explain the universal attractiveness of music, and will therefore not be further considered.

Affective responses act on innately determined stimuli related to, for example, food and sex, but also on associations acquired through personal life experience, and on continuous cognitive processing. A lifelong fear of boats may follow upon a near-drowning accident, or curiosity upon receiving a letter. Associative and cognitive factors must figure prominently in emotional responsiveness to music, since the social and cultural uses of music are laden with value and meaning. Compared with innate grounds, however, they are much less likely to play a universal functional role, and therefore less likely to be associated with a motivational machinery in terms of, for example, emotions. They are also inherently unsystematic, even though cultural transmission may instil a modicum of order. I will therefore focus on innately determined associations, although this should not be taken to mean that acquired associations may not be profound and extremely important for the individual.

One central point for the study of emotion and music has been that emotions are associated with specific expressive behaviours in terms of facial, vocal, and bodily movement displays. These displays are highly general in terms of similarity across humans and higher non-human animals, and features of vocal and bodily displays can be reflected in an acoustic signal (Juslin and Laukka 2003). The timing profile of a caressing hand may be duplicated in a series of pitch changes, or the harshness of an angry voice may be imitated by a strained, distorted timbre on a saxophone. For example, timing patterns in music performance could be described by a non-linear statistic that correlated with perceived emotional expression (Madison 2000). A happy person is inclined to walk steadily and briskly, which may be inferred from music with a fast and steady tempo, and so forth. An extensive list of such homologous features is found in Juslin and Laukka (2003).

This apparent similarity in form is likely to have inspired the notion that music possesses a unique power to express and communicate emotion, and that this might constitute its prime attraction (e.g. Cooke 1959; Langer 1951; Langer 1953; Meyer 1956). The influential *Affektenlehre* was also based on these ideas, with composer Johann Mattheson as its most prominent exponent (Der vollkommene Capellmeister 1739 / Buelow 1983).

Table 17.1 attempts to summarize the affective responses that may be predicted on the basis of the foregoing sections. There are four blocks, one for each musical function, and four rows within each of these, one for each type of affective response.

We know from everyday experience that a musical event can range from the undesirable exposure to music one dislikes, or a failure while attempting to play something on an instrument, to an eagerly awaited concert with a favourite artist. While unpleasant musical situations are very rare and in most cases can be dealt with by simple avoidance, by far the most common musical event can be described as humdrum. (This is, by the way, no doubt a result of ubiquitous exposure to music made possible by audio reproduction technology: in the days when the only source of music was live

Table 17.1 Suggested affective responses for three types of situations with respect to music according to four different functional hypotheses. A dash (—) means that no affective response is expected, question mark (?) means some response may occur, and plus (+) indicates stronger relative intensity of responses. See text for a detailed discussion.

	Type of affective response	Situation		
		Seeking musical event	Mundane/humdrum musical event	Good/peak musical event
Emotion hypothesis	Emotion	—	Any specific basic emotion	Any specific basic emotion +
	Feeling	—		
	Mood	—		
	Affect	—	(Positive)	(Positive +)
Costly signalling hypothesis	Emotion	—	—	Happiness, joy
	Feeling	—	Interest, excitement[a]	Thrill, passion[b]
	Mood	—	Elated	Elated +
	Affect	—	Positive	Positive +
Social bonding hypothesis	Emotion	?	?	Happiness, joy
	Feeling	(Loneliness) [v]	Gregariousness, solidarity	Gregariousness, solidarity
	Mood	(Depressed)	Elated	Elated +
	Affect	(Negative)	Positive	Positive +
Language hypothesis	Emotion	—	—	—
	Feeling	—	—	—
	Mood	—	—	—
	Affect	—	—	—

Notes. Elated is a general term for moods with positive character. [a]It is a matter of debate whether interest and loneliness should be regarded basic emotions: I label them as feelings here in order to distinguish them from the established basic emotions that are most often attributed to music (cf. Plutchik, 1994, pp. 53–64). [b]These are but two of a large number of appropriate feelings, including affection, arousal, bliss, delight, ecstasy, euphoria, joy, jubilation, and satisfaction, and which should be compared with the range of words reported for strong experiences of music.

performance by oneself or others, interest was conceivably higher, on average.) The most coveted musical experiences are, according to some people, intense, joyous, and staggering, and also relatively rare (Maslow 1976; Gabrielsson 2001a). There is accordingly reason to distinguish between humdrum and good or peak musical experiences, a distinction represented by the two rightmost columns of the figure. Hunger motivates us to seek food, not only to eat when food is available (cf. appetitive behaviour, e.g. Timberlake and Silva 1995). By analogy, appetency for music might entail some affective response that motivates us to actively seek musical experiences, for which the column entitled 'Seeking musical event' is intended.

According to the emotion hypothesis, number (1) in the earlier list, the function of music is to induce or evoke emotions. Emotional communication is the strong version of the hypothesis, namely that composers and performers intentionally convey emotions that listeners actually experience (Meyer 1956; Cooke 1959; Juslin 1997; 2000; 2001; Juslin et al. 2003). A weaker version of the hypothesis is that the expression of emotion in music somehow modulates the listener's affective responses in desirable ways (Langer 1951, 1953; Kivy 1990). Both versions predict a variety of emotions accommodated by the phrase 'Any specific basic emotion' in Table 17.1, which leaves open whether the emotion is constant or varies throughout a musical event, or if it is positive or negative. Indeed, a substantial proportion of the world's musics can be characterized as melancholic, serious, or sad, according to the correspondence between their expressive features and human emotionally expressive behaviour. The function should further be limited to basic emotions because these are the ones that have an innate and universal form of expression. Since feelings are the appraisal of emotion, the feeling should be identical to the emotion. Also the mood should have the same valence as the emotion because emotions are intense and pervasive. However, if being emotionally aroused in general is positively appreciated, a positive affect might be expected, as indicated within parentheses. Events with desirable outcomes are sometimes associated with emotions that direct us to seek these events, but among ten such emotion-goal pairs there is no goal even remotely similar to taking an emotional roller-coaster ride, so dashes in this column means that no such prediction is made (e.g. Plutchik 1994, p.56). Finally, it is conceivable that a humdrum musical event induces weak emotions, while a good event may be characterized by strong emotions, and increased intensity of the responses is indicated by plus signs (+) in Table 17.1.

Music experience does not correspond very well with these predictions. Rather, positive emotional feelings are predominant and negative ones are very rare. Also, feelings associated with basic emotions seem to play a lesser role than other experiential dimensions, such as intensity, valence, and grooviness (Madison and Merker 2003; Madison 2006). These and indeed most studies have asked for the perceived expression ('How well is this music described by the word happy?'), which may of course obscure possible affective responses ('How happy do you feel'). Nevertheless, one would expect some amount of transfer from felt emotions to perceived emotional expression, since it is natural to attribute what we feel to the music. A large number of adjective rating studies (partly summarized in Gabrielsson 2001b) have shown that emotional experiential dimensions generally account for a very small part of the variance. This does not necessarily mean that emotion words receive low ratings, but it does show that ratings do not vary much across the included musical selections, contrary to what is predicted by the emotion hypothesis. Instead, ratings are predominantly positive (Juslin and Laukka 2004), even when the music is characterized as sad (Schellenberg et al. 2008). Even when musicians try to express different emotions, ratings are markedly biased in the positive direction across all expressive intentions (Juslin and Madison 1999). One of the few studies that allowed for a wide range of different affective responses found that in order of frequency the most common experiences for classical art music were moist eyes or tears (related to 'being moved'), other specific

feelings, and positive valence, and for non-classical music they were positive valence, other specific feelings, and subjective arousal (Scherer et al. 2001).

Apart from the general lack of fit between this pattern of predictions and musical experience, there are a number of problems with the emotion hypothesis that are not evident from the table, and that should be mentioned before turning to the next functional hypothesis.

First, although several accounts have been suggested, there is no very persuasive argument why music should be needed to express emotions in the first place, since bodily, gestural, vocal, and verbal means of communication would seem to be at least equally efficient.

Second, there is no reason to expect that a sound pattern exhibiting some characteristic feature of the expressive behaviour associated with an emotion should be perceived or appraised as a display of that emotion (Gabrielsson 2001b). Music itself is not a sentient being and hence cannot possess emotions, as argued already by Hanslick (1957). While he acknowledged that homologous features exist and that some music avails itself of them, he maintained that this has nothing to do with emotion, but that the attempt to express an emotion, a feeling, or whatever, might, among a wide variety of factors, endow the music with beauty, and this beauty might in turn move the listener emotionally (cf. Kivy 1999; Zangwill 2004). Although written in 1854, before Darwins's (1872) seminal treatise on emotions from a functional perspective, current theory lends some credibility to Hanslick's argument (see, e.g. Scherer 2004).

For comparison, similarity in form might be created deliberately by a composer or performer by seeking to imitate a battle or a storm, for example. Program music is a case in point, characterized by mixed imitative success depending on how well the object is suited for acoustic portrayal. But similarity does not tell us more about a possible intrinsic relation between music and emotion than between music and battles or storms, but rather that musical patterns can be used to imitate. The analogy with emotions fails because musical elements lack both relational and referential meaning, be it a tone, rhythm pattern, motif, an interval, or harmonic mode. Although a particular musical unit may evoke similar experiences across individuals with a probability higher than chance, there is no reason why this should be the same in another context (Hanslick 1957).

A third problem is that there is no prescribed emotional response for a given emotional display. If I overhear someone speaking angrily into a telephone, I may not experience any emotion at all since I am not being addressed. If someone speaks angrily to me, I might feel anger myself because I perceive the opponent's anger as unfair, or I might feel afraid because the opponent is a bully known to take to his fists, or I might feel amused because the opponent is making a fool of himself. Since the mechanisms related to affects and feelings function to evaluate events, affective responses to music are more likely to be different from, rather than similar to, any feelings that might be portrayed by the music. Evaluation is furthermore based on both immediate and long-term context, which means that affective responses will also depend upon personal and situational factors (Gabrielsson 2001b). This partly complementary and highly context-specific relation means that affective responses bear a complex and unpredictable relationship to the feeling expressed.

Fourthly, affective responses to the affective displays of other organisms may have adaptive value, since it may signal their propensity to help or harm. But it would not make sense to react to, say, movements of branches that resemble the movements of a happy or angry person. That emotions are innate does not imply that their expressive characteristics evoke affective responses indiscriminately. They are, of course, contingent upon appraisal of the context; otherwise our emotional lives would be chaotic. Phobia is a case in point, which exemplifies automatic emotional responses to stimuli with strong significance for survival, such as snakes and spiders (Dimberg et al. 1998).

Finally, if communication of emotions were the purpose of music, would we not long ago have devised optimal means for this? It should not be that difficult, given that we already have the expressive characteristics of emotions built into our limbic system. If music were designed for optimally communicating emotions, it would conceivably focus on these expressive characteristics, and in effect sound quite different. There would be no need for a finite alphabet and hierarchical structure, and certainly no explanation for their ubiquitous presence in music. We should also note that the emotion hypothesis focuses on the experience of the perceiver, for which the sender of the musical signal is merely a means. Once optimal music for communicating or inducing this or that emotion or this or that pattern of emotions has been made, would there really be such a relentless drive to create still new music and still new interpretations and renditions? Indeed, it leaves open the question why such a large proportion of the Western population engages in musical productive behaviour, given that they have all the music of the world available 24 hours a day, 365 days a year, at a negligible cost. If anything, this proportion has increased during the industrial revolution. This points to a motivation for producing music as well, not only receiving, flourishing as wealth and leisure time makes it possible to buy music equipment and spend thousands of hours practising.

The point of *costly signalling* (see number (2) in the earlier list) is to provide an honest measure of mate quality by which, typically, the female can optimize her investment in terms of the quality of her offspring. An ideal signal for serving this function conveys properties that are directly related to the factual cost for obtaining them. One could surmise that a number of features may further contribute to the signal's utility as a basis for mate choice, for example that it is relatively unaffected by extraneous factors and that its significant property bears a continuous, monotonical, and unambiguous relationship with mate quality. Sometimes this signal is merely an elaborate bodily ornamentation, such as the parrot's coloured plumage, but often behaviour is involved. In the appropriate situation the peacock stretches out and vibrates his tail, and the songbird sings. Where the handicap is in the form of a behavioural display, it presumably has motivational underpinnings with positive valence. Thus, if a function of music is to be a vehicle for costly signalling, then it should reasonably be associated with positive affect and elated mood, as indicated in Table 17.1.

Birdsong may be a good model by which to consider music, because it, too, uses acoustic patterns, and it is also the clearest and most extensively studied example of

sexual selection by way of costly signalling (Catchpole et al. 1995). There are many species-specific differences in details, such as the size of repertoire and differentiation of displays for different functions, like mate attraction, territory defence, and male rivalry situations. The main principle is, however, high fidelity duplication, often of song patterns stored in memory since hatching. Weeks or months of solitary practice is dedicated by the male to perfect his song, who during this time is the sole judge of his achievement (Merker 2005). The quality measures that ensue from this principle are pattern fidelity and how much was copied (repertoire size). Some species add new songs or sounds learned from conspecifics or arbitrary models into their repertoire, some disassemble patterns into fragments and reassemble them in different ways, and some invent novel patterns. Therefore, the specific structural content of bird song as predicted from one subpopulation to another will range from being highly predictable, subject only to unintentional errors, to entirely unpredictable, depending on the species (Merker, in press). Once the males have attained adult song and spend many hours a day singing for weeks, the females are the judges, and the eventual payoff is early pair formation. But the basic principle is that the male closely imitates long and complex signals, the success of which inclines the female to mate with him.

What might be suggested by the analogy between bird song and music in light of the costly signalling hypothesis? For sake of argument we can equate unsuccessful imitation with a humdrum event, and successful imitation with a peak event. Very little is known about emotions or other psychophysiological processes that may direct birds to these very specific behaviours. For humans, however, the first action tendency seems best furthered by feelings of interest, excitement, and curiosity, and the second action tendency would seem to be furthered by strong positive emotions that entail appropriate physiological effects, as suggested in Table 17.1. These effects should be related to, or appraised as, feelings such as adoration, compassion, desire, enthralment, infatuation, lust, love, and passion, words that are very common in the description of strong or peak musical experiences (Gabrielsson 2001a).

The description of typical bird behaviours should not be taken to suggest that the same distinct sex roles would obtain for humans, if there is some reality in the costly signalling hypothesis, but both sexes may be sensitive to mate quality indicated by musical behaviours. Interest would nevertheless be a suitable motivating affective response, both for the sender to learn and to produce the patterns, and for the receiver to learn and pay attention to the produced patterns. Apart from strong positive emotions for peak events, no further emotions seem necessary for this scenario, as indicated by a dash in the emotion row in Table 17.1. Nor would any further emotion or other affective response seem to be connected with an action tendency for partaking in musical behaviour, as shown by a dash in the 'seeking a musical event' column. Although space does not permit any systematic review, the pattern of affective responses that I have suggested on account of the costly signalling hypothesis corresponds well with empirical data, some of which are mentioned throughout this chapter.

The social bonding (number (3) in the earlier list) hypothesis would seem to imply a similar pattern as for costly signalling with respect to affect and mood, given that musical behaviours were selected for the function of putting neighbours on friendly terms with one another. Gregariousness is enjoyment of the company of others. If musical behaviours promote socially valuable relations, then peak experiences should reasonably indicate particularly favourable conditions for bonding and cooperation, and should therefore induce positive emotions like joy or happiness. In contrast to the positive affective responses in the costly signalling scenario, gregariousness has an opposite in terms of loneliness (Plutchik 1994, p. 56). I therefore suggest the possibility (within parentheses) that loneliness, negative affect, and depressed mood in this scenario may act as motivators for musical behaviours.

The language hypothesis (number (4) in the earlier list) tries to explain how the capability for music could emerge, although in itself it has never been selected for. There are different varieties on this theme that I need not delve into in order to draw the simple conclusion that this renders innate affective responses highly unlikely, as indicated by the plethora of dashes in Table 17.1. The prevalence of musical behaviour must therefore either reflect some other adaptive function, or some non-adaptive function that has pleasant outcomes. For the latter one could, for example, submit the purely functional part of the emotion hypothesis. Although musical behaviour appears quite irrelevant for adult language, one could argue that it might nevertheless play a role for language acquisition in phylogeny (Hodges 1989). The motivational mechanisms related to the latter scenario are unclear, however, and further work is required to address it properly.

Apart from these four hypotheses, temporal entrainment to music should be mentioned as another possible source of affective responses. The isochronous pulse serves as a synchronization device, without which ensemble performance of music or dance would not be possible. On a more general level, the pulse creates expectations, as amply demonstrated by electroencephalogram responses (so-called event related potentials) at the point in time where an omitted sound event in an isochronous train should have occurred (Jongsma et al. 2005). This indicates a fundamental neural mechanism that may have the function of focusing attention (Large and Palmer 2002) within a relatively narrow range of variability (approximately 8% of the interval), which probably corresponds with a limit for useful precision in temporal prediction (Madison and Merker 2002). On the other hand, it also adapts to gradual tempo change, even to fast rates of change (Madison and Merker 2005), making it useful as a means for synchronizing with variable models, such as other humans. The utility of such a mechanism suggests that it may be associated with some motivating affective response (cf. Damasio 2004), and the strong positive valence associated with the experience of groove is a likely candidate (Madison 2006). However, temporal entrainment will not be considered an alternative to any of the other hypotheses since it represents merely one component of rhythmic music and also yields overlapping predictions (positive affect and mood).

REFLECTIONS ON MUSIC EXPERIENCE
AND PRACTICE

Although the present sketch would seem to favour the perspective that affective responses follow from music's function as costly signalling of mate quality, the kind of argumentation available is no ground for committing to it. To be sure, the social bonding hypothesis yields similar predictions. However, a number of observations come to mind when one considers music in this light, a few of which are mentioned next.

How do people themselves account for their involvement with music? Reasons for performing or becoming a performer are primarily the quest for positive emotional experience, social status and recognition, and the sense of achievement (for a review, see Persson 2001). The most common reason that people report for listening to music is mood regulation, according to several surveys (Juslin et al. 2004, p. 231; Sloboda and O'Neill 2001; Saarikallio 2007). The desired mood is mainly a more positive one, but a more negative mood could also be sought with the goal of increasing happiness and well-being in the long term (Saarikallio 2007). Exposure to a particular music—typically even a particular performance—is critical for the intended effect (Sloboda et al. 2001), which indicates that music in this capacity mainly serves as an interesting and motivating stimulus for recalling memories and associations acquired through personal life experience. Mood induction relies on swift and effortless exposure to specific selections, and hence in practice on audio reproduction technology. It strikes me therefore as a recent invention, subordinate to other functions with a longer history.

It is a widespread notion that music communicates something significant. No attempt to account for this from a referential or semiotic perspective has been very successful, since they assume, in analogy with language, that the significance lies in the information conveyed (for discussions, see Davies 1994; Clarke 1995, 2001; Sloboda 1998). The idea that communication of emotions would provide either a feasible or useful end is also faced with many objections, as I have argued earlier. In this light it is not surprising that composers and performers rarely seem to consider emotions in their work; Igor Stravinsky is one who has publicly disavowed that his music has anything to do with emotions. However, the costly signalling hypothesis resolves these problems, according to which the specific musical structure would be irrelevant. The meaning that music always carries, regardless of melody, complexity, style or whatever, is, rather, a measure of information processing ability, as it were, whose significance is no less than reproductive success for the individual. As such, the relevant level of this communication is from one individual to another. One can therefore speculate that this innate biological significance might somehow endow our experience of music with the character of a personal message or a narrative, as is often described (Laiho 2004). A majority of listeners indicated that music often communicated something to them, and that this something was emotions (47%), emotions, opinions, and

messages (34%), and messages (7%) (Juslin et al. 2004). Another kind of evidence comes from a task in which listeners had to choose one of two opposite words, such as male–female and bright–dull, in response to a number of short music excerpts. It turned out that the agreement among participants was significantly higher for words that might apply to a person (e.g. good–evil, old–young, joyful–sad) than for words unlikely to apply to a person (e.g. narrow–wide, day–night, dry–moist), whereas no such difference was evident for words chosen in response to foodstuffs (Watt and Ash 1998).

But would not the principle of imitation that renders birdsong its utility as a costly signal seem to be at odds with the human creativity so highly esteemed in the field of music? Not at all. Firstly, song patterns do vary in nature, as mentioned, but the point is that memory capacity and time constitute the main biological costs, not innovation as such. Therefore, variation on a theme or rearrangement of song elements is just as costly as high fidelity duplication, because the same memory representation is required. Secondly, we must admit that the lion's share of human music production is indeed replication; some music is performed over and over again by different artists, concert goers may even see the same artists repeat their songs, and we also listen to the same recorded performances again and again. If the primary demand characteristic for music were creativity or novelty, then musical practice would certainly be quite different. Thirdly, even a novel piece of music is quite similar to previous art; otherwise we would not have the concept of musical style or the difficulty in defining plagiarism. Each alleged new composition complies with a multitude of production rules implicitly set by the culture from which it stems, and by which it is judged. In other words, higher-order musical properties may serve as a costly signal just as well as specific pattern structure does, since acquiring such knowledge also requires resources in terms of time and memory. This is one possible explanation for the fact that most of us prefer the musical styles we are familiar with, whereas a demand for novelty and variation would direct us to unfamiliar styles. Familiarity is nothing else than implicit knowledge about higher-order properties, acquired by repeated exposure to a sufficient sample of music. If the ultimate motivation for music is to display and gauge the invested cost, then this knowledge is essential, and the more familiar the style the more precisely can we do it. Indeed, preference for initially unfamiliar music increased monotonically during one month of daily listening, and across four levels of musical complexity (Madison et al. submitted).

Although the particular musical structure would be arbitrary for the purpose of costly signalling, its general characteristics such as complexity, repetitiveness, and constituent elements can be more or less optimal according to the circumstances. It is conceivable that the discrete nature of musical elements (e.g. the particulate principle mentioned under biological and adaptive aspects, see Merker 2002) and the hierarchical, repetitive structure (Krumhansl and Lerdahl, Chapter 16) both conspire to reduce cognitive load while increasing splendour. In addition to simply learning and reproducing patterns as-is, then, inventing strategies for reducing this effort would increase an individual's competitive advantage as a sender by accommodating even longer patterns. However, as soon as this individual applies these devices, others will very

soon break the code and apply it themselves, which leads to an arms race in information reduction. Such may be the path to the various musical systems in different cultures, all characterized by small finite alphabets and repetition of groups with some variation, but some focusing more on pitch (e.g. Western tradition) and other more on rhythm (e.g. West African, Balkan, and Latin America).

Similarly, this selection pressure for apparent splendour could explain why we continue to create new music instead of merely enjoying the apparently very gratifying music we already have, as demonstrated by, for example, the classical works of art music that are recorded and performed in concert houses over and over again. As a competitive signal, music can never be good enough (Miller 2000), but its splendour is only limited by the available resources. As mentioned before, the proportion of musically productive people seems to be much larger than the demand, which suggests an innately founded motivation for producing music. Not only the pattern, but also the speed, precision, and loudness of a musical performance are properties that reasonably may be associated with biological cost. A louder signal does indeed require more energy or a better technique, such as the operatic voice. The volume at concerts and clubs is a growing concern, with hearing loss in its wake. Again, it may be that when resources permit, there is an element of 'the more the better', and one may sometimes suspect some not-so-great artists of having invested a somewhat higher proportion of their resources into sound amplification. Likewise, musical skill is constantly increasing on a par with athletic skill. Industrialized countries see a growing proportion of competent musicians, and the top stratum of musicians today clearly demonstrate greater motor skill than did previous generations. In contrast, a number of human faculties might not exhibit this progressive amelioration, for example other arts such as sculpture, literature, and visual art (nor, for that matter, common sense, craftsmanship, kindness, mathematics, or even verbal skill). One speculative explanation for this difference is that such competences ultimately have a more confined utility than reproductive success, and therefore good enough is quite sufficient.

Early quantum leaps in this regard is a case in point. For example, the city states and developing duchies in Medieval and Renaissance Europe provided concentration of resources in conjunction with relative stability. Potentates were soon to hire musicians, no doubt to increase the magnificence of their courts. This put a selected few in the novel situation of being able to devote all their time to music, rather than working for subsistence in more direct ways, which brought a very fast increase in the duration and complexity of musical works. One can imagine the impressive impact of a 15-minute piece of music with several more or less independent voices, played by a small orchestra. Although there was certainly some repetition, early art music was nevertheless quite different from the common ballad, in which a refrain and a stanza were the only structurally unique units. A point worth making is that, from about 1700 to 1900, the unequal distribution of wealth and other social and practical circumstances had the effect that an extremely small proportion of the entire population could acquire an extreme superiority in the musical sophistication of works composed and played, aided, of course, by proficiency in reading and writing musical notation. However, there is no reason why these skills would imply the general superiority of

a genius if musical ability was not considered something very important in the first place. Although this would seem unlikely given the small practical use music was to the common man, the costly signalling hypothesis could account for why one had to assume divine influence and innate talent. The theory of talent prevails still today, although systematic research has determined that most, if not all, variability in musical ability is accounted for by the quality and quantity of practice (e.g. Sloboda 1990; Ericsson et al. 1993; Ericsson 1997). The musical genius has now faded considerably since its heyday, as would be expected by the widespread exposure to music and distribution of musical skill in the general population.

Finally, I would like to emphasize that the present focus on function, in particular, function related to adaptive value, is a strategy for highlighting large general patterns in a web obscured by the conceptual and empirical difficulties hinted at in the introduction. If the present attempt has any merit, it is certainly not to explain or downplay the utility or experiential value of music or its related affective responses. It may be helpful in furthering our understanding of these complex phenomena, however, by suggesting where to look and what to look for, primarily in terms of ultimate motivational factors leading to the role that music plays in human cultures and in our lives.

ACKNOWLEDGEMENTS

I am grateful to Björn Merker for fruitful discussions and comments on previous versions of this chapter, and indebted to Alf Gabrielsson for his comments and for his pioneering studies of strong experiences of music.

REFERENCES

Åhlberg LO (1994). Susanne Langer on representation and emotion in music. *British Journal of Aesthetics*, **34**, 69–80.

Aristotle (1932). *Poetics*. (Vol. 23.) William Heinemann, London.

Avanzini G, Faienza C, Minciacci D, Lopez L, and Majno M, eds. (2003). The neurosciences and music. *Annals of the New York Academy of Sciences*, **999**, 1–532.

Avanzini G, Lopez L, Koelsch S, and Majno M, eds. (2005). Neurosciences and music II: From perception to performance. *Annals of the New York Academy of Sciences*, **1060**, 1–487.

Balzano GJ (1982). The pitch set as a level of description for studying musical pitch perception. In M Clynes, ed. *Music, mind, and brain*, pp. 321–51. Plenum Press, New York.

Batson C, Shaw LL, and Oleson KC (1992). Differentiating affect, mood, and emotion: Toward functionally based conceptual distinctions. In MS Clark, ed. *Review of personality and social psychology: emotion*, pp. 294–326. Sage, Newbury Park, CA.

Brown SW (2000). The 'musilanguage' model of music evolution. In NL Wallin, B Merker, and S Brown, eds. *The origins of music*, pp. 271–300. MIT Press, Cambridge, MA.

Brown SW, Merker B, and Wallin NL (2000). An introduction to evolutionary musicology. In NL Wallin, B Merker, and S Brown, eds. *The Origins of music*, pp. 3–24. MIT Press, Cambridge, MA.

Budd M (1985). *Music and the emotions: the philosophical theories*. Routledge, London.

Buelow GJ (1983). Johann Mattheson and the invention of the Affektenlehre. In GJ Buelow and HJ Marx, eds. *New Mattheson studies*, pp. 393–407. Cambridge University Press, Cambridge.

Burns EM (1999). Intervals, scales, and tuning. In D Deutsch, ed. *The psychology of music*, 2nd edn., pp. 215–64, Academic Press, San Diego, CA.

Catchpole CK and Slater PJB (1995). *Bird song: biological themes and variations*. Cambridge University Press, Cambridge.

Clarke EF (1995). Expression in performance: generativity, perception, and semiosis. In J Rink, ed. *The practice of performance*, pp. 21–54. Cambridge University Press, Cambridge.

Clarke EF (2001). Meaning and the specification of motion in music. *Musicae Scientiae*, **5**, 213–34.

Cooke D (1959). *The language of music*. Oxford University Press, Oxford.

Damasio AR (2004). Emotions and feelings: a neurobiological perspective. In A Fischer, ASR Manstead, and NH Frijda, eds. *Feelings and emotions: the amsterdam symposium*, pp. 49–57. Cambridge University Press, New York.

Darwin C (1871). *The descent of man and selection in relation to sex*. (Vols. 1–2) John Murray, London.

Darwin C (1872). *The expression of the emotions in man and animals*. John Murray, London.

Davidson RJ (1994). On emotion, mood, and related affective constructs. In P Ekman and RJ Davidson, eds. *The nature of emotion: fundamental questions*, pp. 51–5. Oxford University Press, New York.

Davies S (1994). *Musical meaning and expression*. Cornell University Press, Ithaca, NY.

Davies S (2001). Philosophical perspectives on music's expressiveness. In PN Juslin and JA Sloboda, eds. *Music and emotion*, pp. 23–44. Oxford University Press, New York.

Deutsch D (1999). *The Psychology of Music*. Academic Press, San Diego, CA.

Dimberg U, Hansson G, and Thunberg M (1998). Fear of snakes and facial reactions: A case of rapid responding. *Scandinavian Journal of Psychology*, **39**, 75–80.

Ekman P (1992). An argument for basic emotions. *Cognition and Emotion*, **6**, 169–200.

Ericsson KA (1997). Deliberate practice and the acquisition of expert performance: An overview. In H Jörgensen and AC Lehmann, eds. *Does practice make perfect? Current theory and research on instrumental music practice*, pp. 5–51. The Norwegian State Academy of Music, Oslo.

Ericsson KA, Krampe RT, and Tesch-Römer C (1993). The role of deliberate practice in the acquisition of expert performance. *Psychological Review*, **100**, 363–406.

Falk D (2000). Hominid brain evolution and the origins of music. In NL Wallin, B Merker, and S Brown, eds. *The Origins of music*, pp. 197–216. MIT Press, Cambridge, MA.

Fitch WT (2006). The biology and evolution of music: A comparative perspective. *Cognition*, **100**, 173–215.

Freeman WJ (2000). A neurobiological role of music in social bonding. In NL Wallin, B Merker, and S Brown, eds. *The Origins of music*, pp. 411–24. MIT Press, Cambridge, MA.

Frijda NH (1986). *The emotions*. Cambridge University Press, New York.

Gabrielsson A (2001a). Emotions in strong experiences with music. In PN Juslin and JA Sloboda, eds. *Music and emotion: theory and research*, pp. 431–49. Oxford University Press, New York.

Gabrielsson A (2001b). Perceived emotion and felt emotion: Same or different? *Musicae Scientiae, Special Issue 2001-2002*, 123–47.

Gabrielsson A and Juslin PN (2002). Emotional expression in music. In HH Goldsmith, RJ Davidson, and KR Scherer, eds. *Handbook of affective sciences*, pp. 503–34. Oxford University Press, New York.

Gould SJ and Lewontin RC (1979). The spandrels of San Marco and the Panglossion paradigm: a critique of the adaptationist programme. *Proceedings of the Royal Society of London*, **205**, 581–98.

Gould SJ and Vrba E (1982). Exaptation – a missing term in the science of form. *Paleobiology*, **8**, 4–15.

Greenfield MD (1994). Cooperation and conflict in the evolution of signal interactions. *Annual Review of Ecological Systems*, **25**, 97–126.

Grewe O, Nagel F, Kopiez R and Altenmüller E (2007). Emotions over time: synchronicity and development of subjective, physiological, and facial affective reactions to music. *Emotion*, **7**, 774–88.

Hanslick E (1957). *The beautiful in music / Vom Musikalisch-Schönen*. Bobbs-Merrill, Indianapolis, IN.

Hodges D (1989). Why are we musical? Speculations on the evolutionary plausibility of musical bahavior. *Bulletin of the Council for Research in Music Education*, **99**, 7–22.

Jongsma M, Eichele T, Jenks KM, Desain P and Honing H (2005). Expectancy effects on omission evoked potentials in musicians and non-musicians. *Psychophysiology*, **42**, 191–201.

Juslin PN (1997). Emotional communication in music performance: A functionalist perspective and some data. *Music Perception*, **14**, 383–418.

Juslin PN (2000). Cue utilization in communication of emotion in music performance: Relating performance to perception. *Journal of Experimental Psychology: Human Perception and Performance*, **26**, 1797–812.

Juslin PN (2001). Communicating emotion in music performance: a review and theoretical framework. In PN Juslin and JA Sloboda, eds. *Music and emotion: theory and research*, pp. 309–37. Oxford University Press, New York.

Juslin PN and Laukka P (2003). Communication of emotions in vocal expression and music performance: Different channels, same code? *Psychological Bulletin*, **129**, 770–814.

Juslin PN and Laukka P (2004). Expression, perception, and induction of musical emotions: A review and a questionnaire study of everyday listening. *Journal of New Music Research*, **33**, 217–38.

Juslin, PN and Madison G (1999). The role of timing patterns in the decoding of emotional expressions in music performances. *Music Perception*, **17**, 197-221.

Juslin PN and Sloboda JA, eds. (2001). *Music and emotion*. Oxford University Press, New York.

Kivy P (1990). *Music alone. Philosophical reflections on the purely musical experience*. Cornell University Press, Ithaca, NY.

Kivy P (1999). Feeling the musical emotions. *British Journal of Aesthetics*, **39**, 1–13.

Kivy P (2002). *Introduction to a philosophy of music*. Oxford University Press, Oxford UK.

Kleinginna PR and Kleinginna AM (1981). A categorized list of emotion definitions, with a suggestion for a consensual definition. *Motivation and Emotion*, **5**, 345–71.

Laiho S (2004). The psychological functions of music in adolescence. *Nordic Journal of Music Therapy*, **13**, 49–65.

Langer SK (1951). *Philosophy in a new key*, 2nd edn. New American Library, New York.

Langer SK (1953). *Feeling and form*. Charles Scribner's Sons, New York.

Large EW and Palmer C (2002). Perceiving temporal regularity in music. *Cognitive Science*, **26**, 1–37.

London J (2001). Some theories of emotion in music and their implications for research in music psychology. *Musicae Scientiae, Special Issue 2001-2002*, 23–36.

Madison G (2000). Properties of expressive variability patterns in music performances. *Journal of New Music Research*, **29**, 335–6.

Madison G (2006). Experiencing groove induced by music: consistency and phenomenology. *Music Perception*, **24**, 201–8.

Madison G and Merker B (2002). On the limits of anisynchrony in pulse attribution. *Psychological Research*, **66**, 201–7.

Madison G and Merker B (2003). Consistency in listeners' ratings as a function of listening time. In R Bresin, ed. *Proceedings of the Stockholm music acoustics conference*, pp. 639–42. Royal College of Technology, Stockholm, Sweden.

Madison G and Merker B (2005). Timing of action during and after synchronization with linearly changing intervals. *Music Perception*, **22**, 441–59.

Madison G, Schiölde G, and Paulin J (submitted). Repeated listening increases preference for music regardless of its complexity: implications for music aesthetics and the mere exposure effect. Submitted for publication.

Marler P (2000). Origins of music and speech: Insight from animals. In NL Wallin, B Merker, and S Brown, eds. *The origins of music*, pp. 31–48. MIT Press, Cambridge, MA.

Maslow AH (1976). *The farther reaches of human nature*. Penguin Books, Princeton.

Merker B (1999). Synchronous chorusing and the origins of music. *Musicae Scientiae, Special issue 1999-2000*, 59–73.

Merker B (2000). Synchronous chorusing and human origins. In NLWallin, B Merker, and S Brown, eds. *The Origins of music*, pp. 315–27. MIT Press, Cambridge, MA.

Merker B (2002). Music: the missing humboldt system. *Musicae Scientiae*, **6**, 3–21.

Merker B (2005). The conformal motive in birdsong, music, and language: An introduction. *Annals of the New York Academy of Sciences*, **1060**, 17–28.

Merker B (in press). The vocal learning constellation: imitation, ritual culture, encephalization. In N Bannan and S Mithen, eds. *Music, language, and human evolution*. Oxford University Press, Oxford UK.

Merker B, Madison G, and Eckerdal P (2009). Human rhythmic entrainment: Comparative, functional, and developmental aspects. *Cortex*, **45**, 4–17.

Meyer LB (1956). *Emotion and meaning in music*. University of Chicago Press, Chicago, IL.

Miller GF (2000). Evolution of human music through sexual selection. In NL Wallin, B Merker, and S Brown, eds. *The origins of music*, pp. 329–60. MIT Press, Cambridge, MA.

Mithen S (2005). *The singing neanderthals: the origins of music, language, mind and body*. Weidesfeld and Nicolson, London.

Molino J (2000). Toward an evolutionary theory of music and language. In NL Wallin, B Merker, and S Brown, eds. *The origins of music*, pp. 165–76. MIT Press, Cambridge, MA.

Oatley K and Jenkins JM (1996). *Understanding emotions*. Blackwell, Oxford.

Payne C (2000). The progressively changing songs of humpback whales: A window on the creative process in a wild animal. In NL Wallin, B Merker, and S Brown, eds. *The origins of music*, pp. 135–50. MIT Press, Cambridge, MA.

Peretz I (2006). The nature of music from a biological perspective. *Cognition*, 100, 1-32.

Persson RS (2001). The subjective world of the performer. In PN Juslin and JA Sloboda, eds. *Music and emotion: theory and research*, pp. 275–89. Oxford University Press, New York.

Plutchik R (1994). *The psychology and biology of emotion*. Harper Collins, New York.

Power M and Dalgleish T (1997). *Cognition and emotion: from order to disorder*. Psychology Press, Hove, UK.

Richman B (2000). How music fixed 'nonsense' into significant formulas: On rhythm, repetition, and meaning. In NL Wallin, B Merker, and S Brown, eds. *The origins of music*, pp. 301–14. MIT Press, Cambridge, MA.

Rigg MG (1964). The mood effects of music: A comparison of data from earlier investigations. *Journal of Psychology*, **58**, 427–438.

Roederer J (1984). The search for a survival value of music. *Music Perception*, **1**, 350–6.

Saarikallio S (2007). The role of music in adolescent's mood regulation. *Psychology of Music*, **35**, 88–109.

Schellenberg EG, Peretz I and Vieillard S (2008). Liking for happy- and sad-sounding music: Effects of exposure. *Cognition and Emotion*, **22**, 218–37.

Scherer KR (2004). Which emotions can be induced by music? What are the underlying mechanisms? And how can we measure them? *Journal of New Music Research*, **33**, 239–51.

Scherer KR, Zentner MR and Schacht A (2001). Emotional states generated by music: An exploratory study of music experts. *Musicae Scientiae, Special Issue 2001-2002*, 149–71.

Scruton R (1997). *The aesthetics of music*. Oxford University Press, Oxford, UK.

Slater, PJB (2000). Birdsong repertoires: Their origins and use. In NL Wallin, B Merker, and S Brown, eds. *The origins of music*, pp. 49–63. MIT Press, Cambridge, MA.

Sloboda, JA (1990). Musical excellence - how does it develop? In MJ Howe, ed. *Encouraging the development of exceptional skills and talents*, pp. 165–78. BPS Books, London.

Sloboda, JA (1998). Does music mean anything? *Musicae Scientiae*, **2**, 21–32.

Sloboda JA and O'Neill. SA (2001). Emotions in everyday listening to music. In PN Juslin and JA Sloboda, eds. *Music and emotion: theory and research*, pp. 415–29. Oxford University Press, New York.

Sloboda JA, O'Neill, SA and Ivaldi A (2001). Functions of music in everyday life: An exploratory study using the experience sampling method. *Musicae Scientiae*, **5**, 9–32.

Timberlake WD and Silva KM (1995). Appetitive behavior in ethology, psychology, and behavior systems. In N Thompson, ed. *Perspectives in ethology*, pp. 211–53. Plenum Press, New York.

Tymoczko D (2006). The geometry of musical chords. *Science*, **313**, 72–4.

Ujhelyi M (2000). Social organization as a factor in the origins of language and music. In NL Wallin, B Merker and S Brown, eds. *The origins of music*, pp. 125–34. MIT Press, Cambridge, MA.

Wallin NL, Merker B and Brown S (2000). *The origins of music*. MIT Press, Cambridge, MA.

Watt RJ and Ash RL (1998). A psychological investigation of meaning in music. *Musicae Scientiae*, **2**, 33–54.

Wright AA, Rivera JJ, Hulse SH, Shyan M and Neiworth JJ (2000). Music perception and octave generalization in rhesus monkeys. *Journal of Experimental Psychology: General*, **129**, 291–307.

Zangwill N (2004). Against emotion: Hanslick was right about music. *British Journal of Aesthetics*, **44**, 29–43.

Zatorre RJ and Halpern AR (1993). Effect of unilateral temporal-lobe excision on perception and imagery of songs. *Neuropsychologia*, **31**, 221–32.

Zatorre RJ and Peretz I (2001). The biological foundations of music. *Annals of the New York Academy of Sciences*, **930**, 281–99.

THE MYSTERY OF REPRESENTATION: A CONVERSATION WITH VIK MUNIZ

VIK MUNIZ AND DAVID MELCHER

Davɪᴅ Melcher (D.M.): How has your work been informed by your interest in science?

Vik Muniz (V.M.): I am interested in science in part because, when I was 16, that is what I wanted to do—I wanted to be a psychologist. But also my interests were somehow always related to art, and I was thinking about *why* people saw images. What is the nature of representations? At my art school we had some texts from scientists like James Gibson, Irving Rock, and Julian Hochberg. I started reading about what has now become this multidisciplinary thing called 'cognitive neurosciences', which is the sum of many of the issues in which I have always been interested—but it did not have a name back then.

My work has been informed by science, as by everything else in my experience, both directly and indirectly. I am friends with physicists and psychologists, who are also interested in explaining the world. There is a split between mind and phenomenon, between art and science. You see this in the writings of Galileo. They complement and complete each other, but this allows science to continue its project and for art to go in another way. I think that artists basically have to deal with the same things scientists do. Only the approach is radically different. While scientists are generally trying to define the world around them by focusing on phenomena, artists do so

by focusing on mind. Scientists define a tangible world with formulae and symbols while artists deal with a world made of sensations and feelings, through the making of tangible products.

D.M.: Let's talk about *Atalanta and Hippomenes, after Guido Reni* (2005–6), which is part of your 'pictures of junk' series (Fig. 18.1). From a distance, it appears as a copy of Reni's large canvas dating from 1622–5, emphasizing the outline of the two characters and their shadows. Upon moving closer, however, the image decomposes into the countless objects that form it as if it were a giant collection of worthless trash. Wittily quoting from history of art at large, from Renaissance to Impressionism (which prescribed a certain distance from the canvas in order to recognize what its fragmented surface represented), you managed to shift our attention from the subject matter to the process of vision and of drawing. Humble bins, tyres, crushed cans, ropes, broken motors, and tubing—in short the debris resulting from mechanical work—give visual existence to a subject matter of the highest cultural content: a legend from Greek mythology, painted for a rich patron, which the intelligentsia of the seventeenth century would pride itself in recognizing. In describing your work, you have said:

Recognition is a kind of comfort. It confirms your capacity of looking at something and analysing it, but it also reinforces your familiarity. What is good, however, is to be able to produce that warm feeling where you recognize something and at the same time you're able to subvert that recognition. This brings us back to the joke and the gimmick, like Buster Keaton.

Fig. 18.1 Vik Muniz, *Picture of Junk: Atalanta and Hippomenes, after Guido Reni*, 2005–6. Rovereto, Mart Museum. (See Colour plate 4)

I exaggerate the gimmick in my work because I want to engage the viewer with some kind of mechanical image that is almost inescapable, where they not only see the artist, but they feel the vision.

(Magill 2000)

V.M.: I am involved in a level of art and representation that is very raw—I try to go back to basic things. There are thinkers like Arnheim or Gombrich who were trying to deal with these basic questions about representation from the point of view of psychology. And I also thought, in my work, that I would need to do something related to representation.

D.M.: You have suggested that, historically, two types of art have developed: 'Art that comes from embodiment, which is theatre, dance and music, and art that's a graphical projection like drawing. These two arts were probably developed by primitive shamans. They understood they were exercising a kind of power' (Magill 2000). How does your work tap into these two forms of art?

V.M.: Because I see these as complementary primitive forms of symbolic exchange. Even though my work is predominantly involved with the projective kind of representation, I have always tried to incorporate concepts of theatre and performance art in my work without having to fuse them into a seamless indiscernible format like the motion picture.

D.M.: Millions of people watched your work in which an aeroplane drew pictures of clouds in the sky above New York City (2001). The cloud-watching game is one of the most ancient pastimes, explored also in your series 'Equivalents' (1993). What does our ability to see recognizable shapes in clouds tell us about how our mind works?

V.M.: Clouds have been a recurring theme in my work for 20 years. In 'Equivalents', I made 'cotton clouds' that resembled something like a man rowing a boat, or a kitty cat. We can only read one meaning at a time. If you see the cat, you lose the cotton. If you see the cotton, you lose the cloud. Like Necker's cube, you see one interpretation or the other. J.T. Mitchell called this 'multistable images'. This was used in the early Renaissance, with the goal of creating images that had multiple interpretations.

 In the case of clouds, in the sky, it was even more interesting. I tried to make a *drawing* of a cloud, in the sky, that looked exactly like a cloud. But even so, it did not work, because with a small change over time in the shape of the cloud, people could not help seeing meaning, a baseball glove or even a phallus, in something that was supposed to be self-referential!

D.M.: At the same time, you have also noted how shamans, priests, artists, and con men have used these 'tricks' to evoke power (Magill 2000). You have said :

I don't want to amaze you with my powers to fool you. I want to make you aware of how much you want to believe in the image to be conscious of the measure of your own belief,

rather than of my capacity to fool you. You see it, but at the same time you see how it works. I have been called an illusionist, but I have always considered myself a twisted kind of realist

(Magill 2000)

V.M.: The visual cortex is a sucker—it sees things even when they are not there. We have this tendency to see things; we developed recognition from a very primitive stage as a tool to see shapes for food or survival. And the visual system still fancies the shape of the prey in everything it focuses on. We have become very good at detecting patterns that look like something.

I have a three-year-old, who has been teaching me for two years now about vision science because she tells me that 'this looks like this' or that, and it is amazing the power of associations, to match patterns to recognition.

D.M.: This ability to see patterns links our current experience with our memories. Your work has also explored the role of emotion and memory in lived experience. Your work *Individuals* (1992) is a series of photographs of lumps of Plasticine modelling clay, yet they seem to convey emotions. Feeling is an important theme in your work. To quote from one of your essays:

I remember as a child, running through bed sheets hung out to dry, the exhilarating feeling of moving in space with my entire body. I needed the bed sheets not only as a surface of contact but also as a cognitive instrument that revealed systematically the successiveness of surfaces. Like the peek-a-boo game that teaches a child the parent will always be there, revelation is a tool to generate the emotions that punctuate the secret clock of our lives. We remember the past through these moments when something was revealed, and surprised, we became full of emotion. These two things, surprise and emotion, go hand in hand in such a way that we sometimes don't even notice them. To be able to draw attention to the importance of these things, we must understand the mechanics of surprise and subvert it, positioning the audience at the same time as a victim and analyst of the experience.

(Muniz and Eccher 2003)

V.M.: I was talking the other day with a chef and she said: 'it is no good writing about cooking', and maybe it is no good writing about painting either. There is a big gap between what you can feel and what you can write or explain by language alone. It is interesting to try to create works that bridge this gap between sensation and knowledge.

D.M.: To bridge this gap between sensation and knowledge is difficult, if vision seems so fast and effortless. You have said that:

I try to slow down the perceptual input of the image in my photographs so that you actually look at them . . . What I want to show you is that there is a machine, in the back of your head. I don't want to show you exactly how it works; I want you to guess a little bit.

(Magill 2000)

V.M.: The physiology of the eye and the visual cortex is fascinating. I am surprised when people want to become artists but are not interested in the basics about how

light behaves, how vision works. Maybe 90% of what we know about vision is relatively recent. I am fascinated about the way the eye works, because the eye is very primitive and is not so good at making optical images. Our eyes are not as good as birds' eyes or many other animals. The fovea, with best vision, covers just a few degrees and all the rest is peripheral, it is blurry. It is only by moving the eyes around that you have the impression of a continuous whole. Partly because our eyes are so poorly designed, this creates a narrative through the series of saccades. One of the most impressive things is our ability to recognize faces.

D.M.: A classic image from vision science is Yarbus's (1960) illustration of the gaze pattern when looking at a picture of a face. Most of the fixations alternate between the eyes and the mouth. This reminds us of a quote about your interest in face perception:

When I became involved with portraiture, I was more fascinated by the fact that we can recognize one face from millions of others than anything else. After working for so long with recognition, I decided to explore the subject in which this phenomenon is exercised with the greatest skill by our brains. How do we recognize a face? The eye wanders through a face, scanning for familiarity. It goes from point to point, making every face a narrative. Every face is a story.

(Muniz and Eccher 2003)

V.M.: The development of narratives, through saccades that can also be remembered, is one of the most important elements in the creation of consciousness in the human mind. We have this huge visual cortex devoted to analysing stimuli—that is our true 'eye'. This inability to see everything in focus introduces a concept of narrative and attention, which is important.

D.M.: You have suggested that the human intellect has, to some extent, evolved, based on this limit of clear vision in the fovea and the need to move the eyes. Is the narrative aspect of vision important also for the creation of art?

V.M.: My work *Pictures of magazines* explores this 'saccadic narrative'. There are a series of dots. The viewer stands at a distance where the picture covers the entire visual field, and this means that each dot covers about 3% of the entire visual field.

D.M.: You have said that this idea was inspired by how people look at paintings in museums:

they approach the picture and position themselves so that it comfortably fills up their visual field, but is always close enough so they can sense the texture of the paint itself. The moment when the image dissolves back into matter is as revealing as the moment dabs of paint become the likeness of an angel or a fish. These are the moments that contain in their transcendence, the very nature of representation.

(Muniz and Eccher 2003)

But in your work, there are not just dabs of paint.

V.M.: The dots have an identity themselves: pictures, faces, houses, body parts, letters, or words. This gives your saccades target points, where the local image makes you pause longer; it slows down your saccades. The picture refuses a smooth reading. As your eyes are sweeping the picture, your eyes have to 'stop', and so the picture becomes problematic. This is something I try to do in much of my work: to create little problems that make you 'feel' what is going on. It is like finding a little bone in the fish that makes you stop and realize that, right now, you are eating fish.

D.M.: So this is the idea of making perception 'problematic'. You have said that 'Art is somehow like brain-science; you only get to know something works by looking at things that have stopped working' (Galassi and Muniz 2004).

V.M.: When I was little, electricity shortages were frequent in my native São Paulo and it was only then that we had a chance to evaluate our dependency on machines. Only once it had stopped working. It had a different effect on us than it had on my grandmother who lived most of her life without electricity. In a sense, her numbness to technology and her failure to adapt made her successful in those situations; the frustrated rest of us just ended up with lots of things to think about it.

D.M.: Having something to think about does not necessarily lead to frustration, but there can also be a pleasure to being fooled. You have said that:

The logical blur that one experiences in front of an illusionistic picture is similar to what one experiences after hearing a joke. Suddenly there is an enormous vacuum in your mind that the cognitive apparatus registers as pleasurable because that's what the mind likes to do: to fill these places with wild and abstract thoughts.

(Muniz and Stainback 1998)

How do you know which is the result—frustration or pleasure? Is this a measure of success or failure, like in an experiment?

V.M.: How would you define success in a scientific experiment? There's always a loose measure of satisfaction that, while rewarding you with some merit and sense of direction, always leaves you with the necessary feeling of incompletion to keep on working. I think my work becomes successful the moment when I can identify patterns on the viewers' reactions to it that can be used in further research.

D.M.: Keeping with the theme of scientific experiments, your work also explores the nature of scientific images themselves. For example, your series 'Principia' involved looking at pseudo-scientific images through an apparatus. What motivated this work?

V.M.: What you see when you look through the stereoscope is a series of things that 'look like' the kind of specialized imagery that science generally gives us. The viewers tend to take these absurd concoctions seriously because of the 'scientific' way they are

displayed. Scientific knowledge is worthless if we cannot find ways to demonstrate, sell, and disseminate it, and that usually comes with an unavoidable dose of rhetoric.

REFERENCES

Galassi P and Muniz V (2004). Natura pictrix: Vik Muniz with Peter Galassi. *Natura pictrix: interviews and essays*, pp. 88–97. Edgewood Press, New York.

Magill M (2000). Vik Muniz. *Bomb Magazine*, **73** (Fall 2000).

Muniz V and Eccher D (2003). *Vik Muniz: exhibition catalog*. Museum of Contemporary Art, Rome (September 2003–January 2004).

Muniz V and Stainback CA (1998). Vik Muniz and Charles Ashley Stainback: a dialogue. In *Seeing is believing* (exhibition catalogue). Arena Editions, Verona.

PICTORIAL CUES IN ART AND IN VISUAL PERCEPTION

DAVID MELCHER AND PATRICK CAVANAGH

INTRODUCTION: WHY DO WE LOOK AT PICTURES?

ARTISTS have been looking at the world for thousands of years, and thus paintings and drawings can be considered to form a 40 000-year-old corpus of experimental psychology of perception. Through observation and trial-and-error they have exploited the principles of how our brains interpret the input from the retina, giving priority to only certain regularities of the visual pattern. Thus, a study of pictorial cues can tell us about the way that the brain recognizes objects, understands spatial depth, and uses illumination information in natural environments. Conversely, a better understanding of visual perception may help to explain the effectiveness of certain techniques used by artists. Therefore, this essay will focus on some basic techniques in pictorial depiction that allow blobs of paint or charcoal marks to evoke objects, depth, movement, transparency, illumination, and reflection. The development of these pictorial

techniques by artists can be considered as fundamental discoveries about the neuro-science of perception.

The human eye responds to a limited range of frequencies of electromagnetic radiation known as visible light. This light is focused by the lens of the eye and then, via special cells in the retina, translated into a pattern of neural firing that is sent to the brain. The brain's dedicated network for making sense of the pattern of light evolved to respond to dynamic three-dimensional environments, but even a flat, static image can provide enough cues to trigger the recognition of objects and scenes. These flat pictures do not behave like three-dimensional objects and scenes, nor do they change with self-movement like reflections in water or a mirror. Instead, the projection of a flat picture on the retina is deformed when the viewing point of the observer changes, a fact which is made apparent in photographs of photographs or photographs of a flat object which has been folded or rotated (Fig. 19.1). Across various cultures (Kennedy and Ross 1975) and even in some animals (Itakura 1994), there is a surprising tolerance to flatness and stasis in images: this relative insensitivity to the dramatic difference between a picture and the real world is one of the foundations of visual art. In fact, it is difficult to image modern life without this ability to overcome the

Fig. 19.1 Cindy Sherman, *Untitled n. 246*, 1987–91.

(Mart Museum, *Rovereto*)

The visual system is incredibly adept at reconstructing from a photograph the flatness of objects such as a photograph or even a rubber mask. However, a photograph of a folded, crumpled or bent image no longer supports the percept of the veridical shape of the image. In this case, a simple rubber mask that is twisted and folded takes on a distorted, almost horrific, appearance.

lack of three-dimensionality in pictures. A world without tolerance to flatness would contain no paintings, posters, televisions, or cinema, but would instead be filled with statues of people and sculptures of scenes, in place of pictures and photographs.

This essay will focus on the techniques used by artists to depict recognizable objects and scenes in flat representations. Of particular interest is the many ways in which pictures deviate from 'correct' optical representations. Our visual system has a lifetime of experience with real scenes, but the same brain is able to make sense of pictures which, in many ways, look nothing like optically produced images.

For example, the style of film-making known as the 'Hollywood style', which has developed over the past century (Bordwell et al. 1985) aims to shoot and edit the scenes in such a way that the lighting, placement, and use of cameras, set design, and editing is not noticed by the viewer (Reisz and Miller 1968; Bordwell et al. 1985; Cutting 2005). This focused approach to narrative film-making does not attract attention to the process itself, but rather the story. The principles that allow for seamless perception of such an artificial medium are critical for understanding the mind. In order to go unnoticed, film techniques must work within the constraints of the human visual system. Thus, movies can tell us something also about how we perceive the real world, even if the scene in question (such as a flying superhero) could not exist in everyday life. Similarly, artists working with static media such as photography, drawing, or painting can choose to portray pictorial information—such as object shape and colour, lighting, depth, and reflection—rather than drawing attention to their technique itself. It is useful to investigate the nature of pictorial cues that maximize the ability to recognize objects and scenes in order to better appreciate the deviations from these rules. It is this ability of art to reproduce certain aspects of natural scenes without merely copying them that provides insight into the workings of the human perceptual system: an understanding of the 'psychophysics' of the brain rather than the physics of optics.

Depicting object contours

One common attribute of pictures in a broad array of artistic traditions, starting from the earliest surviving depictions on cave walls, is the use of boundary lines to depict the edges of objects. Of course, there are no actual contour lines dividing real objects from their backgrounds in most cases, which raises the question of why contour lines are so ubiquitous and effective in depiction. One theory is that line drawings are a convention that are imposed within a particular culture and passed down through learning. The fact that some animals (Itakura 1994), human infants (Yonas and Arterberry 1994), and members of stone-age tribes (Kennedy and Ross 1975)

have all been shown to interpret line drawings as objects argues strongly against this idea.

It is clear that boundary lines are important to the brain. The initial stages of visual processing focus on finding discontinuities in brightness, colour, and depth, a scientific discovery which led to the awarding of the 1981 Nobel Prize to Torsten Wiesel and David Hubel. Some of these discontinuities capture important information about the objects and surfaces in a scene, but many are accidental and uninformative. Artists making a line drawing usually focus on the most important of these transitions in brightness, colour, and depth, leaving out the edges of cast shadows and transitions in colours. In particular, contours are used to represent three-dimensional shapes. This is true both from a developmental perspective, as is apparent from looking at children's pictures, and from an art historical point of view—considering that the artists' training has traditionally included sketching from life as one of the most important exercises. When an artist is able to depict the form of an object, this signifies an understanding (implicit or explicit) of the key contours that must be extracted by the visual system in the brain in order to recognize the three-dimensional structure of a particular object. The process of drawing is essentially a process of selection. Extracting all lines from an image would create a confusing mess, which lacks the economy of a child's drawing or the poetry of an artist's sketch (Fig. 19.2). The artists of the Palaeolithic era discovered the essentials of the principles of shape-by-contour, the rules of which are still being investigated by scientists of the twenty-first century. As such, artworks can be viewed as scientific data: perhaps by studying the use of lines by artists, scientists may learn the explicit rules of this implicit, secret knowledge.

Boundaries are critically important not just for vision but also for haptics, understanding objects through touch. Lines perceived through the eyes can support the recognition of objects that have only been experienced through touch. One of the most

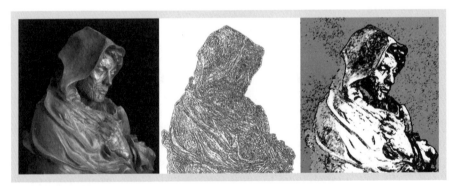

Fig. 19.2 Photograph of the sculpture 'Saint Francis as Brother Wind' by Fiorenzo Bacci (San Damiano, Assisi), a version of the same modified using the 'extract contour' function of Photoshop, a version of the same using the 'sketch/chalk and charcoal effect' function of Photoshop.

(photograph by Nicola De Pisapia and modified versions by Francesca Bacci)

striking examples of this multisensory representation of objects is the case of Sidney Bradford, who acquired vision at age 56 after a life of blindness (Gregory 2004). The vision scientist Richard Gregory interviewed him shortly after the surgery, but suspected a hoax when the patient immediately read the time of the clock on the wall. It turned out that Bradford could visually recognize all objects—and only those objects—that he had previously recognized through touch (see Bacci, Chapter 7, this volume). The similarity between identifying an object by seeing its drawn contours and feeling the contours with the eyes closed has been confirmed in several studies using neuroimaging (see Amedi et al., Chapter 23, this volume). Indeed, there are many blind artists that can create images on flat surfaces that capture their experience of objects they have only touched and are interpretable to the sighted.

Moreover, there are various lines of evidence to show that viewing the outline drawing of a tool can lead to activation in the brain's regions involved in planning grasping movements, even if there is no motor response required for the task (for example, Chao and Martin 2000; Devlin et al. 2002). One line of experimental evidence involves 'affordance' effects, such as the finding that we are quicker to press a button with our right hand when responding to a photograph of a cup whose handle is oriented towards the right (Craighero et al. 1998; Tucker and Ellis 1998). The priming of action by the right hand, in that experiment, occurs even though the stimulus is a photograph and the observer is making a judgement about the name, not the shape, of the object. Some patients with damage to a specific area of their frontal lobes develop a disorder known as 'utilization behaviour' (Lhermitte 1983). If you place a cup in front of the patient, they will pick it up and attempt to drink out of it. If the patient sees eyeglasses, he or she will immediately put them on, even if already wearing another pair. The patient cannot resist a bowl of fruit, they feel that the object 'orders' them to use it.[1]

Overall, research suggests that artworks, even simple line drawings, have the potential of evoking a visual-motor response. This raises the empirical question of which artworks engage the observer's brain in this way and why. Drawings by the artist Claude Heath (see Bacci, Chapter 7, this volume) provide an interesting starting point for discussing the meaning of drawn contours. Heath has drawn objects while blindfolded, using only the sense of touch. He places a small point of reference, such as a piece of Blu-Tack, on the object and another on the piece of paper. Subsequently, he explores the object with one hand while simultaneously drawing with the other, being careful to maintain exactly the same distance from the reference points in both of his hand journeys. This exercise reminds us that drawings tend to use lines which are not real—the contour simply gives the useful information about where the object ceases to 'spread out' in relation to the centre of our gaze at that moment. Movement by the

[1] Interestingly, a recent study of obesity suggests that food also tempts our hands as soon as we see it (Myslobodsky, 2003). According to the Stoics, the perception of an object was automatically tied up with its ability to create an impulse towards or away from that object (*phantasia hormetikê*). Similarly, phenomenological philosophy has stressed the 'embodied' nature of humans within an environment full of objects that are 'at-hand' and suggest action. Recent work in the study of vision is beginning to reveal these links between vision, the other senses and the body.

observer or the object changes the project of this contour in two dimensions. For our visual system, this 'viewpoint specific' representation of shape is useful, but our brain also appears to calculate an estimate of the 'unseen', real three-dimensional shape of the object. Why? Because visual contours are not interesting, *per se*, for actions such as grasping, which are based on where to put the hand in relation to the three-dimensional shape of the object. These 'touch contours' are not viewpoint-specific. When you reach to grab a cup, or to embrace a lover, your grasp extends around into the unseen, but 'perceived' limits of the body. When Heath closes his eyes and draws what he feels with his hands, he may be trying to access the information that we use for action. Interestingly, the artist uses Blu-Tack to anchor his hand at a fixed point on the paper. Does this mean that he is using a hand-centred representation of space with his drawing hand to draw what he is perceiving with his other, feeling hand? The shape of the lines suggests a three-dimensionality that is difficult to translate into the contour-based medium of drawing. That may be one reason why Heath's drawings are so intriguing.

TWO PATHWAYS TO OBJECT RECOGNITION

When it comes to recognizing objects, boundary lines are certainly not the whole story. Let's take a moment to look at how we see. At the centre of our gaze, the world appears in fine detail and in colour, while the percept from the peripheral areas of our field of vision yields less precise information. Central vision is useful for tasks like reading and guiding complicated actions, while peripheral information gives a more general idea of the identity of an object and whether or not it is moving. Because visual acuity is best at the centre of gaze (the fovea), most people look directly at objects of interest. Nonetheless, it is clear that we are able to understand a great deal about the world even out of the corner of the eye or in a dimly lit room where the 'fine detail' pathway is of little use.

One reason that coarse information might be particularly useful is time. There are fundamental constraints on how biological systems can encode and extract information over time. With our big, energy-consuming brains processing all of these minute, fine details, the whole process can get pretty slow. Thus, it seems that in addition to the 'fine detail' pathway there is also a visual 'fast track' that can begin more quickly to influence behaviour based on the coarse pattern without waiting for the exact details to arrive. Presumably, this design allows for quick responses to salient events, such as the arrival of a speeding bus or the presence of a rattlesnake in the hiking path.

Using sophisticated laboratory techniques, it is possible to measure the processing of coarse visual information. One finding from these studies is that certain patterns evoke emotional responses and that it is the coarse information that plays the predominant role (for review, see Vuilleumier and Pourtois 2007). In fact, this coarse

information can affect our responses even to stimuli that we do not really see, when they are presented in the laboratory under conditions in which the stimulus does not reach conscious awareness.

Thus, artists have at their disposal at least two routes to visual recognition: the slow, detailed pathway and the fast but coarse pathway. Face recognition, for example, does not depend on seeing local details or even the presence of eyes, nose, and mouth in the depiction. The right pattern of light and dark patches is sufficient to evoke face recognition in the brain. In fact, people are surprisingly adept at seeing faces or animals in random patterns like clouds. At night, our ancestors played a similar game with the stars: when, connecting mentally the celestial dots, archers or bears appeared before their eyes. On a clear night, even the man on the moon shows his face. Leonardo saw this capacity as the basis of artistic creativity and recommended to his students to stare at natural patterns and try to find people, animals, and scenes hidden inside.

Giovan Battista Alberti noted that 'nature herself seems to delight in painting, for in the cut faces of marble she often paints centaurs and faces of bearded and curly headed kings' (*Della Pittura*, Book II, 28 [author's translation]). People flock to see such miracles of nature, particularly when the subject matter is religious. Recent examples include an appearance by the Virgin Mary on a tortilla, which drew tens of thousands of pilgrims, or her miraculous appearance on a toasted cheese sandwich, which sold on eBay for an incredible US $28 000. Likewise, the devil has appeared on the Canadian dollar bill and in a smoke pattern on the CNN news channel (smoke, like clouds, is a common medium for this phenomenon).

The fact that people tend to see people or animals in naturally occurring patterns is called *pareidolia* (from the Greek *para* (beyond, over) and *eidolon* (image, percept)). The fact that pareidolia tends to involve animals and faces may be related to the way that the visual system quickly and automatically identifies those stimuli (Melcher and Bacci 2008). 'Rapid visual categorization' is the term given by scientists to describe the ability of people in a laboratory setting to discriminate whether or not an animal is present in a picture (Thorpe et al. 1996; Rousselet et al. 2002). This ability appears to be largely automatic, since it requires little or no focused attention and occurs even for stimuli viewed out of the corner of the eye. Rapid categorization seems to work particularly well with animals and people. Moreover, a number of studies have shown that faces in particular can be detected quickly: our brain appears hardwired to process faces even when we do not see them clearly or even consciously (for review, see Johnson 2005). In sum, the visual system *wants* to see faces and animals.

The influential art historian Ernst Gombrich suggested that the visual system is attracted by certain patterns, since 'the greater the biological relevance an object has for us the more will we be attuned to its recognition – and the more tolerant therefore will be our standards of formal correspondence' (1963, pp. 6–7). The scientific evidence for rapid visual categorization, as well as the widespread phenomenon of pareidolia, support Gombrich's claim of perceptual tuning and our ability to recognize objects that appear deformed from the real thing. As Gombrich notes, there are obvious evolutionary advantages to a finely tuned sensitivity to face-like patterns. Infants, despite their initially poor visual acuity, are primed to recognize face-like patterns and

this aids their social interaction with caregivers (Johnson 2005). Similarly, the survival of our ancestors depended on their ability to quickly recognize the presence of an animal in the environment. Poor 'recognizers', who failed to react to faces or predators, would not have been likely to pass along their genes. There is a fine line, of course, between recognizing subtle patterns and seeing objects that are not there. Interestingly, the subject matter of hallucinations tends to follow the same pattern as pareidolia. A recent survey of the phenomenological experience of Parkinson's disease sufferers found that a majority of hallucinations (over 80%) involved people, disembodied faces, or animals (Barnes and David 2001).

Artists may have taken advantage of this quick and coarse processing system in several ways. First, artists can provide only the 'sketch' and expect the brain to fill in the details. Cubism and Impressionism, for example, rely on the brain to reconstruct scenes suggested by a pattern, by exploiting perceptual memory (Cavanagh 2005). The ability of modern artists such as Picasso, Severini, or Miró to distort images while still evoking perception of faces demonstrates the brain's 'holistic' processing of faces based on the gestalt-like pattern, rather than specific details (Figs. 19.3 and 19.4).

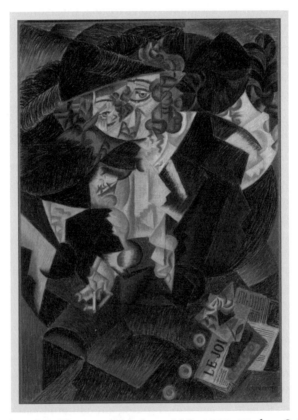

Fig. 19.3 Gino Severini, *Ritratto di Madame M.S.*, 1913–15. (see Colour plate 5)

(Mart Museum, Rovereto)

Understanding this work by Severini requires a series of complex perceptual processes in which elements are grouped together in order to allow the recognition that this is a portrait of Madame M.S.

Fig. 19.4 Joan Miró, *Homme et femme*, 1979. © Succession Miró/ADAGP, Paris and DACS, London 2011.

The tendency to see the human figure in patterns affords artists the freedom to creatively explore the male and female form in an infinite number of stylistic variations, as shown in this drawing by Miró.

Recognizing the identity of patterns is, after all, one of the basic functions of our perceptual system, so it makes sense that many people would enjoy pushing the system to its limits as a form of perceptual problem solving.

Second, it has been hypothesized that artists have used coarse information to specifically target emotional processing (Cavanagh 2005). Coarse information, such as Mooney patches of colour, is sufficient to trigger emotional responses in the brain even without awareness, while more detailed information is needed for recognition of the specific face (Vuilleumier et al. 2003). A painting with numerous distracting or, worse, inaccurate local details might hinder the rapid understanding of the subject matter by the slow pathway. The coarse information present in the work, on the contrary, finds rapid access to the emotions and areas of the brain involved in understanding the context and overall meaning of a scene. What happens, for example, with paintings

using divisionist techniques (such as in many Impressionist works)? The fragmented and crowded texture and mottled brushwork in Impressionist painting do not hinder direct access to emotions, while such information would be distracting for the slow object-recognition pathway. This may help to explain the massive popularity of this artistic movement (and, in particular, artists such as Monet, Degas, and Renoir) with the untrained public. Does the experience of such works tap into the coarse (context/emotion) system instead of into the slow, conscious object-recognition system?

A third implication of the importance of coarse information in visual perception is that it leads to overly generous recognition of random patterns that happen to vaguely resemble a particular object. It is likely that people have always experienced pareidolia. So a rock formation in a cave or a chip of an antler bone might have reminded early humans of an animal such as a deer or bull, just as it does to us today. The oldest artefacts that are representational (that is, they appear to us now as looking like an animal or other object) are stones and bones that have, at least in some cases, been intentionally modified to better fit an interpretation. In the caves in Altamira, Spain, for example, there is an instance in which eyes were painted on to a protrusion in the wall that resembled an animal head (Nougier 1969; Cutting and Massironi 1998). One interesting hypothesis is that the first sculptures or paintings by humans were modifications of natural patterns—such as Alberti's marble faces—rather than a sudden inspiration to create representational art on a blank canvas (for discussion, see Melcher and Bacci 2008).

CUES FOR DEPTH PERCEPTION

Even with a flat image, people are able to understand the depth relations between separate objects when pictorial cues to depth are present. The principles of portraying depth in pictures have been addressed at length elsewhere (Kubovy 1986; Maffei and Fiorentini 1995; Livingstone 2002). Not surprisingly, many of the techniques that have been developed to portray depth take advantage of optics and the physics of how images are projected into our eyes. As such, they are more 'discoveries of physics' than principles of visual neuroscience. There are, however, a number of phenomena related to depth cues in pictures that may tell us something about how the brain processes the input from the eye.

First, in the majority of figurative artworks making use of perspective there are local depth cues that do not conform with the system used in other areas of the picture (Figs. 19.5 and 19.6). These local inconsistencies go largely unnoticed. Even in Renaissance painting, perspective was usually locally linear for particular regions of the painting, not consistent globally. For most artists, linear perspective was simply a tool for telling the story, or a device to show their cultural refinement, rather than a rule to

Fig. 19.5 Fortunato Depero, *Casolari diroccati*, 1943.

(Mart Museum, Rovereto)

Local perspective cues are sufficient to give the perception of depth, even when the overall construction of the scene contains multiple, incompatible vanishing points.

slavishly obey (see Panofsky 1927/1991). Our inability to notice this inconsistency without drawing lines on a reproduction of the picture provides further evidence that the brain does not calculate full three-dimensional representations of the world to view with our mind's eye where the errors would be obvious (Cavanagh 2005).

Second, even the most carefully crafted perspective scheme failed to capture normal visual perception. Leonardo da Vinci, for example, distinguished between mathematical perspective and true psychological perspective. One problem noticed by Leonardo was that a picture of a building with frontal columns that was made using linear perspective would result in columns of unequal width. Paintings and photographs, unless done in stereo, also fail to take account of the fact that we typically view the world with two eyes. Photography, in particular, has been described as the culmination of centuries of investigations on how to use optics to create a permanent, imitative depiction of a visual scene. However, one can argue that the influence of photography is not due simply to its potential to 'substitute' for painting: instead, photography also revealed the *limitations* of imitative optical depictions. Photographs could show that a painted image almost invariably contrasted with psychological perception of the same scene as captured by the camera. The public could evaluate for the first time how heavily artists edited reality, when painting, to fit the expectations of the

Fig. 19.6 Giorgio De Chirico, *Piazza d'Italia (Souvenir d'Italie)*, 1924–25.

(Mart Museum, Rovereto)

The shadows in this work are oriented in varying directions, consistent with the presence of more than one lighting source, yet this confusing feature is not typically noted by observers.

observers' eyes. In addition, many photographs do not look 'real' either. For example, the strange and unnatural way in which movement is often depicted by photography contrasts sharply with our perception of movement. The photograph raises the question: which is the real image: the one created by a camera or the one perceived in the mind's eye?

Contemporaneous with the advent of photography, Wheatstone's invention of the stereoscope sounded the death knell for the assumption that linear perspective reflected perceptual reality (see Pierantoni, Chapter 20, this volume). The stereoscope demonstrated a subjective perception of depth that did not correspond to *either* of the images shown to the separate eyes, challenging the idea that Renaissance perspective is truly an imitation of natural perception. The failure of linear perspective to capture 'perceptual depth' was laid bare, opening up a new investigation by art and science into perception and depiction of space. The first depiction by humans created the 'problem of depth', with the figure automatically perceived in front of the background. In the nineteenth and twentieth centuries, artists have taken up this challenge by exploring space and time, such as in Cubism or Futurism, or by attempting to create flat, 'optical' images (as championed by theorists such as Greenberg and Fried) that do not segregate into figure and ground (such as in works by Mondrian and Pollock).

One can argue that 'the trouble with optics is the trouble with photography: it's not real enough, it's not true enough to lived experience' (Hockney 2005). While this statement is open to interpretation, it does point out the fact that pictorial representation, when based on an artist's sensorimotor interaction with the world, necessarily differs from a single snapshot. Of course, photographers know that there is no such thing as 'the photograph' of a scene: even when a print comes from an unretouched single negative, it still reflects a series of decisions about focus, focal length, aperture, lighting, and composition. In a painting, artists have even greater licence to manipulate the observer's neural response by, for example, changing the surface properties, adding new colours, or enhancing the cues to movement.

MOVING PICTURES AND THE PORTRAYAL OF DEPTH IN CINEMA

Unlike a painting, in cinema the picture changes rapidly. Why are we not bothered by the many 'cuts' that suddenly change the picture shown during the movie? The director John Huston claimed that:

all the things we have laboriously learned to do with film, were already part of the physiological and psychological experience of man before film was invented . . . Move your eyes, quickly, from an object on one side of the room to an object on the other side. In a film you would use a cut. . . . in moving your head from one side [to the other].

(Quote from Messaris 1994, p. 82)

It is interesting to consider in what ways 'cuts' in movies have turned out to be similar and dissimilar to our use of saccadic eye movements and fixations in everyday life. First of all, cuts are typically shorter than saccadic eye movements (which are so long that we should, in theory, see an image smeared across the retina). The two dominant explanations for why we do not perceive smeared images are saccadic suppression (the brain 'turns off' input from the eye before the saccade begins) and a type of backward masking in which the new image over-writes the old (Matin and Pearce 1965). For both cuts and saccades, we know that the visual system is essentially blind during the first 100ms or so after the new scene arrives because conscious visual perception is slow.

There is some concern that MTV-style cuts may be changing the way that we perceive film, but even music videos tend to show relatively long shots between cuts, compared to the average length of stable eye fixation in everyday life. Film cuts that are too fast, not allowing the observer to update their perception before a new cut begins, are disorienting. The film *Easy Rider* (1969) includes single-frame cuts mixed in with longer cuts and such a technique breaks the illusion of the movies by drawing attention to the cuts themselves (Cutting 2005). The single frame, much shorter than a fixation, did not give the brain enough time to process the new image before a new one replaced it.

In addition to limits on minimum duration, cuts must also fulfil other requirements to avoid calling attention to their existence (Hochberg and Brooks 1996). One necessity is that the scenes are very different, from different angles of different objects and, when possible, with a variation in the lighting. These conditions, of course, mimic the differences in fixations that tend to occur after saccadic eye movements. Thus, one can conclude that a major factor in whether or not we notice cuts in films is the degree to which those changes in image match what happens when we move our eyes in natural scenes (Hochberg and Brooks 1996; Cutting 2005).

A third issue is viewpoint. This issue is most clear in photography and cinema, where an explicit choice is made about the location of the camera, but drawings and paintings may take advantage of the same techniques. A simple example is whether to film a mixed group of adults and children from the eye height of the child or the adult. Looking down is equated with dominance, while looking up with a more submissive role (Messaris 1994). Sidney Lumet's 1957 film *Twelve Angry Men* provides a useful example of how viewpoint can be manipulated for narrative effect without the audience noticing (Cutting 2005). The first third is filmed from eye height (for a standing person), enabling a wider view of who is sitting at the table. Then in the second third, the camera is placed at sitting eye height, where the discussion between the jurors is taking place. Memory allows us to remember who is where in the room. In the final third, the camera was lower slightly, eliminating from view the table top and, presumably, making each actor into more of an individual rather than part of a group sharing a table together (Cutting 2005).

The perception of depth can be strongly manipulated by the way in which an artist (or photographer) chooses to portray the texture gradient (Gibson 1950). In general, the texture of an object is most easily seen when it is nearby and when it is viewed at the centre of gaze. This particular depth cue has not been used widely in art history (it was often used, at least in some form, in Renaissance painting), becoming much more important with the advent of photography and, subsequently, cinema. The lens of the camera can be used to exaggerate or minimize texture in a photograph, because the image that it transmits presents, much like eyesight, an area of sharp focus at the very centre and a progressive loss of acuity in the periphery.

Cinema has even attempted to mimic the physiological accommodation of the eye. One exaggerated example is provided by *Vertigo*, where the zoom lens intends to simulate the visual component in the sensation of vertigo. As mentioned earlier, painters also use various tricks of perspective to focus the attention of the observer. A case in point is Mantegna's *Dead Christ*, which seems to suggest that Jesus had very small feet compared to the size of his head. That Mantegna was simply mistaken in his use of perspective is one very unlikely possibility. Perhaps instead he chose to 'zoom' into the area of the scene that was most important for the narrative and emotional power of the work—the face of the dead Christ—by reducing the feet that were in the way. Modern filmmakers have the possibility, not available to Mantegna, to shift focal length over time and thus direct attention using these dynamic cues.

ILLUMINATION

What our eyes detect is the reflection of light off of surfaces. To our brains, this pattern of light is important mainly for allowing us to recognize and act upon objects. Thus, there is a basic distinction between the interpretation of visual perception as concerned with *light* or with *objects*. Artists may choose which of these aspects of perception are most important. The differences in style between Venetian and Central Italian schools (during the Renaissance) reflect these two sides of this argument. Venetian painting, influenced by the mercurial and atmospheric nature of illumination in that region of the world, often emphasized the play of light upon surfaces by privileging the use of colours over the linear construction of the image. It is an introspective approach that attempted to portray the phenomenological experience of the fleeting perception of colour and light as it happened with the flow of time. In contrast, the art of central Italy (such as Florence and Rome) was typically more concerned with portraying the solidity and depth of objects through the use of the line. Lighting, and thus colour, was a secondary factor and served to emphasize the three dimensionality of objects. In other words, these artists were mainly interested in those aspects of objects that do not change with the variations of light—in object permanence, one could say, rather than subjective transience. This impressive ability of the visual system to perceive objects as similar across different viewpoints and lighting situations is known as 'perceptual constancy'.

Artistic conventions to manipulate light and shade have served a number of purposes. The most basic manipulation, used at least since antiquity, is to lighten nearby surfaces and darken further away surfaces. One widespread device, described by Pliny the Elder, was to modulate the lightness of a folded garment so that the near fold was a lighter shade of the colour (see Gombrich 1960). One important caveat to note about this, however, was that the manipulations were entirely local. There was no attempt to make the source of the lighting consistent across the various objects portrayed in the scene. Now, computer generated graphics will perform these sorts of calculations as part of the rendering process. However, such technology may not be necessary, since many inconsistencies in lighting are typically not noticed by the viewer. Thus, there is no reason for artists to worry about overall consistent lighting and, in fact, there are several reasons to avoid consistent lighting, since often the 'impossible lighting' looks better. Photographers, for example, use a variety of techniques during shooting, development, and printing to manipulate the local lighting of scenes. Many of Steichen's most powerful prints (shot before the Photo Secession Movement) used burning and masking techniques that appear to represent, if one analyses closely, multiple lighting sources in the natural world, which would only be possible by adding a few extra suns or moons in the sky (or manipulating the negatives in the darkroom). During his young years the trick of printing from a few different negatives, a process called 'combination print', was largely popular.

A similar situation is found with cast shadows. The use of shadows to portray three-dimensional form and depth has been intermittent in Western art (Casati 2004; Gombrich 1995). One finds examples in classical Greek and Roman works (paintings and mosaics), but it was not widespread until the Renaissance. Initially, investigations into painting shadows in the Early Renaissance can be described as an experiment in trial and error (Casati 2004). Eventually, knowledge about shadows was included in treatises of painting and canonized as part of European painting techniques (Casati 2004) In contrast, there are few examples of shadows in non-Western art before the reciprocal influence between East and West occurred in modern times (Gombrich 1995). Some artists used shadows for practical reasons while others did so to show off their bravura or even play visual jokes (Casati 2004).

Shadows are tricky objects for the scientific study of perception, since in many cases they are not necessary, while in others shadows are a vital cue to interpreting ambiguous situations (Cavanagh and Leclerc 1989; Kersten et al. 1997). The brain appears to have a very limited understanding of physics when it comes to shadows—as shown in Fig. 19.6, we fail to notice when shadows are inconsistent with the lighting source or are even the wrong shape or colour (Casati 2004; Cavanagh 2005). One rule is that the shadow must be darker than the background. This rule is demonstrated by scientific experiments, but also apparent from observing the way that artists have represented shadows. In addition, shadows cannot look opaque (as if they are solid). This can be demonstrated experimentally by tracing a line with a thick pen around the edges of a cast shadow, which transforms our perception so that the shadow then looks like paint. Paradoxically, in order for a shadow to contribute to our understanding of shape in a picture, the shadow must first be recognized as such (Casati 2004).

In sum, the brain computes lighting locally, not across an entire scene. Before the advent of artificial lighting, the source of lighting in real life was fairly obvious (sunlight during the day, moonlight at night, and the occasional fire or candle). There is no 'lighting inconsistency detector' in the brain. On the other hand, the large changes in the brightness coloration of light during the day, as well as the reflectance properties of objects, have led to a sophisticated—but local—set of tricks to understand the true shape, lightness, and colour of objects in the world. Impossible lighting situations have now become commonplace in photography, film, cinema, and theatre. In a case of life imitating art, real-life performances with live actors can now include the use of differential local lighting strength and directionality and other features that have been used by pictorial artists throughout history.

TRANSPARENCY AND REFLECTION

Our earliest experience in colouring surfaces in pictures is to fill in the space within the boundaries with a solid colour (colouring between the lines) to capture the actual or

pure colour of the surface and ignore its variations (impurities) due to lighting or angle. Many objects, however, are shiny rather than matt. Moreover, many objects that one might want to portray in a picture are partially transparent rather than opaque. The importance of gold and jewellery in various cultures has led, naturally, to the desire to paint images that look like gold and jewellery. Likewise, transparent fabrics, glass, and water all might want to be included in a painting, as a testament to the artist's ability in imitating textures. Throughout history, artists have devised ways of making paint look like a different type of surface. The most obvious, but not necessarily most successful, strategy is to attempt to recreate the visual experience of a given material as closely as possible by using that same material as medium. Giotto used marble dust when depicting marble surfaces in the Cappella degli Scrovegni, presumably to try to convey qualities of the surface material that were difficult to replicate only with paint. Another example is the use of glass particles and gold highlights by Venetian artists. These artists were responding to limitations of the medium (al fresco or tempera) that made painting highlights impossible without adding white paint, which washed out the bright colours and weakened their intensity. For these artists, adding glass dust could give sparkle to patches of clothing, light, or water without compromising the saturation and hue of the colour. They were tackling the basic problem in painting of representing light without using a specific colour to indicate light.

One technical challenge for painters has been the depiction of diaphanous or semi-transparent surfaces such as lace or see-through materials. The simplest technique that artists can use is to 'overlay' the transparent material so that it crosses the contours of the background material. These crossings, known as 'X-junctions', appear to be critical for depicting transparency in a convincing way (Metelli 1974). Even a small misalignment of the X-junctions destroys the perception of transparency. Many other deviations from physics, however, are simply not noticed. One example is the depiction of refraction through a medium such as glass or water. The principles of refraction had to be discovered, but this discovery was not at all necessary for artists to convincingly depict objects such as a flower vase. Indeed, correct refraction is not necessary nor, surprisingly, does any refraction need to be depicted at all. People are typically perfectly happy with depictions of vases containing a mysterious liquid in which light moves exactly in the same way as it does in the air. If one believes the paintings, people have been drinking, swimming, and being baptized in this liquid air-like substance, throughout history. This 'found science' demonstrates that the visual brain takes into account only a subset of the information available in an image when determining the transparency of a particular surface (Cavanagh 2005).

Mirrors are another area in which perception and physics appear to part ways. Reflection on a mirrored surface has often been interesting to pictorial artists, allowing them to introduce another viewpoint in the painting without compromising the narrative continuity (Fig. 19.7). Examples include the classical story of Narcissus looking at his reflection in the water, which has been found in mosaic form in Pompeii. Indeed, the two periods during which there was the greatest interest in optical images and reflections are late Roman and Renaissance art, when mirrors, glass, and lenses are most often included in painting. One fascinating question is whether this interest in

Fig. 19.7 Felice Casorati, *BEETHOVEN*, 1928.

(Mart Museum, Rovereto)

It is relatively unimportant to the viewer whether or not the artist has correctly calculated the exact position of the reflected image of the girl in the mirror. The visual system construes this image in terms of a mirror even though that is not the only, or perhaps even the most physically accurate, interpretation.

reflection coincides with interests in realism and in the use of reflected images as a tool for studying projections. In any case, one finds mirrors depicted since antiquity which, almost without fail, disobey the laws of optics.

What do paintings of mirror reflections tell us about our naïve physics? The answer appears to be that the history of painting shows that our brain has no understanding of mirrors. It really does not matter what angle of reflection is portrayed. One typical use of mirrors is to portray a person looking at his or her reflection in such a way that both the person and their reflection are shown—a physical impossibility. This basic ignorance of the physics of reflection is confirmed in experiments, which show that people are clueless about the size and angle of mirror reflections, even for the most basic type of mirrors used in bathrooms and changing rooms around the world (Croucher et al. 2002; Fleming et al. 2003). The reader can test her/his understanding of mirrors by answering the following question: how big is the reflection of your head

in a typical wall-mounted mirror such as those found in a bathroom?[2] Ironically, physics students do not appear to understand mirror reflections either. Artists, while often not getting the physics right, showed a deep understanding of human perceptual psychology, and thus typically avoided making the few mistakes that would actually be noticed. Overall, reflections merely need to curve according to the curvature of the surface (if the mirror is not flat) and generally match the visual properties of an average scene (not necessarily the scene around the mirror (Fleming et al. 2003; Savarese et al. 2004). The brain cannot tell whether the mirror image is accurate or merely good guesswork: we do not notice any inconsistencies in famous works such as Van Eyck's *The Arnolfini Portrait* (1434), Caravaggio's *Narcissus* (c.1597–9) or Manet's *Bar at the Folie Berger* (1881–2).

Moving pictures

The brain is highly sensitive to motion cues, with specialized brain regions involved in detecting different patterns of motion. For the artist, there are two ways to portray motion: imply it with a static image or create a moving image. The advent of 'moving pictures' as a form of art and entertainment is a relatively recent development in art history. Of course, the images do not actually move: the perception of motion is all in our head. There are psychological laws of motion perception that describe the spatiotemporal patterns that do or do not lead to motion perception. Film (and, later, television and digital computer files) involves an economic compromise that allows us to perceive smooth motion without wasting extra frames. This compromise works well for us because of the human brain's visual 'refresh rate', but probably looks like a flickering mess to a fly that wanders into the cinema.

With static pictures and sculptures, the problem of depicting motion, and more general change over time, remains a fundamental challenge. One can see even in the earliest cave paintings the way in which space and time dominate artistic choices. Portraying an animal will always give a sense of relative depth (the figure is seen against a background), while the pose of the animal will make it appear either lifelike or dead. Some cave paintings, even those 30 000 years old, appear to us today to show animals in motion (Cutting and Massironi 1998). Given the importance of motion in art, it is intriguing that the question of movement (time) seems to have received less attention than issues of depth (space) in art history (Gombrich 1982). How, then, is it possible to depict motion in static media such as sculpture or drawing?

The list of artistic techniques that can lead to an understanding of implied motion has been explored in more detail elsewhere (Cutting 2002). Here we will consider instead a basic question about art and brain: do we truly 'perceive' motion in a static

[2] The reflection of one's head is incorrectly perceived as life-sized by most people.

picture or is it a purely 'cognitive', abstract understanding? The first set of evidence for the former hypothesis comes from studies of 'speed lines' in pictures. These lines are used most blatantly and economically in cartoons and comics to indicate motion, but can be used subtly in paintings by making the object or background appear to blur, orient or stretch along the axis of motion. Recently, scientists have taken advantage of the body of knowledge about motion perception to investigate how viewing oriented lines affects it. A variety of experimental (Geisler 1999; Burr and Ross 2002) and neuroimaging studies using functional magnetic resonance imaging (fMRI) (Krekelberg et al. 2005) confirm that motion mechanisms in the brain take these lines into account in computing motion speed and trajectories. So it appears that speed lines are part of the knowledge base of artists about the neuroscience of the brain. As Kennedy has noted, even blind artists use such visual cues in depicting a moving wheel (1993).

Recent research suggests that the perception of motion in a static image is not strictly metaphorical: on the contrary, many of these stimuli activate motion-processing areas of the brain (Kourtzi and Kanwisher 2000; Senior et al. 2000). In these studies, observers were shown 'frozen-motion' stimuli (typically photographs) showing people in motion, pictures of people at rest, or dynamic motion stimuli. The question was how photographs depicting motion would be processed in the brain. Motion processing involves several stages, with 'low-level' brain areas that are sensitive to local motion signals feeding into 'higher' level areas that combine information over space and time. The common finding across these studies is that the earliest levels of visual stimulus processing, such as area V1, are only active for real motion (spatial-temporal change) and not for any of the photographs. Higher-level areas of the brain, which have been implicated in complex motion processing such as biological motion, become active for the frozen-motion stimuli but not the other photographs. Thus, it is now clear that static pictures portraying motion actually stimulate brain regions involved in perceiving real motion. It is not simply a cold, detached understanding of motion based on logical reasoning.

The results of these and related neuroimaging studies may provide a useful way of thinking, more generally, about pictorial depiction. One interesting finding in these studies is that 'secondary'—as opposed to primary—visual processing areas are most influenced by pictures portraying motion. Such processing areas in the brain are interesting for our purposes here, since these brain regions are multisensory and thus may *conflict* with information from unisensory processing areas. In other words, activation of intermediate areas such as V5/MT without motion signals from V1 may tell us 'this looks like it is moving, but at the same time there is no local motion'—thus we are not 'fooled' by an illusion, but we are aware of the perceptual (not merely abstract[3]) meaning of the depiction.

[3] It is possible to imagine an abstract, amodal idea of an object that is divorced from any particular sensory experience. For example, our mind has an abstract, symbolic representation of 'apple' that can be evoked by a word (spoken or heard), picture, or actual object (seen, touched, or tasted). Looking at a still life with fruit will, of course, call to mind this symbolic apple, but experience of the apple has a sensorial aspect that is specific to the way we perceive and recognize objects.

A second issue raised by these image studies is the influence of experience on picture perception. It is reasonable to hypothesize that the techniques used by artists to portray motion build upon other, earlier methods. Once the observer learns to 'see' motion in one type of painting, this increases sensitivity to those motion cues, which then influences how they see other artworks. This is a process known as 'perceptual learning'. One compelling example is provided by the pictorial experiments into the representation of motion that were central to the artistic practice of the 1910s. Artists as diverse as Picasso, Duchamp, and Italian Futurists such as Bragaglia, Balla, Boccioni, and Russolo were influenced by the chronophotographic experiments of Marey and Muybridge. A recent experiment looking at how the brain reacts to such artworks may shed some light on how this developed. Two groups of students, one naïve to such depictions and the other well-versed in art history, were shown images of Duchamp's and Balla's paintings, 'static' abstract works (which do not give any impression of motion), and Marey's chronophotographs (Kim and Blake 2007). For both groups, motion-processing areas were active for the chronophotographs and inactive for the 'static' paintings. The main difference between the groups was that only the art students showed significant activation in motion-processing areas for the works by Balla and Duchamp. This experiment demonstrated, in agreement with other studies of perceptual learning, that experience can influence the way visual cues are used by the brain.

What is not clear from the imaging study is whether the change in the students' brains (which was also reflected in their perceptual judgements) was based on a direct influence of cognitive processes (explicit knowledge) on these motion processing regions, or whether the artistic training with 1910s artworks had influenced the way that the students paid attention to—and utilized—the motion cues that the artists had included in their works. Some evidence for the latter explanation comes from findings with another implied motion stimulus, the rotating rectangle. The rectangle stimulus, which gives an 'impression' of motion that continues into the future, does not seem to activate the same motion-processing areas found in the earlier study. Instead, the rotating rectangle appears to activate more 'cognitive' areas of frontal cortex implicated in expectations and prediction (Rao et al. 2004). Thus, it is reasonable to hypothesize that our experience of viewing art can influence both our expectations and—more interestingly—the way we actually see the world.

Biological motion

Our visual system is fine-tuned to detect 'biological' motion: the movement patterns of people and animals (Fig. 19.8). One of the seminal studies of biological motion is a study by Johansson and colleagues from 1973 in which actors were filmed under conditions in which only lights attached to parts of their bodies were visible. This extension of chronophotography (Fig. 19.9) separates motion and form information: it is impossible to identify the object based on form alone in any given frame. Only by combining

Fig. 19.8 Renato Guttuso, *BOOGIE WOOGIE*, 1953. (See Colour plate 6)

(Mart Museum, Rovereto)

The clever citation of the painting "Broadway Boogie Woogie" (Piet Mondrian, 1942-43) in the background allows this work to portray both biological and abstract motion in the same scene.

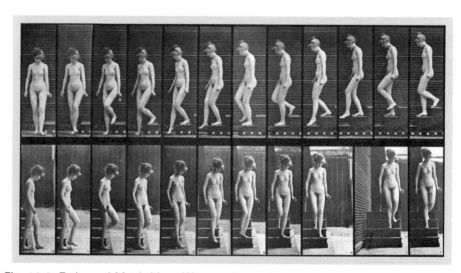

Fig. 19.9 Eadweard Muybridge, *Woman descending a staircase*, 1887.

(Mart Museum, Rovereto)

Human motion is constrained to follow certain paths, based on the structure and physiology of the body. This photograph by the pioneering photographer Muybridge, from the book *Animal locomotion*, captures brief instants within the complex action of walking down the stairs.

information across several different frames, over a period of up to 8 seconds (Neri et al. 1998), can the pattern of motion be understood.

A number of experiments have examined the nature of our perception of these 'point light walker' stimuli. The ability to understand these images does not require experience with movies: infants only 3 months of age (Fox and McDaniel 1982), as well as other animals such as cats (Blake 1993), perceive biological motion in these displays. Interestingly, the pattern of a few dots can yield quite detailed information, including the gender (Kozlowski and Cutting 1977), emotional state (Brownlow and Dixon 1997), and activity of the actor, such as running, leaning forward, or playing sports. Neuroimaging studies suggest that our brain has a specialized network for perceiving human and animal movements (Oram and Perrett 1994; Grossman et al. 2000).

Interestingly, we do not actually have to see *physical movement* (a change in spatial position over time) in order to perceive biological motion. As Socrates is reported to have noted in his discussion with the sculptor Cleiton, 'by faithfully copying the various muscular contractions of the body in obedience to the play of gesture and poise . . . you succeed in making your statues like real beings' (Xenophon, *Memorabilia* III X 7). The French sculptor Rodin brought this principle to its extreme consequences, inaugurating a way to portray motion in sculpture by representing the different limbs at different stages in the movement, so that the observer could 'sense' the motion unfolding in time—thus also proving how sophisticated our sensitivity to detect human motion really is. In other words, even static art forms such as sculpture, relief, drawing, or painting can create a 'feeling' of movement in the depicted agents (Freyd 1983). Studies of the 'mirror neuron system' (see essays by Gallese, Chapter 22, and by Calvo-Merino and Haggard, Chapter 27, this volume) suggest that some actions, particularly goal-directed actions, activate a 'motor-like' reaction in the brain which can even influence muscle tone. The eye is a channel by which images can influence the body and all the senses. The exquisite sensitivity to biological motion may be a precursor of the ability to understand, both through cognitive processes and the mirror neuron system, the meaning of a particular action.

Just as the interpretation of biological motion in a static picture can be influenced by previous experience, the mirror response to watching the action of another person also depends on our own experience with such actions. This idea has fundamental implications for our understanding of how people perceive pictures. Consider the example of dance. Art takes advantage of the human interest in dance and the inferred motion and pleasure in viewing it. The portrayal of dancers is a major theme in Asian and African artworks,[4] a fact which has greatly influenced twentieth-century Western art (Fig. 19.10). It is important to remember, however, that our ability to understand and interpret static dance positions depends on our personal experience with the real, dynamic dance movements. A recent neuroimaging study confirms that the activity of

[4] Dance is a basic human activity found across many cultures. Many dances make use of visual props, such as masks constructed in ways that accentuate the impression of motion during the dance. Some African masks, for example, use reflective material for catching light, while Japanese 'no' masks change expression with change of head position.

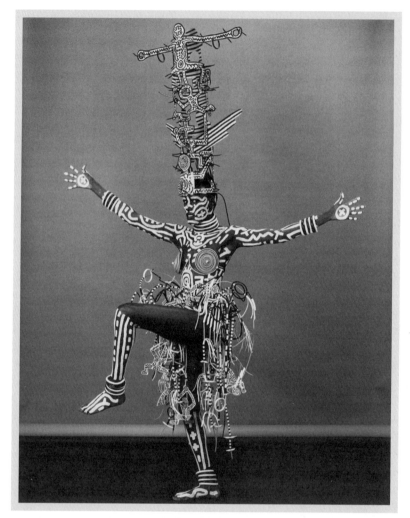

Fig. 19.10 Robert Mapplethorpe. *Grace Jones*, 1984. © Copyright The Robert Mapplethorpe Foundation. Courtesy Art & Commerce.

This is a photograph of Grace Jones who had been painted by the artist Keith Haring. Andy Warhol introduced Haring to Jones and helped arrange for the photography session with Mapplethorpe. Jones is wearing a huge crown and rubber jewelry that were designed by David Spada. The influence of artworks from Africa on 20th-century Western art is well known. At the same time, the interpretation of these artworks, in the West, has been influenced by generalization, ignorance and stereotypes, as cleverly exploited in this photograph by Robert Mapplethorpe. Here, the diverse elements of the decoration and pose of the model play into expectations and stereotypes, while the static (almost sculptural) pose and the medium of photography give the subject matter an 'objective', Western view of the subject.

motor cortex while perceiving dance moves is influenced by personal experience with those dance movements (see Calvo-Merino and Haggard, Chapter 27, this volume). Thus, for example, the response of a typical Western museum-goer when looking at an African sculpture demonstrating the *dooplé* pose may differ fundamentally from that of member of the Quenon people (Ivory Coast), who would recognize the forward tilted torso, bent knees, open hands, and gaze fixed straight ahead as part of a dance pose (Tiérou, 1992).[5] Although the capacity to learn to discriminate biological motion from non-biological motion appears to be innate, the mechanism is flexible enough to be influenced by experience. This suggests that the influence of individual experience and culture is greater at the level of complex perceptions, such as the interpretations of particular movements, than for simpler features such as contour lines or depth.[6]

Our sensitivity to biological motion is a double-edged sword for artists. On the one hand, they can take advantage of the observer's sensitivity to body movement. However, this sensitivity to real bodily motion makes us particularly attuned to detect deviations from natural movement. The Renaissance art theorist Alberti, among others, argued that it was critical to understand the skeleton and the muscles in order to depict a realistic posture. The tricks required to create a natural pose become much more complex with dynamic stimuli. One telling example is computer graphics, which recently has been striving to move from 'cartoonish' depictions to hyper-realistic scenes in film and in video games. There are several interesting techniques that have been developed to incorporate knowledge about the structure and psychology of humans and animals into computer graphics. The 'skeleton system' approach, which started in the late 1980s in university laboratories, and then quickly moved to commercial and artistic applications, involves explicitly modelling the body's mechanical structure (skeleton, muscle, tendons, and so on) in the computer program used to create the image. The animation appears to move in a more natural way because its surfaces move in accordance with an underlying 'natural' structure.

A more advanced form of animation, 'artificial life', moves beyond body mechanics to also include a model of the basic 'psychology' (motivations and perceptions) of the organism. A computer model of fish, for example, can create a cartoon in which the fish move in a strikingly naturalistic way that makes them look like animals rather than drawings (Terzopoulos 1999). Their behaviour evolves over time, with the fish 'learning' how to swim based on the constraints of its body and influenced by its goals— such as seeking prey and avoiding predators.

[5] Artists have been great observers of anatomy and biological motion. Leonardo da Vinci, for example, studied the physiognomy and the physiology of emotional expression, and used this knowledge to detect which aspects of the face were critical in driving the facial expression. Many artists have attempted to draw 'the motion' rather than simply showing a static representation of a body in motion.

[6] The ability to perceive lines and depth disparities does depend on experience in early life. This flexibility is necessary because of the variability across persons in basic factors such as visual acuity and the distance between the eyes. Given normal visual input, most people naturally develop remarkably similar visual systems that have much in common.

Another interesting approach in computer graphics is 'motion capture', famously used in films such as *The Lord of the Rings* (2001) and *King Kong* (2005). The movement of a real actor's body and/or face are recorded as a set of discrete points that change position over time. These points are then 'grafted' on to a computer-graphic skeleton that changes in the same way. The results can be impressively realistic. The motion capture concept descends from ideas developed by the photographers Muybridge and Marey and later extended by Edgerton and by the psychologist Johansson (1973) in his point-light walker displays. In animation, the idea of motion capture was used by Disney studios in the 1937 film *Snow White*, in which animation stills were traced over film footage of real dancers (a technique known as rotoscoping, invented in 1915 by Max Fleischer). This fusion between art and science has been used extensively in dance, film, and also for popular entertainment.

Thus, the most straightforward way to depict human motion is to 'record' and copy the motion of real humans. For a painter, this is not an option. Alberti suggested that painters and sculptors began with an understanding of the skeleton and muscles, in order to understand motion and pose, through the dissection of cadavers, when possible, and anatomical studies on faithful wax models. Leonardo's intense study of anatomy, body postures and physiognomy is well known. What is fascinating about this combination of art and science is how it emphasizes the way in which our perception is based on an understanding of what is *beneath the surface*. Artists, as superperceivers, have tried to understand the driving force behind the optical data. Scientific evidence, along with the more practical evidence of the usefulness of 'motion capture' techniques and 'artificial life' provide, instead, support for Alberti's idea that the artist must understand what is beneath the surface, beyond the optical projection, to capture the coming-to-life ingredient of biological motion.

THE GAZE AND THE MOVING EYE

One great myth about visual perception is that the eye is like a photographic camera. The *camera obscura*, and later devices that fixed an image permanently, were designed based on the optic principles of a pinhole camera like the eye. While there is some similarity between the eye and the mechanical camera, it is clear that in terms of the medium for imprinting the image one would never want to imitate the human eye. In fact, it is difficult to overstate the extraordinary difference between the image at the back of the eye and what we perceive. A partial list of the terrible flaws in the retinal image that is passed to our brains includes: (1) the image is only registered at high resolution at the very small portion in the centre, with most of the peripheral vision mainly useful only for detecting movement and no details; (2) there is a complete lack of uniformity in the presence of each type of cone (colour receptor) across the retina,

with very few cones outside the centre; (3) there is a big hole in the image at the 'blind spot' where the optic nerve leaves the eye.[7]

Since clear and colourful vision is only possible at the centre of gaze, we move our eyes an average of three to five times per second in jumping 'saccadic' eye movements. When it comes to vision, the eye is physically drawn towards what it perceives, in a perception-action cycle: 'The lover is drawn by the thing loved, as the sense is drawn by that which it perceives' (Leonardo da Vinci, Notebooks, Tr. Tav. 9a.). Each day, it is estimated that we make more saccadic eye movements than beats of the heart. Contrary to this jumpy visual input, our perception is smooth and continuous.[8] We are also capable of making smooth eye movements, but only when we are following with our gaze something that is moving within a certain range of speeds. Metaphorically, active vision works somewhat like sonar. We direct our gaze towards a region of space and then wait for the results to hit the retina. Then we move our eyes again and this decision of where to look determines what we see. There is a perception–action cycle of eye and head movements which bookmark brief periods of relatively stable fixation. Eye movements are typically accompanied by a shift in our attentional focus. While it is possible to covertly shift our attention elsewhere from our gaze (perhaps to allow us to scrutinize someone without being caught), shifts in gaze and attention tend to go together.

The consequence of vision with a roving eye is that we never see a scene in uniform detail and colour. This has numerous implications for understanding how people make and perceive artworks. As the art historian James Elkins notes, 'each act of vision mingles seeing with not seeing' (1996, p. 201).[9] Looking at details of specific objects requires us to move our eyes and head and, thus, even stationary objects move across our retina as we look around. The way that our visual system interacts with our eye movements leads to different timescales of perception. When viewing a painting, for

[7] It is extraordinary that there are no known records indicating knowledge of the blind spot previous to 1668. Leonardo had claimed that perception was actually best at the point where the optic nerve enters the eye (mistakenly equating it with the retinal *fovea*, where acuity is highest). The physicist and priest Edme Mariotte published a small book in 1668 (*Nouvelle Découverte touchant la veüe*) based on a simple perceptual experiment that is now replicated in perception classes around the world. Mariotte's demonstration was popularized at the Academie des Sciences (Mariotte was a founding member) and taken 'on tour' for various audiences.

[8] One of the first to notice the fact that saccadic eye movements must pose a 'problem' that our brain must solve was the scholar Alhazen (Ibn al-Haytham, 965-1040). He proposed that the mind must have developed a 'habit' that would take into account the differences between the retinal motion caused by eye movements and by motion in the world.

[9] The important distinction between the vast visual field and the small subset of the world that is actually perceived by the mind has a long history. Examples include Aristotle's theory that it is impossible to perceive two objects simultaneously (*On Sense and the Sensible*, 350 BC), the Stoic concept of the 'phantasia *kataleptikē*' that compares looking to grasping sensations by the mind, Lucretius' idea of vividness in perception (*De rerum natura*, 50 BC), Alhazen's *vis distinctiva* (1040), Leibniz's 'perceptions petit' (*La Monadologie*, 1714), and, more recently, in Wundt's introspectionism and the beginnings of psychology. Freud's ideas of the unconscious have had a great impact on artistic production and an unrelenting influence on art criticism.

example, some visual information is specific to that moment and vanishes from our mind after eyes move on to a new position. Other visual attributes are combined across separate fixations over periods of time measured in fractions of a second (Melcher and Morrone 2003). Details about the visual properties of objects and their locations can accumulate over a period of tens of seconds and persist in mind (Melcher 2001; Tatler et al. 2005), allowing us to keep track of objects in common tasks such as making a sandwich or cup of tea (Land and Hayhoe 2001). Most of these visual details will be forgotten days or weeks later (Melcher 2001). Critically, none of these different visual representations over different time periods is like an image in your head that matches exactly the painting on the wall.

Separate aspects of the painting inhabit different mental places in space and time. One can heuristically examine this problem by observing Cubist paintings or, more recently, the photocollages by David Hockney and Polaroid collages by Joyce Neimanas. These images, like cubist artworks, draw our attention to several fundamental differences between paintings and perception.

First, as described earlier when discussing depth, there is a basic discrepancy between the perception of depth by humans (Leonardo da Vinci's *natural perspective*) and the transformations required to create pictorial representations of depth (*artificial perspective*). This problem becomes infinitely more complex when head and body movements are allowed. There are a number of view point-dependent effects when looking at perspective paintings that we tend to ignore. For example, Deregowski and colleagues have argued that the phenomenon of viewing converging lines as parallel—a foundation of linear perspective—does not hold for oblique views (Deregowski and Parker 1988; Deregowski et al. 1994). On the contrary, observers may judge *converging lines* as parallel under many conditions, in agreement with pre-Renaissance perspective. Another aspect of real-world viewing is that the position of the head and the focus of gaze tend to shift significantly when looking around a real scene. In other words, we often look at one side and then shift completely to look in the other direction. Thus, converging perspective may portray more accurately what it is really like to make these dramatic shifts in view, since it is impossible to have the same vanishing point for a glance 45 degrees to the left of centre and 45 degrees to the right.

Another interesting example is the fact that our eyes converge when viewing near objects and diverge when we stare off into the distance. Leonardo portrayed the struggle to focus the eyes (which he observed in the immature infant's visual system) beautifully in the *Benois Madonna* (c.1478). When our eyes diverge, they gaze into 'optical infinity': the parallel lines of gaze do not meet. Filmmakers, like painters, use depth planes (in particular, the furthermost depth plane in a shot) in order to manipulate the feeling of space and openness. At this point, there is no clear evidence about why it 'feels' different to see the horizon or to be walled in (although estate agents include such information in calculating property prices). Presumably, for our ancestors, a large vista would have been useful for safety and for finding important resources—even today people travel *en masse* to 'outlook points' where they can see far distances. Like in film, painters have exploited convergence and divergence as a cue to depth. A picture blocking the perception of the horizon can create the impression that

the subject matter is closer or even closed in. One can compare David's *Death of Marat* (1793), where a wall behind the dead activist blocks our view, to Gerome's *Death of Ceasar* (1867) with the full perspective that continues into the distance. The former is more closed, claustrophobic and anxious, while in the second painting the vanishing point in the distance underplays the supposed tragedy and makes the cadaver go unnoticed even though it is in the foreground. A similar theme from the same period, which combines the two methods, can be found in Manet's *Execution of the Emperor Maximilian* (1867), where the wall blocks the horizon at eye level thus making the scene take place almost in our personal space, but an escape for the eye is allowed at the top of the painting above the wall.

ARE THERE VISUAL PREFERENCES?

Thus far, we have only considered the techniques which an artist could use to depict the existence of a certain object, scene, or event in a picture, without asking the question of why observers might actually like to see some of these features in an image. Inherent in this question is the intuition that our sensitivity to particular visual cues is somehow tied to our response to an artwork that uses those cues. Gombrich argued that artistic techniques were like 'the forging of master keys for opening the mysterious locks of our senses to which only nature herself originally held the key' (1993, p. 33). Thus, for example, our sensitivity to colour allows the artist to access the ability of those visual processing mechanisms that make the observer think and feel. At the same time, scientists face an enormous explanatory gap between showing that an aesthetic object activates a particular visual process in the brain and understanding *why* that visual object produces an aesthetic experience. The basic problem is that a great number of objects activate visual areas, and most of these objects are not considered artworks (see Hyman 2006).

Visual preferences can be studied at various levels of analysis. At the simplest level, certain techniques make images easier or more difficult to interpret. A blurry image will tend to cut out high spatial frequencies, for example. There is some evidence that, in a world saturated with images, many people prefer stimuli that are slightly challenging (see Schifferstein and Hekkert, Chapter 28, this volume, for a discussion of the MAYA principle in design). Alternatively, certain techniques may focus our attention on one particular feature, such as colour, shape, or motion. Although some have suggested that it is this 'super-stimulus' itself, by effectively driving the neurons in the visual system, which leads to visual preferences (see Ramachandran and Hirstein 1999; Zeki 1999), this idea is controversial and seems to fall into the aforementioned explanatory gap (Hyman 2006).

If preference is not based on exaggeration of bright, colourful, moving stimuli, then how could a particular feature cause an aesthetic response? One limiting factor might

be that certain features give access to the brain's reward system, based on experience and, to some extent, innate tendencies. The colour red, for example, has the potential to stimulate the limbic system—colour is tied to the motivation system because it is critical to survival: red is the colour of blood or raw meat, it is the colour of ripe fruit and dangerous animals. In other words, it makes sense to be aware of the colour red and to associate this colour with the reward system in order to survive. The exact nature of this association will depend on a lifetime of experience.

Another example of this complex mapping between visual features and the brain's reward system is shape. The visual system is highly sensitive to shape, a fundamental visual property. This allows artists to 'suggest' a particular visual interpretation (such as the three-dimensional shape of an object), but it is also an expressive tool to suggest a particular emotional state. In a series of recent studies, neuroscientist Moshe Bar and colleagues have shown that curved and pointed shapes influence people differently and that this difference is correlated with the way that sharp corners (potential dangers) activate the amygdala (Bar and Neta 2006, 2007). The work of Bar and Neta suggests that one of the 'master keys' used by artists might be explainable in terms of visual neuroscience: jagged lines and pointy corners, through their greater activation of the amygdala, offer expressive power to the artist. Given the importance of round versus sharp corners for most people, this artistic tool might tend to work across cultures. In contrast, many other of our shape associations are specific to our own experiences and culture. Laboratory studies have shown that simply associating a particular shape with an otherwise affective stimulus (such as a picture of a gun or a smiling baby) can lead to a change in preference for that shape—even when the participant does not consciously remember this association (for review, see Ghuman and Bar 2006).

Thus, there are at least three key elements to visual preferences. First, visual preferences depend fundamentally on what the visual system processes: no one can like or dislike ultraviolet light or pitches beyond our hearing range. Our sensitivity to features such as symmetry or colour is a precondition for preference for certain values of those features. Second, some preferences are likely based on deep-rooted links between certain visual features and the brain's 'survival system' that manages our search for food, safety and reproduction. Third, these building blocks of pictorial (and non-pictorial) representation have flexibility and cultural specificity. Preferences, such as for particular faces, is directly influenced by our 'diet' of images of faces (for review, see Rhodes et al. 2003). Overall, the sensitivity to particular visual features, and their link to the brain's reward system, provides an expressive tool that artists can use not only to simply make a picture, but to imbue that picture with other suggested resonances.

It is interesting to note the overlap, within the brain's reward system, between the neural activation to different stimuli that people prefer, including one's favourite music, food or touch sensations (Blood and Zatorre 2001; Kawabata and Zeki 2004; Di Dio et al. 2007; Stice et al. 2008; see Calvo-Merino and Haggard, Chapter 27, this volume). This suggests interesting commonalities between the various arts, and also that certain multisensory artforms might be able to lead to an additive, simultaneous stimulation of the reward system. Interestingly, these brain areas also seem to be 'social'—they are also involved in our responses to appropriate or inappropriate

behaviour within the set of rules (Tabibnia et al. 2008). This flexibility to social mores may be critical in shaping behaviour, but it also suggests that inappropriate behaviour can truly be 'ugly' and that the link between good and beautiful is not accidental.

At the same time, the distribution of features within a composition also seems to play a role in preference (Arnheim 1974). Great artists seem to manage a complex balancing act in which the elements fit together in some undefinable, yet satisfying way (Fig. 19.11). As Le Corbusier argued, in the context of architecture, 'the true and profound laws . . . are established on mass, rhythm and proportion' (1985 p. 286). Every choice by the artist works within the context of the entire work: individual features do not exist in isolation. Much work in vision science has attempted to better understand the role of the centre, of symmetry, and of composition in artworks, investigating principles such as golden ratios that recur throughout art and architectural history, and indeed in nature (for example, Locher 1996). In addition, recent studies have also begun to elucidate mechanisms that may underlie balance in terms of visual features in a composition. For example, studies on 'feature-based attention' show that paying attention to a particular value of a feature (such as the colour red or rightward tilted lines) increases the response of neurons to other matching features (Maunsel and Treue 2006; Melcher et al. 2005). Thus, there are long-range interactions between

Fig. 19.11 Alberto Burri, *Bianca Plastica BL1*, 1964.

(Mart Museum, Rovereto)

Many artists balance the elements within a picture, using both relatively simple proportions and more complex balancing acts in which elements seem to fit together in intangible ways.

certain features, based on perceptual opposites (red/green, blue/yellow, up/down, left/right and so on). In a well-balanced composition, paying attention to the red square on the left does indeed 'call forth' the red shapes on the other side of the screen, so that the firing of neurons in the brain create an expectation that may be met when matching features are found in other areas of the visual field.

Conclusions

Our brains are extremely ready and able to interpret flat images in terms of the three-dimensional world. This fact, by itself, is an incredible scientific discovery. It is widely accepted, within the scientific community, that picture perception reflects properties of how the brain normally works, rather than simply a cultural convention. As described in this chapter, pictures embody hidden knowledge by artists about how the brain works, and our willingness to interpret patterns of light and dark on a flat surface in terms of meaningful objects in spatial relationships to each other. One implication is that the brain does not necessarily represent the world, in terms of internal computations, as a full three-dimensional scene. In other words, there is no theatre in the head in which a recreation of the world takes place. We must continually, using our eyes, brains, and body, interrogate the world for more details. When it comes to cues from lighting, this information is strictly local. Otherwise, if the world in our head really was three-dimensional, then flat images should be distorted perceptually when we move. There could be only one seat in a movie theatre and each painting would need to be viewed through a pinhole. At the same time, people rarely confuse pictures with the scene represented in the picture. *Trompe l'oeil*, for example, works at its best with constricted observer motion and viewing from a relatively far distance so that small head and body movements do not break the illusion.

Certain techniques in pictorial representation enable artists to turn pigments into perceptions. Understanding these rules does not, by itself, lead to the creation of 'art', just pictures. It is critical not to confuse recognition with aesthetic experience. On the contrary, any painting can potentially provide a discovery in the alternative physics of pictures and, therefore, the psychophysics of the visual brain. Many of the rules of physics that constrain real scenes are optional in pictures. It is the choice of the artist, based on her or his goals, whether or not to obey the rules discovered by science. Such basic transgressions of standard physics, including contours, blurry images, impossible reflections, or shadows, tend not to concern the observer. For the neuroscientist, previously unnoticed differences between pictures and real physics can be viewed as data, as basic discoveries about the visual brain. For artists, on the contrary, these deviations may allow them to more effectively and economically achieve their aims. For the viewer, the picture can then be used as a stimulus that sets off a chain reaction of events in their body and brain. The outcome can influence the emotional

and bodily state of the observer. Pictures, rather than mere copies of the world, can be a conversation between minds.

Interestingly, recent studies suggest that learning how to look at art can improve our ability to notice fine details. The *Journal of the American Medical Association* published a study showing that training in noticing the details of paintings led to an improvement in detecting medically relevant details in patients (Dolev et al. 2001). Training in art has become part of the core curriculum at Yale University medical school. Thus, the history of art and science, somewhat artificially segregated from each other in recent times, forms a circle, with art influenced by the study of anatomy, while artistic depictions of anatomy have then been used to foster further scientific and medical research. The sculptor Henry Moore expressed a similar idea when he stated: 'All the arts are based on the senses. What they do for the person who practices them, and also the persons interested in them, is make that particular sense more active and more acute.' For the neuroscientist, looking at art can provide deep insights into the physics that matters to the visual brain.

References

Arnheim R (1974). *Art and Visual Perception: The New Version.* University of California Press, Berkeley, CA.

Bar M and Neta M (2006). Humans prefer curved visual objects. *Psychological Science,* **17,** 645–8.

Bar M and Neta M (2007). Visual elements of subjective preference modulate amygdala activation. *Neuropsychologia,* **45,** 2191–200.

Barnes J and David AS (2001). Visual hallucinations in Parkinson's disease: a review and phenomenological survey. *Journal of Neurology, Neurosurgery and Psychiatry,* **70,** 727–33.

Blake R (1993). Cats perceive biological motion. *Psychological Science,* **4,** 54–7.

Blood AJ and Zatorre RJ (2001). Intensely pleasurable responses to music correlate with activity in brain regions implicated in reward & emotion. *Procedures of the National Academy of Sciences,* **98,** 11818–23.

Bordwell D, Staiger J, and Thompson K (1985). *The Classical Hollywood Cinema. Film Style and Mode of Production to 1960.* Columbia University Press, New York.

Brownlow S and Dixon AR (1997). Perception of movement and dancer. characteristics from point-light displays of dance. *Psychological Record,* **47,** 411–21.

Burr DC and Ross J (2002). Direct evidence that 'speedlines' influence motion mechanisms. *Journal of Neuroscience,* **22,** 8661–4.

Calvo-Merino B, Glaser DE, Grèzes J, Passingham RE, and Haggard P (2005). Action observation and acquired motor skills: and fMRI study with expert dancers. *Cerebral Cortex,* **15,** 1243–9.

Casati R (2004). *The Shadow Club.* Little Brown, New York.

Cavanagh P (2005). The artist as neuroscientist. *Nature,* **434,** 301–7.

Cavanagh P and Leclerc YG (1989). Shape from shadows. *Journal of Experimental Psychology: Human Perception and Performance,* **15,** 3–27.

Chao LL and Martin A (2000). Representation of manipulable man-made objects in the dorsal stream. *NeuroImage,* **12,** 478–84.

Craighero L, Fadiga L, Rizzolatti G, and Umiltà CA (1998). Visuomotor priming. *Visual Cognition*, **5**, 109–25.

Croucher CJ, Bertamini M, and Hecht H (2002). Naive optics: understanding the geometry of mirror reflections. *Journal of Experimental Psychology: Human Perception and Performance*, **28**, 546–62.

Cutting JE (2002). Representing motion in a static image: Constraints and parallels in art, science, and popular culture. *Perception*, **31**, 1165–94.

Cutting JE (2005). Perceiving scenes in film and in the world. In JD Anderson and BF Anderson, eds. *Moving Image Theory: Ecological Considerations*, pp. 9–17. University of Southern Illinois Press, Carbondale, IL.

Cutting JE and Massironi M (1998). Pictures and their special status in cognitive inquiry. In J Hochberg, ed. *Perception and Cognition at Century's End*, pp. 137–68. Academic Press, San Diego, CA.

Deregowski JB and Parker DM (1988). On a changing perspective illusion within Vermeer's *The Music Lesson*. *Perception*, **17**, 13–21.

Deregowski JB, Parker DM, and Massironi M (1994). The perception of spatial structure with oblique viewing: an explanation for Byzantine perspective? *Perception*, **23**, 5–13.

Devlin JT, Moore CJ, Mummery CJ, *et al.* (2002) Anatomic constraints on cognitive theories of category specificity. *Neuroimage*, **15**, 675–85.

Di Dio C, Macaluso E, and Rizzolatti G (2007). The golden beauty: brain response to classical and Renaissance sculptures. *PLoS ONE*, **2**, e1201.

Dolev JC, Friedlaender LK, and Braverman IM (2001). Use of fine art to enhance visual diagnostic skills. *Journal of the American Medical Association*, **286**, 1020–1.

Elkins J (1996). *The Object Stares Back*. Simon and Schuster, New York.

Fleming RW, Dror RO, and Adelson EH (2003). Real-world illumination and the perception of surface reflectance properties. *Journal of Vision*, **3**, 347–68.

Fox R and McDaniel C (1982). The perception of biological motion by human infants. *Science*, **218**, 486–7.

Freyd JJ (1983). The mental representation of movement when static stimuli are viewed. *Perception & Psychophysics*, **33**, 575–81.

Geisler WS (1999). Motion streaks provide a spatial code for motion direction, *Nature*, 400, 65–9.

Ghuman AS and Bar M (2006). The influence of non-remembered affective associations on preference. *Emotion*, **6**, 215–23.

Gibson JJ (1950). *The Perception of the Visual World*. Houghton Mifflin, Boston, MA.

Gombrich EH (1960). *Art and Illusion*. Princeton University Press, Princeton, NJ.

Gombrich EH (1963). *Meditations on a Hobby Horse and Other Essays on the Theory of Art*. Phaidon Press, London.

Gombrich EH (1982). *The Image and the Eye: Further Studies in the Psychology of Pictorial Representation*. Phaidon, London.

Gombrich EH (1993). Recognising the World: Pissarro at the RA. *Royal Academy Magazine*, **39**, 33.

Gombrich EH (1995). *Shadows*. National Gallery Publishers, London.

Gregory RL (2004). Seeing after blindness: the blind leading the sighted. *Nature*, **430**, 836.

Grossman E, Donnelly M, Price R, et al. (2000). Brain areas involved in perception of biological motion. *Journal of Cognitive Neuroscience*, **12**, 711–20.

Hochberg J and Brooks V (1996). Movies in the mind's eye. In D Bordwell and N Carroll, eds. *Post-theory: Reconstructing Film Studies*, pp. 268–87. University of Wisconsin Press, Madison, WI.

Hockney D (2005). Interview by Lawrence Weschler. In *David Hockney: Looking at landscape / being in landscape*. LA Louver, Los Angeles, CA.

Hyman J (2006). Art and neuroscience. Art and Cognition Workshops, January, 2006. http://www.interdisciplines.org/artcognition/papers/15

Itakura S (1994). Recognition of line-drawing representations by a chimpanzee (*Pan troglodytes*). *Journal of General Psychology*, **121**, 189–97.

Johansson G (1973) Visual perception of biological motion and a model for its analysis. *Perception and Psychophysics*, **14**, 201–11.

Johnson MH (2005). Subcortical face processing. *Nature Neuroscience Reviews*, **6**, 766–74.

Kawabata H and Zeki S (2004). Neural correlates of beauty. *Journal Neurophysiology*, **91**, 1699–705.

Kennedy JM (1974). *The Psychology of Picture Perception*. Jossey-Bass Inc., San Francisco, CA.

Kennedy JM (1993) *Drawing and the Blind*. Yale University Press, New Haven, CT.

Kennedy JM and Ross AS (1975). Outline picture perception by the Songe of Papua. *Perception*, **4**, 391–406.

Kersten D, Mamassian P, and Knill DC (1997). Moving cast shadows induce apparent motion in depth. *Perception*, **26**, 171–92.

Kim CY and Blake R (2007). Brain activity accompanying perception of implied motion in abstract paintings. *Spatial Vision*, **20**, 545–60.

Kourtzi Z and Kanwisher N (2000). Activation in human MT/MST for static images with implied motion. *Journal of Cognitive Neuroscience*, **12**, 48–55.

Kozlowski LT and Cutting JE (1977). Recognizing the sex of a walker from a dynamic point-light display. *Perception & Psychophysics*, **21**, 575–80.

Krekelberg B, Vatakis A, and Kourtzi Z (2005). Implied motion from form in the human visual cortex. *Journal of Neurophysiology*, **94**, 4373–86.

Kubovy M (1986). *The Psychology of Perspective and Renaissance Art*. Cambridge University Press, Cambridge.

Land MF and Hayhoe MM (2001). In what ways do eye movements contribute to everyday activities? *Vision Research*, **41**, 3559–65

Le Corbusier (1985). *Towards a new architecture*. Dover, New York.

Leonardo da Vinci (1923). In *Leonardo da Vinci's Notebooks*, EMC Curdy trans. Empire State Book Company, New York.

Lhermitte F (1983). Utilization behaviour and its relation to lesions of the frontal lobes. *Brain*, **106**, 237–55.

Livingstone MS (2002). *Vision and Art: The Biology of Seeing*. Harry N Abrams, New York.

Locher PJ (1996). The Contribution of eye-movement research to an understanding of the nature of pictorial balance perception: A review of the literature. *Journal of the International Association of Empirical Studies*, **14**, 143–63.

Maffei L and Fiorentini A (1995). *Arte e Cervello*. Zanichelli, Bologna.

Matin L and Pearce DG (1965). Visual perception of direction for stimuli flashed during voluntary saccadic eye movements. *Science*, **148**, 1485–8.

Maunsel JHR and Treue S (2006). Feature-based attention in visual cortex. *Trends in Neuroscience*, **29**, 317–22.

Melcher D (2001) Persistence of visual memory for scenes. *Nature*, **412**, 401.

Melcher D and Bacci F (2008). The visual system as a constraint on the survival and success of specific artworks. *Spatial Vision*, **21**, 347–62.

Melcher D and Morrone MC (2003). Spatiotopic temporal integration of visual motion across saccadic eye movements. *Nature Neuroscience*, **6**, 877–81.

Melcher D, Papathomas TV, and Vidnyanszky Z (2005). Implicit attentional selection of bound visual features. *Neuron*, **46**, 723–9.

Messaris P (1994). *Visual Literacy: Image, Mind, & Reality.* Westview Press, Boulder, CO.

Metelli F (1974). The perception of transparency. *Scientific American,* **230**, 91–8.

Myslobodsky M (2003). Gourmand savants and environmental determinants of obesity. *Obesity Reviews,* **4**, 121–8.

Neri P, Morrone MC, and Burr DC (1998). Seeing biological motion. *Nature,* **395**, 894–6.

Nougier LR (1969). *Art Preistorique.* Librarie Generale Francaise, Paris.

Oram M and Perrett D (1994). Response of the anterior superior. polysensory (STPa) neurons to 'biological motion' stimuli. *Journal of Cognitive Neuroscience,* **6**, 99–116.

Panofsky E (1927/1991), *Perspective as a symbolic form.* Zone Books, New York.

Ramachandran VS and Hirstein W (1999). The science of art. *Journal of Consciousness Studies,* **6–7**, 15–51.

Rao H, Han S, Jiang Y, et al. (2004). Engagement of the prefrontal cortex in representational momentum: An fMRI study. *Neuroimage,* **23**, 98–103.

Reisz K and Miller G (1968). *The Technique of Film Editing.* Focal Press, London.

Rhodes G, Jeffery L, Watson TL, Clifford CWG, and Nakayama K (2003). Fitting the mind to the world: face adaptation and attractiveness aftereffects. *Psychological Science,* **14**, 558–66.

Rousselet G, Fabre-Thorpe M, and Thorpe SJ (2002). Parallel processing in high level categorization of natural images. *Nature Neuroscience,* **5**, 629–30.

Savarese S, Fei-Fei L, and Perona P (2004). What do reflections tell us about the shape of a mirror? *Applied perception in graphics and visualization (ACM SIGGRAPH),* 115–8.

Senior C, Barnesa J, Giampietroc V, *et al.* (2000). The functional neuroanatomy of implicit motion perception or representational momentum. *Current Biology,* **10**, 16–22.

Solso RL (1994). *Cognition and the Visual Arts.* MIT Press, Cambridge, MA.

Stice E, Spoor S, Bohon C, and Small DM (2008). Relations between obesity and blunted striatal response to food is moderated by the TaqIA A1 allele. *Science,* **322**, 449–52.

Tabibnia G, Satpute AB, and Lieberman MD (2008). The sunny side of fairness: Preference for fairness activates reward circuitry (and disregarding unfairness activates self-control circuitry). *Psychological Science,* **19**, 339–47.

Tatler BW, Gilchrist ID, and Land MF (2005). Visual memory for objects in natural scenes: From fixations to object files. *Quarterly Journal of Experimental Psychology Section A-Human Experimental Psychology,* **58**, 931–60.

Terzopoulos D (1999). Artificial life for computer graphics. *Communications of the ACM,* **42**, 32–42.

Thorpe S, Fize D, and Marlot C (1996). Speed of processing in the human visual system. *Nature,* **381**, 520–2.

Tiérou A (1992). *Dooplé: The Eternal Law of African Dance.* Routledge, London.

Tucker M and Ellis R (1998). On the relations between seen objects and components of potential actions. *Journal of Experimental Psychology: Human Perception and Performance,* **24**, 830–46.

Vuilleumier P and Pourtois G (2007). Distributed and interactive brain mechanisms during emotion face perception: Evidence from functional neuroimaging. *Neuropsychologia.* **45**, 174–94.

Vuilleumier P, Armony J, Driver J, and Dolan RJ (2003). Distinct spatial frequency sensitivities for processing faces and emotional expressions. *Nature Neuroscience,* **6**, 624–31.

Yonas A and Arterberry ME (1994). Infants perceive spatial structure specified by line junctions. *Perception,* **23**, 1427–35.

Zeki S (1999). *Inner Vision: An Exploration of Art and the Brain.* Oxford University Press, Oxford UK.

THE MANY DIMENSIONS OF THE THIRD ONE

RUGGERO PIERANTONI

THE ASTEROID THEY CALLED STEREOSCOPIA

UNDER the entry 'Stereoscope' of the *Encyclopaedia Britannica*, 1926 edition, we find five pages, heavily illustrated, with the history, the technical details, and the military and cartographic implementations of this instrument (Fig. 20.1). In contrast, 'Chopin, Frederic François' would content himself with one page only. And no illustration, at all! The motives of this apparent historical aberration are many; only one may suffice, here. At that time, there were more than one million stereoscopes and, very probably, many fewer pianos. If we take into consideration this encyclopaedic *incipit* it may be of some interest to remember that the same entry, on the *Enciclopedia Treccani* (a ponderous publication edited in Italy, in 1936) covers less than half a page. 'Chopin, Fryderyk Franciszek' covers the same amount of typographic space, but he is illustrated with the famous Eugéne Delacroix portrait.

The author of the entry for the *Britannica*, Carl Pulfrich, was Privatdozent at the University of Bonn; he was also a member of the *Société d'Astronomie* of Paris and Brussels. Ironically enough, he himself had become 'monocular' as the consequence of an accident. While Pulfrich's academic titles, social consequences, and personal misadventures are all very interesting, they have to give the floor to the long-lasting close friendship, collaboration, and industrial association with Herr Carl Zeiss of Jena.

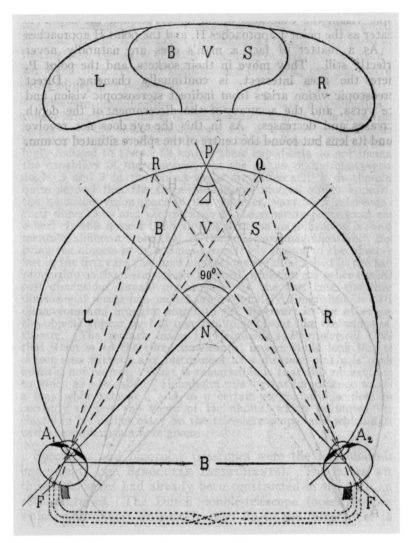

Fig. 20.1 Encyclopaedia Britannica: s.v. Stereoscope.

The most complex, and complicated, instrument of the family of the 'stereoscopes',
the 'Stereo-Telemeter' was built in 1899 by H. de Grousilliers. This object, designed by
Zeiss, was able to provide the 'flâneur de campagne', in love with bell towers, bombs,
and explosive deposits and factories lost among lovely groves, with the exact distance
of these objects from his artillery. Not only that, but the clever machine was also able
to produce a pair of accurate stereo-pictures of the landscape, facilitating the profes-
sional killing. If we would look at the *Britannica*, again, under the entry 'Sight', in Italian,
we would read: 'mirino, sistemi di puntamento, ecc' (systems of targeting) and we
would be rewarded by a beautiful illustration showing the 'Krupp Independent Line of

Sight', a clever system of aiming, which was well appreciated throughout Europe. 'Out of Sight, out of Mind' one could say (or, in Italian 'Lontano dagli occhi, lontano dal cuore', where, curiously enough, the British 'mind' is transformed into its more Mediterranean equivalent 'cuore'). 'Sight', as well, claims more than seven pages. In comparison, 'Karl Philip Emanuel Bach', in Germany, should be content with his three-quarters of a page.

Prof. Pulfrich was not only the most competent man in Europe in the perception and measurement of 'stereopsis', i.e. spatial vision, but he was also a subtle observer of human behaviour. So, he writes: 'The development on stereoscopy has in no way been uniform: on the contrary, a long period during which practically no interest was taken in stereoscopy or stereoscopic phenomena, was preceded, during the middle part of the 19th century, of universal interest . . .' (*Encyclopedia Britannica* 1926).

The essential reason for such an absence of interest may have resulted from the basic ignorance on the part of the potential user about the actual working of the instrument. Obviously, Herr Pulfrich had at hand the final solution, always with the help of the faithful Carl Zeiss. Pulfrich's observation, however, is a surprising one because the stereoscope popular in his times was actually a very basic object made up of a holder, two frames, and an opaque screen in between. The 'working' was very simple. The left frame supported a small print, the left picture; the right frame did the same with the right one. The dividing, opaque, separator allowed the right eye to see only the right image and the left eye to see only the left one. The two pictures could be drawn by hand or, more 'scientifically', obtained with a 'two lens' camera. This special double-lens camera had the two lens axes parallel one to another and separated by a distance of exactly 65 mm. Sixty-five mm is the average distance of the two pupils in the adult man; for the woman, the value is 63 mm. I am afraid that the historical stereoscopes were gender biased. The simultaneous observation of the images induces an irresistible, compulsive, illusion: vision in depth. It is a simple, primitive, easy-to-control experience, nothing difficult, nothing abstract: a plain sensation more than a true perception. It is, also, a quite 'private', almost 'secret', experience. Although the mechanical part of the illusion appears simple and quite elementary, still the emotion, the surprises, and the cognitive puzzles are complex to solve and the psychological management of the 'illusion' may turn out to be heavy and complicated. Pulfrich was very right at pointing at this more cultural than sensorial blindness.

The basic fact, very trivial and elementary, is that the so-called third dimension, when used to represent objects already tri-dimensional, was not 'historically healthy'. On the contrary, for millennia the most used, economical, factual, and practical procedure was to scale down from three to two dimensions. The history of the stereoscope was just one of the many chapters of this history. As mentioned earlier, the instrument provides its user with a most intense, albeit, very private experience. But, humans are social and gregarious and so they would not miss the chance to make the percept public, or even better, political. Two technicians, Rollman in 1853, and D'Almeida in 1858, devised different strategies aimed at the public and contemporary enjoyment of the stereo effect. One of the most successful ones, which enjoyed a temporary glory, was the clever idea to oblige people to use the right eye to see the right

image and the left one to see the other one. The camera, or later on, the movie camera had two lenses again, the right one screened in green, the left one in red. The two pictures, or films, were projected, superimposed on the same screen. The audience was provided with disposable spectacles, having the right eye screened in green and the left one in red. The consequence is simple, the two images are separated: right image to the right eye, left image to the left eye. Unfortunately, the shows met with disaster from the economical point of view. Space was conquered only much later and, surprisingly enough, by sound: the Dolby Stereo system vicariously conquered the space abandoned by the defeat of three-dimensional light.

From Norman Rockwell to Gerhard Richter: from too sharp to sufficiently blurred

The *Saturday Evening Post*, issued on 14 January 1922, has its cover drawn, or better, painted by Norman Rockwell, as was frequently the case during the time period between 1916 and 1963. A boy, his face half hidden by a stereoscope, is staring deep into a very private landscape (Fig. 20.2). On the back of the pair of the stereo-prints he is looking at, you can see the word SPHINX. The boy is, obviously, enjoying a private, and cheap, 'Passage to Egypt' (Finch 1922).

The Egyptian Pyramids, with their simplified form and overpowering volume, were very popular as a subject for stereo-pairs. Their obvious reciprocal position, with the added touch of the Sphinx, made them extremely popular for stereo-shows. In particular the pictures of the Italo-English photographers Felice and Antonio Beato were famous (Fig. 20.3). They circulated also as quite large prints: 24.3 × 35.4 cm and, even after this enlargement, they kept all their crispness and precision of detailing.

Gerhard Richter, in his initial search for a blurred photographical vision of the world may have adopted one of these images as a template for the philosophical universe of his endeavour. This 'illustration' of the Sphinx was shown at his one-man show at the Museo Pecci di Prato, Italy, held from 10 October to 9 January 2000 (Fig. 20.4). Italo Moscati, in his opening text of the exhibition catalogue, chose the image as the whole allegory of the exhibit. The painting, realized in a pale monochrome and very deliberately blurred and smeared, was given a title: in the characteristic descriptive style normally used for historic photographs: *Die Sphinx von Gise (Sphinx des Königs Chepren). Im Hintergrunde die Piramide des Königs Cheops. 4 Dyn. (um 2600 v. Chr.).*

Even the title itself calls attention to the 'visual cliff' between foreground and background, the *Hintergrunde.* But it is precisely in those areas of the painting that the artist blurs the image making the boundary between foreground and background

Fig. 20.2 Cover of the The *Saturday Evening Post*, January 14th 1922.

(Artist: Norman Rockwell.)

indistinct, as if melting into a viscous space. The geometric and optical limits of the objects, their visual boundaries, have been almost completely eradicated from the main gestalt. Under these conditions, even a perfect stereo-pair of the Sphinx would be totally unable to suggest the spatial layout of the image. A technical condition for the success of the stereoscope is that the two pictures should be generously endowed with clearly defined optical boundaries and also rich in abrupt changes in luminosity within very small distances. This may be more precisely stated, in a more academic fashion,

Fig. 20.3 The Sphinx and the Giza pyramid.

(Photograph: F.A. Beato.)

that if the contrast gradient is at its maximum, the stereo effect is at its best. The 'termini expediti delle cose' as Leonardo writes, are the basic elements facilitating the stereo illusion. It is exactly this element, the strong discontinuities in the image, which provides the basis for the working of the hardware and software of our perceptual system. The outcome of this computation will be served to the 'higher' cognitive centres to allow them to produce, eventually, the very idea of space. Or, more accurately, of the reciprocal distance among objects present in a scene.

In contrast, Rockwell's painting shows us, close to the shoes of the American boy, other stereo-pairs which are still to be seen or already seen. Rockwell had worked hard in making them very recognizable, despite their small size in the illustration. It is easy to recognize the 'Colossi of Memmon', the Saqqara pyramid, and a lateral vision of Abu Simbel. All images are sharp, simple, and strongly contrasted: a sure hit.

The physiological mechanism which enables us to build inside us a strong sensation of the distance between two objects involves a differential computation between

Fig. 20.4 Gerhard Richter, *Great Sphinx of Gise* (photo painting), 1964.

pairs of corresponding points in the two retinas. In short: the two retinas can be considered two surfaces sharing the same system of coordinates. Under these simplifying assumptions, each point of the two surfaces is defined by a couple of numbers: its coordinates. Points which occupy the same positions on the two surfaces, i.e. the two retinas, are called corresponding points. If we fixate a point with the two eyes then this point, belonging to the 'object space', projects on to two corresponding points, which belong, now, to the 'image space'. Now, we consider an object located into the 'object space': it may be thought of as composed with an infinite number of points. If we fixate only one among these, the images of the all other ones must fall on points which are not corresponding ones. If we calculate the differences in value between the coordinates on the two retinas of the only one point under fixation, the result is zero. We call this number (zero in this unique case) the 'retinal disparity' for that point. All the other ones must have a retinal disparity different from zero. This computation, done for all of the couples of corresponding points, produces a personal, intense, and true feeling of the distance from us to the object. And, equally important, this computation provides all the spatial information necessary for us to build an internal model of its spatial organization. We extract the immediate consequence that the differential computation of all the retinal disparities (an immense computation of millions of points) is strongly based upon a clear vision of the object or the sharpness of the stereo-pairs.

IN TRIER, TAXES ARE PAID
IN THREE DIMENSIONS

Sometimes, it turns out to be quite healthy for the scientist to leave the lab and leave behind all of its machinery: the stereoscopes, the microscope under which a retina could be observed, or the computer where we simulate processes which, very probably, cannot be simulated. Let us take a walk into a small museum in Trier, Germany.

The bas-relief represents a clear scene: the tax collection which is taking place in front of a benevolent, albeit alert, imperial officer (Fig. 20.5). The admonition is overt, as is the reassuring feeling it should convey to obedient, tax-paying citizens. Around a rectangular table we see the officer with some citizen in the act of depositing his contribution. The money, apparently, is represented as thick discs of metal. To the side, the officer stacks a well-ordered pile of documents: the receipts of the deposit. Near to the documents we see a basket full to the brim with the discs. If we look at the marble slab from a 'legitimate' point of view, at its centre and along a horizontal line of sight, the scene and its spatial setting are explicit and 'ecologically correct'. The table is horizontal, rectangular, and the documents form a perfect rectangular pile. The basket exhibits a logical cylinder-conical shape and its opening is, obviously, circular. The suggested depth of the whole scene is about 50 to 70 cm measured along the horizontal direction. Note that the whole scene is completely logical and absolutely explicit. But if we measure, ruler in hand, the distance between the closest point of the slab (to our eyes) and the farthest point, then we discover that this distance is only 18 mm.

In reality, the surface of the table is strongly tilted (it is almost vertical) and the rectangular documents are slender lozenges that are not piled one on top of each

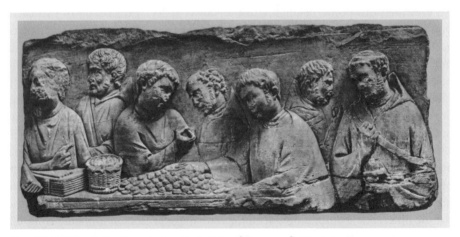

Fig. 20.5 *Tax Collection*, bas-relief. Trier (Germany), Rheinisches Landesmuseum.

other (as coins would be) but rather arranged like the tiles of a very oblique roof. Even more dramatic is the basket: its mouth is an elongated ellipsis and not a circle at all. Although the scene is squeezed into a tiny slab of space, our perception of the scene is compulsively 'spatial' in a way that is comparable to looking into a stereoscope. The slab was sculpted by an anonymous provincial *marmorarius* around the second century AD. It is a small provincial work that was likely commissioned by a central administrator or a local ruler. This bas-relief is not unique. Another similar one has been found in France, at Saintes, in the 'Gallo-Roman' provinces of the empire (Fig. 20.6). In this work, the picture is executed at a strong angle in relation to the plane of the bas-relief, probably due to issues of space. The advantage of such limitation for us is that we may look at the two works side by side. The surface of the table appears almost vertical, as in Trier.

We are, certainly, not at the far limits of the empire; Gallia was an important and powerful province. But we are not in Rome, so the functionary must have been a local officer, not a central figure. Yet despite this, the sophistication of the representation reveals an extremely high competence in the illusive treatment of the space. The sculptor and his team must have been exposed to highly sophisticated works of arts, directly in line with a long-standing Hellenistic tradition and technique in the rendering of the spatial setting of a complex scene. A comparison with an almost contemporary

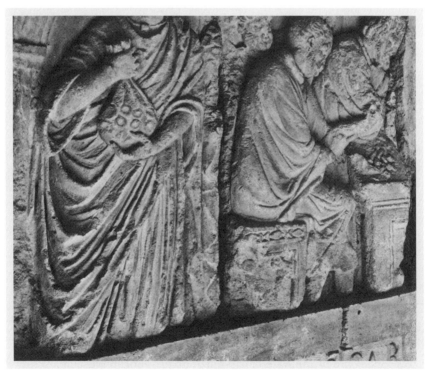

Fig. 20.6 *Tax Collection*, bas–relief. Saintes (France), Musée Archéologique.

work found in Rome may be of some interest (Fig. 20.7). The Hateri were a rich and influential family of builders. Under Domitian they commissioned a sculptor to create a detailed slab representing their family shrine which would communicate their professional skill, technological achievements and private power. The detail we are looking at is the roof of the temple-shrine. The roof appears to be oriented in the same way as real buildings of this type. The line of the tiles follows the slope of the pediment as it should appear in the real space. But here the surprise is similar, albeit,

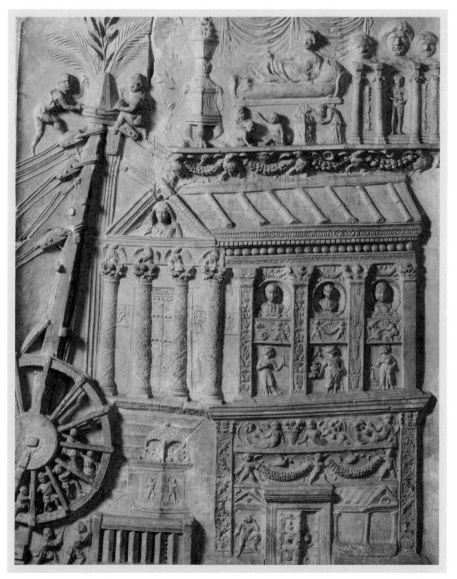

Fig. 20.7 *Sepulchre of the Haterii*, bas–relief. Rome, Vatican Museum.

opposite to the solution of the two 'taxation' slabs. The objective orientation of the sculpted roof is perfectly vertical, and this can be easily deduced in the picture by the shadow cast by the roof on the surface of the slab. The lines of the tiles are strongly oblique, because they have to be parallel to the pediment's sides. Their inclination is logical more than suggestive. But the effect is again achieved with mastery.

At Treviri the horizontality of a table has been obtained by cutting the marble along a very slanted surface; here a slanted surface, the roof, has been obtained with a series of oblique lines, the tiles cutting obliquely across a vertical surface. In both cases the impression of the orientation of a surface has been very successfully obtained. The examples show how easily, under a certain point of view, our stereo-vision can be fooled.

We have considered three cases showing how a tri-dimensional representation may suggest a convincing and coherent spatial setting, even despite 'optically wrong syntax', or ignoring (or perhaps being ignorant of) the canonical laws of stereo-vision. It is clear that the tri-dimensional representations of tri-dimensional objects have met both with unexpected success and equally bitter disappointments. In the third dimension there is more than meets the eye(s).

Marching forward, but in the dark

J. Charbonneaux, in 1948, established a sensational parallel between the *Ara Pacis Augustae* relief in Rome and the *Ionic Frieze* flowing along the sacred walls of the Parthenon in Athens. Over the years, the parallel has lost part of its fascination, but the two representations may still be compared one to another with advantage and suggestion. The Roman frieze is not, in fact, the representation of a people marching forward through history, from perfection to perfection, as in Athens, but to show the people of Rome their rulers (Kellum 1994). The *Ara Pacis* is, in substance, a real altar towards which are walking important citizens charged with immense responsibility but, perfectly human. The *Parthenon* frieze, instead, intends to be a mirror upon which the absolute perfection, beauty, and grace of the sons and daughters of Athens reflect themselves. It is impossible to even approach the melancholy and absolute perfection with which Nicole Loraux in her marvellous book, *L'invention d'Athènes. Histoire de l'oraison funèbre dans la cite classique* writes about the frieze. Two short quotations will illuminate the reader:

However between these two contemporary and competing models of city, there is all of the distance that separates a product of the *logos* from an artwork to be perceived by sight. On the one side, [there is what] the epitaph of the *Menexene* calls "the naked discourse" (*logos psilos*), on the other side a continuous frieze whose unrolling presents itself as if it was the double sculpture of the real path of the procession.

The second one is even more revealing:

In developing the image of the procession of the Athenians around the Parthenon's *sekos*, the sculptor instead has matter and space at his disposal, and his/her work suggests with ease the thickness of reality and the living diversity of the city.

(Loraux 1981, pp. 284–5)

Richard's Stillwell's considerations on the frieze, in particular on its readability from the point of view of an observer, are in line with the intuitions of Loraux, but add something else to our investigation of the third dimension in representation (Stillwell 1969, pp. 231–4). The study makes use of pictures taken on site, but it relies heavily on reconstructions built with physical models and/or geometrical calculations. The optimal positions for the observer are located along a virtual line parallel to the perimeter of the temple and suspended at about 170 cm from the ground. From each one of these points, the observer must gaze along a line oriented at a vertical angle of 45 degrees. The average distance from the frieze is about 14.50 m. From any other point the frieze is practically invisible. Stillwell insightfully considers the percept of an observer walking along in order to see the series of figures and columns:

If he moves in the same direction that the figures are represented as travelling, and observes them without actually stopping, the columns will appear to move in a direction opposite to his motion and hence the procession will seem to move forward just as a distant landscape seen from a train moves forward with one while the telegraph poles near rush rapidly backward.

(Stillwell 1969)

Beyond this well-known 'train illusion', Stillwell also considers the way that the frieze would guide the behaviour of the observer. For example, the west frieze runs high, above the opistodomòs, where the offerings from the islands that were part of the Delya League were deposited. The insistent invitation to proceed, to walk further, would 'discourage' the observer to attempt entry: 'The motive of starting off the procession might be thought of as discouraging any arrangement that would incline the visitor to stop with the idea of entering the west door. . .'. The opposite effect takes place on the east frieze where an accurate symmetrical setting of the figures and their spatial relationships strongly suggests the end of the procession and guides the observer to enter and make an offering to the Goddess, waiting inside: 'Since the east frieze represents the culmination of the Panathenaic procession there is every reason to suppose that the intent was to allow the greatest interrelationship between the sculpture and the architecture. . .' (Stillwell 1969).

This leads us to consider the role of the spatial structure in guiding behaviour. The three-dimensional orchestration of the representation ignites a chain reaction of perception, motion, visuomotor interaction, thought, and even personal and shared memories. However, a technical detail should be taken into consideration: the relief is much higher than the one adopted for the *Ara Pacis*. This higher relief was necessary to introduce into the volume of the sculpted space the necessary 'optical corrections' intended to suggest complex spatial relationships between the bodies: mainly the self-occlusion of a single body and the reciprocal ones between two or more bodies.

But, a higher relief suggests a stronger and more eloquent play with the shadow, which would be expected to be intense under the Acropolis's sun. Both of these points will be considered now—and the second one will bring us a disconcerting 'surprise'.

It was not by chance that Richard Stillwell would express his gratitude to his teacher, Rhys Carpenter, who studied the lost statues of the east pediment in great detail (Carpenter 1933). Carpenter was, eventually, able to reconstruct the dimensions and the general outline of the statues by examining the geometry of the pediment, the depth of the recesses, and also from an acute awareness of the viewpoint of the observer (the conditions of visibility and of invisibility, the social station of the observer, and his/her potential movement in relation to the gods).

We have observed a link between the local use of space in individual episodes of the frieze and the overall space surrounding the temple. This consideration brings us to introduce the unusual theory of the architectural space in Greece proposed by the young Greek architect C.A. Doxiadis in his controversial, but fascinating, study on the distribution of the structures in ceremonial and religious centres in classical Greece. It is not by chance that the title of one of the most interesting histories of architecture written by a Greek architectural historian, Spyro Kostoff, is *Rituals and Settings*. Doxiadis's analysis is based upon very careful surveys of many complexes: Acropolis III, Sanctuary of Aphaya in Egina, sanctuary of Atena in Pergama, and many others. In all the case studies, the strategies of the complexes show a careful avoidance of symmetry so that the main structures would have had to be seen from the main entrance points, always from the side rather than from directly in front of the building. There is the elimination, or, at the least, a deliberate ignoring of any system based on external coordinates such as the classical grid. According to Doxiadis, the centre of the coordinate system—in polar coordinates rather than Cartesian ones—is found at a point midway between the two eyes of the observer. In other words, each object in the space is defined in relationship to the observer and his visual system. An external, eternal, autonomous 'space' is cancelled and replaced instead with an 'observer-centred' estimation of distances and depth. These observations of the architect will appear even more pregnant later in this essay, when we consider that Donatello's bas-reliefs would also evoke an *observer-centred* rather than *object-centred* percept.

As mentioned earlier, the observations of the Parthenon lead to a disconcerting 'surprise'. The frieze runs very high on the wall of the cella, immediately below the ceiling at about 14.3 m of height. Thus, direct light never reaches the sculptures and the only illumination comes from reflections off of the nearby surfaces: the lateral portion of the adjacent columns, the pavement, and the external platform of white rock upon which the Parthenon rests. The greater contribution of illumination comes from the wall of the cella itself. We have to consider the orientation of the building with its long axes oriented along the east–west. In this case the northern side will never receive direct light from the sun (see later for other geographical data), and this implies that the cella's wall is lighted only by the sky and a portion of the platform far from the building perimeter. At the south side, the cella is illuminated only at the end of the day when the rays of the sun shine almost horizontally from the horizon. The consequence is, very simply, that the sculpture is practically invisible. Further information comes from

the Parthenon built in Nashville, Tennessee (Fig. 20.8). The cladding, as far as the absorbance of the light is concerned, is quite similar to the more noble marble from Paros. All of the dimensions and architectural detailing are quoted verbatim from the original. The Nashville Parthenon does not have the frieze, but if you walk along the narrow path between the columns and the cella and you look high, the frieze could well be there: but you would never know for sure, one way or the other. Athens's latitude is about 38 degrees north and Nashville is 36 degrees north. Sun illumination is, then, more propitious in Nashville than in Athens.

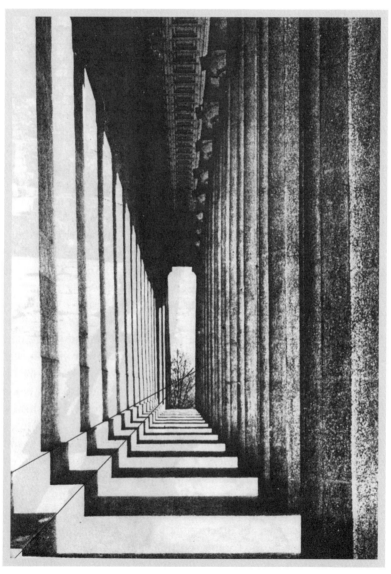

Fig. 20.8 The Parthenon in Nashville.

With her typical clarity of statement and argumentation Gisela Richter, in her seminal 'handbook' on greek art, writes these lines about the frieze:

The 'scorcio' is, now, perfectly understood. The farther parts of the bodies appear reduced in size according to a gradual recession of the planes. Moreover, although a frontal, uniform, plane is always perceivable, the variations of the depth of the relief where the different forms intersect each other give the strong impression of standing or moving figures, one near the other ones. The archaic bi-dimensional idea has been substituted with a tri-dimensional one where the sensation of depth has been perfectly obtained.

(Richter 1959)

Unfortunately, in our case, the tri-dimensional 'effect' has not been obtained because the light, i.e. the shadows, are absent. It is, for certain, very difficult, at least for us, to solve the problem posed by an immense, marvellous and surely very expensive art work, plunged, deliberately we may say, into an almost perfect darkness. The now christened *Elgin Marbles* have been made perfectly visible, but they are located in the absolute wrong position and under historically inaccurate lighting. The third dimension also needs, apparently, shadows in order to be perceived. Retinal disparity it is not sufficient, at least so it seems.

BRUNELLESCHI, DONATELLO, MANTEGNA: STEREO-TRIO WITH 'SPAZIO OBBLIGATO'

An historical survey, even so cursory as the present one, of the tri-dimensional rendering that ignores the extremely rich and complex history of the representation in two dimensions of three-dimensional objects and scenes would be pure nonsense. Here, we will have to be content with a short glance at three artists: Brunelleschi, Donatello, and Mantegna, for whom the passage from two to three dimensions, and back, was a significant characteristic of their professional lives. For example, the relief of *St. George and the Dragon* was executed by Donatello between 1417 and 1420 as the base for his sculpture of *St. George*. The statue of the saint is barely contained in a niche of the Orsanmichele Church in Florence, where the figure has placed at his feet an illustration of courage, elegance, and cleverness (Fig. 20.9). The slab shows, on the right, a portico with four arches seen at a slight slant. Riccardo Pacciani's accurate geometric survey of the relief shows that the portico's plane recedes from about 25 mm to more than 30 mm, which is the total length of the palace façade (Pacciani 1980, pp. 73–95). The delicate slant is, however, more than sufficient to suggest a significant depth. The young Donatello had been intelligent enough to follow two different strategies: (1) the plane's slant is real, objective, even if restrained; (2) the form of the palace facade is trapezoida, as in a correct perspective drawing.

Fig. 20.9 Donatello, *St. George and the Dragon*, bas-relief, 1417–1420.
Florence, Orsanmichele.

This exposure to the so-called *costruzione legittima*, here at its beginnings, will
find even greater realization in the altarpiece for the St. Anthony church in Padua
(1445–1450). The sculpture, in bronze this time, explores the intersection between
the rigorous graphical implementation of classical perspective and the techniques of
three-dimensional rendering. In a few words, we find, astutely woven together, a real
stereo-stimulus, which works on weak but pervasive retinal disparities, and a 'cogni-
tive-perceptual' structure which analyses all of the geometrical cues. It is not difficult
to recognize here some of the basic procedures that were seen earlier in the 'tax collec-
tion' reliefs of the *marmorarii* in Gallia and Germany. The inheritance, in Donatello's
work, of Hellenistic plastic solutions is beyond discussion. But a very dramatic
novelty has been introduced: the stage simulation. Susanne Lang, in her study titled
'Brunelleschi's Panels', analyses the intentions of Brunelleschi to devise and produce
the two famous panels. Lang rules out the idea that the purpose of the 'pannelli' was
merely to produce some didactic, or magic 'perspective exercises'. The main purpose,
instead, was a theatrical proposal for suggestive backdrops, which were to be used on
the stage (Lang 1980, pp. 63–72).

It is of some interest to look now at Donatello's *Herod's Banquet* created in
1423, with its clear-cut division between the actors on the stage and the backdrop
behind them (Fig. 20.10). The *Ara Pacis*, the *Ionic Frieze*, even the two modest 'tax col-
lection' slabs mentioned at the beginning, did not show a foreground that stands out
against a fully separate background. Here, the physical, objective distance between the
heads of the actors and the 'scenario' is dimensionally significant when considered
in relation to the linear dimensions of the whole bas-relief. The retinal disparity,
then, must play a role in building our internal 'sense of space' when looking at this
bas-relief. In contrast, in a flat painting, the only cues to distance are based on line
and colour.

The professional life of Mantegna was spent at the intersection between two
and three dimensions, and he made frequent and deep excursions across this dimen-
sional border. A classical case in point is the centurion saved from the quasi-total

Fig. 20.10 Donatello, *Herod's Banquet*, c.1425. Siena, Baptistery.

destruction of the fresco at the Eremitani representing the *St James before Herod Agrippa* from about 1450 (Fig. 20.11). Its three-dimensional counterpart is a terracotta statue (about 1.66 m in height) representing St. Peter (Fig. 20.12). The statue was originally supposed to be made by Donatello, but the sculptor was busy with the Padua altarpiece and so the commission passed to Mantegna. There is no doubt that the painter, transformed into a sculptor, used themes, patterns and professional procedures that were already well-established from his experience working on frescoes. The statue was completed in 1458. Only the dates of the two works give a clue as to whether the centurion was the painting of a statue or St Peter was a statue based on a painting.

The two works can be compared by looking at Figs. 20.11 and 20.12. However, the statue obviously has more 'degrees of freedom'—it can be considered from many different points of view. The sensorial, but also cognitive, superiority of a statue in relation to a painting may also be a limiting factor for its appreciation. Too many

Fig. 20.11 Mantegna, *St James before Herod Agrippa*, c.1455. Destroyed fresco, formerly Ovetari chapel, church of the Eremitani, Padua. Detail.

potential points of view may compete among themselves, obliterating the unity of the object. In contrast, a painting remains always the same, independently from the direction of sight under which it is seen (one exception, of course, is an anamorphosis). It is always 'that painting'. A sculpture involves a plurality of objects and views rather than a single, unique, 'idea'. When, later, we meet Leonardo's praise of painting vs. sculpture, these considerations will surface again. The ideal dialogue between the *ancient statues* and the *St James before Herod* Agrippa is narrated in a sophisticated passage of *A La Recherche*, where Proust writes of 'a lost race... born from the fecundation of an ancient statue by some Paduan model of the Maestro or some Saxon follower of Albrecht Dürer' (2005). I found this quotation in the splendid book *Su Mantegna I* by Giovanni Agosti (2005), who included as well a portentous phrase of Ulisse Aleotti, where this writer speaks about a portrait painted, around 1447 to 1448, by the young Mantegna: ("he sculpted it in painting, proper, alive and true"). Further down the

Fig. 20.12 Mantegna (attributed), *St. Peter*, terracotta, c.1458. Mantova, Museo civico di San Sebastiano.

same chapter Agosti himself writes: 'We have not to forget that, in this cultural environment, it was common to find the painter-sculptor and the sculptor-painter, and this was the case because the passage from one technique to the other one was common in the 'botteghe' of a few years before' (Agosti 2005, p. 15). However, this lateral shift between two and three dimensions, or the reverse, is not symmetrical. The source and the final text are connected in a complex way and, something always, gets lost in translation, or, even, invented. But the *langue* is similar and in both texts the same mistakes and the same errors are possible.

St. James martyred and
lost in translation

The damage to the Eremitani fresco has almost completely cancelled the figure of the saint, who stands against a pillar to the extreme left of the panel (Fig. 20.13). A good

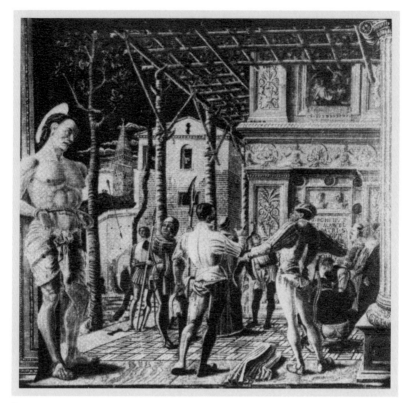

Fig. 20.13 Copy from Mantegna, *St. James,* tempera on wood.
Paris, Musée Jacquemart-André.

copy of the fresco, translated in a quite different pictorial technique, allows us to recon-
struct with some confidence the original appearance of the fresco: the copy, which is
almost contemporary with the original, is on display at the Musée Jacquemart-André
in Paris. The saint is a giant; his stature is twice that of the other persons around him.
At first glance, the size of the saint appears as a very rough 'perspective error', also
because another 'normal sized' figure shares the same marble slab and stands a few
centimetres away from the giant. But the next panel seems to deny the 'error'. In fact
the body of the saint, which lies on the ground, is being carried away, with great efforts,
by his tormentors. Here, the physical contact between an average-sized person and the
saint is made explicit and compelling because the immense leg is directly handled.
Actually, the perspective treatment of the enormous leg and of the body is almost
perfectly rendered, which shows, as if this was necessary, the Mantegna's full control in
the *arte dello scorcio* (Caravaglia 1967; Agosti 2005).

A problem arises, however, in the other part of the cycle, in which the saint is repre-
sented in various situations from his life (such as while engaged in conversation with
demons, baptizing the magus Ermogene, under trial and carried out to execution). In
all of these circumstances, the saint appears to have a normal stature. An excessive size,

reserved only for the martyrdom, seems to be ruled out. Mantegna's work on the panel was confined to between 1453 and 1457. Similarly, Donatello worked on the Padua altarpiece until 1450—in particular on one of its panels, the *Miracle of the new-born child*, which was produced between 1446 and 1450 (Fig. 20.14). In many ways, the scene is typical of the Donatello of those years: it shows a violent and instantaneous commotion of agitated people. But the key element which we seek is a 'gigantic' figure of a young man, standing against a pillar, which opens the narrative on the left side. The man has climbed a pedestal to watch the scene from above. But, apart from this different placement in the scene, he also appears out of scale in relation to the other people.

Could this be another 'perspective error'? By such an expert as Donatello? Of course not: the young man is not a giant. He is only located higher than the other actors. But we are not allowed to see the pavement. The vanishing point is kept so low that the the eye level is practically coincident with the base line. Donatello, very astutely, represents the lateral sides of the pedestals in such a way as to have their receding surfaces slightly trapezoidal in shape, obtaining in this way the total cancellation of the base plane. In absence of any explicit indication of distance we 'must' deduce that the other persons are acting quite far away from the 'limelight'. Our active and very sensible computation of retinal disparities is able to record the weak, but intense, difference in depth between the young man and the others. This sensory-perceptual aid to depth cannot be obtained within the fresco language for two reasons, one technical the other linguistic. First, the fresco lies on a single, flat, vertical plane and so the retinal disparity algorithm does not work under this limiting condition. Second, the grammatical or syntactical rules of paintings, in Mantegna's time, did not allow for the elimination of the horizontal plane (upon which the human figure rests, or runs or stands).

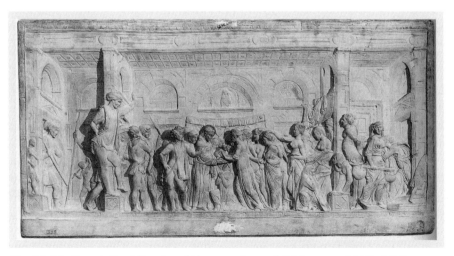

Fig. 20.14 Donatello, *Miracle of the new-born child*, bronze, 1447–1450. Padua, Basilica di Sant'Antonio

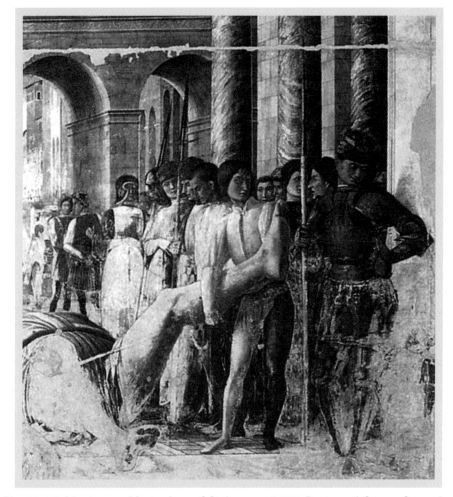

Fig. 20.15 Mantegna, *Martyrdom of St James*, c.1455. Destroyed fresco, formerly Ovetari chapel, church of the Eremitani, Padua. Detail.

Has Mantegna committed a perspective crime? Of course not. But he may have attempted a backward translation from Donatello's 2.5 dimensions to his full 2.0 dimensions. But the two syntaxes were different—while Donatello could easily do away with the horizontal plane at will, Mantegna could not.

A short passing example may clarify this asymmetry in translation. But, this time, the first (source) 'text' in our translation is a tenuous, delicate drawing, while the final (destination) text is an enormous sculpture, indeed a very bulky one. The notebook of Jacopo Bellini is a collection of fabulous, almost immaterial and delicate drawings; some of them represent fable-like architectures and settings.

One of the most famous drawings from this collection is the *Cavaliere*. Drawn in c.1420, it represents a horseman, or a perhaps instead a *statue* of a horseman. The similarity between this drawing and Donatello's monument to the war lord

Gattamelata—which was built, more than sculpted, in Padua from 1445 and 1447—is obvious. From drawing to sculpture, the representation has been 'translated' not only from two to three dimensions, but also from the Venetian *langue* into the Tuscan idiom. The translatability has been made possible by a sort of 'Tuscanization' of Bellini (Joost-Gaugier 1980). The acquaintance of the Venetian painter with the Florentine style has predisposed the source text (the drawing) to the possibility of translation into the third dimension. A further element sheds light on to the path from the *Cavaliere* to the *Gattamelata*. The information about the fact that 'in Florence was visible, from 1439 onwards, a small monument in silver of the condottiero' adds a further element to the history of the common linguistic ground that allowed translation to and from three dimensions (Parronchi 1980).

It is difficult to think about the *Gattamelata* monument without being almost overwhelmed by its assurance and extreme solidity. But the control of the, so-called, third dimension in the panels of the San Lorenzo's Pulpit in Florence is far more subtle and pervasive. This example demonstrates that nothing is more wrong and misleading than the following 'equation':

$$3 \text{ Dimensions} = 1 \text{ Dimension} + 1 \text{ Dimension} + 1 \text{ Dimension}.$$

Never has the classical mantra of the Gestaltists been more appropriate: 'The whole is more than the sum of its parts'. The evaluation of the reciprocal distance among physical objects is a final internal statement, which is the result of a flowing, continuous, and multilevelled process. The retinal disparity may be the first step, but it is immediately 'followed' by computation of luminance levels, shape recognition, mental rotation of the perceived object, and more. When Donatello re-represents, on a much larger scale, a volume very similar to a real horse, he plays on a lower symbolic scale. But his relief sculptures of the San Lorenzo Pulpit in Florence sets in motion a much higher series of perceptual-cognitive sequences (Figs. 20.16 and 20.17). A cursory glance at these works may be useful. In the panels, the pavement is often displayed with great evidence, following a strategy opposite to the *St George* or the *Miracle of the new-born child*. But, in the *Pentecost*, the vision of the pavement is necessary to the narrative because we must see crosses on the ground. Again, the stage is confined between prominent wings that protrude from the background. These wings, in Italian 'alette', have the aspect of low buildings covered by a tiled roof. When seen with the eye located at the canonical point, according to the rules of perspective, they appear correctly shaped. When seen away from the 'legitimate' point of view, then they show all their 'deformation'. This procedure is identical to the one followed in large frescoes, as in the Del Pozzo ceiling in Sant'Ignazio's church, in Rome. We have, here, a representational technique used for a two-dimensional (flat) representation applied to a three-dimensional work. But using a more basic trick, Donatello has given the walls of the wings a rich surface pattern. The suggestion is that we are looking at a surface woven along two orthogonal directions, such as a wall made with reeds. We may recognize the same pattern in the pavement of the fresco by Mantegna. But there is no doubt that the surface pattern helps enormously to give retinal disparity. Had the walls being perfectly polished and homogeneous, the perceived depth would have to be computed based

Fig. 20.16 Donatello, *Pulpit of the Resurrection* (The Pentecost), bronze, c.1465. Church of San Lorenzo, Florence.

on the luminance only. Here the explicit and intense pattern ignites a process, discovered (or at least explored) by Bela Julesz, which we will discuss later.

GIOVANNI BECATTI UNDER THE SUN
OF THE ACROPOLIS

The disconcerting observation of the 'invisibility' of the Parthenon frieze deserves a completely different cultural analysis: after all the *St George and the Dragon* together

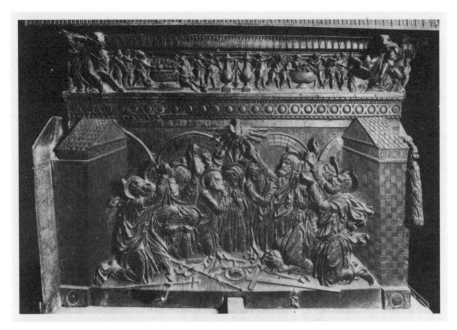

Fig. 20.17 Donatello, *Pulpit of the Resurrection* (The Pentecost), bronze, c.1465. Church of San Lorenzo, Florence.

with other numerous examples of sculpture are perfectly visible. The difficulties in seeing the relief have nothing to do with our discussion about the dialogue between 'dimensions'. But the absence of light, and thus of shadows is, instead, of paramount importance. A different approach may be of some usefulness. In the decade between 1960 and 1970, a sudden acceleration occurred in the field of anatomy, physiology, and biophysics of vision. One of the leading factors was the decision to 'concede' the power of vision to machines. A quasi-perfect handbook on this subject may be suggested for the interested reader: Stephen E. Palmer's *Vision Science: Photons to Phenomenology* (1999). Practically all the lines of inquiry, from anatomy to robotics, from physiology to information processing, have been excellently treated. Here we deal only with one subject: form from shading. It has been demonstrated that a non-planar surface illuminated with a single source, or, in more complex cases, an extended one, gives information about its curvature. The perception of shape may be perfect even if the surface is absolutely homogeneous under all points of view. A surface perfectly homogeneous and diffusive is called lambertian, from the name of the French scientist who theorized such optical objects. A lambertian surface provides only information about luminance, but on these bases only our perceptual system is able to extract spatial information. Such surfaces, by definition, lack of any form of reflection. But this theoretical condition is seldom obtained. Common, every day surfaces show a mixture of reflectivity and specularity. A very smooth surface tends to behave as a mirror and its surface is constellated with intensely luminous spots: the reflections. It is difficult to be fooled by these luminous areas and to take them for 'objects'.

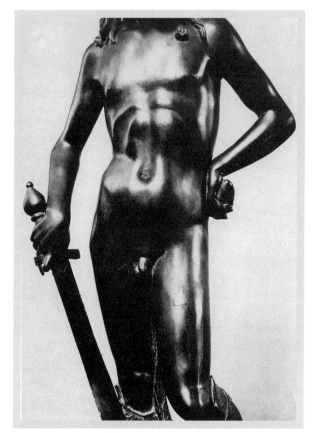

Fig. 20.18 Donatello. *David* a.k.a. *Mercury*, bronze, c.1440. Florence, Museo Nazionale del Bargello.

Let's consider this beautiful picture of Donatello's *David*. The statue is made with extremely smooth bronze. In particular, the photograph shows the body of the boy spotted with 'white' irregular areas. Our tri-dimensional reading is not hampered at all by this black–white puzzle. The form, the spatial distribution of the volumes, stands out, immediately.

Even if we do not know that these 'white spots' are the virtual images, deformed, shifted, enhanced, obliterated, of the source/s of light, we are able, nonetheless, to read the surface with all its evolutions, convolutions, and curvatures. It took a thousand years to connect the geometry of the surfaces to the reflections and then to the light sources. But we have performed, quite successfully, the job for the same thousand years.

Let's move, now, to a quite different sculpture, a different material and, above all, a very different photograph. Giovanni Becatti, for years the head of the Italian archaeological mission in Athens, was given the unique opportunity to photograph

the Ephebe by Critias (Fig. 20.19). He decided to have the statue brought to the open and, under the azimuthal sun of the Acropolis, Ephebe produced a series of unique images. Due to the surface and internal micro-structure of the marble from Paros, we have no reflections, no bright spots, but a continuous variation of the luminance across the body. The boy is lambertian from this point of view. But, exactly as for Donatello's figure, we build our own internal rendering of the surface, without too much effort. The process is, then, independent and based only on computation of luminance value on a very local region, but at the same time extended to the whole image. The simple fact that the intense perception of tri-dimensionality comes from a bi-dimensional image rules out, automatically, retinal disparity algorithms. The ways of the 'third dimension' appear, and perhaps, are infinite. The 'shape from shading'

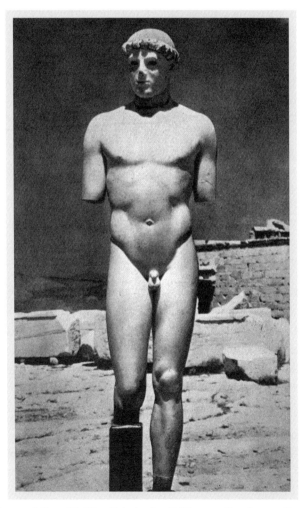

Fig. 20.19 Giovanni Becatti, The Ephebe by Critias on the Acropolis.

algorithms are well treated in a large amount of literature, including, of course, *Robot vision* (Klaus and Horn 1986; Churchland and Sejnowski 1989).

'SE LA SCULTURA AVRÀ IL LUME DI SOTTO PARRÀ COSA MOSTRUOSA, E STRANA' (LEONARDO)

A popular paper on shadows and their role in shape recognition appeared in *Scientific American* in 1988. One of the most quoted illustrations was the one where some objects appeared as concave cavities. It was enough to re-orient the paper and to look at the same illustration, now upside down, and, lo!, the previous shallow plates were transformed into convex bumps. The image was computer generated, monochrome, and without any other detail. The mere substitution of a black pixel with a white one, and this coherently through all the greyscale, was sufficient to revert the spatial perception (Ramachandran 1988; Johnston and Passmore 1994). Shadows were not enough to generate, or to suggest, shapes. The scientists' brilliant observations had been dutifully anticipated by Leonardo, of course. In the "Precetto 38: *Dell'obbligo che ha la scultura col lume, e non la pittura*" introduced into the *Parte Prima del Trattato della Pittura*, Leonardo writes: 'If the sculpture is lit from below, it will appear to be a strange and monstrous thing; this does not happen in painting, which brings all of its parts with it'. In another precetto, number 33, Leonardo takes into consideration the illumination conditions under which the sculpture was originally conceived and built:

(. . .) a mortal enemy of the sculptor in the high and low relief of his works, which will not be worth anything unless they have the lighting set in a way similar to how it was when they were being sculpted. The reason is that, if they are lit from below, the sculptures will appear very [monstrous] and most of all the bas-relief, which almost becomes impossible to recognize and gives origin to opposing readings [of its appearance]

Leonardo connects the conditions under which the sculptor had worked and recommends they must, or should, be present again at the moment of the observation of the completed work. A rather mysterious connection, indeed. The lighting conditions under which Donatello had worked on his *St George and the Dragon*, or Cellini on his *Perseus*, will have no strict counterpart of those 'ecologically' common in Via Orsanmichele, or under the Portico della Signoria. But this 'limitation', or rather 'peculiarity', of the work of the sculptor is in perfect agreement with the low opinion Leonardo pretends to have towards his work, 'La scultura non è scienza ma arte meccanicissima' and, consequently, the sculptor is at mercy of his environment. He cannot 'escape light', the natural, ecological, local light. The painter makes himself

independent from the immediate environment and proceeds, boldly, to follow his very private 'maggiore discorso mentale'. The art work is object centred, space centred, and not observer centred. The tri-dimensional image is built according to a system of external reference. Leonardo cannot be more explicit than here in the *Excusazione dello scultore, 37*:

The sculptor says that he cannot make a figure, without making infinite figures due to the coninuous and thus infinite characteristics [of a sculpture]; one can answer that the infinite characteristics of such a figure can be reduced to two half-figures, i.e. one half back figure and one half front figure. . . and these two half-figures by having all of their proper relieves in all their parts, will represent, without needing anything else, the figures that the sculpture claims to have made.

The sculptor, 'claims to have made all of the infinite figures' but he did not create them. It is the observer, an intelligent painter, maybe, who actually created the forms. But Leonardo in his extreme disdain is not alone. A form of self-sufficient image technology had, independently from him, mechanized the process. It appears that Walter Benjamin's 'age of mechanical reproduction' had already appeared.

A NAKED CYLINDRICAL HERO
WITH A COMPASS ON HIS HEAD

It is difficult to avoid the quotation of the over-celebrated illustration from the *De Statua* of L.B. Alberti and here we make no exception. (Fig. 20.20). The statue of the hero stands upon almost perfect circular bases, while another circle, probably in bronze, is balanced on his head. Its circumference is divided in to equal sectors. A ruler, longer than the diameter, sticks out from the circle. Three plumb lines are knotted on two different points of the circumference, and the third one originates at the end of the ruler. This last line grazes the index of the right hand. Even without an instruction manual we understand that the whole machinery is a physical realization of a system of cylindrical coordinates. The statue is, almost physically, contained in a precise portion of space where each single point is associated with three numerical values: a vertical distance from the end of the ruler, the distance from the axes, and an angle between a given base line and the first plumb line.

It is too obvious that this apparatus is an ideological forgery, similar to Dürer's many 'prospettografi'. These complicated and very inefficient machines, which have actually been built and certainly operated, were made only as a proof of the concept. Their purpose was to show a procedure for the sake of it and not to produce representations of any kind. They were the theatrical demonstration of the 'know how' for the benefit of clients or the rival professional in town. It is obvious that artists

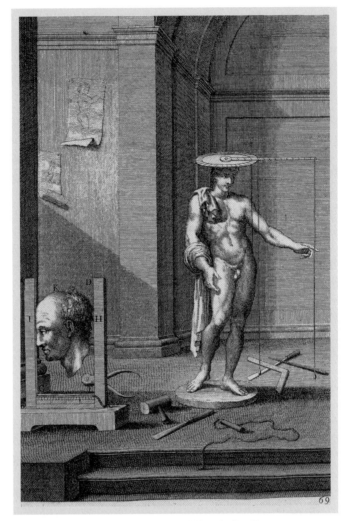

Fig. 20.20 *The definitor*, etching from L.B. Alberti, *De Statua*, 1464.

such as Dürer, Raffael, Michelangelo, Leonardo, etc. did not need such contrivances in order to draw a naked woman, or a lute or a vase. They had only to certify the level of 'investigazione ed invenzione sottilissima degli studi matematici': exactly those competences that Leonardo, so brutally, denies to the sculptor. The extension to the third dimension of the 'quantitative procedure' by Alberti, and not by him alone, confirms the mechanical procedure and lower conceptual level of the act of sculpting. The use of an external reference system confirms the object-centred philosophy, or better technology, of the sculptor. But these 'machines', real or only dreamt about, have not sprung to life by themselves. Behind them we may see, and clearly, the compass, the cartographic representation of the whole planet, Ptolemy, and the scientific

navigation of unknown seas. In 1519 Raphael wrotes, so it seems, a 'letter to Pope Leo X'. The letter was a multipurpose document. It was, at the same time, a short history of the city, an index of buildings in need of immediate restoration, and an erudite text about religion. But the significant part here is the accurate description of the survey of the many buildings. Raffael, or the real author of the text, describes both the instrumental part and the practical procedure used in the surveying. The compass plays a fundamental role and it is entitled to a very accurate description:

Made in such a way that, in its central point, where the lines intersect, we will plant an iron rod, as a small nail, very straight and sharp, and on top of it we will balance a magnet... Then we will seal this place where the magnet is with a glass... one needs to place the instrument on a leveled surface, so that the magnet can point towards its right direction...

The Raphaelesque solution follows the creation of a base line, similar to Pulfrich's stereoscope. The building's elements, corners, columns, etc. are aimed at from two different directions. The applied 'trigonometry' was very straightforward. Apparently, a different approach was followed by Leonardo in his celebrated *Plan of Imola*. In this case it seems that he followed a system of polar coordinates. Rome had been surveyed according to the Doxiadis procedure, Imola according to Alberti's cylindrical, self-centred hero. Although Christopher Columbus was moving into an external reference system, he was always at the centre of his space. He was sculpting his road among the waves.

While Alberti's 'cylindrical hero' may be well known, let us now turn our attention to a much less celebrated image, which shows the atelier, museum, and studio of Bartolomeo Cavaceppi in Rome (Fig. 20.21). Bartolomeo Cavaceppi was an intelligent artist, modest and erudite, admired for his dedication, competence, and virtuosity by all over Europe and, in particular by Winckelmann (see Pinelli 1986). His publication *Princeps*, which followed the commercial trend inaugurated by G. B. Piranesi, appeared in Rome between 1768 and 1772. Our illustration taken from this book shows, at the professional level, the complex interactions between sculpture and the third dimension. The museum-studio-atelier in Via del Babuino shows, in a very un-Piranesian way, many statues under restoration. Some of them are located under large, rectangular frames, probably iron, which have been fastened, horizontally, to the walls. From the side of the frames plumb lines graze significant points of the statue: an index finger, a prominent hip, or the fore leg of the faithful greyhound of the goddess Diana. At first glance, we may think about assonance with the polar coordinate system of L. B. Alberti. Nothing could be more misleading. At the studio in Via del Babuino, the statues arrived already made and consumed by history. They were historical subjects under close study and tender care. Alberti's illustration suggested, instead, a creative or, at least, productive process. The basic act of sculpting involves carving away the stone from a block where the creature may be thought of as still sleeping and waiting for the Pygmalion caress. In contrast, in Cavaceppi's studio, the work took place in the external, public, historicized space. For Cavaceppi, the sculpture was, in substance, only surface. For Alberti it was still a volume.

Fig. 20.21 The atelier of Bartolomeo Cavaceppi in Rome, from *Raccolta di antiche statue busti bassirilievi ed altre sculture restaurate da Bartolomeo Cavaceppi scultore romano*, volume I, Rome 1768.

A final observation on sculptural technique can be found in Canova's studio at Possagno. A large part of Canova's studio work was the change of scale from the *sketch* to the final work. The delicate skin of plaster is constellated with hundreds of small black dots located on strategic points of the body: a buttock, the delicate wrist, the nipple, the root of the nose. The transfer of the same shape on to a larger scale must have been very complicated, but it was not a mechanical multiplication, or division, of a numerical value. Here, also, the replica has been made according to the idea of a faithful 'technical reproducibility' (Fig. 20.22). But the constellation of points,

Fig. 20.22 Canova's statues showing a multitude of reference points used to enlarge the sculptures.

in expansion or contraction, works more under the rhetorical laws of analogy than according to the mathematical operations of division or multiplication.

AND TO THE MACHINE: THE GIFT
OF PERFECT RANDOMNESS

The texts written by Leonardo on the rather artificial, and instrumental, quarrel between painting and sculpture may be considered ungenerous, and, frankly, dishonest, intellectually speaking. But Leonardo is always Leonardo, and so he cannot escape his terrible intelligence. In fact, his observations upon the monstrosity of the sculpture

illuminated upside down are revealing: 'e massime il basso rilievo, che quasi cancella negli opposti giudizi la sua cognizione'. It is sufficient, apparently, to substitute a black dot with a white one in order to spatially invert an image. And to lose its 'knowledge': a typical, seemingly human capacity. But before entering into this new world, our own, where machines have conquered the rights to see, recognize, classify, memorize, and manipulate physical objects, it may be wise to visit again the tax collector's office in Trier. The marble slab presents to us a basket with elongated ellipses as its opening, rhomboidal documents, a table at a nearly vertical plane, and so on. But we 'recognize' the objects immediately, without hesitation. And this happens because we know, we already have 'knowledge' of it. But machines do not pay taxes. The 'objects' appearing in the slab are not 'objects', they do not 'appear', the 'basket' is nothing but a swift transit of electrons into a computer circuit.

The great enterprise to which, in the 1970s, the vision scientist Bela Julesz set to work was the absolute destruction of shape. And the creation of some luminance patterns which, despite their almost perfect absence of meaning, could generate a strong stereoscopic effect' even in a machine (Fig. 20.23). So he invented the Random Dot Stereogram (RDS). This 'stimulus' has been perfectly defined by Patricia S. Churchland and Terrence J. Sejnowski in their book on the 'computational brain'. Here, the definition of the RDS is reported, verbatim:

[A] Pair of images made up of random patterns of black and white dots. The two images are identical except that in one image [a] set of dots has been displaced to the right or the left by a few dots widths. When fused by the two eyes the displaced dots appear to be at a different depth plane from the background.

(Churchland and Sejnowski 1992)

It can be easily seen that the ancient stereoscope has had a very long shadow. After all, a RDS is a stereo-pair that transfers to the observer the computation, point to point, of the retinal disparity. The significant difference is that each of the two 'stereo-pairs' has no meaning. No Sphinx, no approaching train: just ten thousand black and white dots scattered at random on the visual plane. To feel as a machine may do, it may suffice to look at an 'informal' sculpture. Even before falling into some aesthetic trap, or cultural suggestion, our brain is immediately set to work. Is this 'thing' convex or concave, transparent or solid, shiny or matt, cutting or smooth? An impressive number of experiments with 'meaningless' objects had defined an interesting boundary between solid, bulky, massive 'things' and spidery, light, filamentous ones. Let's consider, just as a pure suggestion, a sculpture by Henry Moore and one by Barbara Hepworth. A scientist interested in the phenomenon called 'shape constancy', and to whom the two names are unknown, would concentrate on the 'self occlusion' factor (Palmer 1999, pp. 327–33). A Hepworth sculpture will show a much reduced self-occlusion in comparison with one by Moore. Shape constancy is the ability we have to recognize, for example, a square or a disc under all possible orientations, even the most extreme ones. Leonardo, again, must have the floor: 'Dice lo scultore che non può fare una figura, che non ne faccia infinite per gl'infiniti termini che hanno le quantità continue'. It has been demonstrated that the correct perception

Fig. 20.23 Bela Julesz. Random–dots stereogram (RDS).

of shape is very low with objects with a low 'self-occlusion factor' and yields good results with a high 'self-occlusion'. Bela Julesz intended, at the beginning of his inquiry, to provide machines with information about space, even if the luminance pattern they have to rely upon was deliberately built as meaningless, at least for us. A successive study on the more 'private' statistics of the already thought-of random patterns revealed the unexpected ability of our visual system to 'make sense' of the deep

Fig. 20.24 Sculpture made after Tischbein's famous portrait of Goethe (1787). Central Hall of the Frankfurt airport.

(Photograph: author.)

statistical structure of the RDS. It is as if the study of space—started for and held on behalf of the machines—had given place to a more deep inquiry into the visible world for us (still) humans.

WOLFGANG VON GOETHE AND THE *LAOCOON*:
DIALOGUE BY TORCH-LIGHT

A common word, much used in the preceding discussion, was 'self-occlusion'. This is the progressive revelation and/or concealment of different parts of a single, complex, object, when it is set in rotation or more freely manipulated or displayed through a reciprocal motion between the object and the observer. But rotation, manipulation, movement imply a time factor which has been fully ignored till now. We will, at the

end of this study, 'discover' the fundamental role of time in the perception of space. The third dimension seems to beg for help from the fourth one. We, very briefly, contemplated the *Gattamelata* and the *Cavaliere* of Jacopo Bellini, and we should also have remembered, on that occasion, the *Monument to Giovanni Acuto* painted by Paolo Uccello, high on the barren walls of Santa Maria del Fiore. At that point we must discuss the idea of mental rotation. This extremely interesting ability we have in 'rotating' something in our heads allows us to execute, in some way, a mental manipulation of an internal 'image'. The procedure seems to be performed with a standard and quite constant 'velocity': about 60 degrees per second. This suggests that the intense, even if very private, spatial feeling depends merely on velocity. It looks like we are in the presence of a 'cortical disparity' played along the temporal dimension. Is this ability at work also when we are directly, objectively, confronted with a real object in a real setting?

In the 1990s there was further confirmation that we have a good spatial sensation with a classical RDS even under the temporal interval of some fraction of a second: 200 milliseconds of delay do not destroy the perception of depth. Again, stereo-vision is not impaired by head movements, eye-head movements and is present under very free and liberal stimulation conditions (Utttal et al. 1994).

Let us return finally, to the Privatdozent Herr Pulfrich and to the still-unexplained name 'stereoscopia' with which we began. An interesting photographic technique had been applied to astronomy at the end of the past century. It was notoriously difficult, if not impossible, to spot, between two consecutive photographic plates, the same celestial object which had moved someway between the two shots. The elegant solution was to superimpose the two negatives and to switch them back and forth. The immobile light points, the fixed stars, were not 'moving', but the only small spot which had moved appeared to jump on and off the plates. It was, unintentionally, a brilliant application of the classical RDS (where the random dots were the fixed stars) but with the introduction of the time lapse. The point was left with the only one possibility: to jump.

It is interesting, now, to move to much higher places, or spaces, and higher times: the *Louvre*, 14 July, 1804. Napoleon and Josephine are standing in the Salle des Antiques du Musée. Before the imperial couple, the *Laocoon* in his niche is still struggling with marine serpents. The great hall is in the dark, so two 'operators' move long and slender poles, with rectangular boxes at the end, around the statue. From these containers, flashes are erupting which illuminate the stoic father. What is happening under the imperial eyes? A repetition of a traditional 'torch show' which had been very common in Rome, with the *Laocoon* as the main actor and subject. The statue, illuminated in a discontinuous way, appeared under 'brief exposures'. The perceptual, and much desired, illusion was to see the marble 'come to life' under the torches. Goethe had seen the same show well before the Emperor. In his journal, *Propyläen*, in the first edition of 1798, he describes the experience with his usual detachment and supreme precision:

To catch the *Laocoon* in motion, we will stand in front of the group at the appropriate distance and with our eyes shut. Now we will open and close them in a fast sequence. We will see the

marble turning to life . . . the effect is marvellous when we observe the group, in the dark, under the torch lights.

Evidently, in the experience described in the *Propylæn*, the statue (we know it was a copy seen in daylight and the alternation between light and dark was obtained with the artifice of closing and opening the eyes. But the 'real' experience Goethe had intensely felt comes from his time in Rome when he saw the statue in its niche in the Vatican Gardens: 'the *Laocoon*, in his niche, can be seen appropriately only by torch-light' (Goethe 1989, p. 218).

For us, what had taken place in the eyes, or better, in the brain of Goethe, is deceptively simple. The 'pixels' of the '*Laocoon* one' change state every fraction of a second, giving rise to the '*Laocoon* two'. Most of the background did not change, so the retinal disparities set in motion by the 'movement' of the pixel provided the necessary motion in space: *Laocoon* moves! In this case only the light had moved, not the eyes and, fortunately, not the serpents. The motion of the light had created the third dimension. Retinal disparity can either be interpreted in terms of depth (space) or movement (time). In fact, for perception, space and time are intimately and inextricably linked.

We conclude this discussion of the third dimension in art with another kind of motion. On 24 March 1787 Goethe arrived in front of the temples in Paestum. He is disconcerted, he does not understand them, they appear alien, almost beyond comprehension: 'at first sight they excited nothing but stupefaction . . . these crowded masses of stumpy conical columns appear offensive and even terrifying . . . It is only by walking through them and round them the one can attune one's life to theirs'. These immense stereometric volumes may be understood only by walking around them, moving your eyes in relation to the columns, to their shadows. The wanderer evoked by Stillwell has to move around the Parthenon friezes in order to 'attune its life to his own'. A surprising conclusion arises from these excursions to the temples: 'Reproductions give a false impression; architectural designs made them look more elegant and drawing in perspective more ponderous than they really are'.

This imaginary conversation with Bela Julesz should have taken place while having a drink at the buvette in the central hall of the Frankfurt Airport under the lofty, yet benign, eyes of an intensely tri-dimensional Goethe, clad in plaster-white garments. It is a sculptural translation of the famous two-dimensional portrait of the writer by Johann Heinrich Wilhelm Tischbein (Frankfurt Stadhische Galerie). Walking around the statue, one wonders whether giving Goethe this third dimension added, or took away from our perception of the profundity of the writer.

References

Agosti G (2005). *Su Mantegna I. La storia dell' libera la testa*. Feltrinelli, Milan.
Caravaglia N (1967). *L'opera completa*. Rizzoli, Milan.

Carpenter R (1933). The Lost Statues of the East Pediment of the Parthenon. *Hesperia, Journal of The American School of Classical Studies at Athens*, **2**, 1–110.

Churchland PS and Sejnowski TJ (1989). *The computational brain*. MIT Press, Cambridge, MA.

Finch C (1922). *Norman Rockwell's America*. Harry N Abrams, Inc., New York.

Goethe JW (1989). *Italian journey*, WH Auden and E Mayer, trans. Penguin Books, London.

Johnston A and Passmore PJ (1994). Shape from shading. I: Surface curvature and orientation. *Perception*, **23**, 169–89.

Joost-Gaugier CL (1980). Some considerations regarding the Tuscanization of Jacopo Bellini. In MD Emiliani, ed. *La prospettiva rinascimentale codificazioni e trasgressioni*, pp .165–76. Centro Di, Florence.

Kellum BA (1994). What we see and what we don't see. Narrative structure and the Ara Pacis Augustae. *Art History*, **17**, 26–45.

Klaus B and Horn P (1986). *Robot vision*. MIT Press, Cambridge, MA.

Lang S (1980). Brunelleschi's Panels. In MD Emiliani, ed. *La prospettiva rinascimentale codificazioni e trasgressioni*, pp .63–72. Centro Di, Florence.

Loraux N (1981). *L'invention d'Athènes. Histoire de l'oraison funébre dans la 'cité classique'*. Mouton, Paris, pp. 284–5.

Pacciani R (1980). Ipotesi di omologie fra impianto fruitivo e struttura spaziale di alcune opere del primo rinascimento fiorentino. In MD Emiliani, ed. *La prospettiva rinascimentale. codificazioni e trasgressioni*, pp .73–95. Centro Di, Florence.

Palmer SE (1999). *Vision science. photons to phenomenology*, pp. 242–6. MIT Press, Cambridge, MA.

Parronchi A (1980). *Donatello e il potere*. Cappelli, Florence.

Pinelli OR (1986). Chirurgia della memoria: scultura antica e restauri storici. In *Storia dell' Italiana, vol 3: Dalla tradizione all'archeologia*. Einaudi, Turin, pp. 183–205.

Ramachandran VS (1988). Perceiving shape-from-shading. *Scientific American*, **259**, 76–83.

Richter RMA (1959). *A handbook of Greek art*. Phaidon, London.

Stillwell R (1969). The Panathenaic Frieze. Optical Relations. *Hesperia, Journal of The American School of Classical Studies at Athens*, **38**, 231–42.

Uttal WR, Davis NS, and Welke C (1994). Stereoscopic perception with brief exposures. *Perception & Psychophysics*, **56**, 599–604.

...

FILM, NARRATIVE, AND COGNITIVE NEUROSCIENCE

...

JEFFREY M. ZACKS AND JOSEPH P. MAGLIANO

INTRODUCTION

...

COMPREHENDING a film is an amazing feat of neural and cognitive processing. A series of still pictures are projected quickly on a screen, accompanied by a stream of sound— and a viewer has an experience that can be as engaging, emotionally affecting, and memorable as many experiences in real life. Comprehending film is all the more amazing when one considers how films are constructed. Films typically are comprised of hundreds and into the thousands of individual camera shots, which are continuous runs of the camera. Shots are edited together in such a way to create scenes, which are sequences of goal-directed actions or unintentional events that take place in a particular location (or one or two locations when events are depicted as occurring concurrently). Shots on average last only a few seconds and are edited together in such a way that the vast majority of them go unnoticed by the viewer (Magliano et al. 2001; Bordwell and Thompson 2003; Smith and Henderson 2008).

Consider Fig. 21.1, which depicts about 15 seconds of film from the James Bond film, *Moonraker* (Gilbert 1979). This shot sequence takes place after a fight in mid air between a villain, Jaws, and Bond, in which Bond escapes. Shot 1 depicts the villain pulling the ripcord for his parachute, which breaks. Shot 2 is a high-angle long shot of the character reacting to the fact that the ripcord broke. Shot 3 depicts a reverse, high-angle long shot and the character starts to flap his arms. Circus music, whose source is not yet

apparent, starts during this shot and continues throughout the rest of the scene. Shot 4 is where things get particularly interesting from our perspective. This shot depicts a seemingly incongruent view of the outside of a circus tent; Shot 5 returns to a medium shot of the character who continues to flap his arms. Shot 6 depicts the inside of a circus tent. At this point, many viewers generate the inference that Jaws will land on the circus tent (Magliano et al. 1996). It is impressive that despite the fact that the visual flow of information across shots in film (including those depicted in Fig. 21.1) bears little resemblance to the perceptual flow of information as we interact in the real world (Cutting 2005), viewers can process the juxtaposed and seemly disparate camera shots and comprehend the story events depicted in them with ease. Viewers perceive spatial and temporal continuity across the shots in Fig. 21.1 (Magliano et al. 2001), allowing them to infer that the villain will fall into the circus tent. This example is particularly impressive because viewers must infer that the villain is spatially over the circus tent and that the events depicted in Shot 6 are actually taking place inside the location depicted in Shot 4.

Sequences such as this vividly illustrate that viewers construct representations of events in film that go far beyond the physical stimulus. How do the mind and brain transform a stream of flickering lights and oscillating speakers into a coherent world? Some parts of how people understand film can be explained by examining how the components of film are processed at perceptual, cognitive, and neurophysiological levels: Much of what is said about music and sound in this volume is important for film comprehension. But somehow audition, vision, and their interaction aren't the whole story. This is because films do not simply present audiovisual signals. Rather, in most cases films are vicariously experienced events (Tan 1995; Tan 1996; Zillmann 1995; Copeland et al. 2006; Magliano et al. 2007). Events have their own psychology above and beyond the psychology of the sensory modalities. Thus, to understand how film works one needs to understand how experiences of events are constructed from auditory and visual signals. To do so, we will take a cognitive neuroscience approach, which means we will be interested in phenomena in terms of their information-processing properties and in terms of their neurobiological properties. We will discuss both behavioral and neurological data that shed light into how filmed events are processed and how comprehension emerges from those processes.

NARRATION AND FILM

The technical details of auditory and visual reproduction in commercial cinema have evolved tremendously over the last hundred years, with visual frame rates going from

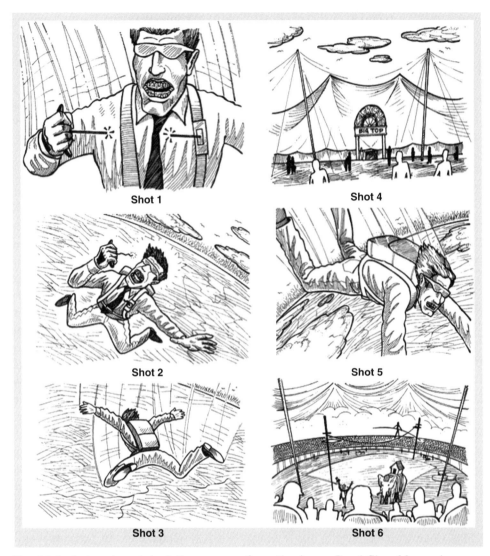

Fig. 21.1 A story board depicting a scene from the James Bond film, *Moonraker.*

16 frames per second to 24, flicker rates tripling to 72 frames per second, visual contrast increasing, colour being added, sound being added, and going from one channel, to two, to five or six. This increased rate in the presentation of images does not change the essential task of a viewer: viewers must construct a mental representation of the depicted events. This situation is complicated in film given the fact that camera shots are often filmed at different times and places and that individual shots that contain minimal feature overlap can be edited together in such a way that viewers perceive continuity of action in spite of the lack of feature overlap (Bordwell 1985; Bordwell and Thompson 2003). (Shots 3 through 4 in Fig. 21.1 illustrate this aspect of films.)

In order to tell a story in film, film-makers rely on formal devices that separate it from activities 'in the wild' (Cutting 2005). Film-makers adopt narrative devices, such as the cut, framing content in a shot, the placement of objects in the scene, directions to actors, music, sound, and dialogue (Bordwell and Thompson 2003). Perhaps the most significant of these is the cut, which is a term used to refer to the juncture between shots. At a cut, every point in the image changes discontinuously. How do human perceptual systems cope with such a jarring transition? According to classical film theory (Bordwell 1985; Bordwell and Thompson 2003), cuts can serve two distinct purposes. The majority of cuts are *continuity edits*, which serve to bridge incidental breaks in the physical features of activity as smoothly as possible in order to maintain continuity of action across spatiotemporal discontinuities. Techniques to do this include preserving the direction of motion across cuts, maintaining ongoing sounds in the soundtrack, and overlapping the objects and characters visible before and after the cut. Approximately 95% of all cuts are continuity edits (Cutting 2005). The remaining cuts are *scene breaks*, at which one action ends and another begins.

Continuity edits are valuable clues to how the brain processes events. This is particularly true for films made in the dominant 'Hollywood style'. Hollywood style attempts to be invisible, so that the viewer is absorbed by the events of the story and does not much notice cuts, camera motion, camera angles, lighting, and so forth. When a film-maker uses a technique (say, a cut) and we as viewers do not notice, this is a hint that whatever is changed by the technique is not very salient to our perceptual and cognitive systems (Levin and Simons 2000; Cutting 2005).

Some authors have argued that cuts in general 'work' because they correspond to visual interruptions that occur naturally due to the movements of the eyes, in particular *blinks* and *saccades* (Murch 2001; Cutting 2005). Blinks, of course, are the brief closures of the eye that typically occur several times a minute. Saccades are rapid ballistic movements of the eye that occur when we shift from looking at one thing to looking at another. Because both result in transient insensitivity to visual input, it is tempting to think they correspond to cuts. The film editor and director Walter Murch (2001, pp. 62–3) proposed that 'a shot presents us with an idea, or a sequence of ideas, and the cut is a 'blink' that separates and punctuates those ideas'. He went on to argue that if you were to watch the eyes of an audience viewing a well-edited film you would see them all blinking together at the cuts. The view that cuts correspond to the transient blindnesses caused by blinks or saccades is intuitive, but a quick investigation suggests

it can't be quite right. Try this: watch a film or TV programme from a distance of at least 6 feet, so the image of the screen on your eyes is not too large. Fix your eyes on the middle of the screen and do not move them. Don't blink for 30 seconds or so. Did the cuts suddenly appear strange and jarring? We suspect not—and the limited experimental data available support this informal observation (Smith and Henderson 2008). So, although in natural viewing some cuts may be effectively hidden by saccades or blinks, this can't be the whole story. Even without transient blindness, a visual change may be effectively camouflaged by another visual change that occurs near it in time. Called *masking*, this effect is pervasive and can lead to pronounced failures to detect changes (Rensink et al. 1997; O'Regan et al. 1999). Many continuity edits may build in masking by placing the cut within or before a period of fast motion, as when a film editor *matches on action*. Match-on-action cuts have been found to be less detectable than cuts that aren't followed by fast motion (Smith and Henderson 2008). So, cuts may be unobtrusive either because they correspond with brief blindnesses or because they are masked by other visual changes. We propose that these two mechanisms account for the unobtrusiveness of most continuity edits. But this still leaves a bunch of cuts left over—those that we seem not to notice despite large unmasked visual changes that don't co-occur with blinks or saccades.

To account for how cuts function more broadly, we make a perhaps counterintuitive proposal: some cuts may 'work' (depending on how they are executed), because human perceptual systems are already segmenting ongoing activity into discrete events all the time. If a cut is placed where the observer would naturally segment the activity, then the cut will be experienced as natural even if it is readily detectable. Such cuts needn't be hidden by an eye movement or visual masking—anything goes. To make this argument, we will have to explain a little bit about the psychology and neuroscience of event segmentation.

EVENT SEGMENTATION

There is good behavioural and neurophysiological evidence that when people watch ongoing activity, they segment it into meaningful events. Segmentation is an ongoing concomitant of normal perception—one that is related to eye movements and blinks, but that reflects the operation of a broader system for orienting attention and updating memory (for reviews, see Zacks and Swallow 2007; Kurby and Zacks 2008). To measure event segmentation behaviourally, one can ask a group of viewers to watch a film and press a button each time they feel one event has ended and another has begun (Newtson 1973). Figure 21.2 gives an example of typical event boundary locations. Viewers agree well with each other on where the boundaries between events are located, and also show individual differences that are stable over time (Newtson and Engquist 1976; Speer et al. 2003). Viewers can segment events at various temporal grains; if the

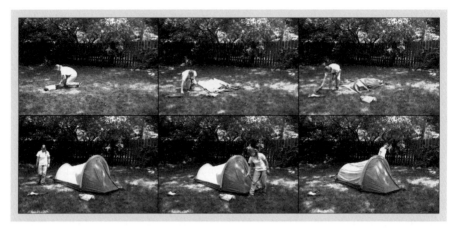

Fig. 21.2 Example of event boundaries. These frames show the six coarse-grained event boundaries selected most frequently by a group of younger and older adults (Zacks et al. 2006b, exp. 2). These boundaries marked the ends of events that could be described as: 1) Put down the tent. 2) Spread it out. 3) Insert the front tent pole. 4) Stake out the ends of the tent. 5) Stake out the sides. 6) Attach the rain fly. Reproduced with permission from Zacks and Swallow (2007).

experimenter asks a viewer to identify more coarse-grained or fine-grained events, participants generally have no problem complying. Fine-grained events appear to be spontaneously grouped hierarchically into larger events (Zacks et al. 2001). In short, viewers' segmentation of films into events is reliable and regular, suggesting that the segmentation task taps into ongoing perceptual processing.

Neurophysiological evidence converges with these behavioural data to suggest that event segmentation happens on an ongoing basis during perception. The relevant studies share a common logic: initially, viewers who are naïve to the event segmentation task watch films while some measure of neural activity is taken. Then, the viewers watch the films again and segment them into meaningful events. The event boundaries identified in this second phase are used as markers to interrogate the previously recorded brain activity recordings, allowing the researcher to ask what was changing in the neural activity during the initial viewing at those points that the viewer would later identify as event boundaries. An attractive feature of this method is that any neural changes observed at event boundaries are unlikely to reflect deliberate event segmentation, because during the initial viewing participants are unaware that they will later be asked to segment the activity. In several studies, this approach has been applied using fMRI (functional magnetic resonance imaging), with stimuli including movies of everyday events (Zacks et al. 2001; Speer et al. 2003), a French art film (Zacks et al. 2010), and simple animations (Zacks et al. 2006). In all cases the fMRI data showed transient increases at event boundaries in activity in a distributed network (Fig. 21.3). Similar results have also been observed using electroencephalography (EEG), which provides a measure of the large-scale electrical activity of the brain (Sharp et al. 2007).

Everyday Events French Cinema

Fig. 21.3 (See Colour plate 7) Evoked responses at event boundaries in
laboratory-made movies of everyday events, and in a narrative French
art film (Lamorisse 1956). Data from (Zacks et al. 2001, left) and (Zacks et al.
2010 right). Arrows indicate the approximate location of area MT+.

Finally, researchers have used pupil diameter as a measure of cognitive load during
film viewing (Swallow and Zacks 2004). In studies of memory and problem-solving,
pupil diameter has been found to increase as the cognitive requirements of a task
increase (Beatty and Lucero-Wagoner 2000). In this study, transient increases in pupil
diameter were observed around those times that viewers would later identify as event
boundaries. Thus, these neurophysiological data converge with the behavioural data to
suggest that viewers spontaneously segment ongoing activity into events as a normal
concomitant of perception.

What determines when observers perceive event boundaries to occur? One recent
theory (Zacks et al. 2007) proposes that, as part of ongoing understanding, observers
make predictions about what will happen next in an activity. A particular individual
doesn't make predictions about everything that might happen in the activity, every-
thing that might change. Rather, viewers monitor a set of features of activity that are
salient and relevant to their goals. When predictions about these features are violated,
viewers perceive the onset of a new event.

According to this theory, event boundaries should tend to occur when features in an
activity change, because in general changes are less predictable than stasis (though
there are some exceptions).

What sorts of changes matter? Viewers tend to segment activity at physical changes—changes in the movement of actors and objects, in spatial location, and in time (Newtson et al. 1977; Magliano et al. 2001; Zacks 2004; Hard et al. 2006). For example, event boundaries tend to occur when objects or body parts are accelerating relative to each other and moving fast (Zacks 2004; Zacks et al. 2009a). If movement is important for event segmentation, one would expect that activity in brain areas specialized for movement processing would be related to event segmentation. This appears to be the case. In particular, area MT+ is an area in the lateral posterior cortex that responds selectively to motion (Tootell et al. 1995; Chawla et al. 1998). As can be seen in Fig. 21.3, MT+ is strongly activated during event boundaries (Speer et al. 2003) such that there is a three-way relationship between movement, event segmentation, and activity in MT+: when things move quickly, activity in MT+ is greater and people tend to perceive event boundaries (Zacks et al. 2006).

In addition to physical changes, viewers tend to segment activity at conceptual changes, such as character goals and causal relationships. These have also been found to predict where event boundaries will occur (Magliano et al. 2005; Zacks et al. 2009b). The neural processes that relate conceptual changes to event segmentation are less well understood than those relating movement to event segmentation. However, we do know that changes to both physical and conceptual features predict activity in most of the areas that increase at event boundaries (Zacks et al. 2010; Speer et al. 2007; Speer et al. 2009). This supports the idea that we perceive event boundaries because we process changes in the features to which we are attending.

CUTS AND CONTINUITY

With this account of event segmentation ready to hand we are in a position to return to the question of how cuts function. We propose that continuity edits and cuts at scene breaks follow different rules. For continuity edits the cut must be hidden by a blink, saccade, visual masking, or something else in order to 'work'. For scene breaks, however, it is not necessary to visually hide the cut if it happens at an event boundary. This leads to a clear prediction: in a well-edited movie, cuts that classical film theory would identify as scene breaks should be identified as event boundaries, whereas continuity edits should not.

We recently set out to test this using behavioural and fMRI data collected while viewers watched *The Red Balloon* (Lamorisse 1956), a French art film about a boy who befriends the balloon of the title. *The Red Balloon* is 33 minutes long and contains 214 cuts. Each cut was categorized based on whether it introduces a change in spatial location (e.g. moving from indoors to outdoors or from a trolley to the street), a change in time (usually jumping forward to elide an unimportant part of the activity), or a change in the action being performed. The remainder of cuts produced changes in viewpoint

on the scene but did not change the temporal or spatial location. According to classical film theory, a scene break occurs when a new action is performed; scene breaks often co-occur with spatial or temporal changes, but this is not necessary.

Viewers segmented the film into coarse and fine events. We used the locations and types of cuts to ask how editing was related to behavioural segmentation and to brain activity during film viewing. The event segmentation data supported classical film theory's account of continuity editing. For both coarse and fine segmentation, cuts that introduced action discontinuities were quite likely to be perceived as event boundaries. Cuts that introduced spatial or temporal discontinuities, but preserved continuity of action, were associated with fine-grained event boundaries but not with coarse-grained boundaries. One possibility is that fine-grained segmentation depends more on the processing of physical changes, whereas coarse-grained segmentation is more sensitive to conceptual changes. Notably, cuts in and of themselves were not associated with event boundaries—if a cut merely changed the camera viewpoint within a scene, it had no discernable effect on coarse-grained segmentation and only a small effect on fine-grained segmentation. In contrast, viewers perceived event boundaries in both the fine and coarse segmentation task if the cuts coincided with a change in action. These data suggest that—at least for *The Red Balloon*—continuity editing techniques are successful in perceptually smoothing over full-field visual discontinuities and that scene boundaries require a break in action.

How does the brain achieve this perceptual smoothing over? The fMRI data provide some hints. We analysed the fMRI response to cuts as a function of whether the cut was perceived as an event boundary and whether it introduced a spatial or temporal change. One set of brain regions selectively increased in activity at those cuts that were event boundaries (shown in blue in Fig. 21.4). These regions overlapped with those that had previously been found to respond at event boundaries, including regions in the lateral temporal and parietal cortex. A different set of regions selectively increased in activity at those cuts that were not judged to be event boundaries but that did have spatial or temporal changes (shown red in Fig. 21.4). These regions included the mid-cingulate gyrus, a region in the lateral inferior parietal lobule, and the lateral anterior temporal lobes. We cannot be sure exactly how these regions participate in bridging spatiotemporal discontinuities in these types of cuts based just on these data, but these results do suggest further lines of experimentation. The activated regions overlap with a network that has been identified with attentional control tasks, in distinction to switches from task to task (Dosenbach et al. 2007). One possibility is that bridging continuity gaps in movies requires the same processes as within-task attentional control. This fits with the proposal that continuity editing works by hiding cuts using blinks, saccades, and masking—all three are associated with attentional reorienting. This hypothesis could be tested using task batteries designed to assess different aspects of attentional control directly (e.g. Fan et al. 2002).

The studies just described were correlational—we did not experimentally manipulate the locations or types of cuts, but took them as they came from the director. Experimental studies also suggest that cuts are less detectable when they correspond to event boundaries. In a study of infant perception (Baldwin et al. 2001), infants watched

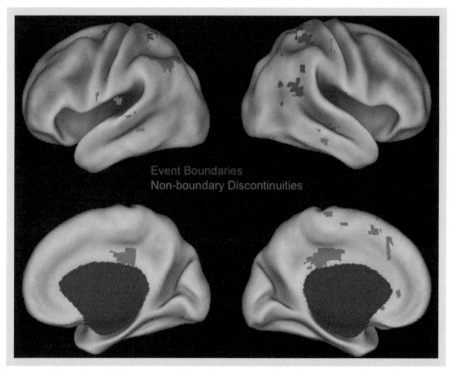

Fig. 21.4 (See also Colour plate 8) Brain regions that increased selectively at cuts that were identified as event boundaries (blue) or points in time that were discontinuous in space or time but were not identified as event boundaries (red). Data from (Magliano and Zacks (under review)).

a short film of a woman cleaning a kitchen until they become bored and looked away. They then were tested with versions of the film that had been modified by introducing brief pauses, placed either to correspond with event boundaries or slightly before or after. The infants looked longer at the versions with the pauses at non-boundaries, suggesting that placing pauses before or after the event boundary made the films more different to them than placing the pauses at event boundaries. Another experiment asked adults to detect cuts in movies presented either intact or with the order of shots scrambled (d'Ydewalle and Vanderbeeken 1990). Scrambling shot order disrupts the structure of events, and thus we would expect it to make cuts more detectable. This was what was found. In a study of memory for events depicted in film, viewers watched brief film clips that contained zero or one cuts, and consisted of one or two actions (Carroll and Bever 1976). After each clip they were shown a six-frame excerpt from the sequence they had just seen or from a similar clip, and asked to distinguish whether the excerpt came from the clip they had watched. The excerpts that did come from the just-watched clip were selected from either the first or second half. Excerpts from the first half were recognized more slowly than those from the second half, particularly when the second half included a new action. This suggests that when a new

action had begun viewers perceived an event boundary, consistent with the segmentation results. Also consistent with the segmentation results, cuts themselves had little effect on recognition. (For reasons that are not clear, however, the authors interpret this as consistent with the idea that cuts themselves produced psychological boundaries.) In a final study (Schwan et al. 2000), viewers watched movies of everyday events with cuts placed either at event boundaries or at points in between the boundaries (based on previously collected normative data). Consistent with the correlational studies, cuts in and of themselves had little effect on where viewers identified event boundaries. Cuts also had relatively little effect on memory: they accentuated memory for details at the locations of the cuts themselves, but did not affect memory for other points in the films.

Beyond cuts—commercials and pauses

Film theorists sometimes speak of cuts—at least in mainstream narrative film—as being largely invisible. Indeed, a major goal of continuity editing is to render cuts unobtrusive. However, film and television make use of a number of more intrusive transitions as well. These include fades, wipes, and iris effects. More rarely, a film can include pauses in which the screen is blank for a brief interval. In commercial television, segments of activity in a programme are interrupted by commercial breaks. If cuts themselves don't affect event segmentation much, perhaps these more intrusive transitions do? A small number of experiments suggest this is the case. In a pair of studies conducted by Boltz (1992, 1995), viewers watched an episode of a detective drama interrupted by zero, three, or six commercial breaks. Breaks were placed either so as to occur at natural event boundaries, or at the points in between event boundaries. The dependent measures included retrospective judgments of the length of the drama (Boltz 1995) and tests of what had happened in the film and when (Boltz 1992). Commercial breaks at event boundaries improved performance on both measures—the more commercials the better viewers' memory. Conversely, commercial breaks at non-boundaries hurt performance.

Schwan and colleagues applied a similar logic in a study using briefer films of everyday events (Schwan et al. 2000). Films were edited to elide sections of the action, either at event boundaries or at the middles between event boundaries. The deleted intervals were replaced with 1-second pauses. After viewing each movie, participants attempted to recall as much as possible. Deleting intervals at event boundaries had little effect on recall. However, deleting intervals in between event boundaries reduced memory for the remaining sections of the movie, and disrupted the temporal organization of memory.

These studies suggest that more intrusive editing techniques may affect event segmentation and memory. However, no studies to date have directly investigated common

editing techniques such as fades and wipes. Commercial breaks are more extended, and do not come into play in current popular or art cinema. Pauses (blank screens) are closer to commonly used editing techniques, but themselves are rarely used. In the future it would be valuable to directly investigate the effects of intrusive editing techniques as they are actually used in cinema on event segmentation and memory.

In sum, some cuts in film may 'work' by being camouflaged in blinks, saccades, or other visual transients, but other cuts may work because they co-opt an ongoing process of segmenting continuous activity into discrete events. As an artist, the director or editor has leverage to work with the natural tendencies of the perceptual system or against those tendencies. Working with natural tendencies will tend to produce smooth, naturalistic continuity editing. Working against them may introduce jarring perceptual effects, comprehension gaps, and memory encoding difficulties. Poorly used, these may frustrate the viewer, but when used to deliberate effect they may afford a richer and stranger cinematic experience. For example, a *jump cut* is a continuity edit that is not well masked and in which an object or person appears in two nearby screen locations on either side of the cut (Anderson 1996). It produces the sensation that something has 'jumped.' In *Dancer in the Dark* (von Trier), Lars von Trier uses a hand-held camera to film the just-jailed protagonist exploring her cell, and several times drops a few frames to produce a jump cut. These jumps disorient the viewer slightly and deepen the sense that time passes very slowly in the cell.

Narrative events

When a viewer segments activity—in everyday life, or in a film—into discrete events, what sort of representation results? Here we draw on theories of narrative comprehension that have been developed and tested in the context of reading and listening as a basis for understanding film comprehension (van Dijk and Kintsch 1983; Kintsch 1988; Zwaan and Radvansky 1998). Although language processing clearly differs in important ways from film processing, it has proven useful to make the working assumption that both text processing and film understanding lead to similar representations of narrated events (Carroll 1980; Bordwell 1985; Branigan 1992; Magliano et al. 2001, 2007; Copeland et al. 2006).

Reading comprehension—and by hypothesis film comprehension—involves constructing a multilevel representation (Kintsch and van Dijk 1978). Readers construct a representation of the *surface structure* of a text, which captures the particular words and phrasing, but this representation is fleeting. In film, this would be analogous to a representation that included visual information about the details of characters' clothing and props. Readers also construct a representation of explicit text content, which is referred to as the *textbase*. This representation contains a network of propositions that is incrementally constructed during reading and represents the explicit ideas contained in a text. Film viewers likely construct a similar representation as well

(Baggett 1979). For example, a representation of the events depicted in this event sequence may consist of several propositions, such as (pull: ripcord, Jaws), (fall: ripcord), (flap: arms, Jaws). Relationships between propositions in this aspect of the representation can be established through co-reference. So, in the sequence shown in Fig. 21.1, continuity can be established because Jaws is present in shots 1, 2, 3, and 5. However, deep meaning emerges with the construction of a model of the situation described by the text (van Dijk and Kintsch 1983; Zwaan and Radvansky 1998; Magliano et al. 1999). This is usually referred to as a *situation model* (sometimes 'mental model'). Here we will use the more general term *event model* (Zacks et al. 2007) to emphasize that we mean an event representation that could be derived from text, from a film, or from real life.

An event model provides an index of how story events are related along a number of dimensions, such as agents and objects, temporality, spatiality, causality, and intentionality (Zwaan et al. 1995a,b; Zwaan and Radvansky 1998; Magliano et al. 1999; Zacks et al. 2009b). For example, comprehending the events depicted in Fig. 21.1 requires viewers to generate spatial temporal relationships between Jaws falling without a parachute and the events depicted in the circus tent. These inferences afford a predictive inference that Jaws will land on the circus tent. These inferences are conceptualized as being part of the event model because they go beyond the propositions that are derived to reflect the explicitly seen events. Finally, narrative plots typically consist of a hierarchy of episodes that are casually related to one another (Thorndyke 1977; Trabasso et al. 1989), and viewers must be able to construct representations that reflect the implicit plot structure. Just as is the case with narrative texts (e.g. Trabasso et al. 1989), viewers must infer and represent the causal relationships between events within a scene and across scenes, the latter of which provide a basis for understanding the plot structure. For example, in a stereotypical action-adventure such as a James Bond film, the character has a primary goal to stop the villain, which can only be accomplished by achieving a series of subordinate goals. If viewers cannot infer that Bond initially visits the villain in order to find out information regarding his involvement in the mystery he is to solve, then they will not be able to comprehend the film.

Neuroimaging studies indicate that narrative comprehension during reading relies on a distributed text-processing network, and also on neural systems that are selectively activated when processing texts that allow one to construct a coherent event model (Ferstl 2007; Ferstl et al. 2008). One important consequence of processing meaningful coherent text is that brain changes throughout the language network increase in strength (Yarkoni et al. 2008). However, there also is evidence that weaving a set of sentences into a coherent discourse selectively activates an area in the prefrontal cortex, specifically on the medial surface near the front of the anterior portion (Ferstl et al. 2008; Yarkoni et al. 2008). This area is usually referred to as dorsomedial prefrontal cortex, or dmPFC. One possibility is that dmPFC is selectively involved in the inference processes that allow one to fill out an event model based on a propositional textbase. Data consistent with this hypothesis come from a study that measured the response to changes in agents, objects, space, time, and goals during narrative reading (Speer et al. 2009). The dmPFC was selectively activated when these situational dimensions changed. Interestingly, a portion of this region increased in activity as more

dimensions changed, but did not show a strong increase for any particular change. Other regions of the brain responded selectively when particular dimensions of the situation changed; we will return to these in the following section.

In sum, event models for narratives reflect the events that are explicit and implicit parts of the narrative, who are involved in them, what are their goals and what to do to achieve those goals, and the outcome of those activities within the spatial temporal framework of the story world (Zwaan and Radvansky 1998; Magliano et al. 1999). Constructing these representations may depend on the dmPFC as well as other brain regions. This sort of conceptual information is relatively abstract—it seems on its face removed from the perceptual experience of watching or reading and the motor experience of acting in the world. How do the contents of event models relate to perceptual and motor experiences? We turn next to this question.

Embodied event representations

Traditionally in artificial intelligence and cognitive psychology, event models were thought to be something like a description in a formal logic or a computer program, specifying parts of the event and features in an abstract language (e.g. Minsky 1972). More recently, however, cognitive scientists and cognitive neuroscientists have come to view event representations as simulations of the situations they represent, which preserve some of the perceptual and motor details of the activity in a form that is closer to perception than to logic (Barsalou et al. 2003). This view is referred to as the *embodied cognition* or *perceptual symbol* view. In this section we will briefly review evidence for the perceptual and motor properties of event models and discuss how these are important for understanding film.

There have been a number of demonstrations that perceptual and motor features are activated automatically during reading. For example, in one study (Zwaan et al. 2002), participants read sentences such as 'The ranger saw an eagle in the sky' or 'The ranger saw an eagle in its nest', and then verified whether a line drawing matched one of the words in the sentence. After reading the sentence about the eagle in the sky, participants were relatively faster to verify a picture of an eagle if it were depicted with its wings outstretched. However, after reading the sentence about the eagle in the nest, participants were relatively faster to verify a picture of an eagle shown sitting with its wings folded. Such data suggest that during reading participants constructed representations that included perceptual information about the spatial configuration of the scene.

Neurophysiological data also support the construction of perceptual-motor content during reading. Some action words such as 'lick', 'pick', and 'kick' are strongly associated with movements of particular parts of the body—in this case the tongue, hand, and leg, respectively. Reading such words selectively activates those parts of

somatosensory and motor cortex that are activated when participants actually move their tongues, hands, and legs (Hauk et al. 2004). Object concepts as well as verb concepts are represented in terms of their perceptual and motor properties (Martin 2007). Similar regions in the temporal cortex are activated by pictures of objects and by their names, and (as noted previously) different categories of objects are associated with activity in different regions in the temporal cortex. Concepts of objects and actions are interrelated, such that the regions activated when thinking about tools are more strongly associated with regions activated during tool use than are the regions activated when thinking about non-manipulable objects (Johnson-Frey 2004). Most of the existing data come from studies in which participants view a simple word, phrase, or picture, and make an explicit judgement about the stimulus. However, recent studies have found evidence that perceptual and motor contents are activated during ongoing story reading (Zacks et al. 2009b) and film viewing (Zacks et al. 2010).

According to this view, whether one experiences an activity in real life, in a film, or through a book, one creates a set of conceptual representations that include perceptual and motor content. If this is true, and if people segment activity into events when features of the activity are changing unpredictably (as we argued above; see 'Event segmentation'), then readers should break up stories into events at changes just as film viewers do. In particular, the account of event models given in the previous section proposes that readers and viewers both segment activity into events when there are changes in the dimensions of the situation represented in their event models—agents and objects, temporality, spatiality, causality, and intentionality. The data seem to support this proposal: whether segmentation is studied in story reading or film viewing, and whether it is measured directly or through indirect measures such as reading time, people appear to segment activity when features in the situation are changing (Zwaan et al. 1998; Magliano et al. 2001, 2005; Rinck and Weber 2003; Speer and Zacks 2005; Zacks et al. 2009b). In neuroimaging studies, selective increases in brain activity are observed at these points, both for reading (Speer et al. 2007, 2009) and for film viewing (Zacks et al. 2006a).

In short, when people understand activity they appear to construct event models that represent what is happening at any given moment. Event models include perceptual and motor content, which may be constructed from language or by inference, as well as directly experienced. Event models are updated at changes in features in the activity, a finding that brings together theories of narrative comprehension with theories of event segmentation.

CONCLUSIONS

What does all of this say for understanding the film viewing experience? First, film directors and editors in the Hollywood style exploit properties of perception and

attention to create unobtrusive cuts. They can do this, we propose, in two distinct ways. One way is to hide a cut using visual masking or by diverting attention. Another way is to make a cut coincide with a perceptual event boundary.

A second conclusion is that perceptual event boundaries mark the major units of narrative comprehension, in film as well as in other media. The nervous system appears to devote a lot of effort to assembling representations of coherent events. Event representations are individuated based on features on multiple dimensions. Previous research has focused on agents, objects, space, time, causes, and goals. We believe—though we can present no evidence for it at this point—that these dimensions are instances of a broader principle: event representations are individuated based on whatever features are important to the viewer's task. Agents, objects, and so forth are often found to be associated with comprehension because these dimensions are often important for understanding. When structural features of film align with the situational features that define events, understanding is easier and memory is better. We believe that thinking about the alignment between structural features in film and situational features in events may allow new creative insights for film artists. By aligning structural elements with situational features one can create a narrative that is comprehensible and flows smoothly. By misaligning the two, one may deliberately disorient the viewer. In this vein, it is interesting to think about commercials in broadcast television such as situation comedies and serial dramas. Our hunch is that commercials often are placed just after situational changes that would typically be perceived as event boundaries. This may encourage viewers to remain in their seats through commercial breaks, but also may reduce comprehension.

Although the psychological and neurophysiological findings we have reviewed here can greatly inform our understanding of the experience of film, they are also greatly incomplete. For one thing, we have said nothing about viewers' affective response to film—though some would argue this is what film (and all forms of narration for that matter) is all about (Brewer and Lichtenstein 1982; Oatley 1995; Tan 1995; Zillmann 1995; Tan 1996). We have done this reluctantly to restrain the scope of the chapter—there is much that could be said. Movies have been widely used to study the emotions in perception, cognition, and memory, because they are effective induces of emotional responses (e.g. Tan 1996). One important bridge between the perceptual-cognitive aspects of film understanding we have discussed here and emotion is the response of surprise, which has both cognitive and affective components (Brewer and Lichtenstein 1982; Brewer and Ohtsuka 1988). For a thoughtful exploration of the cognitive neuroscience of emotion as it applies to film, we recommend a recent volume by Greg Smith (2003).

The results reviewed here are also incomplete because our knowledge is incomplete. As those data reveal, the cognitive neuroscience of perception and cognition has much to tell us about the film viewing experience because our experience of film shares much with our experience of real life. However, some aspects of film are unique, and about these aspects our psychological and neurophysiological knowledge is much less well fleshed out. Here is a partial list of technical features of film that are simply begging for greater psychological and neurophysiological understanding: rate of cutting

(Hochberg and Brooks 2006), viewing angle (Cutting 1987), camera motion, jump cuts, temporal reordering, relations between music and narrative action, deviations from perfect audiovisual synchrony, dubbing, and subtitles. Clearly, the cognitive neuroscience of film is just in its infancy.

ACKNOWLEDGEMENT

Preparation of this chapter was made possible by Grant number #1R01AG031150 from the National Institute on Aging.

REFERENCES

Anderson J (1996). *The Reality of Illusion: An Ecological Approach to Cognitive Film Theory.* Southern Illinois University Press, Carbondale, IL.

Baggett P (1979). Structurally equivalent stories in movie and text and the effect of the medium on recall. *Journal of Verbal Learning & Verbal Behavior*, **18**, 333–56.

Baldwin DA, Baird JA, Saylor MM, and Clark MA (2001). Infants parse dynamic action. *Child Development*, **72**, 708–17.

Barsalou LW, Kyle Simmons W, Barbey AK, and Wilson CD (2003). Grounding conceptual knowledge in modality-specific systems. *Trends in Cognitive Science*, **7**, 84–91.

Beatty J and Lucero-Wagoner B (2000). The pupillary system. In JT Cacioppo, LG Tassinary, and GG Berntson, eds. *Handbook of Psychophysiology*, pp. 142–62. Cambridge University Press, New York.

Boltz M (1992). Temporal accent structure and the remembering of filmed narratives. *Journal of Experimental Psychology: Human Perception & Performance*, **18**, 90–105.

Boltz MG (1995). Effects of event structure on retrospective duration judgments. *Perception & Psychophysics*, **57**, 1080–96.

Bordwell D (1985). *Narration in the Fiction Film*. University of Wisconsin Press, Madison, WI.

Bordwell D and Thompson K (2003). *Film Art: An Introduction*. McGraw-Hill, New York.

Branigan E (1992). *Narrative Comprehension and Film*. Routledge, London.

Brewer WF and Lichtenstein EH (1982). Stories are to entertain: A structural-affect theory of stories. *Journal of Pragmatics*, **6**, 437–86.

Brewer WF and Ohtsuka K (1988). Story structure and reader affect in American and Hungarian short stories. In C Martindale, ed. *Psychological Approaches to the Study of Literary Narratives*, pp. 133–58. Helmut Buske Verlag, Hamburg.

Carroll JM (1980). *Toward a Structural Psychology of Cinema*. Mouton Publishers, The Hague, New York.

Carroll JM and Bever TG (1976). Segmentation in cinema perception. *Science*, **191**, 1053–5.

Chawla D, et al. (1998). Speed-dependent motion-sensitive responses in V5: An fMRI study. *NeuroImage*, **7**, 86–96.

Copeland DE, Magliano JP, and Radvansky GA (2006). Situation models in comprehension, memory and augmented cognition. In C Forsythe, ML Bernard and TE Goldsmith, eds.

Cognitive Systems: Human Cognitive Models in Systems Design, pp. 37–66. Erlbaum, Mahwah, NJ.

Cutting JE (1987). Rigidity in cinema seen from the front row, side aisle. *Journal of Experimental Psychology: Human Perception & Performance*, **13**, 323–34.

Cutting JE (2005). Perceiving scenes in film and in the world. In JD Anderson and BF Anderson, eds. *Moving Image Theory: Ecological Considerations*, pp. 9–27. Southern Illinois University Press, Carbondale, IL.

d'Ydewalle G and Vanderbeeken M (1990). Perceptual and cognitive processing of editing rules in film. In R Groner, G d'Ydewalle, and R Parham, eds. *From Eye to Mind: Information Acquisition in Perception, Search, and Reading*, pp. 129–39. Elsevier, Amsterdam.

Dosenbach NU, Fair DA, Miezin FM, et al. (2007). Distinct brain networks for adaptive and stable task control in humans. *Proceedings of the National Academy of Science of the United States*, **104**, 11073–8.

Fan J, McCandliss BD, Sommer T, Raz A, and Posner MI (2002). Testing the efficiency and independence of attentional networks. *Journal of Cognitive Neuroscience*, **14**, 340–7.

Ferstl EC (2007). The functional neuroanatomy of text comprehension: What's the story so far? In F Schmalhofer and CA Perfetti, eds. *Higher Level Language Processes in the Brain: Inference and Comprehension Processes*, pp. 53–102. Erlbaum, Mahwah, NJ.

Ferstl EC, Neumann J, Bogler C, and Yves von Cramon D (2008). The extended language network: a meta-analysis of neuroimaging studies on text comprehension. *Human Brain Mapping*, **29**, 581–93.

Gilbert L (Director) (1979). *Moonraker* [Motion picture]. Pinewood Studios, United Kingdom.

Hard BM, Tversky B, and Lang D (2006). Making sense of abstract events: Building event schemas. *Memory & Cognition*, **34**, 1221–35.

Hauk O, Johnsrude I, and Pulvermuller F (2004). Somatotopic representation of action words in human motor and premotor cortex. *Neuron*, **41**, 301–7.

Hochberg J and Brooks V (2006). Film cutting and visual momentum. In MA Peterson, B Gillam, and HA Sedgwick, eds. *In the Mind's Eye* pp. 206–28. Oxford University Press, New York.

Johnson-Frey SH (2004). The neural bases of complex tool use in humans. *Trends in Cognitive Sciences*, **8**, 71–8.

Kintsch W (1988). The role of knowledge in discourse comprehension: a construction-integration model. *Psychological Review*, **95**, 163–82.

Kintsch W and van Dijk TA (1978). Toward a model of text comprehension and production. *Psychological Review*, **85**, 363–94.

Kurby CA and Zacks JM (2008). Segmentation in the perception and memory of events. *Trends in Cognitive Sciences*, **12**, 72–9.

Lamorisse A (Writer/Director) (1956). *The Red Balloon* [Motion picture]. Lopert Pictures Corporation.

Levin DT and Simons DJ (2000). Perceiving stability in a changing world: Combining shots and integrating views in motion pictures and the real world. *Media Psychology*, **2**, 357–80.

Magliano JP, Dijkstra K, and Zwaan RA (1996). Predictive inferences in movies. *Discourse Processes*, **22**, 199–224.

Magliano JP, Zwaan RA, and Graesser AC (1999). The role of situational continuity in narrative understanding. In H van Oostendorp and SR Goldman, eds. *The Construction of Mental Representations during Reading*, pp. 219–45. Lawrence Erlbaum Associates, Mahwah, NJ.

Magliano JP, Miller J, and Zwaan RA (2001). Indexing space and time in film understanding. *Applied Cognitive Psychology*, **15**, 533–45.

Magliano JP, Taylor HA, and Kim HJ (2005). When goals collide: Monitoring the goals of multiple characters. *Memory & Cognition*, **33**, 1357–67.

Magliano JP, Radvansky GA, and Copeland DE (2007). Beyond language comprehension: Situation models as a form of autobiographical memory. In F Schmalfolfer and T Goldsmith, eds. *Higher level language processes in the brain: Inference and comprehension processes*, pp. 37–66, Erlbam, Malwah NJ.

Magliano JP and Zacks JM (under review). *The impact of continuity editing in narrative film on event segmentation.*

Martin A (2007). The representation of object concepts in the brain. *Annual Review of Psychology*, **58**, 25–45.

Minsky M (1972). A framework for representing knowledge. In PH Wilson, ed. *The Psychology of Computer Vision*, pp. 211–77. McGraw-Hill, New York.

Murch W (2001). *In the Blink of an Eye: A Perspective on Film Editing*. Silman-James Press, Los Angeles, CA.

Newtson D (1973). Attribution and the unit of perception of ongoing behavior. *Journal of Personality and Social Psychology*, **28**, 28–38.

Newtson D and Engquist G (1976). The perceptual organization of ongoing behavior. *Journal of Experimental Social Psychology*, **12**, 436–50.

Newtson D, Engquist G, and Bois J (1977) The objective basis of behavior units. *Journal of Personality and Social Psychology*, **35**, 847–62.

Oatley K (1995). A taxonomy of the emotions of literary response and a theory of identification in fictional narrative. *Poetics*, **23**, 53–74.

O'Regan JK, Rensink RA, and Clark JJ (1999). Change-blindness as a result of 'mudsplashes.'. *Nature*, **398**, 34.

Rensink RA. O'Regan JK, and Clark JJ (1997). To see or not to see: The need for attention to perceive changes in scenes. *Psychological Science*, **8**, 368–73.

Rinck M and Weber U (2003). Who when where: an experimental test of the event-indexing model. *Memory and Cognition*, **31**, 1284–92.

Schwan S, Garsoffky B, and Hesse FW (2000). Do film cuts facilitate the perceptual and cognitive organization of activity sequences? *Memory & Cognition*, **28**, 214–23.

Sharp RM, Lee J, and Donaldson DI (2007). Electrophysiological correlates of event segmentation: how does the human mind process ongoing activity? *Annual Meeting of the Cognitive Neuroscience Society*, 235.

Smith GM (2003). *Film Structure and the Emotion System*. Cambridge University Press, Cambridge.

Smith TJ and Henderson JM (2008). Edit blindness: The relationship between attention and global change in dynamic scenes. *Journal of Eye Movement Research*, **2**, 1–17

Speer NK and Zacks JM (2005). Temporal changes as event boundaries: Processing and memory consequences of narrative time shifts. *Journal of Memory and Language*, **53**, 125–40.

Speer NK, Swallow KM, and Zacks JM (2003). Activation of human motion processing areas during event perception. *Cognitive, Affective & Behavioral Neuroscience*, **3**, 335–45.

Speer NK, Reynolds JR, and Zacks JM (2007). Human brain activity time-locked to narrative event boundaries. *Psychological Science*, **18**, 449–55.

Speer NK, Reynolds JR, Swallow KM, and Zacks JM (2009). Reading stories activates neural representations of perceptual and motor experiences. *Psychological Science*, **20**, 989–99.

Swallow KM and Zacks JM (2004). Hierarchical grouping of events revealed by eye movements. *Abstracts of the Psychonomic Society*, **11**, 81.

Tan ES (1995). Film-induced affect as a witness emotion. *Poetics*, **23**, 7–32.

Tan ES (1996). *Emotion and the Structure of Narrative Film*. Lawrence Erlbaum Associates Hillsdale, NJ.

Thorndyke PW (1977). Cognitive structures in comprehension and memory of narrative discourse. *Cognitive Psychology*, **9**, 77–110.

Tootell RB, Reppas JB, Kwong KK, et al. (1995). Functional analysis of human MT and related visual cortical areas using magnetic resonance imaging. *Journal of Neuroscience*, **15**, 3215–30.

Trabasso T, Van den Broek P, and Suh SY (1989). Logical necessity and transitivity of causal relations in stories. *Discourse Processes*, **12**, 1–25.

van Dijk TA and Kintsch W (1983). *Strategies of discourse comprehension*. Academic Press, New York.

von Trier L (Writer/Director). *Dancer in the Dark*. [Motion picture]. Fine Line.

Yarkoni T, Speer NK, and Zacks JM (2008). Neural substrates of narrative comprehension and memory. *Neuroimage*, **41**, 1408–25.

Zacks JM (2004). Using movement and intentions to understand simple events. *Cognitive Science*, **28**, 979–1008.

Zacks JM and Swallow KM (2007). Event segmentation. *Current Directions in Psychological Science*, **16**, 80–4(5).

Zacks JM, Tversky B, and Iyer G (2001a). Perceiving, remembering, and communicating structure in events. *Journal of Experimental Psychology: General*, **130**, 29–58.

Zacks JM, Braver TS, Sheridan MA, et al. (2001b). Human brain activity time-locked to perceptual event boundaries. *Nature Neuroscience*, **4**, 651–5.

Zacks JM, Speer NK, Vettel JM, and Jacoby LL (2006). Visual movement and the neural correlates of event perception. *Brain Research*, **1076**, 150–62.

Zacks JM, Speer NK, Swallow KM, Braver TS, and Reynolds JR (2007). Event perception: A mind/brain perspective. *Psychological Bulletin*, **133**, 273–93.

Zacks JM, Kumar S, and Abrams RA (2009a). Using movement and intentions to understand human activity. *Cognition*, **112**, 201–16.

Zacks JM, Speer NK, and Reynolds JR (2009b) Situation changes predict the perception of event boundaries, reading time, and perceived predictability in narrative comprehension. *Journal of Experimental Psychology: General*, **138**, 307–27.

Zacks JM, Speer NK, Swallow KM, and Maley CJ (2010). The brain's cutting-room floor: segmentation of narrative cinema. *Frontiers in Human Neuroscience*, **4**, 1–15.

Zillmann D (1995). Mechanisms of emotional involvement with drama. *Poetics*, **23**, 33–51.

Zwaan RA, Langston MC, and Graesser AC (1995a). The construction of situation models in narrative comprehension: an event-indexing model. *Psychological Science*, **6**, 292–7.

Zwaan RA, Magliano JP, and Graesser AC (1995b). Dimensions of situation model construction in narrative comprehension. *Journal of Experimental Psychology: Learning, Memory, & Cognition*, **21**, 386–97.

Zwaan RA and Radvansky GA (1998). Situation models in language comprehension and memory. *Psychological Bulletin*, **123**, 162–85.

Zwaan RA, et al. (1998). Constructing multidimensional situation models during reading. *Scientific Studies of Reading*, **2**, 199–220.

Zwaan RA, Stanfield RA, and Yaxley RH (2002). Language comprehenders mentally represent the shape of objects. *Psychological Science*, **13**, 168–71.

MIRROR NEURONS AND ART

VITTORIO GALLESE[1]

THE MIRROR NEURON SYSTEM

IN the past 30 years there has been a remarkable increase in our knowledge of the physiology and function of the brain in the appreciation of art. Several scientists believe that the most intriguing discovery in this field is that of the mirror neuron system (MNS). To understand this enthusiasm and assert the possible implications of this discovery for the appreciation and creation of art, we should firstly establish the basic facts. About 16 years ago we discovered in the premotor area F5 of the macaque monkey brain a class of motor neurons that discharge not only when the monkey executes goal-related hand motor acts like grasping objects, but also when observing other individuals (monkeys or humans) executing similar acts (Gallese et al. 1996; Rizzolatti et al. 1996). We called them 'mirror neurons' because, in a sense, their visual properties—the stimuli that excite them when observed—'mirror' their motor properties—the motor acts that excite the neurons when actively performed by the monkey. Neurons with similar properties were later discovered in a sector of the posterior parietal cortex reciprocally connected with area F5 (Gallese et al. 2002). Mirror neurons provide the neurophysiological basis for the capacity of primates to recognize different actions made by other individuals: the same neural motor pattern that characterizes the action when actively executed is evoked in the observer. This matching mechanism, which can be framed within the motor theories of perception, offers the great advantage of using a repertoire of coded actions in two ways at the same time: at the output side

[1] This essay originates from an interview of Prof. Gallese by the editors.

to act, and at the input side, to directly understand the actions of others. What is remarkable is that this matching system has also been demonstrated in humans (see Gallese et al. 2004; Rizzolatti and Craighero 2004). Furthermore, new empirical evidence suggests that the same neural structures that are involved in processing felt sensations and emotions are also active when the same sensations and emotions are to be detected in others (Gallese 2006). It appears therefore that a whole range of different 'mirror matching mechanisms' may be present in the human brain.

When the discovery of mirror neurons occurred, theories regarding embodied cognition and multisensory perception were being explored. Although the discovery seemed to fit in this research context, one should keep in mind that we did not look for mirror neurons. In other words, the discovery was not guided by a preconceived thesis about social cognition. However, we were ready to see mirror neurons, because we were looking for visual properties within the motor system, something that back then was extremely unorthodox. The mainstream view in cognitive science was, and to a certain extent even today is, that action, perception, and cognition are to be seen as separate domains. The discovery of the MNS challenges this view as it shows that such domains are intimately intertwined.

The sharp distinction, classically drawn between the first- and third-person experience of acting and experiencing emotions and sensations, appears to be much more blurred at the level of the neural mechanisms mapping it. The gap between the two perspectives is bridged by the way intentional relations are functionally mapped at the neural-body level. The mirror matching systems in our brains map the different intentional relations in a fashion that is neutral about the specific quality or identity of the agentive/subjective parameter. By means of a shared functional state realized in two different bodies that nevertheless obey to the same functional rules, the 'objectual other' becomes 'another self'. Our seemingly effortless capacity to conceive of the acting bodies inhabiting our social world as *goal-oriented selves* like us depends on the constitution of a shared meaningful *we-centric* space. I propose that this shared manifold space can be characterized at the functional level as *embodied simulation*, a basic functional mechanism by means of which our brain/body system models its interactions with the world. Embodied simulation constitutes a crucial functional mechanism in social cognition, and it can be neurobiologically characterized. The mirror neuron matching systems so far discovered in the human brain represent subpersonal instantiations of embodied simulation.

While one could think that the input to the MNS needs to be visual, we actually showed that a particular class of F5 mirror neurons, the 'audiovisual mirror neurons', discharge not only when the monkey executes or observes a particular type of noisy action (e.g. breaking a peanut), but also when it just listens to the sound produced by the same action (Kohler et al. 2002). These 'audiovisual mirror neurons' not only respond to the sound of actions, but also discriminate between the sounds of different actions. The actions, whose sounds maximally trigger the neurons' discharge when heard, are those also producing the strongest response when observed or executed.

Among their several possible functions, it has been hypothesized that mirror neurons may be involved in the processing of *meaning* (Gallese and Lakoff 2005;

Gallese 2007, 2008). The multimodally driven simulation of action goals instantiated by 'audiovisual mirror neurons', situated in the ventral premotor cortex of the monkey, instantiates properties that are strikingly similar to the symbolic properties so characteristic of human thought. The similarity with conceptual content is quite appealing: the same conceptual content ('the goal of action A') results from a multiplicity of states subsuming it, (sounds, observed and executed actions). The *action simulation* embodied by audiovisual mirror neurons is indeed reminiscent of the use of predicates. The verb 'to break' is used to convey a meaning that can be used in different contexts: 'Seeing someone breaking a peanut', 'Hearing someone breaking a peanut', 'Breaking a peanut'. The predicate, similarly to the responses in audiovisual mirror neurons, does not change depending on the context to which it applies, nor depending on the subject/agent performing the action. All that changes is the context the predicate refers to.

This is particularly interesting also because these results paved the road to a new empirical approach to the study of human language. Several brain imaging studies have shown that processing action-related linguistic material in order to retrieve its meaning activates regions of the motor system congruent with the processed semantic content. Silent reading of words referring to face, arm, or leg actions, or listening to sentences expressing actions performed with the mouth, the hand, and the foot, both produce activation of different sectors of the premotor cortex, depending on the effector used in the action-related linguistic expression read or listened to by participants. These activated premotor sectors coarsely correspond to those active during the execution/observation of hand, mouth, and foot actions. Thus, it appears that the MNS is involved not only in understanding visually presented actions, but also in mapping acoustically or visually presented action-related linguistic expressions (Gallese 2007, 2008).

Such evidence suggests that key aspects of human social cognition are produced by neural exploitation, that is, by the exaptation of neural mechanisms originally evolved for sensory–motor integration, later also employed to contribute to the neurofunctional architecture of thought and language, while retaining their original functions as well (see Gallese 2008). Within the premotor system there is a 'structuring' architecture that can function according to two modes of operation. In the first mode of operation, the circuit structures action execution and action perception, imitation, and imagination, with neural connections to motor effectors and/or other sensory cortical areas. When the action is executed or imitated, the corticospinal pathway is activated, leading to the excitation of muscles and the ensuing movements. When the action is observed or imagined, its actual execution is inhibited. The cortical motor network is activated (though not in all of its components and likely not with the same intensity), but action is not produced, it is only *simulated.*

In the second mode of operation, the same system is decoupled from its action execution/perception functions and can offer its structuring output to non-sensory–motor parts of the brain, among which the dorsal prefrontal cortex most likely plays a pivotal role. When engaged in the second mode of operation, the neurofunctional architecture of the premotor system might contribute to the mastering of the hierarchical structure of language and thought.

MIRROR NEURONS AND ART

The significance of the discovery of mirror neurons for the understanding of responses to art has not yet been fully assessed. In a paper I recently coauthored with the art historian David Freedberg, we argued against the primacy of cognition in our responses to art (Freedberg and Gallese 2007). We proposed that a crucial fundamental element of our aesthetic response to works of art consists of the activation of embodied mechanisms encompassing simulation of actions, emotions, and corporeal feeling sensations; and that these mechanisms are universal. It is true that over the years theorists of art have commented on a variety of forms of felt bodily engagement with works of art, but the mechanisms by which this happens have remained unspecified or entirely speculative. While the evidence we deal with allows for modulation by contextual factors of a wide variety (e.g. temporal, social, cultural, and even personal factors), David Freedberg and I are concerned with the basic mechanisms brought to light by recent research on mirror neurons, empathy and embodiment. While most of the research in these areas has concentrated on responses to living actors, we proposed its relevance not just for realistic representation but also for the understanding of the effectiveness of images and works of art.

Given the variety of forms and techniques employed in contemporary art (video and performance art, digital, painting, and photography), it is interesting to address the difference between representation and object or, more specifically, between watching a video of an action, watching the action being performed for real, and watching a static image portraying the same action. The very few experiments that specifically addressed the issue of the relationship between the degree of activation of the MNS and the real or virtual nature of the agent being observed showed that real action performed in front of the observer elicits stronger responses with respect to videos portraying those same actions. That said, it might be argued that since the activation of the MNS is typically induced by the observation of ongoing actions, the relevance of such mechanism for the aesthetic experience while contemplating static art works could be negligible. However, recent research carried out on the MNS in humans with a variety of techniques has shown that even the observation of static images of actions lead to action simulation in the brain of the observer, through the activation of the same brain regions normally activated by execution of the observed actions. The observation of pictures of a hand reaching to grasp an object, or firmly holding it, activates the motor representation of grasping in the observer's brain. On the basis of these results it is highly plausible to hypothesize that a similar motor simulation process can be induced by the observation of still images of actions carried out by other effectors. In any still image, the 'decisive moment' of the action portrayed, to use an expression of Cartier-Bresson, is captured by an embodied simulation of the contemplator.

There are situations that lead to greater activation than others, which support the view that MNS response can be increased through learning. Recent neurophysiological studies carried out on macaque monkeys have shown that a particular class of ventral premotor mirror neurons starts to respond to the observation of unfamiliar actions

after extensive visual exposure to them, or after motor training. Both results seem to suggest that when an action performed by others becomes familiar, independently from the perceptual or motor source of its familiarization, it is nevertheless always mapped on to a motor representation belonging to the observing individual. Even more strikingly, several brain-imaging studies carried out on humans have shown that the intensity of the MNS activation during action observation depends on the similarity between the observed actions and the participants' action repertoire. In particular, one functional magnetic resonance imaging (fMRI) study by Calvo-Merino and co-workers focused on the distinction between the relative contribution of visual and motor experience in processing an observed action (Calvo-Merino et al. 2005, 2006; see Chapter 27 by Calvo-Merino and Haggard, this volume). The results revealed greater activation of the MNS when the observed actions were frequently performed with respect to those that were only perceptually familiar but never practised. In this sense, one can say that the MNS actually learns through experience. It is, nonetheless, an open question to be empirically investigated, to which extent the professional expertise and/or personal and cultural background of the beholder do play a role in modulating these simulations when contemplating art works.

In the case of mirror neurons, what seems to matter most is that the action must be goal oriented, rather than performed by a human, or at least biological, actor. A recent fMRI paper by Gazzola and co-workers specifically addressed this issue (Gazzola et al. 2007). The results showed that the mirror system was activated strongly by the sight of both human and robotic hand actions, with no significant differences between these two agents. This seems to suggest that the MNS could contribute to the understanding of a wider range of actions than previously assumed, and that the goal of an action might be more important for mirror activations than the way in which the action is performed.

The relationship between art appreciation and empathy is certainly not a new idea. As David Freedberg and I recently pointed out, the notion of empathy (*Einfühlung*) was originally introduced in aesthetics by Robert Vischer in 1873, thus well before its use in psychology. By *Einfühlung*, literally 'feeling-in', Vischer meant the physical responses generated by the observation of forms within paintings. He described how particular forms aroused particular responsive feelings, depending on their conformity to the design and function of the muscles of the body, from those of the eyes to our limbs and to our bodily posture as a whole. Developing Vischer's ideas, Wölfflin (1886) speculated on the ways in which observation of specific architectural forms engage the beholder's bodily responses. Just before the end of the nineteenth century, Aby Warburg, adapting Vischer's notions of *Einfühlung*, developed his own theory of the *Pathosformel*, whereby the outward forms of movement in a work of Renaissance art (e.g. the hair or flowing draperies of a painting by Botticelli) revealed the inner emotions of the figure concerned. Very shortly afterwards, Theodor Lipps wrote at length about the relationship between space and geometry on the one hand, and aesthetic enjoyment on the other (1897, 1903). All these scholars believed that the feeling of physical involvement in a piece of painting, sculpture, or architecture, not only provoked a sense of imitating the motion or action seen or implied in the work, but also enhanced

our emotional responses to such a work. The relationship between embodiment and aesthetic experience was further highlighted by phenomenologists like Merleau-Ponty. Merleau-Ponty not only suggested the possibilities of felt bodily imitation of what is seen in a painting, but also of the implied actions of the producer of the work itself, as in the case of the paintings of Cézanne.

Thus, what is new in our approach? Perhaps the revitalization of this tradition of thought in light of what the empirical research in neuroscience has recently taught us about the enormous importance of the body in a variety of aspects of the human condition, aesthetic experience included. David Freedberg and I are proposing a theory of empathic responses to works of art that is not purely introspective, intuitive, or metaphysical, but that has a precise and definable material basis in the brain. Our theory is articulated in two complementary aspects: 1) the relationship between embodied simulation-driven empathic feelings in the observer and the *content* of artworks, in terms of the actions, intentions, objects, emotions, and sensations portrayed in a given painting or sculpture. This aspect can be viewed as the 'what' of aesthetic experience; 2) the relationship between embodied simulation-driven empathic feelings in the observer and the quality of the artwork in terms of the visible traces of the artist's creative gestures, like brushwork, chisel marks, and signs of the movement of the hand more generally. We can refer to this component as the 'how' of aesthetic experience. Of course, both aspects require now an empirical validation by means of specifically designed experiments, which we will be busy designing and carrying out in the coming years.

Regarding the question of whether the MNS can be activated by abstract art, according to the earlier-mentioned second aspect of our theory, the answer would be affirmative. Our proposal posits that even the artist's gestures producing the art work can induce an empathic engagement of the observer, by activating the simulation of the corresponding motor programme. The marks on paintings and sculptures are the visible traces of goal-directed movements, hence in principle capable of activating the somato-topically relevant motor areas in the observer's brain, as suggested by mirror neuron research. While at present there are no published experiments tackling this issue, there is empirical evidence indirectly suggesting that this could be indeed the case. Several studies show that motor simulation can be induced in the observer's brain also when what is observed is not someone else's action, but the static graphic artefact produced by the action, such as a letter or a graphic stroke (Longcamp et al. 2005, 2006, 2008). This shows that our brain is able to reconstruct actions *a posteriori* by merely observing the static graphic outcome of the agent's past action. This reconstruction process during observation is an embodied simulation mechanism, relying on the activation of the same motor centres required to produce the observed graphic sign. We predict that similar results could be obtained using as stimuli artworks characterized by peculiar gestural signs of the artist, as in the case of Fontana's or Lucis Jackson Pollock's works.

As far as a supposed link between the MNS and creativity, often suggested by the media, it is my opinion that such a relationship at the present stage of the research is too

far-fetched. Creativity is a distinguished feature of the human condition that I am afraid can hardly be reduced to the functional properties of specific populations of neurons, mirror neurons included.

On the other hand, though, I would like to say that creativity cannot either be reduced to the mere product of a disembodied cognitive apparatus. In *L'Œil et l'esprit* Merleau-Ponty writes that we could not possibly imagine how a *mind* could paint. Commenting on the statement by Cézanne that 'nature is on the inside', Merleau-Ponty argues that things arouse in us a carnal formula of their presence. Pushing forward this line of thought, I'd suggest that the artist expresses her/his creativity precisely by being able to retrieve such carnal formula and making it available to others. This shouldn't imply that such expression is the outcome of a deliberate conscious effort. Actually, I think that most of the time it is totally unconscious. As Gilles Deleuze has beautifully emphasized (2005), Bacon is a perfect exemplification of that. Bacon's work epitomizes how the artist's creativity can be so effective in making visible the invisible forces buried inside material objects as well as inside the human psyche.

Many scholars are worried that the idea of mirror neurons has filtered down to a popular level in an inaccurate way, thus often being pushed too far. Some news reports have used it in contexts where it does not apply. Naturally, one should distinguish scientific research from its trivialization by the media. Scientists are responsible for their empirical work and the theories they put forward on the basis of what the evidence suggests to them. How the media communicate, or even distort scientific discoveries, is totally beyond our control.

If we ask ourselves what are the aspects of human social cognition we can shed new light upon on the basis of our discovery of the MNS, the answer would be imitation and mimetic behaviours, action and intention understanding, empathy and its relatedness to aesthetic experience, and language. I'd like to emphasize, though, that the relevance of the MNS in so many different aspects of social cognition does not stem from a specific endowment of these neural cells, as if mirror neurons were 'magic neurons', so to speak. Mirror neurons derive their functional properties from the specific input–output connections they entertain with other populations of neurons in the brain.

The MNS and the functional mechanism describing their activity, embodied simulation, are involved in so many aspects of social cognition because the activation of the multiple and parallel cortico-cortical circuits instantiating mirror properties underpins a fundamental aspect of social cognition, that is, *the multi-level connectedness and reciprocity among individuals within a social group*. Such connectedness finds its phylogenetic and ontogenetic roots in the social sharing of situated experiences of action and affect. The MNS provides the neural basis of such sharing. Embodied simulation and the MNS certainly cannot provide a full and thorough account of our sophisticated social cognitive skills. However, I believe that the evidence accumulated during the last 15 years indicates that embodied mechanisms involving the activation of the sensory–motor system, of which the MNS is part, do play a major role in social cognition, language included. A second merit of our discovery consists in the fact that

it enables the grounding of social cognition into the experiential domain of existence, something that classic cognitivism has totally neglected.

References

Calvo-Merino B, Glaser DE, Grezes J, Passingham RE, and Haggard P (2005). Action observation and acquired motor skills: an FMRI study with expert dancers. *Cerebral Cortex*, **15**, 1243–9.

Calvo-Merino B, Grèzes J, Glaser DE, Passingham RE, and Haggard P (2006). Seeing or doing? Influence of visual and motor familiarity in action observation. *Current Biology*, **16**, 1905–10.

Deleuze G (2005). *Francis Bacon: The Logic of Sensation.* University of Minnesota Press, Ann Arbor, MI.

Freedberg D and Gallese V (2007). Motion, emotion and empathy in esthetic experience. *Trends in Cognitive Sciences*, **11**, 197–203.

Gallese V (2006). Intentional attunement: A neurophysiological perspective on social cognition and its disruption in autism. *Experimental Brain Research Cognitive Brain Research*, **1079**, 15–24.

Gallese V (2007). Before and below theory of mind: embodied simulation and the neural correlates of social cognition. *Philosophical Transactions of the Royal Society of London*, **362**, 659–69.

Gallese V (2008). Mirror neurons and the social nature of language: The neural exploitation hypothesis. *Social Neuroscience*, **3**, 317–33.

Gallese V and Lakoff G (2005). The brain's concepts: the role of the sensory-motor system in reason and language. *Cognitive Neuropsychology*, **22**, 455–79.

Gallese V, Keysers C, and Rizzolatti G (2004). A unifying view of the basis of social cognition. *Trends in Cognitive Sciences*, **8**, 396–403.

Gallese V, Fadiga L, Fogassi L, and Rizzolatti G (1996). Action recognition in the premotor cortex. *Brain*, **119**, 593–609.

Gallese V, Fadiga L, Fogassi L, and Rizzolatti G (2002). Action representation and the inferior parietal lobule. In W Prinz and B Hommel, eds. *Common Mechanisms in Perception and Action: Attention and Performance, Vol. XIX.*, pp. 247–66. Oxford University Press, Oxford.

Gazzola V, Rizzolatti G, Wicker B, and Keysers C (2007). The anthropomorphic brain: the mirror neuron system responds to human and robotic actions. *Neuroimage*, **35**, 1674–84.

Kohler E, Keysers C, Umiltà MA, Fogassi L, Gallese V, and Rizzolatti G (2002). Hearing sounds, understanding actions: Action representation in mirror neurons. *Science*, **297**, 846–8.

Lipps T (1897). *Raumästhetik und geometrisch-optische Täuschungen.* JA Barth, Leipzig.

Lipps T (1903). Einfühlung, innere Nachahmung, und Organempfindungen. *Archiv für die gesammte Psychologie*, **1**, 185–204.

Longcamp M, Anton JL, Roth M, and Velay JL (2005). Premotor activations in response to visually presented single letters depend on the hand used to write: a study on left-handers. *Neuropsychologia*, **43**, 1801–9.

Longcamp M, Tanskanen T, and Hari R (2006). The imprint of action: motor cortex involvement in visual perception of handwritten letters. *Neuroimage*, **33**, 681–8.

Longcamp M, Boucard C, Gilhodes JC, et al. (2008). Learning through hand or typewriting influences visual recognition of new graphic shapes: behavioral and functional imaging evidence. *Journal of Cognitive Neuroscience*, **20**, 802–15.

Merleau-Ponty M (1964). *L'Œil et l'esprit*. Gallimard, Paris.

Rizzolatti G and Craighero L (2004). The mirror neuron system. *Annual Review Neuroscience*, **27**, 169–92.

Rizzolatti G, Fadiga L, Gallese V, and Fogassi L (1996) Premotor cortex and the recognition of motor actions. *Cognitive Brain Research*, **3**, 131–41.

Vischer R (1873). *Über das optische Formgefühl: Ein Beiträg zur Ästhetik*. Credner, Leipzig.

Wölfflin H (1886). *Prolegomena zu einer Psychologie der Architektur*. Berlin.

PICTORIAL ART BEYOND SIGHT: REVEALING THE MIND OF A BLIND PAINTER

AMIR AMEDI, LOTFI B. MERABET, NOA TAL, AND ALVARO PASCUAL-LEONE

Painting is a blind man's profession, as blind people have a clearer vision of reality

Pablo Picasso

I wish I had been born blind, because it would have enhanced my artistic perception of the world

Claude Monet

The average blind person knows more about what it means to be sighted than the average sighted person knows about what it means to be blind

Georgina Kleege, 'Blindness and Visual Culture: An Eyewitness Account', 2005

INTRODUCTION

ARTISTIC expression is a complex behaviour that engages many aspects of perception, cognition, and emotion (Zeki 2001). Painting and, in particular, drawing, represent a form of visual communication associated with the ability to construct, manipulate, and ultimately translate the contents of one's own mental representations (Livingstone 1988). Inherent to this process is the engagement of mental imagery—the role of which has been well established in visuospatial reasoning and creative thought (Kosslyn et al. 2001). Current evidence suggests that in sighted individuals, mental representations are pictorial in nature rather than symbolic or verbal (Kosslyn et al. 2001; Kosslyn 2005; Slotnick et al. 2005), and that mental imagery draws on much of the same neural machinery as visual perception (Mitchison 1996; Kosslyn et al. 2001).

Conventional wisdom assumes that visual mental imagery is largely dependent on recollections of prior visual experience. If so, any impairment in the development, or function, of the visual system should critically modify one's ability to create and manipulate visual mental representations. Thus, the lack of any prior visual experience would likely impede upon a person's ability to create the visual mental constructs required for artistic expression. Is it possible to generate mental pictures via alternate sensory modalities in the absence of any prior visual experience? If so, what are the neural substrates that support such a process? This is what we discuss here in the framework of understanding vision, brain reorganization in blindness, and the interactions between brain research and art.

BRAIN PLASTICITY AND BRAIN REORGANIZATION

The brain, comprised of billions of highly specialized cells, is intricately arranged into precise patterns and connections. Initially, these networks are laid out during development and controlled by a variety of genetic factors. Neurons, given their sophisticated and complex degree of specialization, are likely highly stable and resistant to change. However, what is now becoming increasingly clear is that neural networks and the connections between neurons are highly dynamic and constantly changing in response to environmental input and experience. The nervous system's ability to change, or 'neuroplasticity,' is an ongoing, lifelong process and is an intrinsic property of the brain (Pascual-Leone et al. 2005).

Alcmaeon of Croton, probably the first person to suggest that the mind is located in the brain and not the heart, also suggested that the optic nerves are light-bearing paths to the brain. His revolutionary ideas, formulated about 2500 years ago, were

ignored by Egyptian and Greek scholars alike (most notably by Aristotle). On the basis of the vast amount of anatomical and electrophysiological studies, we now have a picture of a highly diverse and hierarchically structured system (Hubel and Wiesel 1963, 1965; Zeki 1978; Felleman and Van Essen 1991). This hierarchical organization originates in the photoreceptors of the eye, to the optic nerve via the thalamus, to primary visual cortex (visual area V1), and beyond to an array of higher-order visual areas. These visual areas, located in the occipital lobe (one of the four lobes of the cortex) in the back of the brain, cover a large portion of the brain. But what is the fate of these areas in an individual who becomes blind, or even, in an individual born without sight? Studying people who are peripherally blind (for example, from disease or damage to the eye) provides a unique opportunity to investigate this question and, in particular, to uncover the neuroplastic changes that follow blindness and its associated behavioural consequences.

Blind individuals have to make striking adjustments in order to adapt within a world that relies heavily on vision. Remarkably, they learn to extract relevant information about their surroundings using their remaining senses. When assessing behavioural tasks involving touch, hearing, and memory, there is ample evidence that blind individuals perform on par, or in some cases better, than those with sight (Hollins and Kelley 1988; Rauschecker 1995; Lessard et al. 1998; Roder et al. 1999; Van Boven et al. 2000; Amedi et al. 2003; Gougoux et al. 2004; Collignon et al. 2008;). This suggests that changes and adaptations take place in the brain and, in turn, may be responsible for these compensatory behaviours. Accumulating evidence now points to the notion that these neuroplastic changes occur within the part of the brain once dedicated to the process of vision itself. Over the last decade, key studies have shown that, in the blind, the occipital visual cortex is engaged in processing non-visual sensory information such as Braille reading and tactile object recognition (Sadato et al. 1996, 1998, 2004; Buchel et al. 1998; Burton et al. 2002, 2006; Amedi et al. 2003), while deactivating the visual cortex of early blind by transcranial magnetic stimulation (TMS) abolishes Braille reading capacity (Cohen et al. 1997; Kupers et al. 2007), and TMS of the occipital cortex induces tactile sensations in blind Braille readers (Kupers et al. 2006; Ptito et al. 2008). The occipital cortex is also engaged in auditory information processing, including, particularly, sound source localization (Kujala et al. 1995, 2005; Gougoux et al. 2004, 2005) and even cognitive linguistic tasks such as verb generation and verbal memory (Roder et al. 2002; Amedi et al. 2003, 2004; Ofan and Zohary 2007).

Given that the blind use parts of the occipital cortex that sighted use for visual processing, to process other sensory modalities, many interesting questions arise: is the 'visual' brain of the blind the same as that of the sighted? Can the occipital 'visual' cortex always process other sensory modalities, or is it fundamentally different in the blind and the sighted? Do the blind mentally imagine the world the same way as the sighted, or do other sensations cause a form of mental imagery that is inherently different? What is the nature of the mental representations within the blind brain? How could one gain insight into this question? Our brains are fundamentally creative, so how does the lack of prior visual experience influence this process? As we will discuss here, one way to explore these questions is through the expression of art.

Art, mental imagery, and the brain

Art can be considered as an externalization of the inner workings of the brain (Zeki 2001). Inherent to an artistic ability is the engagement of mental imagery—that is, the ability to create a mental image with the 'mind's eye'. The process of mental imagery draws upon much of the same neural machinery (namely visual cortical areas) as visual perception itself (but see Amedi et al. 2005 for a complementary view). As mentioned earlier and taken to the extreme, would the lack of visual experience impede upon a person's ability to create visual mental constructs? From a behavioural level, we know that this is not entirely true.

Research using sensory substitution devices (Bach-y-Rita et al. 1969; Bach-y-Rita and Kercel 2003) provides an opportunity to further test these questions, and shows that blind individuals are able to construct an image perceived by an intact modality (e.g. tactile (Ptito et al. 2005) or auditory (Arno et al. 2001; Renier et al. 2004, 2005; Amedi et al. 2007)) by 'translating' information originated by the substituted modality (vision, via a camera instead of the eyes). Whether this process is performed by cross-modal changes (in other words, the recruitment of brain areas normally devoted to processing information from one sensory modality to process information coming from another modality) or mental imagery is a source of a wider debate (for extensive discussion see Poirier et al. 2007). Evidence also suggests that congenitally blind individuals are able to create mental sensory constructs and manipulate them (e.g. mental rotation or mental maze navigation) at performance levels equal to that of the sighted (Heller and Ballesteros 2006), to construct and understand tactile drawings (Kennedy 1983; D'Angiulli et al. 1998; Kennedy and Merkas 2000; Kennedy and Igor 2003; Kennedy and Juricevic 2006a,b), and according to Bertolo (2005), they are able to construct and make a drawing of one of their dream scenes. Next, we present a summary of recent results (Amedi et al. 2008), of a unique individual, E.A., which serves to discuss and further shed light on the questions we raised so far.

E.A. is a unique case of a blind painter

Subject E.A. is a profoundly blind painter who lost his vision at a very young age. Like other blind individuals, E.A. can capture the external world by touch. However, thanks to his extraordinary drawing ability, he can reveal the nature of his internal representation of objects captured by touch in a manner that is unequivocally under-standable by a sighted person. Thus, by revealing his drawing to us, he is in a sense revealing the internal representations of his brain (for a nice collection of his paintings and drawing visit: http://www.armagan.com/paintings.asp). Furthermore, it appears that this representation matches that of what a sighted person would create despite his lack of prior visual experience.

In a recent study (Amedi et al. 2008), we concentrated on E.A.'s skill of drawing novel objects explored by touch and used functional neuroimaging (specifically, functional magnetic neuroimaging, or fMRI) to investigate the relationship between neural activity within the brain and specific mental functions. fMRI is a powerful tool that has long been used to measure certain aspects of brain function. In short, fMRI measures changes in the concentration of blood oxygen levels near a neural event and, through a carefully designed experiment, allows one to identify the regions in the brain that are associated with a particular task or function (Logothetis and Wandell 2004; Friston 2005).

At the time of study, E.A. was a 51-year-old, right-handed male. A detailed neuro-ophthalmologic examination, including electrodiagnostic testing, confirmed his profound blindness. One of his eyes had never developed and the other showed massive corneal scaring, a dense cataract, and retinal damage consistent with early-onset blindness. Examination of previous medical records revealed that E.A. has never had normal vision and was profoundly blind by the age of five.

E.A. has described himself as a self-taught artist and is Braille illiterate. Growing up, he felt socially isolated because of his blindness and would often spend hours alone drawing in the sand and exploring the relief patterns of the figures he had drawn. At the age of six, he engaged seriously in art and painting. Without any formal instruction or schooling, E.A. started to paint using the tips of his fingers employing fast drying acrylics and water-colours as well as oils. He also learned to draw with a pencil and paper using a specially designed rubberized writing tablet (a Sewell raised line drawing kit) that allows him to generate relief images that he can subsequently detect and explore tactilely.

The themes of his paintings vary, and include objects that both can and cannot be tactilely examined (such as fruit and clouds, respectively). His scenes utilize a vibrant palette of colour, often containing shadows, depth cues, and perspective akin to that employed by sighted artists (see Fig. 23.1). His use of colour has obviously been guided by instruction from sighted individuals who have informed him about typical colour associations (for example, water is blue, trees are green, and the roofs of houses are often red). Other aspects of his painting are likely similarly influenced by information received from sighted observers (e.g. the painting of clouds or mountains). However, his ability to explore a novel object, rapidly draw it in exquisite detail, and from various vantage points, appears to be a skill he has developed without constant input or feedback from sighted observers (see Fig. 23.1).

RESULTS FROM NEUROIMAGING

We designed a study aimed at uncovering the neural activation patterns associated with subject E.A.'s drawing ability (Amedi et al. 2008). Using fMRI, we scanned subject E.A. under six different conditions: (1) while he explored and recognized an object

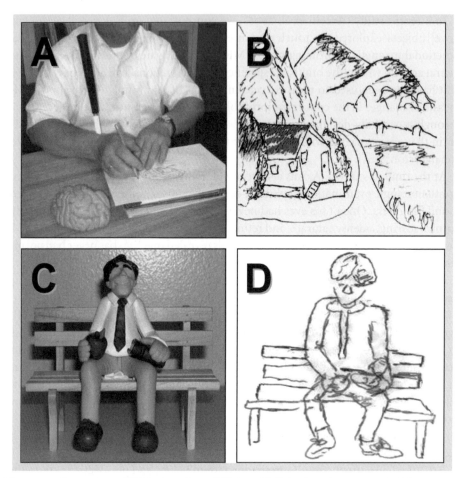

Fig. 23.1 Examples of E.A.'s drawing abilities. A) E.A. drawing a novel object (a model of a human brain) using a pencil and paper and a specially designed rubberized writing tablet (Sewell raised line drawing kit). This technique allows him to generate relief images that he can subsequently detect and explore tactilely. B) The themes of his drawings and paintings vary and include both tactile and non-tactile subjects. The drawing shows a landscape scene and illustrates how he applies colours to his paintings. His paintings often contain vibrant colour, and he uses shading, depth cues, and perspective akin to that employed by sighted artists. C) Example of a complex and novel object which E.A. had never encountered. Once E.A. explored the object by touch for a few minutes, he was able to render a very accurate drawing of the object D).

Adapted from Amedi et al. (2008).

including its tactile features through palpation; (2) while he drew the object he just tactilely explored; (3) while he mentally imagined the same object; and (4) while he retrieved the names of objects from a list previously memorized (verbal memory test). As control conditions, we also scanned E.A. while he (5) scribbled a 'nonsense' figure instead of an actual drawing and (6) moved his hands in space as if he were exploring an object.

In order to reveal the brain activity associated with E.A.'s drawing skill, we subtracted the activity we found while E.A. scribbled from that measured when he actually drew an object. In this way, we could better isolate the brain activation specifically associated with his drawing skill. We found clear activation in a variety of areas in the brain including prefrontal and parietal areas (see Fig. 23.2). Of particular interest was the activation seen within the occipital cortex, that is, the part of the brain that is normally activated when sighted individuals view a visual scene. Thus, when E.A. draws actual objects (even subtracting the activity associated with the sensory and motor acts associated with drawing itself), the part of his brain that is normally associated with seeing is activated even though he never saw (and has never seen) the actual objects he draws.

As a further analysis, we also compared activation patterns for the different control conditions. This included E.A. exploring objects tactilely, imagining the pictures he drew, and recalling the names of the objects he drew. Consistent with previous studies by our group and others (Ishai and Sagi 1995; Ishai et al. 2000a,b; O'Craven and Kanwisher 2000; Kosslyn et al. 2001; Mechelli et al. 2004; Amedi et al. 2005), we found activation in a variety of brain areas in each of these tasks. What was consistent (and contrary to what we found when E.A. drew) was the fact that early visual cortical areas were significantly less activated in all of these control conditions (Fig. 23.3). To further test this directly, we also performed a direct comparison between drawing objects and the tactile objects condition: we subtracted the activity we found while E.A. tactually explored objects from that measured when he drew an object (see Fig. 23.3A). We again found greater and selective activation of the occipital cortex during the drawing condition. Specifically, we found the largest magnitude for drawing in the calcarine sulcus, corresponding to primary visual cortex of sighted (Fig. 23.3B). This suggests that the visual cortex is engaged in the drawing task and that the activation is not a manifestation of basic or high-level object related tactile processing.

DISCUSSION AND CONCLUSIONS

Subject E.A. is a unique example of an early blind individual able to represent and communicate the internal representation of objects in his mind through his drawings. We used functional neuroimaging to investigate what brain areas were involved with E.A.'s drawing skill. We also analysed different components of E.A.'s drawing

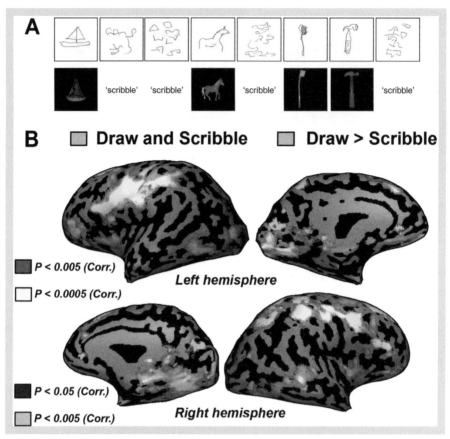

Fig. 23.2 (See Colour plate 9) Neuroimaging data of subject E.A. for drawing and scribbling objects. A) Example of behavioural data collected from a scanning run. Subject E.A.'s sketches (above) are shown compared to the object tactilely explored or in response to the control scribble condition (below). B) Activation patterns associated with the contrast of drawing versus scribbling presented on a full inflated cortical reconstruction of E.A.'s brain (lateral and medial views). Most striking is the activation seen in the occipital areas localized around the calcarine sulcus (identified by cyan arrows). The calcarine sulcus anatomically corresponds to early visual areas (V1 and V2) in normally sighted individuals. In E.A., these areas are active for drawing.

Adapted from Amedi et al. (2008).

ability including the tactile perception of an object, verbal memory of object names, sensory–motor control, mental imagery of objects explored by touch, and scribbling. Thus, we were able to isolate each part of the perceptual and cognitive process involved. When E.A.'s drawing activity was compared to nonsensical scribbling, strong activation implicating a specific network of cortical brain areas was found. This network

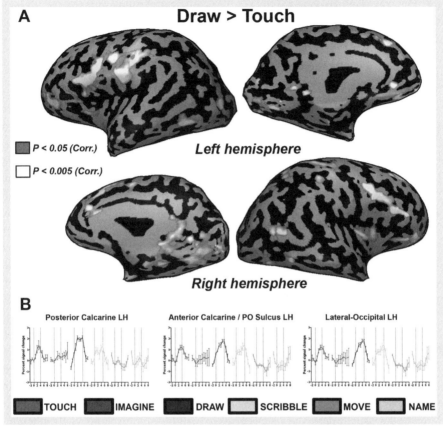

Fig. 23.3 (See Colour plate 10) Neuroimaging data of subject E.A. for a direct comparison of drawing versus tactilely exploring objects. A) The contrast of drawing versus touching objects is presented on a full inflated cortical reconstruction of E.A.'s brain (lateral and medial views). Note again the robust activation in several posterior ventral occipital areas. Activation for drawing was strong and selective even in the calcarine sulcus. See also (B) for the time courses and magnitude of activation from this area. The time courses are depicted by the following colour index: tactile objects (red), mental imagery (brown), drawing (blue), scribbling (cyan), motor control (orange), and naming/verbal memory (green).

Adapted from Amedi et al. (2008).

included different parts of the brain including frontal cortex (known to be involved with planning and executive functions; Smith and Jonides 1999; Miller 2000) and parietal regions (known to be involved with spatial representation and multisensory integration; Colby and Duhamel 1996; Grefkes et al. 2002; Saito et al. 2003; Amedi et al. 2005; Gobel et al. 2006). Given the known function of these areas, it is perhaps not surprising that they were also active while E.A. drew. Studies in sighted subjects

have also revealed strong activity in parietal-frontal networks during drawing tasks (Makuuchi et al. 2003). In the case of both sighted and non-sighted artists, the activity in frontal and parietal regions may correspond to processes that are necessary in drawing, such as transformations from perception to two-dimensional image production.

What is perhaps most astonishing is the fact that while E.A. drew pictures, there was also widespread activation in areas within the occipital cortex including primary visual areas—the part of the brain normally used for processing visual information in a sighted person (Figs. 23.2 and 23.3). Given E.A.'s denial of any visual experience, present absolute blindness, and certain early and longstanding profound blindness, it is surprising that his visual cortex area would be active in a skill that is so inherently visual. The specific pattern activation in E.A. implicating 'visual' cortical areas during drawing is consistent with the notion of recruitment of visual areas for non-visual functions. However, this pattern of recruitment is different from other examples of neuroplasticity reported in early blind individuals. Specifically, unlike other early blind subjects (Amedi et al. 2003), E.A. did not show activation of visual cortical areas during the verbal memory task. This might be because he has practised painting and drawing throughout his life and thus the resources of the 'visual' cortex were recruited for this purpose and not for other compensatory behaviours such as verbal memory skills. Consistent with this idea are the facts that E.A. never learned to read Braille, and he admittedly reports that his verbal memory skill is, in fact, quite poor. We have previously shown that blind individuals showing superior verbal memory capabilities show maximal plasticity in the visual cortex for this skill while blind subjects having average verbal memory showed modest plasticity (Amedi et al. 2003). The resources offered by the visually deprived visual cortex in early blind subjects are likely inherently limited, and thus it is not surprising that extensive and selective training of one skill (drawing in E.A.'s case) may come at the expense of the development of other capacities. A similar scenario exists in the case of proficient Braille readers. The expansion of the brain representation responsible for the preferred reading finger comes at the expense of the representation of adjacent fingers of the same hand (Pascual-Leone and Torres 1993; Sterr et al. 1998). Thus, representation of the preferred reading index finger in the sensorimotor cortex is significantly larger than normal (which is associated with a dramatic increase in precise motor control and tactual perceptual abilities), while the representation of the little finger in the same hand is reduced, apparently encroached upon by the enlarged index finger representation. In a similar manner, recruitment of the 'visual' cortex for drawing may limit the availability of the same brain region for verbal memory or auditory localization, thus accounting for E.A.'s poor verbal memory in the face of his extraordinary drawing abilities (or simply due to the fact that he is not as reliant on his verbal memory).

Another interesting finding is the fact that activation was seen in the occipital cortex while E.A. imagined the objects he drew (albeit at a reduced magnitude of activity). This pattern of activation is also typically seen in normally sighted subjects during visual imagery tasks (Kosslyn et al. 2001, 2005). E.A. is absolutely blind from a very

early age, so, what kind of imagery does E.A. possess? Does the sole fact there is activity within visual areas in E.A. during imagery and drawing signify that his experience must inherently be visual, despite his lack of actual vision? These intriguing questions have yet to be answered.

The process of producing an artistic image requires both a technical and creative component. In this study, it is important to note that we attempted to assess the technical aspects of E.A.'s drawing ability and not the source of his creativity. When asked to draw an object, E.A. was given the instruction to reproduce the object on paper and was specifically asked not to attempt to create an 'artistic rendition', but be as faithful to the details as possible. During the scanning, E.A. was given only 15 seconds to produce each object. Thus, our design emphasizes the more direct translation of internal representations as opposed to large-scale creative elements (an interesting topic for future studies). In light of this, we think that it is more likely that we are revealing the nature of E.A.'s internal representation of objects as essentially visual (or at least unequivocally understandable by vision). This is confirmed by the fact that E.A. is able to comprehend the shape of any novel, previously unexplored object by touch alone and quickly and precisely draw it from any vantage point. However, it is possible that E.A. is revealing a remarkable ability to 'translate' into a visual image a non-visual internal representation of objects.

The study of artistic development in other clinical settings has also revealed many interesting findings and parallels. For example, studies in patients with frontotemporal dementia (FTD; a condition characterized with behavioural symptoms including personality changes and problems with executive function) suggest that this condition can be accompanied by dramatic changes in artistic abilities and expression (Gordon 1999; Drago et al. 2006). Studies of sighted artists have shown dramatic changes in artistic ability and style following focal brain damage (Bogousslavsky 2005). Annoni and colleagues (2005) suggest that new artistic abilities may arise after brain dysfunction, which are dependent upon the lesion site, as well as the ability of the brain to reorganize itself. The occipital activity present in our study of E.A. may demonstrate a similar form of adaptation in a blind painter.

Through his technical and creative skill, E.A. has likewise externalized the workings of a uniquely adapted mind. In a sense, it is perhaps more logical to consider E.A. not so much as a blind individual who has learned to paint but, rather, a true artist who just happens to be blind. While there is still much work to be done to elucidate the neural correlates of artistic creativity, this case provides an important contribution to our understanding of the perceptual transformation that must occur when creating visual art. Evidence from this case also supports the hypothesis that internal mental representations can be generated by sensory experiences that are universal in nature (Pascual-Leone and Hamilton 2001). It is possible that the brain may contain more abstract features of object form rather than just simple representations of visual images. Such evidence contributes towards our understanding of the fundamental organization of the human brain, the basis of creativity, as well as the perception of reality.

ACKNOWLEDGEMENTS

This work was supported by grants from the National Institutes of Health (K24 RR018875 and RO1-EY12091 to A.P.-L.), K 23 EY016131-01 award to L.B.M and by the EU-FP7 MC International Reintegration Grant, German-Israeli Foundation (GIF young grant number 2184-1809.1/2007), National Institute for Psychobiology grant 036/4572 (To AA) and by the generous support of the Moscona and the Eliyaho Pen foundations. The authors would like to thank the following individuals for the invaluable help in the study: Subject E.A. for his patience and willingness to undergo all the testing and share his insights; Joan Eroncel for assisting in the coordination and organization of the study; Dr. Joseph F. Rizzo III, MD for carrying out the neuro-ophthalmic evaluation; Elif Ozdemir for help with Turkish-English translation; and to Elizabeth Axel and Nina Levent of the Art Education for the Blind (AEB) for establishing the contact with subject E.A.

REFERENCES

Amedi A, Raz N, Pianka P, Malach R, and Zohary E (2003). Early 'visual' cortex activation correlates with superior verbal memory performance in the blind. *Nature Neuroscience*, **6**, 758–66.

Amedi A, Floel A, Knecht S, Zohary E, and Cohen LG (2004). Transcranial magnetic stimulation of the occipital pole interferes with verbal processing in blind subjects. *Nature Neuroscience*, **7**, 1266–70.

Amedi A, von Kriegstein K, van Atteveldt NM, Beauchamp MS, and Naumer MJ (2005). Functional imaging of human crossmodal identification and object recognition. *Experimental Brain Research*, **166**, 559–71.

Amedi A, Stern W, Camprodon JA, et al. (2007) Shape conveyed by visual-to-auditory sensory substitution activates the lateral occipital complex. *Nature Neuroscience*, **10**, 687–9.

Amedi A, Merabet LB, Camprodon J, et al. (2008) Neural and behavioral correlates of drawing in an early blind painter: A case study. *Brain Research*, **1242**, 252–62.

Annoni JM, Devuyst G, Carota A, Bruggimann L, and Bogousslavsky J (2005). Changes in artistic style after minor posterior stroke. *Journal of Neurology Neurosurgery and Psychiatry*, **76**, 797–803.

Arno P, De Volder AG, Vanlierde A, et al. (2001). Occipital activation by pattern recognition in the early blind using auditory substitution for vision. *Neuroimage*, **13**, 632–645.

Bach-y-Rita P, Collins CC, Saunders FA, White B, and Scadden L (1969). Vision substitution by tactile image projection. *Nature*, **221**, 963–4.

Bach-y-Rita P and Kercel SW (2003). Sensory substitution and the human-machine interface. *Trends in Cognitive Sciences*, **7**, 541–6.

Bertolo H (2005). Visual imagery without visual perception? *Psicologica*, **26**, 173–88.

Bogousslavsky J (2005). Artistic creativity, style and brain disorders. *European Neurology*, **54**, 103–11.

Buchel C, Price C, Frackowiak RSJ, and Friston K (1998). Different activation patterns in the visual cortex of late and congenitally blind subjects. *Brain*, **121**, 409–19.

Burton H and McLaren DG (2006). Visual cortex activation in late-onset, Braille naive blind individuals: An fMRI study during semantic and phonological tasks with heard words. *Neuroscience Letters*, **392**, 38–42.

Burton H, Snyder AZ, Conturo TE, Akbudak E, Ollinger JM, and Raichle ME (2002). Adaptive changes in early and late blind: a fMRI study of Braille reading. *Journal Neurophysiology*, **87**, 589–607.

Cohen LG, Celnik P, Pascual-Leone A, et al. (1997). Functional relevance of cross-modal plasticity in blind humans. *Nature*, **389**, 180–3.

Colby CL and Duhamel JR (1996). Spatial representations for action in parietal cortex. *Cognitive Brain Research*, **5**, 105–15.

Collignon O, Voss P, Lassonde M, and Lepore F (2008). Cross-modal plasticity for the spatial processing of sounds in visually deprived subjects. *Experimental Brain Research*, **192**, 343–58.

D'Angiulli A, Kennedy JM, and Heller MA (1998). Blind children recognizing tactile pictures respond like sighted children given guidance in exploration. *Scandinavian Journal of Psychology*, **39**, 187–90.

Drago V, Foster PS, Trifiletti D, FitzGerald DB, Kluger BM, Crucian GP, et al. (2006). What's inside the art? The influence of frontotemporal dementia in art production. *Neurology*, **67**, 1285–7.

Felleman DJ and Van Essen DC (1991). Distributed hierarchical processing in the primate cerebral cortex. *Cerebral Cortex*, **1**, 1–47.

Friston, KJ (2005). Models of brain function in neuroimaging. *Annual Review of Psychology*, **56**, 57–87.

Gobel SM, Calabria M, Farne A, and Rossetti Y (2006). Parietal rTMS distorts the mental number line: Simulating 'spatial' neglect in healthy subjects. *Neuropsychologia*, **44**, 860–8.

Gordon N (1999). Unexpected artistic creativity. *Developmental Medicine and Child Neurology*, **41**, 211.

Gougoux F, Lepore F, Lassonde M, Voss P, Zatorre RJ, and Belin P (2004). Neuropsychology: pitch discrimination in the early blind. *Nature*, **430**, 309.

Gougoux F, Zatorre RJ, Lassonde M, Voss P, and Leopre F (2005). A functional neuroimaging study of sound localization: visual cortex activity predicts performance in early-blind individuals. *PLoS BIOLOGY*, **3**, 324–33.

Grefkes C, Weiss P, Zilles K, and Fink G (2002). Crossmodal processing of object features in human anterior intraparietal cortex: an fMRI study implies equivalencies between humans and monkeys. *Neuron*, **35**, 173–84.

Heller MA and Ballesteros S (2006). *Touch and Blindness: Psychology and Neuroscience*. Lawrence Erlbaum Associates, Mahwah, NJ.

Hollins M and Kelley EK (1988). Spatial updating in blind and sighted people. *Perception and Psychophysics*, **43**, 380–8.

Hubel DH and Wiesel TN (1963). Shape and arrangement of columns in cat's striate cortex. *Journal of Physiology*, **165**, 559–68.

Hubel DH and Wiesel TN (1965). Receptive fields and functional architecture in two nonstriate visual areas (18 and 19) of the cat. *Journal of Neurophysiology*, **28**, 229–89.

Ishai A and Sagi D (1995). Common mechanisms of visual imagery and perception. *Science*, **268**, 1772–4.

Ishai A, Ungerleider LG, and Haxby JV (2000a). Distributed neural systems for the generation of visual images. *Neuron*, **28**, 979–90.

Ishai A, Ungerleider LG, Martin A, and Haxby JV (2000b). The representation of objects in the human occipital and temporal cortex. *Journal of Cognitive Neuroscience*, **12**, 35–51.

Kapur N (1996). Paradoxical functional facilitation in brain-behaviour research. A critical review. *Brain*, **119**, 1775–90.

Kennedy JM (1983). What can we learn about pictures from the blind? *American Scientist*, **71**, 19–26.

Kennedy JM and Igor J (2003). Haptics and projection: drawings by Tracy, a blind adult. *Perception*, **32**, 1059–71.

Kennedy JM and Juricevic I (2006a). Blind man draws using diminution in three dimensions. *Psychonomic Bulletin and Review*, **13**, 506–9.

Kennedy JM and Juricevic I (2006b). Foreshortening, convergence and drawings from a blind adult. *Perception*, **35**, 847–51.

Kennedy JM and Merkas CE (2000). Depictions of motion devised by a blind person. *Psychonomic Bulletin and Review*, **7**, 700–6.

Kleege G (2005). Blindness and visual culture: an eyewitness account. *Journal of Visual Culture*, **4**, 179–90.

Kosslyn SM (2005). Mental images and the brain. *Cognitive Neuropsychology*, **22**, 333–47.

Kosslyn SM, Ganis G, and Thompson WL (2001). Neural foundations of imagery. *Nature Reviews Neuroscience*, **2**, 635–42.

Kujala T, Huotilainen M, Sinkkonen J, et al. (1995). Visual cortex activation in blind humans during sound discrimination. *Neuroscience Letters*, **183**, 143–6.

Kujala T, Palva M, Salonen O, et al. (2005). The role of blind humans' visual cortex in auditory change detection. *Neuroscience Letters*, **379**,127–31.

Kupers R, Fumal A, Maertens de Noordhout A, Gjedde A, Schoenen J, and Ptito M (2006). Transcranial magnetic stimulation of the visual cortex induces somatotopically organized qualia in blind subjects. *Proceedings of the National Academy of Sciences*, **103**, 13256–60.

Kupers R, Pappens M, Maertens de Noordhout A, Schoenen J, Ptito M, and Fumal A (2007). rTMS of the occipital cortex abolishes Braille reading and repetition priming in blind subjects. *Neurology*, **68**, 691–3.

Lessard N, Pare M, Lepore F, and Lassonde M (1998). Early-blind human subjects localize sound sources better than sighted subjects. *Nature*, **395**, 278–80.

Livingstone MS (1988). Art, illusion and the visual system. *Scientific American*, **258**, 78–85.

Logothetis NK and Wandell BA (2004). Interpreting the BOLD signal. *Annual Review of Physiology*, **66**, 735–69.

Makuuchi M, Kaminaga T, and Sugishita M (2003). Both parietal lobes are involved in drawing: a functional MRI study and implications for constructional apraxia. *Brain Research: Cognitive Brain Research*, **16**, 338–47.

Mechelli A, Price CJ, Friston KJ, and Ishai A (2004). Where bottom-up meets top-down: neuronal interactions during perception and imagery. *Cerebral Cortex*, **14**, 1256–65.

Miller EK (2000). The prefrontal cortex and cognitive control. *Nature Reviews Neuroscience*, **1**, 59–65.

Mitchison G (1996). Where is the mind's eye? Visual perception. *Current Biology*, **6**, 508–10.

O'Craven KM and Kanwisher N (2000). Mental imagery of faces and places activates corresponding stimulus-specific brain regions. *Journal of Cognitive Neuroscience*, **12**, 1013–23.

Ofan RH and Zohary E (2007). Visual cortex activation in bilingual blind individuals during use of native and second language. *Cerebral Cortex*, **17**, 1249–59.

Pascual-Leone A and Hamilton R (2001). The metamodal organization of the brain. *Progress in Brain Research*, **134**, 427–45.

Pascual-Leone A and Torres F (1993). Plasticity of the sensorimotor cortex representation of the reading finger in Braille readers. *Brain*, **116**(Pt 1), 39–52.

Pascual-Leone A, Amedi A, Fregni F, and Merabet LB (2005). The plastic human brain. *Annual Review of Neuroscience*, **28**, 377–401.

Poirier C, De Volder AG, and Scheiber C (2007). What neuroimaging tells us about sensory substitution. *Neuroscience and Biobehavioral Reviews*, **31**, 1064–70

Ptito M, Moesgaard SM, Gjedde A, and Kupers R (2005). Cross-modal plasticity revealed by electrotactile stimulation of the tongue in the congenitally blind. *Brain*, **128**, 606–14.

Ptito M, Fumal A, Martens de Noordhout A, Schoenen J, Gjedde A, and Kupers R (2008). TMS of the occipital cortex induces tactile sensations in the fingers of blind Braille readers. *Experimental Brain Research*, **184**, 193–200.

Rauschecker JP (1995). Compensatory plasticity and sensory substitution in the cerebral cortex. *Trends in Neuroscience*, **18**, 36–43.

Renier L, Collignon O, Tranduy D, et al. (2004). Visual cortex activation in early blind and sighted subjects using an auditory visual substitution device to perceive depth. *Neuroimage*, **22**, S1.

Renier L, Collignon,O, Poirier C, et al. (2005). Cross modal activation of visual cortex during depth perception using auditory substitution of vision. *Neuroimage* **26**, 573–80.

Roder B, Teder-Salejarvi W, Sterr A, Rosler F, Hillyard SA, and Neville HJ (1999). Improved auditory spatial tuning in blind humans. *Nature*, **400**, 162–6.

Roder B, Stock O, Bien S, Neville H, and Rosler F (2002). Speech processing activates visual cortex in congenitally blind humans. *European Journal of Neuroscience*, **16**, 930–6

Sadato N, Pascual-Leone A, Grafman J, et al. (1996). Activation of the primary visual cortex by Braille reading in blind subjects. *Nature*, **380**, 526–8.

Sadato N, Pascual-Leone A, Grafman J, et al. (1998). Neural networks for Braille reading by the blind. *Brain*, **121**, 1213–29.

Sadato N, Okada T, Kubota K, and Yonekura Y (2004). Tactile discrimination activates the visual cortex of the recently blind naive to Braille: a functional magnetic resonance imaging study in humans. *Neuroscience Letters*, **359**, 49–52.

Saito DN, Okada T, Morita Y, Yonekura Y, and Sadato N (2003). Tactile–visual cross-modal shape matching: a functional MRI study. *Cognitive Brain Research*, **17**, 14–25.

Slotnick SD, Thompson WL, and Kosslyn SM (2005). Visual mental imagery induces retinotopically organized activation of early visual areas. *Cerebral Cortex*, **15**, 1570–83.

Smith EE and Jonides J (1999). Storage and executive processes in the frontal lobes. *Science* **283**, 1657–61.

Sterr A, Muller MM, Elbert T, Rockstroh B, Pantev C, and Taub E (1998). Perceptual correlates of changes in cortical representation of fingers in blind multifinger Braille readers. *The Journal of Neuroscience*, **18**, 4417–23.

Van Boven RW, Hamilton RH, Kauffman T, Keenan JP, and Pascual-Leone A (2000). Tactile spatial resolution in blind Braille readers. *Neurology*, **54**, 2230–6.

Zeki S (1978). Functional specialisation in the visual cortex of the rhesus monkey. *Nature*, **274**, 423–8.

Zeki S (2001). Essays on science and society. Artistic creativity and the brain. *Science*, **293**, 51–2.

VISUAL MUSIC IN ARTS AND MINDS: EXPLORATIONS WITH SYNAESTHESIA

JAMIE WARD

Many forms of art either directly or indirectly stimulate more than one sense. This chapter will consider one of the most common combinations—namely 'visual music' (e.g. Brougher et al. 2005). Multisensory forms of art will be processed by the same mechanisms that support multisensory perception in other contexts, such as listening to speech whilst watching the speaker's lips move. However, the way in which multisensory perception may affect our appreciation and understanding of art has received very little empirical investigation.

In this chapter, I use the term 'visual music' in the broadest sense. At one level, it may refer to forms of art in which both the senses of vision and hearing are directly stimulated. For example, people will opt to go to a live concert not just because of the acoustics, but because they like the visual experience of seeing the conductor and violins moving in time to the music (see also Shaw-Miller, Chapter 13, this volume). Watching ballet, going to a nightclub with a VJ (video jockey), animated movies such as Disney's *Fantasia*, and 'Son et lumières' would be other instances of visual music in which hearing and vision are both directly stimulated. However, there is another sense in which the term visual music may be used. In some instances, only one

sense may be directly stimulated but a second sense may be indirectly conjured. For example, Kandinsky wanted people to be able to hear his paintings (Ione and Tyler 2003) and listening to music may evoke particular visual images.

The appeal of visual music should be explicable, at least in part, from a neuroscientific understanding of multisensory perception. Multisensory perception occurs automatically whenever two or more senses are stimulated in the appropriate way (e.g. at the same time or place). For example, responding to a visual stimulus can be enhanced (faster response, fewer errors) when it is paired with irrelevant sounds (Miller 1982). In some instances, stimulation of a secondary sense can modify the conscious experience of the attended sense. For example, in the McGurk illusion, listening to 'ba' while watching 'ga' results in an auditory percept of 'da' (McGurk and MacDonald 1976). The use of multisensory pathways in the brain may be so common as to be evoked even when a stimulus is presented in a single sensory modality. Thus, functional brain imaging has shown that watching silent lip-reading can activate the auditory cortex (Calvert et al. 1997), discriminating voices can activate regions dedicated to face processing (von Kriegstein et al. 2005), smelling chocolate can activate the gustatory cortex (Leger et al. 2003) and so on.

There are a number of factors that determine whether an event will be processed in a multisensory way (i.e. different sensory parts of the event are combined) or not (i.e. different sensory parts treated independently). The timing and the spatial location of the multisensory parts are crucial. However, the content of the multisensory parts may also be critical. Evidence will be discussed later that shows that certain auditory features (e.g. pitch) tend to combine with certain visual features (e.g. lightness) in systematic ways. The matching of different multisensory attributes on the basis of content is likely to partly reflect the perceptual history of the perceiver. For example, the smell of chocolate but not perfume will activate gustatory cortex because only the odour and taste of chocolate have previously been paired (Leger et al., 2003). Some content-based multisensory correspondences could also reflect innate biases that exist in our perceptual systems that are relatively independent of learning (e.g. Mondloch and Maurer 2004).

In this chapter, I will present evidence to show that certain auditory features tend to be associated with certain visual attributes in systematic ways. Moreover, I will discuss some new research that shows that different combinations of visual and auditory features have consequences for one's hedonic judgements of multisensory stimuli (e.g. which do you prefer, or how pleasant is it?). In particular, I shall draw on evidence from one unusual variety of multisensory perception, namely synaesthesia, in which processing of one stimulus, attribute (e.g. its sound) automatically leads to the conscious perception of an additional attribute (e.g. colour). To some extent, synaesthesia can be viewed as an extension of the normal tendency to process unimodal stimuli in multisensory ways (e.g. watching silent lip-reading activates the auditory cortex). However, the synaesthetic experiences are, by definition, consciously experienced, whereas other forms of multisensory biases elicited from unimodal stimuli are not.

WHAT IS SYNAESTHESIA?

Synaesthesia has three defining characteristics: the experiences are consciously perceived; they are elicited by processing some stimulus that is not normally associated with that conscious percept; and they are elicited automatically (Ward and Mattingley 2006; Ward 2008). In addition, there is a tendency for the experiences to be highly stable over time (Baron-Cohen et al. 1987). For example, the number '5' may always trigger the same shade of brown or a particular note on the trumpet may always elicit a red sphere. There is a trend, particularly in the art literature, to over-extend the use of the term 'synaesthesia' to other situations. For example, normal multisensory perception in which two senses are stimulated is not synaesthesia although it may well share certain properties and mechanisms with it (see van Campen, Chapter 25, this volume). The particular characteristics of synaesthesia described here are believed to have a different causal antecedent. Developmental forms of synaesthesia that persist throughout life tend to run in families and are believed to be under genetic influences (Ward and Simner, 2005). Synaesthesia may also be acquired, typically temporarily, as a result of certain drugs (e.g. from LSD) or from sensory deprivation (e.g. progressive blindness or blindfolding). Here, I shall focus on the developmental forms.

Although once considered very rare, synaesthesia involving elicited experiences in one of the five Aristotelian senses are found in around 4% of the adult population (Simner et al. 2006). Synaesthetic experiences of sequences (days, months, numbers, etc.) arranged spatially occur in at least 12% of the population (Sagiv et al. 2006). The most common forms of synaesthesia are those in which colour or space is elicited by certain verbal material—particularly days, months, letters, and numbers. This need not pose a problem for the suggestion that synaesthesia is an adaptation of normal multisensory perception. This is because normal multisensory integration can occur via semantic levels of processing (i.e. based on stimulus content) rather than reflecting direct sensory-sensory links (e.g. Pourtois and de Gelder 2002). Similarly, there is evidence to suggest that the same types of associations found in synaesthesia can be found in others, albeit unconsciously. Thus, processing of numbers may evoke spatial representations (Fias and Fischer 2005) and non-synaesthetes often associate similar colours to letters when forced to pick one (Simner et al. 2005).

Synaesthetic experiences of vision elicited by sounds (e.g. music, noise) are relatively rare (0.2% of the population, Simner et al. 2006). The visual experiences induced by sound tend to be complex; consisting of colour, texture, shape, and movement. An example is shown in Fig. 24.1. For most people with synaesthesia, the experience is normally unidirectional such that sounds may trigger vision but vision does not trigger sounds. Whilst it was once thought that sound-to-vision synaesthesia was far more common than vision-to-sound, this is now in doubt. Saenz and Koch (2008) reported four synaesthetes (out of 'several hundred' students who were asked) for whom visual motion or the onset or offset of visual stimuli triggered sounds such as popping and whooshing. Moving their eyes across static visual scenes did not trigger sounds for

Fig. 24.1 (See Colour plate 11) An example of a complex synaesthetic visual experience (also consisting of movement) induced by a simple sound (F# on the cello).

these synaesthetes, but this type of synaesthesia does exist. One synaesthete, J.R., describes the Kandinsky painting, *Composition VIII* (1923), as:

There is a huge splurge of sound left-hand top – booming but also a bit vulgar! Below it a rather mousy little meee sound which then translates into ohs and ahs and pops at the various circles. The lines are sharp and moving to the right with the sound of steel (like blades scraping against one another). The triangle and boomerang shape are surprised and pop up laughing with a whooo.

(Goller et al. 2009)

Most contemporary accounts of synaesthesia speak of anomalous links between separate senses (e.g. extra pathways, greater feedback connections). For example, sound-to-vision synaesthesia is generally construed as anomalous connectivity between our senses of hearing and vision. These accounts all depend on the assumption that it is possible to define, from first principles, what our separate senses are. It also assumes that all individuals have the same set of separate senses. Of course, there is no logical reason to limit our senses to the famous five described by Aristotle (what about interoception, proprioception, or pain?) and, to some extent, submodalities within each sense (e.g. colour, motion) are functionally separable. An alternative way of conceptualizing sound-vision synaesthesia is in terms of a failure to develop separate senses, rather than abnormal connectivity between two separate senses. The perceptual world of infants has been described as a 'sensual bouillabaisse. Sights have sounds, feelings have tastes and smells can make him dizzy' (Maurer and Maurer 1988). Indeed there is good empirical evidence to suggest that infants process unimodal stimuli in multisensory ways that could be analogous to some adult varieties of synaesthesia. In this

framework, sound-vision synaesthesia could be viewed as a failure to develop a sense of hearing that is autonomous from vision. These synaesthetes could be said to possess a sense of vision (primarily triggered by the eyes) and a sense of audiovision (primarily triggered by the ears) rather than possessing separate senses of vision and hearing that are atypically connected. Indeed, it is impossible to find sounds that lack visual experiences for these individuals.

SYSTEMATIC WAYS OF LINKING VISION AND MUSIC

In the non-synaesthetic population, the way in which auditory and visual dimensions are linked together has been investigated in a number of ways. One method is to present participants with unimodal stimuli that vary in one dimension (e.g. the pitch) and get them to explicitly vary a second dimension (e.g. visual lightness) to choose a best match. For example, increasing pitch and increasing loudness is associated with greater visual lightness (Marks 1974). The same is found if words are used: thus sunlight is louder than moonlight, and a sneeze is brighter than a cough (Marks 1982). A different methodology involves presenting participants with multisensory stimuli and asking them to respond to one dimension (e.g. the pitch of the stimulus) whilst ignoring another dimension (e.g. visual lightness). If the ignored dimension interacts with performance on the attended dimension then they are considered to be linked. These studies, moreover, establish that such links may be automatically accessed. For example, judging the pitch of a sound is biased by the presence of a visual stimulus such that stimuli that are high pitch/light colour and low pitch/dark colour are faster to class as high/low than stimuli that are high pitch/dark colour and low pitch/light colour (Marks 1987). The same is found for loudness paired with lightness (louder being lighter, Marks 1987); pitch paired with shape (high pitch being sharper and less round, Marks 1987); pitch paired with size (Gallace and Spence 2006) and pitch paired with vertical position (high pitch being higher in space, Ben-Artzi and Marks 1995). The effects are still found when written words (e.g. dark, light, night, day) are used instead of manipulating visual lightness (Martino and Marks 1999). Many of these links develop early and are unlikely to be learned via language (Lewkowicz and Turkewitz 1980), although they nonetheless enter into our language through certain metaphors.

Marks (1975) provided a summary of historical cases of synaesthesia reported in the literature. He noted structured relationships between the auditory and visual dimensions of pitch and brightness (higher pitch being brighter) and pitch and perceived visual size (lower pitch being larger). The fact that similar links between auditory and visual dimensions can be found in synaesthetes as well as in the general population

suggests that synaesthesia may be mediated by the same mechanisms that support multisensory integration more generally.

Although the relationship between auditory pitch and visual lightness had been noted many times before both in synaesthesia and the general population, there had been no direct quantitative comparison of these two groups until very recently. Ward, Huckstep and Tsakanikos (2006) redressed this balance by directly comparing a group of sound-vision synaesthetes with controls. They were presented with a variety of tones comprising different pitches, and different timbres (e.g. strings, piano, pure tones). The task for the synaesthetes was to choose the nearest colour corresponding to their synaesthetic experience and the task for the controls was to choose the 'best' colour that goes with that sound. The experiment was repeated within the same session and several weeks later, in order to ascertain the intrasubject consistency. As expected, the synaesthetes had far higher intrasubject consistency over time than controls. An example of the colour choices from one of the synaesthetes is shown in Fig. 24.2. However, this study was specifically interested in intersubject consistency: would different participants choose colours in the same systematic way? If so, this would provide evidence that synaesthesia recruits the same types of mechanisms used in normal multisensory processing (in this instance, imagining a colour from a sound). Our results confirmed that the two groups did not differ quantitatively in their tendency to associate pitch and lightness. However, the results also revealed more subtle

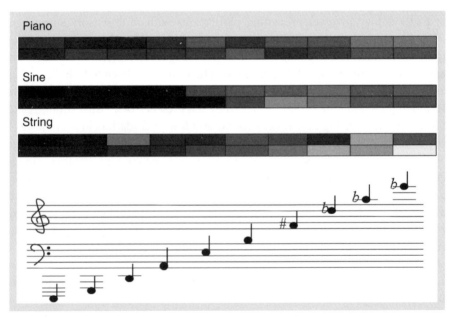

Fig. 24.2 (See Colour plate 12) An example of a synaesthetic participant's choice of colours for 10 different musical notes that were either pure tones (sine wave), or from piano or strings. The synaesthete chose each colour on two different occasions and the Figure shows that similar colours tend to be chosen over time.

relationships between auditory and visual dimensions. For example, the saturation of the colours plotted against increasing pitch showed an inverted-U function, peaking around the middle-C point on the Western scale. Again, this was found for both synaesthetes and controls equally. Moreover, whilst lightness was relatively independent of timbre (a string, piano, and pure tone of the same pitch tends to produce the same lightness) the same could not be said of saturation. The pure tones elicited less saturated and more greyscale colours in both controls and synaesthetes.

The study of Ward et al. (2006) provides evidence of an intricate system of correspondence between sound and vision that is common to synaesthetes and others. However, the study focused specifically on colour. The synaesthetic visual experiences to music consist of far more than colour. They also involve motion, shape, size, spatial position, and texture. The studies reported later in this chapter were designed to take these additional aspects of their synaesthesia into account. Moreover, we were interested in extending our research to take into account people's hedonic ratings of pleasantness and preference. This may lead to a better understanding of how people appreciate and evaluate 'visual music' as a form of art. Combinations of vision and music that obey synaesthetic principles may be judged to be particularly appealing because they are tapping universal multisensory processes.

Evidence that synaesthetic audiovisual experiences are aesthetically pleasing comes from the lifestyle choices of synaesthetes themselves. It is often remarked that synaesthetes are more likely to be engaged in the arts (e.g. painting, music, poetry). However, a recent study by our group suggests that this depends on the type of synaesthesia that they have (Ward et al. 2008a). Sound-vision synaesthetes are the only subgroup of synaesthetes that are more likely to play a musical instrument, and this subgroup are far more likely to spend time producing paintings (or similar) than other synaesthetes or non-synaesthetes. Our explanation of this is that the audiovisual experiences are intrinsically appealing and provide a strong source of motivation to those who perceive them. But would others lacking synaesthesia judge them as appealing too?

Are synaesthetic experiences appreciated by others?

In order to capture the movement, shapes, and textures associated with synaesthesia, short animated clips were prepared (Ward et al. 2008b). These were based on drawings, verbal descriptions, annotations, and colour selections made by the synaesthetes. The sounds used to elicit the synaesthetic visions were taken from cello and violin notes played in a variety of pitches, manners of playing (e.g. plucking, vibrato), duration, loudness, and intervals. Although the animations were not exact reproductions of

their experience, the synaesthetes confirmed that they were adequate approximations. This set of animations was then used as stimuli in a set of experiments conducted on non-synaesthetes in the general population. Our aim was to determine whether combinations of sound and vision based on synaesthesia would be rated as more pleasant and preferable to other sound–vision combinations. The rationale was that the synaesthetic mappings between sound and vision would also be present in the general population and so these would tend to be preferred.

In order to produce a control (i.e. non-synaesthetic) set of sound and vision, several manipulations were used. Firstly, the same set of visual experiences and sounds were randomly paired. This enabled us to determine the extent to which preference/liking was related to the combination of audiovisual parts rather than the parts themselves. Secondly, the actual synaesthetic animations were distorted by changing the hue (by choosing the opposing hue on the colour wheel). Thirdly, the original synaesthetic animations were distorted by rotating them through 90 degrees whilst maintaining the same aspect ratio. This enabled us to assess the effect of position in space and/or direction of motion. The hue-changed stimuli and rotated stimuli were presented with the original sound.

In the first experiment, participants were presented with single audiovisual pairs (AV) corresponding to the original AV synaesthetic experiences or the three distorted AV conditions. In addition they were presented with the sounds alone (A) or the visual animations alone (V). They were required to rate their liking of the stimulus by moving a slider. Points on the slider were marked with smiley faces, ranging from very unhappy through neutral to very happy. The ratings were scored in terms of distance from neutrality. The ratings for the AV pairs were compared to that expected if participants based their rating on the mean of the A and V parts. For the random AV combinations, the liking judgements were entirely predicted from the liking ratings of the parts. However, for the synaesthetic AV combinations the liking judgements were significantly greater than that expected from a part-based analysis. This suggests that these stimuli, but not the random pairings, are treated as multisensory objects in their own right. Contrary to our predictions, the distortions to the hue and spatial position were rated equivalently to the original synaesthetic AV stimuli. As such, this initial study suggests that liking judgements may be governed by the temporal characteristics of the AV combination (which was disrupted in the random pairings) but not necessarily by the synaesthetic content of the stimuli.

In order to explore this further, a second experiment was conducted in which the same stimuli were used but the experimental procedure was changed. There were two visual stimuli presented with a single sound and the participants were required to choose which animation they preferred to go with the sound. The two visual stimuli were drawn from the three conditions in the previous experiment: random pairings, hue change, and position change. This forced-choice manipulation was expected to be more sensitive to the different manipulations given that attention would be drawn to the different contents of the stimuli. Indeed, in this manipulation, the participants were sensitive to the synaesthetic content and, in all three conditions, the synaesthetic animations were preferred over the control 'non-synaesthetic' animations. The results

are summarized in Fig. 24.3. The finding that the synaesthetic colour changes and the random pairings were rated less favourably is perhaps not surprising given the evidence discussed previously. However, the effect of rotating the image is perhaps more surprising. It is to be noted that most of the original synaesthetic animations moved in a left to right direction. At present, the source of this bias is unclear. One possibility is that it reflects the general trend that we all have to attend more strongly to events on the left of space that is believed to be due to the right hemispheric dominance for spatial attention (e.g. Nicholls et al. 1999). A second possibility is that it is a cultural effect arising from reading direction. I shall return to the possible role of culture in synaesthesia in the concluding section.

In the third and final experiment, the synaesthetic AV animations were paired with animations produced from control participants who lack synaesthesia. The participants were instructed to think about the colour, movement, position, size, shape, and texture in order to make them as comparable to the synaesthetic stimuli as possible. As in the second experiment, the control animation and the synaesthetic animation were paired together with the appropriate sound and the participant was required to choose which one they preferred. The participants were significantly more likely to choose the synaesthetic animation over the control animation. This result is perhaps

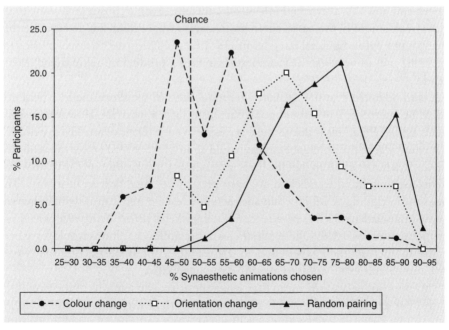

Fig. 24.3 When played a sound and two animated clips, non-synaesthetic participants tend to prefer the animation based upon a synaesthetic experience to that sound than when the same animation is changed for colour or orientation, or when a randomly chosen synaesthetic experience generated by another sound is played. The figure is adapted from data in Ward et al. (2008b).

not surprising given the evidence that non-synaesthetes tend to match auditory and visual features in similar ways to synaesthetes. Whilst this may be true, the animations produced from the synaesthetes were far richer in detail than the controls and it is likely that this could be driving the effect that we observed.

In summary, there are systematic correspondences between the auditory and visual domain that are present in all people but are consciously experienced by those with sound-vision synaesthesia. These correspondences not only bias performance on cognitive tasks (e.g. pitch discrimination in the presence of irrelevant vision) but also affect hedonic judgements of multisensory stimuli (Ward et al. 2008b). It may provide a strong source of motivation for those who experience such sensations to be engaged in music and visual art.

WIDER IMPLICATIONS: SYNAESTHESIA, CULTURE, AND ART

Having discussed the nature of the mechanisms by which sound and vision may be related and how this affects hedonic ratings, it is worthwhile considering some of the wider implications of this research. In particular, to what extent could neuroscientific investigations of audiovisual integration and synaesthesia impact on visual music as an art form, and, to what extent is synaesthesia itself a product of cultural and artistic trends?

It is to be noted that the animated reproductions of the synaesthetic experiences would be interpreted, by contemporary art historians, as abstract. However, it seems highly unlikely that this is due to their exposure to such forms of art. The experiences of synaesthetes in previous generations would almost certainly resemble those of present-day synaesthetes given that the basic multisensory mechanisms of the brain would predate such cultural trends and are even present, to some degree, in infants. This raises the intriguing possibility that abstraction is not a purely cultural phenomenon: it could have existed in the experiences of synaesthetes before being recognized as a distinct artistic style. Although synaesthetes in previous generations would have been unable to interpret their experiences in terms of the concept abstraction they would have comparable experiences to present-day synaesthetes.

This does not necessarily mean that synaesthesia is completely immune to cultural biases. For example, it is possible that the left-to-right direction of visual motion induced by sound (Ward et al. 2008b) reflects a cultural bias of reading direction, although there are no empirical studies of this to date. Other types of synaesthesia do show similar biases. For example, those synaesthetes who experience numbers spatially often have deviations in their number forms at decade boundaries (10, 20, 30, etc.) reflecting our decimal system (Sagiv et al. 2006). However, synaesthetes in nineteenth-century Britain tended to have deviations around the digit 12 (Galton 1880) reflecting,

presumably, the greater use of a duodecimal system (e.g. 12 inches in a foot, 12 pence in a shilling). Non-synaesthetes in Western cultures also show a left–right bias in responding to numbers: they are faster at responding to smaller numbers with their left hand and larger numbers with their right hand (Dehaene et al. 1993). The effect is reduced in Persian speakers who read right-to-left, but is unaffected by handedness or even by crossing the position of the hands over in space (Dehaene et al. 1993). As such, sound–space and number–space relationships may reflect intrinsic properties of the way that the brain represents these dimensions, but the precise nature of the relationship (e.g. direction) could be culturally modulated.

Neuroscientific investigations of audiovisual integration and synaesthesia could potentially be used to create deliberate emotional responses in the perceiver. This need not necessarily consist of the most compatible audiovisual pairings. For example, having visual images that are 'non-synaesthetic' with respect to the music may be used to heighten the experience during moments of musical tension. It is likely that artists working in the field of visual music have, through trial and error, been using such methods for many years (see van Campen, Chapter 25, this volume). However, it is hoped that this enterprise can be guided and illuminated by research in the sciences.

ACKNOWLEDGEMENTS

The animations of synaesthesia were produced by Samantha Moore, University of Wolverhampton, in a project funded by the Wellcome Trust.

REFERENCES

Baron-Cohen S, Wyke MA, and Binnie C (1987). Hearing words and seeing colours: An experimental investigation of a case of synaesthesia. *Perception*, **16**, 761–7.

Ben-Artzi E and Marks LE (1995). Visual-auditory interaction in speeded classification: role of stimulus difference. *Perception and Psychophysics*, **57**, 1151–62.

Brougher K, Strick J, Wiseman A, and Zilczer J (2005). *Visual Music: Synaesthesia in Art and Music Since 1900*. Thames & Hudson, London.

Calvert GA, Bullmore ET, Brammer MJ, et al. (1997). Activation of auditory cortex during silent lipreading. *Science*, **276**, 593–6.

Dehaene S, Bossini S, and Giraux P (1993). The mental representation of parity and numerical magnitude. *Journal of Experimental Psychology: General*, **122**, 371–96.

Fias W and Fischer MH (2005). Spatial representation of numbers. In JID Campbell (ed.) *Handbook of Mathematical Cognition*. Psychology Press, Hove.

Gallace A and Spence C (2006). Multisensory synesthetic interactions in the speeded classification of visual size. *Perception and Psychophysics*, **68**, 1191–203.

Galton F (1880). Visualised numerals. *Nature*, **21**, 252–6.

Goller AI, Otten LJ, and Ward J (2009). Seeing sounds and hearing colors: An event-related potential study of auditory-visual synaesthesia. *Journal of Cognitive Neuroscience*, **21**, 1869–81.

Ione A and Tyler C (2003). Was Kandinsky a synesthete? *Journal of the History of Neuroscience*, **12**, 223–6.

Leger GC, Conley D, Mak YE, Simmons KB, and Small DM (2003). Retronasal presentation of food odor preferentially activates cortical chemosensory areas compared to orthonasal presentation of the same odor and retronasal presentation of a nonfood odor. *Chemical Senses*, **28**, 554.

Lewkowicz D and Turkewitz G (1980). Cross-modal equivalence in infancy: auditory-visual intensity matching. *Developmental Psychology*, **16**, 597–607.

Marks LE (1974). On associations of light and sound: the mediation of brightness, pitch, and loudness. *American Journal of Psychology*, **87**, 173–88.

Marks LE (1975). On coloured-hearing synaesthesia: cross-modal translations of sensory dimensions. *Psychological Bulletin*, **82**, 303–31.

Marks LE (1982). Bright sneezes and dark coughs, loud sunlight and soft moonlight. *Journal of Experimental Psychology: Human Perception and Performance*, **8**, 177–93.

Marks LE (1987). On cross-modal similarity: auditory-visual interactions in speeded discrimination. *Journal of Experimental Psychology: Human Perception and Performance*, **13**, 384–94.

Martino G and Marks LE (1999). Perceptual and linguistic interactions in speeded classification: tests of the semantic coding hypothesis. *Perception*, **28**, 903–23.

Maurer D and Maurer C (1988). *The World of the Newborn*. Basic Books, New York.

McGurk H and MacDonald J (1976). Hearing lips and seeing voices. *Nature*, **264**, 746–8.

Miller JO (1982). Divided attention: evidence for co-activation with redundant signals. *Cognitive Psychology*, **14**, 247–79.

Mondloch CJ and Maurer D (2004). Do small white balls squeak? Pitch-object correspondences in young children. *Cognitive, Affective and Behavioral Neuroscience*, **4**, 133–6.

Nicholls MER, Bradshaw JL, and Mattingley JB (1999). Free-viewing perceptual asymmetries for the judgement of brightness, numerosity and size. *Neuropsychologia*, **37**, 307–14.

Pourtois G and de Gelder B (2002). Semantic factors influence multisensory pairing: A transcranial magnetic stimulation study. *NeuroReport*, **13**, 1567–73.

Saenz, M and Koch C (2008). The sound of change: visually-induced auditory synesthesia. *Current Biology*, **18**, R650–R651.

Sagiv N, Simner J, Collins J, Butterworth B, and Ward J (2006). What is the relationship between synaesthesia and visuo-spatial number forms? *Cognition*, **101**, 114–28.

Simner J, Lanz M, Jansari A, et al. (2005). Non-random associations of graphemes to colours in synaesthetic and normal populations. *Cognitive Neuropsychology*, **22**, 1069–85.

Simner J, Mulvenna C, Sagiv N, et al. (2006). Synaesthesia: the prevalence of atypical cross-modal experiences. *Perception*, **35**, 1024–33.

von Kriegstein K, Kleinschmidt A, Sterzer P, and Giraud AL (2005). Interaction of face and voice areas during speaker recognition. *Journal of Cognitive Neuroscience*, **17**, 367–76.

Ward J (2008). *The Frog who Croaked Blue: Synesthesia and the Mixing of the Senses*. Psychology Press, Hove.

Ward J and Simner J (2005). Is synaesthesia an X-linked dominant trait with lethality in males? *Perception*, **34**, 611–23.

Ward J and Mattingley JB (2006). Synaesthesia: an overview of contemporary findings and controversies. *Cortex*, **42**, 129–36.

Ward J, Huckstep B, and Tsakanikos E (2006). Sound-colour synaesthesia: to what extent does it use cross-modal mechanisms common to us all? *Cortex*, **42**, 264–80.

Ward J, Thompson-Lake D, Ely R, and Kaminski F (2008a). Synaesthesia, creativity and art: What is the link? *British Journal of Psychology*, **99**, 127–41.

Ward J, Moore S, Thompson-Lake D, Salih S, and Beck B (2008b). The aesthetic appeal of auditory-visual synaesthetic perceptions in people without synaesthesia. *Perception.* **37**, 1285–96.

VISUAL MUSIC AND MUSICAL PAINTINGS: THE QUEST FOR SYNAESTHESIA IN THE ARTS

CRETIEN VAN CAMPEN

THROUGHOUT history artists have explored new multisensory ways to reach the public's consciousness. In this chapter, I would like to give a historical review of artistic experiments with synaesthesia and then relate them to current neuroscientific research into synaesthesia. My working definition for this chapter is the following: 'Synaesthesia is an involuntary uncommon cooperation of the senses as we know them.' I will focus on a prevalent type of synaesthesia: coloured hearing, i.e. the co-perception of colour in hearing sounds or music.

MATHEMATICAL EXPLORATIONS

The interest in the synaesthetic phenomenon of coloured hearing is at least as old as Greek philosophy (the terms synaesthesia and *audition colorée* were coined in the middle of the nineteenth century) (Ferwerda and Struycken 2001; Adler and

Zeuch 2002). One of the questions raised by the classical philosophers was whether the colour (*chroia*, what we now call timbre) of music was a physical quality that could be quantified (Gage 1993). Pythagoras had already discovered that there was a mathematical principle behind pitch, demonstrating that the pitch of a note could be determined by the length of the string that produced it. Aristotle and his students tried to take his deductions about pitch one step further to find a similar mathematical explanation for the relationship between pitch and colour. They assumed that the colour spectrum, ranging from dark to light, could be matched to a spectrum of pitch, from low to high. They took just one aspect of colour—lightness—and ordered all colours on a greyscale from black to white (Fig. 25.1). They then linked the lowest pitched note to white and the highest pitched note to black. All notes in between, from low to high pitch, were linked to corresponding grey values, from light grey to dark grey (Gage 1993).

Ever since these early investigations, the quest to find the mathematical principles underlying the correspondence between pitch and colour has been taken up by philosophers, artists, and scientists (Peacock 1988; Gage 1993, 1999; Jewanski 1999; Maur 1999). Some philosophers used their imagination and speculative theory to connect music and colour. For instance, Plato wrote that the eight celestial spheres are coloured and are accompanied by eight tones (Gage 1993).

The seventeenth-century physicist Isaac Newton had a more down-to-earth approach and tried to solve the problem by assuming that musical tones and colour tones have frequencies in common (Peacock 1988; Gouk 1999). He attempted to link sound oscillations to respective light waves. According to Newton, the distribution of white light in a spectrum of colours is analogous to the musical distribution of tones in an octave. He identified seven discrete light entities (colours) to which he then matched the seven discrete notes of an octave ((Newton 1675/1757; see Fig. 25.2).

Inspired by Newton's theory of music–colour correspondences, the French Jesuit Louis-Bertrand Castel took the theory a step further when he designed a colour

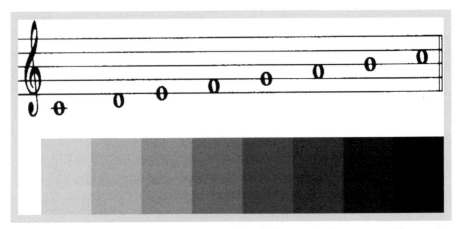

Fig. 25.1 An ascending chromatic scale with pitch matched to tones of increasing darkness.

harpsichord (*clavecin oculaire*) (Peacock 1988; Franssen 1991). Assisted by the instrument builder Rondet, Castel designed a harpsichord with coloured strips of paper which rose above the cover of the harpsichord whenever a particular key was hit. Unfortunately, the coloured strips could only be lit by candlelight and the instrument was never finished. Other versions were under development and a drawing of one by Johann Gottlob Krüger has survived (Fig. 25.3).

Renowned composers like Telemann and Rameau were actively engaged in the development of *clavecins oculaire* (Peacock 1988; Gage 1993), although the practical performance of coloured music remained hampered by the technical impracticality of showing the colours in a large concert hall. A set of paper strips illuminated by candles lacked the power to evoke a convincing visual experience for the audience. The technical limitations made the experience very remote compared with what we can

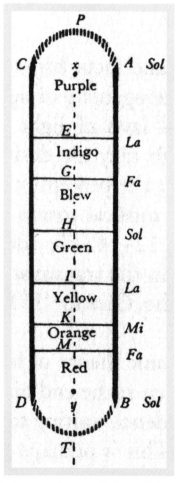

Fig. 25.2 Newton identified seven discrete light entities (colours) and matched them to the seven discrete notes of an octave (Newton 1675/1757)

experience nowadays with light shows in concert halls. At that time, the colours of the sky at dawn or sunset in a natural setting came closer to the idea that the inventors had in mind.

The invention of gas lighting in the nineteenth century afforded new technical possibilities for the colour organ. In England in the 1870s, the inventor Frederick Kastner developed an organ that he named a Pyrophone. He used thirteen gas jets to

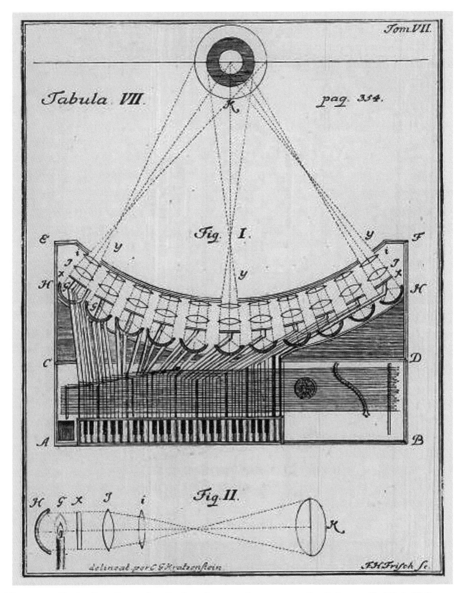

Fig. 25.3 Early drawing of a design for a colour organ by Johann Gottlob Krüger, 1743.

light crystal flasks (see Fig. 25.4A). A few years later an American inventor, Bainbridge Bishop, constructed a machine that could be set on top of a house organ. It consisted of a white semi-circular screen on to which coloured light was projected through a series of levers and shutters operated by the organ player (see Fig. 25.4B). Colour organs would soon become very popular and the simplicity and mobility of the instrument attracted the attention of the famous circus master Barnum, who bought one for his home (Peacock 1988).

The British inventor and professor of fine arts, Alexander Rimington, documented the term 'colour organ' for the first time in a patent application in 1893. Inspired by Newton's idea that music and colour are both grounded in vibrations, he divided the colour spectrum into intervals analogous to musical octaves and attributed colours to notes. The same notes in a higher octave produced a lighter shade of the same colour (Peacock 1988).

At almost three metres in height, Rimington's colour organ (see Fig. 25.5) looks like a common house organ with a compartment on top of it containing fourteen coloured lamps. The light of the lamps could be controlled by the performer in

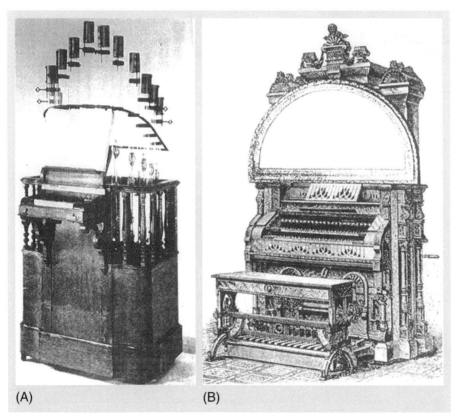

(A) (B)

Fig. 25.4 Colour organs by Frederick Kastner (A) and Bainbridge Bishop (B) from the 1870s.

gradients of colour tone, lightness, and saturation (Peacock 1988). Rimington's colour organ represented a giant step forward from the original harpsichord and paper strips of Castel. However, like most colour organs of that time, Rimington's light machine did not produce musical sound and his colour organ had to be played simultaneously with an organ that did produce musical sound.

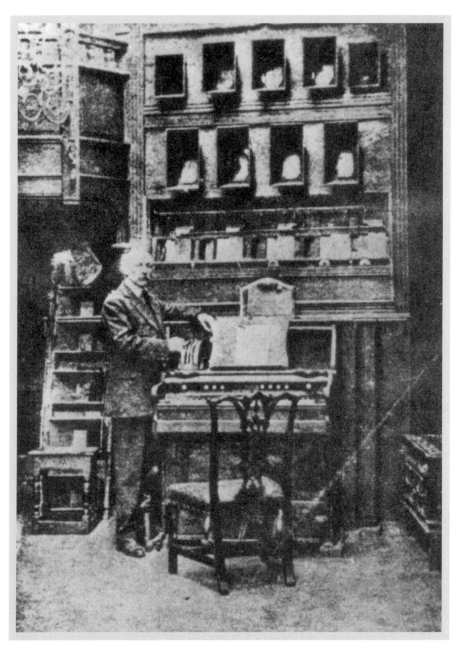

Fig. 25.5 Alexander Rimington in front of his colour organ, end of nineteenth century.

The *Musical Courier* of June 8, 1895, reported that Sir Arthur Sullivan improvised on the colour organ, though with his eyes closed. A few days earlier, Rimington had demonstrated his colour organ in London for an audience of a thousand people. In the same year, Rimington played the colour organ in four more concerts accompanying the music of Wagner, Chopin, Bach, and Dvorak (Peacock 1988).

To summarize, the age-old quest for colour-pitch correspondences in order to evoke perceptions of coloured music had finally resulted in the construction of colour organs and performances of coloured music in concert halls at the end of the nineteenth century (cf. Peacock 1988; Gage 1993; Jewanski and Sidler 2006).

PSYCHOLOGICAL EXPLORATIONS

Around the beginning of the twentieth century, musical performances accompanied by displays of coloured light were given quite regularly. Since most of the technical problems had been overcome by this time, it was the *psychological* questions concerning the effects of these performances that came to the fore. The Russian composer Alexander Scriabin was particularly interested in the psychological effects on an audience experiencing sound and colour simultaneously. His theory was that when the correct colour was perceived together with the correct sound, 'a powerful psychological resonator for the listener' would be created (Myers 1914; Peacock 1985; Galeyev and Vanechkina 2001).

Scriabin became aware of his synaesthetic perceptions while sitting next to the composer Rimsky Korsakov in a concert hall. Scriabin describes noticing that the performance of a piece in D-minor appeared yellow to him, and he mentioned this to Korsakov whereupon his colleague replied that the piece appeared to him in a golden colour. From that moment on, Scriabin started to pay special attention to the colour effects of different tonalities. He realized that he had spontaneous colour perceptions while listening to pieces in the keys of C, D, and F-sharp. Music in the key of C corresponded with red, D with yellow and F-sharp with blue. A single note apart from tonality had no colour for Scriabin (Gleich 1963; Peacock 1985).

Scriabin explained that colour played several roles in the perception of music. When the tonality of a piece changed, the colour changed: 'The colour underlines the tonality; it makes the tonality more evident' (Pear 2007). According to Scriabin, this was one way in which the addition of colour projections to musical performances could intensify the impact of the music. In fact, the music and the colour could enhance each other simultaneously. Sometimes, he even anticipated the change in colour before he heard the change in tonality (Myers 1914; Galeyev and Vanechkina 2001).

His most famous synaesthetic work, which is still performed today, is *Prometheus, Poem of Fire* (Fig. 25.6). He used key-colour correspondences for this work (Table 25.1), and not the tone–colour correspondences which had been commonly used by colour organ performers like Rimington. Thus, only when the tonality or key of the piece changed would Scriabin change the colour (Gleich 1963).

Alongside the other musical parts on the score for 'Prometheus', Scriabin wrote directions for the *tastiere per luce*, the colour organ, treating it almost as another musical instrument. The colour organ's part consisted of two movements, one of which was 'consonant' with the music, and the other 'dissonant'. His intention was to structure and intensify the listeners' experience not simply by imitating or reflecting the music

Fig. 25.6 Jean Delville (1867–1953), Frontispiece of the score for 'Prometheus: Poem of Fire' by Alexander Scriabin, 1911.

Table 25.1 Scheme of colour–key correspondences by Alexander Scriabin

Key	Colour
C	red
C#	violet or purple
D	yellow
D#	gray
E	sky blue
F	deep red
F#	bright blue
G	orange
G#	lilac
A	green
A#	grey
B	light blue

in colour, but by giving the colour organ an autonomous role where it could point and counter point at changes in the musical movement with colour changes (Gleich 1963; Peacock 1985).

Meanwhile, in the visual arts, interest in the correspondences between music and colour was raised by the concept of the painter's palette as a keyboard, which became commonplace in the artistic parlance of the second half of the nineteenth century. Many visual artists considered music the highest form of art and believed that music approached the ideal of an immaterial art form (Gage 1993; Maur 1999).

The Dutch painter Vincent van Gogh (1853–1890) recounted a personal anecdote about the music behind his own paintings. The artist took piano lessons to become acquainted with the subtleties of colour tone. However, his elderly music teacher sent him away soon after he noticed that Van Gogh was constantly comparing the sounds of the piano keys with Prussian blue, dark green, dark ochre, and cadmium yellow. The teacher thought his pupil was a madman. In his later writings, Van Gogh compared painting with pencils to playing the violin with a bow (Uitert 1978; Campen 2007).

He was not the only visual artist in the nineteenth century to experiment with painting and music. It was common for artists to sing or whistle songs while they painted to create paintings that approached a musical expression. In the second half of the nineteenth century, a tradition of musical paintings began to appear that influenced, among others, the Dutch symbolist painter, Janus de Winter (1882–1954). A characteristic of symbolism is the frequent use of musical titles. In that respect, symbolism was a

trailblazer for the synaesthetic experiments conducted by later abstract artists in the twentieth century.

Janus de Winter exhibited works with titles like *Musical Fantasy (Wagner)*. In response to a request by the psychologist Ten Haeff to describe his synaesthetic percepts, de Winter wrote to him:

Trombones, horns, trumpets vary from red to yellow; oboes, clarinets and flutes vary from dark brown to olive green and dark green to light yellow green; cellos, from red or brown violet to blue and purple; violins can express any colour, which are always blended with silvery grey. Beethoven's music appears with lots of red, but also purple, violet and exquisite green, silver and grey, while Chopin evokes dark colours.

(Uitert 1978)

In the first decades of the twentieth century, a group of German artists called *Der blaue Reiter* (The Blue Rider) executed synaesthetic experiments (known as *audition colorée* or coloured hearing at that time) involving a composite group of painters, composers, dancers, and theatre producers. The group's aims were focused on three goals: the unification of the arts by means of Total Works of Art (*Gesamtkunstwerke*); achieving freedom of expression through abstraction; and the expression of spirituality as the ideal of an immaterial art (Hahl-Koch 1985; Evers 1995). Wassily Kandinsky's theory of synaesthesia, as formulated in the booklet *On the Spiritual in Art* (1911), helped to shape the ground for these experiments. He described coloured hearing as a phenomenon of transposition of experience from one sense modality to another. In his Bauhaus lessons, he compared the human nerves to the strings of a piano, and he noted that if a note is struck on one of two pianos that are standing next to each other, the same note on the other piano would resonate. Kandinsky was well acquainted with the scientific debates on perception in academic psychology at that time and explicitly defended his theory of synaesthesia against the arguments of psychologists (Poling 1983; Düchting 1996; Ione 2004).

Presumably, Kandinsky was synaesthetic from childhood.[1] For example, in a description of a concert that he had attended in his youth, he explained that when he heard the performance of Wagner's 'Lohengrin' in Moscow, the music evoked a fantastic vision of colours and lines. After this early discovery of his synaesthesia, he later began to notice that the sounds of musical instruments also had distinct colours for him: a trumpet and a brass band sounded yellow; a viola and a warm alto voice had orange colours; a tuba and drums evoked red colours; a bassoon sounded violet; a cello and an organ produced blue; and the sound of violin evoked green. He played the cello himself and described the dark blue colour of the instrument as the most personal spiritual colour (Kandinsky 1980; Ione and Tyler 2003).

Both Kandinsky and the Viennese composer Arnold Schönberg were interested in the phenomenon of synaesthetic dissonance, which also intrigued Scriabin (Hahl-Koch 1985; Costa Meyer and Wasserman 2003). After Schönberg published his ideas on atonal music and dissonant harmony, Kandinsky wanted to make use of these

[1] There is still debate on Kandinsky's synesthesia (cf. Jewanski and Sidler 2006).

principles in his painting and theatre. In his theatre piece *Der gelbe Klang* (The Yellow Sound) he experimented with the opposition of three types of movement: visual movement (film), musical movement, and physical movement (dance) (Kandinsky 1912). Like Scriabin, Kandinsky wanted to alternate dissonance with consonance in order to intensify synaesthetic perceptions, so they would, in his own words, have a 'deeper inner impact' (Poling 1983; Düchting 1996).

Kandinsky was not the only artist at this time with an interest in synaesthetic perception. A study of the art in the first decades of the twentieth century reveals in the work of almost every progressive or avant-garde artist an interest in the correspondences between music and visual art. Modern artists experimented with multisensory perception like the simultaneous perception of matching movements in music and film. The German art historian Karin von Maur has compiled an elaborate catalogue of the immense production of musical paintings in the twentieth century, published as *The Sound of Images* (Maur 1999).

DIGITAL EXPLORATIONS

In the time of Scriabin and Kandinsky, the performance of sound and colour compositions did not have the technical advantages we have today. The rapid technological advances in computer technology that have occurred since the middle of the twentieth century have allowed for the creation of new digital instruments, and brought sound and colour into the same digital domain (cf. Brougher et al. 2005; Riccò and Cordoba 2007).

From the late 1950s, electronic music and electronic visual art have coexisted in the same medium, and the interaction between these two fields of art has increased tremendously. Nowadays, students of art and music have at their disposal digital software that uses both music and visual imagery. The opportunities afforded by the internet for publishing and sharing digital productions have led to an avalanche of synaesthesia-inspired art on the internet (Collopy 2000). Unfortunately, many projects are not well thought-out. Applying synaesthesia to digital art involves more than applying some computer algorithms that arbitrarily translate music into colours; Windows Media Player on your PC can already do that trick for you. The challenge is to find a form that truly reveals some aspects of synaesthesia.[2]

[2] Perhaps one should study the 'old masters' of visual music such as John Whitney, the animator for *2001: A Space Odyssey*, or Oskar Fishinger, who worked on Disney's *Fantasia*, or even the seventeenth-century inventor of the first colour-organ, Louis-Bertrand Castel; all were limited in their technical opportunities, but they did a good job relating music with images. Fred Collopy's website http://RhythmicLight.com, which details the history of visual music, provides a well-documented introduction to the thinking and practices of these masters.

To give a fine example, Stephen Malinowski and Lisa Turetsky from Berkeley, California wrote a software program, entitled the Music Animation Machine (MAM) that translates and shows music pieces in coloured measures for children (http://www.musanim.com). Children using this tool do not have to puzzle over complicated staves, with flat or sharp symbols and key signatures, but instead see coloured bars that scroll across the screen in time with the music they hear. The vertical positions of the bars on the screen represent the relative pitches, while the colour may indicate instruments or voices, thematic material or tonality.

Figure 25.7 shows a still from the MAM representing the first ten bars of Johann Sebastian Bach's organ work, *In Dulci Jubilo*. Bach loved to employ complex mathematical structures in his music which are not always easy to distinguish by ear. The piece contains a double canon, which means the same melody is repeated with a time shift. In the animation, one can see that the dark green pattern is followed by the light green pattern, while the violet-blue follows the red pattern. By synchronizing them, the sound and the image are easily linked in our perception. Musical structures within Bach's canons or his many-voiced compositions may thus be made more accessible by a visual aid.[3]

Many software devices have been developed, not only for educational purposes but also for use in digital art, which show visual aspects of sound, sound aspects of images, and enhance the perception of sound and vision in an integrated and meaningful way. Several programs, such as MAM, seem to serve as *extensions* of the senses, affording a better awareness of the physical world in which sounds may have colours, as Aristotle and his students had already asserted.

In summary, I have presented three episodes in the history of artistic experiments and three respective models of synaesthetic multisensory perception. The first episode consists of *mathematical* explorations of the senses in order to reveal how the human mind is tuned to universal harmonies, which in the end results in a very practical device: the colour-organ. The second episode consists of *psychological* explorations of the senses in order to reveal introspective regularities and deeper meanings of perceived intermodal perceptions, resulting in a spiritual modern abstract art. And the last episode shows *digital* explorations of the input of the senses in order to find regularities in the man–machine environment, resulting in digital software and systems that 'extend' the reach of the human senses. The distinctions between the episodes are, of course, less sharp than I have presented them here. Thus, the quest for synaesthesia, i.e. coloured hearing, appears to be threefold: synaesthetic perceptions could reveal (1) harmonies in the universe; (2) deeper spiritual meanings in the human mind; and (3) extended perceptions of the human senses.

[3] Malinowski and Turetsky write on their website (http://www.musanim.com) that 3-year-old children enjoy classical music when they can see the animation simultaneously. A study by the Russian music pedagogue Irina Vanechkina (1994) showed that children who have been drawing and painting while listening to classical music developed a better understanding of musical pieces and are better at analysing musical structures later in life.

Fig. 25.7 (See Colour plate 13) Still taken from an animation created by the Music Animation Machine, representing the first ten bars of Johann Sebastian Bach's organ work *In Dulci Jubilo*.

(with permission from Steven Malinowski, www.musanim.com).

COMPARISON TO CURRENT NEUROSCIENCE

The current neuroscientific view[4] on synaesthesia has some overlap with the artistic views discussed earlier, but also some major differences. I shall compare them on a number of points.

First, one should consider the different contexts of investigation. In neuroscience, synaesthesia is mainly a *brain* phenomenon (cf. Ward and Mattingley 2006 and Ward in this volume), while in the arts, synaesthesia is a phenomenon on the *stage* of a theatre, a museum, or digital community (cf. Brougher et al. 2005; Riccò and Cordoba 2007).

Second, the objective of neuroscience is to test theories of mind and the mechanisms of multisensory perception (cf. Emrich et al. 2002). In the arts, the main goal is to develop instruments and devices for public performances. These instruments are very different from the instruments in scientific research that are developed to assess or measure synaesthetic responses in individuals; in the arts the instruments are developed to evoke synaesthetic perceptions in a large audience (cf. Peacock 1988; Jewanski 1999).

[4] Neuropsychological research into synaesthesia (see reviews in Baron-Cohen and Harrison 1997; Ramachandran and Hubbard 2001; Cytowic 2002; Robertson and Sagiv 2004; Ward and Mattingley 2006) is relatively young in comparison with artistic explorations of the phenomenon. Halfway through the 1980s, scientific research into synaesthesia experienced something of a revival when new brain scanning techniques and psychological consistency tests became available. Synaesthetes had not been taken seriously for a long time, but when physiological and psychological proof was given for synaesthesia it soon became a serious scientific and popular subject of research. Note that coloured hearing and synaesthesia had been studied extensively by scientists around the end of the nineteenth century (cf. Marks 1978; Campen 1999, 2007).

Third, the selection of the forms of synaesthesia to be studied differs. Scientific research into synaesthesia in the last decades has focused mainly on the perception of coloured letters and numbers (graphemes) (cf. Ward and Mattingley 2006). On the other hand, artists have focused on different forms of synaesthesia: visual music, musical paintings, coloured music, and have mostly been concerned with relating the visual arts and music (Gage 1993; von Maur 1999; Brougher et al. 2005; Riccò and Cordoba 2007).

Fourth, given these different types of synaesthesia that are the focus of scientific and artistic investigations, different typical characteristics of synaesthesia have been studied:

- While scientists started with a strong causal model of unidirectional synaesthesia (e.g. a sound evoking a colour image) (Baron-Cohen and Harrison 1997), artists started from a simultaneous model in which several sensory domains influence each other at the same time (cf. Maur 1999; Collopy 2000).[5]
- Another assumption of the scientific model was that synaesthesia is idiosyncratic, strictly individual; e.g. the letter A can be consistently blue for one synaesthete and consistently red for another synaesthete (cf. Duffy 2001). To the contrary, artists used a model of synaesthesia as a universal trait of perception (cf. Gage 1999; Galeyev and Vanechkina 2001). Practically, an idiosyncratic model would not be feasible for public performance.[6]
- While medical research started from the assumption that synaesthesia was a result of a brain impairment (using metaphors like miswiring and leakages between brain sections) (cf. Baron-Cohen et al. 1993), artists have always considered synaesthesia as a talent or a gift, a state of consciousness one could become aware of (cf. Duffy 2001; Campen 2007; Dittmar 2007). Fortunately, synaesthesia is considered a perceptual ability by most synaesthesia researchers nowadays, after conducting interviews with synaesthetes who did not feel handicapped at all by this 'impairment'.[7]

The concept of synaesthesia in neuroscience has a different background and is defined slightly differently from that in the arts. In contrast to the classic neuroscientific definition of synaesthesia as 'a stimulation of one sensory domain leading to a perception in another sensory domain' (Baron-Cohen 1997), or in a recent definition as 'the elicitation of perceptual experiences in the absence of the normal sensory stimulation' (Ward and Mattingley 2006), I would define the concept of synaesthesia

[5] By the way, it is interesting to observe that scientific models of synaesthesia are being adjusted on the basis of reports of bidirectional synaesthesia by synaesthetes and artists (Cohen Kadosh et al. 2005; Cohen Kadosh and Henik 2007).

[6] Also in this respect, scientists have moved more to the artistic model, since several studies have been carried out to find universals in, for instance, colours of letters (Day 2004).

[7] In line with the reports on synaesthesia as an ability, 'creativity' has become a current theme in scientific research. The prevalence of synaesthesia appears to be higher among persons in creative professions than in the general population (Rich et al. 2005; Ward et al. 2008). Many artists that I have interviewed seemed to consider synaesthesia as self-evident and as another one of their tools in their artistic toolbox.

in the arts as 'the simultaneous perception of two or more stimuli as one gestalt experience'.[8]

To distinguish the neuroscientific and artistic definitions of synaesthesia I will use the terms 'neural synaesthesia' and 'synchronaesthesia'. The two definitions do not refer to the same, but rather to two closely related phenomena. Both the phenomena that scientists and artists study are real perceptions. I suggest investigating how they are related within the framework of multisensory perception. As a start I would put forward a hypothesis.

My thesis, or conjecture, is that 'neural synaesthesia' is a particular form of the more common perception of 'synchronaesthesia'. Many people, synaesthetes and non-synaesthetes alike, have a common sense (*sensus communis* in the Aristotelian sense) or ability to match stimuli from different sensory domains (cf. Adler and Zeuch 2002; Marks 1978). One can tell that a double bass corresponds better to a darker colour than a flute and one can relate the typical Boogie Woogie rhythms better to the late paintings by Piet Mondrian than to colour field paintings by Mark Rothko.[9]

But then, what's the difference between 'neural synaesthesia' and 'synchronaesthesia'? A neural synaesthetic perception is the result of a stimulation of one sense, which results in a multisensory perception. For instance, a sound evokes a coperception of colour in a person. A synchronaesthetic perception is considered the result of a synchronous stimulation of two or more senses, resulting in a multisensory gestalt perception. For instance, a simultaneous perception of a melody and a visual animation on a screen evokes the feeling of a match of music and image in a person (cf. MAM, Fig. 25.7).

Figure 25.8 shows a schematic comparison of 'neural synaesthesia' and 'synchronaesthesia' in human information processing. I will explain the scheme with two examples. Fig. 25.8 can illustrate, as a first example, why synaesthetes do not like music video clips in general, and as a second example, why children (and adults too) can understand music animations without being synaesthetic.

When a coloured hearing synaesthete hears music (the red arrow) his brain adds colours and forms (blue arrow), so he experiences music in colour and form (purple field in the smiley). When he watches a music video clip, his senses are stimulated like in 'synchronesthesia' (blue and red arrows). But his brain is already producing a visual perception (blue arrow). So on top of his musical perceptions he gets two visual perceptions (= a dark and a light blue arrow). If the blue arrows interfere with each other, say one is producing a green colour and the other a purple colour, the synaesthete

[8] I consider a gestalt perception as a direct (almost pre-conscious or pre-intellectual) perception of meaningful configuration in the physical environment. This is in line with theories by, among others, Merleau-Ponty, Wertheimer, Lipps, beginning with the aesthetics of Baumgarten—a tradition of thought that can be retraced in the work of current thinkers on synesthesia like Ramachadran, Marks, Cytowic, and Emrich (Campen 2007).

[9] Artistic and scientific experiments have shown that non-synaesthetes are also capable of consistently matching stimuli from different sensory domains, which suggests that many non-synaesthetes implicitly prefer these sensory correspondences while synaesthetes explicitly perceive them (Marks 1978; Ward et al. 2006; Galeyev 2007).

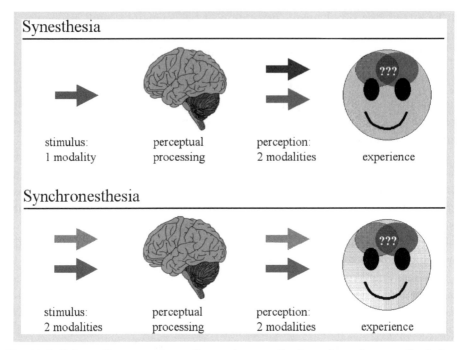

Fig. 25.8 Schematic comparison of neural synaesthesia and synchronaesthesia in human information processing.

(with permission from Robert Hulsman).

gets an awkward experience of music that is green and purple at the same time. He will perceive this as a mismatch.

As a second example, non-synaesthetic children need the stimulation of hearing and vision to perceive a match. For instance, first they only hear a funny melody (red arrow), that is going up and down in pitch. They find it hard to follow and do not understand well what is happening. Then a video (blue arrow) is played synchronous with the music. They see coloured marbles going up and down the screen in the rhythm of the melody. Their brains connect the melody and the visual movement and the children have the experience that the movements of the marbles match with the musical movement. Here a mismatch can be perceived too, when for instance either the music or the video is played a bit slower, and the children miss the match.

'Neural synaesthesia' looks to me like an internalized form of 'synchronaesthesia'. If non-synaesthetic children can match sound and colour externally, synaesthetic children can do that internally. When non-synaesthetes can perceive it with the aid of a screen, synaesthetes perceive it continuously with an internal screen always available.

Finally, in order to understand better the mystery of synaesthesia, I would suggest not to isolate synaesthesia by demarcating it sharply from other perceptual phenomena, but to relate it to them. Maybe perceiving music in colours by synaesthetes is a particular type of a more common human ability to match sound and image.

REFERENCES

Adler H and Zeuch U (2002). *Synästhesie: Interferenz, Transfer, Synthese der Sinne.* Königshausen and Neumann, Würzburg.

Baron-Cohen S and Harrison JE, eds. (1997). *Synaesthesia: Classic and contemporary readings.* Blackwell, Cambridge.

Baron-Cohen S, Harrison J, Goldstein LH, and Wyke M (1993). Coloured speech perception: Is synaesthesia what happens when modularity breaks down? *Perception,* **22,** 419–26.

Brougher B, Strick J, Wiseman A, and Zilczer J, eds. (2005). *Visual Music: Synaesthesia in Art and Music since 1900.* Thames and Hudson, London.

Campen C van (1999). Artistic and psychological experiments with synesthesia. *Leonardo,* **32,** 9–14.

Campen C van (2007). *The Hidden Sense: Synesthesia in Art and Science.* MIT Press, Cambridge, MA.

Cohen Kadosh R and Henik A (2007). Can synaesthesia research inform cognitive science? *Trends in Cognitive Sciences,* **11**(4), 177–84.

Cohen Kadosh R, Sagiv N, Linden DEJ, Robertson LC, Elinger G, and Henik A. (2005). When blue is larger than red: colors influence numerical cognition in synesthesia. *Journal of Cognitive Neuroscience,* **17**(11), 1766–73.

Collopy F (2000). Color, form, and motion. Dimensions of a musical art of light. *Leonardo,* **33,** 355–60.

Collopy F. Rhythmic Light (website). http://rhythmiclight.com/index.html

Costa Meyer E da and Wasserman F, eds. (2003). *Schoenberg, Kandinsky and the Blue Rider.* Scala, New York.

Cytowic RE (2002). *Synaesthesia: A Union of the Senses.* MIT Press, Cambridge, MA.

Day SA (2004). *Trends in Synesthetically Colored Graphemes and Phonemes – 2004 revision.* http://home.comcast.net/~sean.day/Trends2004.htm

Dittmar A (2007). *Synästhesien. Roter Faden durchs Leben?* Die blaue Eule, Essen.

Düchting H (1996). *Farbe am Bauhaus. Synthese und Synästhesie.* Gebr. Mann, Berlin.

Duffy PL (2001). *Blue Cats and Chartreuse Kittens. How Synesthetes Color their World.* Henry Holt, New York.

Emrich HM, Schneider U, and Zedler M (2002). *Welche Farbe hat der Montag?* Hirzel, Stuttgart.

Evers F (1995). Muziek en de eenheid der kunsten. In F Evers, M Jansma, and B de Vries, eds. *Muziekpsychologie,* pp. 313–38. Van Gorcum, Assen.

Ferwerda R and Struycken P (2001). *'Aristoteles' over kleuren.* Damon, Budel.

Franssen M (1991). The ocular harpsichord of Louis-Bertrand Castel: The science and aesthetics of an eighteenth-century cause célèbre. *Tractrix,* **3,** 15–77.

Gage J (1993). *Colour and Culture. Practice and Meaning from Antiquity to Abstraction.* Thames and Hudson, London.

Gage J (1999). Making sense of colour. The synaesthetic dimension. In J Gage, ed. *Colour and meaning. Art, Science and Symbolism,* pp. 261–8. Thames and Hudson, Oxford.

Galeyev BM (2007). The nature and functions of synesthesia in music. *Leonardo,* **40**(3), 285–8.

Galeyev BM and Vanechkina IL (2001). Was Scriabin a synesthete? *Leonardo,* **34,** 357–61.

Gleich CCJ von (1963). *Die sinfonischen Werke von Alexander Skrjabin.* Creyghton, Bilthoven.

Gouk P (1999). *Music, science and natural magic in seventeenth-century England.* Yale University Press, New Haven, CT.

Hahl-Koch J (1985). Kandinsky, Schönber und der 'Blaue Reiter'. In K von Maur, ed. *Vom Klang der Bilder*. Prestel, München.

Harrison J (2001). *Synaesthesia: The Strangest Thing*. Oxford University Press, Oxford.

Ione A (2004). Kandinsky and Klee: chromatic chords, polyphonic painting and synesthesia. *Journal of Consciousness Studies*, **11**, 148–58.

Ione A and Tyler CW (2003). Was Kandinsky a synesthete? *Journal of the History of the Neurosciences*, **12**, 223–6.

Jewanski J (1999). What is the color of the tone? *Leonardo*, **32**, 227–8.

Jewanski J and Sidler N, eds. (2006). *Farbe - Licht - Musik. Synaesthesie und Farblichtmusik*. Peter Lang, Bern.

Kandinsky W (1911). *Ueber das Geistige in der Kunst*. Bentelli, Bern.

Kandinsky W (1912). Der gelbe Klang: Eine Bühnenkomposition von Kandinsky. In W Kandinsky and F Marc, eds. *Der blaue Reiter*. Piper, München.

Kandinsky W (1980). *Die gesammelten Schriften*, HK Roethel and J Hahl-Koch eds. Benteli, Bern.

Marks LE (1978). *The Unity of the Senses: Interrelationships Among the Modalities*. Academic Press, New York.

Maur K von (1999). *The Sound of Painting*. Prestel, München.

Myers C (1914). A case of synaesthesia. *British Journal of Psychology*, **6**, 228–32.

Newton I (1675/1757). An hypothesis explaining the properties of light. In T Birch, ed. *The History of the Royal Society*, Vol 3, pp. 247–305. London.

Peacock K (1985). Alexander Scriabin's color hearing. *Music Perception*, **2**, 483–506.

Peacock K (1988). Instruments to perform color-music: Two centuries of technological experimentation, *Leonardo*, **21**, 397–406.

Pear TH (2007). *Remembering and Forgetting*. Church Press.

Poling CV (1983). *Kandinsky – lessen aan het Bauhaus: kleurentheorie en analytisch tekenen*. Cantecleer, De Bilt.

Ramachandran VS and Hubbard E (2001). Synaesthesia. A window into perception, thought and language. *Journal of Consciousness Studies*, **8**(12), 3–34.

Riccò D and Cordoba MJ de, eds. (2007). *MuVi. Video and moving image on synesthesia and visual music*. Edizioni Poli design, Milano.

Rich AN, Bradshaw JL, and Mattingley JB (2005). A systematic, large-scale study of synaesthesia: Implications for the role of early experience in lexical-colour associations. *Cognition*, **98**, 53–84.

Robertson LC and Sagiv N, eds. (2004). *Synesthesia. Perspectives from Neuroscience*. Oxford Press, New York.

Uitert E van (1978). Beeldende kunst en muziek: de muziek van het schilderij. In C Blotkamp, ed. *Kunstenaren der idee: symbolistische tendenzen in Nederland*. Haags Gemeentemuseum, Den Haag.

Vanechkina IL (1994). Musical graphics as an instrument for musicologists and educators, *Leonardo*, **27**, 437–9.

Ward J and Mattingley JB (2006). Synaesthesia: an overview of contemporary findings and controversies. *Cortex*, **42**, 129–36.

Ward J, Huckstep B, and Tsakanikos E (2006). Sound-colour synaesthesia: To what extent does it use cross-modal mechanisms common to us all? *Cortex*, **42**, 264–80.

Ward J, Thompson-Lake D, Ely R, and Kaminski F (2008). Synaesthesia, creativity and art: What is the link? *British Journal of Psychology*, **99**, 127–41.

DANCE, CHOREOGRAPHY, AND THE BRAIN

IVAR HAGENDOORN

YOUTUBE, the videosharing site where users can upload, view, and share video clips, is one of the latest internet success stories. It is also a cultural phenomenon and an online laboratory for social experiments. As I'm writing this the video accompanying the song 'Here it goes again' by American band OK Go, in which the four band members can be seen dancing on treadmills, has been viewed more than 40 million times. As a matter of fact, OK Go rose to fame because of another video posted on YouTube, in which the band members were dancing in a small backyard. It is a fun video and it spawned numerous imitations, which led the band to organize a competition for viewers to post their own version of the video on YouTube.

The fact that a video has been viewed one million times does not mean that one million people have seen it, nor does it mean that those who have seen it, have watched it in its entirety. Still, these numbers are significant, also because there are other clips with far less views. We can surmise that many people who watch the video clip by OK Go on YouTube are sufficiently internet-savvy to also be able to find a recording of the song, perhaps even with better audio quality. Yet the video has been viewed more than 40 million times, suggesting that it is the *video* that people want to see and not just the song they want to hear. The band members look like ordinary guys and the video is basically a recording of the dance. In the absence of any other factors that might explain the video's popularity, we are left with the conclusion that people enjoy watching the dance.

Dance is a universal cultural phenomenon. In many societies it is an important aspect of religious ceremonies and celebrations commemorating weddings, victories, inaugurations, and rites of passage. In some cultures, such as India, Cambodia, and Bali, the dances performed as part of religious ceremonies have reached great refinement. Additionally, dance may fulfil various military (McNeill 1997) and social functions as part of courtship rituals (Brown et al. 2005) and as a means to self-expression and entertainment. Throughout history dance has been part of theatre, but it wasn't until the nineteenth century that dance emerged as an independent artform. The second half of the twentieth century saw a tremendous proliferation of dance styles and a rapid catching up of dance with modernist and avant-garde movements in the other arts.

The fact that dance videos that play in a small window on a computer screen receive millions of views provides some statistical evidence for the hypothesis that watching dance can be interesting in its own right. But why are all these people glued to their computer screens? Why do people pay to watch some strangers move about on a stage? The question of how dance can give rise to thoughts and emotions has intrigued me ever since I first saw a dance performance. In searching for an answer to this question I have found it useful to study the psychological and cognitive neuroscience literature on perception and emotion. People find something interesting, boring, thrilling, or moving because of what happens, as a consequence, in their brain. This is hardly an original or controversial observation. Experimental psychology and cognitive neuroscience may tell us more about the underlying mechanisms and processes that make human capacities such as thinking, perceiving, and feeling possible. Elsewhere I have argued that for this reason psychology and cognitive neuroscience can be said to have a critical dimension (Hagendoorn 2004a). Like structuralism and post-structuralism, they reveal some of the processes that underlie human behaviour and the cultural artefacts it produces.

As a philosopher I am aware of the limitations of cognitive neuroscience. Functional neuroimaging studies only reveal that a certain brain region or network is activated in an experimental task, but this doesn't say anything yet about the contribution of this region to execution of the task and the underlying causal relationship. The relationship between functional magnetic resonance imaging (fMRI) signals and neural activity is also far from resolved (Heeger and Ress 2002). Neuropsychological studies may show that damage to a particular brain region impairs execution of certain tasks, but the extent of the damage can be difficult to determine. If a certain brain region is activated when healthy individuals perform a task and if damage to that region impairs performance at the same task, we may conclude that this region is an essential component of the network subserving this task, but we still don't know exactly what it contributes. These are but some of the methodological problems that one should be aware of when extrapolating findings from cognitive neuroscience to other fields such as the arts. If we piece together findings from different studies, a picture may emerge of what goes on inside the brain, when people perform a wide-ranging task such as watching a dance performance and of how this affects and constrains perception, emotion, and judgement.

Some videos on YouTube, especially illegal recordings of dance performances filmed with a mobile phone from the rear of a theatre, are heavily pixelated and yet we have no difficulty discerning the dancers and may even take pleasure in their movements. It is quite remarkable how little information is needed to detect a human body and a human body in motion. From an evolutionary point of view it makes sense to be able to quickly detect a moving body and recognize conspecifics. It is therefore not surprising that recent experiments have pointed towards the existence of at least two areas in the human brain that are selective for the visual presentation of human bodies (Peelen and Downing 2007).

In the early 1970s, following in the footsteps of the nineteenth-century French scientist and pioneer of photography and cinematography, Étienne-Jules Marey, the Swedish psychologist Gunnar Johansson filmed an actor as he walked about in a darkened room with lightbulbs attached to some key joints. Still frames from the resulting video show nothing but a random collection of dots, but when the video is played, the moving actor instantly pops out from the screen. Johansson's experiment has since been reproduced in a wide range of settings, with the actor performing all kinds of actions, the markers placed on other parts of the body, and with animals instead of a human actor (Blake and Shiffrar 2007).

In *Biped* (1999), a ballet by Merce Cunningham with visual décor by multimedia artists Paul Kaiser and Shelley Eshkar, a similar technique is deployed to great artistic effect. At the time of the rehearsals some movement phrases were recorded using motion-capture, a technique whereby sensors track reflective markers placed on the body. Using motion graphics software the data files were transformed into dot figures, stick figures, and blurred pencil-drawn figures. As Paul Kaiser explains:

we took care never to lose the underlying perception of real and plausible human movement. When our stick figure leaped, its various lines were flung upward in the air, then gathered back together again on landing. While no human body could do this, you could still feel the human motion underlying the abstraction.

(Kaiser 2001)

During the performance the final animation sequences were projected on a transparent scrim covering the entire front of the stage, with the dancers performing behind it. The visual effect is breathtaking, as real and virtual dancers blend together in one visual image (Fig. 26.1).[1]

Neuroimaging studies have implicated one particular region, the posterior part of the superior temporal sulcus (STS), in the perception of what has been termed biological motion. Neuropsychological studies report the case of patients with damage to brain regions involved in motion perception, but intact STS, who have difficulty recognizing motion, yet are still able to perceive biological motion (Vaina et al. 2000). In another experiment, temporarily disrupting cortical activity in the posterior STS

[1] The production is part of the repertory of the Merce Cunningham Dance Company and is regularly performed on tour. A video recording is available on DVD from French label MK2, http://www.mk2.com.

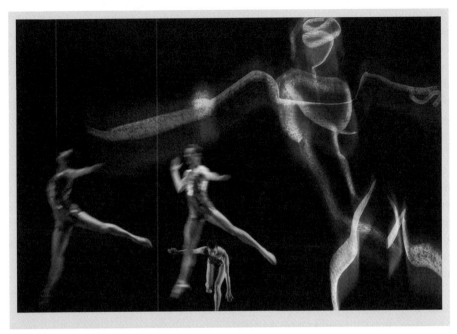

Fig. 26.1 Merce Cunningham, *Biped* (1999). Projected onto a scrim pencil–drawn figure of a dancer.

(Photograph: Stephanie Berger.)

using a technique called transcranial magnetic stimulation,[2] resulted in impaired recognition of biological motion displays (Grossman et al. 2005). Interestingly, another study demonstrated that the posterior STS is also activated when people listen to footsteps (Bidet-Caulet et al. 2005). These findings suggest that the STS plays a central, cross-modal role in the perception of human motion.[3]

Some years ago, the neuroscientist Vilayanur Ramachandran and philosopher William Hirstein advanced eight principles of aesthetic experience derived from Gestalt psychology and various properties of the visual system (Ramachandran and Hirstein 1999). The main principle is what they refer to as a peak shift effect, a phenomenon known from studies of animal behaviour, according to which the response to exaggerated features is stronger than to average features. This hypothesis can be illustrated with reference to caricatures and representations of women in Indian art and popular culture. In an interview, Ramachandran speculated that motion capture displays of biological motion would serve as a hyper-optimal stimulus for brain

[2] Transcranial magnetic stimulation, often abbreviated as TMS, is a technique whereby a brief but strong electric pulse is applied through a coil placed on the head, creating a magnetic field, which temporarily disrupts local neural activity.

[3] It should be noted that the STS has also been associated with the perception of facial expression and eye gaze (e.g. Engell and Haxby 2007).

regions involved in human motion perception and, as such, would generate a stronger response (Ramachandran 2001). It is interesting to observe that the stimuli used in neuroimaging studies are usually presented in isolation in highly controlled settings and that the reported activity may therefore already represent a peak shift effect. In the case of biological motion studies, though, the original idea was to show how *little* information is needed to still observe motion. Biological motion displays therefore do not present a hyper-stimulus but a hypo-stimulus. As I would argue, dance in itself already constitutes a peak-shift effect in human motion perception.[4]

In the remaining part of this essay, I will juxtapose some aspects of dance and choreography and some insights from cognitive neuroscience and psychology. I will show how each may illuminate the other, whereby the emphasis will be on how cognitive neuroscience may add to our understanding of dance. I will take the perspective of a choreographer creating a dance performance. I will deconstruct the creative process into various decision moments and will show how they can be related to various brain processes. For budgetary and artistic reasons, but also to keep things simple, I will assume that we will create a solo.

We will start from scratch. At this moment anything is possible. For this reason I will not concern myself here with a definition of dance. In much contemporary dance there is nothing perceptible to differentiate dance movements from everyday movements. What's more, dance performances need not involve any movement at all. In 1957 the American choreographer Paul Taylor performed a piece called *Duet*, in which he and another dancer stood and sat still for four minutes.[5] The dance critic Louis Horst responded with a review in the *Dance Observer*, which consisted of four square inches of blank space with the initials 'L.H.' at the bottom (Reynolds and McCormick 2003, p. 383).

Let us suppose that our performance is taking place at a theatre. Even though performing at alternative locations may be interesting, there are good reasons for our choice. Theatres have all the necessary facilities to stage a performance. They are like an empty canvas. Although in some theatres you can hear cars or the underground passing by, theatres are relatively closed off from the outside world, thus limiting whatever may distract the audience from watching the performance.

Most of the people who attend the performance will have paid to see it. They may have seen a flyer or have heard about it from friends. Some may be interested in dance, others may have been dragged along by their partner, and some may be paid to write a review. All of this influences how people perceive and will remember the performance. Experimental psychologists use a technique called priming to study how prior information in general, and unconscious attitudes in particular, bias people's perception

[4] I should add that, as I have argued elsewhere (Hagendoorn 2005), this line of reasoning extends to other goals. A choreographer wishing to confuse the audience would have to organize his or her material to this effect. Actual dance performances, however, are always a mixture of different goals and principles, whether implicit or explicit.

[5] The piece is reminiscent of John Cage's *4'33"* (1952), in which the performer sits behind his/her piano without touching a single key for the duration of the piece, and Robert Rauschenberg's series of white paintings, which he painted in 1951.

and judgement. This knowledge can be put to creative use and I would like to contend that, unconsciously, this is what many artists do.

In a performance setting almost everything can be controlled and that means that almost everything involves a decision. Before the audience take their seats, we already have to make a decision. We could have the performer take the stage before the doors open, so that, upon entering, the audience has a sense they have to hurry so as not to miss something. This is how the American choreographer William Forsythe begins many of his performances. Let us assume that for our piece the lights in the audience are on and that the stage is closed off from the audience by a black curtain.

When the audience has entered and taken their seats, at some point the lights in the audience are dimmed. This signals to the audience that they should stop their conversations and switch off their cell phones, because the performance is about to begin. Dimming the lights in the audience also removes some more potentially distracting elements in the form of the visible shape of other people in the audience and emphasizes the division between audience and stage, between the real and the imaginary. Some choreographers like to confound the audience's expectations by keeping the lights on until well into the performance[6] or by transgressing the imaginary boundary between stage and audience, for example by having the performers mingle with the audience. But we will refrain from such experiments.

With the lights in the audience dimmed we can, overtly or covertly, open the curtains. Now we face another decision. We could switch on the stage lights to reveal the dancer, who can be either just standing there or already dancing, in which case the audience again would feel as if it has dropped in on a conversation, or we could keep the stage empty. This is what we will do for our present piece. The audience will be waiting, curious as to what is going to happen. They will be on high alert. In neural terms the baseline activity of neurons in visual, auditory, and somatosensory cortices will be raised (Voisin et al. 2006).

When at some point, not surprisingly but still unexpectedly, the dancer walks on stage, all eyes will be focused on him or her. The moment the dancer takes the stage the audience will notice whether the dancer is male or female. We could postpone this moment and put it to creative use by obscuring the dancer's body and unveiling it later. Let's assume that our dancer is female and that she is simply wearing a non-obtrusive pair of jeans and a plain tank top. There is a reason the costumes in dance tend to be simple. The lavish costumes in classical ballet notwithstanding, anything too sumptuous may distract from the movements.

Now that the dancer is on stage and has captured the audience's attention something has to happen. We could have our dancer stand there for a few minutes and then walk off stage again.[7] We could call this short conceptual piece *Breathing*. Never mind that Paul Taylor has done something similar. Most people in the audience won't know.

[6] A famous example is *Steptext* (1984) by William Forsythe.

[7] The German theatre director Einar Schleef (1944–2001) began his production of Oscar Wilde's *Salome* (1997) with a tableau vivant of the entire cast facing the audience for about 15 minutes in utter silence, interrupted only by the protests of some people in the audience and the sounds of people coughing, laughing, and leaving.

However, it is a bit cheap and we should be able to do better than this. With more dancers we could continue having dancers enter the stage until the space is full, which might actually be fun,[8] but with only one dancer at our disposal, if we don't want to just let her stand there, we have to come up with something different. If we don't allow our dancer to talk, she will have to do something, that is, she will have to move in such a way as to keep the audience's attention fixed on her body. This is the hard part and there are no easy answers as to how to proceed, for we are now at the heart of dance and choreography as an artform. In a way, every solo performance can be seen as an attempt to answer the question of how a single body can capture and hold the audience's attention. Here, again, expectations are important, since each new piece fits in or deviates from an existing repertoire of previous choreographies.

In the work of choreographers such as William Forsythe and Merce Cunningham, at any moment there is a lot of concurrent activity on stage. Dancers perform in seemingly random groupings and orderings at different locations on stage. There is no main action, which dominates the stage. It is impossible to keep track of everything at once. The audience has to choose where to look and is constantly challenged to shift its attention (Fig 26.2). This observation has a parallel in various scientific experiments, which show that there is a task-dependent upper limit to the number of objects people can track simultaneously (Cavanagh and Alvarez 2005; Alvarez and Franconeri 2007).

Attention is the process of selectively concentrating on one object, feature, or event, while relaying everything else to the background. It can be modulated both by top-down and bottom-up signals. Trying to focus on one particular dancer because one knows that s/he is a famous performer is an example of top-down attentional control. On the other hand, the fact that other events may automatically grab our attention shows that attention can also be driven by sensory cues. In the absence of both top-down control and salient stimuli, attention drifts and the mind wanders. Some people may therefore experience performances in which not much happens, as in *butoh*, a dance form which originated in post-Second World War Japan in which stillness plays an important role, as boring. They can also be a revelation, *because* the mind is free to wander or because one is invited to pay close attention to more subtle changes, a slight tilting of the head or a tiny movement of a finger, which can make all the difference.

Salient stimuli tend to grab our attention. A female dancer will stand out among a group of men, she will stand out even more if she is dressed differently and even more if she is wearing a colourful floral dress and the men wear plain trousers and shirts. The dress will stand out at a perceptual level, but it will also emphasize her femininity. In many dance performances we can observe such a doubling of contrast. Women in the work of German choreographer Pina Bausch always wear dresses. The example I just gave is, in fact, taken from a scene in *Masurca Fogo* (1998). In the work of choreographer and pioneer of contemporary ballet George Balanchine (1904–1983) women often wear white pants and black tops, whereas men wear black pants and white t-shirts. This relates to what is known in cognitive neuroscience as grouping by features

[8] *Glass Pieces* (1983) by the American choreographer Jerome Robbins opens with a seemingly endless stream of dancers crisscrossing the stage from all directions.

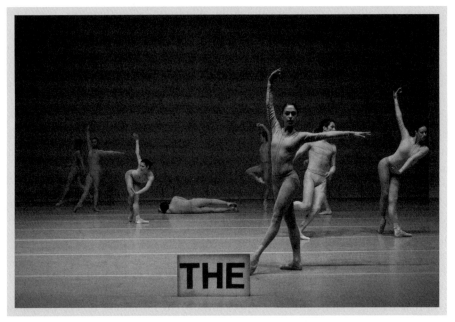

Fig. 26.2 William Forsythe, *The Second Detail* (1991). Dancers: Ballet de L'Opéra de Lyon.

(Photograph: Vincent Jeannot.)

and 'object-based' (global) attention, in which all stimuli sharing a similar feature are selected.

It is important to note that salient sensory stimuli only grab our attention when they are relevant to the task we engage in, are known to be of behavioural significance, or when we diffusely attend to a broad spatial region, as in our opening scene just before the dancer entered. Various experiments have demonstrated that, when focusing on a particular task or when attending to a particular object, people may fail to notice another salient and distinctive object or event, a phenomenon known as inattentional blindness. In one experiment, people had to watch a video of a group playing a ball-game and to count the number of passes (Simons and Chabris 1999). At some point a person in a gorilla costume walked through the scene. After the experiment about half of the participants reported not having seen anything unusual. Dance performances offer many illustrations of this phenomenon. When our attention is focused on one dancer, we may fail to notice the entrance of another dancer in the periphery of our visual field, a change in the lighting, or the fact that a television on stage has started playing.

Motion and novelty are two features that tend to guide the deployment of attention. Both are, of course, related, since motion can be seen as a change of the position of the body as a whole or as a change in the configuration of the body, that is, a change in

the position of the limbs relative to each other. Now, if we add motion and novelty, we see that to keep attention focused on the dancer, she would have to move and, more than that, she would have to diversify her movements. If she were to repeat the same movement over and over again, attention would again wane.

A simple technique for bringing variation into a movement sequence is this: start with a random limb and then keep moving a different limb or part of the body, left arm, right leg, head, left shoulder, etc., one limb at a time. To add some more variation the number of body parts being moved can be alternated, as can the time span between movements and the speed with which they are performed. This is similar to musical compositions in which a theme is repeated with different instruments and changes in tempo. We can also imagine drawing figures with the hand, foot, head, elbow, or shoulder, or imagine avoiding and stepping over imaginary obstacles. We can also define a vocabulary of ten or more movements, which we can then deconstruct and perform in different constellations (Hagendoorn 2003). If you practise these techniques yourself, you will notice that what you are doing resembles dance.

There is a risk that after a few minutes the audience will lose interest. They may wonder what the fuss is all about. All they may see is a person moving about on a stage, twisting and turning and swinging her arms. They may admire the dancer's virtuosity and bodily agility, but it may leave them unmoved. To keep the audience interested, we don't just need variation and differentiation we also need structure. As William Forsythe once commented, 'if there isn't a directing mind, it looks like a can of worms'.[9] This may be fascinating to look at for a little while, but not for a full hour.

In recent years, psychologists have begun to study what makes people interested in something. One theory proposes that interest depends on an appraisal of novelty and/or complexity on the one hand and an appraisal of comprehensibility on the other (Silvia 2005). Various experiments using both experimental artefacts, pieces of modern art, and contemporary poems have provided evidence for this hypothesis. Participants in the experiments tended to spend most time with a picture when it was complex and, in the case of modern art and poetry, when they felt able to understand it.[10] These results may sound obvious, since they confirm what we may have guessed ourselves. They explain why minimal and conceptual dance can be boring at a perceptual level, but intellectually interesting, compared with musicals and classical ballet. They also explain why the opinion of experts, such as critics, and the general public, may differ, and why, over the course of a career, the work of many artists becomes more complex and subtle, as is evident in the work of choreographers such as Merce Cunningham, William Forsythe, Sasha Waltz, and Jiří Kylián. Whereas the audience will usually only see a performance once or twice, the choreographer is, of course, totally familiar with his or her own work. A choreographer's benchmark for appraising the novelty and or complexity of his or her own work is therefore likely to

[9] William Forsythe interviewed on BBC Radio 3 by John Tusa, 2 February 2003. The interviewer refers to another unnamed source. http://www.bbc.co.uk/radio3/johntusainterview/forsythe_transcript.shtml

[10] These findings provide some experimental evidence for the MAYA, Most Advanced Yet Acceptable, principle coined by the American industrial designer Raymond Loewy.

increase over time. Similarly critics, whose job it is to watch and critically evaluate dance performances, are likely to have a different benchmark than the average person in the audience.

Structure can be narrative, as in the work of Pina Bausch and Sasha Waltz, or purely spatiotemporal, as in the work of Merce Cunningham and Lucinda Childs. The techniques introduced earlier to bring variation into a movement sequence can also be used to add structure. We can also invent some new rules and techniques. We could alternate between performing at a point in space and along a line. We can divide the stage into left and right and front and back and perform different movements in different regions. By thus emphasizing geometrical relations and the 'spatiality' of space, the audience's awareness of space may be heightened.

With the help of these techniques we may have succeeded in bringing some structure into the dancing, but that doesn't necessarily make it interesting. What we need is judgement. Up until now I have assumed that our dancer entered the stage unprepared and that she is just dancing around or 'improvising' as this is called in dance and theatre. We can also put ourselves into the seat of the audience and rehearse the piece. We can try out different beginnings and endings and different movement sequences, which we can fine-tune to the desired effect, judging every subsequent rehearsal in an ongoing trial-and-error process. As I would argue, this is how most choreographers and dancers work, whether the breakdancer wishing to impress his friends at their next meeting or the poledancer who uploads a video of herself on YouTube to show off her skills.

Journalists always like to know where an artist gets his or her inspiration from and most likely it is something audiences like to know as well, since it is a question I am often asked in one form or another. My own work is not an illustration of my research and I don't take any direct inspiration from what I've read and learned. This may sound odd. Of course I carry it with me, but there is so much that I carry with me. Inspiration may come from anywhere and may strike at any time. When I start work on a new dance production I may have some ideas, but the actual work is created in the studio, not in my mind. I totally concur with the American choreographer William Forsythe, who once said in an interview that on day one he usually tells his dancers he has absolutely no idea what he is doing because he has never made this ballet before.[11]

In a recent review of a performance by the New York City Ballet of Balanchine's *Agon* (1957), one of the greatest ballets of the twentieth century, Clement Crisp, dance critic for the *Financial Times*, wrote that 'after half a century it remains an innovative marvel, questioning and discovering, time-travelling still, and still light-giving' (Crisp 2008). In an article for the *New York Times*, dance critic Anna Kisselgoff once wrote of Merce Cunningham, that 'his idea that any movement can follow any other symbolizes the discontinuity of our time' (Kisselgoff 1992). When I read such statements I am often reminded of a remark by Susan Sontag: 'interpretation is the revenge of the intellect upon art' (Sontag 1966). Leaving aside the question whether our time is discontinuous, how can dance symbolize it? And how can dance be questioning, discovering and

[11] William Forsythe interviewed on BBC Radio 3 by John Tusa, 2 February 2003. http://www.bbc.co.uk/radio3/johntusainterview/forsythe_transcript.shtml

light-giving? How can a dancer by 'writing with her body (. . .) suggest things which the written word could express only in several paragraphs of dialogue or descriptive prose' as the French poet Stéphane Mallarmé wrote? (Mallarmé 1886/1983).

Suppose we want to render the idea of futility in dance. The archetype of futility is perhaps Sisyphus, who was forced to roll a rock up a mountain slope. But every time he neared the top it would roll down again. With this in mind we could have a dancer try and then try again, without ever succeeding. But try what? Since we have restricted ourselves to movements, we could choreograph a movement sequence and have the dancer perform it several times in a row. After each attempt she stands still, her head slightly tilted sideways, visibly breathing, as if reviewing her movements. She walks back to the starting position. Once or twice she may break off the sequence in-between, as if realizing that she did something wrong. Perfection in dance is unattainable. It may be what, in ballet, dancers strive for, but the perfect arabesque, *épaulement*, or attitude does not exist. It is an idea.

Let's review what we have just proposed. We started with a familiar scenario, which we made more abstract. We then added some familiar poses. Throughout our life we witness countless events; some are regular, others singular. We know of many events how they unfold and we understand the emotional impact if there is one, even if we ourselves have never experienced it. Through experience we acquire habits and knowledge of the world around us. When watching an action movie we know that the hero will eventually prevail. When we brush our teeth and get dressed, we do so in more or less the same order every day. All of this is laid down deep inside our memory in the form of templates, action scripts, and scenarios.

We also instantly recognize emotional body postures expressing fear, joy, aggression, anger, or sadness (de Gelder 2006). One consequence is that if we *don't* want the audience to get emotionally involved we should take great care to avoid familiar gestures. This is why Merce Cunningham frequently uses random procedures to determine the order of movements. One of the classic experiments in experimental psychology, in which the participants watched an animation movie featuring some geometrical figures, showed that people even attribute intentions, desires, and fears to inanimate objects (Heider and Simmel 1944). So we can surmise that they will do so, too, when watching people perform more or less abstract movements outside of the context of everyday life. This is one reason why the work of Merce Cunningham can still have great expressive power.

As you're reading this you may have formed an image of the scenes I have described thus far. If you didn't, you will when I tell you to do so. Picture an empty stage. After a few seconds the dancer reappears from the back end of the stage and walks in a straight line to the front of the stage, where she stops. She stands facing the audience, crosses her arms in front of her body and slowly begins to pull up her shirt, baring the upper half of her body. When you picture the stage or the dancer you will form a visual representation in your mind. When you picture a movement you form a motor representation. Neuroimaging studies have shown that mentally rehearsing a movement and reading action verbs such as walking or throwing activate motor regions in the brain. So, what about watching movement?

In an intriguing neuroimaging study researchers compared the brain activity of ballet dancers and capoeira dancers as they watched short videos of each others' movements (Calvo-Merino et al. 2005). They found greater activity in parts of the premotor and parietal cortex when dancers watched movements in their own style. In a follow-up study the authors compared the brain activity of male and female ballet dancers as they watched short clips of gender-specific movements (Calvo-Merino et al. 2006). The idea behind the experiment was that both male and female dancers are equally visually familiar with all movements, because they take class together, but they don't perform all movements. The authors found greater activity in parts of the premotor and parietal cortex and the cerebellum when dancers watched their own gender-specific movements. They concluded that 'observing an action can activate the corresponding motor representation'. But what if there are multiple dancers in your field of view (Fig 26.2)? Is there really a motor representation for each movement? I doubt it.

In recent years, so-called motor theories of cognition have become increasingly popular in cognitive neuroscience. According to one version of this theory we understand others by simulating their actions (Blakemore and Decety 2001). With reference to Freud's book on jokes, the French neuroscientist Marc Jeannerod gives the example of watching a clown:

pretending to make an enormous effort to lift an apparently heavy object and then falling on his back. We laugh because we have created within ourselves an expectation by simulating the effort of the clown, and we see something that is very different from the expectation. The effect we see is at discrepancy with respect to our internal model, and this is the source of comedy. The simulation of the action we observe does not meet the expectation.

(Gallagher and Jeannerod 2002)

The discovery of mirror neurons, a class of neurons in the ventral premotor cortex of the monkey brain that respond both when the monkey performs and observes a goal-directed action such as grasping a raisin, added considerably to the popularity of simulation theory (Gallese et al. 1996). Various neuroimaging experiments have since provided tentative evidence for the existence of a similar mirror system in the human brain (for a review, see Rizzolatti and Craighero 2004; Iacoboni 2005). As yet there is little hard evidence to support the claim that the mirror system contributes to our understanding of the meaning and intention of observed actions (Dinstein et al. 2008). Some caution in interpreting these findings is therefore warranted (Jakob and Jeannerod 2005).

I once believed the mirror system could provide the basis for an explanation as to why dance can be fascinating to watch (Hagendoorn 2002; 2004b), but I have since become more sceptical. I wonder how the mirror system might contribute to the perception of the concurrent movements of multiple dancers, and how it could account for our understanding of the simultaneous pushing and pulling in a duet.

After another brief interval our dancer returns to the stage. This is our little trick to connect disconnected scenes and to give the audience some time to breathe (and cough). The dancer is carrying a portable music player. Music can be a means to amplify reality, to envelop the audience in moods and waves of feeling. Only few dance performances are performed in silence. I've got nothing against music, I enjoy

listening to music, or some music sometimes, but as a choreographer I've always found it somewhat disconcerting that dance in itself isn't strong enough as a stimulus to capture and hold the audience's attention for say 30 or 60 minutes. That this is so can be inferred by adopting the line of reasoning popular in economics: if silent dance performances would have immense popular and critical appeal, they would abound and draw huge crowds.[12] Why isn't this so when people can be immersed in a book for hours on end? I must say that I myself rarely go to concerts, because I get bored from just watching musicians play their instruments. I mean, do something visually interesting on stage, like a dance performance! I'm afraid I don't have an answer to this question, but we can offer a conjecture on why music and dance seem like brother and sister.

One of the principal components of music is rhythm. Rhythm can be weak or strong, dense or extended, single or multilayered, regular or irregular. Across cultures people have been found to spontaneously synchronize their body movements to music with a strong regular rhythm and a beat that is neither too slow nor too fast. Neuroimaging studies have shown that the production and perception of auditory rhythms activate motor areas in the brain (Janata and Grafton 2003). Interestingly, one of these regions, the lateral premotor cortex, has also been associated with a number of sequential prediction tasks (Schubotz 2007). Earlier, we saw how at a macro-level cognitive structures, habits, and our own episodic memory create an expectation in us of how events unfold. The picture that is beginning to emerge from studies of the premotor cortex is that, at a micro-level, the premotor cortex extracts the sequential structure from a series to allow the prediction of its continuation. Watching dance accompanied by music, on this account, creates expectations in both the auditory, visual, and motor domain. This may explain why dance and music go together so well. The expectations engendered in each domain are mutually reinforcing. However, setting a step to every note in the music may be too predictable and as a result may be experienced as boring.

It is now two days before the premiere and we sense that something is still missing. It's not quite what we wanted yet. Thankfully, our dancer comes to the rescue. She's a real professional. Dancers understand when you tell them not to go through the movements, but to let the movements go through them. They know how to emphasize a movement, how to add an exclamation mark here and a question mark there. They know how to let a movement linger and how to alter its intensity. Of course all of this is metaphor and somehow it has to be translated into motor commands. An important concept in Graham technique, the movement system developed by the American choreographer Martha Graham (1894–1991), is 'contraction'. An example of a typical contraction would be to imagine holding a very large ball and to then squeeze it with the entire body. The opposite of contraction is release. Various choreographers have developed their own version of release technique. An example would be stretching your arm and then letting go off the muscles in the shoulder. Gravity will cause the arm to drop. These two examples may give some idea of how the quality of a

[12] Some dance pieces are performed in silence, but their number is negligible.

movement sequence can be modulated. The use of contractions gives movements an angular look, while release technique tends to look loose and floppy.

We have now finished choreographing our performance. Whether it will be any good is for the audience to judge and depends on whatever else they may have seen and the mood they are in when they attend the performance. All we need is a title. A title can be descriptive, *Solo*, or borrow from the title of the music that accompanies it, like *Violin Concerto*. Titles can also be used to prime the audience. A good title is ambiguous, mysterious, and open to interpretation. It raises the curiosity of the audience. Let's call the piece we just created *To be is to be better than is not*.[13] Coming soon, to a theatre or a computer screen near you.

References

Alvarez GA and Franconeri SL (2007). How many objects can you track? Evidence for a resource-limited attentive tracking mechanism. *Journal of Vision*, 7, 1–10.

Bidet-Caulet A, Voisin J, Bertrand O, and Fonlupt P (2005). Listening to a walking human activates the temporal biological motion area. *Neuroimage*, 28, 132–9.

Blake R and Shiffrar M (2007). Perception of human motion. *Annual Review of Psychology*, 58, 47–73.

Blakemore S-J and Decety J (2001). From the perception of action to the understanding of intention. *Nature Reviews Neuroscience*, 2, 561–7.

Brown WM, Cronk L, Grochow K, et al. (2005). Dance reveals symmetry especially in young men. *Nature*, 438, 1148–50.

Calvo-Merino B, Glaser DE, Grèzes J, Passingham RE, and Haggard P (2005). Action Observation and Acquired Motor Skills: An fMRI Study with Expert Dancers. *Cerebral Cortex*, 15, 1243–49.

Calvo-Merino B, Grezes J, Glaser DE, Passingham RE, and Haggard P (2006). Seeing or doing? Influence of visual and motor familiarity in action observation. *Current Biology*, 16, 1905–10.

Cavanagh P and Alvarez GA (2005). Tracking multiple targets with multifocal attention. *Trends in Cognitive Sciences*, 9, 349–54.

Crisp C (2008). New York City Ballet. *Financial Times*, 15/16 March.

de Gelder B (2006). Towards the neurobiology of emotional body language. *Nature Reviews Neuroscience*, 7, 242–9.

Dinstein I, Thomas C, Behrmann M, and Heeger DJ (2008). A mirror up to nature. *Current Biology*, 18, 13–18.

Engell AD and Haxby JV (2007). Facial expression and gaze-direction in human superior temporal sulcus. *Neuropsychologia*, 45, 3234–41.

Gallagher S and Jeannerod M (2002). From action to interaction: An interview with Marc Jeannerod. *Journal of Consciousness Studies*, 9(1), 3–26.

Gallese V, Fadiga L, Fogassi L, and Rizzolatti G (1996). Action recognition in the premotor cortex. *Brain*, 119, 593–609.

Grossman ED, Battelli L, and Pascual-Leone A (2005). Repetitive TMS over posterior STS disrupts perception of biological motion. *Vision Research*, 45, 2847–53.

[13] Excerpts will be made available on my website, http://www.ivarhagendoorn.com.

Hagendoorn IG (2002). Einige Hypothesen über das Wesen und die Praxis des Tanzes. In G Klein and Ch Zipprich, eds. *Tanz Theorie Text*, pp. 429–44. LIT Verlag, Hamburg.

Hagendoorn IG (2003). Cognitive dance improvisation. How study of the motor system can inspire dance (and vice versa). *Leonardo*, **36**, 221–7.

Hagendoorn IG (2004a). Towards a neurocritique of dance. *BalletTanz Yearbook*, 62–7.

Hagendoorn IG (2004b). Some speculative hypotheses about the nature and perception of dance and choreography. *Journal of Consciousness Studies*, **11**(3/4), 79–110.

Hagendoorn IG (2005). Dance, perception and the brain. In S McKechnie and R Grove, eds. *Thinking in Four Dimensions*. Melbourne University Publishing, Melbourne.

Heeger DJ and Ress D (2002). What does fMRI tell us about neuronal activity? *Nature Reviews Neuroscience*, **3**, 142–51.

Heider F and Simmel M (1944). An experimental study of apparent behavior. *American Journal of Psychology*, **57**, 243–9.

Iacoboni M (2005). Neural mechanisms of imitation. *Current Opinion in Neurobiology*, **15**, 632–7.

Jakob P and Jeannerod M (2005). The motor theory of social cognition: a critique. *Trends in Cognitive Sciences*, **9**(1), 21–5.

Janata P and Grafton ST (2003). Swinging in the brain: shared neural substrates for behaviors related to sequencing and music. *Nature Neuroscience*, **6**, 682–7.

Kaiser P (2001). Steps (l'arte della collaborazione). In A Menicacci and E Quinz, eds. *La Scena Digitale. Nuovi Media Per La Danza*, pp. 143–62. Marsilio Editori, Venezia.

Kisselgoff A (1992). Merce Cunningham, Explorer and Anarchist. *The New York Times*. 15 March.

Mallarmé S (1886/1983). Ballets. In R Copeland and M Cohen, eds. *What is dance?* p. 112, Oxford University Press, Oxford.

McNeill WH (1997). *Keeping Together in Time. Dance and Drill in Human History*. Harvard University Press, Cambridge, MA.

Peelen MV and Downing PE (2007). The neural basis of visual body perception. *Nature Reviews Neuroscience*, **8**, 636–48.

Ramachandran VS (2001). Sharpening up 'The science of art'. An interview with Anthony Freeman. *Journal of Consciousness Studies*, **8**(1), 9–29.

Ramachandran VS and Hirstein W (1999). The science of art: A neurological theory of aesthetic experience. *Journal of Consciousness Studies*, **6**, 15–51.

Reynolds N and McCormick M (2003). *No Fixed Points. Dance in the Twentieth Century*. p. 383, Yale University Press, New Haven, CT and London.

Rizzolatti G and Craighero L (2004). The mirror-neuron system. *Annual Review of Neuroscience*, **4**, 169–92.

Schubotz RI (2007). Prediction of external events with our motor system: towards a new framework. *Trends in Cognitive Sciences*, **11**, 211–18.

Silvia PJ (2005). What is interesting? Exploring the appraisal structure of interest. *Emotion*, **5**, 89–102.

Simons DJ and Chabris CF (1999). Gorillas in our midst: sustained inattentional blindness for dynamic events. *Perception*, **28**, 1059–74.

Sontag S (1966). *Against Interpretation and Other Essays*. Anchor Books, New York.

Vaina LM, Lemay M, Bienfang DC, Choi AY, and Nakayama K (2000). Intact "biological motion" and "structure from motion" perception in a patient with impaired motion mechanisms: a case study. *Vision Neuroscience*, **5**, 353–69.

Voisin J, Bidet-Caulet A, Bertrand O, and Fonlupt P (2006). Listening in silence activates auditory areas: a functional magnetic resonance imaging study. *Journal of Neuroscience*, **26**, 273–8.

NEUROAESTHETICS OF PERFORMING ARTS

BEATRIZ CALVO-MERINO AND PATRICK HAGGARD

INTRODUCTION

DANCE, as a dynamic art form, has classically been included in the performing arts, alongside other disciplines such as music, opera, and theatre. Dance refers to human movement either used as a form of expression or presented in a social, spiritual, or performance setting, often associated with an aesthetic value. Many dance disciplines have evolved in different cultures over hundreds, or thousands, of years. Therefore definitions of what constitutes dance may depend on social or cultural constraints and preferences. These might vary from relatively simple, everyday movements (e.g. folk dances) to highly skilful techniques (e.g. ballet), to more virtuosic movements typically found in sport (gymnastics, figure skating, synchronized swimming) and in martial arts (katas, capoeira). Finally, dance often involves the integration of several components (e.g. movements, costumes, music, scenography), each contributing to the expression of this artform.

In this chapter, we focus on two observations that we consider important for studying the neural underpinnings of dance. The first acknowledges that, despite individual differences, dance can, in most cases, be decomposed into single units of movements. It is the choreographer's challenge to design and combine sequences of movements in order to achieve a maximum level of expression and connection

between the performing dancer on the stage and the audience. This leads us to the second matter of interest. As with any art form, the ultimate aim of a dance performance is to evoke responses in the observer. This essay will focus on one specific response elicited in an observer while watching dance: the aesthetic experience. In particular, we will describe models to guide investigation of the neural mechanisms associated with aesthetic experience while watching the core element of dance: movements.

Neuroaesthetic research and
aesthetic processing components

We use the term 'aesthetic experience' to indicate a particular psychological state produced by a type of sensory stimulus that is often, but not exclusively, a work of art. With the advent of neuroimaging techniques, neuroscience has started to investigate the relationship between the human mind and the human brain. More recently, a new field called 'neuroaesthetics' has emerged, focusing on the neural mechanisms underlying the internal processes associated with aesthetic experience (i.e. aesthetic evaluation, aesthetic judgement, aesthetic perception) (Cela-Conde et al. 2004; Kawabata and Zeki 2004; Vartanian and Goel 2004).

A key aspect of aesthetic and neuroaesthetic studies is the concept of evaluation. We can define two types of evaluation related to aesthetics. The first one focuses on the properties attributed to the evaluated object ('this is a beautiful item'), while the second one focuses on the subjective experience or attitude of the observer ('he likes it'). This division has led aesthetic research into two perspectives: *objectivist* theories and *subjectivist* theories. *Objectivist theories* postulate that the perceptual system of an observer will treat beauty and other aesthetic properties of our environment like any other attribute of it. This perspective emerged from early psychophysical studies that focused on identifying particular stimulus properties or arrangements of attributes that induced aesthetic experience, such as symmetry, balance, complexity, and order of stimuli. These studies have used a range of stimuli, from geometrical figures to more complex stimuli such as paintings (MacManus 1980; McManus and Weatherby 1997; Jacobsen 2004; Jacobsen and Hofel 2002; Jacobsen et al. 2004). A common finding is that aesthetic experience depends on compositional arrangements between parts of the stimulus, and between individual parts and the whole, and that all observers share a common perceptual mechanism for seeing these attributes (Leder et al. 2004). On the other hand, *subjective theories* counter the objectivist viewpoint by focusing primarily on the observer, and considering each human as a special individual. This perspective assumes that preference is largely a matter of attitude, individual taste, personal experience and cultural environment (Zajonc 1968), and support the common saying 'beauty is in the eye of the beholder'. While psychologists might find

it difficult to create models of subjective responses that vary among individuals and stimuli, the emerging field of neuroaesthetics has taken on the challenge to investigate *subjective accounts* by focusing on the neural correlates of aesthetic feeling, using modern neuroimaging techniques.

In general, most early studies in neuroaesthetics aimed to describe the brain mechanisms involved in aesthetic evaluation *per se*, regardless of the physical properties of the preferred item. These studies recorded brain activity while participants explicitly evaluated the aesthetic properties of static images such as paintings, objects, casual scenes or geometrical figures (Cela-Conde et al. 2004; Kawabata and Zeki, 2004; Vartanian and Goel, 2004; Jacobsen et al. 2006). As often in the early stages of a new discipline, there has been little consensus on the concepts, predictions, or methodologies required for studying neuroaesthetics. Several studies addressed similar questions through different paradigms, and this has produced a mix of both converging and diverging results (an exhaustive reflection of these earlier studies can be found in Nadal et al. 2008). Nevertheless, the brain activations reported in these studies suggest that neural responses related to the *explicit* process of evaluating or judging beauty of static visual stimuli might be distributed along different processing stages. Here, we identified three aesthetic components: sensory, cognitive, and hedonic responses.

Studies showing brain activity in visual brain areas when participants watch stimuli for the purpose of providing an aesthetic evaluation suggest that an initial perceptual or sensory component is part of early stages of the aesthetic process (Kawabata and Zeki 2004; Vartanian and Goel 2004; Jacobsen et al. 2006). Among these regions, extrastriate areas (Jacobsen et al. 2006) and the occipital and fusiform gyri (Vartanian and Goel 2004) are repeatedly reported as active when subjects see stimuli that they like, as opposed to dislike. Although these activations might not be related to preference but to a functional specialized processing and perception of the category of stimuli being judged (Zeki et al. 1991; Moutoussis and Zeki 2002), some of these areas also respond to viewing other types of stimuli such as faces, while evaluating different degrees of attractiveness (Paradiso et al. 1999; Iidaka et al. 2002).

Furthermore, we can describe a cognitive or semantic component during aesthetic processing. Positive evaluation of beauty, for example, when watching paintings, evokes activity in the prefrontal dorsolateral cortex (Cela-Conde et al. 2004). This region has also been described as the centre of the perception–action interface and is critical for the monitoring and comparison of multiple events in working memory (Petrides 2000; Cela-Conde et al. 2004). Another study that compared brain responses during aesthetic judgements and perceptual judgements (i.e. symmetry) also showed activity in frontomedian and prefrontal regions, as well as temporal-parietal brain areas (Jacobsen et al. 2006). Interestingly, these areas are also classically found in studies investigating other types of human judgements, such as social and moral judgements (Cunningham et al. 2003).

Finally, a hedonic or emotional component might be extracted from reports of neural activity associated with observation of preferred stimuli in the orbitofrontal region of the prefrontal cortex. This area has been often associated with the reward value of stimuli, regardless of their aesthetic properties (Rolls 2000a,b; Small et al.

2001; O'Doherty et al. 2003; Kawabata and Zeki 2004; Kirk et al. 2008). This relation between hedonic responses and reward links systems for individual preference behaviour to basic pleasure and emotion.

Taken together, one can conclude that there is a dedicated set of regions that participate in the explicit aesthetic evaluation of beauty. Although these neural activations are not fully consistent across studies due to the use of different paradigms, the emerging picture is that there might be different ways of 'seeing' when looking for beauty. These ways of seeing include early perceptual processing (similar to the visuokinetic view of Zeki and Lamb 1994), cognitive processes related to memories, as well as emotional components associated with reward.

It is important to remember, however, that previous studies have mainly focused on subjective approaches and have compared different sets of stimuli according to individual preferences, allowing for a general view of the brain responses of the observer during the aesthetic evaluative process. However, they have given little attention to the physical properties of the selected stimuli. This provides little information about which physical properties of stimuli are responsible for the aesthetic experience of a participant.

Neuroaesthetics of dance

After evaluating the state of the art, we propose a new approach for studying neuroaesthetics. Our approach differs from existing studies in three ways. First, and most importantly, it complements the number of studies that focus on static stimuli such as paintings (Cela-Conde et al. 2004; Kawabata and Zeki, 2004; Vartanian and Goel, 2004) or music (Blood and Zatorre 2001), by focusing on a specific dynamic stimulus from the performing arts never studied before: dance. Second, we move away from the classical explicit evaluation of beauty to study implicit processing embedded in the automatic perception of stimuli. Lastly, we use a consensus approach, which compared to the individual and subjective approach, allows us to identify brain responses for an average observer. This last issue is particularly important, because it allows us to relate the brain regions sensitive to aesthetics of our average observer to each of the movements used in the experiment. In this way, we will be able to describe the physical properties of the dance movements that influence the neural response to the aesthetic experience of the observer.

There are at least two important components to take into account when studying the aesthetic experience of dance. Neuroaesthetic research in vision has been driven by the detailed understanding of the neural mechanism underlying visual processing (Zeki et al. 1991; Moutoussis and Zeki 2002). Therefore, a first required step is to understand the neural and perceptual process involved in watching dance and its key elements: movements. Moreover, in order to adopt an objectivist approach, we must

control and manage the physical properties of the movements that elicit aesthetic responses. In this way we will be able to look at the stimulus space and describe which physical properties of the movements may trigger an aesthetic response.

Mechanisms of seeing dance

To understand how humans perceive dance, we should start by briefly reviewing how the human brain perceives movements generally. It is well established that we recruit parts of our own motor representations when watching others' actions. This was suggested for the first time by electrophysiological studies. Rizzolatti and his colleagues recorded activity of neurons in the premotor and parietal cortices of the monkey brain and described how these neurons (well known for their motor properties during action execution) responded in similar manner during observation of the same movements they code in motor terms (Di Pellegrino et al. 1992; Gallese et al. 1996. See also Gallese, Chapter 22, this volume). This population of neurons was called mirror neurons as they seemed to reflect like a mirror the observed motor act on to their motor representations. Soon, researchers investigated whether humans have a similar system to match observed and executed actions, and measured brain activity while observing hand actions directed towards an object. These studies identified a network of areas that participated in action observation, including a range of visual and sensorimotor regions, such as parietal and premotor cortices and the superior temporal sulcus (Grafton et al. 1996; Grèzes and Decety 2001; Rizzolatti and Craighero 2004).

Later studies provided new evidence on the role and extent of the action observation network by employing more complex stimuli, such as whole body movements. These studies resolve a pending issue: do humans internally simulate the precise action they are watching, or do they merely show an unspecific internal response?

In order to answer this question, one needs to compare observation of actions whose motor representation have already been acquired by the observer, with other actions that are visually similar but that have never been acquired. One can thereby control for the observer's level of 'familiarity' with the different movements. This is precisely what we did in an early study by using dancers that had been trained in different types of movements: ballet dancers and capoeira dancers (Calvo-Merino et al. 2005). Dance offers a promising opportunity to experimentally address this question for two reasons: (1) it is formed by a well-defined vocabulary of movements that can be kinematically controlled; (2) it is easy to evaluate the level of experience that a dancer or an observer has with each movement. A critical finding was that brain activity in mirror neuron areas, including premotor and parietal cortex, was higher when these dancers watched videos of the dance style that they were familiar with, compared to watching visually similar movements of a dance style they had never performed before (Calvo-Merino et al. 2005). This and subsequent studies (Calvo-Merino et al. 2006; Cross et al. 2006) demonstrated that brain activity during action observation is modulated by the degree of motor familiarity that the observer has with the observed action.

The more knowledge we have with the observed action, the stronger the internal motor simulation in sensorimotor regions while watching the movements. These results also show that the action simulation network for watching whole body dance movements recruits the action observation network bilaterally, and extends the premotor activation from the initial ventral regions, shown in hand action observation, to more dorsal parts of the human mirror neuron system (see Fig. 27.1 for a schematic representation of the network).

Neural correlates of implicit aesthetic responses to watching dance

When we walk into a dance theatre as a spectator, we prepare ourselves for intense aesthetic stimulation, and expect a change in our cognitive or emotional state caused by the observed dance performance. We are setting ourselves in a context that can be mimicked experimentally when an experimenter asks whether or not we like a picture or movie. We place ourselves in an *aesthetic mood*. However, do we need to be in a certain emotional or cognitive state in order to appreciate beauty? This specific mood for aesthetics has been called 'aesthetic attitude' (Cupchik and László 1992). As already stated by Kant (1790/1987), an observer needs to be in a certain state to have an aesthetic

Fig. 27.1 Schema of brain regions that participate in perception of movements. IPS, intraparietal sulcus; dPM, dorsal premotor cortex; SPL, superior parietal lobe; STS, superior temporal sulcus; vPM, ventral premotor cortex.

experience. The majority of earlier studies in neuroaesthetics aimed to localize the brain regions that participate in making explicit judgements about the beauty of the presented stimuli. They induced in subjects an *aesthetic mood*, by asking them explicitly to judge the beauty of visual stimuli, while recording their brain activity. However, is there more to aesthetic processing than the active search for beauty?

We recently designed a study to investigate the neural correlates of *implicit* aesthetic responses to dance (Calvo-Merino et al. 2008). The experiment was carried out in two parts. In a first session, we measured brain responses in naïve participants with no formal dance experience while they watched dance movements and performed a dummy task (to ensure they paid attention to the stimuli). It is important to note that no explicit aesthetic question was asked during the brain scan. A range of dance movements from different cultural backgrounds (classical ballet and capoeira) were selected with the help of a choreographer, to evaluate general responses to dance perception (irrespective of style). The selected movements were classified on the bases of four kinematic properties: speed, body part used, direction of movement, and vertical and horizontal displacement.

In a second session, participants rated the complete set of movements on different dimensions related to aesthetic experience (liking–disliking, simple–complex, interesting–dull, tense–relaxed, weak–powerful) (Berlyne 1974). From this questionnaire, only the 'liking–disliking' pair correlated with brain activity. Therefore, we will focus on this dimension. The ratings for each movement were first normalized within each subject and then averaged across subjects to create a *consensus* rating of the group of participants for each movement. Finally, we divided the movements into two subsets: one group contained the top half movements with the highest scores (more liking), the other those with the lowest scores (more disliking). We then used this group average of all subjects' ratings to identify brain areas sensitive to whether they were watching a generally high or low rating in this aesthetic dimension, as determined by the consensus scores.

We found two specific brain regions showing significant neuroaesthetic tuning. These regions were more activated when subjects viewed movements that (on average, in the consensus) they liked, compared to movements that, on average, they disliked. These aesthetic sensitive areas are localized in the early visual cortex, in the medial region, and in the premotor cortex of the right hemisphere. These areas therefore may be relevant for implicit positive aesthetic experience of dance. No significant results were found for the opposite comparison, i.e. when looking for brain regions sensitive to viewing less favoured rather than preferred movements. The idea of having such a sensorimotor response automatically triggered while seeing dance movements we implicitly like may explain why dance is so easily appreciated in so many human cultures.

The role of the dance unit: the movement

Most previous studies have focused on individual responses, and brain imaging analyses have commonly used individual aesthetic ratings. This approach allows for identifying brain areas that participate in aesthetic decisions, but it does not allow for

making any inferences about the stimuli that evoke this response. The consensus approach that we have described here (for further details see Calvo-Merino et al. 2008), does not allow generalizing the result to the general population, as we eliminate differences between individuals when generating the consensus average. Nevertheless, it does allow us to identify stimulus quantities that specifically modulate aesthetically relevant brain areas of the group of subjects that participated in this study. In this way, we identify which specific dance movements were responsible for maximal and minimal activation for the two aesthetically responsive brain areas. Figure 27.2 shows an example of the movements that achieve highest and lowest neural responses for the occipital area in the left hemisphere and the equivalent stimuli for the right premotor activation. Because movements were selected on the basis of four criteria, we can now produce a physical description of those dance movements that preferentially target these aesthetically sensitive areas. This suggested that, on average, these areas preferred whole body movements, such as jumping in place or with a significant displacement of the entire body in space (e.g. horizontal jumps). When we performed the same type of analysis based only on the behavioural data (Fig. 27.3), we observed that the kinematic properties of the movements that received highest and lowest consensus liking score in the subjective rating show clear correspondence with the moves that target the brain areas revealed as aesthetically relevant in the functional imaging analysis.

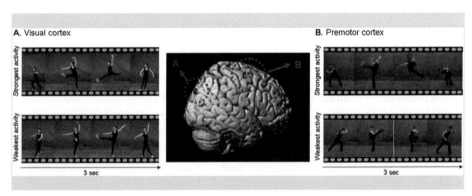

Fig. 27.2 This figure illustrates brain areas whose responses correlate with the group consensus aesthetic evaluation of dance movements on a scale between 'like' and 'dislike'. These are dorsal premotor cortex in the right hemisphere and visual cortex bilaterally. The lateral images show footages of the 3–second dance movements that activate strongly and weakly the premotor and visual brain regions. Note that the movements in the top row (stronger activation) include horizontal and vertical displacement (jumping), while those in the bottom row (weaker activity) involve mainly one limb and little displacement.

(modified from Calvo-Merino et al. 2008)

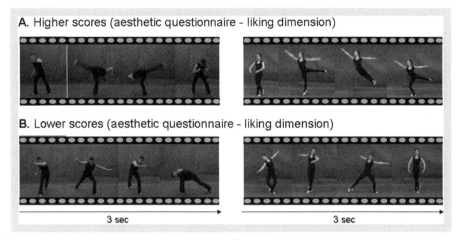

A. Higher scores (aesthetic questionnaire - liking dimension)

B. Lower scores (aesthetic questionnaire - liking dimension)

3 sec 3 sec

Fig. 27.3 Footage of the 3-second video illustrating dance movements that achieved highest (A) and lowest (B) scores on the aesthetic questionnaire (liking–disliking). A physical analysis of the movements reveals that higher scores include vertical displacement/jumping, while the movements with lower scores involve minimal horizontal displacement.

(Calvo-Merino et al. 2008)

FROM NEUROSCIENCE TO DANCE PERFORMANCE AND BACK AGAIN

Initial conversations between artists and scientists can resemble the tower of Babel. There is a need to embrace these different views and synthesize a common language. Once this is done, ideas can flow and fertilize the other approach and knowledge for a common matter of interest: in this case, dance. From our experience, the collaboration of scientists and artists can be achieved in two ways. First, a full collaboration and interaction needs to take place during the entire course of a study. This helps to address questions of common interest, leading to a common and shared output. While this may be a desired and ideal scenario, in reality it is often difficult to pursue, due to the different methodological approaches of each discipline. The second approach is mostly unilateral, and can work for both artists and scientists. A classic example is when artists benefit from science as a source of inspiration for choreographing new movements or whole performances (see for an example; Wayne McGregor, *AtaXia*, 2004, http://www.choreocog.net/ataxia.html). On the other hand, scientists might use dance or dancers as model participants, in order to address specific experimentally driven questions (this can include dance itself) (Calvo-Merino et al. 2005, 2006; Brown et al. 2006; Cross et al. 2006). In this last type of interaction, the artist–scientist

collaboration might be necessary only at some stage of the research. We can briefly illustrate our personal experience in the collaboration process.

In scientific research as well as in dance production, there are several stages that might involve people with different abilities and responsibilities. A dance performance requires the involvement of choreographers and dancers, and an audience to observe the final product. Our research focus has mainly been on dance perception rather than dance execution. In particular, we studied how neurocognitive mechanisms involved in observing dance movements are sensitive to different factors, such as the observer's experience with the observed movement. In order to achieve this, the collaboration with choreographers and performers was essential. In an initial stage, it was the experimenters' role to define stimulus requirements (i.e. kinematic properties, length, colours, etc.) to test the experimental hypotheses. This information and the aim of the study was then discussed with the choreographer, who, being familiar with our experimental framework and approach, made a final selection of movements appropriate for the experiment, and then guided the dancers while performing the steps in the video recording session. This process occurred only once at the beginning of the research, but its role in the experiment was essential. Even if the aim of the study was to focus on the observer (watching a dance), there was an inestimable contribution from the dance execution section of the performance team, just as in an actual performance for a live audience.

One interesting difference between science and art is their approach to the relation between the whole and its parts. Science generally aims to understand a phenomenon (here a dance performance) by analytically breaking it down into simpler constituent elements, and investigating each of these elements separately. It is essential to study each independent component and its contribution to a single process. On the other hand, artists create a piece by combining together parts or elements (e.g. a dance performance is a combination of movements, dancers, music, scenario, costumes, etc.). The result is a performance that represents the interaction of these elements rather than just their sum. In our studies, we reduced dance movements to their minimal expression, by using short video clips and minimizing variability between dancers' bodies and costumes. In our previous study (Calvo-Merino et al. 2008), we showed how different movements elicited liking responses and neural responses in different ways. Because the stimuli differ only in their kinematic properties, one can consider each video clip as an independent movement unit. It would be interesting to see how choreographers collect these movement units and pull together a whole performance. For example, can a choreographer use this material to develop a dance performance *à la carte*, and thereby stimulate specific brain regions required for aesthetic experience? One could then create a performance that intentionally and effectively stimulates different levels of the aesthetic processing such as sensorimotor, cognitive, and hedonic or emotional.

Finally, and crucially, dance would hardly survive without an audience. In recent decades art has evolved incredibly fast, and the role of the observer has evolved from that of a mere passive spectator to being a key interactive ingredient of the piece (for a recent example see Antony Gormley 'Fourth Plinth Commission', entitled *One and*

other —http://www.antonygormley.com/now/news/). Besides, there is no doubt that the performing arts have embraced and benefited from new technologies to enhance their productions. New instruments have open doors to creativity and new horizons. An important tool that neuroscience can offer to dance is information and details about how the observer's mind works. Here we propose to provide an account, which could be incorporated into the choreographic process, for cognitive and neural mechanism of the observer while watching dance movements. Nevertheless, how the dance and scientific community will respond to and use this experimental approach remains to be seen.

ACKNOWLEDGEMENTS

We are grateful to Deborah Bull of the Royal Opera House (ROH2), Emma Maguire of the Royal Ballet, and Giuseppe Vitolo (Professor Polvo – Capoeira Abolicao) for assistance with preparing the stimuli, and to Tom Sapsford for choreography. We thank Daniel Glaser, Julie Grèzes, Corinne Jola, and Dick Passingham for help with planning and analysing the imaging studies. And we thank Sven Bestmann and Matthew Longo for their useful comments in an earlier version of the manuscript. This work was supported by a Leverhulme Trust Research Grant, Economical Social Research Council (ESRC- PTA-026-27-1587) and City University Fellowship (City University London).

REFERENCES

Berlyne DE (1974). *Studies in the new experimental aesthetics: Steps toward an objective psychology of aesthetic appreciation.* Hemisphere Publishing, Washington, DC.

Blood AJ and Zatorre RJ (2001). Intensely pleasurable responses to music correlate with activity in brain regions implicated in reward and emotion. *Proceedings of the National Academy of Sciences of the United States of America*, **98**, 11818–23.

Brown S, Martinez MJ, and Parsons LM (2006). The neural basis of human dance. *Cerebral Cortex*, **16**, 1157–67.

Calvo-Merino B, Glaser DE, Grèzes J, Passingham RE, and Haggard P (2005). Action observation and acquired motor skills: an FMRI study with expert dancers. *Cerebral Cortex*, **15**, 1243–9.

Calvo-Merino B, Grèzes J, Glaser DE, Passingham RE, and Haggard P (2006). Seeing or doing? Influence of visual and motor familiarity in action observation. *Current Biology*, **16**, 1905–10.

Calvo-Merino B, Jola C, Glaser DE, and Haggard P (2008). Towards a sensorimotor aesthetics of performing art. *Consciousness and Cognition* **17**, 911–22.

Cela-Conde CJ, Marty G, Maestu F, *et al.* (2004). Activation of the prefrontal cortex in the human visual aesthetic perception. *Proceedings of the National Academy of Sciences of the United States of America*, **101**, 6321–5.

Cross ES, Hamilton AFDC, and Grafton ST (2006). Building a motor simulation de novo: observation of dance by dancers. *Neuroimage*, **31**, 1257–67.

Cunningham WA, Johnson MK, Gatenby JC, Gore JC, and Banaji MR (2003). Neural components of social evaluation. *Journal of Personality and Social Psychology*, **85**, 639–49.

Cupchik GC and László J (1992). *Emerging Visions of the Aesthetic Process Psychology Semiology and Philosophy*. Cambridge University Press, Cambridge.

Di Pellegrino G, Fadiga L, Fogassi L, Gallese V, and Rizzolatti G (1992). Understanding motor events: a neurophysiological study. *Experimental Brain Research*, **91**, 176–80.

Gallese V, Fadiga L, Fogassi L, and Rizzolatti G (1996). Action recognition in the premotor cortex. *Brain*, **119**, 593–609.

Grafton ST, Arbib MA, Fadiga L, and Rizzolatti G (1996). Localization of grasp representations in humans by positron emission tomography. 2. Observation compared with imagination. *Experimental Brain Research*, **112**, 103–11.

Grèzes J and Decety J (2001). Functional anatomy of execution, mental simulation, observation, and verb generation of actions: a metaanalysis. *Human Brain Mapping*, **12**, 1–19.

Iidaka T, Okada T, Murata T, et al. (2002). Age-related differences in the medial temporal lobe responses to emotional faces as revealed by fMRI. *Hippocampus*, **12**, 352–62.

Jacobsen T (2004). Individual and group modelling of aesthetic judgment strategies. *British Journal of Psychology*, **95**, 41–56.

Jacobsen T and Hofel L (2002). Aesthetic judgments of novel graphic patterns: Analyses of individual judgments. *Perceptual and Motor Skills*, **95**, 755–66.

Jacobsen T, Buchta K, Kohler M, and Schroger E (2004). The primacy of beauty in judging the aesthetics of objects. *Psychological Reports*, **94**, 1253–60.

Jacobsen T, Schubotz RI, Hofel L, and Cramon DY (2006). Brain correlates of aesthetic judgment of beauty. *Neuroimage*, **29**, 276–85.

Kant I (1790/1987). Analytic of the beautiful. In *Critique of Judgment*, WS Pluhar trans., Hackett Publishing Co.

Kawabata H and Zeki S (2004). Neural correlates of beauty. *Journal of Neurophysiology*, **91**, 1699–705.

Kirk U, Skov M, Christensen MS, and Nygaard N (2008). Brain correlates of aesthetic expertise: a parametric fMRI study. *Brain and Cognition*, **69**, 306–15

Leder H, Belke B, Oeberst A, and Augustin D (2004). A model of aesthetic appreciation and aesthetic judgments. *British Journal of Psychology*, **95**, 489–508.

McManus IC (1980). The aesthetics of simple figures. *British Journal of Psychology*, **71**, 505–24.

McManus IC and Weatherby P (1997). The golden section and the aesthetics of form and composition: a cognitive model. *Empirical Studies of the Arts*, **15**(2), 209–32.

Moutoussis K and Zeki S (2002). The relationship between cortical activation and perception investigated with invisible stimuli. *Proceedings of the National Academy of Sciences of the United States of America*, **99**, 9527–32.

Nadal M, Munar E, Capó MA, Rosselló J, and Cela-Conde CJ (2008). Towards a framework for the study of the neural correlates of aesthetic preference. *Spatial Vision*, **21**, 379–96.

O'Doherty J, Winston J, Critchley H, Perrett D, Burt DM, and Dolan RJ (2003). Beauty in a smile: the role of medial orbitofrontal cortex in facial attractiveness. *Neuropsychologia*, **41**, 147–55.

Paradiso S, Johnson DL, Andreasen NC, et al. (1999). Cerebral blood flow changes associated with attribution of emotional valence to pleasant, unpleasant, and neutral visual stimuli in a PET study of normal subjects. *American Journal of Psychiatry*, **156**, 1618–29.

Petrides M (2000). The role of the mid-dorsolateral prefrontal cortex in working memory. *Experimental Brain Research*, **133**, 44–54.

Rizzolatti G and Craighero L (2004). The mirror-neuron system. *Annual Review of Neuro-science*, **27**, 169–92.

Rolls ET (2000a). Precis of the brain and emotion. *Behavioral and Brain Sciences*, **23**, 177–91.

Rolls ET (2000b). The orbitofrontal cortex and reward. *Cerebral Cortex*, **10**, 284–94.

Small DM, Zatorre RJ, Dagher A, Evans AC, and Jones-Gotman M (2001). Changes in brain activity related to eating chocolate: from pleasure to aversion. *Brain*, **124**, 1720–33.

Vartanian O and Goel V (2004). Neuroanatomical correlates of aesthetic preference for paintings. *Neuroreport*, **15**, 893–7.

Zajonc RB (1968). Attitudinal effects of mere exposure. *Journal of Personality and Social Psychology*, **9**, 1–27.

Zeki S and Lamb M (1994). The neurology of kinetic art. *Brain*, **117**, 607–36.

Zeki S, Watson JD, Lueck CJ, Friston KJ, Kennard C, and Frackowiak RSJ (1991). A direct demonstration of functional specialization in human visual cortex. *Journal of Neuroscience*, **11**, 641–9.

MULTISENSORY AESTHETICS IN PRODUCT DESIGN

HENDRIK N.J. SCHIFFERSTEIN
AND PAUL HEKKERT

The sensory aspects of the normal human being should be taken into consideration in all forms of design. Let's take the Coca-Cola bottle, for instance. Even when wet and cold, its twin-sphered body offers a delightful valley for the friendly fold of one's hand, a feel that is cozy and luscious.

Loewy 1951, p. 297

INTRODUCTION

THE quote from Loewy (1951) provides a perfect example of sensuous delight or how a product can gratify the senses, in this case the sense of touch. Analogously, the smell of your favourite soup in a three-star restaurant makes your mouth water, a glimpse of your new pair of Prada shoes makes you fall in love with them all over again, and hearing the heavy sound of a car door closing behind you instantly gives you the comfortable feeling of being safe and secure. Apparently, consumer products can evoke feelings of intense enjoyment in multiple ways and through multiple sensory modalities. In our view, all the senses can contribute to pleasant experiences (Suzuki et al. 2006; Fenko et al. 2010) and all such experiences are aesthetic. 'Aesthetics' can thus be defined as the pleasure attained from sensory perception (see Hekkert 2006; Hekkert and Leder 2008), a definition in line with the notion of the eighteenth-century

philosopher Baumgarten, who used the term aesthetics in terms of 'gratification of the senses' or 'sensuous delight' (Goldman 2001).

The types of stimulation that are most powerful in gratifying the senses seem to differ between sensory modalities. For instance, auditory stimulation is probably enjoyed most through listening to music. In the tactual domain, the pleasure attained from touching is felt strongly in a massage or in sexual activities. Visual beauty can be enjoyed in a van Gogh painting, but also in viewing a natural landscape outdoors. Furthermore, olfactory stimulation is typically enjoyed when smelling fragrances or luxury personal care products, while tasting and smelling in concert with all other modalities provide enjoyment when a culinary specialty is consumed. These examples illustrate that some objects (e.g. paintings, music) seem to be specifically 'designed' to evoke aesthetic pleasure through a single modality, whereas other objects (e.g. foods) can evoke pleasure through multiple modalities. Despite the differences between the objects that gratify the senses, the mechanisms involved in evoking pleasure may be largely shared among modalities. In this chapter, we try to provide descriptions of mechanisms that underlie aesthetic experiences in all the separate sensory modalities. In addition, we describe mechanisms that operate when sources of sensory stimulation in multiple modalities together contribute to an aesthetic experience.

In the latter case, the experiences evoked in the different modalities are not necessarily aesthetically similar. Nonetheless, Lindauer and colleagues found that aesthetic reactions to sculpted objects were largely comparable when experienced through vision or touch (Lindauer 1986; Lindauer et al. 1986). According to these authors, a sculptor who is working on an object does not only optimize visual input, such as colour and patterning, but also the unique tactile characteristics of the object, such as its coldness, roughness, and weight. The authors suggested that since these two sensory modalities share the general function to extract, pick up, and organize information about the world, the processing of visual and tactual information and, consequently, the aesthetic appreciation, is interrelated, holistic, and essentially amodal. This could suggest that aesthetic quality is mainly inherent to the physical properties of the object, and is hardly dependent on the sensory modality through which these properties are perceived. However, comparing vision and touch may be a special case, because several object features (e.g. shape, size, surface texture) can be directly perceived through both modalities and, therefore, the aesthetic judgements are also partly based on the same input. Aesthetic reactions to objects may not be that closely connected when sensory modalities are involved that use very different indicators of the same property. For instance, the ripeness of an apple can be evaluated based on its colour (vision), its hardness (touch), and its sweetness (taste), but these three perceived properties are derived from distinct product features.

Figure 28.1 tries to summarize the relationships between the properties of an object and the different types of aesthetic evaluations that can be made of the object. The physical object contains a number of physical features (e.g. the type and amount of light it reflects, its three-dimensional shape, the volatile odorants it releases, its temperature, its thermal conductivity) that can be perceived through the different senses. These perceived properties (e.g. its colour, weight, smell, warmth) form the basis for

its aesthetic evaluation. For instance, we can ask people to indicate the extent to which they appreciate how the product looks, how it feels, how it sounds, how it smells, or how it tastes. In addition, we can ask them how much they like the product as a whole, which requires integration over different sensory modalities.

The studies by Lindauer and colleagues described earlier, in which liking for objects is compared using different sensory modes, concern a comparison between the outcomes of a visual aesthetic, a tactual aesthetic and a multisensory visual–tactual aesthetic evaluation process. However, the differences and commonalities these authors found between conditions may have different sources: They may stem from (lack of) inter-relationships between physical object features, the ways in which properties of the objects were perceived, the rules relating perception to liking for the different modalities, or from the ways in which people reported their experiences.

The present chapter aims to further explore one of the proposed options, i.e. the rules relating perception to liking for the different modalities. These rules may take on different forms. First of all, some rules can be defined for a specific sensory modality. We can wonder about the mechanisms that underlie these rules, and the extent to which these rules are modality-specific or applicable to all the senses. Although the properties on which the aesthetic evaluation is based may differ over modalities, the principles governing these evaluations may be uniform. This can, of course, only be determined if the property central to the rule is not modality-specific. For instance, an effect of the auditory property, loudness, on aesthetic appreciation can only be transferred to other modalities if an equivalent of loudness can be found within these modalities. Second, there are rules that involve multiple sensory modalities, and that describe the conditions under which inputs from multiple sensory modalities enhance the aesthetic experience of the whole product.

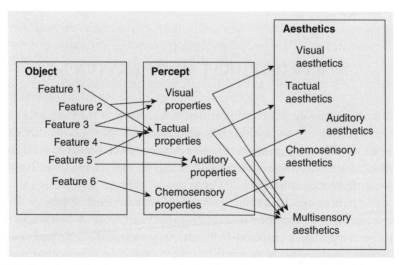

Fig. 28.1 Relationships between physical object features, perceived object properties, and aesthetic evaluations of such properties.

We specifically focus on the appreciation of designed products, because these are generally multisensory in nature, in contrast to some artistic artefacts that gratify only a single modality, such as paintings (visual) and music (auditory). Although some products are deliberately designed to evoke aesthetic pleasure (e.g. to be beautiful to look at or nice to hold), in principle each and every product can be aesthetically appreciated to some extent (e.g. Charters and Pettigrew 2005; Charters 2006). However, for many durable consumer products, the sounds and smells they produce have not been designed deliberately and seem to be the mere consequence of the user-product interaction. Designers have often worked on reducing noise levels and odour levels because they thought these were undesirable, instead of trying to improve the quality of these properties (e.g. van Egmond 2008). As a consequence, the number of studies on the aesthetic appreciation of these product properties has also been limited. Therefore, occasionally we may discuss studies that were performed on artistic artefacts (e.g. sculptures, music, fine fragrances) in order to demonstrate that specific aesthetic principles operate in multiple modalities, in cases in which no equivalent studies are available that have used products or their features as stimuli.

In our discussion, we make a distinction between principles based on the *structural properties* of products, and principles dependent on the *meaningful properties* attached to the product or its features. Some of the principles based on structural stimulus properties may be directly related to specific object features and, as a consequence, the underlying rule may be modality-specific. Therefore, our discussion will be mainly limited to principles involving the more generic properties that may apply to stimuli for all sensory modalities: contrast, similarity, balance, and complexity. Principles based on meaningful properties are not necessarily linked to specific object features and are, therefore, domain-independent. The meaningful properties we discuss include familiarity, novelty, and challenge.

STRUCTURAL PROPERTIES

The way in which people perceive and structure information may be partly linked to the sensory modality through which it is perceived. For instance, the way in which people react to olfactory stimulation is quite different from how they react to visual stimulation. Some fiction writers, film makers, and fragrance advertisers like to make the public believe that smells may be very powerful in unconsciously influencing people's preferences and behaviour. For example, at the end of Patrick Süskind's book *Perfume*, the main character makes a crowd of people lose all their sexual restrictions by dispersing a special perfume in the air. Although such a vehement reaction to a smell seems highly unlikely to occur in reality, empirical evidence on the effects of fragrances does show that people react instantly to the pleasantness or the unpleasantness of smells by an approach or avoidance reaction. However, for smells that

are hedonically neutral to positive these effects are rather subtle. Although pleasant smells can influence behaviour in ways that are to some extent predictable (Bone and Ellen 1999), it seems highly unlikely that behaviour can ever be steered through olfaction.

As regards sexual attraction, it has been found that odours can inform people about a person's health, fitness, and fertility (e.g. Doty 1981). Whereas some of these smells are more or less universally attractive or unattractive, the appreciation of some smells seems to be part of a very specific mechanism related to the immuno-competence of two partners. Females might be able to use a male's odour to obtain disease-resistant genes for their offspring by mating with males carrying dissimilar genes of the major histocompatibility complex, which is part of the body's defence mechanism against parasites (Wedekind and Füri 1997). The existence of such a mechanism suggests that it might be possible to use specific odorants to increase the aesthetic appeal of particular objects, at least for certain individuals.

For the auditory modality, mathematical equations have been developed that estimate the sensory pleasantness of a sound based on several perceived sensations, which in their turn can be estimated using algorithms employing psychoacoustical measures (e.g. Aures 1985; Fastl and Zwicker 2007, p. 245). These models show that sensory pleasantness increases with decreasing loudness, sharpness, and roughness and increasing tonalness (the relative amount of harmonic structure) of sounds (van Egmond 2008). In music, consonant chords tend to be preferred to dissonant chords. When a harmonic structure is judged to be consonant, the ratio of vibrating frequencies tends to be at a minimum (e.g. Butler and Daston 1968). The pleasantness of the sound is an important characteristic for the design of alarm signals, e.g. for medical equipment, because medical staff have been known to disable or silence alarms if they consider them to be too irritating (e.g. Meredith et al. 1999).

Given that the examples described above are very specific for the way in which sensory information is processed, we may assume that some of the principles that will be described later, and that were mainly derived from research on the visual modality, cannot be transferred directly to the other modalities. Nevertheless, other principles may operate in equivalent ways for the other senses. Therefore, we considered it interesting to explore if certain aesthetic (visual) principles hold across the senses, and can be regarded as 'universal' principles.

The way in which people perceive the structure of an object depends on the ways in which perceptual information is organized. The world is loaded with information and, therefore, people must be able to detect order in the chaos in order to make sense of the world. As a consequence, people tend to see things that are close together or things that look, sound, or feel the same as belonging together. The principles of perceptual organization have been summarized in the gestalt laws. On the basis of gestalt laws, several structural stimulus properties or grouping principles (e.g. similarity, balance, harmony, unity in variety) can be defined that have been shown to positively affect the aesthetic appreciation of objects (e.g. Ramachandran and Hirstein 1999; Hekkert and Leder 2008). However, in order to be able to organize a number of stimuli, people first need to detect the different elements and determine whether they are similar or not.

Detection will improve when elements stand out from their background and, therefore, the perception of both contrast and similarity are important prerequisites for the organization of perceptual elements. Therefore, we will start out by discussing the role of contrast and similarity in multisensory aesthetic judgements, and we continue with other structural stimulus properties that seem to be common across the senses: balance, symmetry, proportion, complexity, and unity in variety.

Contrast

A characteristic that helps in perceptual grouping is contrast. Contrast helps to detect dissimilarities between features or objects that are close, but do not belong together. Such a principle is widely applied in the design of interfaces where buttons of functional similarity are clearly contrasted from buttons holding other functions by differences in shape or colour (see Fig. 28.2). Moreover, objects that stand out against their background will be more easily recognized. Ramachandran and Hirstein (1999) suggest that contrast extractions may be intrinsically pleasing to the eye, because regions in which perceptual changes occur generally contain much information. Therefore, they grab attention, are more interesting and, possibly, more pleasing.

Pleasing effects of contrast can also be witnessed in other sensory domains. For instance, Hyde and Witherly (1993) proposed that the most highly palatable foods produce higher levels of dynamic contrast. While foods are manipulated in the mouth, the properties of the food change (e.g. due to mastication, mixing with saliva,

Fig. 28.2 Display of a Sony-Ericsson W580i mobile phone, showing that buttons with similar functions are similar in appearance (e.g. dial a number) and contrast with the buttons performing other functions (e.g. navigate in the menu).

and temperature changes) and the conditions in the oral cavity change (e.g. cooling or warming). According to these authors, highly palatable foods produce a large number of instances at which sensory contrast can be perceived. The sense of touch seems to play a dominant role in perceiving many of these contrasts. For instance, the melting of ice-cream in the mouth includes a transition from a hard and ice-cold texture to a soft and creamy texture. In addition, cooling the tongue makes it less sensitive to the taste of sucrose, producing local sweetness sensitivity differences over the tongue. Furthermore, the melting releases tastants and odorants from their matrix. Combining ice-cream with a crunchy waffle, nuts, caramel, or pieces of chocolate is likely to increase its palatability, because it produces additional opportunities for perceiving contrasts. Analogously, contrasts in appearance, flavour, and texture are critical in enjoying the different elements of a dish or a meal (e.g. Lawless 2000). Think, for instance, about the differences between the juicy, elastic, fibrous texture of meat, the thickness and lumpiness of mashed potatoes, and the firmness and crispiness of freshly cooked vegetables. The contrasts between these foods make them delicious: they lose most of their appeal if you mix them and miniaturize them in a blender, which turns them into a single, homogeneous mass.

Similarity

According to the gestalt principle of similarity, similar stimuli tend to be grouped together. Figure 28.2 already showed that buttons related to similar functions have the same shape and colour, thereby facilitating perception and use. This perceptual grouping seems to occur spontaneously for stimuli perceived with the same sensory modality. Within a single modality, people find it relatively easy to determine whether two stimuli are similar or not (e.g. Thurstone 1927; Farell 1985).

However, to what extent do people also observe similarity between stimuli that impinge on different sensory systems? Generally speaking, people tend to connect stimuli that perform similarly on the dimensions that underlie sensory perception in all modalities: location, time, and intensity (e.g. Boring 1942). For instance, when you hear a person talking and see his lips moving in the same pattern (temporal synchrony), and you hear the voice coming from the same location as where you see the lips (location similarity), you are likely to conclude that the voice comes from the moving mouth.[1] In the latter case, the covariation in the temporal pattern is a more powerful conjunction than the apparent location of the two sources: if you are watching a movie in the cinema, the voices will come from loudspeakers at the side, but you will still perceive the voice as coming from the actor's mouth. This is the so-called ventriloquist illusion (e.g. Bertelson 1999).

Furthermore, people are likely to classify low-intensity stimuli (e.g. a dim light and a soft tone) and high-intensity stimuli (e.g. a bright light and a loud tone) in

[1] In fact, the gestalt law of similarity is equivalent to the gestalt law of proximity, if 'similar' is interpreted as similar in time or location, respectively.

separate groups. This probably occurs because in real life, small natural objects (plants, animals, rocks) are likely to be lighter and to produce less noise than larger objects. Apparently, within a natural environment natural covariation exists on the intensity dimensions (a phenomenon called cue redundancy in studies using the Brunswik lens model, e.g. Hogarth and Karelaia 2007). This correspondence lies at the basis of psychophysical scaling techniques, such as cross-modality matching (e.g. Stevens and Marks 1980). Moreover, even for modality-specific dimensions people may find some connections between stimuli intuitively more applicable than others, such as for the dimensions of colour and odour quality (Schifferstein and Tanudjaja 2004; Demattè et al. 2007).

Possibly, people may also base similarity judgements partly on semantic information. For instance, environmental sounds are generally grouped not only on the basis of acoustical features, but also on a priori knowledge of the sounds and the events that produce them (Gygi et al. 2007; Aldrich et al. 2009; Özcan et al. submitted). Analogously, the similarity of smells seems to be partly determined by whether they originated from a fruit, a flower, an animal, and so on (Chastrette et al. 1988; Chrea et al. 2004, 2005). However, the connections between elements in cross-sensory groups are bound to be weaker than in unisensory similarity groups.

Balance: proportion and symmetry

People seem to have sensitivity for a balanced composition in visual art. If an original and presumably balanced painting is changed by leaving out certain elements or by changing the distribution of the elements, this leads to a decrease in preference ratings (Boselie 1992; Locher 2006). Furthermore, people may perceive tactual balance when they lift an object, they can perceive olfactory balance when they evaluate the composition of a perfume, or auditory balance when they listen to a Mozart symphony. However, objects that are balanced visually may not be balanced tactually, and do not necessarily spread a balanced smell. Also, the rules that underlie the perception of balance in the different modalities may differ. Whereas the balance of an olfactory or auditory stimulus may be typically related to the intensity of the different elements of a composition (i.e. the strength of the various notes in a perfume, or the loudness of the various instruments in a music recording), the balance in visual or tactual stimuli may be mainly determined by the spatial arrangement (i.e. the location) of the different elements within the composition.

In the visual domain, there is debate about which ratio between the elements of a design makes it aesthetically most attractive. For centuries people believed that a golden section ratio was aesthetically superior. The golden section ratio is obtained when the ratio of the shortest to the longest of two lengths, such as in a rectangle or a cross, equals the ratio of the longest to the sum of the two. The numerical value of this ratio, often denoted as φ, is approximately 1.618 (or its reciprocal 0.618). Despite its mathematical elegance, empirical studies in the twentieth century have not consistently supported the special status of this ratio (see for an overview e.g. Berlyne 1971; McWhinnie 1987;

Hekkert et al. 1994). At best, ratios close to the golden section seem to be preferred over other ratios, but the empirical findings could easily be due to a range effect in the studies (Godkewitsch 1974) or to an effect of averaging (Plug 1980). Next to ratios in the vicinity of the golden section, the square was often found to be a preferred ratio (McManus 1980). Nevertheless, the golden ratio remains a proportion of unprecedented appeal and many see this ratio reflected in the organization of, and responsible for, great works of art and classic design pieces, such as the Chaise Longue by Le Corbusier (Fig. 28.3) and the Volkswagen Beetle car (Fig. 28.4).

Fig. 28.3 Chaise Longue designed by Le Corbusier, 1929. The proportions of the chaise relate to the harmonic subdivisions of a golden rectangle. The width of the rectangle becomes the diameter of the arc that is the frame of the chaise. The stand is in direct relationship to the square in the harmonic subdivision. Reprinted with permission of Princeton Architectural Press, from Elam (2001).

Fig. 28.4 Volkswagen Beetle car designed by Jay Mays, Freeman Thomas, and Peter Schreyer, 1997. The body of the car fits into the upper half of a golden ellipse, inscribed in a golden rectangle construction diagram. Reprinted with permission of Princeton Architectural Press, from Elam (2001).

Nevertheless, studying properties in isolation may tell us little about the effects of these properties in the context of art and design objects. Hekkert (1995) found that aesthetic preference for particular rectangular proportions highly depended on the type of object the rectangle represented, such as a window, a cabinet door, or a bathroom tile (see Fig. 28.5). More interestingly, preference was linearly related to the rated commonness of the proportion, a measure of familiarity.

What a good proportion is, is likely to be modality-specific. For instance, for the tactual modality a product's proportions are good if the product fits well with the human body (see Sonneveld and Schifferstein 2008). Clothes and shoes fit well if they are not too big, nor too small. Tools should nicely fit in the hand and provide a steady grip. A chair should support the body in all the right places. For the auditory modality, on the other hand, the right proportions may be determined by the effect of object shape on the properties of the sounds that are produced. Musical instruments are typically designed to optimize the quality of the sounds they produce.

Besides being a matter of proportion, the perceived balance in a design also depends on the degree of symmetry. Locher, Smets and Overbeeke (1995) compared the perception of balance in vision and touch. They performed non-metric Euclidean multidimensional scaling analyses on balance rank orders derived from sorting tasks and rank order tasks for 14 clay objects. These authors found several differences between the visual and the tactual stimulus configurations: whereas visual balance appears to be a holistic object property, which results from the synthesis of component stimulus information, for touch balance implies a symmetric distribution of weight/shape about the central axis (see Fig. 28.6). Hence, balance in touch is closely linked to symmetry, while balance in vision is not.

Nevertheless, symmetry can enhance aesthetic appreciation in visual perception as well: symmetrical faces are preferred over non-symmetrical ones (Grammer and Thornhill 1994) and symmetrical abstract patterns are often seen as more beautiful (Jacobsen and Höfel 2003). In the case of human faces, this preference is possibly related to physical fitness, i.e. symmetrical faces signal health and the absence of parasites. On the other hand, when it comes to patterns or objects symmetry may be appreciated because it facilitates perception and ease of processing (Reber et al. 2004).

Fig. 28.5 Examples of rectangles representing a product (from Hekkert 1995).

Fig. 28.6 Two-dimensional MDS plots for the similarity in visual balance (left) and tactual balance (right) in shapes. Reprinted with permission from Locher et al. (1995), copyright Pion Limited, London.

Symmetry is such a powerful 'organizer' that designers must have a very good reason to violate it. In fact, most products are symmetrical around one or more axes (see Fig. 28.7).

Unity in variety: searching for optimal complexity

Most designed artefacts obey the grouping rules described earlier and could, therefore, be seen as rather clean and simple: 'less is more' is still one of the leading principles in product design. Nevertheless, a world consisting of only orderly and balanced patterns would probably be experienced as rather boring. We also encounter products that are rather complex to grasp, and demonstrate a wide variety of elements, shapes and colours.

Fig. 28.7 Symmetry in the front view of a Renault Alpine.

According to Berlyne's (1971) collative-motivation model, objects are preferred for their ability to generate arousal. Objects with low arousal potential, i.e. very orderly and simple, are not stimulating and leave the observer indifferent; patterns with very high arousal potential, i.e. very complex and diverse, are too difficult to process and are considered unpleasant. Preferred are patterns with an arousal potential at a medium (or optimum) level, leading to the famous prediction of an inverted U-shaped function for hedonic tone (pleasantness) as a function of arousal potential. Designers should thus strive for a perfect balance between order and complexity or unity in variety, a result that seems universally appealing. Although the inverted U-function could not always be demonstrated in empirical studies (e.g. Frith and Nias 1974; Walker 1980), the general principle seems very robust: the greatest beauty is achieved by as much variety or complexity as possible with a maximum of unity or order. Examples could be drawn from all design domains, but this principle is probably most easily witnessed in the field of graphic design (see Fig. 28.8).

Complexity can be increased in any modality by using more or a larger variety of elements. For instance, the complexity of music can be enhanced by adding more instruments or by playing more notes in the same time frame. In meals, complexity can be increased by adding more dishes or more ingredients. For these sensory domains, it can be easily deduced that increasing complexity can have an adverse effect on consumer appreciation. For instance, music can become extremely restless if too many events occur within the same time frame. Or in a dish the specific character of the main ingredient may be lost if too many spices or garnish elements are added.

Fig. 28.8 Set of posters developed by Fabrique for the Holland Dance Festival, expressing 'unity in variety' in many different ways. For example, the text in each poster is restricted to specific locations (unity), but several different font types and sizes (variety) are used for different types of information.

'Unity in variety' is a special case of the 'maximum effect for minimum means' principle, according to which people prefer solutions, ideas, and formulas that consist of as few elements or parameters as possible, while solving or explaining a large range of problems or phenomena (e.g. Boselie and Leeuwenberg 1985). Designers often refer to this principle when they resort to 'minimal solutions', as exemplified by the iPod shuffle, an MP3 player in a tiny white box that only has a connector for an earplug, a USB connection for battery power and uploading songs, and a click wheel for navigation, but no display (Fig. 28.9). Another typical example is the building in Fig. 28.10 designed by the Swiss architects Herzog & de Meuron. When commissioned to build a winery in the hills of California that would be one with its surroundings, they simply took the rocks scattered in the vicinity of the location and put these into steel frames for the construction of the building. This minimal design choice had a great effect at various levels: the building fits naturally in the landscape and, even though the construction is very solid, it allows a poetic rhythm of lights to enter the interior (see Fig. 28.10).

Fig. 28.9 The Apple iPod shuffle. Reprinted with permission from Hekkert & Leder (2008), copyright Elsevier, Amsterdam.

Fig. 28.10 Dominus winery in Napa Valley California, designed by Herzog and de Meuron.

MEANINGFUL PROPERTIES

Besides structural properties that can, in principle, be measured and formalized, a number of meaningful properties can be identified that may also function as determinants of aesthetic appreciation in products (Hekkert and Leder 2008). Meaningful properties are by definition subjective and are thus not properties of things, but rather properties as people experience them. Based on knowledge and previous experiences, people qualify something as familiar or novel, typical or strange, original or outdated.

Depending on the extent to which people have overlap in their backgrounds, the formal attributes on which these meanings are based may be quite consistent. As a result, people tend to attribute the meaning perceived to these characteristics. For example, in recent experiments on the meaning of materials, participants talked about material meanings as if they were talking about their technical/sensorial properties (Karana et al. 2008). Logically, however, the degree to which something is perceived as novel or familiar does not depend on the presence of an attribute as such. Because meaning resides in the cognitive interpretation of the stimulus, there is no a priori reason why the principles we discuss in this section should be modality-specific. Therefore, they may operate in a similar way for all the sensory modalities.

Familiarity, prototypicality, and other determinants of recognition

In 1968 Robert Zajonc suggested that mere exposure to a stimulus increased its aesthetic appreciation (Zajonc 1968). He varied the number of times that faces, Chinese characters or pseudo-Turkish words were repeated in experiments, and found that with increasing repetition the objects were liked more. He discussed his findings as a general principle of aesthetic appreciation that can explain why we often like the people we know, why we feel comfortable in our homes, and stick to the brand of the car we own. Preferring things that are familiar has evolutionary advantages in that it leads to safe choices (Bornstein 1989). In addition, repetition or familiarity can make perceptual and cognitive processing easier and somehow more fluent, and this fluency is intrinsically pleasant (Reber et al. 2004), not because it is a property of the stimulus, but because it is a property of the processing dynamics of the perceiver.

In order to recognize things, people tend to classify them into groups of objects, which share some properties. For object categories for which there are many exemplars, such as human faces, cars, or toasters, people construct so-called prototypes through experience. These are typical representations that summarize the information that all objects of that category have in common. Empirical research in several product categories, including chairs (Whitfield and Slatter 1979; Whitfield 1983) and houses (Purcell 1984), has shown that aesthetic appreciation is linearly related to prototypicality. In the domain of music, a similar monotonic relationship has been demonstrated repeatedly (Gaver and Mandler 1987; Repp 1997). Although familiarity is not the only defining variable of (proto)typicality (Barsalou 1985), the two concepts are clearly related. Moreover, their aesthetic attractiveness is in both cases partly derived from ease of classification or processing (Reber et al. 2004).

Apart from their preference for prototypes, people seem to prefer objects in which the defining characteristics have been exaggerated. This tendency is consistent with the so-called 'peak shift' principle demonstrated in behavioural discrimination experiments with animals (Hanson 1959). Animals tend to respond more strongly to stimuli that go somewhat beyond the one the animal has learned to be rewarding. 'Because of

peak shift, female birds that prefer to mate with males with bright rather than dull plumage will show even greater preference for males with supernormal or above-average brightness' (Martindale 1990, p. 47). Analogously, designers apply the peak shift principle in products to amplify the 'very essence' (Ramachandran and Hirstein 1999) or defining characteristic of the category, such as the quality of aerodynamics in car design (see Fig. 28.11).

Familiarity and prototypicality play an important role in the recognition of objects, animals, and people. During the interaction with an object, the object provides sensory feedback: it provides information about itself and the physical world surrounding it. Gathering this sensory information is important in order to recognize the object at a future occasion.

With the information the object supplies, it can guide people in what they are trying to achieve, but it can also mislead them. The way in which objects give tactual feedback may be experienced as the integrity or honesty of the object (e.g. Sonneveld and Schifferstein 2008). For example, porcelain cups provide information about the temperature of the coffee inside, whereas polystyrene foam cups do not. Therefore, people may feel fooled when the coffee in a polystyrene cup is much hotter than expected. Furthermore, touch screens do not let the user feel what they are actually doing, whereas other interfaces, such as steering wheels of cars, let you know exactly what is going on. In architecture, the theme of honesty plays a central role in the Brutalism style. Brutalist buildings expose the materials they use, their structure, and the services they offer to humans in the interior or exterior of the building (Fig. 28.12). Because of its exposition of construction materials, the Brutalist style is often referred to as 'the celebration of concrete' (e.g. Banham 1966).

Whether an object is perceived as honest or not may be more important for interactions involving the proximal senses touch and taste than for distal senses, because the former sensory modalities require direct contact with objects to enable perception.

Fig. 28.11 The Chrysler Aviat. (Courtesy Chrysler company.)

Fig. 28.12 The Aula of the Technical University in Delft: an example of the Brutalism style.

Therefore, interacting with an object that provides poor sensory feedback may lead to injuries, as is evident from the example with the hot coffee. As a consequence, we may predict that people generally enjoy using products that give clear and unambiguous feedback through touch and taste. Recognition is particularly important for food products, where ingestion of an inappropriate object can have an immediate effect on the person's health. Therefore, recognizing foods is important in selecting safe sources of nutrients.

In addition, nature has developed a mechanism by which many substances that are toxic taste or smell unpleasant (e.g. bitter), and substances that are nutritious like carbohydrates, protein, and fats generally taste and smell good (e.g. Logue 1991). For this reason, the chemical senses are considered the 'gatekeepers' of the human body. However, besides ingesting enough food to fulfil the body's water and energy needs, adequate nutrition also implies that additional needs for micro-nutrients, such as vitamins and minerals, will be satisfied. Indeed, research has shown that in some cases specific nutritional needs may lead to a preference for food containing the missing nutrient over the deficient food (P Rozin 1972, 1976). Hence, the latter mechanism does not help in identifying objects or finding foods that are edible in general, but in finding foods that match one's specific, momentary dietary needs.

The importance of recognition is evident also in the way people react to events in which several sensory modalities are stimulated. People seem to prefer objects and sensory stimuli that communicate similar—or at the least non-conflicting—messages through all modalities (Lindstrom 2005). Consistency of impressions will lead to elevated identification accuracy (Zellner et al. 1991). The congruence of sensory messages in product design is desirable from an ergonomic perspective, where coherence helps to clarify what a product is about and what it can do. In addition, perceived unity in visual stimuli has been shown to correlate with ratings of both aesthetic appeal and liking (Bell et al. 1991; Veryzer and Hutchinson 1998). Therefore, if product designers would like to express an idea, to elicit a specific experience among its users, or to communicate a personality (Govers et al. 2004), they may benefit from adapting a multi-sensory design approach (Schifferstein and Desmet 2008). By employing multiple sensory channels and by transmitting a consistent message through all these channels, the product experience is likely to be more involving and more overwhelming than if only a single modality is used.

Novelty

Despite people's preferences for familiar products, they are also attracted to new, unusual and innovative products, partly to overcome boredom and saturation effects (Martindale 1990). It has been proposed that such a preference for novel instances is an adaptive trait, in that novelty facilitates learning (e.g. Bornstein 1989). It allows people to adapt to a new environment or changing circumstances. Furthermore, it is instrumental that people seek, for example, variety in the foods they eat, because a varied diet is more likely to fulfil all dietary needs than a monotonous diet. As a matter of fact, many foods that are initially pleasant lose their sensory appeal during eating, a phenomenon called sensory-specific satiety (e.g. Rolls 1986), the chemosensory equivalent of momentary boredom. Sensory-specific satiety has been demonstrated not only for taste and smell properties, but also for texture (Guinard and Brun 1998).

The reconciliation of the tendency to look for the familiar and also look for the novel is coined in the MAYA (Most Advanced, Yet Acceptable) principle (Loewy 1951), which suggests that people prefer products with an optimal combination of typicality and novelty. Hekkert, Snelders, and van Wieringen (2003) recently found empirical evidence for this principle in product design. They selected various products, such as telephones and tea kettles, which differed considerably along the dimensions of typicality and novelty. Participants rated all objects according to typicality, novelty, and aesthetic preference. As expected, novelty and typicality highly intercorrelated and each correlated poorly with preference. The trick of the study was to analyse the effect of both variables on aesthetic preference independently by keeping the other variable (statistically) constant. In full accordance with the predictions of the MAYA principle, Hekkert et al. found independent effects on aesthetic preference of both novelty and prototypicality, and these effects were nearly equally strong. Thus indeed, attractive designs comprise a thoughtful balance between novelty and typicality.

A good example of the operation of MAYA in the auditory domain is the popularity of remixes of old songs, such as the contemporary beat added to Elvis Presley's 'A little less conversation' (JunkieXL 2002). Furthermore, Simonton (2001) demonstrated that the actual success of classical musical compositions was highest for compositions with intermediate levels of melodic originality. Low melodic originality was preferred over high melodic originality, suggesting that listeners are rather quietly entertained than anxiously provoked, but compositions with an intermediate level of originality proved most successful.

In the food domain, Elisabeth and Paul Rozin (1981) have suggested that the introduction of a new food staple in a culture may be facilitated by adding a familiar combination of seasonings. According to Elisabeth Rozin (1973), many of the world's cuisines involve the use of distinctive and pervasive seasoning combinations, such as the tomato–garlic–olive oil combination for Italian dishes or the soy sauce–rice wine–ginger mixture for Chinese cooking. She refers to these seasoning combinations as flavour principles. Adding a familiar flavour principle to an unfamiliar food may help to bridge the cultural gaps, by increasing people's willingness to try the new food (Stallberg-White and Pliner 1999).

Challenges, surprises, and the acquisition of self-knowledge

While interacting with the world, it is important for people to know their own body. In fact, recent theorizing in neuroscience, cognitive science, and linguistics point at the bodily roots of the construction of meaning, concept formation, and language (Barsalou 1999; Pecher and Zwaan 2004; Johnson 2007). Studies following this line of thought demonstrated how our (repeated) bodily interactions with the world allow us to understand such things as metaphorical expressions (Lakoff and Johnson 1980; Gibbs et al. 2004), abstract concepts (Pecher et al. 2004), and product expressions (van Rompay et al. 2005).

Getting to know one's own body, one's own strengths and weaknesses, one's possibilities and limitations is also important for evaluating whether one can perform certain actions or not, and to predict the probability of getting hurt. It may, therefore, be predicted that products (or product features) contributing to self-knowledge are considered pleasant. The seemingly endless and repetitive manipulations babies employ on their toys support this prediction (Power 2000).

The sense of touch makes people aware of having a body and, thereby, forms a basis for the experience of the self (Bermudez et al. 1995). By touching and being touched, people get to know their own body: their size, their reaction to touch, their reaction to skin damage. It also makes people aware that not all bodies are the same, and that some products fit their body much better than others. Hence, people try on different clothes and shoes to make sure the size is correct, and they try out tools and appliances to make sure they fit well in their hand. An object that matches the hand can be used comfortably and using it is likely to be enjoyable. For that reason, people may really enjoy experiencing a product that fits well (Sonneveld and Schifferstein 2008).

During interactions with (objects in) the surrounding environment, people also get to know their other perceptual and motor capabilities. For example, people can test how fast they can run, how loud they can shout, or how good they are in recognizing the taste of different beer brands. All this information contributes to self-knowledge and people can use this knowledge to develop their skills. If skills are developed further, people will be able to handle more difficult challenges, and they will enjoy complex challenges more (Csikszentmihalyi 1990). In physical interactions with objects, such a challenge can take on the form of a power match: will you be able to open the marmalade jar with the tight lid, or will the marmalade jar win this fight? (Sonneveld and Schifferstein 2008). Challenges are not necessarily limited to perceptual and motor skills; they may also involve cognitive skills. For instance, a challenge may be incorporated in a design by evoking the curiosity of the potential user without giving all interesting information away at once, such as in complex buildings or in products that make use of translucent materials to partly conceal the internal components from the eyes, like the Apple iMac (Fig. 28.13).

In some cases, a product designer may wish to trigger an experience of surprise, for example, to increase interest or prolong the attention value of a product. In those cases, incorporating incongruity between sensory messages in a design could be an effective strategy (Ludden et al. 2009). The designer's challenge in these cases seems to be to combine familiarity and originality within the same design: even designers who want to surprise people will generally make sure that the majority of the product-related information communicates the same message, while only one particular aspect is responsible for the surprise. Designers typically limit surprising designs to well-known product categories that consumers can easily identify, such as furniture and other interior products (Ludden et al. 2008), to enhance the familiarity in their designs.

Because music evolves over time, unexpected events could be of particular importance in its appreciation (e.g. Meyer 1973). When listeners hear the start of a melody, they expect it to continue in a particular way. When an unstable chord is heard, they

Fig. 28.13 The Apple iMac.

anticipate its resolution. Composers can choose to fulfil, delay, or deny such musical expectations. Therefore, some have suggested that the appreciation of music might stem from 'an exquisite game of expectational cat and mouse with the composer, in which the listener enjoys the tensions and resolutions, the problems posed, and the problems solved, the confusions followed by comprehension' (Smith and Melara 1990, p. 280). However, in their study of harmonic progressions, Smith and Melara (1990) found that untrained listeners generally preferred to hear the harmonic prototypes, even though they found atypical progressions more interesting and complex. This preference for the familiar may not come as a surprise, given that many radio stations tend to have a playlist consisting of very familiar 'golden oldies' songs, or play the same popular song several times a day. People apparently need to get used to new and unfamiliar songs, before they appreciate them (Smith et al. 1994).

Conclusion

In this chapter we evaluated principles of aesthetic pleasure across several sensory modalities. These principles and mechanisms can predict and explain people's aesthetic responses for different domains of sensory experience. Some of these principles may be shared by all sensory modalities, whereas others may be modality-specific. Principles related to the meaning of objects (familiarity, prototypicality, novelty) rely on people's interpretation of sensory information and are likely to function in a similar way for all sensory modalities. However, principles related to the organization of perceptual information are more closely linked to sensory perception and may, therefore, be partly modality-specific.

Elsewhere (Hekkert 2006; Hekkert and Leder 2008), we have argued that both crossmodal correspondences and differences in aesthetic principles may be accounted for by theories of evolutionary psychology (e.g. Voland and Grammer 2003; Buss 2005) or evolutionary functionalism (Johnston 2003). In trying to explain why people derive pleasure from seemingly useless activities, such as listening to music or looking at paintings, evolutionary theories seek an answer in the origin of our perceptual systems. The aesthetic sense might be seen as a 'by-product' of the adaptation of the human brain and the sensory systems to problems associated with survival and reproduction. Simply stated, people may have come to derive pleasure from those environmental features and patterns that facilitate the functioning of our perceptual systems. Some of these functions are cross-modal, such as the ability to extract, pick up, and organize information, and the ability to identify types and sources of stimulation, leading to principles that are uniform across the senses. For this reason, people enjoy order, symmetry, and balance in all modalities. However, some functions are specific for a particular sensory system and, logically, they may lead to aesthetic principles that are sensory-specific. Nevertheless, the evolutionary rule 'what is beneficial is pleasant' still holds.

Needless to say, evolutionary explanations of aesthetic preference (or any other mental phenomenon) are not without criticism. Part of this critique centres on the post-hoc character of such explanations and the inherent impossibility to test them empirically. However, if aesthetic pleasure is regarded as a by-product of the functioning of perceptual systems, it is possible to reverse the line of thought by starting out from the specific functional roles of the sensory systems and to formulate specific, testable hypotheses on what sensory properties will be aesthetically preferred (see Hekkert 2006). Second, evolutionary aesthetics has been repudiated for being unduly reductionistic. This type of criticism is mainly fed by people's rich experiences of artworks that can include, for example, symbolic meaning, historical meaning, stylistic considerations, and emotional impact. Nevertheless, when using aesthetics in the limited sense proposed here as 'gratification of the senses', evolutionary logic may work very well in explaining the underlying principles at stake.

Some rules of aesthetics concern the integration of information over multiple sensory modalities. For example, people seem to like sensory messages to be mutually consistent and appropriate for the product conveying them. For instance, think about the way in which the senses are typically orchestrated to work in concert in entertainment: in a movie, the emotion expressed by the characters is enhanced by the music played on the background. Although one may not even be consciously aware of the music during the film, just try to watch a movie with subtitles without hearing the sound: the degree of engagement will generally be much lower, although all visual information is there and the factual information from the dialogue is conveyed through the subtitles. Therefore, gratifying all the senses simultaneously in a coherent and harmonious way may provide a simple means to shift an experience from the aesthetic to the ecstatic.

ACKNOWLEDGEMENTS

We would like to thank René van Egmond, Marieke Sonneveld, and our other co-workers for their helpful comments and suggestions. In addition, we thank Kimberly Elam (Figs. 28.3 and 28.4) and Jeroen van Erp (Fig. 28.8) for providing graphical materials.

REFERENCES

Aldrich KM, Hellier EJ, and Edworthy J (2009). What determines auditory similarity? The effect of stimulus group and methodology. *Quarterly Journal of Experimental Psychology*, **62**, 63–83.

Aures W (1985). Berechnungsverfahren für den sensorischen Wohlklang. *Acta Acustica*, **59**, 130–41.

Banham R (1966). *The new Brutalism: Ethic or Aesthetic?* Karl Krämer, Stuttgart.

Barsalou LW (1985). Ideals, central tendency, and the frequency of instantiation as determinants of graded structure in categories. *Journal of Experimental Psychology: Learning, Memory, and Cognition*, **11**, 629–54.

Barsalou LW (1999). Perceptual symbol systems. *Behavioral and Brain Sciences*, **22**, 577–660.

Bell SS, Holbrook MB, and Solomon MR (1991). Combining esthetic and social value to explain preferences for product styles with the incorporation of personality and ensemble effects. *Journal of Social Behavior and Personality*, **6**, 243–74.

Berlyne DE (1971). *Aesthetics and Psychobiology*. Appleton-Century-Crofts, New York.

Bermudez JL, Marcel A and Eilan N, eds. (1995). *The Body and the Self*. MIT Press, Cambridge, MA.

Bertelson P (1999). Ventriloquism: a case of cross-modal perceptual grouping. In G Aschersleben T Bachmann, and J Müsseler, eds. *Cognitive Contributions to the Perception of Spatial and Temporal Events*, pp. 347–62. Elsevier, Amsterdam.

Bone PF and Ellen PS (1999). Scents in the marketplace: explaining a fraction of olfaction. *Journal of Retailing*, **75**(2), 243–62.

Boring EG (1942). *Sensation and Perception in the History of Experimental Psychology*. Appleton-Century-Crofts, New York.

Bornstein RF (1989). Exposure and affect: overview and meta-analysis of research 1968-1987. *Psychological Bulletin*, **106**, 265–89.

Boselie F (1992). The golden section has no special aesthetic attractivity! *Empirical Studies of the Arts*, **10**, 1–18.

Boselie F and Leeuwenberg E (1985). Birkhoff revisited: beauty as a function of effect and means. *American Journal of Psychology*, **98**(1), 1–39.

Buss DM, ed. (2005). *Handbook of Evolutionary Psychology*. Wiley, Hoboken, NJ.

Butler JW and Daston PG (1968). Musical consonance as musical preference: a cross-cultural study. *Journal of General Psychology*, **79**, 129–42.

Charters S (2006). Aesthetic products and aesthetic consumption: a review. *Consumption, Markets and Culture*, **9**, 235–55.

Charters S and Pettigrew S (2005). Is wine consumption an aesthetic experience? *Journal of Wine Research*, **16**, 121–36.

Chastrette M, Elmouaffek A, and Sauvegrain P (1988). A multidimensional statistical study of similarities between 74 notes used in perfumery. *Chemical Senses*, **13**, 295–305.

Chrea C, Valentin D, Sulmont-Rossé C, Ly Mai H, Hoang Nguyen D, and Abdi H (2004). Culture and odor catgeorization: agreement between cultures depends upon the odors. *Food Quality and Preference*, **15**, 669–79.

Chrea C, Valentin D, Sulmont-Rossé C, Nguyen DH, and Abdi H (2005). Semantic, typicality and odor representation: a cross-cultural study. *Chemical Senses*, **30**, 37–49.

Csikszentmihalyi M (1990). *Flow: The Psychology of Optimal Experience*. Harper Collins, London.

Demattè ML, Sanabria D, and Spence C (2007). Olfactory-tactile compatibility effects demonstrated using a variation of the Implicit Association Test. *Acta Psychologica*, **124**, 332–43.

Doty RL (1981). Olfactory communication in humans. *Chemical Senses*, **6**, 351–76.

Elam K (2001). *Geometry of design: studies in proportion and composition*. Princeton Architectural Press, New York.

Farell B (1985). "Same"–"different" judgments: a review of current controversies in perceptual comparison. *Psychological Bulletin*, **98**, 419–56.

Fastl H and Zwicker E (2007). *Psycho-acoustics*, 3rd edn. Springer, Berlin.

Fenko A, Otten JJ, and Schifferstein HNJ (2010). Describing product experience in different languages: The role of sensory modalities. *Journal of Pragmatics*, **42**, 3314–27.

Frith C and Nias D (1974). What determines aesthetic preference? *Journal of General Psychology*, **91**, 163–73.

Gaver WW and Mandler G (1987). Play it again Sam: on liking music. *Cognition and Emotion*, **1**, 259–82.

Gibbs RW, Lima PLC, and Francozo E (2004). Metaphor is grounded in embodied experience. *Journal of Pragmatics*, **36**, 1189–210.

Godkewitsch M (1974). The 'Golden Section': An artifact of stimulus range and measure of preference. *American Journal of Psychology*, **87**, 269–77.

Goldman A (2001). The aesthetic. In B Gaut and D McIver Lopes, eds. *The Routledge Companion to Aesthetics*, pp. 181–92. Routledge, London.

Govers PCM, Hekkert P, and Schoormans JPL (2004). Happy, cute and tough: can designers create a product personality that consumers understand? In D McDonagh, P Hekkert J van Erp, and D Gyi, eds. *Design and Emotion. The Design of Everyday Things*, pp. 345–9. Taylor & Francis, London.

Grammer K and Thornhill R (1994). Human (Homo Sapiens) facial attractiveness and sexual selection: the role of symmetry and averageness. *Journal of Comparative Psychology*, **108**, 233–42.

Guinard JX and Brun P (1998). Sensory-specific satiety: comparison of taste and texture effects. *Appetite*, **31**, 141–57.

Gygi B, Kidd GR, and Watson CS (2007). Similarity and categorization of environmental sounds. *Perception & Psychophysics*, **69**, 839–55.

Hanson HM (1959). Effects of discrimination training on stimulus generalization. *Journal of Experimental Psychology*, **58**, 321–34.

Hekkert P (1995). 'Artful judgments. A psychological inquiry into aesthetic preference for visual patterns.' Unpublished doctoral dissertation, Delft University of Technology.

Hekkert P (2006). Design aesthetics: principles of pleasure in design. *Psychology Science*, **48**, 157–72.

Hekkert P and Leder H (2008). Product aesthetics. In HNJ Schifferstein and P Hekkert, eds. *Product experience*, pp. 259–85. Elsevier, Amsterdam.

Hekkert P, Peper CE, and van Wieringen PCW (1994). The effect of verbal instruction and artistic background on the aesthetic judgment of rectangles. *Empirical Studies of the Arts*, **12**, 185–203.

Hekkert P, Snelders D, and van Wieringen PCW (2003). 'Most advanced, yet acceptable': typicality and novelty as joint predictors of aesthetic preference in industrial design. *British Journal of Psychology*, **94**, 111–24.

Hogarth RM and Karelaia N (2007). Heuristic and linear models of judgment: Matching rules and environments. *Psychological Review*, **114**, 733–58.

Hyde RJ and Witherly SA (1993). Dynamic contrast: a sensory contribution to palatability. *Appetite*, **21**, 1–16.

Jacobsen T and Höfel L (2003). Descriptive and evaluative judgment processes: Behavioral and electrophysiological indices of processing symmetry and aesthetics. *Cognitive, Affective & Behavioral Neuroscience*, **3**, 289–99.

Johnson M (2007). *The Meaning of the Body*. The University of Chicago Press, Chicago, IL.

Johnston VS (2003). The origin and function of pleasure. *Cognition and Emotion*, **17**, 167–179.

JunkieXL (2002). 'A little less conversation' [CD-single]. RCA.

Karana E, Hekkert P and Kandachar P (2008). Material considerations in product design: A survey on crucial material aspects used by product designers. *Materials & Design*, **29**, 181-189.

Lakoff G and Johnson M (1980). *Metaphors We Live By.* The University of Chicago Press, Chicago, IL.

Lawless HT (2000). Sensory combinations in the meal. In HL Meiselman, ed. *Dimensions of the Meal: The Science, Culture, Business and Art of Eating*, pp. 92–106. Aspen, Gaithersburg, MD.

Lindauer MS (1986). Seeing and touching aesthetic objects: II. Descriptions. *Bulletin of the Psychonomic Society*, **24**, 125–6.

Lindauer MS, Stergiou EA, and Penn DL (1986). Seeing and touching aesthetic objects: I. Judgments. *Bulletin of the Psychonomic Society*, **24**, 121–4.

Lindstrom M (2005). *Brand Sense: Build Powerful Brands Through Touch, Taste, Smell, Sight, and Sound.* Free Press, New York.

Locher P (2006). The usefulness of eye movement recordings to subject an aesthetic episode with visual art to empirical scrutiny. *Psychology Science*, **48**, 106–14.

Locher P, Smets G, and Overbeeke K (1995). The contribution of stimulus attributes of three-dimensional solid forms and level of discrimination to the visual and haptic perception of balance. *Perception*, **24**, 647–63.

Loewy R (1951). *Never Leave Well Enough Alone.* Simon and Schuster, New York.

Logue AW (1991). *The Psychology of Eating and Drinking: An Introduction*, 2nd edn. Freeman and Company, New York.

Ludden GDS, Schifferstein HNJ and Hekkert P (2008). Surprise as a design strategy. *Design Issues*, **24**(2), 28–38.

Ludden GDS, Schifferstein HNJ, and Hekkert P (2009). Visual-tactual incongruities in products as sources of surprise. *Empirical Studies of the Arts*, **27**, 61–87.

Martindale C (1990). *The Clockwork Muse. The Predictability of Artistic Change.* BasicBooks, New York.

McManus IC (1980). The aesthetics of simple figures. *British Journal of Psychology*, **71**, 505–24.

McWhinnie HJ (1987). A review of selected research on the golden section hypothesis. *Visual Arts Research*, **13**, 73–84.

Meredith C, Edworthy J, and Rose D (1999). Observational studies of auditory warnings on the intensive care unit. In NA Stanton and J Edworthy, eds. *Human Factors in Auditory Warnings*, pp. 305–17. Ashgate, Aldershot.

Meyer LB (1973). *Explaining Music: Essays and Explorations.* University of California Press, Berkeley, CA.

Özcan E, van Egmond R and Jacobs J (submitted). Bases for categorization and identification.

Pecher D and Zwaan RA, eds. (2004). *Grounding cognition: the role of perception and action in memory, language and thinking.* Cambridge University Press, Cambridge.

Pecher D, Zeelenberg R, and Barsalou LW (2004). Sensorimotor simulations underlie conceptual representations: modality-specific effects of prior activations. *Psychonomic Bulletin & Review*, **11**, 164–7.

Plug C (1980). The golden section hypothesis. *American Journal of Psychology*, **93**, 467–87.

Power TG (2000). *Play and Exploration in Children and Animals.* Erlbaum, Mahwah NJ.

Purcell AT (1984). The aesthetic experience and mundane reality. In WR Crozier and AJ Chapman, eds. *Cognitive Processes in the Perception of Art* pp. 189–210. Elsevier, Amsterdam.

Ramachandran VS and Hirstein W (1999). The science of art: a neurological theory of aesthetic experience. *Journal of Consciousness Studies*, **6**, 15–51.

Reber R, Schwarz N, and Winkielman P (2004). Processing fluency and aesthetic pleasure: Is beauty in the perceiver's processing experience? *Personality and Social Psychology Review*, **8**, 364–82.

Repp BH (1997). The aesthetic quality of a quantitatively average music performance: Two preliminary experiments. *Music Perception*, **14**, 419–44.

Rolls BJ (1986). Sensory-specific satiety. *Nutrition Reviews*, **44**, 93–101.

Rozin E (1973). *The Flavor Principle Cookbook*. Hawthorne, New York.

Rozin E and Rozin P (1981). Culinary themes and variations. *Natural History*, **90**, 6–14.

Rozin P (1972). Specific aversions as a component of specific hungers. In MEP Seligman and JL Hager, eds. *Biological boundaries of learning*. Appleton-Century-Crofts, New York.

Rozin P (1976). The selection of foods by rats, humans, and other animals. In JS Rosenblatt, RA Hinde, E Shaw, and C Beer, eds. *Advances in the study of behavior*. Academic Press, New York.

Schifferstein HNJ and Desmet PMA (2008). Tools facilitating multisensory product design. *The Design Journal*, **11**(2), 137–58.

Schifferstein HNJ and Tanudjaja I (2004). Visualising fragrances through colours: the mediating role of emotions. *Perception*, **33**, 1249-1266.

Simonton DK (2001). Emotion and composition in classical music: historiometric perspectives. In PN Juslin and JA Sloboda, eds. *Music and Emotion: Theory and Research*, pp. 205–22. Oxford University Press, Oxford.

Smith JD and Melara RJ (1990). Aesthetic preference and syntactic prototypicality in music: 'tis the gift to be simple'. *Cognition*, **34**, 279–98.

Smith JD, Kemler Nelson DG, Grohskopf LA and Appleton T (1994). What child is this? What interval was that? Familiar tunes and music perception in novice listeners. *Cognition*, **52**, 23–54

Sonneveld MH and Schifferstein HNJ (2008). The tactual experience of objects. In HNJ Schifferstein and P Hekkert, eds. *Product experience*, pp. 41–67. Elsevier, Amsterdam.

Stallberg-White C and Pliner P (1999). The effect of flavor principles on willingness to taste novel foods. *Appetite*, **33**, 209–21.

Stevens JC and Marks LE (1980). Cross-modality matching functions generated by magnitude estimation. *Perception & Psychophysics*, **27**, 379–89.

Süskind P (1985). *Perfume*. Penguin Books, London.

Suzuki M, Gyoba J, Kawabata H, Yamaguchi H, and Komatsu H (2006). Analyses of the sensory-relevance of adjective pairs by the modality differential method. *Shinrigaku Kenkyu*, **77**, 464–70.

Thurstone LL (1927). A law of comparative judgment. *Psychological Review*, **34**, 273–86.

van Egmond R (2008). The experience of product sounds. In HNJ Schifferstein and P Hekkert, eds. *Product experience*, pp. 69–89. Elsevier, Amsterdam.

van Rompay T, Hekkert P, Saakes D, and Russo B (2005). Grounding abstract object characteristics in embodied interactions. *Acta Psychologica*, **119**, 315–51.

Veryzer RW and Hutchinson JW (1998). The influence of unity and prototypicality on aesthetic responses to new product designs. *Journal of Consumer Research*, **24**, 374–94.

Voland E and Grammer K, eds. (2003). *Evolutionary aesthetics*. Springer Verlag, Berlin.

Walker EL (1980). *Psychological Complexity and Preference*. Brooks/Cole, Monterey.

Wedekind C and Füri S (1997). Body odour preferences in men and women: do they aim for specific MHC combinations or simply heterozygosity? *Proceedings of the Royal Society of London Series B*, **264**, 1471–79.

Whitfield TWA (1983). Predicting preference for familiar, everyday objects: An experimental confrontation between two theories of aesthetic behaviour. *Journal of Environmental Psychology*, **3**, 221–37.

Whitfield TWA and Slatter PE (1979). The effects of categorization and prototypicality on aesthetic choice in a furniture selection task. *British Journal of Psychology*, **70**, 65–75.

Zajonc RB (1968). Attitudinal effects of mere exposure. *Journal of Personality and Social Psychology, Monograph Supplement*, **9**, 1–27.

Zellner DA, Bartoli AM, and Eckard R (1991). Influence of color on odor identification and liking ratings. *American Journal of Psychology*, **104**, 547–61.

ARCHITECTURE AND THE BODY

ALBERTO PÉREZ-GÓMEZ

SINCE it is commonplace to state that architecture is 'the art of space', I would like to start by paraphrasing Georges Perec's meditation on the topic, adding a few remarks taken from the work of two philosophers, Maurice Merleau-Ponty and Plato. Our field of vision reveals a limited space, something vaguely circular, which ends very quickly to left and right, and doesn't extend very far up or down (Perec 1999, p. 188). If we squint we can manage to see the end of our nose; if we raise or lower our eyes, we can see there is an up and down. If we turn our head in one direction, then in another, we don't even manage to see completely everything there is around us. We have to twist our bodies round to see properly what was behind us, and yet we take for granted the stability of the environing world, never hesitating to drive or fly in a plane. Our gaze travels through space and we recognize depth, a primary dimension, unlike all others, irreducible to breath and height. Depth is the dimension of human love and longing, hardly analogous to 'perspective', an enigma made manifest by every human culture in their most significant artefacts.

Our spatiality is constructed with an up and a down, a left and a right, an in front and a behind, a near and a far. When nothing arrests our gaze, it carries a very long way. But if it meets with nothing, it sees nothing. Space therefore arrests our gaze, it is also the substance, the obstacle, whether bricks or a 'vanishing point'. Plato understood this very well. In his famous dialogue *Timaeus, chora* is characterized as *both* space and primordial substance, and conceived as the mode of reality through which the things of the world (ideas embodied in concrete things) actually appear to our experience (Plato 1965, p. 66). Properly understood, human space *is* limits, most clearly when it makes an angle, when it stops. There is nothing ghostly about space, it has edges. Human space is, in fact, all that is needed for the parallel lines of the straight road to

meet *well short* of infinity: it is *not* Cartesian space (for one of the best articulations of this problem in modern philosophy see Merleau-Ponty 1964/1993).

Of course, our mobile and digitally ubiquitous civilization, avid consumer of seductive images, can easily accept that true space *is* Cartesian space, that the photograph depicts 'real' space. It can be further swayed by the argument that speed changes something basic in the primary *given* structure. We can all agree with Paul Virilio's observation that machines, ranging from television to the automobile, transform our visual relationship to the environing world, proposing their own space/time, and as a consequence have an effect on our perceptions.

Nevertheless, when we ask questions about the design of architecture related to this 'new' condition, we must be careful not to confuse the issues. It is easy to celebrate the world of instantaneous communication, speed, and mobility, claiming some radical change in the human condition and the structure of the senses, one that may justify an architecture reduced to seductive, seemingly innovative imagery, regardless of its medium. While it is true that the speeds with which we can move our physical or mental bodies transforms one's understanding of the world, it is an even more fundamental truth that, if we were not first and foremost embodied consciousness, already engaged through our frontal and vertical position in a gravity-bound world, we wouldn't be able to make any sense of so called cyberspace, we wouldn't, in fact, be able to drive at 120 kilometres an hour while paying close attention to a piece of music, or to our friend's words, nor would we have the certainty that we fit between the truck and the curb, for we have no scaled model of the world in our brain, nor little computer-men inside our heads providing ultra-fast solutions to our pressing dilemmas. Of course we make mistakes, and we may be fooled by illusions, but generally we are not. Even when very tired we know well it is a common miracle that we arrive safe to our destination. Regardless of neurological explanations, it is phenomenology's contention that this ultimately has more to do with bodily knowledge overcoming the limitations of an impaired brain (see Merleau-Ponty 2002).

Phenomenology rejects the idea of perception as constituted by independent senses, simply communicating data to the brain where a synthesis of some kind may be constantly taking place. The analogy of the brain with a computer always falls short. While something of this sort also contributes to our perception of meanings, phenomenology rather privileges an obvious reality: the world is first given unfragmented to the whole sentient body. Thus it argues for the primacy of embodied perception at the roots of being and understanding, grounding other modalities of intellectual articulation. For example: we know that the earth does not move. This is a primary truth for our bodies, one indispensable in order eventually to construct an endless number of scientific or mythical explanations of the universe. This first truth is a precondition for all others. Bodily perception is synaesthetic and precedes our common understanding of perception occurring *partes-extra-partes*, through the independent five senses. Granting the primacy of embodied perception also leads to questioning all mechanistic or causal models of human understanding that have been prevalent since the seventeenth century, and in a transformed fashion, are still at the root of many sophisticated contemporary neurological models. Meaning is not something merely constructed in

the brain, the result of judgement or the association of ideas, meaning is *given* in our normal, bodily engagement with things, things that we recognize, not as an aphasic patient may through deduction and association, but instantly as the embodiment of an idea, word, or category.

Our sentient bodies are our means for thinking and understanding. Acutely aware of this reality, and at odds with our modern conceptualization of cognition processes, most traditional cultures tended to identify feeling and thinking. Modern civilization has privileged the sense of vision, the main vehicle for empirical experimentation, and the sense capable of discriminating clarity, associated with logic. It has also radically dissociated feeling, thinking, and imagining as independent mental processes. Vision, however important it may be in the constellation of perception, and particularly in our Western scientific tradition constructed upon the Greek notion of *theoria*, is nevertheless rather fragile and prone to error when the question is to assess a reality that is given intersubjectively.

In this light, and coming closer to our topic, it is interesting to recall that in the tradition of architectural theory, treatises ranging from the Vitruvius' *Ten Books* (c.30 BCE), to works dating to the second half of the seventeenth century, argued for the importance of 'optical correction' (see Pérez-Gómez and Pelletier 1997). Optical correction is nothing less than the acknowledgement of the weakness of vision when it comes to questions of architectural meaning. Drawing from Euclid's original under-standing of the discrepancy between what appears to our eyes and what actually *is* (in a predominantly tactile, synaesthetic world), architects always expected buildings' forms and dimensions to be corrected in order for the experience of ordered regularity to be conveyed to a living inhabitant or spectator.

Today, in a world where vision has become hegemonic, we need to recall the so-called experiment of inverted vision to illustrate this fragility. It is common knowledge that the image projected on the back of the retina is inverted. If one wears lenses that then invert the field of vision, it is not surprising to encounter a few unpleasant hours of disorientation and even vomiting; we may touch things with the left hand, while having feeling in the right hand, for example. Simple acts become problematic. Yet, what is most surprising is how rapidly the body recovers its bearings. Except for a small place in our backs, usually inaccessible to touch, the whole body and its world return to normal in less than two days, demonstrating how bodily orientation lays at the root of meaning.

Maurice Merleau-Ponty has argued for a double engagement of our embodied conscience with the world. At a primary level, our body *knows*, this is a body inhabited by motility—the motion of life itself. Our body recognizes its location in our surround-ings without 'paying attention', through 'motor intentionality'. This is the body capa-ble of unspeakable athletic feats when threatened, and the body that knows another person or a place long before exchanging a word with the stranger or reading a travel guide. It is also the body housed by architecture. Only upon this primary understanding, a body image and concepts of space and time can be constructed.

Imagine that we are spending some time in the beautiful Tuscan city of Siena. We stand in the main square, the Piazza del Campo, contemplating the tower. We marvel

at the proportions of the whole ensemble, and then our architectural imagination naturally leads us to estimate the tower's height, and then how far it would fall if it ever collapsed (this example is taken from the beautifully written introduction to phenomenology by van den Berg 1970). We have substantial experience with dimensions, and we are quite certain of our perception. A few minutes later we wander into a bookstore nearby where a measured survey of the square is available to us. We simply can't believe the discrepancy between the distance we estimated and the 'real measure' of the tower's height. Is it possible to dismiss this phenomenon as an 'optical illusion' if it happens consistently every time we 'turn' a horizontal dimension into the vertical? Does the scale or measuring tape stretch when we move it from a horizontal to a vertical position? Is this why even though we carefully measure the dimensions of an elevation in a flat, horizontal drawing, when we build the building it seems to have grown? Is there a more sophisticated neurological explanation? It is perhaps better simply to recognize that in our primary perceptual engagement with the world, before we measure, vertical distances are larger than horizontal distances. We must acknowledge that embodied orientation is fundamental for our perception of meanings. In our primary engagement with the world this discrepancy is not an illusion but a fact. Our vertical position is unique among animals. We are like a hyphen between the earth and the sky, endowed with a spherical head and frontal vision, in a world whose transparent atmosphere made it possible to contemplate the heavens and thus discover the regularity of mathematics, eventually leading to our scientific theories. This verticality is not incidental; it allows us to *know* in a particular way.

The body is not a machine like Descartes imagined, a machine controlled by a computer-like mind. Modern medicine has found limits in this understanding of physiology that are not encountered by holistic or non-Western medicine, which tends to consider the living body in its own terms, different from an objectified cadaver or a collection of mechanical systems. Research into so-called artificial intelligence demonstrates how difficult it is to have a robot accomplish even simple tasks, like making a bed, for example. Our consciousness is embodied—the stomach knows and the hand thinks. Everything in our environments is first given to this synaesthetic, perceiving body of ours. The distance between my home and place of work changes constantly, invariably qualified by this embodied consciousness. If, on diverse occasions, while travelling home from work, I am tired, hungry, or depressed, the distance I experience is always different, and this is a more primary truth than the distance in kilometres read by the odometer of my car. It is primary, for the quantification of distance (the abstract numbers in the odometer) is meaningless apart from a specific experience, situation, or context. Likewise, time is elastic; the present has a thickness, rather than being a non-existing instant or *punctum* between past and future. To justify regret for wasted time, we usually say: the lecture felt like an eternity, but it only lasted 50 minutes. We should at least acknowledge that the lecture actually took a very long time out of my life experience, though in my watch I could see that only 50 minutes went by. And when we step outside in winter, we may notice that the colour of snow is always different, at night, under the glowing sun, or sheltered by a grey sky. Of course, the whiteness of snow is not a delusion either. And no one would deny the importance of measurement;

time and space can indeed be conceived in mathematical terms, and this has proven immensely useful. Rather, phenomenology shows that in human perception the mystery of simultaneity is always operating: both the ideal essence of the snow, its whiteness, and the particular shade of colour are given at once. Neither is possible without the other. This is the enigmatic nature of human perception, the ground of meaning and linguistic understanding.

When we address the issue of architectural meaning, thinking about either the creation or the reception of architecture, this primary reality must not be forgotten (see, for example, Holl et al. 1994/2006; Pallasma, 2004, 2005; Zumthor, 2006). Architecture is not what appears in a glossy magazine, it is not reducible to two- or three-dimensional images on the computer screen, or even to a comprehensive set of precise working drawings. The most significant architecture is not necessarily photogenic. In fact, often the opposite is true. Its meanings include sound (and eloquent silence), the tactility of materials, smell, and the sense of humidity, among infinite other factors that appear through the motility of embodied perception and are given *across* the senses. Furthermore, because architectural projects effectively propose a way to dwell in the world, in the best instances both ethical and poetic, it can be problematic to reduce their effect to mere aesthetic experience (in the old eighteenth-century sense of the term). Architecture, in this sense, is also a form of political action (see Pérez-Goméz, 2006).

This bears some further clarification. It is an important first step not to take for granted that architectural phenomena across civilizations can be reduced to one easily definable class of objects, like oranges or houses. The reality of architecture is very complex, both shifting with cultural changes, and, in some ways, also remaining the same. Architecture responds to the human condition that demands we continually address the same basic questions: to reconcile our personal mortality with the possibility of cultural transcendence opened up by language. Though the questions are similar, architecture provides diverse answers appropriate to specific times and places. More specifically, it is naïve to identify the full tradition of architecture with a chronological collection of buildings, understood as useful 'creations', whose main significance was to delight through more or less irrelevant aesthetic ornament. This popular modern conception was a product of the Enlightenment that only came to fruition in the nineteenth century. Such a reduced and objectified understanding leads us to a dead-end. A more careful appraisal of our architectural traditions, and their changing political and epistemological contexts, suggests a different way to understand architecture's 'universe of discourse'—operating in the realm of what Giambatista Vico called, in the early 1700s, 'imaginative universals': a discipline that over the centuries has seemed capable of offering humanity, through widely different incarnations and modes of production, far more than superfluous pleasure or a technical solution to pragmatic necessities.

While the threats of a polluted physical environment are relatively easy to grasp, the dangers posed to our spiritual health (i.e. to our embodied minds) by a banal built environment are generally misunderstood. The technological world often encourages the view that the real meaning of architecture is simply to fulfil a programme and

provide for shelter. This is not surprising, for in our global village the only truths that seem to have universal validity are the technical achievements of applied science, ultimately issuing from a mathematical language: these are the sort of truths that seem to 'stand' for all, regardless of local languages or cultures. Our technological world is one driven almost exclusively by efficiency of means. Efficiency stands as an absolute value, not only in economics or industrial production, but also in all orders of life, demonstrable through mathematical argumentation. Thus the means can claim to be unaffected or unconcerned by the social consequence of its ends, which at best will be open for subjective debate. Within this framework, good architecture would be nothing other than efficient building. Indeed, both the poetic potential of architecture to create a world of beauty and the insidious capacity of the built environment to contribute to psychic malaise and a repressive politics go generally unnoticed by the public, and are often insufficiently understood by architects.

Our reason may be capable of dismissing the quality of the built environment as central to our spiritual well-being, yet our dreams and our actions are always set *in place*, and our understanding (of others and ourselves) could simply not *be* without significant places. As I have suggested, our bodies are indeed capable of recognizing and understanding, despite our so-called 'scientific' common sense and its Cartesian isotropic space, the wisdom embodied in a place, the profound and irreducible expressive qualities of a culture. Architecture is manifest in those rare places that speak back to us and resonate with our dreams, it incites us to real meditation, to personal thought and imagination, opening up the 'space of desire' that allows us to be 'at home' while remaining always 'incomplete' and open to our personal death, unveiling a glimpse of the sense of existence. We are first and foremost mortal, self-conscious bodies *already* engaged with the world through orientation and gravity. As embodied consciousness we are deeply intertwined in a given world, in an unarticulated, preconceptual 'ground' that depends greatly upon 'architecture' as the external order, one primarily responsible for making our limits present.

I will finish by evoking some important qualities of an architecture 'for the body', one that may contribute to our human self-understanding. Most crucial is not architecture's capacity to communicate a particular meaning that could be 'read' or 'deciphered' (like a sign or the logo of a corporation or national state), but rather the possibility of merely *presenting* meaning as it appears in the cultural and natural worlds. In the best cases, architecture may allow us to *recognize* ourselves as complete, in order to dwell poetically on earth and thus be wholly human. In the Western tradition, the products we may associate with the 'architectural phenomenon' have ranged from the *daidala* of classical antiquity (objects such as ships, temples, and deceptive war machines, all put together from small parts through carefully crafted joints), to the sun-dials, *machinae*, and buildings that Vitruvius named as the three manifestations of the discipline. Architecture, in this sense, has included the gardens and ephemeral architecture of the Baroque period and the built and unbuilt 'architecture of resistance' of modernity, ranging from Piranesi's *Carceri* etchings to Daniel Libeskind's *Micromegas* drawings, and including such twentieth-century works like Le Corbusier's La Tourette, Antoni Gaudi's Casa Batlló, and John Hejduk's 'masques', to give

a few examples. This *recognition* of wholeness that architecture may offer is not merely one of semantic equivalence, rather it occurs in experience and, like in a poem, its 'meaning' is inseparable from the experience of the poem itself. In other words, architectural meaning cannot be reduced to concepts that one may paraphrase. The moment of recognition is embedded in culture, it is playful by definition, and is always circumstantial. These artefacts, which the Greeks qualified as *thaumata*, convey wonder, a form of beauty grounded in *eros* (which Vitruvius significantly called *Venus-tas*, a quality of Venus, rather than using the more common Latin word *pulchritudo:* see Vitrivius, 1960). This was still clearly understood during the Renaissance by philosophers like Marsilio Ficino and architectural writers like Francesco Colonna; a quality altogether different from 'formal composition' in the sense of modern aesthetics. Architectural beauty, like erotic love, burns itself into our soul; it inspires fear and reverence through a 'poetic image'. It affects us primarily through our vision, and yet is fully sensuous, synaesthetic: it is thus capable of seducing and elevating us to understand our embodied soul's participation in wholeness.

Unlike most buildings in postindustrial cities, architecture offers societies a place for existential orientation. Architecture is the embodiment of a radical orientation. When successful, architecture allows for *participation* in meaningful action, conveying to the participant an understanding of his or her place in the world. In his description of theatre architecture, Vitruvius recognized that its plan responded to the circle of the heavens and that the twelve divisions of the zodiac were to be reflected in its geometry. He also developed his analysis of musical harmony in relation to these important classical buildings, for he acknowledged that besides temples, theatres were the most important institutional buildings in ancient cities. And yet, he also suggested that the meaning of a theatre is not 'objective' or 'aesthetic', insisting that it appears particularly in the moment of catharsis, during a performance, when the spectator sits 'with open pores', in harmony with the breath of the actors and that of the universe. This 'meaning' is therefore not what a tourist may appreciate today during a visit to a classical Greek or Roman theatre. Beautiful details and a clever, efficient plan do not suffice. Understood as Vitruvius suggests, architecture opens up a clearing for the individual's experience of purpose through participation in cultural institutions. It orients through *experience*, in a realm 'beyond words'. So, while its theory may be rooted in mythic or poetic stories, philosophy, theology, or science during different times of its history, architecture is none of these, but an *event* for the living body. Its disclosure of beauty and meaning is ephemeral, yet it has the capacity of changing one's life in the vivid present—exactly like magic, or an erotic encounter. Like falling in love, it strikes a blow that reveals 'reality as is'—an experience, which, according to Socrates, is crucial to the understanding of philosophical problems beyond the scope of logical reason. Thus, architecture can be said to embody knowledge, but rather than clear logic, it is knowledge understood in the Biblical sense: a carnal, fully sexual and therefore opaque experience of truth. For this reason, and despite the still ongoing efforts of many architects claiming either rational or aesthetic aspirations, its 'meaning' can never be objectified, reduced to functions, ideological programmes, formal or stylistic formulas. Likewise, its technical medium is open, including artefacts from

diverse media that make possible human dwelling and which, by definition, stand 'at the limits of language', establishing the boundaries of human cultures within which other more properly linguistic forms of expression may take place.

References

Holl S, Pallasmaa J and Pérez-Gómez A (1994/2006). Questions of perception: Phenomenology of Architecture. *A+U*, July 1994, reprint 2006.

Merleau-Ponty M (1964/1993). Eye and mind. In GA Johnson, ed. *Merleau-Ponty Aesthetics Reader – Philosophy and Painting*. Northwestern University Press, Evanston, IL.

Merleau-Ponty M (2002). *Phenomenology of Perception*, C Smith trans. Routledge, London.

Pallasma J (2004). *Encounters*. Rakennustietot, Helsinki.

Pallasma J (2005). *The Eyes of the Skin*. Wiley, Chichester.

Perec G (1999). *Species of Spaces and Other Pieces*, J Sturrock trans. Penguin, London.

Pérez-Gómez A (2006). *Built upon Love: Architectural Longing after Ethics and Aesthetics*. MIT Press, Cambridge, MA.

Pérez-Gómez A and Pelletier L (1997). *Architectural Representation and the Perspective Hinge*. MIT Press, Cambridge, MA.

Plato (1965). *Timæus and Critias*, HDP Lee trans. Penguin, London.

van den Berg H (1970). *Things; Four Metabletic Reflections*. Duquesne University Press, Pittsburgh, PA.

Vitruvius MVP (1960) *The Ten Books on Architecture*, MH Morgan trans. Dover, New York.

Zumthor P (2006). *Atmospheres*. Birkhäuser, Boston, MA.

ARCHITECTURE AND THE EXISTENTIAL SENSE: SPACE, BODY, AND THE SENSES

JUHANI PALLASMAA

DISPLACEMENT OF THE HUMAN BODY

SINCE the early eighteenth century, architecture has been increasingly understood as a rationalized, secularized, and visual artform. This development has resulted in the gradual displacement of the human body from its central role in architectural thinking, an idea that grew stronger during the Renaissance, but that originated already much earlier, from Vitruvius (Fig. 30.1).[1]

At the same time, a growing visual bias has suppressed the role of the other sensory realms. This condition reflects the general course of Western culture, and has

[1] In book III of his treatise *De Architectura* (written around 15 BC), the Roman architect correlated the ideal human proportions with geometry. This idea was later illustrated and popularized, with some variations, by Leonardo Da Vinci in a famous drawing (c.1492), now preserved at the Gallerie dell'Accademia, in Venice.

Fig. 30.1 Vitruvian figure from Cesariano's edition of *Vitruvius*, Como, 1521. The figure is one of a multitude of illustrations, of which Leonardo's version is best known, that demonstrate the aspiration for a harmony between the world, architecture, and man.

been further reinforced by technological development and prevailing forms of industrial production.

The Renaissance thought still aspired for the unification of microcosm and macrocosm, man and the universe, the material and the spiritual. Rudolf Wittkower asserts:

The belief in the correspondence of microcosm and macrocosm, in the harmonic structure of the universe, in the comprehension of God through the mathematical symbols of centre, circle and sphere – all those closely related ideas which had their roots in antiquity and belonged to the undisputed tenets of medieval philosophy and theology, acquired new life in the Renaissance . . .

(Wittkower 1988, p. 39)

Architecture was not seen as an autonomous realm of artistic expression but as a mediation between the universe and man, divinities and mortals. A special application of this mediating task of architecture was the use of the Pythagorean harmonic canon, which sought to unify ideas of harmony both in the auditive phenomenon of music and the visual realm of architecture, to reflect the harmony of the spheres (Fig. 30.2).

Referring to Pythagoras, Alberti argued in his *Ten Books on Architecture*: 'The numbers by means of which the agreement of sounds affects our ears with delight are the very same which please our eyes and mind' (quoted in Wittkower 1988, p. 109).

The architectural writings of the late eighteenth and early nineteenth centuries viewed the language of architecture dualistically. Some writers demanded that architecture should be abstract; it was to be the language of calculation and reason. Others regarded architecture as an imitative art, whose signs of expression came directly from nature. In both cases, the metaphysical dimension, as well as the centrality of the human body and the senses, were lost. In the early nineteenth century, J.N.C. Durand

Fig. 30.2 The use of Pythagorean harmonics has continued until today as an attempt to combine the harmonies of the visual and musical worlds. Aulis Blomstedt, Pythagorean Study of musical intervals applied to subdivision of the measures of the human body, early 1960s, Aulis Blomstedt Estate.

(Source: Aulis Blomstedt Estate/Severi Blomstedt.)

developed a systematic architectural language similar to Lavoisier's classification of chemical phenomena and Linnaeus's system of flora (Fig. 30.3).

As with scientists of the period, Durand believed that every discipline was reducible to a specific language. He aspired to build his architectural language on solid foundations by keeping it apart from 'the errors of religion, tradition and superstition' (Vidler 1978, pp. 57–9). These ideas implied a total rationalization of architecture as an autonomous discipline, and this development has continued, culminating in today's fully technologized high-tech architecture based on pure utilitarian and technological reason, and aspiring to turn reason into aesthetics.

The detachment of construction from metaphysical concerns and from the dimensionality of the human body was underlined during the Napoleonic reign by the abandonment of harmonic proportional systems, and the replacement of measures deriving from the human body, by the abstract metric system. Architecture began to develop its independent and self-sufficient aesthetic logic at the same time that the numerous utilitarian, technical, and economic criteria of construction also begun to gain ground. This rationalized and instrumentalized architecture has gradually turned into an uncontested artform of the eye.

VISION AND PHILOSOPHY

Ever since the Greek thinkers, the supremacy of vision has been supported by philosophical thought, as vision was regarded as the most precious and reliable of the senses, and even the very symbol of understanding and truth. Already Heraclitus claimed that 'the eyes are more exact witnesses than the ears' (quoted in Levin 1993, p. 1), but Plato regarded vision and philosophy as humanity's greatest gifts, and insisted that 'ethical universals must be accessible to the mind's eye' (Levin 1993, p. 287). Aristotle, likewise, considered sight as the most noble of the senses 'because it approximates the intellect most closely by virtue of the relative immateriality of its knowing' (Levin 1993, p. 274).

Numerous examples in the more recent history of philosophy lend support to the observation that the association of the clarity of thought with clear vision has been a central metaphor in philosophical writings (see Franzini, Chapter 6, this volume). The impact of vision on philosophy is summed up by Peter Sloterdijk: 'The eyes are the organic prototype of philosophy [. . .]. This gives them a prominence among the body's cognitive organs. A good part of philosophical thinking is actually only eye reflex, eye dialectic, seeing-oneself-see' (quoted in Jay 1994, p. 27).

It is here worth noticing that, regardless of the early philosophical argumentation for the supremacy of vision, the actual shift to one-sided visuality seems to have taken place rather slowly. The primordial dominance of hearing was only gradually replaced by vision. In Lucien Febvre's view:

The sixteenth century did not see first; it heard and smelled, it sniffed the air and caught sounds. It was only later that it seriously and actively became engaged in geometry, focusing

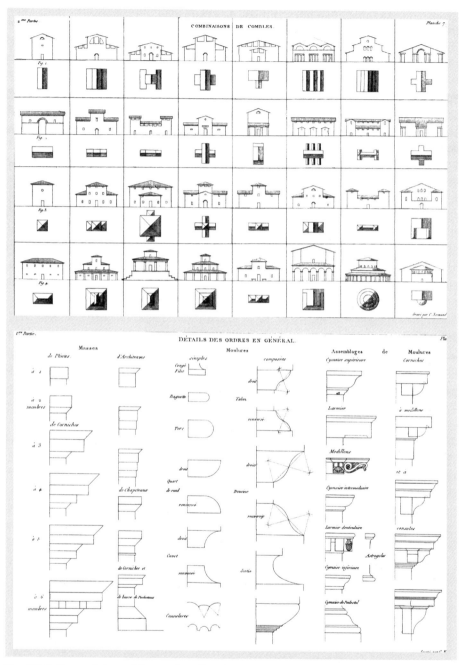

Fig. 30.3 The origins of the rationalization of architecture 1819. J.N.L. Durand's system of architectural elements. A) Roof shape combinations. B) Details of architectural orders.

(Source: J.H.L. Durand, *Leçons d'architecture. Partie Graphique des cours d'architecture*, 1819.)

attention on the world of forms [. . .] It was then that vision was unleashed in the world of science as it was in the world of physical sensations, and the world of beauty as well.

(Quoted in Jay 1994, p. 34)

Robert Mandrou makes a similar argument:

The hierarchy [of the senses] was not the same [as in the twentieth century] because the eye, which rules today, found itself in third place, behind hearing and touch, and far after them. The eye that organizes, classifies and orders was not the favoured organ of a time that preferred hearing.

(Quoted in Jay 1994, pp. 34–5)

Anyone walking through the intimacy and tactility of matter and echo in the narrow paved streets of an old town, experiencing the density of sounds in the market halls and fish markets, or entering the multisensory microcosm of a Romanesque church or Gothic cathedral, can easily grasp an experiential world that is not dominated by the sense of vision (Fig. 30.4).

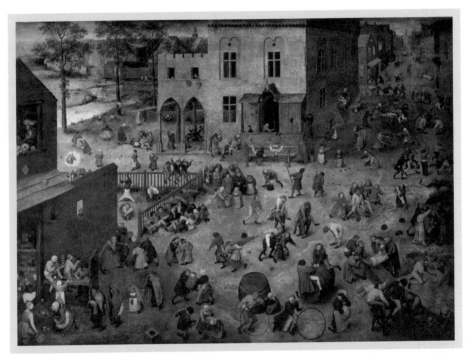

Fig. 30.4 A multisensory city of intimacy and interaction. Pieter Bruegel the Elder, *Children's Games*, 1560. Vienna, Kunsthistorisches Museum.

(Source: Wikimedia Commons.)

VISION AND MODERNITY

During the twentieth century, the modernist artistic strategies of distancing, detachment, estrangement, and fragmentation completed the gradual rejection of human embodiment and led to the full acceptance of the hegemony of vision. Le Corbusier's credos, 'I am and I remain an impenitent visual – everything is in the visual' (quoted in Grosset 1987, p. 115), and, 'Architecture is the masterly, correct and magnificent play of masses brought together in light' (Le Corbusier 1959, p. 164), epitomize the abstracted and purely visual understanding of architecture. We need to remember, however, that regardless of his polemical emphasis of vision, Le Corbusier was a powerfully plastic and tactile artist and designer. He also sought to revive the tradition of systemic proportional harmony and architecture's connection with the human body through his *Le Modulor* system of measures and proportions (1948) based on the dimensions of the human figure and the Golden Section. Le Corbusier's *Le Modulor* reconnects architecture with its age-old idea of proportionality deriving from the measures of the human body and aspiring for cosmic harmony, the unification of the proportional principles of the physical and biological worlds. Golden Section, the proportional principle of *Le Modulor*, which is not based on exact numerical values, has been challenged and questioned by supporters of Pythagorean harmonics based on relations of simple full numbers, which is also (in principle) the harmonic base of Western musical harmony.[2]

However, in opposition to its general orientation, the history of Modernism also includes architects, such as Alvar Aalto and Erik Gunnar Asplund, or the Nordic modernity at large that aspired for tactile and multisensory architecture.

The 'other tradition of modern architecture', as presented by Colin St John Wilson, is concerned with the sensory reality of architecture as well as the significance of tradition (Wilson 1995). Asplund's own summerhouse at Stennäs in Sweden (1937) and Aalto's Villa Mairea in Noormarkku, Finland (1938–9) exemplify this multi-thematic, multisensory and comforting architecture that addresses the senses of movement, touch, hearing and even smell through their natural materials, rich textures and rhythms, tactile and ergonomic detailing, and potent imagery (Figs. 30.5 and 30.6).

Already during the period of high modernity Asplund wished explicitly to expand architectural expression beyond vision:

The idea that only design, which is comprehended visually, can be art is a narrow conception. No, everything grasped by our other senses through our whole human consciousness and which has the capacity to communicate desire, pleasure, or emotions, can also be art.

(Asplund 1936)

[2] The most notable scholar of Pythagorean harmonics in the modern age was Dr. Hans Kayser, the founder of the Institute of Harmonics at the Music Academy of Vienna. See Hans Kayser (1950). *Lehrbuch der Harmonik*. Occident Verlag, Zurich. See also, Juhani Pallasmaa (2005).Man, Measure and Proportion. In Peter MacKeith, ed. *Juhani Pallasmaa: Encounters*, pp. 231–48. Rakennustieto, Helsinki.

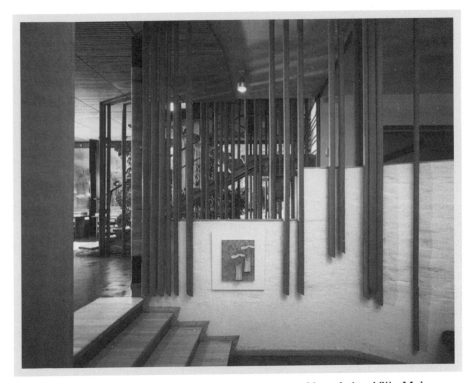

Fig. 30.5 Sensuous and intimate multisensory space. Alvar Aalto, Villa Mairea, Noormarkku, 1938–9. Entrance hall on a lowered level, living room and main staircase leading to private rooms above.

(Photograph: Rauno Träskelin.)

Needless to say, today architecture continues to be theorized, taught, practised, and assessed as a visual phenomenon. The harmonic principles and cosmic relations of architecture, which used to be its very essence, are hardly touched upon in today's education and professional practice. In the architecture of the industrialized world the aesthetic intention has taken over the existential, and instrumentality has replaced metaphysical concerns.

THE AGE OF AESTHETICIZATION

In our materialist and digital age, buildings are regarded as aestheticized objects and judged primarily by their visual characteristics. In fact, the dominance of vision has never been stronger than in the current era of the technologically expanded eye and industrially mass-produced visual imagery—the 'unending rainfall of images', as Italo Calvino appropriately described the present cultural condition (Calvino 1988, p. 57).

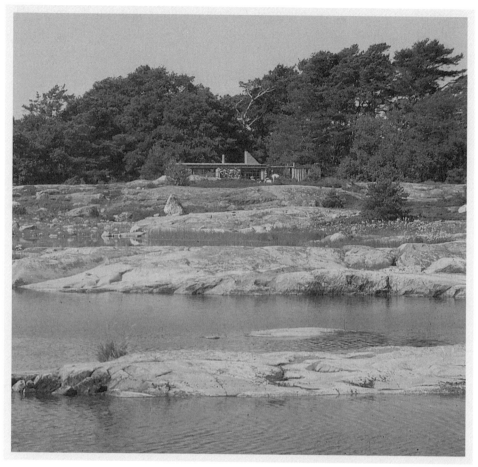

Fig. 30.6 Site-specific and tactile architecture built of materials collected from the site. Juhani Pallasmaa, Summer atelier of a painter, Vänö Islands, 1970.

(Source: Juhani Pallasmaa Architects, Helsinki.)

In today's media culture, architecture has been turned into an artform of image and instant retinal gratification. The rapid triumph of computerized design methods over sketching by hand and the involvement of the body in the design process have brought about yet another level of detachment from embodiment and immediate sensory contact.

The consumer culture of today has a blatantly dualistic attitude towards the senses and human embodied existence. On the one hand, the fundamental fact that we exist in the world through the senses and the embodied cognitive processes is neglected in the established views of the human condition. The prevailing world view continues its 'naïve realism' that accepts reality as an objective and unproblematic fact. This attitude is also directly reflected in educational philosophies as well as practices of daily life. On the other hand, our culture has developed an obsessively aestheticized and eroticized cult of the body, and we are increasingly manipulated and exploited through our senses. The body is regarded as the medium of identity and self-presentation as well as

an instrument of social and sexual appeal. Current consumer capitalism has even developed a 'new technocracy of sensuality' and shrewd strategies of 'multi-sensory marketing' for the purposes of sensory seduction and product differentiation. This commercial manipulation of the senses aims at creating a state of 'hyperaesthesia' in the consumer (see Howes 2005). Artificial scents are added to all kinds of products and spaces, whereas 'muzak' conditions our mood in shops, vehicles, and increasingly also in public spaces. We have undoubtedly entered an era of manipulated and branded sensations. As we enter one of today's shopping malls, department stores, or boutiques, we are usually secretly manipulated and seduced by colour, sound, smell, and tactile materials as well as directing and sequencing of movement, attention, and desire. Signature architecture, aimed at creating eye-catching, recognizable, and memorable visual images, or architectural trademarks, is another example of sensory exploitation, the attempt 'to colonize by canalising the "mind space" of the consumer' (Howes 2005, p. 288).

We are living in an age of aestheticization without being hardly aware of it. Everything is aestheticized today; consumer products, personality and behaviour, politics, and ultimately even war. Formal and aesthetic qualities in architecture have replaced functional, cultural, and existential criteria. An aestheticized surface appeal has displaced meaning and social significance. The social idealism and compassion that gave modernism its sense of optimism and empathy have frequently been replaced by formalist retinal rhetoric.

REVOLUTION THROUGH THE SENSES

The long neglect of the human sensory essence, and the disregard of the embodied processes in our existential experiences and cognition are, however, giving rise to an expanding literature on the senses and the various aspects of human embodiment (Ackerman 1991; Howes 2005; Pallasmaa 2006, 2009). The biased retinality and the displacement of the body in western cultural awareness have been convincingly revealed by a number of philosophers (e.g. Levin 1993; Jay 1994). The recent studies of the role of embodied processes extend all the way to the acts of memorizing and thinking (e.g. Casey 2000; Johnson 1987; Lakoff and Johnson 1999). These writers emphasize the significance of the senses in the entire human mode of being, as well as in the emancipation of the individual. Michel Serres states explicitly: 'If a revolt is to come, it will have to come from the five senses' (1995, p. 71). David Michael Levin, a critic of biased retinality, makes an equally concerned argument:

I think it is appropriate to challenge the hegemony of vision – the ocular-centrism of our culture. And I think we need to examine very critically the character of vision that predominates today in our world. We urgently need a diagnosis of the psychosocial pathology of everyday seeing – and a critical understanding of ourselves as visionary beings.

(Levin 1993, p. 205)

The 'pathologies' of today's architecture can likewise be revealed through an analysis of the biased views of the human condition that prevail in the standard practices of architecture today (see Pallasmaa 2005). Instead of aspiring to create impressive visual objects that evoke awe and admiration, profound architecture aims at rooting us in our very life world and emancipating our senses for an autonomous and authentic encounter with the world.

The evident experiential impoverishment and mental meaninglessness of today's standard buildings have given rise to a deepening concern of the suppression of the sensory realm. The urgency of this concern is exemplified by the anthropologist Ashley Montagu: 'We in the Western world are beginning to discover our neglected senses. This growing awareness represents something of an overdue insurgency against the painful deprivation of sensory experience we have suffered in our technologized world' (Montagu 1986). Several recent books analyse the embodied and sensory essence of architecture at large (e.g. Bloomer and Moore 1977; Malnar and Vodvarka 2004), as well as the neglected potentials of the repressed senses of hearing (e.g. Blesser and Salter 2006), touch (e.g. Classen 2005), and smell (e.g. Barbara and Perliss 2006) in experiences of space, place, and architecture.

Along with the philosophers' critique of biased visuality and the displacement of the body, a renewed interest in the multisensory essence of architecture has arisen among practising architects, architectural writers, and educators. Today we can see a decisive shift from abstract conceptuality and visual formalism towards a sensory realism taking place in schools of architecture around the world. The renewed interest in the experiential and existential dimensions of architecture has also resulted in the popularity of phenomenological philosophy as a theoretical approach to the art of building. Many of today's internationally recognized architects of differing stylistic persuasions, such as Tadao Ando, Peter Zumthor, Steven Holl, Rick Joy, Tod Williams and Billie Tsien, John and Patricia Patkau, and Kengo Kuma, have expressed their explicit interests in the sensory qualities of architecture. Their buildings are often formally deliberately simple in order to strengthen and focus sensory experiences of materiality, gravity, colour, and light. Their architectures give rise to open poetic images instead of calculated or sentimental effects. Countless architects in Spain, Portugal, and the Nordic countries as well as many South American countries explore the sensory and sensual qualities of architecture more than architects of the celebrated metropolitan centres of the world.

REDISCOVERING THE SENSES

It is thought-provoking, indeed, that even the number of the human senses is arguable. The psychologist James J. Gibson identifies five sensory *systems* instead of five independent and isolated modalities: visual system, auditory system, the taste–smell system,

the basic orienting system, and the haptic system. Already medieval philosophy identi-
fied a sixth unifying sense, the sense of selfhood, through which the self acknowledges
itself as a distinct entity (Connor 2005). Regardless of the fact that the concept of the
singular self, 'the I', is central in Western consciousness, the origins of selfhood in our
embodied experiences and the sensory world continue to be neglected in contempo-
rary culture.

To make the notion and categorization of the senses even more ambiguous, we need
to be reminded that the philosophy of Rudolf Steiner argues that we actually utilize no
less than twelve senses. The twelve senses identified by Steinerian anthropology and
spiritual psychology are: touch, life sense, self-movement sense, balance, smell, taste,
vision, temperature sense, hearing, language sense, conceptual sense, and ego sense
(Soesman 1998). The Steinerian ego sense is obviously related with the sixth sense of
medieval thought.

It is evident that experiences and qualities of architecture cannot be fully described
by our five sense modalities. In addition to the five senses, experiences of architecture
involve, for example, the sensations of gravity and lightness, the counterpoint of hori-
zontality and verticality, movement and balance, sense of centre and focus, tension and
ease, time and duration, not to speak of the role of memory and projection of intentional
meanings. These sensations call for skeletal and muscular imageries, as well as the engage-
ment of the body scheme, memory, and imagination. Profound architecture evokes and
addresses our comprehensive existential sense. The phenomena of architecture do not
take place in an abstracted and detached world; architecture occupies our life world, and
it is encountered and measured primarily by our very sense of being.

Primacy of touch and
haptic awareness

Our contact with the world takes place at the boundary of the self, through specialized
parts of the enveloping membrane and its extensions and projections. The senses are
truly amazing extensions of the physical body; as Martin Jay notes, 'through vision we
touch the sun and the stars' (quoted in Levin 1993, p. 130).

The senses are specializations of skin tissue, and all sensory experiences are modes
of touching, and thus fundamentally related with tactility. We also touch the world by
the eyes, ears, nose, and tongue. In fact, Aristotle already described taste and seeing as
forms of touching (Stewart 2005, p. 61).

The skin and the sense of touch are essential in the 'philosophy of mingled bodies'
(Connor 2005, p. 322) of Michel Serres:

In the skin, through the skin, the world and the body touch, defining their common border.
Contingency means mutual touching: world and body meet and caress the skin. I do not like

to speak of the place where my body exists as a milieu, preferring rather to say that things mingle [. . .] The skin intervenes in the things of the world and brings about their mingling.

(Connor 2005, p. 322)

In addition to rendering a diffuse and dynamic boundary, the haptic body sense integrates our experiences of the world and ourselves (Fig. 30.7).

The experience of the self is primarily a haptic continuum rather than a cerebral entity and recollection. Also Serres associates the capacity of self-awareness with the skin and the faculty of touch (Connor 2005, p. 323). 'How would the painter or poet express anything other than his encounter with the world', asks Merleau-Ponty poetically (Kearney 1994, p. 82), and this remark surely also applies to the expressions of architecture.

Even visual perceptions are fused and integrated into the haptic continuum of the self; my body remembers who I am and how I am located in the world. At the moment of waking up from his sleep, the protagonist of Marcel Proust's *In Search of Lost Time* reconstructs his identity and location through 'the composite memory of its [his body] ribs, its knees, its shoulder-blades' (Proust 1913/1992, pp. 4–5).

It is evident that the miraculous consistency, continuity, and permanence of the experiential world cannot arise from fragmentary visual percepts; the world is held together by a haptic awareness and the continuum of the sense of self. My sensing and sensual body is truly the navel of my world, not merely as the viewing point of a central perspective, but as the sole locus of integration, reference, memory, and imagination.

Fig. 30.7 Design for the touch of hand. Juhani Pallasmaa, door pull studies based on the grip of three fingers, bronze, 1991.

Photograph: Rauno Träskelin. Source: Juhani Pallasmaa Architects, Helsinki.)

Sensory understanding

The sensory systems are not only passive receptors of stimuli; they constantly stretch out, seek, investigate, and shape the entity of the world and ourselves. My senses and bodily being are centres of tacit knowledge, and they structure my entire being-in-the-world. All the senses as well as my very being 'think', in the sense of processing, structuring, and grasping utterly complex existential situations. Phenomena of art and architecture are essentially engaged with our sense of existential understanding; works of art are encountered and lived rather than understood intellectually. As Jean-Paul Sartre states: 'Understanding is not a quality coming to human reality from the outside; it is its characteristic way of existing' (Sartre 1993, p. 9).

We need to distinguish a silent existential or lived knowledge that is distinct from conceptual knowledge attached to intelligence, concepts, and language. Yet, the significance of embodied and existential understanding is grossly underestimated in contemporary educational philosophies.

Scientists associate the evolution of the human brain with the development of the hand as a precision instrument, and Martin Heidegger, among others, extends the sensory processes of thinking to the hand:

[T]he hand's essence can never be determined, or explained, by its being an organ which can grasp [. . .] every motion of the hand in every one of its works carries itself through the element of thinking, every bearing of the hand bears itself in the element. All the work of the hand is rooted in thinking.

(Heidegger 1977, p. 357)

Interplay and fusion of the senses

During the past couple of decades, numerous writers have pointed out the biased dominance of the eye in the Western culture, 'the hegemony of vision' (Levin 1993), and especially in today's reality of mass-produced visual imagery. However, a characteristic of vision, that has been studied much less, is the implicit tendency of vision to interact and integrate with the other sense modalities (see essays by Spence, Chapter 4, and by Melcher and Zampini, Chapter 14, this volume). We learn about the optics of vision and the mechanics of perspectival representation, but not about the thickness and impurity of vision, the essential merging of other sensory modalities with vision. Even the current interest in the significance of the senses continues to regard them as independent and detached sensory realms instead of understanding our sensory relation with the world as a fully integrated existential complex of interaction. 'The hands want to see, the eyes want to caress', as Goethe already provocatively argued (quoted in Hodge 1998, p. 130).

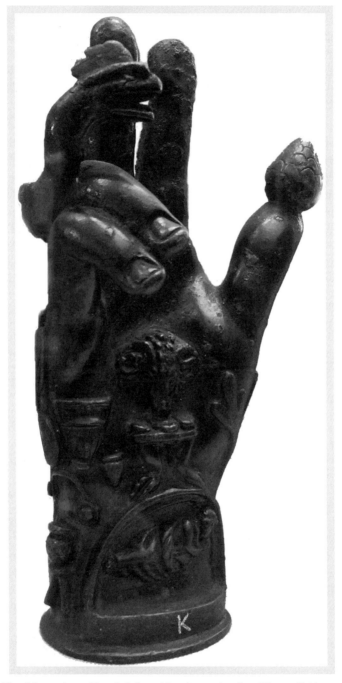

Fig. 30.8 *The Mysterious Hand.* A hand in the attitude of benediction embellished with charms to increase its power, late Roman period, bronze. British Museum, London.

(Photograph: Mike Young.)

In the words of Merleau-Ponty:

We see the depth, the smoothness, the softness, the hardness of objects; Cézanne even claimed that we see their odour. If the painter is to express the world, the arrangement of his colours must carry with it this indivisible whole, or else his picture will only hint at things and will not give them in the imperious unity, the presence, the unsurpassable plenitude which is for us the definition of the real.

(Merleau-Ponty 1964, VII)

A profound painting, a landscape, still-life, or an abstract image, is not only what it seems to portray; every significant artistic image is a world, a microcosmic and condensed representation of the world, or perhaps more precisely, of the human condition and destiny in the world. An architectural work must likewise generate an indivisible complex of impressions in order to mediate a sense of life and project the authority of a complete microcosm. A profound building merges with our lived world and becomes part of it.

In his seminal book *Art as Experience*, first published in 1934, John Dewey points out suggestively the significance of this sensory interplay, exchange, and integration:

Qualities of sense, those of touch and taste as well as of sight and hearing, have aesthetic quality. But they have it not in isolation but in their connections: as interacting, not as simple and separate entities. Nor are connections limited to their own kind, colours to colours, sounds with sounds [. . .] The eye, ear and whatever, is only the channel *through* which the total response takes place [. . .] In seeing a picture, it is not true that visual qualities are as such, or consciously, central, and other qualities arranged about them in an accessory or associated fashion. Nothing could be further from the truth [. . .] When we perceive, by means of the eyes as causal aids, the liquidity of water, the coldness of ice, the solidity of rocks, the bareness of trees in winter, it is certain that other qualities than those of the eye are conspicuous and controlling in perception. And it is as certain as anything can be that optical qualities do not stand out by themselves with tactual and emotive qualities clinging to their skirts [. . .] Any sensuous quality tends, because of its organic connections, to spread and fuse.

(Dewey 1980, pp. 122–4)

We do not only touch with vision, but we also induce, project, and experience auditive, olfactory, and gustatory qualities through visual perceptions. Besides, all our perceptions are in constant but unnoticed interaction with memories, dreams and fantasies. We are able to grasp the full and integrated properties and qualities of the physical world because we are ourselves part of the same 'flesh of the world'.[3]

Merleau-Ponty also argues strongly for the unavoidable and instant integration of the senses: 'My perception is [therefore] not a sum of visual, tactile and audible givens: I perceive in a total way with my whole being: I grasp a unique structure of the

[3] Merleau-Ponty describes the notion of the flesh in his essay 'The Intertwining – The Chiasm' in *The Visible and the Invisible*, Claude Lefort, ed.. Northwestern University Press, Evanston, IL., fourth printing, 1992: 'My body is made of the same flesh as the world . . . this flesh of my body is shared by the world [. . .]' (p. 248); and, 'The flesh (of the world or my own) is [. . .] a texture that returns to itself and conforms to itself' (p. 146). The notion derives from Merleau-Ponty's dialectical principle of the intertwining of the world and the self. He also speaks of the 'ontology of the flesh' as the ultimate conclusion of his initial phenomenology of perception. This ontology implies that meaning is both within and without, subjective and objective, spiritual and material. See Kearney (1994).

thing, a unique way of being, which speaks to all my senses at once' (Merleau-Ponty 1964b, p. 48). Bachelard calls this sensory interaction 'the polyphony of the senses' (1971, p. 6). 'The senses translate each other without any need of an interpreter, and are naturally comprehensible without the intervention of any idea', Merleau-Ponty claims (1962, p. 235). Altogether, in normal situations of life the senses do not mediate specific, detached, and categorized percepts. All sensations are integrated in the full experience of the world and of ourselves, our full existential experience, and sense of life.

Research in the neurosciences provides swiftly increasing information on the extraordinary interconnectedness and interactions of the various sensory areas of the brain (Sachs 2005, p. 33). The flexibility of the human sensory complex has also become evident in studies of the sensory capabilities of the blind. 'The world of the blind, of the blinded, it seems, can be especially rich in such in-between states – the intersensory, the metamodal – states for which we have no common language', Oliver Sachs argues, continuing: 'And all of these [. . .] blend into a single fundamental sense, a deep attentiveness, a slow, almost prehensible attention, a sensuous, intimate being at one with the world which sight, with its quick, flickering, facile quality, continually distracts us from' (Sachs 2005, p. 36).

SENSES IN EXPERIENCING ARCHITECTURE

Spaces, places, and buildings are undoubtedly encountered as multisensory lived experiences. Instead of registering architecture merely as visual images, we scan our settings by the ears, skin, nose, and tongue. The suggestions that the sense of taste would have a role in the appreciation of architecture may sound preposterous. However, polished and coloured stone as well as colours in general, and finely crafted wood details, for instance, often evoke an awareness of mouth and taste. Carlo Scarpa's architectural details frequently evoke sensations of taste. Adrian Stokes, the British artist and writer writes appropriately of the 'oral invitation of Veronese marble' (Stokes 1978, p. 316).

Every piece of architecture has its auditive, haptic, olfactory, and gustatory qualities, and those qualities even give the visual percept its sense of fullness and life, in the same way that a painting of Claude Monet, Pierre Bonnard, or Henri Matisse evokes a full sense of lived reality. Profound architectural experiences also evoke the sensations of gravity and balance, near and far, in front and behind. In addition to the physical and material qualities, architecture also conditions our sense of duration and time, historicity, and silence.

Structuring and articulating time—slowing down, halting, speeding up, reversing— is as important in architecture as the manipulation of space. And more importantly, we do not live in physical settings like being on a stage; the space creates a continuum with our mental space and our very sense of self. As I occupy a space, the space occupies me forming a chiasmatic singularity. Rainer Maria Rilke has introduced the poetic

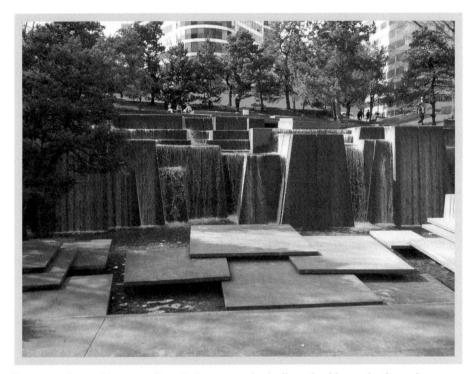

Fig. 30.9 An architecture for all the senses including the kinaesthetic and olfactory senses. The design creates countless places for intimate or group encounters. Lawrence Halprin, *Auditorium Forecourt* (now Ira Keller Fountain), 1956. Portland, Oregon.

(Photograph: courtesy of Portland Water Bureau.)

notion of *Weltinnenraum*, the inner space of the world (Enwald 1997, p. 8). An instant unconscious exchange takes place; I project my body, memories and values on the space and the space becomes part of me and my consciousness. 'I am what is around me', Wallace Stevens, the poet, argues (1990, p. 86). 'I am the space where I am', establishes Noel Arnaud, another poet (quoted in Bachelard 1969, p. 137), and finally, 'I am my world', Ludwig Wittgenstein, the philosopher, concludes (1972, p. 68).

A particularly important aspect of architectural experience is the unconscious tactile perception concealed in vision; as John Dewey and Merleau-Ponty argue, we experience the weight, texture, temperature, and moisture of materials and surfaces, and these hidden qualities make the scene inviting or repulsive, protective or threatening. The sense of alienation, and even necrophilia, often encountered in buildings of today arises, at least partly, from the tactile poverty, abstraction, and unreality of the unconscious haptic experience mediated by vision. The routine curtain wall office buildings in any city today exemplify this feeling of outsideness and alienation, or 'existential outsideness', to use the powerful notion of Edward Relph.[4] The immateriality and

[4] 'Existential outsideness involves a selfconscious and reflective uninvolvement, an alienation from people and places, homelessness, a sense of the unreality of the world, and of not belonging.' Edward Relph (1976). *Place and Placelessness*, p. 51. Pion Limited, London.

transparency of today's architecture that are fundamental expressions of modernity frequently contribute to this alienating sense of unreality as a consequence of the poverty of the sensory and haptic experience. Instead of living in a world of the veracity of matter and duration that would strengthen our very sense of self, we occupy the unreal world of immaterial and passing images that tend to alienate us even from ourselves, from our full experience of life.

The mental task of architecture is to emancipate the senses and to strengthen the existential foothold, as well as the sense of reality and self. The existential sense, invigorated by poetic images, also emancipates the capacities of dreaming, imagination and desire. Profound architecture always turns the attention away from itself back to the lived world and ourselves. The art of architecture is fundamentally not about creating objects of visual beauty, but about the mystery of human existence and how to understand our very being in the world.

REFERENCES

Ackermann D (1991). *A Natural History of the Senses.* Vintage Books, New York.

Asplund EG (1936). *Konst och Teknik* [Art and Technology]. Byggmästaren, Stockholm.

Bachelard G (1969). *The Poetics of Space.* Beacon Press, Boston, MA.

Bachelard G (1971). *The Poetics of Reverie.* Beacon Press, Boston, MA.

Barbara A and Perliss A (2006). *Invisible Architecture: Experiencing Places through the Sense of Smell.* Skira, Milan.

Blesser B and Salter LR (2006). *Spaces Speak, Are you Listening?: Experiencing Aural Architecture.* The MIT Press, Cambridge, MA.

Bloomer KC and Moore CW (1977). *Body, Memory and Architecture.* Yale University Press, New Haven, CT.

Calvino I (1988). *Six Memos for the Next Millennium.* Vintage Books, New York.

Casey ES (2000). *Remembering: A Phenomenological Study.* Indiana University Press, Bloomington, IN.

Classen C (2005). *The Book of Touch.* Berg Publishers, Oxford.

Connor S (2005). Michel Serres' five senses. In D Howes, ed. *Empire of the Senses*, pp. 318–34. Berg Publishers, Oxford.

Dewey J (1980). *Art As Experience.* The Berkley Publishing Group, New York.

Enwald L, ed. (1997). Lukijalle. In *Rainer Maria Rilke: The Silent Innermost Core of Art: Letters 1900–1926.* TAI-teos, Helsinki.

Grosset PA (1987). Eyes which see. *Casabella*, **115**, 531–2.

Heidegger M (1977). What calls for thinking. In D Krell, ed. *Martin Heidegger Basic Writings*, pp. 341–58. Harper & Row Publishers, New York.

Hodge B, ed. (1998) *Not Architecture But Evidence That It Exists – Lauretta Vinciarelli: Watercolours.* Harvard University Graduate School of Design, Harvard, MA.

Howes D (2005). Hyperesthesia, or The Sensual Logic of Late Capitalism. In D Howes, ed. *Empire of the Senses*, pp. 281–303. Berg Publishers, Oxford.

Jay M (1994). *Downcast Eyes – The Denigration of Vision in Twentieth-Century French Thought.* University of California Press, Berkeley, CA.

Johnson M (1987). *The Body in the Mind: The Bodily Basis of Meaning, Imagination, and Reason.* The University of Chicago Press, Chicago, IL.

Kearney R (1994). Maurice Merleau-Ponty. In R Kearney, ed. *Modern Movements in European Philosophy*, pp. 73–90. Manchester University Press, Manchester.

Lakoff G and Johnson M (1999). *Philosophy in the Flesh*. Basic Books, New York.

Le Corbusier (1959) *Towards a New Architecture*. Architectural Press, London, and Frederich A Praeger, New York.

Levin DM, ed. (1993). *Modernity and the Hegemony of Vision*. University of California Press, Berkeley, CA.

Malnar JM and Vodvarka F (2004). *Sensory Design*. University of Minnesota Press, Minneapolis, MN.

Merleau-Ponty M (1962). *Phenomenology of Perception*. Routledge and Kegan Paul, London.

Merleau-Ponty M (1964a). Cezanne's doubt. In *Sense and Non-Sense*, pp. 9–25, H Dreyfus and P Dreyfus trans. Northwestern University Press, Evanston, IL.

Merleau-Ponty M (1964b). The film and the new psychology. In *Sense and Non-Sense*, pp. 48–59, H Dreyfus and P Dreyfus trans. Northwestern University Press, Evanston, IL.

Montagu A (1986). *Touching: The Human Significance of the Skin*. Harper & Row, New York.

Pallasmaa J (2005). *The Eyes of the Skin: Architecture and the Senses*, John Wiley & Sons, London.

Pallasmaa J (2009). *The Thinking Hand: Embodied and Existential Wisdom in Architecture*, John Wiley & Sons, London.

Proust M (1913/1992). *In Seach of Lost Time: Swann's Way*, CK Scott Moncriett and T Kilmartin trans. Random House, London.

Sachs O (2005). The mind's eye: what the blind see. In D Howes, ed. *Empire of the Senses*, pp. 25–42. Berg Publishers, Oxford.

Sartre J-P (1993). *The Emotions: An Outline of a Theory*. Carol Publishing Co., New York.

Serres M (1995). *Angels: A modern Myth*. Flammarion, New York.

Soesman A (1998). *Our Twelve Senses: Wellsprings of the Soul*. Hawthorn Press, Stroud.

Stevens W (1990). Theory. In *The Collected Poems*. Vintage Books, New York.

Stewart S (2005). Remembering the Senses. In D Howes, ed. *Empire of the Senses*, pp. 59–69. Berg Publishers, Oxford and New York.

Stokes A (1978). Smooth and Rough; *The Critical Writings of Adrian Stokes*, vol 2, pp. 213–56. Thames and Hudson, London.

Vidler A (1978). The Writing on the wall: architectural theory in the late Enlightenment. *Architectural Design*, **48**, 57–9.

Wilson CSJ (1995). *The Other Tradition of Modern Architecture: The Uncompleted Project*. Wiley Academy Editions, Chichester.

Wittgenstein L (1972). *Tractatus Logico Philosophicus eli Loogis-filosofinen tutkielma, proposition 5.63*, p. 68. Werner Söderström, Porvoo and Helsinki.

Wittkower R (1988). *Architectural Principles in the Age of Humanism*. Academy Editions, London/St. Martin's Press, New York.

MULTIMODAL, INTERACTIVE MEDIA AND THE ILLUSION OF REALITY

ELENA PASQUINELLI

CECILIA is sitting in a movie theatre and watching *The Purple Rose of Cairo* (1985) once again. Suddenly, Tom Baxter, the main character, comes out from the screen and invites Cecilia for a romance. Tom, a character, has become alive and now walks with her in the real world, while Cecilia, the real girl, can have a walk in the shining, fictional world of *The Purple Rose of Cairo* (Fig. 31.1). To Cecilia, Tom is no longer a representation, a moving image with sound, which excites her imagination to behave 'as if' he was real. Cecilia can now believe in the reality of Tom.

Do we believe in the reality of fictional characters, places, and worlds, as Cecilia believes in the reality of Tom? Can we forget the presence of the medium or the fact that what we perceive is not 'filmed' reality? Can we feel as if being there, in the fictional world, or as if fictional characters were here in our real world?

It is a fact that we are strongly captivated by the story, that we are moved by fictional characters and worlds. But are we fooled as to believe that what we perceive is real?

Fig. 31.1 Poster of the movie 'The Purple Rose of Cairo' (directed by Woody Allen, 1985).

ILLUSION OF REALITY IN
TRADITIONAL MEDIA

It is meaningful that one of the seminal myths of cinema consists of the image of terrified spectators running away from the theatre during the first projections of *Arrival of a Train at La Ciotat* (1896) (Loiperdinger and Elzer 2004). This myth aptly describes the fact that cinema, since its birth, has aimed to be the most 'illusionistic' of arts. Movement of images is the first ingredient of this achievement, in contrast with the stillness of photography. Later, the introduction of sound will reinforce this realism. But the illusionism of cinema will not be bound to the reproduction of reality, and to Lumière's documentary style. Since the very beginning of cinema history, authors like Georges Méliès have exploited the new medium for presenting their audiences with fantasy worlds, trips to the Moon, uncanny monsters. And creative authors like René Clair have accused sound of spoiling cinema and ruining the capacity of spectators to forget reality and enter a fictional world (Clair 1985). In 1817, Coleridge the poet had described this mental state as 'suspension of disbelief' (Coleridge 1817). Others have referred to it as an 'illusion of life' or 'illusion of reality' (Thomas and

Johnston 1984): the illusion that fictional characters, including animated characters, are real and alive.

Philosophers have long discussed the nature of fiction and of the public's engagement in fiction. An exemplary debate was raised in 1975 by a paper from philosopher Colin Radford, who introduced the 'paradox of fiction' (Radford 1975). In short, Radford asked: how can we be moved by the fate of Anna Karenina? In fact we can only be moved if we believe in the existence of Anna Karenina (if we hold existence beliefs). But we know that Anna Karenina is not real (we do not hold existence beliefs). And in spite of this, we are moved, irrationally moved. The subsequent debate shows a substantial accord on the fact that existence beliefs are not sufficient and not necessary in order to explain the public's engagement and emotions produced by fiction. It is a fact that reactions to fiction are similar but not identical to reactions to reality and beliefs (Carroll 1990; Currie 1995; Walton 2001). First of all, behavioural reactions are mostly inhibited. Spectators might close their eyes, startle, cry, shout, but they do not go further as if they did really believe in the reality of what they see. They do not call the police or flee away from horror movies. And if we accepted the myth that Lumière's spectators did leave their seats because they did believe in the existence of the filmed train, we should nevertheless acknowledge that this phenomenon has not often been reproduced. Second, emotions and beliefs generated by cinema and fiction in general have a short duration: they disappear more or less with the end of the movie. In short, it is true that we are moved by the fate of Anna Karenina, thrilled by the menace of green slime and horrified by blood-sucking entities, but we do not come to believe that our world is populated by monsters or grieve for long. This difference can be explained if we assume that adults who endorse fictional experiences just *pretend* to believe in the existence of the green monster, and for consequence pretend to feel (or really feel) afraid (Walton 1978, 2001). Like mud and sand in children's games of make-believe, images, sounds, and words are the props that excite, sustain, and constrain a mental activity that does not consist in forming beliefs, but imaginings. Imagination and belief must nevertheless be related if we want to account for the similarity—and not just for the difference—between responses to the real world and responses to fictional ones: because during the green monster movie we are afraid or quasi-afraid. This is possible if we consider—as Currie does (Currie 1995)—that the activity of imagination which responds to fiction is a form of simulation in which beliefs are run offline. This means that while beliefs are cut off from their normal causes (the existence of some entity or event) and from their behavioural consequences (actions and full emotions), the connections that normally hold between beliefs (a monster is a dangerous creature) and between beliefs and emotions (a monster is frightening) are preserved. Fictional worlds that are capable of inducing this belief-like mental state of imagination can be defined as *believable worlds*. Since theories based on existence belief can explain only the similarity between responses to real and fictional worlds, theories based on imagination have a greater explanatory power, because they can account also for the differences.

ILLUSION OF REALITY IN NEW MEDIA

The debate about the illusion of reality has recently been reactualized by the development of 'virtual reality' applications of various kinds. Virtual reality applications include new art forms, such as virtual drama, and in general interactive forms of creative and/or aesthetic experience. The term 'virtual reality' ambiguously refers to a form of representation and to the technologies that mediate representations that are ideally multimodal and interactive. Another ambiguity is introduced by the notion of 'immersion' in the virtual world. Immersion is obtained thanks to multimodal stimulation or immersive systems, like head-mounted displays or gigantic screens that cover at least three of the walls of the virtual reality room. It is not uncontroversial whether the term 'virtual reality' refers to immersive systems only, or can be applied to more diffused systems like video games and online games (Slater and steed 2000, Lombard and Ditton 1997; Witmer and Singer 1998). For these reasons, I prefer to illustrate my use of the term 'virtual reality' through some examples.

I will start with *LifePlus* (Figs. 31.2 and 31.3), an interactive drama set up in the real environment of the Pompeii ruins (for this reason called 'mixed reality system'). The application consists of the simulation of a day in ancient Pompeii life. Five realistic virtual humans interact with each other and manipulate objects around a tavern following a script. Users wear a head-mounted display and witness the representation while moving through real ruins. Hair and cloth animation, skin rendering, behavioural animation, facial emotion expression, intentionality, desires, beliefs, and actions are accurately represented (Papagiannakis et al. 2002, 2005). Virtual characters of the virtual world do not have, however, any 'awareness' of the real users: they do not react to their presence, but continue to play their script. Additionally, real users simultaneously exploring the scene cannot interact between each other. It is as if Cecilia could jump into the world of the *Purple Rose of Cairo* without being noticed by Tom Baxter and the other characters.

Fig. 31.2 Reconstruction of a travem in Pompeii, with virtual animated characters. Project Life Plus, MIRALab, University of Geneva.

(Source: http://lifeplus.miralab.unige.ch/.)

Fig. 31.3 Interacting with virtual animated characters in Pompeii ruins. Project
Life Plus, MIRALab, University of Geneva.

(Source: http://lifeplus.miralab.unige.ch/.)

Other experiences of virtual drama have been conceived to allow users to interact
with virtual agents embedded into the virtual environment, and to actively modify
the original script of the play. This is the case in *Edge of Intention* (Reilly 1996) and
Animated puppets (Doyle 2002, Hayes-Roth 2001): the fictional world is inhabited
by four ball-like creatures called Woogles (Fig. 31.4). One of them is controlled by the

Fig. 31.4 The Woggles in the world called 'Edge of Intention' (interactive
animated art piece). A product of the Oz project, Carnegie Mellon University.

(Source: http://www.cs.cmu.edu/.)

Fig. 31.5 An avatar in the virtual world of *Second Life.*

(Source: http://community.flexiblelearning.net.au/.)

user, while the others are controlled by the computer. There is no set story, but the Woogles have personalities, emotions, and engage in social behaviours. Spectators become actors in a not-completely predefined world. The world is, nevertheless, structured by the definition of the environment, personality, and possible reactions of the computer-guided characters. There's no interactivity between human users.

Interactivity between users is, on the contrary, an essential attribute of *Second Life*, a synthetic online world where agents are digital representations of users (called 'avatars'). In addition to human-to-human social interaction, *Second Life* users are enabled to create virtual objects of art, pieces of furniture, and architectural buildings. This is done by combining and modifying elementary forms (a sort of virtual and flexible Lego building set). Complex objects are subsequently associated with colours and textures, but also sounds in order to create multimodal objects, including art objects (Figs. 31.5 and 31.6).

Fig. 31.6 Virtual environment with avatars in *Second Life.*

(Source: http://www.jmir.org/.)

It is not difficult to imagine a further evolution in which users will be able to feel and not just to see the texture of the virtual objects of art (Frisoli et al. 2006).

This is the scope of so-called haptic devices, a crucial feature of virtual reality systems. Force feedback or haptic devices exploit one specific component of active touch: the fact that material objects resist (oppose a contrary force to) the force which is impressed by the touching agent. This force is perceived through deep touch receptors that are located in the muscles and joints rather than in the skin. It conveys sensations that are identified by users as specific textures, materials, or as specific shapes. A 'haptic shape' can then be represented by producing a characteristic pattern of resistance and by applying it—thanks to a material, suitable device—to the fingers, hand, or arm of the user. Haptic devices are exemplary of the multimodal possibilities and of the interactive nature of virtual reality systems. Perceptual experience depends, as in perception of the real world, on the specific perceiver's actions and exploratory movements (other devices exist that passively stimulate the skin through vibrations and provide tactile, superficial sensation, or even temperature perception). Haptic devices are currently in use for producing virtual museums of *Pure Form* in which users can visualize three-dimensional graphic reproductions of distant works of art (sculptures), and also explore them with their hands and feel their shape from the contact (Carrozzino et al. 2005). In a creative perspective, virtual sculptures could also be modified and exploration could become active creation of new works of haptic or multimodal art (Figs. 31.7 and 31.8).

It is a fact, then, that thanks to virtual reality systems, new forms of aesthetic, social, and creative experiences are within reach that enlarge the field of human possibilities. But the question is: are virtual reality systems responsible for a qualitative shift from the realm of traditional engagement through imagination to the realm of illusion of reality? Does virtual reality make a real, qualitative difference in the perception and cognition of users by inducing existence beliefs?

An optimistic answer is largely shared in the domain of virtual reality (Lombard and Ditton 1997; Witmer and Singer 1998; Dinh et al. 1999; Slater and Steed 2000). Applications like *Second Life*, *LifePlus*, or the *Museum of Pure Form* would then be better candidates than traditional cinema to produce a compelling illusion of reality. Multimodality and interactivity are identified as the responsible factors for this qualitative shift.

Optimism about the capacity of new media for producing full illusions of reality encounters nonetheless a major conceptual difficulty: the notion of illusion of reality has not yet received an uncontroversial definition. How, then, can we measure a qualitative shift towards an objective that we are not able to precisely identify? In the literature about virtual reality we encounter, in fact, at least three different definitions of 'illusion of reality': illusion of non-mediation, fidelity, and illusion of being there. In what follows I will show that each of these uses of the term 'illusion of reality' corresponds to specific cognitive and perceptual attitudes. Furthermore, each of them entails different possibilities of success, different enhancing conditions, and different measures of achievement. My claim is thus that designers of creative and artistic experiences with virtual reality systems should rather carefully choose their objective rather than pursuing an underspecified idea of illusion of reality.

Fig. 31.7 Touching the virtual reproduction of the scultpure' St John the Baptist'
by Nicola and Giovanni Pisano (1300) in the Museum of Pure Form, a project of
PERCRO laboratory, Scuola Superbre Sant'Anna.

(Source: http://www.pureform.org/, photo courtesy of Massimo Bergamasco, Antonio Frisoli.)

Illusion of reality as illusion of non-mediation

The first definition we can give of the illusion of reality is: illusion of non-mediation.
The user fails to acknowledge (cognitively and perceptually) the presence of the tech-
nological medium that is responsible for the experience of the artificial world:
'an illusion of nonmediation in which users of any technology overlook or misconstrue
the technology's role in their experience' (International Society for Presence Research
2000). The failure to acknowledge the presence of the medium would produce the
'hallucination of an apparently concrete and persisting three-dimensional object in

Fig. 31.8 Experiencing the Museum of Pure Form in a highly immensive Virtual
Reality System.

(Source: http://www.pureform.org/, photo courtesy of Massimo Bergamasco, Antonio Frisoli.)

the real world . . .' (Dennett 1991, p. 7). The illusion of non-mediation thus reminds us of the famous mental experiment of the brain in a vat (Putnam 1982). A mad scientist has removed the brain from the body of a person. The brain is now kept alive in a vat, thank to a special liquid. Wires connect the brain to a computer which stimulates the brain so as to produce perceptual sensations. These sensations include sensations of movement, and all the sensations that a human being can receive in response to their actions in a real world. Only, the world is a synthetic, digital simulation produced by the computer. The mental experiment of the brain in a vat has been used in order to illustrate the sceptical argument that we cannot know whether there is a world outside or if we are just brains in vats or . . . lost in a virtual reality environment. Science fiction experts can recognize the basic plot of *The Matrix* (1999), the direct brain recordings of *Strange Days* (1995), the basic features of cyberpunk literature. As people immersed in the matrix or brains immersed in a vat, deluded users of virtual reality systems are supposed to fail perceiving the medium (perceptual component) *and* to forget their knowledge of the medium (cognitive component). The illusion of non-mediation is double: perceptual and cognitive.

This definition attracts an objection on the side of motor theories of perceptual functioning (O'Regan and Noë 2001; Stoffregen and Bardy 2001). According to these theories, perception is not the simple recording of states of the world: the content of perception varies both along factual conditions (how the world is) and along other conditions, such as the way the perceiving organism moves. Let us discuss an example. A visual representation, for instance a statue of the *Museum of Pure Form*, is transmitted through a head-mounted display, while an exoskeleton mediates haptic representations of the contours of the same statue. The user perceives the presence of both media through their tactile system. The medium is then perceptually acknowledged as part of the factual content of perception. When the visual stimulus is presented through large screens that cover the virtual reality room by transforming it into what is called a 'cave', the visual medium is no longer experienced in this direct fashion. Nonetheless, the presence of the medium could still affect the perceiver's relation to how things are: seeing a baseball game on television, for instance, structures the optical flow in a way that is different from seeing the same baseball game live, and the movements of the perceiver have a different effect on the perceptual result in the two situations (Stoffregen 1997); immersion in a flight simulator will leave behind the vestibular components that are typical of the same multimodal experience in the real world (Stoffregen et al. 2003). The presence of a medium can thus have an effect upon perspectival or motor contents of perception, even in the case in which the medium would not affect the factual contents. These effects make clear the difference between mediated and non-mediated conditions, and perceptually inform the user about the mediated nature of its experience.

In addition to non-interpretative, natural capacities, other interpretative, learnt capacities are used in order to make sense of experiences with virtual and fictional environments. A long apprenticeship with make-believe games paves the way to adults' capacity of dealing with representations that are not displayed though a particular perceptual medium. Can knowledge of wearing material devices (even if they are not

perceived) and awareness that the experience is of an artificial world be evicted from the mind of the user?

Weaker versions of this definition exist, however, that do not entail similar objections. It has been proposed, for instance, to consider the 'illusion of non-mediation' as an attentional state (Witmer and Singer 1998; Slater and Steed 2000). Attention can alternatively be focused on the virtual world (like the world represented in *Second Life*), the mixed world (the real Pompeii ruins with virtual agents moving around), or on the real room and devices. Shifts towards the second condition can be provoked by sounds (produced by other people in the room, by the functioning of the devices), by uncomfortable conditions (heavy, constraining haptic or visual devices, nausea), or other perceptual agents of distraction (odours from the kitchen announcing lunchtime). These shifts can be qualitatively and quantitatively measured; they will quantify the compelling power of the virtual world in engaging the user's attention to focus on a selected group of stimuli. However, shifting the focus of attention cannot be considered as an illusion, because there is no error. The weaker version of the illusion of non-mediation is, then, not an illusion at all. It is now an empirical matter whether this compelling focalisation of attention is enhanced by new media in comparison with traditional ones, and which media characteristics are more effective. Multisensoriality and immersion in the virtual environment seem to be rather effective (Witmer and Singer 1998; Dinh et al. 1999; Slater and Steed 2000). In fact, they both isolate users from the stimuli that come from the real world and require their attention in order to cope with multiple stimuli and to correctly act.

Illusion of reality as fidelity

The second definition of the term 'illusion of reality' is: illusion of fidelity to reality. Users are aware that their experience is the effect of a medium, but believe that the medium reproduces or presents reality. Now, this is not true, since the medium represents events that do not occur in reality. As for the illusion of non-mediation, the fact that the user is mistaken is a crucial condition for ranging the experience between illusions. *Cannibal Holocaust* (1980), *The Blair Witch Project* (1999), and fake snuff movies all try to establish this form of illusion or hoax: that a fiction film is, in fact, a documentary that represents actual reality. Let us consider the most famous case of such a hoax. In 1938, a series of newsflashes interrupted a music programme of CBS in the United States: it was Orson Welles announcing a Martian landing close to a US farm. Some audiences took the fake newsflashes for real, and panicked. Audiences knew that the sounds of destruction came from a radio and were recorded in a distant place from them, but some of them also thought they were listening at the sound produced by real events. The smuggling of fictional contents in place of real ones is the object of strict rules in several ethical codes of communication targeting hoax and fraud (Steele and Black 1999). At the time of Welles' broadcast of the *War of the Worlds*, CBS escaped punishment because the audience was reminded of the fictional nature of the performance several times during the broadcast. Nonetheless, CBS was

formally invited to avoid the 'we interrupt this programme' device for fiction. Since then, US television broadcasts featuring realistic news bulletins post messages to inform audiences of the fictional nature of the spectacle. It is reasonable to require that new media, such as virtual reality, do not escape this rule of ethical communication.

The form of fidelity to reality which is invoked in the domain of virtual reality is of a special type: it concerns the perceptual and eventually motor aspects of the experience and is called *subjective fidelity* (Riccio 1995). It consists in the extent of subjectively experienced similarity between simulator and the real-life situation, hence between the simulator and the simulated (Stoffregen et al. 2003; Morice et al. 2008). Thus it is grounded in a comparison between reality and simulation.

The user of a flight simulator who finds sensations produced by the simulation very similar to sensations experienced during natural experiences thus continues to acknowledge the perceptual medium (the simulator), or the artificial nature of the experience. Again, mystification and misperception of the medium are not necessary conditions for undergoing the experience of subjective fidelity.

However, other forms of illusion can be useful for producing subjective fidelity. Subjective fidelity is, in fact, significantly different from realism as the simulation of the features of the world. As we have seen before, for instance, force-feedback devices cannot reproduce all the variety of tactile, kinesthetic, thermal stimulation that is produced by the manipulation of real objects. The sensation of touching a virtual representation of a statue through a state-of-the-art haptic device will, then, be far from the complexity of natural sensations generated by the touching of a real statue with no medium. However, the fidelity of the perceptual experience obtained through these systems can be enhanced or suitably modified by appropriate associations with visual stimuli. Multimodal devices can thus exploit multimodal illusions in order to produce fidelity through 'unrealistic' stimulations. Let us examine some examples of classic visuo-haptic illusions, as they have been described in literature, and as they can be exploited by multimodal displays. Gibson (1933) describes the following illusion: a subject moves his hand along a straight surface while looking through a prism that causes the surface to look curved; he feels it to be curved as well. Nielsen (1963) introduces the use of the mirror. The subjects follow a straight line with their hand in full sight; on some of the trials, a mirror is introduced, unbeknownst to the subjects, so that they see another person's hand (which they believe to be their own): the subjects continue to have the sensation that the seen hand is their own, but they also feel as if they had lost control over its movement. In both cases discrepant visual and haptic/proprioceptive information produces a vivid haptic/proprioceptive experience which does not correspond to the haptic/proprioceptive stimulation, but to the visual one. Other cognitive components can play a role in the aspect of the final percept, hence on subjective fidelity. Lederman et al. (1981) have presented the subjects of their experiments with two different abrasive surfaces, one to be examined by vision and the other by touch; the subjects were led to believe that they were exploring one and the same surface (the experimenters induced an assumption of unity). When asked to match the perceived surface with one from a set of surfaces, the results showed that touch is more influential when the subject is requested to evaluate the roughness of a

surface, while vision is more influential when the subject is requested to evaluate the spatial distribution of the dots for the same surface: the kind of solution adopted thus varies with the verbal instruction assigned to the subjects. This fact indicates that narratives, stories and even simple verbal instructions can influence what the user will feel and thus have an effect on subjective fidelity.

Perceptual fidelity can be evaluated through subjective measures, like free reports in which the user evaluates the degree of similarity between sensations in the artificial set and sensations experienced during comparable natural situations (Stoffregen et al. 2003). Rather than asking 'how real does this seem?', a better question might be 'how closely does this resemble the real situation?' Stoffregen et al. (2003) propose the concept of action fidelity as a measure of the perception of fidelity for interactive systems (like flight simulators): when actions in the virtual world are comparable to actions in the real one, then the system shows a great fidelity.

This measure makes sense only in the case of perceptual experiences that, moreover, aim at reproducing real experiences. This can be the case for the *Pure Form* museum. The user will, in fact, be able to compare how the simulated experience resembles previous experiences in real museums. But this measure will be unsuitable for virtual theatre with caricatured, purely fictional characters such as the Woogles. In this case, the concept of fidelity will, rather, be applied to the complexity of the character's personality, the reactions of computer-guided characters to the user-guided character's actions, and their relative coherence with natural human beings (a form of social rather than a perceptual or motor fidelity). In the same way, multimodality will lose much of its power as an enhancing factor of fidelity, while the nature of the social interactions will take the most importance.

Illusion of reality as illusion of transportation

A third possible definition of the term 'illusion of reality' is: illusion of *being there* in the virtual environment (Riva et al. 2003; Slater and Steed 2000). Can users experience an illusion of being there *without* being mistaken about its fictional nature and without losing the awareness of mediation? In the literature about virtual reality, the illusion of non-mediation and the illusion of being there are confounded into the definition of presence: 'The International Society for Presence Research (ISPR) supports academic research related to the concept of (tele)presence, commonly referred to as a sense of 'being there' in a virtual environment and more broadly defined as an illusion of nonmediation in which users of any technology overlook or misconstrue the technology's role in their experience' (ISPR 2000). This is not necessarily so. I will consider that the illusion of being there is the label assigned to a group of illusions of position and movement (proprioceptive illusions) in the artificial environment, and of identification of parts of the body with artificial representations. Now, the experience of *local* perceptual illusions like these (rather than of a massive illusion of reality, or cognitive illusion) is compatible with the knowledge of the mediated nature of the experience. Perceptual illusions present, in fact, a special feature described as

'resilience to knowledge': they persist in spite of the fact that the subject of perception knows that what he or she is experiencing is an illusion.

Let us go back to one of our examples. *Second Life* users 'enter' the virtual world after having created an avatar of themselves, a virtual representation of their self. They see their avatar flying, assisting virtual expositions of art and performances, creating objects, manipulating them. The illusion of being there in the virtual environment is then equivalent to the illusion of moving when the avatar is seen moving, and to the illusion that, to some extent, the hands of the user are there where the hands of the avatar are manipulating virtual objects. We have, then, three main components in the 'illusion of being there': the first component is a general visual (or haptic, or acoustic) bias upon proprioception. The second component is an experience of spatial identification with some artificial entity, associated with an out-of-body experience induced by vision (a proprioceptive illusion biased by vision). The third component is an illusion of movement. In fact, users are often not allowed to move around while exploring the virtual world (they can do it in mixed reality like *LifePlus* or in immersive systems), and, for sure, they cannot fly. This component includes specific illusions of movement.

As an example of visual bias, in the previous section I have illustrated a proprioceptive illusion induced by vision, in which the subject feels as if the hand of someone else was their own (Nielsen 1963). There are many other examples of visual bias over other perceptual modalities (Hay et al. 1963; Rock and Victor 1964; Welch and Warren 1981; Mon-Williams et al. 1997; Holmes 2004). More recently, some experiments on out-of-body experience have used virtual reality in order to present experimental subjects with discrepant visual and proprioceptive information. These studies have independently confirmed the possibility, given certain conditions, of visual bias upon proprioception when the two are discrepant even for the whole body, and not only for limited parts of it like the hand (Ehrsson 2007; Lenggenhager et al. 2007; Miller 2007). Proprioceptive illusions so produced are currently exploited for the treatment of pathologies such as phantom limbs, stroke, hemiplegy, and spatial neglect—the success with pathologies other than phantom limbs is, however, still uncertain (Ramachandran et al. 1995; Altschuler et al. 1999; Sathian et al. 2000; Holmes 2004). Vision has long been considered the dominant perceptual modality in case of mismatch between information presented to the visual perceptual modality and information presented to the auditory, proprioceptive, or haptic modalities. The model of visual dominance has been contested, and evidence shows that all the sensory modalities contribute differently to the aspect of the final percept; however, the more precise, less variant information biases the less reliant one (Ernst and Buelthoff 2004). Nevertheless, it is justified to consider that vision normally dominates other modalities in spatial tasks, because vision is usually more precise and reliable for spatial location. So, vision can be very helpful in broadening the limits of non-immersive virtual reality systems.

In addition, the identification of a part of the body or self with artefacts (like avatars) seems to be possible, in certain conditions. In experimental conditions, for instance, a subject can feel a rubber hand placed in face of them as their own hand. The illusion is known under the name of 'fake hand illusion' or 'rubber hand illusion' (Tastevin 1937; Botvinick and Cohen 1998; Pavani et al. 2000; Austen et al. 2001): a subject watches

a rubber hand; the hand is stroked synchronously with their own hidden hand (positioned congruously with the rubber hand). Subsequently, subjects undergo an illusion of identification and an illusion of dislocation: they identify their hands with the rubber hand and feel their hands to be 'there', where the rubber hand is. It is then possible to quantify the illusion by measuring how close the felt position is to the real position of the rubber hand. It is worth noting that this illusion depends on both visual and tactile stimulation of the real hand. A variance of the rubber hand illusion can, in fact, be obtained without vision—with tactile and proprioceptive modalities (Ehrsson et al. 2005). In order to produce the same phenomenon with a digital rather than a rubber hand it would then be necessary to dispose of a multimodal virtual reality set that includes tactile or haptic devices. Another important aspect of the illusion is the level of 'realism' or fidelity that is required in order to generate the illusion. Can we undergo this kind of illusion with avatars that look like animals (as many *Second Life* avatars) or like Woogles? It is controversial whether the 'sense of ownership' and the displacement of the sensed position of the hand can be obtained with objects that do not resemble the human body—as suggested by Armel and Ramachandran (2003) but invalidated by Tsakiris and Haggard (2005). Evidence from the incorporation of tools seems to confirm that realism is not a necessary condition for the extension of the peripersonal space to hand-held tools (Holmes et al. 2004). Experiments in mediated conditions are required in order to validate the hypothesis that intermodal bias upon proprioception occurs during perceptual experiences with virtual agents and objects, and that users locate their body or parts of it in the place where their avatar is. For the time being, IJsselsteijn et al. (2006) have reproduced rubber-hand experiments in virtual (projected rubber hand and stimulus) and mixed reality (projected rubber hand and real stimulus) conditions, showing the presence of a weaker illusion in the two synthetic conditions than in the non-mediated one. Different factors can explain the difference. In all the 'natural' cases of visual bias upon proprioception, for instance, active movement and the activation of another perceptual modality (touch or audition) seem to be necessary conditions for the illusion to take place. The induction of proprioceptive illusions could hence depend on multimodality and interactivity.

The role of multimodality in the enhancement of proprioceptive illusions is confirmed by the third component of the illusion of 'being there': illusions of self-motion or vection. Vection illusions are illusions of movement that can be induced by vision, but also by audition and are enhanced by the combination of visual and auditory cues and of visual cues with vibration. Top-down processes seem to enhance the illusion as well: when the source of the auditory stimulation can be consistently interpreted with self-movement, chances of undergoing illusions of vection produced are increased (Riecke et al. 2005). The role of multimodality in the production of illusions of position and movement confirms the idea that virtual reality systems are the best candidates for producing effects of presence and movement in the synthetic world (Lombard and Ditton 1997; Witmer and Singer 1998). Virtual reality systems are, in fact, normally multimodal and haptic, and tactile and vibratory devices are increasingly added to visual and auditory displays. On the other hand, Holmes et al. (2004)

highlight the fact that the presence of discrepancies between proprioception and the visual position of the hand have disruptive effects on reaching tasks (measured in terms of lowered speed and of accuracy, that is, of the distance between the finger tip and the target to be reached).

This fact confirms a general consideration about the importance of coherence for successful behaviour (Stein and Meredith 1993), and is pragmatically significant for virtual reality contexts: the bringing about of illusions does necessarily not have positive effects, and while it enhances the sense of presence it can disrupt performance. For this reason, the production of illusions of presence and transportation cannot be considered as a universal desideratum for virtual reality applications.

BELIEVABILITY AND IMAGINATION

We have seen that the correct manipulation of multimodal stimuli can give rise to local illusions of movement and of presence in the setting of virtual dramas, virtual museums, or artistic landscapes, and in the use of virtual creative tools. These illusory phenomena are far from equivalent to the massive form of delusion which is described as illusion of non-mediation. They can be associated (but are not necessarily associated) with focalized attention. They can also be associated with judgements of fidelity to the perceptual experience of the parts of the real world or to social and motor behaviour of inhabitants of the real world. Focalized attention and the judgement of fidelity to a certain perceptual experience can never be considered as an illusion, even if the second can be sustained by multimodal stimulation. Proprioceptive illusions, attention, and subjective fidelity are, then, three important mental components of the experience of virtual or fictional worlds. Each of them can be differently and separately measured and enhanced in order to produce a more vivid, more engaging experience of virtual forms of art—performative, visual, or multimodal.

Subjective fidelity and multisensoriality can be especially important in virtual-reality training applications such as flight simulators, in tele-operation such as at-distance surgery, but also in cultural heritage settings like museums composed of representations of existing objects of art. On the contrary, in the domain of virtual arts, realism and also multisensoriality could present undesired drawbacks, while unrealistic experiences seem to be very effective in stimulating a rich and engaging activity of imagination.

We have said that visual, acoustic, and haptic representations work as props that awaken and constrain imagination. We have also seen that this particular form of imagination can be identified as the running offline of beliefs. Works of art or of fiction that are capable of exciting this kind of activity are 'believable'. Believable fictional worlds can be inhabited by green monsters, ancient Pompeiians, and Woogles. Believability is thus not the same as subjective fidelity, because believability does not require that the fictional world resembles the real one. It just requires that the representation succeeds

in exciting and constraining imagination towards the imaginings that are appropriate to that particular representation. Believability can thus be defined as the condition that enables users, audiences, and readers to imagine the specific world which is represented by the work of fiction, and of running the relevant beliefs offline. For these reasons, even abstract representations can be considered as believable (Walton 2001). If the representation is supposed to guide audiences in imagining colours, shapes, sounds, and bodily sensations in a certain way—and audiences do this—then the representation is believable as the representation of a perceptual world where colours, shapes, sounds, and bodily sensations occur in a certain way.

But it is possible that a work of art fails in exciting the relevant beliefs and imaginings that belong to the world that the work of art intended to represent. The work of art is not believable, then. What are the conditions that enhance or threaten believability? Believability seems to depend heavily on expectations. When expectations raised by the experience are unfulfilled or coherence between the elements of the experience is violated, one is not disposed to form beliefs, and judges the experience as unbelievable. This is shown in particular by experiences of conflict, like perceptual conflicts between perceptual modalities: prosthetic hands that look very realistic but feel hard and cold can raise a sense of uncanniness that immediately lowers believability (Mori 1970). In this case, believability concerns the belief that the hand is a real one. In the domain of fiction, spectators and users can be asked to imagine that a certain fictional world is inhabited by agents that fully look like real human beings, for example, as in recent animation movies such as *The Polar Express*, or *Final Fantasy*. To achieve this, motion capture systems are employed to provide agents with realistic biological motor behaviours (obtained through captors that are placed at the level of the principal joints of real human beings and that serve to represent the movement of the artificial agents). However, facial expressions are not as realistic as bodily movements. The result is again an uncanny effect of unbelievability. Realism can, then, represent a risk for the believability of virtual agents, since it exposes the public to conflicts and to the frustration of expectations (Garau et al. 2003). If this is proved, a recipe for obtaining believable agents could be: lower the user's expectations, display odd animals and quirky aliens rather than simulations of human beings (follow the example of the successful virtual pets called *Tamagotchi*), and eventually provide broad, if shallow, characters with a specific personality, tics, social and goal-directed behaviours, and reactivity to the environment (Bates 1994; Reilly 1996; Papagiannakis et al. 2005).

In any case, an important consequence of the dependence of believability on the fulfilment of expectations is that believability is enhanced rather than bothered by the awareness of mediation and virtuality. In fact, the awareness that virtual agents and objects are not real lowers the users' expectations and makes their fulfilment easier, thus reducing the risk of a drop in believability.

Naturally, artistic applications can choose to play with the frustration of the expectations they raise. The *Pebble Box* is a multimodal mixed object composed of a real box filled with pebbles and of a library of sounds that are activated when the users manipulate the pebbles and stop when haptic exploration ends (Essl et al. 2005). The sound library contains synthetic sounds of pebbles, sounds of pebbles in water, sounds of

coins, sounds of crunching apples, and sounds of birds. While the first three sounds appear believable when associated with the haptic sensation produced by the pebbles, crunched apples and birds appear weird and the proposed world is unbelievable as a world of pebbles that crunch or chirp. Users do not imagine themselves touching pebbles that crunch or chirp, but rather as touching pebbles and hearing sounds that do not correspond to how pebbles *should* sound.

The examples of the *Pebble Box* and *LifePlus*, of virtual dramas featuring the *Woogles*, of virtual museums of *Pure Form*, and of online fictions like those one can invent in *Second Life*, show that very different virtual reality devices represent a wonderful tool for exploring how far artists can go in manipulating stimuli for different perceptual modalities, for measuring the limits of believability and exploring the effects of unbelievability, and for creating worlds never experienced to make imagination alive in them through the senses.

REFERENCES

Altschuler EL, Wisdom SB, Stone L, et al. (1999). Rehabilitation of hemiparesis after stroke with a mirror, *Lancet*, **353**, 2035–2036.

Armel KC and Ramachandran VS (2003). Projecting sensations to external objects: evidence from the skin conductance response. *Proceedings of the Royal Society of London: Biological*, **270**, 1499–506.

Austen EL, Soto-Faraco S, Pinel JPJ, and Kingstone AF (2001). Virtual body effect: Factors influencing visual–tactile integration. *Abstracts of the Psychonomic Society*, **6**, 2.

Bates J (1994). The Role of Emotion in Believable Agents, Cmu-Cs-94-136, Pittsburgh, PA, School of Computer Science, Carnegie Mellon University.

Bates J, Loyall AB, and Reilly WS (1991). Broad Agents. *Proceedings of the AAAI Spring Symposium on Integrated Intelligent Architectures*, Stanford University.

Botvinick M and Cohen J (1998). Rubber hands 'feel' touch that eyes see. *Nature Reviews Neuroscience*, **391**, 756.

Carroll N (1990). *The philosophy of horror. Or, paradoxes of the heart.* Routledge, New York.

Carrozzino M, Frisoli A, Rossi F, Tecchia F, Ruffaldi E, and Bergamasco M (2005). The Museum of Pure Form. *Proceedings of MIDECH Workshop.* Milano, Italy.

Clair R (1985). The art of sound. In E Weis and J Belton, eds. *Film sound. Theory and practice*, pp. 92–6. Columbia University Press, New York.

Coleridge WW (1817). *Biographia Literaria.* Rest Fenner, London.

Currie G (1995). *Image and mind: Film, philosophy, and cognitive science.* Cambridge University Press, Cambridge.

Currie G (2005). Imagination and make-believe. In B Gaut and DM Lopes, eds. *The Routledge companion to Aesthetics*, pp. 335–46. Routledge, New York.

Dennett DC (1991). *Consciousness explained.* Little, Brown & Company, Boston, MA.

Dinh HQ, Walker N, Song C, Kobayashi A, and Hodges LF (1999). Evaluating the importance of multi-sensory input on memory and the sense of presence in virtual environments. *Proceedings IEEE Virtual Reality*, 222–8.

Doyle P (2002). Believability through context: Using 'knowledge in the world' to create intelligent characters. *Proceedings of the International Joint Conference on Agents and Multi-Agent Systems (AAMAS)*, pp. 342–9. Bologna, Italy, July 2002.

Ehrsson HH (2007). The experimental induction of out-of-body experiences. *Science*, **317**, 1048.

Ehrsson HH, Holmes NP, and Passingham RE (2005). Touching a rubber hand: feeling of body ownership is associated with activity in multisensory brain areas. *Journal of Neuroscience*, **25**, 10564–73.

Ernst MO and Buelthoff HH (2004). Merging the senses into a robust percept. *Trends in Cognitive Sciences*, **8**, 162–9.

Essl G, Magnusson C, Eriksson J, and O'Modhrain S (2005). Towards evaluation of performance, control, and preference in physical and virtual sensorimotor integration. 2nd International Conference on Enactive Interfaces Enactive'05. Genova, Italy, November 2005.

Frisoli A, Ruffaldi E, Gottlieb C, Tecchia F, and Bergamasco M (2006). A haptic toolkit for the development of immersive and web enabled games. *Proceedings of ACM Symposium on Virtual Reality Software and Technology*, pp. 320–3. VRTS 2006. Limassol, Cyprus, 2006.

Garau M et al. (2003). The impact of avatar realism and eye gaze control on perceived quality of communication in shared immersive virtual environment, paper presented at CHi 2003: proceedings of the SiGCHi Conference on Human Factors in computing systems.

Gibson JJ (1933). Adaptation, after-effect, and contrast in the perception of curved lines. *Journal of Experimental Psychology*, **16**, 1–31.

Hay JC, Pick HL, and Ikeda K (1963). Visual capture produced by prism spectacles. *Psychonomic Science*, **2**, 215–16.

Hayes-Roth B (2001). *What is a virtual person – not just a pretty face!* SIGGRAPH, Los Angeles, August 2001.

Holmes NP, Crozier G, and Spence C (2004). When mirrors lie: 'visual capture' of arm position impairs reaching performance. *Cognitive, Affective & Behavioural Neuroscience*, **4**, 193–200.

IJsselsteijn WA, De Kort YAW, and Haans A (2006). Is this my hand I see before me? The rubber hand illusion in reality, virtual reality, and mixed reality. *Presence: Teleoperators and Virtual Environments*, **15**, 455–64.

International Society for Presence Research (ISPR) (2000). The concept of presence: explication statement. http://www.ispr.info/

Lederman S and Abbott SG (1981). Texture perception: studies of intersensory organisation using a discrepancy paradigm and visual versus tactual psychophysics. *Journal of Experimental Psychology: Human Perception & Performance*, **7**, 902–15.

Lenggenhager B, Tadi T, Metzinger T, and Blanke O (2007). Video ergo sum: manipulating bodily self-consciousness. *Science*, **317**, 1096–9.

Loiperdinger M and Elzer B (2004). Lumiere's *Arrival of the Train*: cinema's founding myth. *The Moving Image*, **4**, 1, 89–118

Lombard M and Ditton T (1997). At the heart of it all: the concept of Presence. *Journal of computer-mediated communication*, **3**, 2.

Loyall AB (1997). *Believable Agents: Building Interactive Personalities.* (CMUCS-97-123) School of Computer Science, Computer Science Department, Carnegie Mellon University, Pittsburgh, PA.

Miller G (2007). Out of body experiences enter the laboratory. *Science.* **317**, 1020–1.

Mon-Williams M, Wann JP, Jenkinson M, and Rushton K (1997). Synaesthesia in the normal limb. *Proceedings of the Royal Society of London, Series B*, **264**, 1007–10.

Mori M (1970). The Uncanny Valley. *Energy*, **7**, 33–5.

Morice AHP, Siegler IA, and Bardy B (2008). Action-perception patterns in virtual ball bouncing: Combating system latency and tracking functional validity. *Journal of Neuroscience Methods*, **169**, 255–66

Nielsen TI (1963). Volition: a new experimental approach. *Scandinavian Journal of Psychology*, **4**, 225–30.

O'Regan K and Noë A (2001). A sensorimotor account of vision and visual consciousness. *Behavioral and Brain Sciences*, **24**, 939–1011.

Papagiannakis G, Ponder M, Molet M, Kshirsagar S, et al. (2002). LIFEPLUS: Revival of life in ancient Pompeii. 8th International Conference on Virtual Systems and Multimedia, VSMM 2002. Gyeongju, Korea, September 2002.

Papagiannakis G, Schertenleib S, O'Kennedy B, et al. (2005). Mixing virtual and real scenes in the site of ancient Pompeii. *Computer Animation and Virtual Worlds*, **16**, 1, 11–24.

Pavani F, Spence C, and Driver J (2000). Visual capture of touch: out-of-the-body experiences with rubber gloves. *Psychological Science*, **11**, 353–9.

Putnam H (1982). *Reason, truth and history.* Cambridge University Press, Cambridge.

Radford C (1975). How can we be moved by the fate of Anna Karenina? *Proceedings of the Aristotelian Society*, **49**, 67–80.

Ramachandran VS, Rogers-Ramachandran D, and Cobb S (1995). Touching the phantom limb. *Nature Reviews Neuroscience*, **377**, 489–90.

Reilly WS (1996). *Believable social and emotional agents.* (CMU-CS-96-138) School of Computer Science, Carnegie Mellon University, Pittsburgh, PA.

Riccio GE (1995). Coordination of postural control and vehicular control: Implications for multimodal perception and simulation of self-motion. In JM Hancock, PA Flach, J Caird, and K Vicente, eds. *Local applications of the ecological approach to human-machine systems*, pp. 122–81. Lawrence Erlbaum Associates, Hillsdale, NJ.

Riecke BE, Schulte-Pelkum J, Caniard F, and Bulthoff HH (2005). Spatialized auditory cues enhance the visually-induced self-motion illusion (circular vection) in Virtual Reality. *IEEE Virtual Reality*, 131–8.

Riva G, Davide F, and Ijsselsteijn WA, eds 2003. *Being there: Concepts, effects and measurements of user present in synthetic environments.* Ios Press, Amsterdam.

Rock I and Victor J (1964). Vision and touch; an experimentally created conflict between the senses. *Science*, **143**, 594–6.

Sathian K, Greenspan AI, and Wolf SL (2000). Doing it with mirrors: A case study of a novel approach to neurorehabilitation. *Neurorehabilitation & Neural Repair*, **14**, 73–6.

Schaefer M (2006). Fooling your feelings: artificially induced referred sensations are linked to a modulation of the primary somatosensory cortex. *Neuroimage*, **29**, 67–73.

Slater M and Steed A (2000). A virtual presence counter. *Presence: Teleoperators and Virtual Environments*, **9**, 413–34.

Steele R and Black J (1999). *Media ethics codes and beyond.* American Society of Newspapers editors. http://usinfo.stategov/journals/itic/0401/ijge/gjog.htm

Stein BE and Meredith ME (1993). *The merging of the senses.* MIT Press, Cambridge, MA.

Stoffregen TA (1997). Filming the world. An essay review of Anderson's The Reality of Illusion. *Ecological Psychology*, **9**, 161–7.

Stoffregen TA and Bardy B (2001). On specification and the senses. *Behavioral and Brain Sciences*, **24**, 195–261.

Stoffregen TA, Bardy B, Smart LJ, and Pagulayan RJ (2003). On the nature and evaluation of fidelity in virtual environments. In LJ Hettinger and MW Haas, eds. *Virtual & adaptive environments: Applications, implications, and human performance issues*, pp. 111–28. Lawrence Erlbaum Associates, Mahwah, NJ.

Tastevin J (1937). En partant de l'expérience d'Aristote. *Encéphale*, **32**, 57–84.

Thomas F and Johnston T (1984). *Disney: The illusion of life.* Abbeville, New York.

Tsakiris M and Haggard P (2005). The rubber hand illusion revisited: visuotactile integration and self-attribution. *Journal of Experimental Psychology: Human Perception and Performance*, **31**, 80–91.

Walton K (1978). Fearing fictions. *Journal of Philosophy*, **75**, 5–27.

Walton K (2001). *Mimesis as make-believe: On the foundations of the representational arts.* Harvard University Press, Cambridge, MA.

Welch RB and Warren DH (1981). Immediate perceptual response to intersensory discordance. *Psychological bulletin*, **88**, 638–67.

Witmer BG and Singer MJ (1998). Measuring Presence in Virtual Environments: a Presence Questionnaire. *Presence*, **7**, 225–40.

INDEX

Note: page numbers in *italics* refer to Figures.

4'33," John Cage 261, 276, 306, 517
2001, Stanley Kubrick 286

A1 area of brain, multisensory integration 270–1
Aalto, Alvar, Villa Mairea 585, *586*
Abramovic, Marina 10
absolute music 253–4, 256, 260
absolute pitch, prevalence, differences between
 blind and sighted musicians 269–70
abstract art
 activation of mirror neuron system 460
 relationship to synaesthesia 490
abstract expressionism 127
abstraction 127, 169
Abstraction and empathy, Wilhelm
 Worringer 123
Academy of Baccio Bandinelli, The, Agostino
 Veneziano 76
accessibility of art, conflict with preservation
 14–15, 136–7
Acconci, Vito 10
acetone, smell on breath 199
action fidelity 610
Action Painting 127
action possibilities 140
action potentials, early studies 32
adaptive value of music 334–5
Adoriction Clock, Gregory Cowley 222
Adrià, Ferran 208
Adrian, Edgar Douglas 32
Ægineta, Paulus, on vertigo 25
aesthetic attitude 534–5
aesthetic experience 530
 multisensory 544–5
 sensory, cognitive and hedonic
 components 531–2
aestheticization, age of 587–8
aesthetics 119, 543–4
 contemporary 244
 evolutionary theories 563–4
 modern incarnation 168–9
 origin of concept 167–8
 relationship to logic 116–18
aesthetic sensibility 169
aesthetic touch 107–8, 109–10

bodily aspects 111–12
 as an emotional trigger 113
 engagement of the imagination 114
 openness to individual interpretation 110
 palpability of space 112–13
 unconscious aspects 113–14
 see also touch
affect 247–8, 332
 autonomy of 249
 as a social experience 248
affective responses 332
 adaptive value 340
 functions 335
 to music 335–7
 predictions for costly signalling
 hypothesis *337*, 340–1
 predictions for emotion hypothesis *337*,
 338–40
 predictions for language hypothesis
 337, 342
 predictions for social bonding
 hypothesis *337*, 342
 temporal entrainment as source 342
affordance effects 363
affordances, touchability 140–1
afterimages, Wells' study 45–6
Aftertrace, Georgia Chatzivasileiadi 15–16
Agon, George Balanchine 522
Agosti, Giovanni 412–13
Alberti, Leon Battista 365, 383, 384
 attitude to sculpture 63
 De Statua 423–4
 on primacy of vision 61
 on Pythagoras 581
 on the task of a painter 117
album/ cover art 285
Alcmaeon of Croton, on location of the
 mind 21, 466
Aleotti, Ulisse 412
Alhauser, Sonja, edible sculptures 209
Al-Haytham, Ibn 243
 on saccadic eye movements 385
Al-Kindi 242–3
Allen, Woody, *What's Up, Tiger Lilly* 266
Amoore, John 198

anatomical studies of the senses 28–31
Anaxagoras 21
'animal electricity', Galvani's studies 31
animals, recognition in naturally occurring
　　patterns 365–6, 368
Animated Puppets 603
animation, portrayal of motion 383–4
anosmia 185, 201–2
　specific 198
anti-rationalism 245
Antoninus, on primacy of vision 61
Antonioni, Michelangelo, *Blow-Up* 131
aphasia, Melodic Intonation Therapy 280
Apollo and Daphne, Gian Lorenzo Bernini 80
appetite, relationship to smell 192, 202
Apple iMac 562
Aquinas, St Thomas
　on *sensus communis* 135
　on touch 62
Ara Pacis Augustae relief, Rome 405
architectural language 581–2, *583*
architecture 575–6
　age of aestheticization 586–8
　as art of space 571–2
　Calvin 575
　displacement of the human body 579–82
　meaning 575–7
　multisensory perception 575, 590, 595–7
　optical correction 573
　perception of vertical distances 574
　revolution through the senses 588–9
　vision and modernity 585–6
Areni, C.S. and Kim, D. 213
Aristotle
　De Anima 117
　on discriminative accuracy of touch 141
　on the five senses 19, 20, 21
　on illusions 26
　partial portrait *21*
　on relationship of pitch to colour 496
　science of universals 116
　sensus communis 135
　on smell 240
　on supremacy of vision 582
　on touch 61, 62
　on vertigo 25
　on visual perception 385
Arnaud, Noel 596
Arnheim, Rudolf, on radio 262
arousal level, effect of background music 215
arousal potential of objects 554
Arrival of a Train at La Ciotat, illusion of
　　reality 600
art
　role in awareness of the senses 3
　two forms of 353
　windowpane analogy 168–9

'Art and the Senses' workshop, Oxford
　　(2006) v, 1, *177*
　conference dinner 208
　food perception, effect of environmental
　　sounds 222–6
Art as Experience, John Dewey 594
artificial life (animation form) 383
artists, interaction with scientists 537–8
artist's atelier, The, Louis Daguerre 137
art music, development 253–7
Asplund, 585
Atalanta and Hippomenes, after Guido Reni,
　　Vik Muniz 352
AtaXia, Wayne McGregor 537
attention 519–21
　and illusion of non-mediation 608
　psychological studies 521
attraction 317
　Tonal Pitch Space (TPS) model 315, 317
　　in Chopin's *E major Prelude* 319–20
audiences for dance performances 517
audio–grapheme synaesthesia 166
audio–olfactory synaesthesia 166–7
audiovisual congruence 266
audiovisual integration 268–9, 282–3
　cost 269–70
　neural processing 270–2
　　role of planum temporale 272, 274–5
audiovisual interactions 267–8, 287, 289
　adding sight to sound 284
　auditory illusions caused by vision 266–7
　film and video music 285–7
　visual illusions caused by sound 267–8
　visualizing sound 284–5
audiovisual mirror neurons 456
　functions 456–7
Auditorium Forecourt (now Ira Keller Fountain),
　　Lawrence Halprin 596
auditory cues *see* sound
Auger, James, *Smell + Apocrine gland secretion
　　transfer system* 194–5
Augustin, F.L., on vertigo 42
autobiographical memory 200
awareness of the senses, role of art 3

babies
　recognition of smell of mothers 194
　responses to tastes and smells 191–2
Bach, Johann Sebastian, *In Dulce Jubilo*, Music
　　Animation Machine representation 506, *507*
bacon and egg ice cream, flavour perception,
　　influence of environmental sounds 222–5
Bacon, Francis, creativity 461
Bacon, Roger, on primacy of vision 61–2
balance
　role in visual preference 389–90
　role of muscle sense 34

balanced composition 550
 proportion 550–2
 symmetry 552–3
Balanchine, George 519
 Agon 522
Bandinelli, Baccio 76–7
Bárány, Robert 43
 perceptual portrait *46*
 studies of vestibular function 48–9
'barbaric art', Willhelm Worringer 128
Barker, Jennifer M., *The Tactile Eye* 151
Bar, Moshe et al. 388
Barthes, Roland 251
basic emotions 331
basic pitch space 317
bas-relief 402–5
 Donatello *409–11*
baton, use by conductors 256
Baudelaire, Charles Pierre, on correspondence
 of the senses 169
Baumgarten, Alexnder von 167–8, 178, 240, 544
Bausch, Pina 519
Baxandall, Michael 3
Bayard, Hippolite, *Plaster casts* 137, *138*
beauty 240
 architectural 577
 Lessing on 119
 relationship to tactility 119–20
Becatti, Giovanni, *Krytias Ephebe* 420–1
beer, 'pitch of harmony' 216
BEE'S, Susana Soares 199
BEETHOVEN, Felice Casorati *376*
behaviour, modification by smell 201, 546
'being there', sense of 610–13
believability, virtual reality systems 613–15
Bell, Charles 27–8
 on muscle sense 33, 34
 perceptual portrait *27*
 on temperature sense 36
 on vertigo 42
Bellini, Jacopo, notebook 416–17
Bellisle, F. and Dalix, A.M. 215
Bell, R. et al. 211–12
Benois Madonna, Leonardo da Vinci 386
Berenson, Bernard 60
 on 'tactile values' 122
Bergstein, Mary 137
Berkeley, George 25
Berlyne, D.E., collative-motivation model 554
Bernini, Gian Lorenzo
 *Monument of the Blessed Ludovica
 Albertoni 81*
 tactility as theme of sculptures 80
Bertoia, Harry, sound sculptures 287, *288*
Bianca Plastica BL1, Alberto Burri *389*
Bill, Clara Ursitti 194
biological motion, pictorial cues 379–84

biological motion processing 515–16
 peak-shift effect 516–17
Biped (ballet), Merce Cunningham 515
birdsong, as model for music 340–1, 344
Bishop, Bainbridge, colour organ *499*
Blair Witch Project (1999), and illusion of
 reality 608
blaue Reiter, Der, synaesthetic works 504
blindfold drawing series, Claude Heath 144–6,
 145, 363–4
blindfolding, enhancement of sense of touch 143
blindness
 consequences for other senses 97–9, 595
 enhanced auditory skills 269–70
 mental imagery 467–8
 recognition of objects through touch 135, 363
 tactile evaluation of art as subject of
 artworks 64–5
 visual cortex recruitment 98, 163, 467
blind painter (E.A.) , case study 468–9, *470*
'blind sight' 271
blind spot 385
blinking, correspondence to cinema cuts 438–9
Blix, Magnus 38
 perceptual portrait *37*
Blomstedt, Aulis, Pythagorean Study *581*
Blood, A.J. and Zatorre, R.J. 324
Blow-Up, Michelangelo Antonioni 131
Blumenthal, Heston 209
 experiments at 'Art and the Senses'
 conference 222–6, *223*
body image 109
body odour, uniqueness 193–4
body rotation, after effects 42–7, 52
body schema 125–6
Boissier de Sauvages, François, on vertigo 41
Boltz, M. 445
BOOGIE WOOGIE, Renato Guttuso *380*
Book of the Courtier, Baldasarre Castiglione 76
Borghini, Vincenzio
 on *paragone* debate 70
 on primacy of vision 61
Boring, E.G., on vestibular system 43
Borromini 13
boundary lines, importance 362–4
Bradford, Sidney 135, 363
Braille readers, brain representation of preferred
 reading finger 474
brain
 audiovisual integration 270–2
 role of planum temporale 272, 274–5
 as centre of sensation 21
 motion processing 378
 olfactory pathways 187
 taste pathways 190
'brain in the vat' mental experiment 606–7
Brenson, Michael, on Giacometti's figures 110

Breuer, Joseph 43
 perceptual portrait *44*
 study of vestibular system 47
Brewster, David, *Natural Magic* 86
Bronzino, Agnolo 77–8
 Portrait of Pierantonio Bandini with a Venus
 Pudica *Statuette 78*
Brougher, K. et al., *Visual Music* 179
Brown, Carolyn *520*
Brown, Thomas, on muscle sense 33
Bruegel, Pieter the Elder, *Children's Games 584*
Bruguera, Tania, *Poetic Justice* 209
Brunelleschi's Panels 410
Bruno, Giordano, on memory 62
brutalist buildings 558, *559*
Buggles, *Video killed the radio star* 284
Bulli, El, restaurant 208
Burke, E., *On the Sublime and Beautiful* 120
Burri, Alberto, *Bainca Plastica BL1 389*
Bust of a Lady with Flowers, Andrea del
 Verrocchio 72, *74*
Byard, Jackie 307
Byatt, A.S., *The Cambridge Companion to John
 Donne* vi, vii
Byrne, David, *Playing the Building*
 installation 284, 306

Cage, John 260–2
 4'33" 276, 306, 517
Cajal, Santiago Ramón y 29–30
 perceptual portrait *31*
caloric stimulation 49
Calvert, G. et al. 272
 The Handbook of Multisensory Processes 162
Calvino, Italo 586
Calvo-Merino, B. et al. 459
*Cambridge Companion to John Donne,
 The*, Byatt, A.S. vi, vii–viii
camera obscura 384
Cameron, Leslie 198
cancer, detection by dogs 199
Candlin, Fiona 136
Cannibal Holocaust (1980), and illusion of
 reality 608
Canova, Antonio, sculptural technique 426–7
carbonated water, auditory perception 218–19
Carnatic music 307
Carnie, Andrew, *Magic Forest* viii
Carole Andrews, *Sentinels* 12, 13
Carpenter, Rhys 407
Casolari dirocatti, Fortunato Depero *369*
Casorati, Felice, *BEETHOVEN 376*
Castel, Louis-Bertrand 505
 colour harpsichord (*clavecin oculaire*) 496–8
Castiglione, Baldasarre, *Book of the Courtier* 76
Cattrell, Annie, 'Seeing' and 'Hearing' ix, *x*
Cavaceppi, Bartolomeo, atelier of 425–6

Cavaliere, Jacopo Bellini 416–17
cave paintings, depiction of motion 377
cell doctrine 29
Cellini, Benvenuto *73*
central Italian painting, three dimensionality 373
central vision 364
Chaise Longue, Le Corbusier *551*
challenges 562
chance, role in music 278
Chancler, 'Ndugu' 298
changes in blindness 98
Charbonneaux, J. 405
Chatzivasileiadi, Georgia, *Aftertrace* 15–16
'chemical' senses 183
 see also smell; taste
Chen, D. and Haviland-Jones, J. 196
Children's Games, Pieter Bruegel the Elder *584*
chocolate as a medium 10
chocolate grinder, Duchamp, Marcel 209
Chopin,, *E major Prelude*, application of TPS
 model 318–22
chord, definition 325
chord (harmonic) hierarchy, definition 325
chords
 definition 325
 distance between 316–17
choreography
 beginning a performance 518–19
 feedback from neuroaesthetic studies 538–9
 interpretation 522–3
 judgement 522
 keeping the audience's attention 519–21
 modulation of movements 525–6
 novelty and complexity of work 521–2
 sources of inspiration 522
 structure 521, 522
 title 526
 see also dance
chronophotography 379, *380*
Chrysler Aviat car 558
Chu, Simon 201
cinema
 affection-images 248
 comprehension 435–6, 449–51
 cuts and continuity 442–5
 embodied event representation 448–9
 event segmentation 439–42
 narrative events 446–8
 cuts 371–2
 depth perception 372
 'Hollywood style' 361
 illusionism 600–1
 illusion of fidelity to reality 608
 illusion of non-mediation 607
 incongruent dubbing 266
 music 285–7
 narrative devices 438–9

pauses 445–6
tactility 149–52
 musculature 154–6
 skin 152–4
 viscera 156–8
three-dimensional effect 397–8
ventriloquism effect 267
viewpoint 372
circumvallate papillae 189
Clair, René 600
classicism 118
classifying the senses 26–8
 anatomical studies 28–31
 physiological studies 31–3
clavecin oculaire (colour harpsichord) 496–8
Clocksin, Ella, *Touch together* 9, 10
close-up photography of sculpture 137–8
clouds, as theme in Vik Muniz's work 353
coarse visual information 364–5
 pareidolia 368
 pattern recognition 365–6
 triggering of emotional responses 367–8
Coasting, Jonathan Raban xi
coffee, marketing 245
cognitive aesthetic responses 531
Cognitive Foundations of Musical Pitch,
 Krumhansl, C.L. 312, 316–17
cognitive neuroscience 351
Coleridge, W.W. 600
collative-motivation model, Berlyne, 554
collecting 16
colour
 cultural significance for Dessana Indians 174–5
 of food and drink 208
 'interior sound' (Kandinskij) 272, *273*
 red, stimulation of limbic system 388
 scientific developments 26
coloured hearing 495–6
 Alexander Scriabin 501–3
 digital explorations 505–6
 mathematical principles 496
 relationship of pitch to visual lightness *486–7*
 visual artists' experiments 503–5
 see also colour harpsichord (*clavecin oculaire*);
 colour organ; visual music
colour–grapheme synaesthesia 164
 cross-cultural variation 166
colour harpsichord (*clavecin oculaire*) 496–8
colour organ 498–501, *499, 500*
combination print 373
commercial breaks, impact on film
 comprehension 445
common sense (*sensus communis*) 126, 135, 509
common themes 2–3
communicability of sense experience 241
 smell 248–9
communication, role of smell

advertising your genes 196
fear and happiness 196
mate selection 194–5
menstrual synchrony 196
reproductive status indication 197
communication of emotions, music 343–4
complexity
 relationship to interest 521
 unity in variety 553–5
composition of music 301–3
Composition VIII, Kandinsky, synaesthetic
 perception 484
computer graphics, portrayal of motion 383–4
concatenation effect, multisensory
 perception 163
conceptual changes, role in event
 segmentation 442
concert halls 254–5
 modern design 256
 Teatro La Fenice, Venice 255
Condillac, Etienne Bonnot de, *Treatise of
 sensations* 119–20, 120
conductors 256
Connecticut Chemosensory Clinical Research
 Centre (CCCRC) study 201–2
consonance 2–3
consumer capitalism, multisensory
 products 245–6
consumer products
 aestheticization 588
 aesthetics 543, 546
 see also designed products
contemporary artworks
 distinguishing features 15
 restoration 14–15
contextual effects
 influence on culinary experience 229
 influence on food selection 211–*12*
continuity edits, cinema 438
contour of music 275
 social and physical aspects 279–80
contours, as pictorial cues 361–4
contraction and release 525–6
contrast, role in aesthetic judgement 548–9
conversation, musical 303–4
Cooking with Fernet Branca, James
 Hamilton-Patterson 228
copies of artworks, use for tactile access 136
Corbin, Alain 242
correspondence to cinema cuts 438–9
costly signalling hypothesis, music 334, 343, 343–5
 predicted affective responses *337,* 340–1
'cotton clouds', Vik Muniz 353
Cowley, Gregory, *Adoriction Clock* 222
creative touch 141–7
creativity 460–1
 association with synaesthesia 508

crispness ratings of food
 relationship to auditory feedback 218, *219*
 relationship to sounds of food
 packaging 220–*1*
Critique of Judgement, Immanuel Kant 168
cross-disciplinarity 251
cross-modal plasticity 163–4
cross-modal transfer 135, 363
cruel body, Gilles Deleuze 126–9
Crum Brown, Alexander 50
 on after effects of body rotation 44, 47
 perceptual portrait *44*
 on rotation sense in deaf-mutes 48
Cubi, David Smith 113
Cubism, pattern recognition 366
cue redundancy 550
cultural differences
 in appreciation of smell 192
 in attitudes towards preservation of
 artworks 15
 in food and drink 209
 in multisensory perception 99–100, 165–6,
 177–8
 Desana Indians 174–6
 Japanese 'way of incense' 172–4
 Shipibo-Conibo Indians, healing
 arts 170–2
 in synaesthesia 490–1
culture, influence on music 307–8
Cunningham, Merce 519, *520*, 521, 522, 523
 Biped 515
cuts, cinematic 371–2, 438–9, 446
 continuity 442–5

Daguerre, Louis, *The artist's atelier* 137
Dahlhaus, Carl 253, 254
dance
 association with music 524–5
 attention 519–21
 audience 517
 beginning of performance 518–19
 choice of location 517
 costume 518, 519
 cultural importance 514
 definition 517, 529
 interpretation 522–3
 judgement 522
 modulation of movements 525–6
 neuroaesthetics 532–3
 correlates of implicit aesthetic responses 535
 feedback to choreographic process 538–9
 interaction of artists and scientists 537–8
 mechanisms of seeing dance 533–4
 relationship of response to type of
 movement 535–7
 OK Go, video performances 513
 perception of human motion 515–17

portrayal in artworks, perception of
 motion 381–3
relevance of mirror neurons 524
salient stimuli 519–20
sources of inspiration 522
structure 521, 522
title 526
Dancer in the Dark (von Trier), jump cuts 446
dancers, neuroimaging studies 524
Darwin, Charles, on evolution of music 334
Darwin, Erasmus 36
 perceptual portrait *37*
Darwin, Robert 45
David, Michelangelo 79
David, Jacques-Louis, *Death of Marat* 387
Da Vinci Code, The, audio content 286–7
Dead Christ, Andrea Mantegna 372
deaf-mutes, postrotational vertigo 48
De Architectura, Vitruvius 579
Death of Caesar, Jean-Léon Gerome 387
Death of Marat, Jacques-Louis David 387
deceptive cadences 315
De Chirico, Giorgio, *Piazza d'Italia (Souvenir
 d'Italie)* 370
déjà vu, evocation by smell 200
Deleuze, Gilles 461
 and the cruel body 126–9
Delvoye, Wim, eating machine 209
Demattè, M.L. et al. 95–6
Democritus 21
'dendrite', derivation of the word viii
dendrites, *Magic Forest*, Andrew Carnie *viii*
Depero, Fortunato
 Casolari diroccati 369
 Sketch for a Plastic-Motor-Noise Apparatus
 with Coloured Lights and Spray
 Mechanism 286, *287*
depression, association with anosmia 202
depth 571
depth perception 386
 in cinema 372
 pictorial cues 368–71
 role of shading 420–2
Deregowski, J.B. et al. 386
Desana Indians, cultural synaesthesia 174–6
Descartes, René 25
designed products
 meaningful properties 556–7
 challenges and surprises 561–3
 determinants of recognition 557–60
 novelty 560–1
 multisensory nature 546
 structural properties 546–8
 balance 550–3
 contrast 548–9
 similarity 549–50
 unity in variety 553–5

De Statuta, Leon Battista Alberti 423–4
Dewey, John, *Art as Experience* 594
Diderot, D. 119
digitalization, sensory impoverishment 12
diseases, smell of 198–9
disintegration of artworks, incorporation into
 design 137
distance perception 400–1
 elasticity 574
distraction, music as 215
DITHERNOISE, Simon Longo 277
Dogon, audio–olfactory synaesthesia 166–7
dogs, detection of cancer 199
dominance effect, multisensory perception 163
 see also sensory dominance
Dominus winery, Nappa Valley, Herzog, and de
 Meuron, 555–6
Donaldson, Henry 38
Donatello
 Gattamelata 417
 Herod's Banquet 410, 411
 Mercurio-David 420
 Miracle of the new-born child, bronze 415
 sculptures of the *Altare di San Lorenzo* 417,
 418, 419
 St. George and the Dragon, bas-relief 409–10
Doni, Anton Francesco 67–8
Donne, John vi, vii–viii
Doritos project, *Value Meal: Design and (over)
 eating* exhibition 222
dorsomedial prefrontal cortex (dmPFC), role in
 narrative comprehension 447–8
Doxiadis, C.A. 407
Drake, C. and Ben El Heni, J. 282
drawing
 capture of tactility 145–7
 case study of E.A. (blind painter) 468–76, 470
Driscoll, Rosalyn 142–4
 Limen 108
drumming
 communication of emotions 295–6
 elements of a good solo 305
 improvisation 303–4
 influence of technology 307
dubbing of movies, incongruent 266
Duchamp, Marcel 11
 chocolate grinder 209
Duet, Paul Taylor 517
Dunn, Douglas 520
Durand, J.N.C., architectural language 581–2, 583
Dying Slave, Michelangelo 79

Early Modern Italy, tactility 59–61, 63–9
 Michelangelo 78–80
 paragone debate 69–73
 social status of sculptors 74–7
 as theme of sculpture 80

Early Modern period 59
Easy Rider (film), single frame cuts 371
Eau Claire, Clara Ursitti 193
Edge of Intention 603
efficiency 576
'Egyptian' way (Riegl) 127–8
Einfühlung notion, Robert Vischer 459
electricity, physiological studies 31–2
Elegy 5 (sculpture) 111
Elgin Marbles 409
Elkins, James 385
embodied event representation, cinema 448–9
embodied music 281–3
embodied perception 124, 243–4, 572–3
 double engagement with the world 573–4
 elasticity 574–5
embodied simulation
 in responses to art 458
 role of mirror neuron system 456
embodiment 3
emergence effect, multisensory perception 163
emotional responses, triggering by coarse visual
 information 367–8
Emotion and Meaning in Music, Leonard
 Meyer 312, 313
emotion hypothesis, music 334
 predicted affective responses 337, 338–40
emotions 331
 communication by music 343–4
 responses to music 215, 294–6, 312–13, 323–4,
 329–30
 triggering by touch 113
 see also affective responses
empathic responses 459
 role of mirror neuron system 460
Empedocles 22
Encyclopaedia Britannica, on stereoscope 395–7
endorphin release ix
energy, activation of sense organs 27
entrainment, temporal 282, 297, 332–3, 525
 as source of affective responses 342
environment, effect on food and drink
 perception 229–30
environmental sounds, use in music 276, 278, 306
epilepsy, seizure prevention by conditioned
 smells 200–1
equivalence signals 162–3
'Equivalents', Vik Muniz 353
Ernst, Max, as inspiration for jazz 300
Ernst, M.O. and Banks, M.S. 91–2, 93, 135–6
Esguard de Sant Andreu de Llavaneres, L',
 restaurant 209
Eshkar, Shelley 515
ethical dimension, multisensory experience 247–8
'Euro-whiff' 184
evaluation of aesthetics 530–1
event boundaries 440

event models 447–8, 449
event segmentation 439–42, 450
 and cinema cuts 442–5
evolution
 aesthetics as a by-product of adaptation 563–4
 selection of music 334–5
Execution of the Emperor Maximilian,
 Manet, 387
existential outsideness 596
expectation
 in music 313–14
 fMRI study of expectancy violation 324
 relationship to physiological reactions 323
 role in believability 614
experience
 influence on picture perception 379, 383
 influence on the senses 3
extra-opus knowledge, music 313
extrapersonal space 134
eye
 central and peripheral vision 364
 convergence and divergence 386
 physiology 354–5, 360, 384–5
 perception of distance 400–1
eye movements, viewing paintings 385–7

Fabrique, Holland Dance Festival Posters 554
face perception 355, 365
 in natural objects 365–6
 symmetry 552
fake hand illusion 611–12
familiarity of objects 557–60
familiarity with actions, relationship to mirror
 neuron activation 458–9, 533–4
familiarity with music 344
Fat Duck, The, restaurant 209
 bacon and egg ice cream 223–4
 'Sounds of the Sea' seafood dish 227
the FEAR of smell–the smell of FEAR, Sissel
 Tolaas 196–7
fear, smell of 196
feature-based attention 389, 389–90
Febvre, Lucien 582, 584
feelings
 contemporary value over thinking 245
 distinction from emotions 331–2
 in Vik Muniz's work 354
Feld, Steve 164
female sculptures, male handling of 77
Ferber, C. and Cabanac, M. 216
Ficino, Marsilio, on primacy of vision 61
fiction, illusion of reality 600–1
fidelity to reality, illusion of 608–10
fields of vision 571
fight or flight response 331
figure, Deleuze on 126–7

film *see* cinema
film music 285–7
Finn, David, photography of sculpture 137–8
fish, food expectancy behaviour 221
Fishinger, Oskar 505
Fishkin, S.M. et al. *88*
five senses 20, 589
 historical accounts 21–6
flat pictures, visual perception 360–1
 see also pictorial cues
flavour 192
flavour perception
 effect of music 216
 influence of environmental sounds 222–6
 perceptual gestalts 208
flavour principles 561
flight simulators, illusion of reality 609
Floating Point, The, John McLaughlin 307
Flourens,, study of vestibular system 47
Focillon, Henri 122, 123
Foeckler, Philip 222
foliate papillae 189
Fontana, Lucio 14
food and drink
 auditory influences 228–30
 on consumption rate 214–17
 environmental sounds 222–8
 food as source of sound 218–20
 music, influence on selection 212–14
 cultural variation 209
 familiarity 559
 flavour principles 561
 multisensory perception 208–10
 palatability, role of dynamic contrast 548–9
 selection, contextual effects 211–12
 sensory-specific satiety 560
 temptation by 363
food names 228
food packaging, sound of 220–2
food preferences, relationship to nutritional
 needs 559
form
 musical 303, 304
 symbolic idea of 118, 118–19
Forsythe, William 518, 519, 522
Fourier, Charles 244
'Fracture Flickers' series 266
frame, role in definition of art 15
Francis Bacon: The Logic of Sensation, Gilles
 Deleuze 126–7
Freedberg, David 458–60
Freeman, W.J. 335
frescoes, perspective 413–18
Freud, Sigmund, on sense of smell 241
Fried, Michael 260
Frolov, Y.P. 221

frontal cortex, activation during drawing
 473–4
frontal lobe damage, utilization behaviour 363
frontotemporal dementia, effect on artistic
 abilities 475
Fulcrum, Richard Serra 139–40
functional magnetic resonance imaging (fMRI)
 E.A. (blind painter) 469–71, 471, 472–3
 limitations 514
 responses to event boundaries 440, 441
 responses to cinema cuts 443, 444
 'Seeing' and 'Hearing' project, Annie
 Cattrell ix, x
 study of musical expectancy violation 324
fungiform papillae 189
Fur Covered Cup, Meret Oppenheim 208
Futurism 169
Futurist Cookbook, F.T. Marinetti 208

Galen
 study of the senses 22
 on vertigo 39–40
Galileo Galilei
 on *paragone* debate 70
 perceptual portrait 23
 on senses 22–4
galvanic stimulation studies 31–2
 production of vertigo 42
 temperature sense 36–7
Galvani, Luigi 31
 perceptual portrait 32
Ganly, Helen 10, 179
gap-fill melody 314
Gaston de Foix, Gian Girolamo Savoldo 71
Gattamelata, Donatello 417
Gauricus, Pomponius 68
Gazzola, V. et al. 459
Gebhart-Sayer, A. 170–2
gelbe Klang, der, Wassily Kandinsky 504–5
Generative Theory of Tonal Music (GTTM),
 Lerdahl, F. and Jackendoff, R. 316
Gerome, Jean-Léon, *Death of Caesar* 387
gestalt law of similarity 549
gestalt perception 509
gestalt principles 312
 in generation of expectations 314
Ghiberti, Lorenzo 63–4, 67
Ghost, Rachel Whiteread 112
Giambologna
 Rape of a Sabine 65–6, 68
 tactility of statuettes 65–6, 68
Gibson, James J. 87, 140–1, 151, 589, 609
Giorgione, *St George* (lost painting) 71
Giotto,, depiction of marble surfaces 375
glass dust, use by Venetian artists 375
Glass Pieces, Jerome Robbins 519

goal of actions, relationship to mirror neuron
 activation 459
Goehr, L. 253–4
Goethe
 on interaction of the senses 592
 on Lessing's *Laocoon* 431–2
 sculpture, Frankfurt airport 430, 432
gold, use by Venetian artists 375
golden section ratio 550–1
 Le Corbusier's use 585
Goldscheider, Alfred 38
Golgi, Camillo 30
 perceptual portrait 31
Gombrich, Ernst 365, 387
Gonzales-Torres, Felix, *Portrait of
 Ross in L.A.* 137
Graham, Martha, contraction 525–6
Grammer, Karl et al. 196
Grant, A.C. et al. 97
graphemes 508
Great Sphinx of Gise, Gerhard Richter
 398–400, 401
Gregory, Richard 135, 363
groove, musical 283, 297
Guéguen, N. et al. 214
Guest, S. et al. 89, 92, 94
Guttuso, Renato, *BOOGIE WOOGIE* 380

Hadden, Skip 294, 295
Halprin, Lawrence, *Auditorium Forecourt*
 (now Ira Keller Fountain) 596
Hamer, Andrew xiii
Hamilton-Patterson, James, *Cooking with Fernet
 Branca* 228
Handbook of Multisensory Processes, The, Calvert,
 G. Spence, C. and Stein, B.E. 3, 162
handicap principle *see* costly signalling hypothesis,
 music
'hand-journeys', F.T. Marinetti 143
hands
 physical engagement in sculpture 67–8
 prominence in Michelangelo's work 79–80
Hanslick, Eduard 257, 339
happiness, smell of 196
haptic awareness 590–1
haptic devices, virtual reality systems 605, 609
haptic moment 121
haptic sense 108, 109
haptic vision 128, 151
 cinema 152–4
 importance of boundary lines 362–4
Hartley, D. 25, 39
Hasegawa, T. et al. 274–5
Hashimoto, Y. et al. 220
healing arts, Shipibo-Conibo Indians 170–2
health, relationship to smell 198–9

hearing
 consequences of blindness 97
 influence on culinary experience 209–11,
 228–30
 effect on rate of consumption 214–17
 environmental sounds 222–8
 selection of food and drink 211–14
 sound of food and drink 218–20
 sound of food packaging 220–2
 primordial dominance 582, 584
 see also sound
Heath, Claude 363–4
 blindfold drawing series 144–6, *145*
hedonic aesthetic responses 531–2
hedonic senses 240
hedonism, consumer capitalism 245–6
Hegel, G.W.F. 240
Heidegger, Martin 278
 on the hand 592
 on 'readiness-to-hand' 141
Hekkert, P., Snelders, D., and van Wieringen,
 P.C.W. 552, 560
Heller, M.A. 89
Helmholtz, Hermann von 34, 134–5
Henry, Charles 176
Heraclitus, on supremacy of vision 582
Herder, J.G., *Plastic Art* 120–4
Herod's Banquet, Donatello 410, *411*
Herz, M., on vertigo 41
Herzog, and de Meuron,, Dominus winery,
 Nappa Valley 555–6
Herz, Rachel et al. 194, 201
hierarchy of the senses 582, 584
Hildebrand, Adolf von 122
Hirstein, William, principles of aesthetic
 experience 516–17
Hitzig, Eduard, on vertigo 42
HLA (human leucocyte antigen) molecules
 relationship to perfume choice 196
 role in body odour 193, 194
Hoffman, Malvina 141–2
holiness, association with pleasant smell 199
Hollanda, Francisco da, on Michelangelo's
 statues 80
'Hollywood style' of film-making 361, 438
Holmes, N.P. et al. 612
Holt-Hansen, Kristian 216
Homme et femme, Joan Miró 367
honesty of objects 558–9
Hooke, Robert 28
 perceptual portrait 29
hormones
 changes in smell sensitivity 198
 effect on smell 197–8
Horst, Louis, response to Paul Taylor's *Duet* 517
Hötting, K. and Röder, B. 98, 99
Howes, David *177*, 242

Humphrey, Nicholas v
Hunter, John 28
Huston, John 371
Huygens, Christian 297
Hyde, R.J. and Witherly, S.A. 548–9
hyposmia 201–2

Ijsselsteijn, W.A. et al. 612
illumination, painting techniques 373–4
illusion of reality
 believability 613–15
 illusion of fidelity to reality 608–10
 illusion of non-mediation 606–8
 illusion of transportation 610–13
 three definitions 605
 in traditional media 600–1
 virtual reality systems 602–5
illusions 26
 audiovisual 266–8
 McGurk effect 163, 165, 266, 269, 482
 parchment skin illusion 92, 94
 rubber hand 611–12
 trompe-l'-oeil 11, 390
 ventriloquism effect 267
 Vik Muniz 353–4, 356
 visuo-haptic 609–10
Il Tribolo, on *paragone* debate 69–70
Imaginary Landscape No. 1, John Cage 261–2
Imaginary Landscape No. 4, John Cage 262
imagination 116
 engagement in aesthetic touch 114
 in response to fiction 601
imaginative universals 575
immune system, role in body odour 193, 194
Impressionism 14
 emotional responses 368
 pattern recognition 366
improvisation of music 303–4
 elements of good solos 304–5
 groove 283
 influences on quality of performance 305–6
 thinking and intuition 304
inattentional blindness 520
incense
 gustatory lexicon 173
 use in Japan 172–3
Incredulity of St Thomas, Andrea del
 Verrocchio 73–4, *75*
Individuals, Vik Muniz 354
In Dulce Jubilo, Johann Sebastian Bach, Music
 Animation Machine representation 506, *507*
infants, synaesthesia 484
inflow theories 34
information theory 312
Inner Circle Music 294
In Search of Lost Time, Marcel Proust xiv–xvi,
 200, 242, 591

inspiration, in musical composition 301–2
integration, audiovisual 268–9
 cost 269–70
 neural processing 270–5
intelligence, four kinds v
interaction of the senses 135–6, 592, 594–5
interdisciplinarity 251–2
International Society for Presence Research
 (ISPR) 610
Internet, impact on music 307
intersensory conflict 86–90
 see also sensory dominance
intra-opus knowledge, music 313–14
intuition, role in musical improvisation 304
inverted vision experiment 573
invisibility 118
invisible forces, Gilles Deleuze 127
invitation to cinematic space (Sesonske) 156
'Ionization', Edgar Varèse 276, 278
iPod shuffle 555
Irigaray, Luce 61
Islamic civilization, classical, multisensory
 aesthetics 242–3

Jacob, C. 215
jagged lines, expressive power 388
James, William, on rotation sense in deaf-
 mutes 48
Japan
 incense use 172–3
 'way of incense' (kodo) 173–4
Jarrett, Keith, 'The Melody at Night with
 you' 299
jasmine, smell of 247
Jaws, musical score 286
Jay, Martin 61, 590
jazz 293
 history and culture 306–8
 improvisation 303–6
 parallels with other forms of art 300–1
 see also music
Jazz Singer, The 285
Jeannerod Marc, on watching a clown 524
Johansson, Gunnar 379–80, 515
Jones, Grace, photograph by Robert
 Mapplethorpe 382
Jonic Frieze, Parthenon 405–6, 407–8
 invisibility 418–19
judgement 121
 link between aesthetics and logic 116
 requirement of vision and touch 121
Juhan, Deane 109
Julesz, Bela, Random Dot Stereogram 428–30, 429
jump cuts, cinema 446

Kaiser, Paul 515
Kandinsky, Wassily 272
 Composition VIII 484
 Rot in Spitziform 273
 synaesthesia 504–5
Kant, Immanuel 179, 240
 on aesthetic experience 534
 Critique of Judgement 168
Kastner, Frederick, colour organ 498–9
Katz, David 109
Kayser, Hans 585
Keller, Helen xii
keys, musical
 definition 325
 distance between 316–17
King Kong (film), use of motion capture 384
Kirmayer, Laurence 165–6
Kitagawa, N. and Igarashi, Y. 94
knowledge 116
knowledge assimilation, vision as requirement
 for 61–2
Knowles, Alison, giant salad 230
kōdō 172, 173–4
Koelsch, S. et al. 324
Köhler, Wolfgang 272
Korsemeyer, Carolyn 244, 247
Kounellis, Jannis 11–12
Kracauer, Siegfried 154
Kroeber, Alfred, on touch 66–7
Krüger, Johann Gottlob, colour harpsichord
 (clavecin oculaire) 497, 498
Krumhansl, C.L. 324
 Cognitive Foundations of Musical Pitch 312,
 316–17
Krytias Ephebe, Giovanni Becatti 420–1
Kubrick, Stanley, 2001 286
Kupfermann, I. 221–2
Kuusisto, Stephen, The Planet of the Blind x–xi

Laird, 95
lambertian surfaces 419
language v–vi
 description of smells, Outsidien xiii–xiv
language hypothesis of music 335
 predicted affective responses 337, 342
language processing, involvement of mirror
 neurons 457
Laocoon, G.E. Lessing 119
 torch-show 431–2
La Schiavona, Titian 71, 73
Late Roman art industry, Alois Riegl 121
Latin music 306–7
Le Corbusier 585
 Chaise Longue 551
Lederman, S.J. et al. 88, 609
Leeuwenhoek, Antoni van 28
 perceptual portrait 29
Leonardo da Vinci
 Benois Madonna 386

Leonardo da Vinci (continued)
 contrasting views of sculptors and
 painters 75–6
 and linear perspective 369
 *Motto and emblems on fictive marble
 background* 72
 Portrait of Ginevra de' Benci 70–1, 72
 on primacy of vision 61
 study of emotional expression 383
 on superiority of painting 117, 422–3, 427–8
 surveying technique 425
Lerdahl, F. and Jackendoff, R., Generative
 Theory of Tonal Music (GTTM) 316
Lessing, G.E. 240
 Laocoon, torch-show 431–2
 on visibility 119
Levin, David Michael 588
Life of Forms, Henri Focillon 123
LifePlus (interactive drama) 602–3
lighting 373–4
light, speed of 268
limbic system 187
Limen, Rosalyn Driscoll 108
Lindauer, M.S. et al. 544
linear perspective 368–71, 386
*L'invention d'Athènes. Histoire de l'oraison funèbre
 dans la cite classique*, Nicole Loreaux 405
Lipps, Theodor 459
Liszt, Franz 256–7
 caricature 259
 theatricality 258–60
literature 2
 description of sensory deficits x–xii
Locher, P., Smets, G., and Overbeeke, K. 552
L 'Œil et l'esprit, Maurice Merleau-Ponty 460–1
Loewy, Raymond 543
 MAYA principle 521, 560–1
logic, relationship to aesthetics 116–18
Longo, Simon, DITHERNOISE 277
Loops, The OpenEnded Group 516
Lord of the Rings (film), use of motion
 capture 384
Loreaux, Nicole, *L'invention d'Athènes.
 Histoire de l'oraison funèbre dans la cite
 classique* 405
Lota, Rosalyn Driscoll 143–4
loudness of music 276, 280–1, 345
 adaptation to audience 298
 influence on drinking behaviour 214
 influence on purchasing behaviour 213–14
Lucretius
 on vertigo 25
 on visual perception 385
Ludovici, Anthony M. 146
Lumet, Sidney, *Twelve Angry Men*, use of
 viewpoint 372
lure of cinema (Kracauer) 154

Mach, Ernst 43
 on after effects of body rotation 47
 perceptual portrait 44
 on visual orientation 49–50
Machine, Tonu Oursler 285
Macia, Oswaldo, *Smellscape* 179, 200
Madonna, Christ Child and Young Baptist,
 Michelangelo 69
Magic Forest, Andrew Carnie viii
Malinowski, S. and Turetsky, L., Music Animation
 Machine (MAM) 506, 507
Mandrou, Robert 584
Manet, Edouard, *Execution of the Emperor
 Maximilian* 387
Manifesto of Tactilism, F.T. Marinetti 143
Mantegna, Andrea 411–12
 Dead Christ 372
 Martyrdom of St. James 411–12, 414, 416
 St. Jacob 413–14
 St. Peter, terracotta statue 411–12, 413
manual labour, sculpture as 74–7
Man With an Antique Male Torso, Giovanni
 Battista Moroni 77
Man with a Statuette of St Sebastian, Paolo
 Veronese 77
Manzoni, Pierre, egg-eating performance 209
Mapplethorpe, Robert, photograph of Grace
 Jones 382
Marinetti, F.T. 169, 230
 Futurist Cookbook 208
 Manifesto of Tactilism 143
Marks, Laura 151, 152
Marks, L.E. 485–6
Martyrdom of St. James, Andrea Mantegna 411–12,
 414, 416
Marx, Karl 244
masking effect, visual perception 439
Massumi, Brian 248, 249
Masurca Fogo 519
match-on-action cuts 439
material properties, assessment, auditory
 cues 94–5
mate selection, role of smell 194–5
Matrix, The (1999), illusion of
 non-mediation 607
Matteucci, Carlo 32
Maur, Karin von, *The Sound of Images* 505
maximum effect for minimum means
 principle 555
maximum-likelihood account of sensory
 dominance 91–2, *93*, 135–6
MAYA (Most Advanced Yet Acceptable)
 principle 521, 560–1
McCarron, A. and Tierney, K.J. 214
McClintock, M.K. 196
McElrea, H. and Standing, L. 214–15
McGregor, Wayne, *AtaXia* 537

McGurk effect 163, 266, 269, 482
 cross-cultural variation 165
McLaughlin, John, *The Floating Point* 307
meaning
architectural 576–7
processing of, role of mirror neuron system
 456–7
meaningful properties, designed products
 556–7
 challenges and surprises 561–3
 determinants of recognition 557–60
 novelty 560–1
meaning of art 115
Melanesia, audio–olfactory synaesthesia 166
Méliès, Georges 600
Melodic Intonation Therapy 280
melodic originality 561
melody, definition 325
Melody at Night with you, The, Keith Jarrett's
 recording 299
memory
 association with music 248
 association with smell 186, 187–8, 199–201, 242,
 248
 effect of taste and smell, Proust's
 description xiv–xvi
 for events in films
 effect of cuts 444–5
 effect of pauses 445–6
memory cues, in aesthetic touch 111
Mendelssohn, Felix 280
Ménière's disease 40
menstrual synchrony, role of pheromones 196
mental imagery
 blind people 467–8
 influence of visual experience 466
 in response to art vi–vii
mental rotation 431
Mercurio-David, Donatello 420
Merker, B. 335
Merleau-Ponty, Maurice 122, 123, 151, 155, 460,
 573, 591
 on interaction of the senses 594–5
 L 'Œil et l'esprit 460–1
 and the 'total experience' 124–6
Merz, Mario 11
 spiral tables with fruit 209
Messiaen, influence of natural sounds 296
metal imagery, blind people, case study of E.A.
 (blind painter) 468–76
metaphor explanation, synaesthesia 164–5
metaphysical poetry vi
Meyer, Leonard, *Emotion and Meaning in
 Music* 312, 313
Michelangelo
 focus on hands 79–80
 Madonna, Christ Child and Young Baptist 69

Moses 79
 poetry 78–9
 reliance on touch 64
 on sculptural tactility 78
 as subject of cartoon 75
 unfinished surfaces 68–9
microscopy, development of 28–31
Milinski, M. and Wedekind, C. 196
Miller, G.F. 334
Milliman, R.E. 213–14
mingled bodies, philosophy of, Michel
 Serres 590–1
minimal solutions 555
Miracle of the new-born child, bronze,
 Donatello 415
Miró, Joan, *Homme et femme* 367
mirror neuron system 16, 381, 455–6, 524, 533–4
 activation by abstract art 460
 degree of activation
 relationship to familiarity of action 458–9
 relationship to nature of observation 458
 functions 456–7
 link to creativity 460–1
 role in social cognition 461–2
 significance in art 458–61
mirrors, painting techniques 375–7
Mithen, Steven v
modality appropriateness hypothesis 90–1
modern objectivism 125
modulation of sensory information 162–3
 cross-cultural variation 165–6
Modulor system, Le Corbusier 585
Molyneux's problem 63, 65
Montagu, Ashley 589
Montes, Aurelio 217
Montessouri, Maria, educational method 143
monumental sculpture, haptic verification 139–40
Monument of the Blessed Ludovica Albertoni, Gian
 Lorenzo Bernini 80, *81*
mood regulation, as motivation for listening to
 music 343
moods 332
 see also affective responses
Moonraker (Gilbert 1979), shot sequence 435–6,
 437
Moore, Henry 391
Moreau, Gustave 169
Moroni, Giovanni Battista, *Man With an Antique
 Male Torso* 77
Moses, Michelangelo 79, 80
'motherese' 279
mothers, recognition of smell of babies 194
motion capture technique 384, 515, 614
motor theories of cognition 524
 and illusion of non-mediation 607
Motto and emblems on fictive marble background,
 Leonardo da Vinci 72

movement
 involvement in touch 109
 perception 533
 pictorial cues 377–9
 biological motion 379–84
 role in event segmentation 442
 role in focussing attention 520–1
movement sense 39, 51–2
 body rotation, after effects 42–7
 clinical studies 48–9
 vertigo 39–42
 vestibular system 47–8
 visual orientation 49–50
Müller, Johannes
 perceptual portrait 27
 specific nerve energies doctrine 22, 28, 32
multidisciplinarity 251
multilevel representation, film
 comprehension 446–7
multisensory aesthetic experience 544–5
 designed products 546, 563–4
 meaningful properties 556–63
 structural properties 546–55
multisensory Archaeology of Knowledge 243
multisensory artworks 10–13
 use of new media 13–14
multisensory experience, ethical dimension 247–8
multisensory perception 2–3, 85–6, 100–1, 584
 of architecture 575, 595–7
 auditory contributions to tactile
 perception 92, 94–5
 consequences of sensory loss 97–9
 consistency of impressions 560
 cross-cultural variation 165–6, 177–8
 Desana Indians 174–6
 Japanese 'way of incense' 172–4
 Shipibo-Conibo Indians, healing arts 170–2
 cultural influences 99–100
 Desana Indians 174–6
 of food and drink 208–10
 interaction of vision with other senses 592,
 594–5
 neuropsychology 162–4
 synaesthesia 164–7
 olfactory contributions to tactile
 perception 95–6
 sensory dominance 86–90
 early theories 90–1
 maximum-likelihood account 91–2, 93
 visual music 482
 way of incense (kodo) 172–4
 see also synaesthesia
multistable images 353
Muniz, Vik
 Atalanta and Hippomenes, after Guido Reni 352
 clouds as recurring theme 353
 Individuals 354

interest in science 351–2
 Pictures of Magazines 355–6
 'Principia' 356–7
muscle sense 20, 33–6
musculature, tactility of cinema 151–2, 154–6
Museum of Pure Form 605
music
 absolute 253
 adaptation to audience 298
 adaptive value and function 334–5
 affective responses 335–7
 predictions for costly signalling
 hypothesis 337, 340–1
 predictions for emotion hypothesis 337,
 338–40
 predictions for language hypothesis
 337, 342
 predictions for social bonding
 hypothesis 337, 342
 temporal entrainment as source 342
 art music, development 253–7
 association with dance 524–5
 association with memory 248
 basic components 275–6
 biological aspects 332–3
 Cage, John 260–2
 challenging expectations 298–9
 cognitive science of 311–12
 communication of emotions 343–4
 composition 301–3
 concert halls 254–5
 conductors 256
 costly signalling hypothesis 340–1, 343–5
 creation of new works 345
 discursive conception 260
 disposition of players 255–6
 effect on food choices 212–14
 effect on rate of food and drink
 consumption 214–17, 230
 embodied 281–3
 emotional responses 294–6, 312–13, 323–4,
 329–30
 emotion hypothesis 338–40
 environmental sounds, use of 276, 278
 expectation 313–14
 groove 297
 history and culture
 Latin music 306–7
 urban music 306
 imitation of natural sounds 296
 impact of reproduction technologies 261
 improvisation 303–6
 influence on wine-making process 217
 influence on wine tasting 217
 language hypothesis 342
 learning 308–9
 link with vision in non-synaesthetes 485

listening to 308
Liszt, Franz, theatricality 258–60
loudness 345
MAYA principle 561
mirroring of composer's interests 297
physiological reactions, association with
 expectancy violations 323
piano pieces, identification from key-touching
 movements 274–5
'pitch of harmony' 216
response to 283, 297
sensory pleasantness 547
sight-reading, role of planum temporale
 272, 274
social and emotional aspects 278–80
social and individual aspects 299–300
social bonding hypothesis 342
surprises 562–3
and trance states 299
universals 333
unplayable works 260
visual 481–2
 animated synaesthetic experiences,
 appreciation by others 487–90
visual perception 252
see also jazz
musical experiences 336–7
musical involvement, motivation 343
musical skill 345
musical space 280–1
musical tension 314
 Tonal Pitch Space (TPS) model 314–18
 application to Chopin's E major
 Prelude 318–22
music analysis 252
Music Animation Machine (MAM) 506, 507
musicians, blind 269–70
music therapy 280
music videos 284
Muybridge, Eadweard, chronophotography 379
 Woman descending a staircase 380
Mysterious Hand, The (Roman bronze) 593

Narmour, E. 314
narrative comprehension, cinema 446–8
narrative devices, cinema 438–9
Natanson, Ludwig 38
natural harmonics 279
Natural Magic, David Brewster 86
natural sounds, imitation in music 296
neural synaesthesia 509–10
neuroaesthetics 530–2
 of dance 532–3
 correlates of implicit aesthetic responses 535
 feedback to choreographic process 538–9
 interaction of artists and scientists 537–8
 mechanisms of seeing dance 533–4

relationship of response to type of
 movement 535–7
neuroplasticity 466
 in blindness 467
 fMRI study of E.A. (blind painter) 469, 471,
 472–3, 474–5
neuropsychology
 Desana Indians' theories 176
 limitations 514
 of synaesthesia 507–10
Newton, Isaac, on relationship of pitch to
 colour 496, 497
Nielsen, T.I. 609
Nietzsche, F.W. 243
Noë, Alva, on Richard Serra's Fulcrum 140
noise 276
Noli me Tangere, Jacopo Pontormo,
 Michelangelo's design 79–80
non-adjacent dependencies 323
non-mediation, illusion of 606–8
North, Adrian 212–13, 217
notation, musical 253
novelty 560–1
 relationship to interest 521
number of senses 20, 589–90
nystagmus, post-rotational 52
 clinical studies 48–9
 early studies 44–6
 William James' account 48

objective impression 109
objectivist theories of aesthetics 530
object recognition, pictorial cues 364–8
observer-centred structures, classical Greece 407
octave generalization, tonal systems 333
ocularcentrism 60–1
 in pre-Modern era 61–2
odorant binding proteins (OBPs) 184
odorants 184
odour see smell
odour–taste synaesthesia 164
OK Go, video performances 513
Oldenburg, Claes, fictional giant food items 209
olfactory cues see smell
olfactory pathways 187
olfactory receptor neurons (ORNs) 184–5, 186
olfactory systems 184
 human 184–5
olfactory unconscious 242, 247
On the Sublime and Beautiful, E. Burke 120
openness, pictorial cues 386–7
opera houses 254–5
operational diagram, painting as 127
Oppenheim, Meret, Fur Covered Cup 208
optical correction 573
orchestras, arrangement of 255–6
Orfaly, Mark 301

Osborne, Harold 169, 172
Osby, Greg 294
Oursler, Tony 285
outflow theories 34
Outsidien, Sissel Tolaas xiii–xiv
Over the Rainbow
 deceptive cadence 315
 expectations 313–14
oysters, flavour perception, influence of
 environmental sounds 225–6

pain, sensory spots 38
'painterly fact' (Deleuze) 128
painter-sculptors 413
painting
 case study of E.A. (blind painter) 468–76
 Deleuze's account 126–9
 nature of 118
 superiority over other arts 117
 'total experience', Merleau-Ponty 124–6
paintings
 musical 503–5
 viewing
 eye movements 385–7
 training in 391
Pallasmaa, Juhani
 door pull studies 591
 Summer atelier of a painter 587
Palmer, Stephen E., *Vision Science: Photons to
 Phenomenology* 419
Panofsky, Erwin, on perspective 62
paradox of fiction 601
paragone debate 69–73, 80, 121, 122
 Agnolo Bronzino's stance 77
'parchment skin' illusion 92, 94
pareidolia 365, 368
parietal cortex, activation during drawing 473–4
parrots, entrainment, musical 282
Parthenon, *Jonic Frieze* 405–6, 407–9
 invisibility 418–19
Parthenon, Nashville 408
particulate principle, music 333
Party Number One, Michael Petry 144
Pathosformel theory, Aby Warburg 459
pattern recognition 354, 366–7
pauses in cinema 445–6
Pavlov, Ivan 221
peak-shift effect 516–17, 557–8
Pebble Box 614–15
Peers, Heather 10, 179
Peirce, C.S. 243
perception, rationalization of xi
perception-action cycle 385
perceptual consistency 373
perceptual fidelity 610
perceptual gestalts, flavour perception 208
perceptual grouping, role of contrast 548

perceptual learning 379
perceptual portraits 19–20
perfect intervals 279
perfume, facsimiles of commercial
 fragrances 247
Perfume, Patrick Süskind 193, 546
perfume choice, relationship to HLA type 196
'period eye' 3
peripersonal space 134
Persepolis Event. Shiraz Art Festival 520
personal space, link to touch 134
perspective 13–14
 in frescoes 413–18
 and subjectivity 62
Petry, Michael, *Party Number One* 144
phantasia kataleptike 385
phantom limb images, Alexa Wright xii–xiii,
 xiv, xv
phenomenology 116, 572, 589
Phenomenology of Perception, Maurice
 Merleau-Ponty 125
pheromones
 role in menstrual synchrony 196
 smell of fear 196
philosophical approach to the arts 129–30
philosophy, impact of vision 582
phobia, survival value 340
photography
 limitations 369–70
 manipulation of lighting 373
 of sculpture 137–9
physical object properties, relationship to
 aesthetic evaluation 545
physical responses to art vi
physics, rules of, transgression in paintings 374,
 375–7, 390
physiological reactions to music 323
piano pieces, identification from key-touching
 movements 274–5
Piazza d'Italia (Souvenir d'Italie), Giorgio De
 Chirico 370
Picasso, Pablo 14
pictorial cues 359, 361, 390–1
 depth perception 368–71
 illumination 373–4
 motion 377–9
 biological 379–84
 object contours 361–4
 object recognition 364–8
 reflection 375–7
 transparency 374–5
picture perception, influence of experience
 379, 383
Pictures of Magazines, Vik Muniz 355–6
Pilgrims visiting a saint's shrine 65
Pino, Paulo, on *paragone* debate 70
pitch 275, 325

mathematical principles 496
 and nature of objects producing sound 278–9
 relationship to visual lightness 486–7
pitch attractions 314–15
'pitch of harmony', beer tasting 216
Piulfrich, Carl 395–7
Planet of the Blind, The, Stephen Kuusisto x–xi
planum temporale, role in audiovisual
 integration 272, 274–5
Plaster Cast of Head and *Drawing 138*, Claude
 Heath 145
Plaster casts, Hippolite Bayard 137, 138
Plastic Art, J.G. Herder 120–4
Plato
 on relationship of pitch to colour 496
 on space 571
 on touch 22, 61
 on vision 582
Platter, Felix
 perceptual portrait 40
 on vertigo 40
Playing the Building installation, David
 Byrne 284, 306
Pliny the Elder, on illumination 373
'plonk paradox' 229
Plotinus 62
pneuma concept 22
Poetic Justice, Tania Bruguera 209
poetry, superiority of painting 117
point light walker stimuli 379, 381, 515
Pompeii, *LifePlus* (interactive drama) 602–3
Pontormo, Jacopo, *Noli me Tangere*,
 Michelangelo's design 79–80
Porterfield, William, on after effects of body
 rotation 44–5
Portrait of Ginevra de' Benci, Leonardo da
 Vinci 70–1, 72
Portrait of Jacopo Strada, Titian 64, 66, 77
Portrait of Pierantonio Bandini with a Venus
 Pudica *Statuette*, Agnolo Bronzino 77, 78
Portrait of Ross in L.A., Felix Gonzales-Torres 137
positron emission tomography (PET), study of
 emotional response to music 324
Posner, M.I. Nissen, M.J. and Klein, R.M. 90
postcentral gyrus 190
pregnancy, changes in smell and taste 198
pre-Modern era, and touch 61–3
premotor system, modes of operation 457
preservation of artwork, conflict with
 accessibility 14–15, 136–7
priming of audiences 517–18
Prinz, Jon 219
prior entry, law of 269
problem of shape, The, Adolf von Hildebrand 122
product evaluation
 influence of auditory cues 94
 influence of olfactory cues 96

programme music 257–8, 339
prolongational tree, Tonal Pitch Space (TPS)
 model 317
 in Chopin's *E major Prelude* 319–21
Prometheus, Poem of Fire, Alexander Scriabin
 501, *502*
proportion 550–2
proprioception, visual bias over 611
proprio-ceptors 36
 see also muscle sense
n-propylthiouracil (n-PROP), supertasters
 189–90
prosody 279
prototypicality of objects 557–60
Proust effect 200, 201
Proust, Marcel 412
 In Search of Lost Time xiv–xvi, 200, 242, 591
Psycho, musical score 286
Ptolemy, on vertigo 25
Pulpit of the Resurrection (*The Pentecost*),
 Donatello 417, *418, 419*
pupil diameter, responses to event
 boundaries 441
Purkinje cells 29, *31*
Purkinje, Jan Evangelista 29
 perceptual portraits *31, 46*
 on vertigo 42, 46–7
Purple Rose of Cairo, The (film) 599, *600*
Pythagoras, on pitch 496
Pythagorean harmonics 581, 585

Quay Brothers, *The Street of Crocodiles* 149–50
quinquin, Shipibo-Conibo term 170–1

Raban, Jonathan, *Coasting* xi
Radcliffe Camera as a Celebration Cake, The,
 Helen Ganly and Heather Peers 10, *11*, 179
Radford, Colin, paradox of fiction 601
radio
 imagery production 262
 RCA Victor Golden Throat Radio 262, *263*
radios, use by John Cage 261–2
Raffaello, on surveying technique 425
'rainbow effect', *Aftertrace*, Georgia
 Chatzivasileiadi 15–16
Ramachandran, Vilayanur ix, 164–5, 548
 principles of aesthetic experience 516–17
Rancière, Jacques 239
Random Dot Stereogram 428–30, *429*
 application to astronomy 431
Rape of a Sabine (marble), Giambologna *68*
rapid visual categorization 365
ratio, golden 550–1
Rauschenberg, Robert, white paintings 517
RCA Victor Golden Throat Radio 262, *263*
reader-response criticism (reception theory) 59
readiness-to-hand 141

reading, perceptual-motor activation 448–9
reading comprehension, multilevel
 representation 446
reality 599
 see also illusion of reality
recapitulation, music 302
reception theory (reader-response criticism) 59
receptive field 32
receptors
 cutaneous 38
 discovery of 30–1
 olfactory system 184, *186*, 191
 to taste 188–9, 191
recognition 352
recruitment of sensory-specific areas 163
rectangular proportions 550–2
red, stimulation of limbic system 388
Red Balloon, The (Lamorisse 1956), study of
 cuts 442–3
Redfield, Robert 168
redundancy hypothesis 162
referred sensation 28
reflection, painting techniques 375–7
refraction, in depiction of transparency 375
Reid, Thomas 36
religious practices, role of touch 64, *65*
Relph, Edward 596
Renault Alpine car, symmetry *553*
replication of music 344
representation 116
reproduction of artworks 15
reproductive status, communication by smell 197
restoration, contemporary artworks 14–15
retinal disparity 401
reverberation 281
reward system 188, 388
 link to hedonic responses 531–2
Reymond, Emil du Bois 32
Reynolds, Joshua 254
rhythm 276, 281–2, 525
 see also entrainment, temporal
rhythmic activities, comparison between body
 and film 157
Richter, Gerhard 398
 Great Sphinx of Gise 398–400, *401*
Richter, Gisela, on *Ionic Frieze* 409
Riegl, Alois
 'Egyptian' way 127–8
 Late Roman art industry 121
Rilke, Rainer Maria 595–6
Rimington, Alexander, colour organ 499–501, *500*
Ritratto di Madame M.S., Gino Severini *366*
Ritter, Johann Wilhelm 36–7
 on vertigo 42
ritual, in classical concerts 254
Rizzolatti, G. and Craighero, L. 533
Robbins, Jerome, *Glass Pieces* 519

Rock, I. et al. *87*
Rockwell, Norman 398
 depiction of stereoscope *399, 400*
Röder, B. et al. *97*
Rodin, Auguste
 drawing technique 146–7
 portrayal of motion 381
Romera, Michel Sánchez 209
rotating rectangle 379
Rot in Spitziform, Wassily Kandinskij *273*
rotoscoping 384
Rowan-Hull, Mark 272, *274*
Rozin, Elizabeth and Paul 561
rubber hand illusion 611–12
Russolo, Luigi 276, 306
 audiovisual art objects 287

saccadic eye movements 385
 comparison with 'cuts' in movies 371, 438–9
saccadic narratives 355–6
Sachs, Oliver 595
Saint Francis as Brother Wind, Fiorenzo Bacci,
 photography , Photoshop adaptations *362*
Saldaña, H.M. and Rosenblum, L.D. 268
salient stimuli, dance 519–20
Samper, Gereard 228
sandalwood, smell of 199
Satre, Jean-Paul 592
Savoldo, Gian Girolamo, *Gaston de Foix* *71*
saxophone
 communication of emotions 296
 elements of a good solo 304–5
scales, musical 325
scene breaks, cinema 438
Schleef, Einar, production of *Salome* 518
Schleiden, Matthias 29
 perceptual portrait *30*
Schönberg, Arnold 260, 504
 tonal system 333
Schopenhauer, A. 254
Schulz, Bruno, *The Street of Crocodiles* 153
Schumann,, on Liszt's *Etudes* 259
Schwann, Theodor 29
 perceptual portrait *30*
Schwan, S. et al. 445
scientific advancement
 response of artists 15
 see also technology
scientific knowledge, impact on experience of
 sensing 125
scientific language, A.S. Byatt's use vii–viii
scientists, interaction with artists 537–8
Scriabin, Alexander
 coloured hearing 501–3
 colour–key correspondences *503*
 Prometheus, Poem of Fire 502
sculptor–painters 413

sculptural technique 423–7
sculpture
 creative and exploratory touch 141–7
 link with touch 120–1, *121*
 monumental 139–40
 multisensory perception 544
 photography 137–9
 portrayal of motion 381
 Sentinels, Carole Andrews 12, *13*
 tactile access 136–41
 tactility
 Early Modern Italy 63–9
 paragone debate 69–73
 use of fabricators 12
 virtual 605
Sculpture inside and out, Malvina Hoffman 141
Second Life 604
 illusion of transportation 611
'Seeing' and 'Hearing', Cattrell, Annie ix, *x*
seizures, prevention by conditioned smells 200–1
self, experience of 591
 relationship to space 595–6
self-knowledge 561–3
self-motion, illusions of 612–13
self-occlusion 428–9, *430*
senses, interactions 1
Senses and Society, The (journal) 60
sensibilia 116
sensory aesthetic responses 531
sensory deficits ix–x
 description in literature x–xii
 recruitment of sensory-specific areas 163,
 269–70
 smell loss 201–2
 see also blindness
sensory dominance 100–1, 135–6, 163
 early theories 90–1
 influencing factors 90
 maximum-likelihood account 91–2, *93*, 135–6
 touch, dominance over vision 89–90
 vision, dominance over touch 86–8
sensory feedback 558–9
sensory hierarchy 239–40, 242, 249
 contemporary reversal 243–4
sensory loss, consequences for multisensory
 perception 97–9
sensory-specific satiety 560
sensory 'spots' 38
sensory understanding 592
sensotypes 99–100
sensuous unconscious 242
sensus communis 126, 135, 509
'sentence form', music 313
Sentinels, Carole Andrews 12, *13*
separable components of music 275
Sepulchre of the Haterii, bas-relief, Rome *404*,
 404–5

Serra, Richard, *Fulcrum* 139–40
Serres, Michel, philosophy of mingled
 bodies 590–1
Sesonske, Alexander 154, 156
Severini, Gino, *Ritratto di Madame M.S.* 366
sexual attraction, role of smell 547
sexual function
 effect of taste and smell 201–2
 importance of smell 186
sexual magnetism, in musical performance
 259–60
sexual selection, in evolution of music 334, 340–1
shading, role in depth perception 420–2
shadows
 painting techniques 370, *374*
 role in shape recognition 422
Shams, L. et al. 267–8
Shannon, Claude 312
shape, sensitivity of visual system 388
shape constancy 428–9
shape recognition, role of shadows 422
sharp corners, expressive power 388
Sherman, Cindy, *UNTITLED n. 246* 360–1
Sherrington, Charles
 on muscle sense 35–6
 perceptual portrait *35*
Shipibo-Conibo Indians
 geometric design *170*
 healing arts 170–2
Shkovsky, Viktor 285
Shorter, Wayne 304
Shove, P. and Repp, B.H. 282
silence, in John Cage's work 262
similarity of stimuli, role in aesthetic
 judgement 549–50
Simonton, D.K. 561
sister arts, painting and poetry as 117
situation models *see* event models
sixth sense 50–*1*
 muscle sense as 33–6
 recognition of 20
size perception, auditory cues 94–5
skeleton system approach, computer graphics 383
skin, haptic qualities of cinema 151, 152–4
skotoma (vertigo), Galen on 39–40
Sloboda, J.A. 323
Sloterdijk, Peter 582
Small, Christopher 283
smell 183–4, 202
 association with memory 186, 187–8, 199–201,
 242, 248
 Proust's description xiv–xvi
 central pathways 186–8
 changes in sensitivity
 hormonal effects 197–8
 to hormones 198
 in classical Islamic civilization 242–3

smell (continued)
 communicability 241
 contribution to tactile perception 95–6
 cultural significance for Dessana Indians 175
 Galileo's account 23–4
 in history of Western philosophy 240
 importance 185–6
 influence on behaviour 546–7
 of jasmine 247
 loss of 201–2
 mechanism of 184–5
 oil of truffles 241
 Outsidien, Sissel Tolaas xiii–xiv
 perception of, consequences of blindness 97
 personal associations 240–1
 pleasant, association with holiness 199
 receptors 191
 relationship to health 198–9
 repression of 241, 242, 245
 role in communication
 advertising your genes 196
 fear and happiness 196
 mate selection 194–5
 menstrual synchrony 196
 reproductive status indication 197
 role in flavour 192
 role in sexual attraction 547
 as a social sense 248–9
 specific anosmias 198
 and starvation 199
 synthetic 247
 unique body odour 193–4
 Untitled, Clara Ursitti 202–3
 as warning signal 191–2
Smell + Apocrine gland secretion transfer system,
 James Auger 194–5
smell conditioning 200–1
Smellscape, Oswaldo Macia 179, *200*
Smith, David, *Cubi* 113
Smith, J.D. and Melara, R.J. 563
Smith, P.C. and Curnow, R. 213–14
Snow White (film), use of motion capture 384
soap, marketing 245
Soares, Susana, *BEE'S* 199
Sobchak, Vivian 155
social aspects of music 299–300
social bonding hypothesis of music 335
 predicted affective responses *337, 342*
social cognition, role of mirror neuron
 system 456, 457, 461–2
social intelligence v–vi
social status, painters versus sculptors, Early
 Modern Italy 74–7
Sontag, Susan 522
Sony–Ericsson mobile phone, use of
 contrast *548*
Souk al-Hamadiya, Damascus 246–7

sound
 contribution to tactile perception 92, 94–5
 Galileo's account 24
 sensory pleasantness 547
 speed of 268
sound-induced flash illusion 267–8
Sound of Images, The, Karin von Maur 505
sound sculptures, Harry Bertoia 287, *288*
'Sounds of the Sea" seafood dish, *The Fat
 Duck* 227
Sound–vision synaesthesia 483, 484–5
 animated reproductions, appreciation by
 others 487–90
 relationship of pitch to visual lightness
 486–7
space
 human 571–2
 palpability 112–13
 pictorial cues 386–7
 relationship to sense of self 595–6
spatial judgement, dominance of vision over
 audition 268
spatial position, influence on sensory
 dominance 90
specific nerve energies doctrine 22, 28
spectators, coparticipation in art 16–17
speech interpretation, role of planum
 temporale 272
speed lines 378
Spence, Charles 178
 experiments at 'Art and the Senses'
 conference 222–6, *223*
spiral tables with fruit, Mario Merz 209
Srinivasan, M. 216–17
stability—tension theory, music 315–16
'star conductors' 256, *258*
starvation, smell of 199
static graphic artefacts, activation of mirror
 neuron system 460
static images, activation of mirror neuron
 system 458
Steichen, Edward, lighting techniques 373
Steinbeis, N. et al. 324
Steiner, Rudolf, twelve senses 590
Sterbak, Jana, *Vanitas: Flesh dress for albino
 anorectic* 209
stereoscope 138–9, 395–7, *396*
 impact on linear perspective 370
 Norman Rockwell's depiction 398, *399, 400*
 Vik Muniz on 356
Stevenson, R.J. and Boakes, R. 164, 167
Stevens, Wallace 596
St. George and the Dragon, bas-relief,
 Donatello *409–10*
St George (lost painting), Giorgione 71
still life paintings, multisensory nature 11
Stillwell, Richard 406

stimulus, relation to sensation, Galileo's
 account 22–3
St. Jacob, Mantegna, Andrea 413–*14*
Stoffregen, T.A. et al. 610
Stokes, Adrian 595
stop-motion animation, tension between
 continuity and discontinuity 157–8
St. Peter, terracotta statue, Mantegna,
 Andrea 411–12, *413*
Strange Days (1995), illusion of non-
 mediation 607
Strauss, Eduard *258*
Stravinsky, Igor 343
Street of Crocodiles, The (novella, Bruno
 Schulz) 153
Street of Crocodiles, The (Quay Brothers
 film) 149–50
 tactility
 musculature 154–6
 skin 152–4
 viscera 156–8
structural properties, designed products 546–8,
 547–8
 balance 550–3
 contrast 548–9
 similarity 549–50
 unity in variety 553–5
structure
of dance 521, 522
of music 302–3
subjective fidelity 609
subjective impressions, touch 109
subjective theories of aesthetics 530–1
subject–object split, transcendence 141
sugar cubes as a medium 10–11
superadditive signals 163
superior temporal sulcus (STS)
 audiovisual processing 271
 biological motion processing 515–16
super-stimulus, role in visual preference 387
surface dissonance 317
 in Chopin's *E major Prelude* 319–20
Sur, M. 163
surprising designs 562–3
surveying technique 425
Süskind, Patrick, *Perfume* 193, 546
suspension of disbelief 600
symbolic idea of form 118, 118–19
symbolism, musical titles 503–4
Symbolist Movement 169
symmetry 552–3
synaesthesia 483–5, 495
 animated reproductions, appreciation by
 others 487–90
 audiovisual 271–2
 relationship of pitch to visual lightness *486–7*
 cultural biases 490–1

Desana Indians 174–6
differences between artistic and neuroscientific
 perceptions 507–9
and engagement in the arts 487
in music 300–1
neuropsychology 164–5
 cross-cultural variation 166–7
relationship to abstract art 490–1
Shipibo-Conibo Indians, healing arts 170–2
taste–sound, beer consumption 216
way of incense (kodo) 172–4
see also coloured hearing
synchronaesthesia 509–*10*
synthetic smells 247
systems of the arts 122
 Herder's challenge of 122

tactile access to sculpture 136–41
Tactile Eye, The, Jennifer M. Barker 151
tactile perception, in vision 596–7
tactility 119–22
 of food and drink 208
 value of 123
 see also touch
tactual balance 552, *553*
tactual feedback 558
tailor shop scene, *The Street of Crocodiles* 153
taste 183, 188, 202
 central pathways 190
 difference from flavour 192
 effect on memory, Proust's description xiv–xvi
 Galileo's account 23–4
 mechanism of 188–9
 receptors 191
 as a social sense 248
 supertasters 189–90
 as warning signal 188–9, 191
taste buds/papillae 188–9
Tax Collection , bas-relief, Saintes (France) *403*
Tax Collection , bas-relief, Treviri *402–3, 405, 428*
Taylor, Paul, *Duet* 517
Teatro La Fenice, Venice *255*
technology
 application to coloured music 505–6
 influence on music 306–7, 336–7
 response of artists 15
temperature sense 36–9
tempo of music 276, 281–2
 adaptation to audience 298
 influence on food and drink consumption 214
 influence on purchasing behaviour 213
temporal entrainment 282, 332–3
 as source of affective responses 342
temporal events, dominance of audition over
 vision 268
temporal integration, auditory and visual
 stimuli 268–9

tension graphs, Chopin, *E major Prelude* 321, 322
tension , musical *see* musical tension
test-tone records, use by John Cage 261
theatre architecture, Vitruvius 577
theatricality, in musical performance 258–60
Theophrastus, on vertigo 25
three-dimensional effects 397–8
 Ara Pacis Augustae relief and *Jonic Frieze*
 405–9
 bas-relief 402–5
 distance perception 400–1
 painter-sculptors and sculptor-painters
 409–13
 perspective in frescoes 413–18
 Random Dot Stereogram 428–30
 role of time 430–2
 sculptural technique 423–7
 shading 420–2
 subjects for stereo-pairs 398–400
 see also stereoscope
timbre 275–6
 and nature of objects producing sound 278–9
time
 in marketing of multisensory products 246
 role in space perception 430–2
time perception
 effect of background music 215
 elasticity 574
timescales of musical patterns, correlation with
 bodily activities 281–2
Tiravanija, Rirkrit 209
Titian
 La Schiavona 71, 73
 Portrait of Jacopo Strada 64, 66, 77
Tolaas, Sissel
 the *FEAR of smell-the smell of FEAR* 196–7
 Outsidien xiii–xiv
tonal centre (tonic), definition 325
tonality, definition 325
Tonal Pitch Space (TPS) model 312, 315–17
 application to Chopin's *E major Prelude* 318–22
 conclusions 323
tonal systems, octave generalization 333
tone hierarchy 317
tones, distance between 316–17
tongue 614–15
 taste papillae 188–9
top-down/bottom-up processing xi
'total experience' 124–6
Total Works of Art 504
touch
 auditory contributions 92, 94–5
 beauty through 120
 and cinematic experience 149–52
 musculature 154–6
 skin 152–4
 viscera 156–8

classical accounts 21
consequences of blindness 97, 98
creative and exploratory 141–7
division into separate qualities 36
dominance by vision 86–8, 90, 100
dominance over vision 25, 89–90, 100
and Early Modern Italian art 59–61, 63–9
Galileo's account 22–3
involvement of movement 109
link with sculpture 120–1
metaphors for mental processes 62
multiple dimensions 20–1
multisensory perception 85–6
neuroscience 133–6
olfactory contributions 95–6
paragone debate 69–73
in pre-Modern era 61–3
primacy of 590–1
reciprocal nature of 108–9
role in self-knowledge 561
sculpture
 involvement of manual labour 74–7
 Michelangelo 78–80
 sexual aspects 77
as a single sense 20
subjective impressions 109
use of the term 108
see also aesthetic touch; tactility
touchability, affordance of 140–1
Touch together, Ella Clocksin 9, *10*
'train illusion', *Jonic Frieze* 406
trances, induction by music 299
transcranial magnetic stimulation (TMS)
 occipital cortex, blind subjects 467
 posterior STS 516
transparency, painting techniques 374–5
transportation, illusion of 610–13
Treatise of sensations, Etienne Bonnot de
 Condillac 119–20, 120
tree structure, musical tension and
 relaxation 316
trespassing, art of 10
trigeminal stimulation, modulation of flavour
 perception 208
tri-tone 297
trompe-l'-oeil 11, 390
Troy (sculpture) 112
truffles, smell of 241
Twelve Angry Men (film), Sidney Lumet, use of
 viewpoint 372
twelve senses, Rudolf Steiner 590

ugliness, complexity of 119
umami 188
unity in variety 553–5
universals, in synaesthesia 508
unplayable works of music 260

Untitled, Clara Ursitti 202–3
urban music 306
Ursitti, Clara 193
 Untitled 202–3
utilization behaviour 363

valence 332
van Gogh, Vincent, interest in music 503
Vanitas: Flesh dress for albino anorectic, Jana
 Sterbak 209
*Vanitas Still Life at the Wildgoose Memorial
 Library*, Jane Wildgoose vii
Varchi, Benedetto, on *paragone* debate 70
Varèse, Edgar 278
 'Ionization' 276, 278
Vasari, Giorgio
 on Michelangelo's *Moses* 80
 on primacy of vision 62
vection illusions 612–13
Venetian painting
 illumination 373
 use of glass dust and gold 375
Veneziano, Agostino, *The Academy of Baccio
 Bandinelli* 76
ventriloquism effect 163, 267
Venus bathing (bronze), after Giambologna 67
verbal memory capabilities, blind people 474
Verdi, *Requiem*, outdoor performance, Polo
 grounds, New York City 257
Veronese, Paolo, *Man with a Statuette of St
 Sebastian* 77
Verrocchio, Andrea del
 Bust of a Lady with Flowers 72, 74
 Incredulity of St Thomas 73–4, 75
vertical distance, perception of 574
vertigo 25–6, 39–42
 postrotational 43–7, 52
 clinical studies 48–9
 in deaf-mutes 48
Vertigo (film) 372
vestibular system 47–8, 50, 52
 body rotation, after effects 42–7
 clinical studies 48–9
 galvanic stimulation studies 42
Vickers, Zata 218
Video killed the radio star, Buggles 284
Viennese Actionism 10
viewpoint, cinema 372
virtual museums, use of haptic devices 605
virtual reality 602–5
 believability 613–15
 illusion of fidelity to reality 609
 illusion of transportation 610–13
viscera, tactility of cinema 152, 156–8
Vischer, Robert, *Einfühlung* notion 459
visibility
 Lessing on 119

Merleau-Ponty on 124–5
 nature of 118–19, 124
vision
 dominance by touch 89–90, 100
 dominance over touch 86–8, 90, 100
 Galileo's account 24
 impact on philosophy 582
 interaction with other senses 592, 594–5
 link with music in non-synaesthetes 485
 in modern architecture 585–8
 necessity of knowledge 135
 supremacy of 117, 573, 582, 611
 synaesthetic experiences 483–4
 unconscious tactile perception 596–7
 see also ocularcentrism
vision, field of 571
Vision Science: Photons to Phenomenology, Stephen
 E. Palmer 419
Vision–sound synaesthesia 483–4
visual anxiety 62
visual balance 552, 553
visual capture 100
visual cortex recruitment 98, 163, 467
 fMRI study of E.A. (blind painter) 469, 471,
 472–3, 474–5
visual cues, use during eating 208
visual deficit, Stephen Kuusisto, *The Planet of the
 Blind* x–xi
visual experience, influence on mental
 imagery 466
visual lightness, relationship to pitch 486–7
visual-motor response to artworks 363
visual music 481–2, 491
 animated synaesthetic experiences,
 appreciation by others 487–90
Visual Music, Brougher, K. et al. 179
visual orientation 49–50
visual perception 354–5, 360, 390, 390–1, 467
 event segmentation 439–42
 eye movements 385–7
 inverted vision experiment 573
 motion processing 378
 slow and fast pathways 364–5
visual preferences 387–90
visuo-haptic illusions 609–10
Vitrilio, Paul 572
Vitruvius 576, 577, 579
 human figure 580
Vittoria, Alessandro, as a sitter 77
Voco, Giambatista 575
Volkswagen Beetle car 551
Volta, Alessandro 31–2
 perceptual portrait 32
 on vertigo 42
von Frey, Max 38
 perceptual portrait 37
von Hildebrand, Adolf 122

Wagner, Richard 253
Warburg, Aby, *Pathosformel* theory 459
Ward, J. Huckstep, B., and Tsakanikos, E. 486–7
Warhol, Andy, packaged food 209
warning systems
 smell 191–2
 taste 188–9, 191
War of the Worlds broadcast (1938), illusion of
 fidelity to reality 608
Warwick Olfaction Research Group (WORG)
 study 202
way of incense (kodo) 172, 173–4
Weber, Ernst Heinrich
 on muscle sense 35
 perceptual portrait 35
 on temperature sense 37–8
Wedekind, C. et al. 194
weight, judgement of 34–5
Welch, R.B. and Warren, D.H. 86, 91
Wells, W.C.
 on after effects of body rotation 45–6
 on muscle sense 34
 on visual orientation 50
Wernicke's area 272
What's Up, Tiger Lilly, Woody Allen 266
Whiteread, Rachel, *Ghost* 112
Whitney, John 505
Whytt, Robert, on vertigo 41
Wildgoose, Jane vi–vii
Williams, Dave 217
Willis, Thomas
 perceptual portrait *40*
 on vertigo 40–1
windowpane analogy, art 168–9

wine, marketing 245
wine-making process, influence of music 217
wine purchases, influence of background
 music 212–13
wine tasting, influence of music 217
Winter, Janus de, synaesthesia 503–4
Witkower, Rudolf 580
Wittgenstein, Ludwig 596
Wober, M. 99–100
Wölfflin, H. 459
Woman descending a staircase, Eadweard
 Muybridge *380*
Wong, Amanda and Spence, Charles 220–*1*
'Wooden Oesophagus' prelude, *The Street of
 Crocodiles* 149–50
Woogles *603*
work-concept, music as 253
Worringer, Willhelm 123
 "barbaric art' 128
Wright, Alexa *xv*
 phantom limb images xii–xiii, *xiv*
writing 116
Wysocki, C.J. et al. 198

X-junctions 375

Young, Thomas 26
YouTube, dance performances 513, 515

Zacks J.M. et al. 439–42
Zajonc, Robert, on familiarity 557
Zampini, M. et al. 94, 218–19, 269
Zeiss, Carl 395–6
Zotterman, Y. 38